ANTHONY VAN DYCK

D1429961

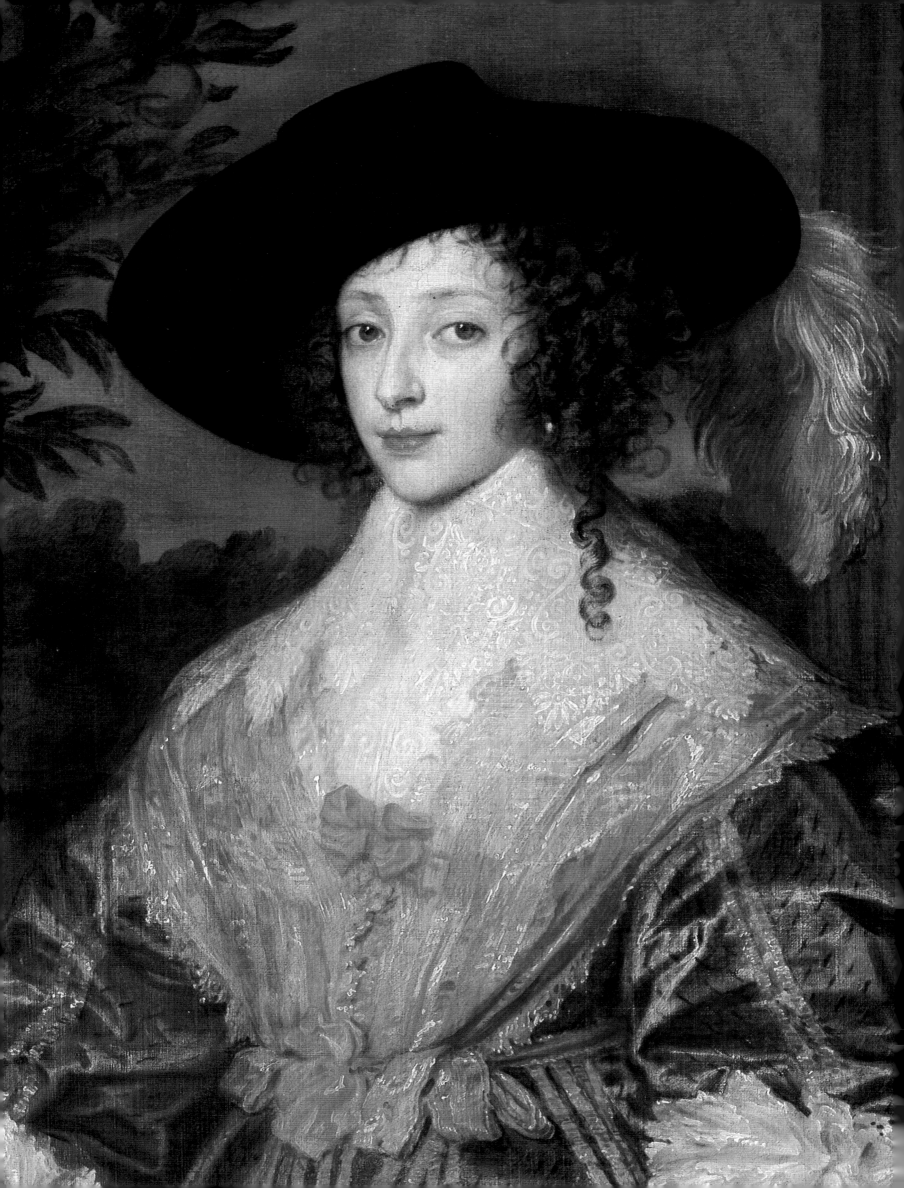

Anthony van Dyck

Arthur K. Wheelock, Jr. Susan J. Barnes

Julius S. Held

Christopher Brown Oliver Millar
Carol Christensen Jeffrey M. Muller
Zirka Zaremba Filipczak J. Douglas Stewart

NATIONAL GALLERY OF ART, WASHINGTON

Anthony van Dyck was organized
by the National Gallery of Art.
It was supported by an indemnity
from the Federal Council on the
Arts and the Humanities

Exhibition dates: 11 November 1990–24 February 1991

Copyright © 1990 Board of Trustees, National Gallery of Art. All rights
reserved. This book may not be reproduced, in whole or in part, in any
form (beyond that copying permitted by Sections 107 or 108 of the U. S.
Copyright Law and except by reviewers for the public press) without
written permission from the publishers

Produced by the Editors Office, National Gallery of Art
Editor-in-Chief, Frances P. Smyth
Edited by Jane Sweeney

Typeset by Photocompo Center, Brussels, in Palatino
Printed in Belgium by Erasmus, Wetteren
Design by Louis Van den Eede
Coordination by Paul Van Calster
Production by Ludion, Brussels

Library of Congress Cataloging-in-Publication Data

Wheelock, Arthur K.
Anthony van Dyck / Arthur K. Wheelock, Jr., Susan J. Barnes
[principal authors]... et al.
384 p. 32.5 cm.
Catalogue of the exhibition held Nov. 11, 1990–Feb. 24, 1991.
Includes bibliographical references and index.
ISBN 0–89468–155–9
1. Van Dyck, Anthony, Sir, 1599–1641— Exhibitions. I. Barnes,
Susan J., 1948– . II. Van Dyck, Anthony, Sir, 1599–1641.
III. National Gallery of Art (U.S.). IV. Title.
ND673.D9A4 1990
759.9493—dc2090–6631
CIP

Cover: **Anthony van Dyck,** *Rinaldo and Armida* **[cat. 54], detail.**
The Baltimore Museum of Art

Back cover: **Anthony van Dyck,** *Clelia Cattaneo* **[cat. 35], detail.**
National Gallery of Art, Washington

Frontispiece: **Anthony van Dyck,** *Queen Henrietta Maria with Sir Jeffrey*
Hudson **[cat. 67], detail. National Gallery of Art, Washington**

Note to the Reader
Dimensions, height before width, are given in centimeters
followed by inches in parentheses

Table of Contents

Foreword

Van Dyck belonged to a generation of artistic giants including Bernini, Velázquez, and Rembrandt who were born at the dawn of the seventeenth century. Like them he gave distinctive and enduring visual form to the societies he knew. These extended from Flanders and Italy to the court of King Charles I in London. His style, a beautiful blend of the grand and the natural, the formal and the intimate, the epic and the personal, made him one of the most sought-after artists in his day and an inspiration for later artists as diverse as Sir Joshua Reynolds and John Singer Sargent.

Through a fortuitous coincidence of taste, both Andrew Mellon and P. A. B. Widener enriched their collections of old masters with remarkable paintings by Sir Anthony van Dyck. The aristocratic elegance of this artist's portraits appealed enormously to the collectors, and they went to great efforts to find the best Van Dycks and to bring them to these shores. Their combined bequests to the National Gallery of Art, which have been added to by significant contributions from the Kress and Whitney collections, have created an extraordinarily rich ensemble of Van Dyck's works that has long been one of this institution's greatest sources of pride. It is thus fitting to focus a major international exhibition on this artist, who has had such a tremendous impact on portrait traditions in western Europe and America, as part of our celebration of the Fiftieth Anniversary of the founding of the National Gallery of Art.

As well as celebrating our own anniversary, this major exhibition also commemorates the 350th anniversary of Van Dyck's untimely death in 1641. The first comprehensive exhibition on this artist to be mounted in many years, it provides an opportunity to see together paintings from all phases of his career, from his first dated work of 1613, when this prodigy was fourteen years old, to his last portraits when he was court artist for King Charles I and Queen Henrietta Maria in London. Special efforts have been made, moreover, to bring together a large selection of Van Dyck's religious and mythological scenes. These paintings, often less familiar than the images he created of his distinguished patrons, have a unique sensitivity and poetic character.

Arthur Wheelock wisely recognized that it was time to take a fresh look at Van Dyck's full career. He invited Susan J. Barnes to join him as co-curator, and together they selected the paintings and produced the catalogue. Indispensable as well has been Julius S. Held, who both advised on the selection and wrote about the oil sketches in the catalogue. We are particularly appreciative of the support and scholarly contribution of the dean of Van Dyck scholars, Sir Oliver Millar, and are deeply grateful for the advice of the members of the Scientific Committee and for the outstanding essays contributed by Christopher Brown, Carol Christensen, Zirka Zaremba Filipczak, Jeffrey Muller, and J. Douglas Stewart.

We thank the Federal Council on the Arts and the Humanities for granting an indemnity for the exhibition. Finally, we are deeply indebted to our many lenders, whose generous cooperation made this exhibition possible.

J. Carter Brown
Director
National Gallery of Art

List of Lenders

Akademie der bildenden Künste, Gemäldegalerie, Vienna
Anonymous lenders
The Baltimore Museum of Art
Bayerische Staatsgemäldesammlungen, Munich
City of Bristol Museum and Art Gallery
British Rail Pension Fund
The Viscount Camrose
The Governing Body, Christ Church, Oxford
The Cleveland Museum of Art
The Viscount Cowdray
Dulwich Picture Gallery
Her Majesty Queen Elizabeth II
The Trustees of the Rt. Hon. Olive, Countess Fitzwilliam's Settlement and the Lady
 Juliet de Chair
Galleria di Palazzo Bianco, Genoa
Galleria Sabauda, Turin
The J. Paul Getty Museum, Malibu
Harari & Johns Ltd., London
Herzog Anton Ulrich-Museum, Braunschweig
Institut de France-Musée Jacquemart-André, Paris
The Iveagh Bequest, Kenwood (English Heritage), London
Kerkfabriek O.L. Vrouw, Dendermonde, Belgium
Koninklijk Kabinet van Schilderijen "Mauritshuis," The Hague
Koninklijk Museum voor Schone Kunsten, Antwerp
Kunsthistorische Musea-City of Antwerp
Kunsthistorisches Museum, Vienna
Collections of the Prince of Liechtenstein, Vaduz Castle
Memphis Brooks Museum of Art
The Methuen Collection
The Metropolitan Museum of Art, New York
The Minneapolis Institute of Arts
Musée du Louvre, Département des Peintures, Paris
Musées Royaux des Beaux-Arts de Belgique, Brussels
Museo Civico d'Arte e Storia, Vicenza
Museo del Prado, Madrid
National Galleries of Scotland, Edinburgh
The Trustees of the National Gallery, London
National Gallery of Art, Washington
National Gallery of Canada, Ottawa
National Portrait Gallery, London
The National Trust, Petworth House (Egremont Collection)
The Duke of Norfolk
North Carolina Museum of Art, Raleigh
The Duke of Northumberland
The Earl of Pembroke
Pinacoteca di Brera, Milan
Pinacoteca Capitolina, Rome
Rijksdienst Beeldende Kunst, The Hague
The Duke of Rutland
Graf von Schönborn
Staatliche Kunstsammlungen, Gemäldegalerie Alte Meister, Dresden
Staatliche Museen Preussischer Kulturbesitz, Gemäldegalerie, Berlin
The State Hermitage Museum, Leningrad
Státní Zámek, Kroměříz, Czechoslovakia
Yale University Art Gallery, New Haven

Acknowledgments

This anniversary gives us an opportunity not only to celebrate the founding of the National Gallery of Art, but also to present a comprehensive exhibition of Van Dyck's work such as has not been seen for almost a century. The visual excitement of seeing so many of his paintings together is heightened by our knowledge that new scholarly insights into the artist's achievements will be made possible by this overview. Recent exhibitions have focused on selected aspects of Van Dyck's career, with the result that the extent of his artistic contributions has not been fully demonstrated. With this in mind we have invited prominent scholars in the field of Van Dyck studies to make contributions to the catalogue. We have hoped to advance our understanding of the artist's works, as well as his relationships to the cultural, religious, and political forces of the day. A chronology and comprehensive bibliography, the most extensive ever assembled, provide up-to-date information on Van Dyck's peripatetic career and the critical thought that has accumulated in more than three centuries.

The planning of this exhibition has extended over a number of years, and has benefited from the contributions of many friends and colleagues. Martha Wolff, associate curator of northern art at the National Gallery in the early 1980s, helped formulate the original idea for the exhibition. We are most grateful for the support and advice, particularly about the selection of works, from the members of the Scientific Committee.

The research and insights of collectors, conservators, and other colleagues past and present have contributed immeasurably to the exhibition. We thank them all, and would like to particularly acknowledge the assistance of the following: Maria Antonio Lopez Asiain, Arnout Balis, Reinhold Baumstark, Carlo Bitossi, Piero Boccardo, the late Carlotta Cattaneo-Adorno, Michael Clarke, Dena Crosson, Giorgio Doria, Carmen Garrido, Clario di Fabio, Jacques Foucart, Sydney J. Freedberg, Martina Friedrich, Jeroen Giltay, Beatrice Graf, Francis Greenacre, Paul Huvenne, Michael Jaffé, Sona Johnston, Jan Kelch, George Keyes, Rudiger Klessmann, Alastair Laing, Jennifer Lambert, Willy Laureyssens, Arnold Lehman, Walter Liedtke, Christopher Lloyd, Julia Lloyd-Williams, Neil MacGregor, Pietro Marcheselli, Manuela Mena, Meda Mladek, Rita Omwal, Michael Pantazzi, Gerhardt Pieh, Bianca Alessandra Pinto, Nora de Poorter, Wolfgang Prohaska, Konrad Renger, Brenda Richardson, Giles Robertson, Pierre Rosenberg, Rodolfo Savelli, Kay Silberfeld, Katlijne van der Stighelen, Angus Stirling, Ronald Strom, Stefano Susinno, Peter Sutton, Perry Carpenter Swain, Laura Tagliaferro, Sarah Tanguy, Nicholas Thomas, Evan Turner, Mark van de Venne, Carlo Virgilio, Hans Vlieghe, Giles Waterfield, Alice Whelihan, Lucy Whitaker, and Eliane de Wilde.

We are also indebted to the professional staffs and scholarly resources of several research institutions, including the Biblioteca Hertziana, Rome; the Rijksbureau voor Kunsthistorische Dokumentatie, The Hague; the Rubenianum, Antwerp; and the Warburg Institute and the Witt Library, London. In Washington, Neal Turtell, Tom McGill, and other staff members of the library of the National Gallery of Art have provided indispensable assistance over the years. Thanks are due also to many graduate students at the University of Maryland, who shared their ideas in Arthur Wheelock's Van Dyck seminars.

Anke van Wagenberg put the myriad literary references to Van Dyck into comprehensible order. Her efforts also made the chronology and bibliography possible. In the work on the bibliography she was assisted by Pamela Hall and by the class in art historical methods at the University of Maryland, under the direction of Prof. James Douglas Farquhar.

Many people on the staff of the National Gallery worked tirelessly in the preparation of the catalogue manuscript. The book was edited by Jane Sweeney of the editors office, under the direction of Frances P. Smyth, and with the assistance of

Abigail Walker and Meg Alexander. Sara Sanders-Buell of the department of photo services was responsible for assembling the transparencies. Leslie Schwarz and Sarah McStravick were instrumental in the formative phase of the exhibition; assembling the final draft was undertaken by Valerie Guffey. The text and bibliography have benefited from the careful reading and suggestions of two curatorial interns, Anthony Geber and Mary Brantl.

The National Gallery staff was instrumental also in the organization and execution of the exhibition. Foremost has been the support of the deputy director, Roger Mandle. Mervin Richard coordinated conservation efforts for all works in the exhibition; several of our Van Dycks were given treatment and analysis in the conservation labs by Sarah Fisher, Carol Christensen, Michael Palmer, and Michael Swicklik. The exhibition was administered by D. Dodge Thompson, Cameran G. Castiel, and Lena Hernández of the department of exhibition programs. Mary Suzor, registrar, arranged for the transportation of the works of art. Educational materials were prepared by Susan M. Arensberg. Gaillard Ravenel, Mark Leithauser, Gordon Anson, and the staff of the department of installation and design were responsible for the installation. We extend our gratitude to all who helped make this undertaking a reality.

Arthur K. Wheelock, Jr.	Susan J. Barnes
Curator of Northern Baroque Painting	Senior Curator of Western Art
National Gallery of Art	Dallas Museum of Art

Scientific Committee

Christopher Brown
Egbert Haverkamp-Begemann
Julius S. Held
Roger d'Hulst
Irina Linnik
Anneliese Mayer-Meintschel
Sir Oliver Millar
Hubertus von Sonnenburg

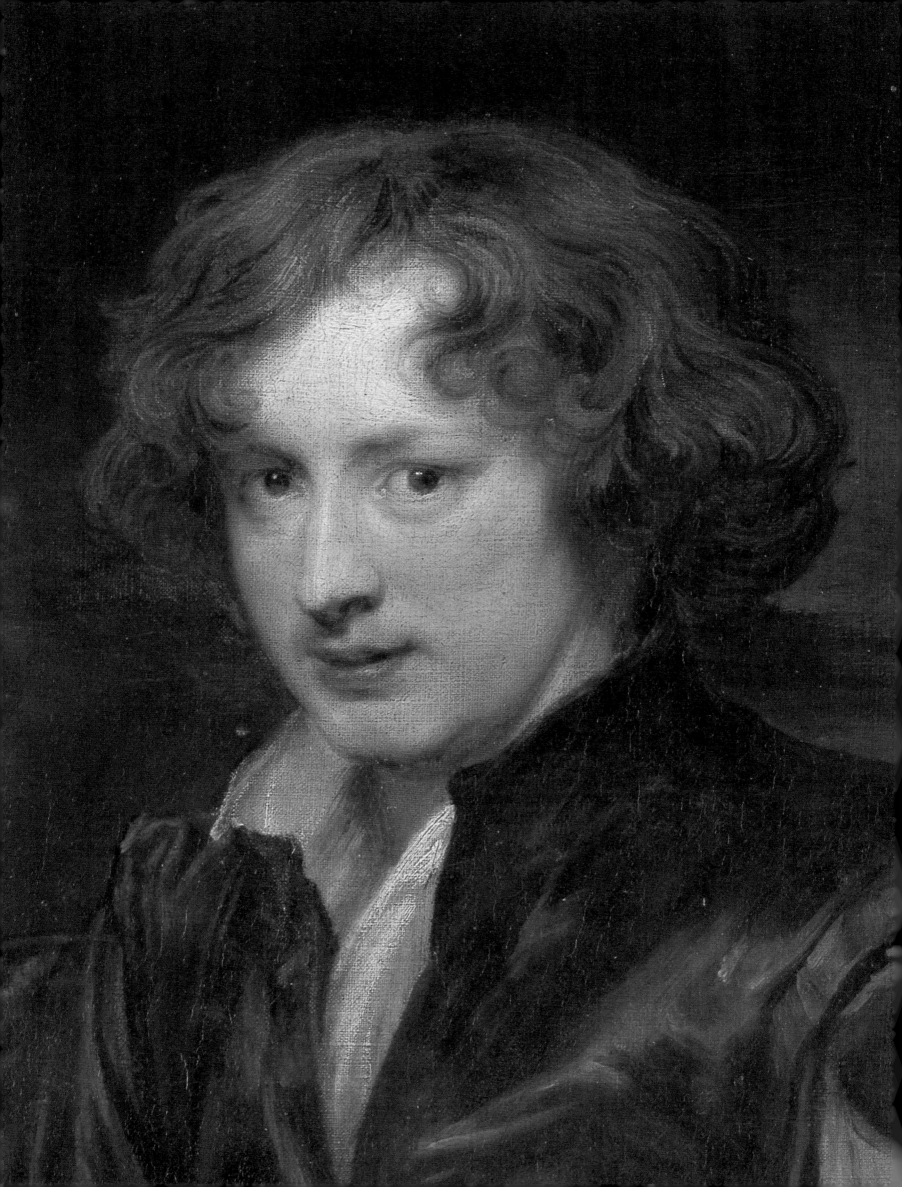

The Search for "The Central Orb":
Van Dyck and His Historical Reputation

ARTHUR K. WHEELOCK, Jr.

"Yet, to come back to what I was saying, with his personal genius, personal grace, personal talent, the whole Van Dyck would be inexplicable, were it not for the central orb whose beautiful light he reflects. We should try to find out who it was that showed him this new manner, that taught him this new language which has nothing of the old accent left in it. We should see in him lights that have come from somewhere else and were not the products of his own genius, and, finally, we should suspect that there must have been somewhere in his neighbourhood a great star that had disappeared.

"We should then no longer call Van Dyck the son of Rubens; we should add to his name, *master unknown*: and the mystery of his birth would be worth the historian's study."
<div align="right">Eugène Fromentin, 1876[1]</div>

These concluding sentences to Fromentin's provocative assessment of Van Dyck's character and artistic achievements convey the ambivalence that has marked historical appraisals of Van Dyck as an artist. This child prodigy, who at the age of fourteen was already painting masterful portraits, who by his early twenties was courted by some of the most distinguished and discerning patrons of the day, and who by the end of his relatively short life had created a style that would transform the history of portrait painting, has nevertheless been uneasily received into the firmament of great artists by historians and theorists ever since the seventeenth century. Van Dyck's fate is that shared by other artists who developed in the shadow of an overpowering mentor like Peter Paul Rubens: his successes are deemed tainted because of their dependence on the master's style while his individuality is either overlooked or seen as evidence of his inability to absorb fully the master's teachings.

Fromentin, as all those who study Van Dyck, would have liked to think the best of him, to come to a firm conclusion that history has somehow dealt poorly with this magnificent artist who did so much so easily in such a wide range of circumstances. The fault, in large part, rests with the artist himself. He was too talented. Success came without any evidence of uncertainty or struggle. The burden of unlimited potential is a heavy one, and can lead too easily to the appearance of failure. In Van Dyck's case, the aura of failure overwhelmed his last years. Faced with the insecurities of the English court, which was on the verge of civil war, he moved impetuously from London to Antwerp to Paris to London in desperate search for a stage he could dominate. On a personal level he also lacked that magisterial presence associated with the artistic elite. He was proud, ambitious, and yet too ready to ingratiate himself with his patrons by acceding to their demands.

All of these problems, however, pale before the historical circumstances that saw Van Dyck develop as an artist in Antwerp just when Rubens was at the height of his fame. Although he had been named a master of the Guild of Saint Luke in 1618; had been called to the court of James I in London only two years later at the age of twenty-one; and had quickly become one of the most admired and sought after painters in Italy, Flanders, the Netherlands, and England; Van Dyck could never free himself from the designation "student of Rubens." Their careers paralleled each other too closely for Van Dyck to ever remove himself from Rubens' ubiquitous shadow.[2] Wherever he went Rubens had been. Not only had he been, but he had painted, and left behind impressive portraits, altarpieces, mythological paintings, and huge series of wall paintings or tapestry designs. His style, so innovative and so grand in concept, became a standard against which all others were judged. Van Dyck, who owed much to Rubens, must also have felt a burden in Rubens' genius, his fame, and his worldly success.

Clearly, Fromentin needed assurance that more than Rubens underlay Van Dyck's artistic vision before he could conclude that Van Dyck's career was worthy of serious

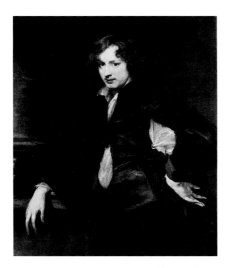

Fig. 1. Anthony van Dyck, *Self-Portrait* [cat. 33]

study.3 Even now, more than a hundred years after Fromentin's queries and three hundred years after Van Dyck's death, Van Dyck's artistic personality is difficult to assess. At the very least it can be asserted that Van Dyck diverged from Rubens' shadow through a careful study of Venetian art, and in particular the paintings of Titian. Time and time again Van Dyck's indebtedness to the great Venetian master is mentioned in this publication. Nevertheless, the more subtle differences that separate Van Dyck from Rubens—whether they result from the generations to which they belonged, the educations that formed them, their religious beliefs, the circles in which they moved, or their sensitivities to others—are little known still.

As Fromentin's search for the "central orb" implies, Van Dyck is an artist whose character and beliefs are only imperfectly understood. Documentary evidence, much of which is contained in the Chronology included in this book, does not always accord with contemporary assessments of the way he conducted his life. Born on 22 March 1599 in Antwerp, he was the seventh child and second son of Frans van Dyck and his wife Maria Cuypers. His father was a prosperous merchant who sold fabrics both at home and abroad. Documents indicate that his family had strong religious convictions: three sisters became Béguines, another sister an Augustinian nun, one brother a priest, and his father served as president of the Confraternity of the Holy Sacrament. Van Dyck himself became a lay member of the Confraternity of Bachelors in Antwerp in 1628 and maintained his Catholic faith throughout his years working at the English court. His will, written in 1640, confirms that he remained extremely close to his family in the way he provided for his sisters, his illegitimate daughter Maria Teresa, his wife Mary, whom he had married only the year before, and their infant daughter Justiniana.

Anecdotes about his life mention neither the role of religion in Van Dyck's life nor his family ties. While Bellori credited Van Dyck with being "good, honest, noble and generous,"4 most commentators, including Bellori, emphasized his pride, fickleness, and love of luxury. As is clear from his self-portraits [fig. 1], the artist was small but elegant in appearance. He had an intelligent and refined air, and a natural grace in his movements and attitudes. He was also ambitious. Whether or not the story is true, the legend is that even during Van Dyck's apprenticeship, Rubens, his master, became concerned about competition that might arise from Van Dyck's prowess as a painter. Bellori wrote that Rubens steered Van Dyck away from the production of religious paintings to portraiture.5 Once in Italy in the early 1620s, Van Dyck quickly earned the nickname "il pittore cavalieresco" because of his servants, magnificent wardrobe, which included fine fabrics, feathers, and gold chains, and his refusal to associate with those below his station.6 Not surprisingly he quarreled with artists in Italy,7 and had disputes with patrons in Antwerp after his return to Flanders in the fall of 1627 [see cat. 55].

In England during the 1630s, when he was court painter to Charles I and Henrietta Maria, the luxury with which he surrounded himself rivaled that of many of the courtiers he portrayed. He entertained lavishly and frequently.8 Walpole related that Van Dyck "was fond of music, and generous to musicians. His luxurious and sedentary life brought on the gout, and hurt his fortune. He sought to repair it, not like his master, by the laboratory of his painting-room, but by that real folly, the pursuit of the philosopher's stone. ..."9 His mistress in London, Margaret Lemon, was a woman of notoriety, both for her beauty and her temper. When she heard that Van Dyck was about to marry Mary Ruthven, presumably at the instigation of Charles I, she is said to have tried to mutilate the painter's right hand by biting his thumb.10 By the end of his career, at a time he had a chance to return to Antwerp as head of the Flemish school of painting after Rubens' death in 1640, Van Dyck's arrogance and unpredictability were such that Archduke Ferdinand wrote to King Philip IV of Spain that Van Dyck could not be depended upon and that his manner was "archi-fou."11 Indeed, it has been thought that Van Dyck's early demise, for he died at the age of forty-two, was the result of both his dissolute habits and his despair that the respect and honor he so actively sought would never be his.

While the reliability of specific accounts of Van Dyck's actions occasionally may be

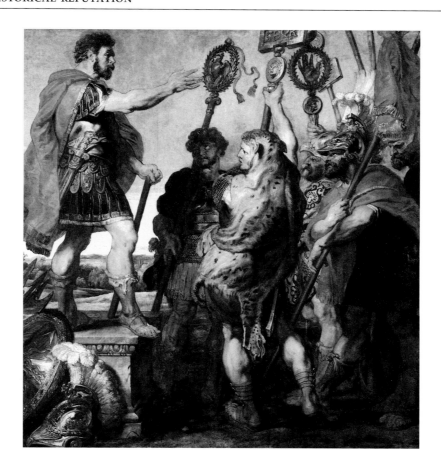

Fig. 2. Peter Paul Rubens, *Decius Mus Relating His Dream*, 1616–1618, canvas, 293.5 x 277 (115¹/₂ x 109). Collections of the Prince of Liechtenstein, Vaduz

suspect, the general tenor is consistent enough to present a portrait that is not altogether flattering. It suggests an artist with inordinate talent whose gifts were never developed through diligence. His love of luxury, his ostentatious life style, and his seemingly arbitrary decisions to move from one location to another throughout his life would not appear to be attributes of one who feels deeply about his work, his family, or his religion.

The message of his art, however, belies such an interpretation. Van Dyck did not reach his success without study and discipline. He started very young as an artist, enrolled as he was by the age of ten in the workshop of Hendrik van Balen. Formal education, which would have provided him with a humanistic foundation similar to Rubens', was thus sacrificed to his obvious talents as a painter. The importance of drawing after Antiquity to understand the sculptural qualities of the human form was of less importance to him than the mastery of a variety of pictorial effects, gained through painting on such diverse surfaces as smooth panels or loosely woven fabric. Even in his early years he was drawn naturally to the broken, rough palette of Titian and the Venetians. As an assistant for Rubens, however, he had to suppress these inclinations for an individually expressive style to accord with the classicism of Rubens' approach. The discipline required of him was remarkable, as was the success with which he carried through the master's ideas on the basis of the most cursory of drawings and oil sketches. To this day debate continues as to whether Van Dyck or Rubens were responsible for major works produced in that workshop in the late 1610s [fig. 2].

In a similar fashion Van Dyck would not have understood Titian's concept of portraiture, or ways of composing religious and mythological subjects, had he not looked carefully at the Venetian artist's paintings, drawings, and prints. The numerous records of his observations in his Italian sketchbook testify to the single-mindedness with which he approached his task. Only with this understanding could he have developed his own magnificent compositions, ones imbued with the grandeur and sensitivity of Titian's touch as well as the poetry of his narration.

Fig. 3. Anthony van Dyck, *Cupid and Psyche* [cat. 85]

Looking at Titian's paintings and copying them, however, was not the extent of his admiration for this Venetian master. Van Dyck acquired Titian's paintings as well, so many that by the end of the 1620s he was reputed to have an important cabinet of Titian's works [see cat. 60].

Van Dyck responded to other artists as well—Raphael, Correggio, the Carracci, Veronese, Guido Reni—but none matched the importance of Rubens and Titian. From these he forged a style that spoke to different sensitivities and different needs. While he drew his inspiration from his predecessors, he modified their portrait conventions and figural compositions to focus more intently on the psychological than on the physical. Neither Titian's self-assured approach to the world nor the stoicism that so infused Rubens' personality were fully shared by Van Dyck. While grandeur and forcefulness are characteristics to be found in Van Dyck's portraits as well as in those of Titian and Rubens, he was more comfortable conveying the tender relationships of parent and child or the melancholic reflections of those whose worldly position might seem unassailable to an outsider. No artist ever explored so fully as did Van Dyck the human interactions that could be expressed in the double portrait.

A similar psychological sensitivity is found in Van Dyck's religious paintings, where even in large altarpieces he speaks more to private than to public worship. Mythological paintings are likewise conceived in personal terms; the subjects he chose focus on intimate episodes about love rather than victorious exploits of heroes [fig. 3]. In most if not all of his works, the sentiments are too profound to suggest that he did not care deeply about the art he was creating. The puzzle, thus, is to reconcile the emotional sincerity of his paintings with the public image he presented that seems so uncaring and so ostentatious.

Aside from his personal delight in finery, Van Dyck's elegant wardrobe and luxurious style of life would have appealed to the type of patron he sought. When he had been with Rubens he would not have been oblivious to the deference of aristocrats as they entered the master's splendid home and came into the presence of the renowned painter. Van Dyck learned this lesson and took the knowledge with him to Italy, Flanders, and England. He dressed and conducted himself in the manner of his patrons. This mode of operating reached its apogee during his latter years in England when his studio became a favorite haunt for the nobility as well as for the king and queen. There his elaborate displays of food and wine, his musicians and fools, were meant to put his patrons at ease, when their public face had been replaced by a private one, so that he could better observe them in their different moods and capture them in paint.[12]

Whether or not these feasts brought upon Van Dyck's illnesses at the end of his career as Walpole suggests, they do seem to have been an integral part of his life, at least during the later 1630s. Nevertheless, even if Bellori and Walpole were astounded by the amount of money and energy consumed by these celebrations, no one ever accused Van Dyck of being lazy. Walpole wrote that he was "indefatigable," and noted how Van Dyck had taken seven entire days to paint the portrait of Nicholas Lanier before being satisfied with it [fig. 4].[13] As the demands for his services expanded during the 1630s, necessity forced him to spend less time on his paintings than previously. If one can accept Eberhard Jabach's description of Van Dyck's typical working day, it consisted of a rapid sequence of sittings with distinguished patrons in which each sitter came at an appointed time and stayed an hour. During the sitting Van Dyck sketched in the face on the canvas and drew the pose he had contrived with black and white chalk on a gray paper. The portrait would then be worked on by assistants who painted the costumes from the sitter's own clothes, which were left behind for that purpose. After the costumes, draperies, and background had been completed, Van Dyck would quickly go over the work "et y mettoit en très peu de temps, par son intelligence, l'art et la vérité que nous y admirons."[14]

Jabach's commentary raises an important question about the role of apprentices in Van Dyck's work. Of this we know very little. As is clear from testimony concerning the attribution of an Apostle series painted about 1620 [see cats. 19, 20], assistants worked with Van Dyck at a very early stage of his career on at least one project.

Fig. 4. Anthony van Dyck, *Nicholas Lanier* [cat. 48]

Although he made preliminary drawings and oil sketches for his paintings [see cats. 88, 90], these seem to have been more to develop ideas for his own use than to serve as models for assistants to follow in the manner of Rubens. Virtually nothing is known about the artists who subsequently worked with Van Dyck, among them Jean de Reyn, Remi Leemput, and Jan van Belcamp.[15] Their primary function was probably to assist in the preliminary build-up of his paintings and to make replicas of his works. Van Dyck did ask one colleague in Genoa, Jan Roos, to paint still-life elements in his pictures [see cat. 39], but selective assistance from specialists in his works seems more the exception than the rule.

Van Dyck almost certainly developed a workshop to help execute the numerous large altarpieces he was commissioned to paint once he returned to Antwerp in 1627, although no specific information about collaboration in these paintings is known. Already at this stage, however, he began to work with engravers to make prints after his compositions [see cat. 46, fig. 4]. The idea of producing a series of engraved portraits of distinguished statesmen, artists, and art lovers, called the *Iconography*, seems to have developed during these years, but, once again, nothing is known about the arrangements Van Dyck had with engravers and publishers.[16]

Van Dyck probably did not develop the complex procedure for portraits outlined by Jabach until the 1630s, at a time when his work was in great demand. This system would help to account for his prodigious production during these years. Backgrounds and costumes in many of his portraits were standard enough that Van Dyck could well have relied on assistants to block them in before he went over them to unify the whole. Not all portraits, moreover, would have required separate sittings. Van Dyck undoubtedly made a number of portraits, particularly those of the king and queen of England, on the basis of a study made at a single sitting.

Jabach's statement that Van Dyck worked up the heads first from life seems to explain the different character of the paint in and around the heads of a number of sitters in his portraits from the 1630s [fig. 5]. As is clear from the works in this exhibition, however, not all paintings he executed in this manner were completed with workshop assistance. Prime versions of portraits of patrons Van Dyck considered particularly important undoubtedly received his full attention. Thomas Wentworth, for one, insisted that Van Dyck personally execute the portraits the artist made of him. In one instance Wentworth instructed his agent to "minde Sr. Anthonye that he will take good paines upon the perfecting of this picture wth his owne pensell."[17]

While replicas and versions of his compositions exist from virtually all phases of his career, these were produced in greater numbers during the 1630s. This problem becomes particularly acute in England because Van Dyck was frequently commissioned to paint versions of portraits for the king and queen and for other members of the court. Although autograph replicas exist, most, it would seem, were executed primarily by assistants.[18] A large number of them, which vary greatly in quality, unfortunately have been accepted into the canon of Van Dyck's work and have given rise to the opinion that Van Dyck's production became very uneven during his English years.[19]

The exceptional quality of the works in this exhibition, which cover the full range of Van Dyck's career, will hopefully redress that misconception. It will also demonstrate the broad evolution of his style, which has been difficult to appreciate because recent exhibitions have focused on distinct periods of his career, whether they be Antwerp, Italy, or England, or separate genres of painting, such as religious scenes or portraiture. Most important, the exhibition should dispel the perception that Van Dyck is a one-dimensional artist, a portrait painter insistent upon flattering his sitters but one who never probed deeply into the human psyche. He was far more than that. Here, through the generosity of both public institutions and private collectors, we are able to experience the vast range of his work: the strength and vigor of his religious and mythological paintings as well as their tenderness and lyricism; the nobility of his portraits as well as their intimacy and humanity.

The mystery of Van Dyck's birth, to use Fromentin's phrase, is real enough. The

Fig. 5. Anthony van Dyck, *Cesare Alessandro Scaglia* [detail, cat. 70]

path that he took to his unique style—Fromentin's "great star"—is still imperfectly understood. Too little is known about the important relationships in his life, about his beliefs and feelings, to assess fully his attitudes toward his art. Nevertheless, more evidence about his artistic training and interests has been uncovered since the time of Fromentin, above all the existence of his Italian sketchbook. It is now clear that if Fromentin's unnamed influence were to be identified it would surely take the form of Titian, for in this great Venetian artist Van Dyck found the inspiration that lifted him from the shadow of Rubens. Titian's paintings encouraged him to free his brushwork, to explore the psychology of sitters, and to compose his history paintings with poetic sensibility. Van Dyck's genius was that he could forge his own identity in the wake of such powerful forces, that he could draw those qualities, from both his Flemish and his Venetian master, that were most suited to his own temperament without in the end becoming enslaved by either.

From what can be gathered about his life, it does seem that his character and his art perfectly mirrored the worlds in which he lived. Despite the trappings of power that were to be found in Genoa and Brussels as well as in London, the political fabric of Europe was in constant flux. Van Dyck perceived the accompanying underlying insecurity that the balance of power was all too fragile, and that new alliances, honorable or dishonorable, would threaten the aura of stability that had been so painstakingly established. He saw this problem all around him, and painted portraits of those whose lives, including his own, had been transformed by the fates that had befallen them.

Van Dyck, to no less an extent than his patrons, felt uncomfortable in the raw reality of the world. He gladly acceded to the mythology of an Arcadian realm ruled by an enlightened monarch, which greeted him at the court of Charles I and Henrietta Maria in both his portraits and mythological paintings. Even in his portraits of those not associated with the English court, where melancholic resignation weighs on the faces of sitters burdened with cares [see fig. 5], Van Dyck helped perpetuate the myth of stability that was so fervently desired through the poses and settings he devised. Indeed, Van Dyck's style as well as his choice of subject matter is a reflection of the aspirations of the different societies in which he lived. The degree to which he helped define those aspirations and give them expression is one of the intangibles of history, one worthy of the historian's study.

NOTES

1. Eugène Fromentin, *The Masters of Past Time: Dutch and Flemish Painting from Van Eyck to Rembrandt*, ed. H. Gerson (Ithaca, 1981), 86 (trans. Andrew Boyle from Fromentin 1876).
2. Houbraken 1753, 1:181, complained that Van Dyck's career had been presented by writers in such a way that it seemed as if "VAN DYK door *Rubbens* als van de straat was opgeraapt, en opgevoed, zonder de weten van wien hy voortgesproten was" (Van Dyck had been picked up from the street and educated by Rubens, without knowing who his parents were).
3. Fromentin, however, elevated Rubens to such a level of genius that it would have been impossible for him to conceive

of Van Dyck outside Rubens' sphere of influence.
4. Bellori 1672, 254.
5. Bellori 1672, 254.
6. Larsen 1975a, 57.
7. The jealousy and envy of artists in Italy are described by Soprani 1674, 447–448, Bellori 1672, 256, and the anonymous biographer from the mid-eighteenth century, Larsen 1975a, 57.
8. Bellori 1672, 259–260.
9. Walpole 1862–1876, 1:334–335.
10. Cust 1900, 142.
11. Cust 1900, 143.
12. See Bellori 1672, 259–260.
13. Walpole 1876, 1:328–332.
14. As quoted in Cust 1900, 139. Van Dyck was similarly methodical when he

came to paint history scenes. Bellori 1672, 264, wrote that he would estimate how much could be accomplished on a painting in one day, and did no more than that.
15. Little or no research has been done on this interesting question in recent years. For discussion of the followers of Van Dyck see Larsen 1975a, 111–128; and Cust 1900, 150–160.
16. See Mauquoy-Hendrickx 1956.
17. Quoted by Millar in London 1982–1983, 67.
18. The problem is greatly compounded by later copies that were not executed in his workshop.
19. The problems are particularly evident in a number of attributions accepted by Larsen (1988).

The Young Van Dyck and Rubens

SUSAN J. BARNES

Van Dyck's departure for Italy in the fall of 1621 brought to an end one of the richest collaborations in the history of painting. Although he was then only twenty-two years old, for almost a decade Van Dyck had worked in a variety of capacities with Rubens, under whose guidance and in whose studio he had grown from a precociously talented child into a highly accomplished and experienced painter.

Early on, Rubens recognized Van Dyck as an extraordinary artistic talent. He was the most naturally gifted artist of his generation, and, after Rubens, the greatest painter to come out of Antwerp from the death of Peter Bruegel the Elder in 1569 to the present day. It was fortunate for Rubens, and particularly so for Van Dyck, that their lifetimes overlapped by forty years and that they were able to work side by side. Through his work in the studio, both on Rubens' paintings and on his own, Van Dyck learned that he and Rubens had fundamentally different artistic temperaments and inclinations. When they first met, they had quite different life experiences as well. Rubens, twenty-two years Van Dyck's senior, was an established master and a leading citizen of Antwerp. Learned, a collector, a man of the world, he was also a very successful entrepreneur, the most famous artist in Europe and the head of a large studio that had been organized to satisfy clients in Italy, Germany, and England, as well as Flanders. Van Dyck was a very gifted and ambitious boy of about fourteen, hungry for knowledge, challenges, and opportunities. Young though he was, he had an eye and a mind of his own.

The fruitful and mutually beneficial professional relationship shared by Rubens and Van Dyck, which came at a crucial time in the career of each, is our subject. A discussion of their relationship inaugurates almost every study of Van Dyck's œuvre, beginning with Félibien's and Bellori's seventeenth-century biographies. In the scholarly literature of the past 110 years, which includes several serious studies, most of these discussions are colored to some extent by the nineteenth-century cult of genius and the twentieth-century taste for psychological profiles. Even so worthy a study as Bode's begins thus: "In contrast to Rubens' grander, more versatile and harmonious character, whose makeup and manner present a figure nearly of Antique greatness, Van Dyck stands as one-sided, excitable and sensitive, having a highly independent and at the same time dependent nature—a Romantic nearly in the modern sense. ..." Bode continued, quoting Max Rooses: "The disciple with his weak physical constitution and his agitated spirit roved ever wider but never achieved that goal in which he found satisfaction and harmony of form with his idea. The master, healthy both of body and of spirit, in the calm of his authority and with unperturbable satisfaction, perceived his glittering, complete ideal that was born of expression. And he reigned over the fields of art like a prince, celebrated everywhere."[1] Such imaginative elaboration—unsupported by contemporary accounts—of the evident differences between the personalities and œuvres of Rubens and Van Dyck obscures the truth of their respective contributions to art as well as the fundamental issues of their collaboration.

Once beyond questions of personality, the first monographic studies on Van Dyck properly set about defining his œuvre. Glück's Klassiker der Kunst volume of 1931 is not the most recent œuvre catalogue on Van Dyck; although inevitably out of date, however, it still stands as the most reliable guide to Van Dyck's corpus. It represents the fruit of nearly fifty years of thought and published discourse by scholars who largely accomplished the task of separating paintings made independently by the young Van Dyck from the products of Rubens and his studio.[2] Still remaining is the much more difficult undertaking of identifying the hand of Van Dyck among other assistants in works from Rubens' studio.[3] Several scholars in the past sixty years have addressed one aspect or another of Rubens' and Van Dyck's relationship. Their contributions and opinions will enter into the following discussion.[4]

As had Frans Floris before him, Rubens organized his Antwerp studio according to

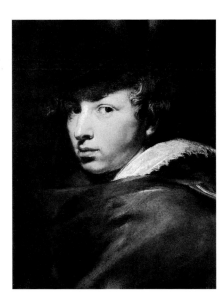

Fig. 1. Peter Paul Rubens, *Portrait of Van Dyck*, 1613–1615, panel, 36.5 x 25.8 (14³/₈ x 10¹/₈). Kimbell Art Museum, Fort Worth

principles learned in Italy, where painters had waged a long campaign to win for their discipline the status of a liberal art.[5] In theory and in the kind of practice exemplified in Raphael's studio, a distinction was made between the artist's creative intellectual activity—*invenzione*—and the manual skills required to bring the work of art into existence. The true work of the painter was to design, to create a composition that embodied his unique conception. The execution of that conception was secondary in importance, and could be left to trained assistants. While it is clear that Rubens would have sincerely subscribed to this theory in any case, its day-to-day application also solved his serious practical need to cope with the many commissions that came to him from all around Europe. His informed English and Antwerp patrons were aware of this studio procedure and took its consequences into account.

We are surprisingly ignorant of the operating procedures of Rubens' early studio and of his roster of resident assistants, among whom Van Dyck was the only one specifically named. Rubens had been exempted from the rules of the painters' guild when he received his patent as painter to the Hapsburg Regents of the Netherlands on 23 September 1609. That meant, among other things, that he was free of the requirement to register his apprentices. Thus our knowledge about his studio assistance during this period is derived from three well-known documents: a letter of 1618; a contract of 1620; and one eyewitness account.[6] The letter, which Rubens wrote to the discerning and demanding patron Sir Dudley Carleton on 28 April 1618, describes a group of his own paintings being offered in exchange for a collection of antiquities. According to Rubens' terminology, their execution falls into three categories: those that were "original" or "entirely by my hand"; those "begun by my disciples" and "entirely retouched by my hand"; and one, *Prometheus*, in which Frans Snyders, an independent specialist in animals, painted the eagle. A fourth important category of the studio production, paintings copied or executed by assistants and retouched little or not at all by Rubens, was not mentioned in the letter for obvious reasons. Rubens' contract of 29 March 1620 with the Antwerp chapter of the Jesuit order spells out the division of labor in his studio along the lines of the Italian ideal. It stipulates that Rubens design thirty-nine paintings for the decoration of the ceiling bays in the new church of Saint Ignatius, and that he be responsible for their successful execution in the hands of Anthony van Dyck and other unnamed studio assistants. When Dr. Otto Sperling visited Rubens' house in 1621, he was given a tour of the studio at the time the Jesuit paintings were completed. "We saw a vast room without windows," Sperling wrote, "but lighted by a large opening in the ceiling. There were gathered a good number of young painters who worked on different pieces of which Rubens had given them a chalk drawing touched here and there with color. The young men had to completely execute these paintings, which then were finished off with line and colors added by Rubens himself."[7] From these documents we conclude that Rubens had two kinds of assistants: those who were younger and worked in his studio, as Van Dyck did for much of their collaboration; and those such as Frans Snyders, Jan Brueghel the Elder, and Jan Wildens, who had studios of their own. They were engaged in their areas of specialization: animal painting, flower painting, or landscape.[8]

There has been a substantial difference of opinion among scholars concerning the terms and the time period of Van Dyck's collaboration with Rubens. The evidence is small and scattered. Van Dyck's name appears in the logs of the Guild of Saint Luke three times during these years, once in 1609, when he was registered as an apprentice to Hendrik van Balen, and twice in 1618, when he became a master.[9] Two rare contemporary documents, both from 1620, a full two years after Van Dyck became a master painter, refer indisputably to his work with Rubens: the Antwerp Jesuit contract cited above, and a letter written by Francesco Vercellini to Lord Arundel from Antwerp on 17 July mentioning that Van Dyck was then still working with Rubens, a letter to which we shall return.[10] The earliest instance of their collaboration that can be specifically inferred, Van Dyck's work on the tapestry cartoons for the History of the Consul Decius Mus, comes from later seventeenth-century documents. Bellori mentioned that Van Dyck painted the cartoons, and sale records of the

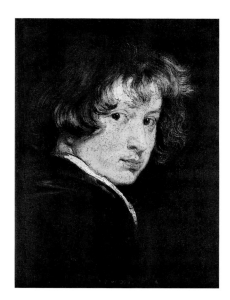

Fig. 2. Anthony van Dyck, *Self-Portrait*, 1613, canvas, 43 x 32.5 (17⅞ x 12¾). Gemäldegalerie der Akademie der bildenden Künste, Vienna

paintings from 1661 and 1692 both name Van Dyck as the painter.[11] From Rubens' own correspondence, which does not refer to Van Dyck, we know that those paintings had been completed and handed over to the weavers in Brussels by May 1618.[12]

No biography of Van Dyck was published during his lifetime, but the two earliest and most complete accounts of his early career, Bellori's published in 1672 and Félibien's in 1666–1688, both state that he entered Rubens' studio as a pupil. Nevertheless, scholars in the late nineteenth century led by the archivist Van den Branden used newly discovered documentary evidence to form another idea altogether: that after training with Van Balen, Van Dyck had established his own studio, and that he had worked with Rubens only thereafter, and only with the status of an independent master. The central documentation upon which this hypothesis rests is the records of a lawsuit of the early 1660s, a dispute over Van Dyck's authorship of a group of paintings depicting Christ and the twelve apostles [see cats. 19, 20]. The painters Herman Servaes and Justus van Egmont testified that Van Dyck had had his own studio in a house called "den Dom van Ceulen," where they had been engaged to make copies of the *Apostles*. Testimony of Guilliam Verhagen, who had commissioned the *Apostles*, set that date at 1615 or 1616. His testimony, combined with the fact that Van Dyck's known works for Rubens and his recorded presence in Rubens' studio postdate his becoming a master himself, supported the conclusion made by Van den Branden that Van Dyck had his own studio before he entered that of Rubens.[13]

Other interpretations of Verhagen's testimony, however, and other evidence support the viewpoint shared by McNairn, Müller Hofstede, Roland, and myself, that Van Dyck's relationship with Rubens was more complex and of far longer duration than that.[14] Thanks to Margaret Roland's exacting analysis of the facts, we now may confidently reject the seventy-five-year-old Verhagen's testimony about distant events and place Van Dyck's studio in the period 1620–1621.[15] Glück, who first suggested that date, thought that Van Dyck entered Rubens' studio by 1617.[16] There is ample visual evidence as well that Van Dyck and Rubens had special ties even before then. Rubens' *Portrait of Anthony van Dyck* [fig. 1], a penetrating likeness of the grave, intelligent, elegant young man, was painted as early as 1613 and no later than 1615. Because Rubens matter-of-factly refused portrait commissions from the Antwerp bourgeoisie, the very existence of this painting suggests that Rubens had a personal relationship with the boy. Even more telling is the intimacy of the image and its unusual form, which seems, as Müller Hofstede proposed, to respond directly to Van Dyck's *Self-Portrait* of about 1613 [fig. 2].[17] Other painted evidence of their association comes from Van Dyck's own brush. His earliest religious paintings, such as *The Martyrdom of Saint Sebastian* [see cat. 3, fig. 1], and *Saint Jerome* [cat. 2], both from 1615, were clearly made with the knowledge of works either by Rubens or in his collection.

Thus we return to the idea of Van Dyck's relationship to Rubens expressed in the early biographies of Bellori and Félibien. According to Félibien, once in Van Balen's studio: "Van Dyck, who had an extreme passion for learning, lost no time in advancing in knowledge and in the practice of painting. Before long he had surpassed all of the young people who worked with him. But as he had heard much about Rubens and had admired his works, he arranged through friends for Rubens to take him into the studio. This excellent man, who saw right away that Van Dyck had a beautiful talent for painting, conceived a particular affection for him and took much care to instruct him."[18]

We may speculate that Jan Brueghel the Elder, who was a close friend of and collaborator with both Van Balen and Rubens, might have appreciated the talented young Van Dyck's work with Van Balen and brought him to Rubens' attention. Probably by 1613, when Van Dyck produced the first surviving proofs of his ability as a painter [fig. 2 and cat. 1], he began to frequent Rubens' studio, receiving some instruction from the master, learning through observation and through copying, assuming the tasks of an assistant as quickly as he could, and evolving rapidly from an apprentice to a full-fledged collaborator. From then on, at least until his departure

for England in the fall of 1620, he was in Rubens' studio and an active member of Rubens' team. He became the preeminent assistant, as was recognized in the contract for the Antwerp Jesuit church and Vercellini's letter to Lord Arundel, documents which, in 1620, come at the end of their long collaboration.

What were the fruits of this partnership? Van Dyck was surely the greatest beneficiary of their long relationship, which completed his training and then brought him challenges of an order and number that matched his own ambitions and abilities. For both men it was a complex, evolving relationship of many facets, including the dependence of pupil on master, the interdependence of master and assistant, and the autonomy of individual talents working together and independently in the same place. In spite of their great differences in age and experience, their technical skills were nearly on a par. That was the key to Rubens' satisfaction, for he also benefited mightily from his association with Van Dyck.

Bellori provided a lively summary of their relationship and described some of the tasks Van Dyck undertook in the studio: "Rubens admired the youngster's good manners and his grace in drawing and thought he was fortunate to have found an apprentice to his liking, who could translate his designs into drawings for engravings: one of these is *The Battle of the Amazons*, which Antonio drew at the time. He was no less valuable in painting. The master could not keep up with his large number of commissions, so he set the boy to copying and put him to work on his own canvases, sketching out and even executing on canvas his drawings and painted sketches, to Rubens' very great advantage. Antonio did the cartoons and paintings for the tapestries of the story of Decius Mus, which he executed with ease because of his great talent. It is said that, facilitating his efforts this way, Rubens got a good hundred florins per day out of Antonio's labors, while the youth obtained even more from his master, who was the jewel of art."[19]

As Félibien pointed out, in a period when Rubens was overwhelmed with work, he found it invaluable to have an assistant whose paintings could be taken for his own. Van Dyck's help could not have come at a better time. Ever since his return from Italy at the end of 1609, Rubens' fame and the demand for his works had only increased. Among the major commissions he completed between 1610 and 1617 were two enormous triptychs for Antwerp, *The Elevation of the Cross* and *The Descent from the Cross*; another triptych, *The Martyrdom of Saint Stephen* for the Abbey of Saint-Amand-les-Eaux; *The Assumption of the Virgin* for Brussels; *Saint Francis of Assisi Receiving the Stigmata* for Cologne; a series of portraits of the Hapsburg regents and members of their court; the large *Last Judgment* for Duke Wolfgang Wilhelm of Neuburg; *The Adoration of the Magi* for Mechlin; *The Entombment of Christ* for Cambrai; and *The Descent from the Cross* for Lille. In addition, he produced great numbers of religious and mythological paintings for private clients and for his own stock, along with many designs for book illustrations and title pages. Van Dyck came into Rubens' studio in the midst of this expansion, and the development of his skills fortuitously paralleled the growth in the commissions, enabling Rubens to engage in ever more remarkable undertakings.

Their collaboration embraced the execution of the two largest and most complex commissions Rubens had received to date. With the Decius Mus series and the decorations for the Antwerp Jesuit church, Rubens inaugurated what would be a decade-long phase in his career, one in which series dominated his output. He thereby took on new conceptual and artistic challenges of a monumental order that could be likened to the accomplishments of Raphael and Michelangelo.[20] There were many "firsts" in the Decius Mus commission: it was the first time Rubens created a sequence of images in a large-scale narrative cycle; the first important engagement of this antiquarian and humanist artist with an episode from Roman history; and the first series of images that he designed to be woven in tapestries.[21] The ceiling decorations for the Antwerp Jesuit church posed a different but analogous set of challenges, including the depiction of a large range of subjects from the Bible and the lives of the saints and their integration in relation to one another in an architectural setting. The destruction by fire of the church interior in 1718 has robbed us of one of

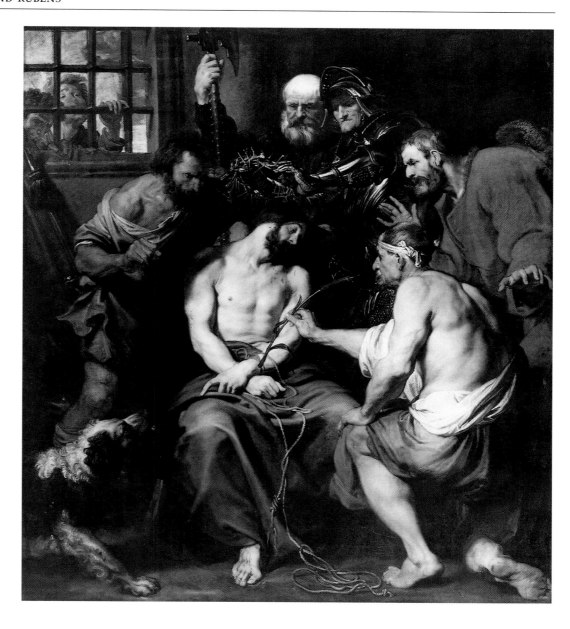

Fig. 3. Anthony van Dyck, *The Crowning with Thorns*, 1620, canvas, 223 x 196 (87³/₄ x 77¹/₈). Museo del Prado, Madrid

the greatest ensembles of painted architectural decoration of the seventeenth century. Rubens seized on these intellectual challenges and carried out his designs brilliantly on his own, perhaps with some advice from his scholarly friends. Their execution, which fell principally to Van Dyck among his assistants, was a daunting enterprise in and of itself, particularly so because the Jesuit commission was carried out under extreme pressures of time. In less than one year, all thirty-nine paintings for the church ceiling were made and delivered.

For Van Dyck, the association with Rubens provided a magnificent training in art and in life. It is not surprising that, even for some time after he became entitled to practice in his own right, Van Dyck chose to remain in the master's studio. The intellectual ambience of Rubens' domain was remarkable for an artist's studio in any place or era, a reflection of the artist's outstanding cultivation. One of Rubens' greatest pleasures was reading. If we may believe Dr. Sperling, he regularly had someone read texts from ancient history and philosophy to him aloud while he worked. He was fluent in Latin and several modern languages, and had a wide and lively correspondence with some of the best minds of his time. The French humanist Nicolas Claude Fabri de Peiresc wrote after he met Rubens in 1622: "I cannot but admire him exceedingly and I cannot let him go without regretting the loss of the most scholarly and pleasing conversation that I have ever enjoyed." Rubens' house was "one of the focal points of learned society in Antwerp," as Muller termed it.[22]

It was a treasury for the mind and the eye. In the very years of Van Dyck's activity there, the house and studio were being expanded in grand modern style, decorated with erudite tributes to the arts, and filled with important collections.[23] The scope of Rubens' collection as summarized by Muller would be the envy of any present-day museum: "The arts of Egypt, Greece, Rome, the old Netherlands, Germany, the Italian Quattrocento and Cinquecento of the Venetian, Roman, and Lombard schools, and of Holland, Belgium, and Italy in Rubens' day were all represented. There was an equal variety of media and modes: monumental sculpture, coins, gems, ivory carvings, miniatures, drawings, prints, oil sketches, and paintings; of history, portraiture, peasant scenes, landscapes, animals, and still life."[24] Also on hand were numerous drawn and painted copies that Rubens had made, for his own purposes, of masterworks he admired by Italian, German, and Netherlandish artists. In addition, as Rubens' letter of 28 April 1618 to Sir Dudley Carleton attests, he retained in stock many earlier pictures of his own from previous times, as well as the vast array of preparatory studies in chalk, ink, and oil that he carefully kept and mined for the creation of new compositions.

This impressive repository served Van Dyck in numerous ways as he created paintings independently while also working on Rubens' studio production. On the most direct level, it was a library of images from ancient and modern Italian art with which he could nourish his own invention, as Rubens did. Some were sources for specific motifs, such as Rubens' drawings of the Borghese *Hermaphrodite* and *Belvedere Torso* for the poses of Van Dyck's sleeping Samson [cat. 11], and his seated Christ in *The Crowning with Thorns* [fig. 3]. Even in later years Van Dyck would call up from memory some things from this storehouse, using *The Laocoön* for *Samson Captured* [cat. 11, fig. 2], and the general compositional scheme from Rubens' *The "Madonna of Vallicella" Worshipped by Saint Gregory and Other Saints* (Musée de Peinture, Grenoble) for his own *Madonna of the Rosary* [cat. 46, fig. 4]. More fundamentally, however, the artistic resources assembled by Rubens gave Van Dyck exempla of the highest quality as inspiration and incentive. The collection allowed him to create his own early works in dialogue with Michelangelo, Raphael, Titian, Tintoretto, and Rubens himself, among many other masters.

Van Dyck's work in Rubens' studio offered him the widest possible range of practical experience, an insider's knowledge of the workings of a large, efficient studio, and a significant role in the production of important commissions for the churches and courts of Europe. That led, in turn, to his receiving independent commissions—witness the contract for the Antwerp Jesuit church, which provides for Van Dyck's executing an altarpiece of his own, above and beyond his work assisting Rubens. In the studio, we have seen that he created drawn *modelli* for prints after existing paintings, as well as executing tapestry cartoons and paintings large and small from the designs of the master. He was also able to observe Rubens' creative method close at hand. During the years that they were associated, Van Dyck adopted some of Rubens' approaches, some of his subjects, and some of his working proce-dures. For instance, like Rubens, Van Dyck would develop a complex composition as a whole, working in pen and brush on paper, and then come back to do chalk drawings of individual poses from the model. Vey has pointed out that, unlike Rubens, the young Van Dyck went through numerous compositional studies for a single painting, making dramatic and unexpected changes from one to the next and discovering his design in the process.[25] For his final preparatory state he also chose drawing. Only in later years, apparently after his return from Italy, did Van Dyck regularly use compositional oil sketches as part of his preparatory process in painting as Rubens had. While in Rubens' studio, Van Dyck also adopted a practice that went back to Frans Floris—making expressive head studies in oil—which he and Rubens both abandoned about 1620.[26] As the 1660s suit documented, Van Dyck even as a young man engaged less-experienced artists to assist him in the execution of his commissions, a modest emulation of Rubens' practice. In Italy, he followed another Flemish custom by seeking the collaboration of specialists—namely Jan Roos, who painted animals and still-life elements to accompany Van Dyck's figures [cat. 39]. Not

until he worked in England did Van Dyck need to set up an elaborate studio organization resembling the one he had known as a youth with Rubens. That model served his successors in English court portraiture from Lely to Lawrence.

It is a truism that Rubens' artistic personality was so powerful and his influence so sweeping that his was the visual language of Antwerp for most of the seventeenth century. His long shadow, which might have stunted a lesser talent, only encouraged the development of young Anthony, whose very first paintings, made at age fourteen, show him to be proudly self-conscious of his own artistic prowess [fig. 2 and cat. 1]. In Van Dyck were combined the rebellious spirit and brash assurance of an adolescent and the professional skills of someone much older. While he worked with Rubens, long before becoming an independent master, he charted his own course in style and technique. The "rough style" of his earliest *Saint Jerome* [cat. 2] and *The Martyrdom of Saint Peter* [cat. 3], with their slashing, laden, dry brushwork, strong primary colors, and brutal naturalism could not have been more different from the metallic smoothness and coolness of Rubens' paintings in 1615. In these works Van Dyck forged his own early synthesis—albeit exaggerated—of the critical influences of the day, rendering a Caravaggist naturalism with Venetian color and technique.

Far more important than technique for the long term were Van Dyck's profound differences from Rubens in interpretation and in meaning, which soon emerged. By 1618 Van Dyck began to find his voice and to demonstrate that his unique contribution lay in representing the fortunes of the human soul. The same sensitivity to the individual that would make him an outstanding portraitist enabled him to create incomparably compelling religious narratives and stirring devotional images. We see this in the pathos of the Dresden *Saint Jerome*'s private religious experience [cat. 8], and in the more complex interactive drama of *Samson and Delilah* [cat. 11]. As he worked with and for Rubens, Van Dyck realized that his particular subject was the story of individual experience, rather than the epic sweep of history, enacted on a grand stage. That he was conscious of it is clear from his reinterpretation of Rubens' *Saint Ambrose and Theodosius* [cat. 10], whose modifications lay bare and particularized the nuances of the narrative. Van Dyck was extraordinarily gifted at humanizing even familiar religious tales. He did so in part by depicting the poignancy of personal response in climactic moments—of confrontation in *The Betrayal of Christ* [cats. 13, 14] and *Susannah and the Elders* [cat. 16], or of grace received in *The Brazen Serpent* [cat. 15]. Thus the key to understanding Van Dyck's chronology in 1618–1621 is not style—he is a stylistic virtuoso—but rather the emotional maturity and refinement of his message, as the successive versions of *Saint Sebastian* evince [cat. 22]. We still do not completely understand the rationale for Van Dyck's stylistic choices. It is remarkable, for instance, how rarely he carried over the Rubensian style of the studio production into his own work. One exception, the Saventhem *Saint Martin*, might be explained by the theory that he was carrying out a commission awarded to Rubens.[27] But what of the very Rubensian versions of *The Crowning with Thorns*, one in the Prado [fig. 3] and one lost to Berlin in World War II, whose patrons, if they existed at all, are unknown? Why did Van Dyck use the smooth panel support and sculptural figurative style of his master there? In his Italian years and afterward, Van Dyck at times adopted a style that had a historic resonance suited to his subject, rendering *Vertumnus and Pomona* [cat. 39] with the romantic tenderness of Titian's late style, or *The Mystic Marriage of Saint Catherine* (The Metropolitan Museum of Art, New York) in a sweet Correggesque *sfumato*. Likewise, the Rubensian plasticity of *The Crowning with Thorns* may have corresponded best to the strength and dignity that Van Dyck wanted to impart in that picture. Be that as it may, we should note that it and the Saventhem *Saint Martin* were painted after Van Dyck became a master in his own right, at a time we might speculate he felt he had established his autonomy sufficiently.

Constantly in these early years, Van Dyck aligned himself as a painter with the light, the color, the techniques, and in the end—most importantly—in the human grace and pathos of Titian, Veronese, and Tintoretto. Although before going to England he knew their works in large part from Rubens' copies and Rubens'

collection, he saw there and pursued what Rubens had not and would not develop fully for another decade. Van Dyck was a bellwether of his generation's interest in Venetian painting, and his passionate pursuit of that interest must have made an impression on Rubens. The final transformation in style, scale, and subject that Rubens' work underwent after his encounter in 1628 with Titian's late paintings in Madrid is well known. The seeds of that change had been planted earlier, however, and it is tempting to believe that the loosening of Rubens' brushwork, the softening of his light, and the clarification of his palette, evident in some works of about 1620, including *The Coup de Lance* (Koninklijk Museum voor Schone Kunsten, Antwerp) were stimulated in part by Van Dyck's presence and his independent activity in the studio.[28]

Van Dyck undoubtedly gave Rubens many things during their close association, and he received even more in return. In addition to the abundant intellectual and professional opportunities suggested above, Rubens presented Van Dyck with a social and courtly ideal, for Rubens was the very model of the artist as gentleman and courtier. Each artist had the advantage of being well brought up, as their biographers are careful to note, but each had to earn a living. Their noble manners, described by Bellori, smoothed their paths of ascent, through service to royalty, from the "honest" bourgeoisie to knighthood. Rubens lived well. His palatial house and his magnificent collection were of a princely order.[29] Van Dyck followed suit. Early in his thirties, when he had returned to Antwerp from Italy, he already had an important collection of pictures, including numerous works by the revered Titian. Even before that, according to Bellori, Van Dyck appeared to live grandly, dressing richly and going about with servants while he was in his twenties and living in Italy. His manners, "more of an aristocrat than of a common man," though mocked by his Flemish colleagues in Rome, made him completely suited to the company of his patrons. Van Dyck was knighted by Charles I shortly after his move to England in 1632, and it is apparent that the English nobility, beginning with the king himself, felt quite at home coming to Van Dyck's place in Blackfriars for their sittings. Indeed, the scene as described by Bellori, with "servants, carriages, horses, musicians, singers, and dwarfs," sounds more like a court than a painter's studio.[30]

Years before that, it was Van Dyck's collaboration with Rubens that brought him first to the attention of Thomas Howard, earl of Arundel, who apparently hoped to bring him to England. When Vercellini wrote Arundel on 17 July 1620, he expressed some doubt that Van Dyck could be thus tempted: "Van Dyck is still with Rubens, and his own work is coming to be appreciated as much as his master's. He's a young man, only twenty-one, and his parents who live here are quite wealthy. It is hard to imagine that he would want to leave, even more so since he sees the fortune that Rubens has made."[31] Van Dyck knew, however, that after the completion of the paintings for the Antwerp Jesuit church his "fortune," in terms of success, income, and of destiny itself, lay elsewhere. So he left Rubens' studio and began to travel, first for several months to England, then for several years to Italy. During the eight-month interval between his return from England and his departure for Italy, Van Dyck probably helped Rubens out again from time to time, but he had a lively independent practice as well, both in portraiture and history painting, including his own studio production of *Apostles*.

In departing for Italy, Van Dyck presented Rubens with the stunning portrait of his wife, *Isabella Brant* [cat. 23]. We now can see that the painting also pays strong tribute to Rubens himself, through the depiction of the stone gateway to the Rubens' garden. The portal is an emblem of a kind, representing at once Rubens' interest in classical and modern Italian art and culture, his distinguished social position and financial accomplishments, and above all his own artistic triumphs. Van Dyck had known Rubens well and long, first as his pupil, then as his peer. His homage to Rubens in the portrait of *Isabella Brant* displays his own subtle wit and his fervent Venetianism, as well as an informed admiration for his master's accomplishments and for his master's triumphs, in which he too had a share.

NOTES

I gratefully acknowledge the kind contributions of various colleagues to this study, including Arnout Balis, Reinhold Baumstark, Natalie Lee, Larry Silver, Katlijn van der Stighelen, Suzanne Stratton, and Hans Vlieghe. Egbert Haverkamp-Begemann has been an unfailing counselor and friend since he inspired me to work on Van Dyck years ago. In a small measure of gratitude, I dedicate to him my contribution to this exhibition.

1. Bode 1906, 255.
2. Guiffrey (1882), Cust (1900), Bode (1906), Schaeffer (1909), Rosenbaum (1928), and Glück himself (numerous articles and reviews, reprinted in 1933).
3. This was recently joined by the able Arnout Balis in *Rubens Hunting Scenes*, trans. P. S. Falla (New York, 1986).
4. Particularly those of Vey (1962) on Van Dyck's drawings, of Vlieghe (1977) and Balis (1986) on Rubens' studio, of Van Puyvelde (1933, etc.), McNairn (Ottawa 1980), and Roland (1983, 1984) on Van Dyck's early studio, and of Müller Hofstede (1987–1988) on his early portraits.
5. On Rubens' studio, see Hans Vlieghe, "Rubens en zijn atelier," *Spiegel Historiael* 12, no. 6 (June 1977), 340–347, and Balis 1986, 36–43.
6. C. Ruelens, *Correspondance de Rubens et documents épistolaires concernant sa vie et ses œuvres*, 6 vols. (Antwerp, 1887–1909), 2:135–144; John Rupert Martin, *The Ceiling Paintings for the Jesuit Church in Antwerp* (London, 1968), 213–221.
7. Ruelens 1887–1909, 2:156.
8. Balis 1986, 36.
9. Ph. Rombouts and Th. van Lerius, *De Liggeren en andere historische archieven der Antwerpsche Sint Lucasgilde*, 2 vols. (Amsterdam and The Hague, 1864–1876), 1:457, 545.
10. Ruelens 1887–1909, 2:250–251.
11. Van den Branden 1883, 702, n. 1.
12. Letter to Sir Dudley Carleton, 12 May 1618 (Ruelens 1887–1909, 2:150).
13. This opinion, which held as late as Brown (1982, 12), clearly lay behind Cust's statement: "Van Dyck was never in any way a pupil or apprentice of Rubens" (1900, 9), and Van Puyvelde's detailed argument of the same point in his articles from 1933 on.
14. McNairn in Ottawa 1980, 15–16; Müller Hofstede 1987–1988, 142; Roland 1984, 215.
15. Roland 1984.
16. Glück 1931, XVI, XVIII.
17. Müller Hofstede 1987–1988, 141.
18. "Vandéik qui avoit une extrême passion d'apprendre, ne perdoit pas un moment pour s'avancer dans la connoissance & dans la pratique de la peinture: de sorte qu'il ne fut pas longtems qu'il surpassa tous les jeunes gens qui étudioient avec lui. Mais comme il eut entendu parler du grand merite de Rubens, & qu'il eût vû ses Ouvrages, il fit en sorte, par le moyen de ses amis, que Rubens le reçût chez lui. Cet excellent homme, qui connut d'abord les belles dispositions que Vandéik avoit pour la Peinture, conçût une affection particulière pour lui, & prit beaucoup de soin à l'instruire (Félibien 1666–1688, repr. of 1725 edition, 3:438–439).
19. "... Rubens, il quale, amando li buoni costumi e la grazia del giovinetto nel disegnare, gli parve gran ventura di aver trovato uno allievo a suo modo, che sapesse tradurre in disegno le sue invenzioni per farle intagliare al bulino: fra queste si vede la battaglia delle Amazzoni disegnata allora da Antonio. Non fece egli minor profitto nel colorito, poiché il maestro, non potendo supplire al numero grande de' lavori, impiegavalo a copiare, e l'indirizzava sopra le sue proprie tele in abbozzare ed in condurre ancora li suoi disegni e schizzi in pittura, traendone commodo grandissimo. Fece li cartoni e quadri dipinti per le tapezzerie dell'istorie di Decio, ed altri cartoni ch'egli per lo grande spirito risolveva facilmente. Dicesi che il Rubens, in questo modo facilitando le sue operazioni, veniva a cavare ben cento fiorini il giorno dalle fatiche di Antonio, il quale molto pié ritraeva dal maestro, che era il tesoro dell'arte." Bellori 1672 from edition by Evelina Borea (Turin, 1976), 271–272. I am most grateful to Ronald Strom for his translation.
20. Baumstark suggested that with the Decius Mus cycle, Rubens consciously competed with Raphael's tapestry cycle of *The Acts of the Apostles* (New York 1985, 339–340).
21. Baumstark, in New York 1985–1986, 338.
22. Jeffrey M. Muller, *Rubens: The Artist as Collector* (Princeton, 1989), 65.
23. See Elizabeth McGrath, "The Painted Decorations of Rubens's House," *Journal of the Warburg and Courtauld Institutes* 41 (1978), 245–333.
24. Muller 1989, 11.
25. Vey 1962, 22 (text vol.).
26. Julius S. Held, *The Oil Sketches of Peter Paul Rubens* (Princeton, 1980), 1:597.
27. The other version, in Windsor Castle, is quite different, being executed on canvas and in a more freely brushed, linear manner.
28. Glück 1931, XXVII.
29. On the role played by Rubens' collection in his aspirations to nobility, see Muller 1989, 55.
30. Bellori 1672, 259.
31. Ruelens 1887–1909, 2:250. "Van Deick sta tuttavia con il Sigr. Rubens e viene le sue opere stimate pocho meno di quelle del suo maestro. E giovane de vintiun anno, con padre et madre in questa città molto ricchi; di maniera che è difficile, che lui si parta de queste parti; tanto più che vede la fortuna nella quale è Rubens."

The Quality of Grace in the Art of Anthony van Dyck

JEFFREY M. MULLER

Fig. 1. Titian, *Cain Killing Abel*, 1543–1544, canvas, 292 x 280 (115 x 110¹/₄). Santa Maria della Salute, Venice

It is a remarkable fact that the earliest published critical judgment of Anthony van Dyck's painting has been ignored in all subsequent commentary on the artist. Evidence is frequently ignored when it goes against deeply ingrained prejudice, and this could be true of the passages devoted to Van Dyck in Marco Boschini's *La Carta del Navegar Pitoresco*, printed at Venice in 1660.[1] In the "third wind" of his grand poem in defense of the Venetian tradition of painting, Boschini described Titian's paintings *The Sacrifice of Isaac*, *David Killing Goliath*, and *Cain Killing Abel*, which once decorated the ceiling of the church of Santo Spirito in Isola at Venice and which are now in the church of Santa Maria della Salute [fig. 1].[2] Looking up at the *Cain Killing Abel*, one of the partners in Boschini's dialogue exclaims:[3]

"This is drawing, this is color!
This, how natural, this is style!
No one has ever made something so true!
Oh, what beautiful contours! oh what grand forms!
What animated and bold movements in foreshortening!
Enough that these are the thoughts of Titian!"

In Boschini's eyes, these are the finest ceiling paintings in the world, and to justify such lavish praise he calls to witness:[4]

"That Anthony van Dyck, so valorous,
Who has dissected this picture,
By copying this truth and this bravura,
And by saying: this time I will make myself famous.
Because whoever does not stroke in this style,
And does not grind the grain in this mill,
Will never make light fine white bread,
Nor know what is good: this is the genuine article.
I have drawn all the statues of Rome;
I have put all Antiquity through one sieve:
All these are trifles next to this modern master:
This is a mixture of flesh which can be molded."

In Boschini's account, Van Dyck thoroughly studied the art of ancient Rome but chose instead to form his style on the example of Titian, because Titian's painting incorporated all that was best in ancient sculpture and combined the beautiful contours and proportions of fine drawing with the harmonious arrangement of colors to produce work true both to nature and to the perfection of art. Out of this material Van Dyck fashioned the most refined manner: "light fine white bread."

 I agree with Boschini's judgment of Van Dyck, but it is a judgment that runs against a very different conception of the artist that has prevailed since it was first devised in the late seventeenth century. Especially in the biographies written by Giovanni Pietro Bellori (1672) and Joachim von Sandrart (1675), critical judgment was warped by forcing Van Dyck's art onto the Venetian side of a debate that split the traditions of Italian and then European painting into opposing camps, with Venice set against Florence and Rome.[5] Because the proponents of the Florentine-Roman position dismissed Venetian painting as a mere play of color, thoughtlessly imitating nature, Van Dyck's art could be misunderstood in the same way.[6] If he was praised as a great portraitist, then he was denigrated as a painter of narrative pictures, of history paintings as they were called. Portraiture was always considered the lesser genre in the "humanistic theory of painting," the paradigm that supplied the

Fig. 2. William Hogarth, title page, *The Analysis of Beauty* (London, 1753)

concepts, vocabulary, and values for all discussion.[7] Van Dyck's history paintings were habitually measured against those of his teacher Rubens, and were found wanting; as if this told us anything beyond the fact that Van Dyck was the first great painter who fully confronted the overwhelming achievement of Rubens. Van Dyck was condemned as a facile talent who neglected serious study and ignored the rules of art.

I hope to demonstrate that Boschini's picture of Van Dyck is more accurate because it corrects the distortion imposed by the polemical separation of Venetian painting from the ideal order of drawing and from the rules of art. There is plenty of evidence to show that Van Dyck consciously formed his art within a framework of ideas and traditions of practice that articulated the issues vital to painting in his time: around concepts such as drawing, in the seventeenth-century sense of proportion and outline; chiaroscuro, as an ordered pattern of light and dark; invention, as the imaginative composition of narrative; and expression, as the appropriate depiction of human emotions. My argument will rest on one critical issue: the problem of how Van Dyck sought to represent grace in his painting. It will become evident that this question was central to Van Dyck's development, that it encompassed the other issues he addressed, that he pursued it from around 1620 to his death in 1641, and that it gave distinctive character to his mature work.

My argument is that Anthony van Dyck intentionally formed a style representative of grace.[8] The characteristics that make grace recognizable in art shift through history. In his *Schilder-Boeck* published in 1604 the artist Karel van Mander praised the paintings of Bartholomaeus Spranger for their exceptional grace.[9] But, as we shall see, twenty years later an acquaintance of Van Dyck's criticized Spranger's pictures for their affectation. Van Dyck's work also fell victim to this change in sensibility. For example, William Hogarth's *Analysis of Beauty*, printed in 1753, reveals the secret of grace with the confidence of Lockian empiricism. According to Hogarth, the sixteenth-century Milanese theorist Gian Paolo Lomazzo came closest to solving the mystery of grace in his discussion of the *figura serpentinata* used by Michelangelo. Hogarth narrowed this down to "one precise serpentine-line that I call the line of grace," which, for perfection, must not bulge or taper too much.[10] This line of grace is inscribed in a pyramid on the title page of Hogarth's book [fig. 2]. Hogarth surveyed the work of the best painters from the previous two centuries to see who, more or less, had intuitively discovered the serpentine line of grace: "that which may have puzzled this matter most, may be that Vandyke, one of the best portrait painters in most respects ever known, plainly appears not to have had a thought of this kind. For there seems not the least grace in his pictures more than what life claimed to bring him."[11] Typically not taking Van Dyck's history painting into account and citing, as an example, the artist's iconic *Portrait of Charles I*, now at Windsor Castle, signed and dated 1636, Hogarth complained that although it is "as fine a picture as need be painted yet it hath simplicity without grace."[12] At the other extreme, I believe that many people today are put off by what they perceive as affectation in the attitude of Van Dyck's portraits.[13] Unadorned simplicity and affectation are the extremes that grace must avoid.[14]

By contrast, many writers, starting with Bellori in 1672, have agreed that grace is a distinctive quality of Van Dyck's art.[15] Although the serpentine line that Hogarth saw as the essence of grace played an important role in the composition of Van Dyck's history paintings, Van Dyck and his contemporaries associated grace with many other visual forms as well. Despite the paradoxical nature of grace as art that conceals art, it is possible to identify in seventeenth-century texts conventions for the recognition of grace and to see that these are intentionally represented in Van Dyck's art.

Several texts are important for the question, working back in time to the artist's own statements of intention. First, Joachim von Sandrart, in his *Teutsche Academie* of 1675, tells us that "Gentle Mother Nature helped Anthony van Dyck to our art at a still tender age so wonderfully through the infusion of a great spirit that he reached the highest grade of perfection almost without effort and made everything with

Fig. 3. Anthony van Dyck, *Portrait of Jan Snellincx*, c. 1635, etching, 15.8 x 24.8 (6¹/₄ x 9³/₄). The Metropolitan Museum of Art, New York, Gift of George C. Graves, 1920. The Sylmaris Collection, 20.46.28

special delicacy, in a refined fashion, and with charm, despite the fact that he still did little to train his thoughts in the hard school of the difficult rules of art. ..." [16] In the Latin edition of 1683 all these qualities are translated with one word, *gratia*, grace.[17] Then, after laying the foundations of his art as Rubens' assistant, Van Dyck journeyed in 1621 to Italy where, Sandrart said, "he devoted himself with the greatest diligence to the manner of the excellent Titian, and attained his grace and charm to the degree that no one ever came closer."[18] In his biography of Titian, Sandrart described Titian's early work, especially *Bacchus and Ariadne* and the other pictures painted for the *camerino* of Alfonso d'Este, as delicate and attractive, while he denigrated Titian's late and rough style.[19] It is likely that Sandrart praised Van Dyck for studying Titian's earlier paintings. By contrast, Van Dyck in Italy did not like "the rules of Rome, academies of antiquities, also of Raphael and other serious studies of this kind."[20] Sandrart saw Van Dyck's art as the product of grace: a natural gift, beyond the rules of art, made visible through delicacy and charm, perfectible by the emulation of graceful models (Titian).[21]

Sandrart's conception of Van Dyck's art implies an opposition between grace and rule in the sense that a supremely gifted artist could rely solely on inborn grace to the exclusion of hard-won rules that are necessary to attain the most exalted heights. But it may be that Sandrart exaggerated Van Dyck's dependence on sheer natural talent. The paradoxical nature of grace veils the answers to many questions. Did Van Dyck ignore the rules or did he conceal their trace with art? It remains an open question, for example, whether he made a careful study of ancient sculpture as Boschini and, in our own time, Rensselaer Lee have claimed.[22] Van Dyck wanted to give at least the appearance that practice as the free play of grace was more important than theory in his art. I will return later to the question of practice.

Sandrart's book appeared in 1675 and interprets Van Dyck's position through the polarities of later seventeenth-century theory that I outlined above. The problem of the time and place in which Van Dyck framed the ideal of a graceful style raises further methodological issues. Hans-Joachim Raupp, the one writer who has given careful thought to this problem, argued that Van Dyck constructed images recognizable to his contemporaries as graceful for the express purpose of idealizing artists as gentlemen-virtuosos.[23] This was accomplished, according to Raupp, specifically to set apart the artist portraits included in the print series of illustrious men called the *Iconography*. In portraits like that of the painter Jan Snellincx, reproduced here in the state of Van Dyck's etching, Raupp suggested that the flickering chiaroscuro, animated curves of drapery, penetrating glance, and vital counterpoint of the pose are meant to represent the spiritual animation of grace [fig. 3]. Raupp believed this reading possible only on the basis of knowing the contemporary literature of art. In particular, he cites Franciscus Junius' *De pictura veterum* (Painting of the Ancients), printed in 1637, but seen by Van Dyck in some prepublication form during the summer of 1636.[24] Junius, for the first time, made grace one of the principal parts of painting, equivalent to invention or color. In his English translation published in 1638, he said: "A picture ... may very well be commended for the excellencie of invention, Proportion, Colour, Life, Disposition, and yet want that comely gracefulnesse, which is the life and soule of Art."[25] Junius devoted a whole chapter to the analysis of grace in painting. What Raupp extracted from this discussion as relevant for Van Dyck's artist portraits is the link established by Junius between grace as the source of artistic genius and the primary means of expressing grace through the human body in which an unaffected harmony of spirit is made evident by the qualities of *leggiadria* (comely charm) and *sprezzatura* (nonchalance).[26] Raupp observed that Junius' theory, in which the artist is animated by grace, is the contemporary verbal account closest to Van Dyck's ideal image of artists. Given that Van Dyck's *Iconography* and *The Painting of the Ancients* both were produced in England during the 1630s, Raupp ventured the hypothesis that Van Dyck was influenced by Junius. Thus theory becomes the cause of intention and takes precedence over practice.[27]

I agree with Jochen Becker, who has criticized Raupp for exaggerating the

Fig. 4. Anthony van Dyck, *A Scene of Abduction* with inscription, c. 1620, drawing. Devonshire Collection, Chatsworth. Reproduced by permission of the Chatsworth Settlement Trustees

Fig. 5. Anthony van Dyck, *The Continence of Scipio*, late 1620–early 1621, canvas, 182.9 x 232.4 (72 x 91 1/2). The Governing Body, Christ Church, Oxford

importance of theory at the expense of artistic practice, and I think Raupp is plain wrong to suggest that Junius' theory influenced Van Dyck.[28] Van Dyck conceived the goal of a graceful style years before he saw Junius' book. Artist's practice and writer's theory are closely parallel historical developments. If anything, Junius' emphasis on grace might be seen as theoretical justification of the style of Van Dyck, an artist favored by Junius' patrons, the earl of Arundel and Charles I. Nevertheless, Raupp must be credited as the first to make a convincing argument that Van Dyck fashioned his art thoughtfully according to ideas of theory as they relate to practice, and I think that his observation of conventions expressive of grace in Van Dyck's portraits of artists can be applied as well to many other portraits by the artist and to many of the figures in Van Dyck's history paintings executed after 1620.

Indeed, I suggest that Van Dyck formulated the goal of a graceful style around 1620 and that he perfected this style until his death in 1641. The work bears this out.[29] However, this development has not been understood as a result of the artist's intention framed within contemporary ideas of theory and traditions of practice.

The most important textual evidence of Van Dyck's intention is an inscription on the compositional drawing for a scene of abduction, now in the Devonshire Collection [fig. 4]. Vey placed the drawing in a group from the end of the artist's first Antwerp period; thus around 1620.[30] The second line of this fragmentary inscription, which stands independently from the rest, reads in Flemish: "tis om een loechte maniere." This phrase can be translated as: "it's about [or concerns] an airy style."

What did Van Dyck mean by an "airy style," "een loechte maniere?" The pre-eminent Netherlandish-Latin dictionary of the time, Cornelius Kilianus' *Etymologicum Teutonicae linguae*, equates "lochtigh" with adjectives in Latin that indicate speed, lightness, and agility: *celer, levis, agilis*. To be "locht van geeste," "airy of spirit," is to be *animosus*: full of life, animated.[31]

Van Dyck's "airy style" can be related to grace in two ways. First, an "airy style" would convey the sense of a quick and agile hand, of facility in which effort is not apparent. Junius wrote that "A heavie and difficult diligence doth marre and quite kill the grace of the worke, whereas a light and nimble Facilitie of working addeth life to the worke."[32]

The goal of an "airy style" suggests grace in another way. Junius tells us that when a painter has mastered all the rules of art, then "The consummation of a picture consisteth chiefly therin, that, the several parts concurring, and lovingly conspiring, should breath forth a certaine kinde of grace, most commonly called the *aire* of the picture: which in it selfe is nothing else but a sweet consent of all manner of perfections."[33] Van Dyck's "airy style" can thus be understood as a style that seeks to evoke the "air," the delicate spirit that ideally would animate the whole painting. If one takes into account the similarity of meaning among terms such as the Italian *aria* (air), *maniera* (manner or personal style), and *grazia* (grace), then Van Dyck's reference to an "airy style" also can be interpreted as an appeal to a personal

manner that embodies the graceful air innate in the painter's character.[34]

The change in Van Dyck's painting around 1620 can thus be seen as the first realization of the artist's intention to form an "airy style" of grace. He achieved this goal in one picture that is of greatest importance for understanding the development of his art, *The Continence of Scipio* [fig. 5].[35] By contrast with a slightly earlier picture, the *Samson and Delilah* at Dulwich [cat. 11], one truly can say that the *Scipio* was painted in an "airy style."[36] Whereas the *Samson* is executed with a heavy, encrusted impasto and a variety of very intense and saturated colors, the *Scipio* is painted with thinly applied areas of less intense local color, such as the cloak of Scipio or the dress of the bride, highlighted and shaded with light and delicate touches.

I do not think it is a coincidence that Van Dyck began to formulate a graceful style on his first visit to England where he was encouraged to come by Thomas Howard, earl of Arundel.[37] Just at this time, English critics in the circle of Arundel attacked Rubens' painting as forced and affected. Rubens sent a *Lion and Tiger Hunt* to Lord Henry Danvers who wanted to give the picture as a present to Charles I, then still prince of Wales. In a letter dated 27 May 1621, Danvers reported: "now for Ruben in every paynters opinion he hath sent hether a peece scarse touched by his own hand, and the postures so forced, as the Prince will not admitt the picture into his galerye."[38] Edward Norgate was a courtier in the service of Arundel and later of Charles I who probably met Van Dyck in Italy during 1622 and was the artist's host when he first returned to London in 1632. Norgate wrote a treatise around 1623 on how to paint miniature portraits, in which he warned against those painters who "in their Invention ... assume themselves such a liberty, or rather lycence, as well in their Collouring, as in their designes and drawings, as many times is unnaturall, extravagante, and impossible, and somtymes rediculous. ... Soe *Blomart* and Spranger in theire Racte and distended proportiones, *Rewbens* in his affected Colourings, and *Cornelison of Harlaim* in his loose, squailed and untrust Figures, like ould and beaten gladiatours, seeme soe farr to have abused and mistaken that gentle and modest licence, that soe grace the workes of the admirable Titianus, *Michelangelo* &c., that tis not safe to goe at all by the life, rather soe farr to exceed any other patterne then the *Chimaera* which theire owne Braynes and phantasy, have suggested unto them."[39] Norgate's criticism is important because it challenges our crude categorization of Rubens as a "Baroque" artist whose work stood monolithically in opposition to the style of "Mannerists" such as Bloemaert, Spranger, and Cornelis van Haarlem. Indeed, the flesh color in many pictures by Rubens painted during the 1610s contains a mixture of intense and distinct strokes of blue, red, and yellow that understandably could have been perceived as "affected."[40] Early critics such as Bellori and De Piles noted especially that Van Dyck painted flesh color more delicately than Rubens did and in the sixteenth century Lodovico Dolce had already identified the delicate and sweet painting of flesh color as a source of grace.[41] It is possible that Van Dyck came to share the view of Rubens' art as affected and forced in pose and color and that he began to develop a graceful style in opposition to it.

It is significant in this regard that, with the help of the earl of Arundel, Van Dyck received permission to leave England on 2 March 1621, and that eight months later he left Antwerp for Italy where, in 1622, he linked up at Venice with the countess of Arundel.[42] Arundel, Charles, Buckingham, and other English nobles had by this time acquired a special taste for Titian, and it is possible that Van Dyck was influenced by this predilection.[43] One can agree with Sandrart that Van Dyck in Italy learned better than anyone to imitate the secret of Titian's grace.

In Italy Van Dyck must also have taken into account the art of Guido Reni, which was understood by contemporaries as an exemplification of grace in opposition to rule.[44] As in the art of Guido Reni, the opposition to rule in Van Dyck's painting is not absolute, but more a matter of degree in comparison with artists such as Domenichino and Poussin where the appearance of the art expresses the importance of calculated order, while the appearance of Van Dyck's and Reni's art hides any trace of studied order that might kill the delicate grace of the work.

The most important characteristic linking Reni and Van Dyck, as artists working in

Fig. 6. Guido Reni, *The Assumption of the Virgin*, 1617, canvas, 442 x 287 (174 x 113). Chiesa di Sant' Ambrogio, Genoa

graceful styles, can be seen in Reni's *Assumption of the Virgin* painted in 1617 for the Jesuit church of Sant' Ambrogio in Genoa, a picture we know Van Dyck studied closely [fig. 6].[45] Reni produced the effect of delicate restraint and the veiled air of grace by joining the underlying force and clarity of a stable composition with a sweet play of light and dark, gently curving draperies, and exquisitely poised gestures of the figures. Movement comes from the shimmer of light and from linear rhythms over the whole surface instead of from the figure composition and poses of the figures, which are still. Van Dyck, in his finest works painted after around 1625, achieved the same effect of bridled movement, but more through the individual brushstrokes of highlights in his draperies and in the delicate finishing strokes of hair and foliage where, in the paradox that lies at the heart of grace, one sees the trace of the artist's hand in a movement that simultaneously appears free and tightly controlled. This network of highlights in pictures such as the *Rinaldo and Armida* now in Baltimore [cat. 54] also sets into motion a play of light over forms that are clearly outlined and restrained in their poses. It is this screen of optical movement over a quiet composition which in the case of both Reni and Van Dyck creates the illusion of an "air" of grace hovering over the whole picture.[46]

Sandrart noted that Van Dyck did not like "academies of antiquities, also of Raphael and other serious studies," and this statement is accurate insofar as it records Van Dyck's opposition to rote study for its own sake. Van Dyck's anti-academic viewpoint in Italy agreed with the attitude taken by his mentor Rubens. Rubens believed that exclusive devotion to the Italian "Academicall course" of drawing from the nude would make the artist a mechanical drudge and blast his spirit.[47] According to Rubens, the slavish imitation of ancient sculpture would destroy the painter's art by substituting the appearance of cold stone for warm flesh.[48] Van Dyck himself later warned against wasting time in finicky drawing once sufficient mastery had been attained.[49] In the same vein, Van Dyck required the artist to learn the conventions of proportion so well that they could be applied without effort to the composition of lifelike figures.[50] The artist therefore should learn anatomy from life drawing, ideal beauty from ancient sculpture, the mastery of drawing from careful study, and the measure of proportion from the most beautiful modular types. But once this knowledge was attained it had to be subordinated to freedom of touch, play of spirit, and exercise of judgment. Grace could arise only through the illusion of spontaneity.

Van Dyck constructed a style of graceful facility through the effort he made to perfect his technique. Sir Theodore Turquet de Mayerne, physician to Charles I, reported that on 30 December 1632 Van Dyck told him: "The oil is the principal thing that painters must search for, trying to have it good, white, liquid, since otherwise if it is too thick, it kills all the most beautiful colours."[51]

Recognition of the importance of a thin medium for Van Dyck's art comes early in Arnold Houbraken's (1718) variation on Pliny's story of the contest between Apelles and Protogenes over who could paint the finest line. Van Dyck, incognito, visits the studio of Frans Hals and is recognized by his inimitable style. Houbraken ended the tale with Van Dyck's judgment of Hals: "That if Hals had blended his pigments somewhat more delicately and thinly, he would have been one of the greatest masters."[52] Apelles was the paragon of grace among ancient artists and it could be that Van Dyck used a thin medium to attain the refined line for which Apelles was renowned and which gives Van Dyck's figures an extra grace.[53]

Van Dyck, I suggest, attained a graceful style through practice, and this fact is very important for his theoretical position and for his position in the history of art. Grace is a quality of art beyond the rules. But Junius' painter and Castiglione's graceful courtier, if born with a modest gift of grace, could perfect it, not by following theoretical precepts, but by judging what are examples of grace and emulating them, and by practicing these lessons until they become habit. As Sandrart implied, Van Dyck followed this course by diligently studying the *gratia* and *Annehmlichkeit* of Titian. Practice becomes the rule in grace where the painter must conceal art with art.

Because practice was so important for him, it is no accident that the most exten-

Fig. 7. Jacob Jordaens, *Erichthonius Discovered by the Daughters of Cecrops*, c. 1640, canvas, 150 x 208 (59 x 81 7/8). Kunsthistorisches Museum, Vienna

Fig. 8. Peter Paul Rubens, *Venus and Adonis*, c. 1635, canvas, 197.5 x 242.9 (77 3/4 x 95 5/8). The Metropolitan Museum of Art, New York

sive record we have of Van Dyck's views on art is a historically conscious, conservative, step-by-step guide to the technique of painting, known from a manuscript in the Bodleian Library at Oxford.[54] His advice there to finish a picture by imitating "prettily the greatest refinement of the hair with winding brushstrokes" speaks again of a technique of grace in the sense that grace can be expressed only by an action that is exquisitely skillful and apparently effortless at the same time. His recommendation to finish a picture with sensuous winding strokes also explains why Van Dyck's paintings can be fully appreciated only when the surface is in excellent condition.[55]

Van Dyck also sought to represent grace through the slender proportions of his figures. The association between slenderness and grace is ancient, present in Vitruvius' commentary on the proportions of the Ionic and Corinthian orders.[56] Leonardo da Vinci said graceful figures are to be made "delicate and elongated."[57] Vasari praised the slender figures of Parmigianino especially for their grace.[58] Junius cited as descriptive of grace the Italian adjective *svelto*.[59] In 1640 Charles I had to decide whether he would award Rubens or Jordaens a commission to paint the story of Cupid and Psyche. The king's agent in Brussels, Sir Balthasar Gerbier, recommended Rubens: "they are both Dutchmen & not to seeke to represent robustious boistrous druncken headed imaginary Gods and of the two most certaine Sir Peter Reubens is the gentilest in his representations."[60] When Jordaens won by default, the king insisted that "the painter Jordaens must bee remembered to make, in the first peece of painting (intended for Her Majesty), the faces of the woemen as beautifull as may bee, the figures gracious and svelta."[61]

Van Dyck may have painted his *Cupid and Psyche* [cat. 85] for the same program in 1638.[62] Jordaens' picture of *Erichthonius Discovered by the Daughters of Cecrops*, dated around 1640, can serve as a comparison of style [fig. 7]. Van Dyck's picture achieves grace through an "airy style" in which a light and quick facility hides any obvious display of skill, where winding brushstrokes depict Cupid's flowing locks, where line is delicate and fine, forms gently intertwine, highlights shimmer across the surface reflecting light with luster like mother of pearl, proportions are slender and limbs are tapered, and the surface breathes forth a gentle air that suffuses both the landscape and the picture. Jordaens' picture is in a "robust style," with its ruddy, warm tonality, thick brushstrokes, and heavy proportions.

The contrast holds, to a lesser degree, in a comparison with Rubens, even in his later works: for example, the *Venus and Adonis* of around 1635 [fig. 8]. Rubens, as Hogarth observed, did not use "the *precise line* ... which gives the delicacy we see in the best Italian masters."[63] Van Dyck reacted against what he considered as the gross elements in Rubens' art because he wanted to attain a more delicate, airy grace.

By bringing together different characteristics such as tender flesh color, elongated

proportions, tension between freedom and control in brushstrokes, and an "air" that suffuses his pictures, Van Dyck formed a style, like "light, fine white bread," representative of grace.

Van Dyck aspired to an ideal of grace that emphasized apparent freedom of imagination and innate artistic gifts over academic rule. He presented himself in his art in the way he described the Italian painter Sophonisba Anguisciola when he met her in Sicily in 1624, as a painter "di natura," by nature.[64] Sandrart's account of Van Dyck as an immensely gifted artist opposed to the careful study of rules is accurate only on the surface. The grace embodied in Van Dyck's history painting really was like the social grace of the aristocrats whose portraits he painted. Whether it was painstakingly acquired so as to express freedom in the most rigid of codes, or was easily carried as a gift of birth, we are not meant to know.

NOTES

I have profited greatly in writing this paper from the advice and help of Susan Barnes, Karen Bowen, Deborah Del Gais Muller, Hubert von Sonnenburg, Jane Sweeney, and Arthur Wheelock. Research was conducted with support from a Fulbright grant under the Western European Regional Research Program and from the Brown University Faculty Development Fund.

1. Marco Boschini, *La Carta del Navegar Pitoresco*, ed. Anna Pallucchini (1660, repr. Venice and Rome, 1966), 167. Mitchell Merling drew my attention to this passage and I have learned a great deal about Boschini's point of view from talking with him.

2. See Juergen Schulz, *Venetian Painted Ceilings of the Renaissance* (Berkeley and Los Angeles, 1968), 77–79, no. 20.

3. Boschini 1660, 191: "Questo è dessegno! questo è colorito!/Questo xe natural! questa è maniera!/Nissun ha fato mai cosa sì vera!/... Oh che bei contornoni! oh che gran forme!/Che movimenti in scurzo vivi e fieri!/Basta che de Tician sia stà i pensieri." Franco Fido kindly advised me on the translation.

4. Boschini 1660, 191: "Quel Antonio Vandich, sì valoroso,/ Ha fato notomia de sta Pitura,/ Col copiar sto dasseno e sta bravura,/ E dir: sta volta me fazzo famoso./ Perché chi no colpisse in sta maniera,/ E no masena el gran su sto molin,/ Mai farà pan bufeto, bianco e fin,/ Né 'l bon cognosserà; questa è la vera./ Tute le statue ho dessegnà de Roma;/ Tuto l'Antigo int'un tamiso ho messo:/ Tute xe bagie a sto moderno appresso:/ Questo è impastà de carne, che se doma." Boschini's story may in gist be true. Van Dyck's Italian sketchbook in the British Museum contains copies of Titian's *Pentecost* which also was in Santo Spirito in Isola: see Adriani 1965, fols. 96v–97r, and the style of Van Dyck's altarpieces depicting the Passion of Christ executed during his second Antwerp period, c. 1627–1632, is strongly influenced by just these paintings by Titian. Boschini could have heard the story from his teacher Odoardo Fialetti

who was in close contact with the circle of Lady Arundel to which Van Dyck belonged when he was in Venice in 1622. See below, n. 42.

5. Bellori 1672 (repr. Turin, 1976), 269–284; Sandrart 1925, 174. For an account of the critical debate between Venice and Florence and Rome, see J. A. Emmens, *Rembrandt en de regels van de kunst* (Utrecht, 1968), 28–62, on "The Birth of the Classicistic Critique," and especially 38–40, on "The Tuscan-Roman Negative," with its *locus classicus* in Vasari's biography of Titian. See also Maurice Poirier, "The Disegno-Colore Controversy Reconsidered," *Explorations in Renaissance Culture* 13 (1987), 52–86, who argued convincingly that this critical polarity distorts our understanding of both sixteenth-century theory and painting.

6. See Bellori 1672, 283–284.

7. See Rensselaer W. Lee, *Ut Pictura Poesis: The Humanisitic Theory of Painting* (New York and London, 1967).

8. For a survey of the ideal of grace in early modern theory, see Samuel Holt Monk, "A Grace Beyond the Reach of Art," *Journal of the History of Ideas* 5 (1944), 131–149.

9. Karel van Mander, *Het Schilder-Boeck* (1604, repr. Utrecht, 1969), f.274r: "Het heeft doch van aenvangh altijt een besonder Apellische gratie in al zijn dinghen gespeelt. ..."

10. William Hogarth, *The Analysis of Beauty*, ed. Joseph Burke (1753, repr. Oxford, 1955), 5–6; Gian Paolo Lomazzo, *Trattato dell'arte della pittura, scoltura, et architettura*, in *Scritti sulle arti*, ed. Roberto Paolo Ciardi, 2 vols. (1584, repr. 1973–1974), 2:29.

11. Hogarth 1955, 9–10.

12. Hogarth 1955, 181.

13. For an expression of this view see Held 1982, 334.

14. For the *locus classicus* of this definition of grace as an Aristotelian virtue of moderation see Baldesar Castiglione, *Il Libro del cortegiano, con una scelta delle Opere minori*, ed. Bruno Maier (Turin, 1964), 14.

15. Bellori 1672, 271–272, observed that Rubens admired the young Van Dyck's *grazia* in drawing and, 283, noted that Van Dyck used reflections and deep shadows that rendered his lights with "grazia e forza."

16. Sandrart 1925, 174: "Es hat die milde Mutter der Natur verwunderlich dem Anton von Dick gleich in seiner zarten Jugend durch Eingießung eines großen Geists zu der edlen Mahlkunst dergestalt geholffen, daß er fast ohne Mühe zu dem höchsten Grad der Vollkommenheit gelanget und alles mit absonderlicher Zierlichkeit, netter Art und Annemlichkeit gemacht ... unangesehen er seine Gedanken noch wenig in die mühsame Schul der schweren Kunstregeln geschicket. ..."

17. Joachim von Sandrart, *Academia nobilissimae artis pictoriae* (Nuremberg, 1683), 297: "Obstetricante quasi naturâ in teneris ahhuc aetatis suae annis ad artem nostram, infusâ, ut ita dicam, potius, quàm acquistâ molestiùs scientiâ promotus: ut quicquid pencillo referret, gratia quadam polleret singulari."

18. Sandrart 1925, 174: "Von dannen hat er sich nach Italien begeben, woselbst er sich im höchsten Fleiß auf die Manier des fürtreflichen Titians geleget, auch deßelben Gratia und Annehmlichkeit dergestalt erreicht, daß ihm keiner jemalen näher kommen. ..."

19. Sandrart 1925, 270–272; also see Sandrart 1683, 161.

20. Sandrart 1925, 174: Van Dyck left works behind in Rome: "... weil ihn aber die Romanische Reglen und Academien der Antichen, auch Raphaels und anderer dergleichen seriose Studien nicht gefällig, bliebe er nicht lang allda. ..."

21. Sandrart's account of Van Dyck's art agrees closely with the concept of grace in Castiglione's *Il Cortegiano* as it is interpreted by Eduardo Saccone, "Grazia, Sprezzatura and Affettazione in Castiglione's *Book of the Courtier*," *Glyph* 5 (1979), 39–40. Also see Victoria Kahn, "Humanism and the Resistance to Theory," in *Literary Theory/Renaissance Texts*, ed. Patricia Parker and David Quint (Baltimore and London, 1986), 388, who suggested that Castiglione's *sprezzatura* can serve as "a figure for the resistance to theory."

22. Lee 1963, 26, argued that the study of ancient sculpture was important for the development of Van Dyck's art.

23. Raupp 1984, 137–153.

24. Van Dyck sent Junius a letter dated 14 August 1636: see Franciscus Junius, *De pictura veterum libri tres* (1637: 2d ed. 1694, repr. Soest, 1970), front matter: "De vrucht van UE. werck sal wesen tot hervatting van de verloren kunste, 't welck een groote glorie ende content voor den Auteur sal wesen." For Van Dyck's letter see Allan Ellenius, *De arte pingendi, Latin Art Literature in*

Seventeenth-Century Sweden and Its International Background (Uppsala and Stockholm, 1960), 94, who suggested that in Van Dyck's apparently empty praise there may lie a serious criticism of "the now vanquished Mannerism, perhaps also of a baroque style of painting which he considered excessively full of movement and colouristic brilliance." Ellenius 1960, 91, without arguing for any causal relationship, was the first to note a general similarity between the principles espoused by Junius and the "simpler and more austere" character of Van Dyck's art.

25. Junius 1972, 321.

26. Castiglione 1964, 124, coined the word *sprezzatura* especially to describe that quality of easy mastery in which grace was thought to reside.

27. Raupp 1984, 150, put forward the hypothesis that Junius influenced Van Dyck, but then, 153, contradicted himself by admitting that there is no proof of a causal connection between Junius' theory and Van Dyck's portraits.

28. Jochen Becker, review of Raupp 1984, in *Oud Holland* 101 (1987), 282.

29. See for example the discussion in Brown 1982, 52.

30. Vey 1962, 1:174, no. 103. The whole inscription as recorded by Vey reads: "tis gegaen sanderen tijde, soo moeten wij [cut at the top]/tis om een loechte maniere/tiekent dat ens./betaelt." Especially at this period Van Dyck was in the habit of inscribing on his drawings words, phrases, and sentences that do not necessarily have any significant relationship one to the other. Although the first line of the inscription under discussion is cut at the top right, the second line that refers to "een loechte maniere" seems neither to continue the meaning of the first line nor to lead into the meaning of the third line. This drawing develops part of the invention set down on a sheet in the British Museum: Vey 1962, 1:173–174, no. 102.

31. Cornelius Kilianus, *Etymologicum Teutonicae linguae: sive dictionarium Teutonico-Latinum* (Amsterdam, 1605), 288.

32. Junius 1972, 327.

33. Junius 1972, 321.

34. On this group of related concepts see David Summers, *Michelangelo and the Language of Art* (Princeton, 1981), 56–59; also see Leo Spitzer, "Milieu and Ambiance," in *Essays in Historical Semantics* (New York, 1948), 258–260.

35. See Oliver Millar in London 1982, 43–44, no. 3.

36. This comparison is made by Millar in London 1982, 12–13, but without any consideration of theoretical context.

37. On Arundel as patron see Howarth 1985. Susan Barnes reported to me that David Howarth has discovered a letter of 20 October 1620 from Thomas Locke to William Trumbull that mentions that Viscount Purbeck, the duke of Buckingham's brother, officially invited Van Dyck to England. But this in no way discounts the interest and importance of Arundel in bringing Van Dyck to England. See the letter of 17 July 1620 from an anonymous correspondent to Arundel in Ch. Ruelens and Max Rooses, eds., *Codex diplomaticus Rubenianus*

(correspondance de Rubens), 6 vols. (Antwerp, 1887–1909), 2:250: "Van Deick sta tuttavia con il Sigr. Rubens e viene le sue opere stimate pocho meno di quelle del suo maestro. E giovane de vintiun anno, con padre et madre in questa citta molto ricchi; di maniera che è difficile, che lui si parta de queste parti; tanto più che vede la fortuna nella quale è Rubens."

38. See Ruelens and Rooses 1887–1909, 2:277. Arnout Balis, *Corpus Rubenianum Ludwig Burchard, part 18, Landscapes and Hunting Scenes, 2, Hunting Scenes*, trans. P. S. Falla (London, Oxford, and New York, 1986), 148–149, no. 7b, suggests that a picture now in the Palazzo Corsini, Rome, could be the *Hunt* Rubens sent to Danvers.

39. London, British Library, MS Harl. 6000, fol. 12r: *An exact & Compendious Discours concerning the Art of Miniatura or Limning*. ...

40. An excellent analysis of Rubens' painting of flesh color and of its place in the history of technique is given by Hubert von Sonnenburg, "Rubens' Bildaufbau und Technik," in *Rubens: Gesammelte Aufsätze zur Technik* (Munich, 1979), 35–40. Junius 1972, 286, stated a general principle similar to Norgate's criticism of Rubens: "a decent grace of colors commendeth a picture very much; but when it followeth the nature of things of it selfe, and not when it is drawne in by an importunately odious affectation."

41. Bellori 1672, 283: in comparison with Rubens, Van Dyck "riuscí piú delicato nelle incarnazioni e si avvicinò piú alle tinte di Tiziano. ..." Roger de Piles, *Dialogue sur le coloris* (1673, repr. Geneva, 1973), 70, said that Van Dyck surpassed his master "dans certaines delicatesses de l'Art, & il est constant qu'il a fait des carnations plus fraiches & plus veritables que Rubens." Lodovico Dolce, *Dialogo della pittura intitolato l'Aretino*, in *Trattati d'arte del Cinquecento fra Manierismo e Controriforma*, 3 vols., ed. Paola Barocchi (1557, repr. Bari, 1960), 1:178, preferred the delicate figures of Raphael to the anatomical specimens of Michelangelo: "chi fa il delicato, accenna gli ossi ove bisogna, ma gli ricope dolcemente di carne e riempie il nudo di grazia." Brian D. Steele kindly brought this passage to my attention.

42. For Arundel's role in obtaining Van Dyck's travel pass see Hookham Carpenter 1844, 10. The most important evidence of Van Dyck's contact with Lady Arundel in 1622 is contained in the anonymous late eighteenth-century biography of the artist, which bases much of its information about the Italian period on letters by Van Dyck's host in Genoa, Cornelis de Wael: see Larsen 1975a, 58.

43. Evidence that the English aristocracy had developed its taste for Titian by 1622 is contained in Tizianello, *Breve Compendio della Vita del Famoso Titiano Vecellio di Cadore Cavalliere, et pittore, Con l'Arbore della sua vera consanguinità* (Venice, 1622), dedication to Lady Arundel, which notes her husband's high esteem for Titian's work; the printer's address to the reader which notes the

collections where Titian's pictures are to be found: "particolarmente dell'Inghil- terra, dove al presente vi regna grandissima dilletatione della Pittura, & Scoltura, sono adorni tutti dell'opere di questo immortal Pittore, come appresso l'Altezza del Sereniß. Prencipe di Waglia figliuolo di Sua Maestà, dalla gran Bertagna [sic], dell'Illustriß. & Eccellentiß. sig. Marchese di Buchimghan gran Consegliero di S. Maestà ... & anco appresso l'Illustriß. & Eccellentiss. Signor Marchese Hamilton ..., dell'Illus- triß. & Eccellentiss. Signor Conte di Penburc ..., & particolarmente appresso l'Illustrissimo ... Signor Conte d'Arundell. ...; vi si vede di mano del sudetto, oltre molti altri Quadri Lugretia Romana sforzata da Tarquinio ..., & il ritratto del Duca di Borbone." Brown 1982, 62, suggested that Tizianello could even have been Van Dyck's guide in Venice.

44. See D. Stephen Pepper, *Guido Reni* (New York, 1984), 24–27 and 38–40.

45. For this picture see Pepper 1984, 232–233, no. 50. Van Dyck's keen interest in Reni's *Assumption* is evident from the oil sketch in the Akademie der bildenden Künste in Vienna, which is a free adaptation of Reni's composition: see Otto Kurz, "Van Dyck and Reni," in *Miscellanea Prof. Dr. D. Roggen* (Antwerp, 1957), 179–181.

46. The anonymous eighteenth-century biographer of Van Dyck, perhaps relying again on information from letters by Cornelis de Wael, reports that both in Rome and in Bologna Van Dyck studied closely the paintings of the Bolognese school: "c'est à dire la force et la fierté du dessin du Carrache, la pureté de celui du Dominiquin, les graces et la finesse de celui du Guide": Larsen 1975a, 55. Günther Heinz, "Studien über die Anwendung des Helldunkels in den Werken Guido Renis," *Jahrbuch der Kunsthistorischen Sammlungen in Wien* 51 (1955), 207, made a sustained argument for mutual influence between Reni and Van Dyck during the years 1622–1627. While Van Dyck may have inspired the open decorative brushstrokes that Reni began to use in the late 1620s, Reni would have provided the model for the elongated proportions that Van Dyck introduced into his work during the 1620s. Both artists, according to Heinz, followed parallel paths by combining elegant figures with free painterly execu- tion in response to the example of "post- classical" Renaissance painting, presum- ably that of Parmigianino above all.

47. Rubens' views on the academy are reported by Edward Norgate in the second version of his treatise on miniature painting, written 1648–1650: Oxford, Bodleian Library, Tanner MS 326, "Miniatura or The Art of Limning, The Names Order & use of the Couleurs both for Picture by the Life Landscape and History," 79–80, described the Italian practice of life drawing at the "Academy," by which "they pretend to great skill in the naked *Anatomy*, & Muscles of The Body, and other eminences appearing in the Life, but Peter *Rubens* told mee that at his being in Italy, divers of his nation had followed

the *Academy* course for 20 Yeares together to little or noe purpose Besides these dull, tedious and heavy wayes Doe ever presupose *animam in digitis*, a man whose soule hath taken up his Lodging in his fingers ends."

48. In his essay "De imitatione statua- rum" published in Roger de Piles, *Cours de peinture par principes* (Paris, 1708), 139.

49. Van Dyck's views on drawing are reported by Norgate Tanner MS 326, 79: "Having attained to a competent and laudable proficiency in neat exact and curious Disigne I shall never wish you to continue that neatnes and curiosity in any designe you make, but to consider all drawing but as a servant and attendant, and as the way of painting, not the end of it. To this purpose the excellent Vandike, at our being in italie was neat exact and curious in all his drawings, but since his cominge here, in all his Later drawings, was ever iuditious, never exact. My meaning is the long time spent in curious designe he reserved to better purpose, to be spent in curious painting, which in drawing he esteemed as Lost, for when all is done, it is but a drawing, which conduces to make profitable things, but is none it selfe." This passage is discussed by Julius S. Held, *Rubens, Selected Drawings*, 2 vols. (London, 1959), 1:15; Vey 1962, 1:19–20; Christopher White, "The Theory and Practice of Drawing in Early Stuart England," in *Drawing in England from Hilliard to Hogarth* [exh. cat. British Museum] (London, 1987), 23.

50. See Vey 1960, 195. In his step-by-step instructions on the correct way to paint a history painting Van Dyck defined his terms, including "Teyckenen," "draw- ing": "Het teyckenen bestaet in de handt daer toe te gewennen, dat se so seker gae in haer werk, dat de proportie onser teykeninghe int'groot te worpen sijnde so nauw over een come met t gene het ooghe siet, dat men van weghen d'onderscheydelicke gelijkenis licthelick t'een voor t'ander soude nemen."

51. See Mansfield Kirby Talley, *Portrait Painting in England: Studies in the Technical Literature before 1700* (London, 1981), 116–117.

52. Arn. Houbraken, *De Groote Schou- burgh der Nederlantsche Konstschilders en Schilderessen*, 3 vols. (Amsterdam, 1718–1721), 1:90–92, with Van Dyck's comment on Hals, 92: "Dat, indien hy in zyne vermenginge wat meer van het teere, of dunne gehad had, hy een der grootste meesters zoude hebben geweest."

53. For Apelles' special "venustas," which the Greeks call "charis," see Pliny the Elder, *Natural History*, 35:79. Van Dyck's cultivation of a refined Apellian line suggests the parallel development observed by Charles Dempsey, "The Greek Style and the Prehistory of Neoclassicism," in *Pietro Testa 1612–1650*, ed. Elizabeth Cropper [exh. cat. Philadel- phia Museum of Art] (Philadelphia, 1988), xxxvii–lxv, in the art of Poussin and François Duquesnoy, which took place, on the basis of their study of ancient sculpture, around 1626. The anonymous eighteenth-century biographer of Van Dyck reported that

Van Dyck met Duquesnoy in Rome in 1622 and that "Le jeune artiste dut beaucoup aux conseils et à l'exemple de ce sculpteur célèbre": Larsen 1975a, 53.

54. Vey 1960, 194–196.

55. Vey 1960, 195: the painter should "d'uijterste netticheyt vant' hair met slingerende penceelstreken aerdighlyck nae bootsen, en t' gantsche werk op t' aller sinnelickste voltoyen."

56. Vitruvius, *De architectura*, 4:1, 8-9.

57. Jean Paul Richter, ed., *The Notebooks of Leonardo da Vinci*, 2 vols. (1883, repr. New York, 1970), 1:295.

58. Giorgio Vasari, *Le opere di Giorgio Vasari*, ed. Gaetano Milanesi, 9 vols. (Florence, 1906), 4:12, 5:218, 235. This view of Parmigianino was repeated in the seventeenth century by Francesco Scanelli, *Il Microcosmo della pittura*, ed. Guido Giubbini (1657, repr. Milan, 1966), 309: Parmigianino formed his own personal style "che in sveltezza, spirito vivace, e gratiosa leggiadria ha superato ogni più eccellente Pittore. ..." Also see Sydney J. Freedberg, *Parmigianino, His Works in Painting* (1950, repr. West- port, 1971), 5–12, for an analysis of grace in Parmigianino's art, including a discussion of the elongated figures.

59. Only in the Latin edition, Junius 1637, 199, speaking of the sources of grace: "Italice est *morbido & vago, leggiadro, svelto*."

60. Ruelens and Rooses 1887–1909, 6:251, Gerbier to Edward Norgate, 4 February 1640.

61. Ruelens and Rooses 1887–1909, 6:258, Gerbier to Inigo Jones, 24 March 1640.

62. Millar 1982, 97–98, no. 58.

63. Hogarth 1753, 8.

64. Adriani 1965, fol. 110r. Also see the transcription of Van Dyck's inscription, 29–30.

Van Dyck's Pembroke Family Portrait: An Inquiry into Its Italian Sources

CHRISTOPHER BROWN

Van Dyck's monumental portrait group of the *4th Earl of Pembroke and His Family* [fig. 1] has recently been reinstalled in its spectacular setting in the Double Cube Room at Wilton House after extensive restoration and a short stay at the National Gallery in London. At Wilton it takes its commanding place as part of one of the greatest baroque interiors in Britain. In the past, however, while the Double Cube Room has always excited open-mouthed praise, the Pembroke family portrait has, even among very discerning critics of Van Dyck, had a generally poor critical press. Lionel Cust thought it "a conspicuous instance of the inability shown by Van Dyck in composing a portrait group of several figures,"[1] while Ellis Waterhouse, half a century later, wrote that "Van Dyck's few portrait groups, of which the most notable is the huge 'Pembroke Family' at Wilton, had no immediate following. For an artist so accomplished in the single figure and in occasionally inspired double portraits they are curiously awkward and clumsily designed."[2] More recently Oliver Millar has defended the painting, praising its masque-like theatricality,[3] and David Howarth has described it as "that most operatic of all the artist's pictures."[4] The return of the painting to Wilton, cleaned and relined, is an appropriate moment to take a fresh look at it and to assess Van Dyck's achievement in this immense undertaking.

The starting point for this fresh look must be the realization that the picture is not just a family portrait: it is also an ambitious history painting. Van Dyck was reinterpreting the family portrait in terms of the history painting of the High Renaissance and, in particular, the history painting of Titian. What Van Dyck did in this painting is in some senses analogous to what Rembrandt was to do a few years later in *The*

Fig. 1. Anthony van Dyck, *The 4th Earl of Pembroke and His Family*, c. 1633–1634, canvas, 330 x 510 (128³/₄ x 199). Collection of the Earl of Pembroke, Wilton House, Wiltshire

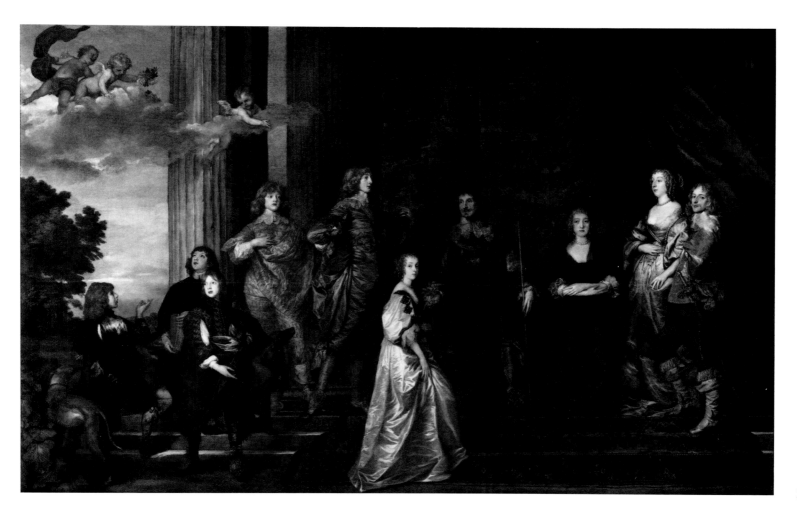

Fig. 2. Anthony van Dyck, *The Echevins of Brussels Seated around a Statue of Justice*, 1638, panel, 26 x 58 (10 1/8 x 22 5/8). Ecole Nationale Supérieure des Beaux-Arts, Paris

Fig. 3. Anthony van Dyck, *John of Nassau-Siegen and His Family*, 1634, canvas, 292.5 x 265 (114 x 103 5/8). Collection of Viscount Gage, Firle Park, Sussex

Night Watch, that is, to take a tired and static group portrait formula, in Rembrandt's case the militia company portrait, and recast it as a baroque history painting.

Both artists worked, of course, to the particular demands of their respective patrons. In Van Dyck's case we must presume that Pembroke specified the size of the painting, although it is also possible that Van Dyck was involved in the decision to work on such a massive scale. Shortly before his return to England in 1635 from a year-long stay in Flanders, Van Dyck had completed his life-size group portraits of the *échevins* of Brussels, which were to hang in the Town Hall. The paintings were destroyed in 1695, and our principal visual record of this project is Van Dyck's oil sketch [fig. 2],[5] which shows seven *échevins* grouped around an enthroned figure of Justice.[6] It was truly monumental, although, judging from the sketch, the *échevins* favored a conventional and distinctly lackluster compositional scheme. We also know of Van Dyck's eagerness to carry out ambitious decorative schemes from the abortive project for a series of tapestries, one showing the Garter procession for the Banqueting House [see cat. 101], and from his willingness to risk his health dashing to Paris in the last months of his life in a vain attempt to secure the commission for the decoration of the Grande Galerie of the Louvre. So, while the decision to commission a painting as large as eleven by seventeen feet must have been Pembroke's and depended, of course, on its intended location,[7] Van Dyck would have welcomed it. Naturally the number of figures and their relative positions would have been specified by Pembroke, as would have been the prominence accorded to the coat of arms. The painting was a dynastic statement. It was intended to celebrate the marriage on 18 January 1636 in the Royal Closet at Whitehall of Pembroke's eldest son, Charles, Lord Herbert, on Pembroke's right, to Lady Mary Villiers, who had become a royal ward in 1628, following the assassination of her father, the duke of Buckingham, the favorite of both James I and Charles I. They had been betrothed since August 1626, when Lady Mary was five. The marriage was of the utmost economic and political significance for the Pembroke family: Mary Villiers brought a large dowry, which was to be used to remodel Wilton; and, more important, the marriage signaled the final *rapprochement* of two hostile political factions at court. It marked a reassertion of the power and influence of the Pembroke family. That this royal ward and wealthy heiress should be joining the Pembroke family was a great honor, and it was the very *raison d'être* of the picture that Mary Villiers should be portrayed being welcomed into the family by the earl and at the same time being shown off as a great prize intrigued for and won.

Van Dyck's task was to meet Pembroke's exacting requirements in a very large format—this is, we must always bear in mind, the largest portrait group ever painted by Van Dyck—and yet at the same time create a lively and unified composition. It was a unique undertaking, not just in British but in European terms. None of Van Dyck's previous patrons, who had included the richest families of Genoa, the regents

Fig. 4. Anthony van Dyck, *Charles I and Henrietta Maria with Prince Charles and Princess Mary*, 1632, canvas, 370.8 x 274.3 (144 5/8 x 107). Copyright reserved to H. M. Queen Elizabeth II

of the Netherlands and their Flemish and Spanish courtiers, the prince of Orange and assorted German princelings, had ever commissioned a family portrait on anything like the scale chosen by Pembroke. The portrait of the Lomellini family (National Gallery of Scotland, Edinburgh) and the portrait of John of Nassau-Siegen and his family [fig. 3], his most ambitious non-royal portraits, seem almost self-effacing when compared to the Pembroke picture. Nor did Charles I ever commission a portrait group on this scale: the "Greate peece" [fig. 4],[8] the largest family group painted by Van Dyck since his years in Italy, is less than half the size of the Pembroke group portrait. George Vertue wrote intriguingly that Pembroke begged the king to allow him to commission "a picture of the King and all the Royal Family by Vandyke … designed as a fellow to that great picture of the Pembroke family … but the troubles of the king coming on and the death of Vandyke, prevented its being done."[9] We know, however, no more about the proposed royal "fellow." Whether or not there was to be a royal pendant, the Pembroke family portrait is a uniquely vainglorious picture, a Hampton Court or Vaux-le-Vicomte among paintings, which in a different time might have been the prelude to the royal curbing of an over-mighty subject.[10]

There were only two major precedents for such an ambitious family portrait in Britain.[11] Both are by Holbein. The "Privy Chamber" mural at Whitehall Palace,[12] which was destroyed in the fire of 1698, showed Henry VIII and Jane Seymour with Henry VII and Elizabeth of York standing in a palatial setting around a monument on which are inscribed Latin verses praising the Tudor dynasty and its renewal of religion. The cartoon, in the National Portrait Gallery, London, which shows only the left-hand section of the composition, is 258 x 137 cm (8 x 4 feet), and the whole mural has been estimated to have been 270 x 360 cm (almost 9 x 11 feet). The second is the portrait of Thomas More and his family,[13] destroyed by fire in the archiepiscopal palace at Kroměříž in 1752, but in Arundel's collection during Van Dyck's years in London. It is recorded in the preparatory drawing by Holbein (Öffentliche Kunstsammlung, Basel), which was taken by him to Basel and given to Erasmus as a record of the composition. It was similar in size to the "Privy Chamber" mural, that is about two-thirds the size of the Pembroke family group. It is, however, quite different in kind, being domestic in mood; three of the women, including Dame Alice, More's second wife, kneel on the floor at the right. When Erasmus looked at the drawing, he would have recalled the deeply Christian character of More's family life which he, from personal experience, had described as Plato's academy christianized. The More family portrait is essentially an ancestor of the conversation piece. Neither of these family groups would have provided a useful model for the task set by Pembroke for Van Dyck.

Nor were there any Continental (which, in the case of Van Dyck, is to say, Flemish or Italian) prototypes from the sixteenth or early seventeenth centuries. Rubens' most ambitious group portrait had been painted in 1620 for an English aristocrat, Lady Arundel,[14] when Van Dyck was in Antwerp, but the commission to show Alatheia Talbot virtually enthroned with her dwarf, fool, dog and secretary called for a conventional composition with the countess dominating the center of the canvas. Rubens had, of course, glorified a living person, Maria de' Medici, in the most extravagant terms, not in the form of a monumental dynastic portrait but rather in a series of paintings presenting in allegorical guise an account of the principal events of her life. When a Continental prince wished to commission a major work of art glorifying himself and his dynasty he would order a series of paintings celebrating the notable deeds of his ancestors and, at the end of a long and distinguished list, of himself: such, for example, is the pattern of the decoration of the Palazzo Vecchio by Duke Cosimo de' Medici. In Italy the glorification of the present members of a family in the form of a monumental family portrait is most unusual. None of the great Italian dynasties—Medici, Sforza, Este—chose to immortalize themselves in this way. The best-known fifteenth-century example is, of course, the portrait of the Gonzaga family painted by Mantegna in the Camera Picta ("the Camera degli Sposi") in the Palazzo Ducale in Mantua. Although Van Dyck visited Mantua during his years in Italy, he does not ever seem to have shown any interest in Mantegna.

Fig. 5. Anthony van Dyck, list of places where Van Dyck had seen "le cose di Titiano," Italian sketchbook, fol. 120r. Courtesy of the Trustees of the British Museum, London

Fig. 6. Anthony van Dyck, *Virgin and Child after Titian*, Italian sketchbook, fol. 46. Courtesy of the Trustees of the British Museum, London

Fig. 7. Anthony van Dyck, *The Abbé Scaglia Adoring the Virgin and Child*, c. 1634–1635, canvas, oval, 106.7 x 120 (41 5/8 x 46 3/4). National Gallery, London

40

There was therefore no tradition, neither a local British tradition nor a Flemish or Italian tradition, of representing a family in the way in which Pembroke wished his to be shown. Faced with the absence of an existing tradition, Van Dyck turned to Venice, and in particular to Titian. That he should have turned to Titian for inspiration when faced with this demanding commission is no surprise. Indeed, it is impossible to exaggerate the importance of Titian for Van Dyck. For Van Dyck the Venetian was the greatest artist before the present day: he studied Titian's work wherever and whenever he could, sketched it, painted copies of it, and collected it. The example of Titian permeates Van Dyck's art. Not the least striking feature of this intense identification with the great Venetian painter is the fact that it began so early in Van Dyck's career. In his Italian sketchbook,[15] today in the British Museum, which he used in Italy between early 1622 and late 1624, we can observe the reactions of Van Dyck in his early twenties to what he saw in Italy, and the single most remarkable aspect of the sketchbook is the selectivity of its maker. At the age of twenty-two the precocious Van Dyck was already largely formed as an artist: he knew what he was looking for in Italy, and more than anything what he was looking for was the work of Titian. There are drawings after only three Antique works of art; there is a single drawing after Leonardo, several after Raphael, but none after Michelangelo. The vast majority of the drawings are copies after the Venetian school, and the majority of those are after Titian. Such an attitude is, of course, in marked contrast to that of Rubens when he was in Italy twenty years earlier. Rubens had been responsive to the wide range of visual experience—Antique, Renaissance, and post-Renaissance painting and sculpture—available to him.[16]

Van Dyck's interest in Titian was fully developed before he left for Italy in 1621. He can have seen few originals in Antwerp. In all the twenty-one inventories of Antwerp collections listed by Denucé prior to Rubens' of 1640, there are only three mentions of works by Titian: a Magdalene, a Leda, and "een Marienbeeldt."[17] Nor is there anything in the work of Van Dyck's master, Hendrik van Balen, that points to a particularly close identification with the Venetian painter. Van Dyck's contacts with Rubens may have developed Van Dyck's enthusiasm for Titian.[18] But it was his first visit to London in 1620 that gave him his first opportunity to study a significant number of originals. In 1620 Charles had yet to begin his career as a collector in earnest, but the earl of Arundel and the duke of Buckingham, both of whom were patrons of Van Dyck on his first visit to London, had Venetian paintings in their collections, although the absence of inventories before 1620 makes it difficult to be certain of their number or significance. However, the fame of these collections had already spread to Venice itself as early as 1622. In the anonymous life of Titian, which was published in Venice in that year with an introduction by Tizianello, a painter who was one of the artist's descendants, and a dedication to Lady Arundel, the collections of the prince of Wales, and of Buckingham, Hamilton, Pembroke, and Arundel are singled out for praise.[19]

With his taste for Titian formed in Antwerp and his appetite stimulated in London, Van Dyck was eager to see and study the Venetian artist's work when he arrived in Italy in 1621. The Italian sketchbook records that process. At the back of the sketchbook is a page on which he recorded the locations in which he had seen "le cose de Titian" [fig. 5]. Many of the great Roman collections are there: the Ludovisi, Aldobrandini, Borghese, and Farnese palaces. Here too in Venice is the "casa de daniele nys," who bought so energetically for English collectors, among them Charles I and Arundel. For our present purposes we may note "alle Frari" and "un quadro de putini di Titiano," which he saw in the collection of Francisco di Castro.

After his return from Italy in 1627 Van Dyck made constant use of his sketchbook, plundering its repertory of Venetian compositions, and in particular those of Titian, for his portraits and history paintings. Here one example may stand for many. When asked in 1634 by the Abbé Scaglia to show him in adoration to the Virgin and Child, Van Dyck turned to the page in the sketchbook [fig. 6] where twelve years earlier he had recorded a now-lost painting by Titian and adapted the composition [fig. 7].

In Charles I Van Dyck found a patron whose esteem for the Venetian artist was

Fig. 8. Titian, *The Presentation of the Virgin in the Temple*, 1538, canvas, 345 x 775 (134 1/2 x 302 1/2). Accademia, Venice

the equal of his own. Ever since his trip to Madrid in 1623 when he had seen the great collections of the Spanish royal family, Charles had been confirmed in his passionate devotion to the Venetian school and to Titian in particular. It is no accident that the painting by Van Dyck that seems to have prompted Charles to invite the Flemish artist to London on terms unprecedented in the history of royal patronage in Britain, the *Rinaldo and Armida* [cat. 54], shows Van Dyck at his most Titianesque. There seems little doubt that in his patronage of Van Dyck Charles I was consciously emulating Charles V's patronage of Titian and that he saw in his Flemish court painter Titian *redivivus*.

For these reasons it is not surprising that when, late in 1635 or early in 1636, Van Dyck was composing his great group portrait-cum-history painting of the 4th earl of Pembroke and his family, he turned once again to Titian. The compositional scheme places Mary Villiers before the flattened semicircle of members of the family. Pembroke gestures toward her, welcoming her and at the same time displaying her. The way Mary Villiers approaches the family up the steps and is greeted by Pembroke is the key to the painting, its central drama. It is similar in its composition to a Presentation, and the scheme used by Van Dyck to solve his unique problem was the Venetian Presentation. There are intriguing similarities with the *Presentation of the Virgin in the Temple* [fig. 8], the great canvas painted for the Scuola della Carità and still in its original location in what is now the Accademia, in particular the figure of the Virgin isolated on the flight of steps ascending toward the high priest, but in fact a far closer compositional type is the presentation of doges, senators, and saints *to* the Virgin and Child. One example will stand for this large class of images: Titian's votive painting of Doge Andrea Gritti of 1531, destroyed in 1574 but recorded in a woodcut in which Doge Francesco Donato has been substituted for Doge Gritti [fig. 9]. Here are all the elements of this very familiar Venetian compositional scheme: the Virgin and Child are placed at the top of a flight of steps against or alongside a palace, here indicated by the bases of three columns. Mary and the child are surrounded by saints, while at the foot of the steps kneels the doge who is being presented to them by Saint Mark. It is a formula used in slightly varying forms by Titian, Tintoretto, and Veronese. This particular example was well-known to Van Dyck: he made two drawings after it, one of Saint Bernardino and the other of the Virgin and Child, in his Italian sketchbook (fols. 93v, 15r). It was a formula that Van Dyck found readily adaptable to the special requirements of the Pembroke family portrait.

41

Fig. 9. After Titian, *Doge Francesco Donato Adoring the Virgin and Child*, woodcut on two sheets, 43.4 x 38.8 (16⁷/₈ x 15¹/₈) and 43.4 x 39 (16⁷/₈ x 15¹/₄). Courtesy of the Trustees of the British Museum, London

Another painting by Titian said to have been influential on the Pembroke family group lacks the key element of Presentation, but it too is a family portrait conceived as a history painting. In *The Vendramin Family* [fig. 10], the members of the family are shown not just posing as a group but engaged in an act of worship, venerating a relic of the True Cross that had been presented to an ancestor in 1369. Titian used a flight of steps seen from a low viewpoint to create the rising curve of the figure group at the left, and both these features of Titian's composition are also present in the Pembroke family portrait. There is also some similarity between the two groups of three boys on the left and right of Titian's composition and the animated group of the three youngest Pembroke boys on the left of the Van Dyck. Van Dyck knew Titian's painting well, as it was in his own collection.[20] There are two early inventories of Van Dyck's paintings: one, in Italian, can be dated to about 1644. It was presumably drawn up in connection with the sale of the paintings on the Continent after his death, and the first item is "Tre Senatori di Venezia con loro figlioli in un quadro di Titiano." Among the numerous copies after Titian by Van Dyck listed in the inventory is a copy of *Venus Blinding Cupid*, a painting Van Dyck had seen in the Borghese Collection in Rome and had drawn in the Italian sketchbook. It is described as "Una fictione Poetica di 3 Donne et diesi Cupidetti." The second inventory, in English, is undated but probably slightly earlier than the one in Vienna. Here the *Vendramin Family* is also the first item, and is described as "One picture called the Senators."[21] Exactly when Van Dyck acquired the *Vendramin Family* or indeed his other Titians is not known, but it has usually been thought that the most likely time would have been his stay in Italy when he had both the resources, being a successful and so presumably a well-paid portrait painter in Genoa, and the opportunity. Certainly his collection of Titians was already famous by 1631 when Maria de' Medici visited his studio in Antwerp and there saw "le cabinet de Titien: je veux dire tous les chefs d'oeuvre de ce grand maistre."[22] However, we cannot be sure that Van Dyck did own the painting in 1635: it has been suggested that the *Vendramin Family* is the painting described by Lord Maltravers in a letter of September 1636. He wrote of "a picture of Titian at Venice to bee sould for five or 6 hundred duccatts. ... As I heare it hath some 4 or 5 figures in it, drawn after the life of some of the Nobilitye of Vennice."[23] It is perfectly possible that the similarities between the *Vendramin Family* and the Pembroke family portrait are no more than their both depending upon the Venetian Presentation formula.

A particularly interesting idea for a source for the composition of the Pembroke family group is Titian's *Ecce Homo* of 1543 [fig. 11].[24] The idea of placing a young woman in a white dress at the foot of a flight of steps could have been suggested to Van Dyck by this painting. The complex pose of the soldier standing to the left of the

Fig. 10. Titian, *The Vendramin Family*, c. 1543–1547, canvas, 205.7 x 301 (80 1/4 x 117 3/8). National Gallery, London

Fig. 11. Titian, *Ecce Homo*, 1543, canvas, 242 x 361 (94 3/8 x 140 3/4). National Gallery, London

Fig. 12. Anthony van Dyck, *Lady Elizabeth Thimbelby and Dorothy, Viscountess Andover*, c. 1638, canvas, 132.1 x 149 (51 1/2 x 58 1/8). National Gallery, London

girl is similar (in reverse) to that of the youngest Pembroke boy. Van Dyck would certainly have known the painting well and it would have had a particular resonance in this context because it was in the collection of Mary Villiers' father, the duke of Buckingham, having been bought for him by Balthasar Gerbier in Venice in 1621.

An important Titianesque element in the Pembroke family portrait is the group of three winged children in the top left-hand corner. One throws down roses. There is a Pembroke family legend, repeated in the last earl's catalogue of the paintings at Wilton,[25] that they represent three children who died at birth or shortly afterward.[26] This is most unlikely: such dead children would not be shown winged; nor is it the kind of symbolism that Van Dyck usually employed.[27] In fact they are a Titianesque flourish, lending visual interest to an otherwise empty area of the picture space, but they also have a particular meaning. The painting celebrates a marriage, and roses, the flowers of Venus, were associated with marriage: Hawkins, in his *Parthenia Sacra* (1633), described the rose as "the chiefest grace of Spouses on their Nuptial dayes."[28] The children are therefore *amorini*, or to use the term employed by the Italian cataloguer of Van Dyck's collection in 1644, *cupidetti*. The middle boy looks up in order to draw the spectator's attention to the throwing of roses, which reinforces the significance of the painting as a celebration of marriage. A presentation of roses by a cupid to mark a marriage can be seen in the double portrait of *Lady Thimbelby and Dorothy, Viscountess Andover* [fig. 12]: the occasion for that portrait was Lady Andover's marriage in 1637.[29]

The *cupidetti* are Titianesque. The closest specific source in Titian's work is the group of putti in the Pesaro altarpiece in the Frari in Venice, which, as we have noted, Van Dyck saw and sketched. In the Frari altarpiece they are putti rather than very secular *cupidetti*, but here we find the same combination of clouds, columns, and winged children.

Such literal-minded tracing of sources for details in the Pembroke family portrait is, however, largely beside the point. Indeed, in the cases of the *Vendramin Family* and the *Ecce Homo*, it is distinctly speculative. So profound was Van Dyck's knowledge of Titian's work and so total his absorption in Titian's world that understanding this relationship is not simply a matter of identifying borrowed motifs, gestures, and poses. Faced with this uniquely difficult commission and realizing its dramatic possibilities, Van Dyck turned to Venice and to Titian. The bold placing of Mary Villiers on the steps, the spaciousness and grandeur of the setting, the statuesque poses of the older couples, the vivacity of the three youngest boys, the playfulness and visual wit of the *cupidetti*, not forgetting, of course, the saturated color of the whole: in all these essential aspects, the *Pembroke Family* is an intensely Venetian, and an intensely Titianesque painting.

43

NOTES

Julius Held and Sir Oliver Millar kindly read this essay in draft and made a number of valuable suggestions, which have been incorporated into the final text. I am most grateful to them both.

1. Cust 1900, 119. He continued: "It is, however, a work of great importance, though its surface and colouring have been almost entirely ruined by an unfortunate and injudicious restoration."

2. E. Waterhouse, *Painting in Britain 1530–1700*, 4th ed. (Harmondsworth, 1978), 77.

3. O. Millar in London 1982–1983, 27–28.

4. Howarth 1985, 164.

5. For the Paris sketch, see Paris 1977–1978, cat. 44.

6. Antwerp 1960, cat. 133. The authors list the related sketches and drawings for this project.

7. It is by no means clear where the Pembroke family portrait was originally planned to hang. It is first recorded in Pembroke's London residence, Durham House in the Strand, in 1652. Pembroke did not, however, take over the lease of Durham House until 1641. It seems unlikely to have been intended for the old Tudor house at Wilton, although the rebuilding for which Mary Villiers' dowry was earmarked may have been planned to make its display there possible. It was presumably not intended for the medieval town house of the Pembrokes, Baynards Castle, as that had been made over to the countess of Pembroke (Anne Clifford) under the terms of the legal separation of the earl and countess in 1634. The only remaining possibility is Pembroke's quarters in Whitehall Palace, but unfortunately we do not know where or how large they were. However, the great equestrian *Portrait of Charles I with Monsieur Saint Antoine* hung at Whitehall, and it may well have been the original location of the family portrait prior to its planned move to Wilton after Isaac de Caus' remodeling of the house. In any event, it was probably moved to Durham House in 1641 and then to Wilton in about 1680 where it is first recorded in the 1683 inventory. It remained there until its trip to Bristol (for restoration) and to London (for display at the National Gallery) in 1987.

8. Royal Collection 1963, cat. 150.

9. Vertue 1930–1955, 18, The Vertue Notebooks, 1, 47.

10. It has been asserted that Van Dyck planned a portrait of the earl of Arundel and his family on a similar scale and that the composition is preserved in a watercolor of 1643 by Philip Fruytiers, which is inscribed VAN DYKE Inv. With the cataloguer of the watercolor in the Arundel exhibition held at the Ashmolean Museum, Oxford, in 1985 (20–21, cat. 11), the present writer has considerable doubts that it in fact preserves a design by Van Dyck. For the Arundel family portrait project, see also Rowlands 1970, 162–166.

11. In this essay I have concentrated on the Italian sources of the overall compositional scheme of the Wilton family group. There are, however, interesting precedents for certain aspects of the painting in Tudor and Early Stuart portraiture. In particular, the stiffly composed central group of the earl and countess beneath the massive coat of arms, the most *retardataire* and least Titianesque section, has certain formal similarities to two portraits of Henry VIII and his family, one attributed to Lucas de Heere at Sudeley Castle (R. Strong, *The English Icon*, London, 1969, cat. 95) and a second (which remains unattributed) in the royal collection (Royal Collection 1963, cat. 43). (My colleague, Dr. Susan Foister, kindly drew my attention to these paintings.)

12. J. Rowlands, *Holbein: The Paintings of Hans Holbein the Younger* (Oxford, 1985), cat. L14.

13. Rowlands 1985, cat. L10.

14. Alte Pinakothek, Munich. Canvas, 261 x 265 cm (8 1/2 x 8 5/8 feet). Alte Pinakothek 1983, 352.

15. Adriani 1940 (reprint, 1965). The present writer is currently preparing a new critical edition of the sketchbook.

16. For Rubens' response to Italian art, see M. Jaffé, *Rubens and Italy* (Oxford, 1977).

17. Denucé 1932.

18. We do not know which of Titian's paintings Rubens owned by 1620, but nine paintings, two drawings, and thirty of his own painted copies after Titian are listed in the 1640 inventory. For Rubens' collection (and a transcription of the 1640 inventory), see J. Muller, *Rubens: The Artist as Collector* (Princeton, 1989).

19. *Breve compendio della vita del famoso Titiano Vecellio di Cadore* (Venice, 1622). Reprinted in Venice in 1809 by Abbate Acordini (in that edition, the British collections are discussed on pp. XII–XIII).

20. The inventory of Van Dyck's collection made in Italian and now in the National Library in Vienna was first published in Müller-Rostock 1922. The contents of the English inventory are summarized in Brown 1983, 69–72. It will be published in full, with other documents concerning his collection and its dispersal, in the *Burlington Magazine* in October 1990 by the present writer and Nigel Ramsay.

21. It was still known as *The Senators* after its purchase from Van Dyck's heirs by the duke of Northumberland (O. Millar, "Notes on British Painting from Archives: III," *Burlington Magazine* 97 (1955), 255.

22. P. de la Serre, *Le Voyage de Marie de Medicis en la Flandre* (Antwerp, 1632), quoted in Brown 1982, 131.

23. For Maltravers' letter from Venice, written to William Petty, see Millar 1985, 255, n. 2.

24. O. Millar in London 1982–1983, 28.

25. Sidney, 16th earl of Pembroke, *A Catalogue of the Paintings and Drawings at Wilton House* (London, 1968), cat. 158.

26. Julius Held has noted that deceased children are shown throwing fronds in the family portrait by Jacob Jordaens in the Hermitage, Leningrad. However, they are not winged.

27. For Van Dyck's use of symbolic elements in his portraits, see Brown 1984.

28. Quoted by O. Millar in London 1982–1983, 29.

29. London 1982–1983, no. 29.

Van Dyck's Painting Technique, His Writings, and Three Paintings in the National Gallery of Art

CAROL CHRISTENSEN, MICHAEL PALMER, MICHAEL SWICKLIK

The examination and conservation treatment of three paintings by Van Dyck in preparation for this exhibition afforded the opportunity to compare the paintings themselves with documents recording the artist's painting theories. An aim of this inquiry was to determine how closely Van Dyck's actual creative process followed his written prescriptions.

What we know of Van Dyck's theory of painting technique is contained in two manuscripts. The first, the De Mayerne manuscript, is a collection of technical notes on painters' methods made between 1620 and 1646 by Theodore Turquet de Mayerne, court physician to James I, Charles I, and Charles II of England.[1] Because of his position at court De Mayerne was able to collect from various court painters, the most prominent being Rubens and Van Dyck, information that he recorded in his memorandum book, which has become a valuable source of information about seventeenth-century artists' techniques. In this manuscript there are a number of recipes and miscellaneous bits of advice for which Van Dyck is mentioned as the source.

The second source of information about Van Dyck's painting technique is a four-page manuscript in archaic Dutch dating from the 1640s, inscribed at the top "Observation of Ant ... Dykii" and attributed to Van Dyck, forming part of the Commonplace-book of Dr. Thomas Marshall (1621–1686), in the Bodleian Library, Oxford.[2] In this document, Van Dyck wrote:

> Most art lovers are so little aware of what the work of art they see really consists of, that they find it difficult to point out a real master among hundreds, who can explain understandably in which way and in what manner the artist has accomplished what he set out to do.
>
> The tempera painters whose manner of applying the tempera technique was reflected in the way they handled techniques in oil, were the best. Nowadays painters have discovered that they do not have to follow the rules of tempera painting so closely, and therefore have strayed from the basic rules of art; that is why they have fallen into various confusions, and they have lost their sense of direction. It would be desirable that the artists at the start of their work would pay particular attention to all of the following issues (namely, sketching, underpainting [dead-colouring],[3] painting, shadowing, heightening, final touching).

> 1. SKETCH
> 1. It is important to sketch in the forms, so perfectly, that afterwards there will be no reason to make a change.

> 2. UNDERPAINTING
> 2. He must, following the rules, choose lean colours (tempered colours), so that the first layer, when it will be dry enough, will have a light tone; he has to see to it, of course, that those colours used in the underpainting are basically the same as those with which he is going to do the final painting, that is, that underpainting of nudes will always be done with carnation colours, and clothed figures will have an underpainting in a darker paint, without trying to accomplish in this rough work a degree of finish which will closely anticipate the final colour; it must be noted that this underpainting should be lighter in some places and darker (browner) in others as is seen fit by the artist in view of his final conception.

> 3. MODELLING
> 3. The painter should realize ..., when the underpainting is dry, that when he gives final form to his figures he will use darker colours; which means that he will pay special attention to a correct rendering of those parts of his final modelling in accordances with the pre-modelling he did in the underpainting. But here the

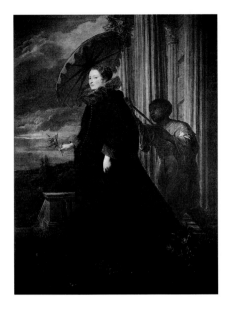
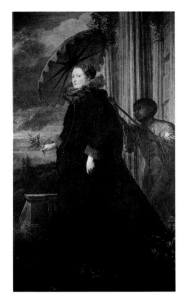
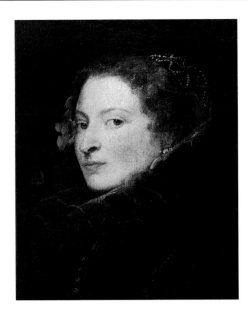

Fig. 1. Anthony van Dyck, *Marchesa Elena Grimaldi*, 1623 [cat. 36], before conservation treatment

Fig. 2. *Marchesa Elena Grimaldi*, without later additions

Fig. 3. Anthony van Dyck, *Preparatory Study for Marchesa Elena Grimaldi*, c. 1623, painting on fabric, 42.5 x 31.25 (16 3/4 x 12 1/4). National Museum of American Art, Smithsonian Institution, Washington, Gift of John Gellatly

painter should see to it that he will not attempt to accentuate the round forms with highlights. Which means that the round forms should not be brought forward by highlights but only through the use of darker (browner) colours.

After the round forms have dried the painter should put in the darkest shadows, whereby the colours of the clothing should be glazed in some places with lakes, ultramarine, and other colours in accordance with the work. This is the way the work was carried out by Titian, Giorgione, Pordenone, Palma Vecchio, and many others who left us such extremely fine works.

4. DRAWING

Proper drawing means to get the hand used to it that it will function so assuredly that the proportions in the drawing will be so correct that they will be in accordance with that which the eye perceives, that it will not be possible to confuse one element for another.

Underpainting is called *la maniera lavata* because it is a washing process; because the space within the contours seems to have been touched up with a wash only. The second manner is called *maniera sbozzata*, or the modelling or forming process; because it is supposed to give the entire work its final form. The third one is called *la maniera finita*, which is the finishing or completing process; because this one gives the work its final touch. 4

Based on these two documents, it appears that Van Dyck was critical of the *alla prima* technique of some of his fellow artists. (Artists who work in this technique achieve their final effects in the initial application of paint, rather than by building up the paint in a series of layers.) His own view was that the method of constructing a painting followed by the tempera painters of previous centuries was the best. This included a well-thought-out undersketch, lean underpainting, modeling by building up paint more densely in the shadows than in the highlights, and final glazing. The practice of using lean pigment for underpainting, in which there is a low proportion of binding medium to pigment, was the traditional way of constructing oil paintings. If the reverse method were followed, that is, painting lean over "fat," or oil-rich colors, the leaner and less flexible upper paint layer would be unable to adjust to the underpaint's expansion and contraction due to changes in temperature and humidity. As a result, the painting would crack.

The three paintings examined in the light of these documents are *Elena Grimaldi* [cat. 36], *A Genoese Noblewoman and Her Son* [cat. 43], and *Philip, Lord Wharton* [cat. 63]. The earliest of the three paintings, *Elena Grimaldi*, was painted around 1623, during the first part of Van Dyck's Italian sojourn.[5] It is painted on the characteristic

light-weight tightly woven fabric that Van Dyck used increasingly in preference to panel after he left Antwerp. The painting was originally painted on a single piece of linen, but at a later date strips of a coarser heavier fabric were sewn on to the right, left, and bottom edges of the painting [fig. 1]. These strips expanded the painting by 24.5 cm (9^1/$_2$ in.) on the right side, 16 cm (6^1/$_4$ in.) on the left side, and 6 cm (2^3/$_8$ in.) at the bottom, until after the painting's recent restoration, when the added strips were removed [fig. 2].

A rather thick (90 microns) layer of size, which appears brown in cross-sectional samples of the paint layer, was applied on top of the fabric to seal it before the oil-bound priming was applied. This cream-colored priming layer is composed of a mixture of lead and chalk whites, with a few particles of charcoal black and iron oxide red.

No evidence of underdrawing was found during infrared vidicon examination, although cross-sectional samples taken from the sky at the left suggest it may be present there (in one sample, there is a thin dark line of what may be black underdrawing beneath the juncture of blue sky and gray cloud). This lack of underdrawing is surprising, because although an oil sketch for the sitter's head survives [fig. 3], there are no firmly attributed compositional sketches for the painting, and this is generally true for Van Dyck's Italian paintings.[6] This suggests that he may have sketched his designs directly on the canvas. The lack of evidence of underdrawing in all three paintings when examined using an infrared monitor may be explained by the possibility that Van Dyck sketched an underpainting with brush-applied umber paint, which is not visible on an infrared monitor. This was the case in Van Dyck's painting *Saint Rosalie Interceding for the Plague-Stricken of Palermo* (The Metropolitan Museum of Art, New York); that sketch has been made visible only through neutron activation autoradiography, which revealed an image based on the element manganese present in the umber undersketch.[7]

The presence of a brushed underpainted sketch rather than the traditional dry-medium underdrawing is consistent with contemporary accounts of Van Dyck's rapid painting technique. He planned his workday in order to be able to paint as many portraits as quickly as possible, and a quickly executed undersketch was undoubtedly an integral part of the process. In the following passage from Roger de Piles' "Cours de Peinture par Principes," Eberhard Jabach, a Paris art collector who knew Van Dyck in Antwerp and sat to him three times, described the artist's studio practices: "Van Dyck told people what day and hour to arrive for a sitting, and he never worked more than one hour at a time on each portrait, whether it be to sketch (*ébaucher*) or finish. ... After making the next appointment for his client, Van Dyck's servant would clean his brushes, present the artist with another palette, and he would paint the next sitter for an hour. In this manner he worked on many portraits with extraordinary speed. After lightly sketching a portrait, he had the person stand in the position he had just sketched, and with grey paper and white and black chalk he drew in fifteen minutes his figure and clothing in a grand manner and with exquisite taste. He then gave the drawing to capable assistants whose job it was to paint the clothing, which his clients sent expressly at Van Dyck's request. His students having done from life what they could with the drapery, he lightly painted in the finishing touches ... as to the hands, he had at his studio people in his employ who served as models for hands of both sexes."[8] It would appear from this account that Van Dyck first sketched in the painting on the canvas, and then made a chalk sketch in black and white of what the finished portrait would be like, to serve as a guide for the studio assistants who painted the underlayers of the sitter's clothing. He would then paint the topmost "finishing" layer himself.

A series of amusing contemporary documents suggests that Van Dyck did not always strictly adhere to exact details of dress, but may have been somewhat uncompromising in his depiction of his sitters. In a group of letters from 1640 quoted by Cust in his monograph on Van Dyck, the countess of Sussex wrote a London representative, "I am glad you have prevailed with Sr. Vandike to make my picture leaner for truly it was too fat—if he made it fairer it will be to my credit—I see you will make him trim it for my advantage every way."[9] However in the next letter she

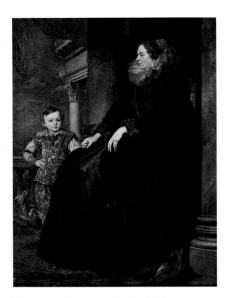

Fig. 4. Anthony van Dyck, *A Genoese Noblewoman and Her Son*, c. 1626 [cat. 43]

complained, "I doubt he has made it leaner or fairer, but too rich in jewels I am sure, but tis no great matter for another age to think me richer than I was." Of the final product she said, "the picture is very ill-favored, makes me quite out of love with myself, the face is so big and so fat that it pleases me not at all … if I ever come to London before Sr. Vandike goes, I will get him to mend my picture, for though I be ill-favored, I think that makes me worse than I am." Perhaps luckily for the sitter, the portrait is now lost.

In *Elena Grimaldi*, Van Dyck laid down an underlayer of red paint where the flesh tones and robe of the sitter's servant would be painted. Above this, he applied the oil-bound paint layers with rather more impasto than is evident in the two later paintings examined. Van Dyck painted out a red flower in the sitter's hair that was present in the preparatory oil sketch [fig. 3], and also made small contour adjustments both in her head and in her proper right hand, which is clumsily executed and may have been a troublesome area for the painter. Throughout the painting, the paint layer covers the priming so completely that the priming is seldom evident.

The layering of the paint is also more complex than in the two other paintings examined. In a cross-sectional sample [pl. 1] taken from the sky of *Elena Grimaldi*, there were four layers of paint. The lowest layer of underpaint was a light-colored mixture of chalk, the blue pigment smalt, and lead white, with a small amount of red lake. Above this was a thin black line, which is likely to be under-drawing. Over this Van Dyck painted a thick layer of light-blue paint consisting of lead white, smalt, and chalk. The final layer was a thin mixture of lead white, smalt, and ultramarine. In contrast, a cross-sectional sample of a similarly colored area of sky in *A Genoese Noblewoman and Her Son*, presumably painted several years later, contained a single layer of blue (composed of smalt, lead white, chalk, and charcoal black) over a gray priming, which was left exposed to act as a middle tone [pl. 2].

A similar contrast is notable in comparing the paint layering in the clothing of the sitters in the two Italian portraits. In the cross-sectional sample taken from the earlier *Elena Grimaldi* [pl. 3], the servant's robe consists of at least three layers of paint above the ground. The lowest layer is a thin (9 microns) underpaint of red iron oxides, brown earths, and charcoal. The middle layer is a thicker (36 microns) mixture of orange iron oxide and charcoal. The topmost layer consists of a very thick (99 microns) yellow highlight of lead-tin yellow and lead white. However, in the robe of the child of *A Genoese Noblewoman and Her Son* [pl. 4], the background tone of the brocaded fabric is the tinted ground itself. Highlights are built up by glazing red lake over a thin layer of opaque vermilion and lead white. Even the areas of thickest paint buildup in the later painting are no more than 20 microns thick, only one-sixth the thickness of the paint in the earlier Italian painting.

The palette in *Elena Grimaldi*, as in all three paintings examined, was rather limited, with a surprising variety of effects derived from a small number of pigments. The flesh tones were composed of a mixture of lead white, iron oxide red, ocher, and lead-tin yellow. The reds were made with a red lake glaze over an opaque underpaint of vermilion and lead white. The yellow highlights of the servant's robe were created by layering a mixture of lead-tin yellow and lead white over red iron oxides, brown earths, and charcoal black. Despite references to Van Dyck's use of the yellow pigment orpiment (arsenic trisulfide) in the De Mayerne manuscript,[10] it was not used in any of the three paintings examined, perhaps because it was known to be a poor drier that "killed" other colors (possibly a reference to its incompatibility with lead or copper-containing pigments)[11] and therefore could not be mixed with them. It was also highly poisonous. In the sky, smalt was used for underpainting. Ultramarine was used only in the top layer of bright blue areas, probably because of its great expense.

Van Dyck painted *A Genoese Noblewoman and Her Son* [fig. 4] approximately three years after *Elena Grimaldi*, probably around 1626. The support is again finely woven linen. The fabric is joined horizontally through the center with a sewn seam. The priming is quite thick (180 microns) in relation to the paint layer (10–20 microns). The priming is a single warm pale gray layer made by combining a small amount of lead white, a large amount of chalk, and small admixtures of lamp black and red lake in an

Pl. 1. Cross-sectional paint sample taken from the sky of *Elena Grimaldi*. Magnification 160x
1. (bottom) brown layer of discolored size
2. cream-color priming of lead and chalk whites with small amount of charcoal black and iron oxide red
3. underpaint of chalk, smalt, and lead white
4. black line of charcoal (probably underdrawing)
5. light blue layer of lead white, chalk, and smalt
6. (top) bright blue mixture of lead white, smalt, and ultramarine

Pl. 2. Cross-sectional paint sample taken from the sky of *A Genoese Noblewoman and Her Son* [cat. 43]. Magnification 110x
1. (lower) gray priming composed of chalk white and charcoal black
2. (upper) gray-blue mixture of chalk, smalt, lead white, and charcoal black

Pl. 3. Cross-sectional paint sample taken from servant's robe in *Elena Grimaldi*. Magnification 160x
1. (bottom) brown layer of discolored size
2. white priming composed of lead white, chalk white, with a small amount of charcoal, and a large unidentified orange agglomerate (possibly from layer above)
3. thin dark red underpaint composed of red iron oxides, brown earths, and charcoal
4. orange layer composed of orange iron oxide and charcoal
5. (top) thick pale yellow layer of lead-tin yellow and lead white

Pl. 4. Cross-sectional paint sample taken from tunic of child in *A Genoese Noble-woman and Her Son*. Magnification 220x
1. (bottom) gray priming composed of chalk white and small amounts of lead white and charcoal
2. orange underpaint composed of lead white with a small amount of vermilion and red lake
3. (top) thin glaze of red lake

Pl. 5. Cross-sectional paint sample taken from green curtain, top right, of *Philip, Lord Wharton*. Magnification 160x
1. (bottom) very thin layer of size
2. white priming composed of chalk and lead whites
3. darkish gray-blue underpaint composed of a copper blue, lead white, and a small amount of charcoal black
4. (top) thick green layer composed of lead white, lead-tin yellow, and a copper blue

Pl. 6. Cross-sectional paint sample from yellow cloak of *Philip, Lord Wharton*. Magnification 160x
1. (bottom) white priming
2. orange-brown thin layer of underpaint composed of dark brown ocher and a small amount of charcoal
3. (top) thick pale yellow layer composed of lead-tin yellow and lead white

Pl. 7. Cross-sectional paint sample taken from the warm grayish-purple cloak of *Philip, Lord Wharton*
1. (bottom) white priming
2. thin red underpaint
3. dark gray layer composed of charcoal black and lead white
4. (top) light gray layer composed of more lead white and less charcoal black

49

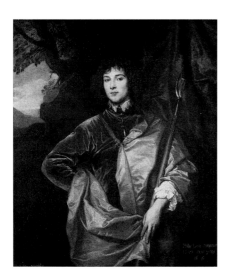

Fig. 5. Anthony van Dyck, *Philip, Lord Wharton*, 1632 [cat. 63]

oil binder.[12] Although Van Dyck made no written recommendations for priming preparation other than that it be oil-bound[13] and not sealed with glue (due to its tendency to cause flaking),[14] a very similar priming, attributed to "Imprimeur Wallon residing in London," appears in the De Mayerne manuscript.[15] This gray priming is present in several other Van Dycks in the National Gallery of Art; however, white priming is found just as commonly.

The paint layer of *A Genoese Noblewoman and Her Son* is extremely thin, and in many areas the priming is left intentionally exposed to act as a middle tone, as in the costume of the child. The paint is very lean, especially in the lower layers, following Van Dyck's advice in Dr. Marshall's book: "he [the artist] must, following the rules, choose lean colors (tempered colors), so that the first layer, when it will be dry enough, will have a light tone."[16]

Van Dyck's use of the words "tempered colors" for his underpaint is ambiguous, leaving unclear whether the artist meant by this term colors bound in egg or simply lean colors, mixed with only a small proportion of binding medium. A tempera underpainting would not be impossible even at this late date, although it was decidedly old-fashioned by 1600. Both Armenini (*De' veri precetti*, 1586) and Karel van Mander (*Het Schilder-Boeck*, 1604) described how the great masters speeded their work by using fast-drying tempera for underpainting. According to the introduction of *Het Schilder-Boeck*, the tempera manner was still in use in northern Europe at the beginning of the seventeenth century.[17] However, medium analysis of the three paintings at the National Gallery indicates that most of the pigments were oil-bound, even in the underlayers.

Van Dyck recommended linseed oil over nut oil, which he felt was too oily, and over poppy oil, which was not only too oily but also too thick.[18] An exception is the blues, for which he preferred *détrempe* (distemper) as a binder. Medium analysis indicated that the blues in both Italian-period paintings examined were bound with egg yolk. This follows Van Dyck's advice as transcribed in the De Mayerne manuscript: "oil is the principal thing painters should research making sure to obtain it in a good white liquid state, because if it is too fat it kills the most beautiful colors, the azures mainly, and the cool ones, like the greens. ... Azurite and greens can be bound in gum water, fish glue and/or distemper [*colle de poisson à destrempe*]; after varnishing they are like pigments bound in oil."[19] It is certain that Van Dyck would have coated these areas with a spirit varnish to seal them; however, no trace of this original varnish has survived the harsh restorations that are an unfortunate part of both paintings' histories.

The use here of the archaic French term *destrempe* is confusing, since the word has been used to mean variously egg yolk, egg white, or more commonly glue, but in this case the medium for the blues appears to be predominantly egg yolk. Traces of glue were found bound to the egg yolk during HPLC (high performance liquid chromatography) analysis of the blue pigments, but it is unclear whether the glue was mixed with the egg yolk by the artist or migrated into the paint layer during the heated glue lining used to reinforce the canvas support probably in the early part of this century.

According to Van Dyck, the main problem of using gum or distemper-bound paint was its lack of adhesion to the oil priming beneath it. Van Dyck's solution was to rub onion or garlic juice, mordants used for centuries in gilding, on the priming before applying the tempera paint.[20]

The paint layer of both Italian-period paintings is applied wet-into-wet with a tight brushstroke in the flesh tones, but in the darks the underlayers of paint were allowed to dry before subsequent layers were applied. The modeling is achieved by adding successively darker layers, so that the deepest shadows are the most thickly built up, as Van Dyck recommended in the manuscript included in Dr. Marshall's Commonplace-book.

The palette for *A Genoese Noblewoman and Her Son* includes lead and chalk white, vermilion, red lake, smalt, yellow ocher, various iron oxides, and charcoal black. It is noteworthy that smalt was the only blue pigment Van Dyck used in this painting. The sky is presently much paler and grayer than was originally intended due to a

deterioration of the smalt, which has been attributed to a variety of causes.[21] The difficulties of working with smalt were well known even in the seventeenth century, as outlined in passages in the De Mayerne manuscript,[22] and in John Smith's 1687 treatise, *The Art of Painting in Oil*.[23] Although it may seem surprising that an artist would use a pigment that was known to be unstable and difficult to work with, it had the advantage of being less expensive than other alternatives. In her study of smalt, Joyce Plesters noted that in 1676 an English painter traded half an ounce of ultramarine for four pounds of "the best and finest smalt that ever came into England."[24] The use of smalt may also have accelerated during this period because of a possible shortage of azurite, the other pigment that was a cheaper alternative to ultramarine.[25]

Van Dyck worked out his composition clearly enough that no major design changes were made once the painting was begun, as he described in the de Mayerne manuscript. However, as in *Elena Grimaldi*, his first sketch was not so careful as he himself recommended, since minor changes visible as pentimenti during conservation treatment were evident in the proper right sleeve of the boy, in the outline of the dog's head, and in a slightly higher position of the woman's chair. Interestingly, these changes were not evident in the X-radiograph of the painting, due to the thinness of the paint layer in relation to the thickness of the ground.

In contrasting the techniques of the two Italian-period paintings to *Philip, Lord Wharton* [fig. 5], an early English-period painting from 1632, a number of significant differences become evident. In this painting the technique of the Italian paintings becomes almost formulaic in its simplicity, particularly in the layering of the paint and the use of colored underpainting. This simpler layering allows more rapid and vivacious brushwork than that in the earlier paintings. Likewise, by glazing over the strongly colored underpainting with bright transparent colors, Van Dyck achieved a more vibrant color scheme.

Philip, Lord Wharton is painted on a finely woven linen, similar in thread count to those used in the paintings discussed earlier. It is primed with a single fairly white layer made with lead white and chalk in roughly equal amounts; oil is the binder. A small proportion of black pigment particles are seen in the priming in cross section but not in enough quantity to make the appreciable coloration noted in the primings of the two Italian-period paintings. In contrast to the very thick layer of size in *Elena Grimaldi* there is only a thin layer of size between the ground and canvas of *Lord Wharton*. No drawing can be found on top of the priming by infrared reflectography or from studying the cross-sectional samples. If there is drawing present, in all probability it would be masked by Van Dyck's system of localized colored underpainting, which serves as his initial paint layer.

The layering of the paint in *Philip, Lord Wharton* is notable for its simplicity, particularly in comparison to the complex layering in *Elena Grimaldi*. In almost every area of *Philip, Lord Wharton*, Van Dyck used a two-layer system of paint application. Highlights are added over the first layer in opaque impastoed strokes; shadows are glazed over it in thin transparent paint; the tone of the underpainting shows in the spaces between highlight and shadow as the middle tone. Only the hands and face are painted in a single layer, wet into wet, directly on top of the ground. These areas are blended with remarkable facility, showing subtle gradation of tone quite different in feeling than in the less refined, coarsely blended flesh tones found in the Italian-period paintings.

Beneath the brown areas of the landscape there is a thin reddish-brown layer; the green curtain has a gray-blue layer under the painting on top [pl. 5]; the yellow cloak has a dark brown ocher beneath it [pl. 6]. There is also a red layer beneath the purple-blue jacket of Lord Wharton [pl. 7]. In all these areas the underpainting is clearly evident and therefore influences the final surface color in its particular area. The most striking example of this technique is the creation of the purple jacket. The tone of the red underpainting shows through the upper blue-black paint layer to create an optical purple rather than one made by using purple pigment mixtures.

A significant artist's change is evident at the juncture of the purple jacket and the yellow cloak, where some of the jacket is painted up over an area of the dark brown

ocher underpainting of the yellow cloak. Here, as in the earlier *Genoese Noblewoman and Her Son*, Van Dyck was not so careful in his preliminary undersketch that changes were unnecessary in the paint layers.

As in the Italian-period paintings, the palette for *Philip, Lord Wharton* is limited and reasonably uncomplicated. The yellow consists of lead-tin yellow and ocher pigments; only verdigris is found in the greens, only azurite in the blues. Van Dyck utilized both red lake and vermilion in the reds. Lead white, charcoal black, and earth browns are also present. Despite a tonal appearance that suggested the possibility of indigo, a pigment often recommended in the De Mayerne manuscript, only black and white were present in the blues of the purple jacket.

In conclusion, the evidence gathered from examination of the three paintings treated for this exhibition suggests that in his later painting Van Dyck used a more formulaic system of painting than is evident in his earliest Italian work. This system consisted of less complex paint layering and using more extensively a system of localized colored underpainting that served as a middle tone and influenced considerably the tone of the paint layer laid above it. Both the priming layer and these colored layers of underpaint were left increasingly visible in his later work. This rather mechanical system of paint buildup is as described in the manuscript attributed to Van Dyck that forms part of Dr. Marshall's Commonplace-book. Of the three paintings examined, the English-period *Philip, Lord Wharton* most closely follows these written recommendations, as one would expect, since the manuscript was compiled at the time Van Dyck was painting in England. The pigments in all three paintings were similar, apart from the blues, which varied considerably in individual paintings. In two of the three paintings (the earlier of those examined), egg yolk was found to be the binder for the blues (evidence in *Lord Wharton* was inconclusive), as was recommended to Van Dyck by the Italian painter Orazio Gentileschi, according to the De Mayerne manuscript. All other pigments were oil-bound. The pigment orpiment, supposedly used by Van Dyck according to the De Mayerne manuscript, was not found to be present in the three paintings examined. Finally, although the technique of paint layering was similar to recommendations made by Van Dyck in Dr. Marshall's Commonplace-book, the composition was not so rigidly planned that artist's changes were not necessary in the underpainting.

NOTES

1. M. Faidutti and C. Versini, eds., *Le Manuscrit de Turquet de Mayerne: Pictoria Sculptoria & quae subalternarum artium 1620* (Lyons, 1974).
2. Vey 1960, 193–201.
3. The archaic Dutch word for underpainting (dead-coloring) in the original manuscript was *doodverf (dootwerwe)*, which meant literally "the color of a corpse." Originally the term probably meant a monochromatic underpainting, with an implied absence of color. However the term eventually came to mean also underpaintings in color. For this reason the term has been translated as both "underpainting" and "dead-coloring" to avoid confusion. In Horst Vey's German translation, the word *Untermahlung* (underpainting) was used. Because "dead-coloring" appears to have originally implied the more specific monochromatic underpainting, I have used the term "underpainting" wherever the term appears elsewhere in the translation, because this broader term of a colored underpainting is closer to Van Dyck's meaning. For a more complete discussion, see Ernst van de Wetering, *Studies in the Workshop Practice of the Early Rembrandt* (Amsterdam, 1986), 23 and n. 51.
4. English translation as quoted in Talley 1981, 150–151. However, for the word

"dead-coloring" the term "underpainting" has been substituted, as explained in note 3.
5. For information about this painting, we are indebted to Sarah Fisher, head of painting conservation, National Gallery of Art, Washington, who undertook its conservation treatment.
6. Vey 1956, 174, and Princeton 1979, 125–131.
7. Ainsworth 1982, 12.
8. Cust 1900, 138–139.
9. Cust 1900, 175–177.
10. J. A. van de Graaf, *Het De Mayerne Manuscript als Bron voor de Schildertechniek van de Barok*, Ph.D. Diss., Utrecht, 1958, nos. 73, 175.
11. Rosemund D. Harley, *Artists' Pigments c. 1600–1835* (London, 1970), 87.
12. Technical analysis was undertaken by the members of the National Gallery of Art's scientific research department. Susana Halpine and Suzanne Quillen Lomax were responsible for binding medium analysis using high performance liquid chromatography and gas chromatography. Michael Palmer used optical microscopy of cross sections, energy-dispersive X-ray fluorescence analysis, and microchemical tests on pigment samples to identify the pigments in these paintings. Barbara Berrie

identified the pigments in cross-sectional samples taken from *A Genoese Noblewoman and Her Son*.
13. Faidutti and Versini 1974, 149.
14. Faidutti and Versini 1974, 24.
15. Faidutti and Versini 1974, 14.
16. Vey 1960, 196.
17. Vey 1960, 198.
18. Faidutti and Versini 1974, 149.
19. Faidutti and Versini 1974, 149.
20. Faidutti and Versini 1974, 149.
21. Possible causes of smalt disease include low refractive index of the pigment compared with that of its oil binder, interaction of alkali or cobalt content with oil media; chemical reactions resulting from smalt being mixed with other pigments or added as a drier. For a complete discussion of the subject of smalt discoloration, see Joyce Plesters, "A Preliminary Note on the Incidence of Discolouration of Smalt in Oil Media," *Studies in Conservation* 14 (1969), 62–74.
22. Faidutti and Versini 1974, 26 and 34.
23. John Smith, *The Art of Painting in Oil*, 2d ed. (London, 1687), 26, 74–76. Here the author noted a different problem, saying that smalt darkens when mixed with oil.
24. Plesters 1969, 63.
25. Van de Graaf 1958, 145.

Van Dyck in London

OLIVER MILLAR

Fig. 1. Anthony van Dyck, *Le Roi à la Ciasse*, c. 1635, canvas, 272 x 212 (107 1/8 x 83 1/2). Musée du Louvre, Paris

On 8 August 1632, some four months after he had arrived in London, Van Dyck received the first payment of which we have record from Charles I. The sum was £280; and to consider the list of pictures in the warrant for payment, and those mentioned in the next payment from the Crown (£444 to be paid by warrant dated 7 May 1633),[1] is to understand the challenging responsibilities Van Dyck had taken on when he agreed to enter the king's service and for which he would have received scant preparation at the austere court of the archduchess at Brussels. Recollections of the demands made by the noble families of Genoa would have been more helpful.

In the earlier payment £20 was included for a picture of the emperor Vitellius and £5 for "mendinge" a picture of the emperor Galba: for making good, in other words, the damage that the twelve Roman emperors by Titian had sustained on the sea voyage from Leghorn to London. *Vitellius* ("utterly spoiled by quicksilver and quite washed away the colours quite removed from the cloth, almost nothing remaining") had been sent earlier to Brussels for repair and it is probable that Van Dyck had actually brought it over to London with him. *Galba* he would have "mended" after he had settled there.[2] The king's new painter was so well versed in Titian's technique that he could be entrusted with these very difficult tasks in the conservation field: a reminder of the admiration for Titian that Van Dyck was to share with his new royal patron; of the importance of the painter's own collection of works by Titian; and of the renewed impact Titian was to make upon him in the great collections in and around Whitehall.

The king knighted Van Dyck, now "principall Paynter in Ordinary to their Majesties," on 5 July 1632. "He emulated Titian, whom Charles V translated to the ranks of the nobility; so our Charles appointed this follower of Titian to the order of the Golden Knights." In 1633 the king granted Van Dyck an annual pension of £200. Van Dyck was to occupy at the English court a position very like that filled by Velázquez at the court of Philip IV. Velázquez, too, was ennobled, retained with an annual pension, and was surrounded, throughout his long career at court, with a superb and rapidly growing collection of Renaissance and contemporary works of art. His chief task was to provide a succession of portraits of the king and his family. In 1634 or 1635 a new causeway and stairs were constructed on the Thames at Blackfriars so that Charles I could visit Van Dyck and "see his Paintings": we are reminded of Pacheco's description of Philip IV's visits to Velázquez' workshop.[3]

The principal item listed in the payment authorized in August 1632 was, at £100, the "greate peece oʳ royall selfe, Consort and children" [see Brown, fig. 3], painted to be hung at a vantage point in the Long Gallery at Whitehall. It is among the largest pictures Van Dyck had painted up to that moment in his career, the first family group he had painted at length since he had left Italy, and the largest group portrait he painted before he was commissioned to portray the family of the earl of Pembroke.

It is conceivable that Van Dyck was enabled to carry out such a task under a patron's roof; but it is more likely that the studio eventually provided for him by the king in Blackfriars contained at least one very large room in which such huge areas of canvas could be made up, handled, and worked on. In due course Van Dyck was to paint two equestrian portraits of the king, both larger than the "greate peece" and the portrait [fig. 1] of the king dismounted beside his charger. In other words Van Dyck would have had to organize, immediately after he had arrived in London, a studio in which he could cope, on occasion, with pictures almost as big as the altarpieces commissioned after his return to Antwerp from Italy: pictures, moreover, larger, as well as more masterly in composition and beautiful in execution, than anything painted earlier in England. To other painters working in London, or to a suspicious visitor from the Painter-Stainers' Company, a glimpse of the new studio at Blackfriars would have been a humbling experience.

Fig. 2. Daniel Mytens, *Charles I*, 1627, canvas, 307 x 240 (120⁷/₈ x 94¹/₂). Galleria Sabauda, Turin

To produce such large works would have presented no problems to a painter of Van Dyck's experience; but he can scarcely have comprehended, before he actually found himself in London, the nature of the tasks that faced a "Principal Painter in Ordinary" at the early Stuart court, because, with the possible exception of those imposed on his painters by Christian IV of Denmark, they were unique in Europe at that time.

Van Dyck's principal official duty, taken over from his predecessors and briefly shared with one of them, was to produce portraits of the king and his family and to provide replicas or versions of them that his royal patrons wished to distribute.[4] This was an aspect of a painter's practice that Rubens had scarcely had to tackle. In addition, Van Dyck was soon to find himself running a private practice far more extensive than that built up by any earlier artist in England.

Daniel Mytens, appointed by the king, soon after his accession, "one of our picture-drawers of our Chamber in ordinarie" for life, remained in London for the first two years of Van Dyck's time there. He had coped competently with the demands made on him by the king. Between the accession in 1625 and Van Dyck's arrival he had produced two main images of his patron, in each of which he could modify the background and the colors of the costume, but which he could repeat without a radical reassessment of the royal countenance. After Van Dyck's arrival he evolved three new portraits that are much more ambitious. They reveal, moreover, significant connections with compositions Van Dyck had painted or was to paint for the king. A full-length in Garter robes, painted in 1633 for Lord Wentworth, fore-shadows Van Dyck's state portrait of 1636; a double portrait [see cat. 62, fig. 2] of the king and queen, "both half-way in one piece," for the cabinet at Denmark House and paid for on 21 March 1634, is closely connected with the double portrait by Van Dyck from Kroměříz [cat. 62]; and a large hunting picture [cat. 67, fig. 2] foreshadows two of Van Dyck's most sumptuous and seemingly inventive royal portraits.

The king's two painters reacted differently, however, to some of the demands made on them. Neither could evade the task of painting posthumous portraits needed to fill gaps in a particular royal sequence. When Mytens produced, in 1627, the first example of a new portrait of the king [fig. 2], he painted it into an elaborate per-spective, which had been prepared in the previous year by Hendrik van Steenwyck as, some ten years earlier, he had painted a perspective for a seated full-length of the king when he was prince of Wales.[5] Toward the end of Van Dyck's life, among pictures standing in the Banqueting House, was still to be seen a large piece of perspective, painted on instructions from the king so that his and the queen's likenesses could be painted into it: "but Sir Anthony Van Dyck had no mind thereunto."[6]

Although it was to Mytens' position that Van Dyck succeeded, the role he played in developing for his royal patrons a series of portraits, varied in their iconographical content, was closer to that which the king's elder brother, Henry, prince of Wales, had entrusted to a much less accomplished painter, Robert Peake,[7] of whose work Van Dyck, even on his brief visit to the court of James I, might scarcely have been aware. On the basis of very few sittings from the prince, Peake had evolved a comparatively wide range of images: informal portraits on a modest scale, formal full-lengths, hunting scenes, and an equestrian portrait that anticipates, if rather less obviously than was believed, Van Dyck's second equestrian portrait of the king.

Van Dyck made use on occasion of one of his earlier, or slightly earlier, likenesses of a patron when commissioned to paint him a second or even a third time. For example: the same sitting, or series of sittings, could have been used for the formal full-length of the duke of Richmond [cat. 66], the informal three-quarter-length of the duke at Kenwood [cat. 66, fig. 4], and the second image in the same vein, of which the most familiar version is in the Louvre.[8] The head of the earl of Strafford in the portrait with Sir Philip Mainwaring [fig. 3] is disappointingly dull because it was probably not painted *ad vivum*, but from a portrait [fig. 4] Van Dyck had painted earlier. The earl of Northumberland, possibly, after the king, the painter's most generous patron, was content for Van Dyck to paint the same head in three separate

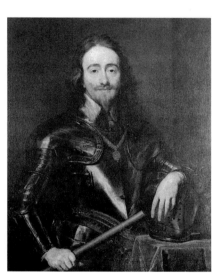

Fig. 3. Anthony van Dyck, *Thomas Wentworth, 1st Earl of Strafford, with Sir Philip Mainwaring* [cat. 86]

Fig. 4. Anthony van Dyck, *Thomas Wentworth, 1st Earl of Strafford*, c. 1636-1640, canvas. Collection of the Duke of Grafton, Euston Hall, Thetford, Norfolk

Fig. 5. Anthony van Dyck, *Charles I in Three Positions* [cat. 75]

Fig. 6. Anthony van Dyck, *Charles I*, c. 1632-1633, canvas, 100 x 81.8 (39 3/8 x 32 1/4). Arundel Castle, Sussex. Reproduced by kind permission of the Duke of Norfolk

compositions, two of them formal, one of them less so, but all of which he, the earl, was to retain. On the other hand Van Dyck very seldom used the same posture for different sitters: a practice developed, under great pressure, by Lely.

This point should in an ideal world only be made after seeing all the pictures concerned side by side; but it could be made with some confidence in considering how Van Dyck contrived to cope with the demand for portraits of the king and his family. The first payment had referred to a full-length of the king and a half-length of the queen; the second was for nine pictures of the king and queen then "lately made." Payments of £1,200 in 1637, £603 in December 1638, and £305 in February 1639, all for pictures for the king, must have included royal portraits. The famous "Memoire" of pictures for which payment had not been made included six portraits of the king, thirteen of the queen, two of the prince of Wales, and one important group of the royal children. The likeness of the prince in this group could have enabled the painter to produce, without further sittings from a restless little boy, the single portrait "Le Prince Carles en armes. Pour Somerset"—or, if it is the earlier version, the portrait given to the earl of Newcastle.9

Responsible students of the œuvre would probably, at the present time, limit to eleven the number of portraits of Charles I which the painter himself can unequivocally be felt to have painted. This includes as one item the triple portrait of the king [fig. 5], but does not take into account portraits that record lost originals. Even in this comparatively short list not every portrait was necessarily from life. The head in the

55

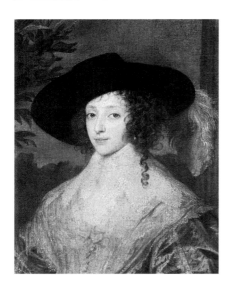

Fig. 7. Anthony van Dyck, *Queen Henrietta Maria* [detail, cat. 67]

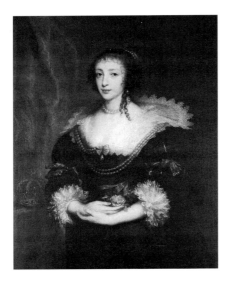

Fig. 8. Anthony van Dyck, *Queen Henrietta Maria*, 1632, canvas, 106.3 x 81.3 (41 7/8 x 32). Collection of the Earl of Radnor, Longford Castle, Wiltshire

three-quarter-length [fig. 6] at Arundel Castle, for instance, is of the same type as the central head in the triple portrait; and the construction of the right-hand head of the three is close to the deeply felt and much more spontaneously worked head in the equestrian portrait in the National Gallery in London. Again: the countenance of the king in the late three-quarter-length at Dresden [cat. 66, fig. 1], dated 1637 and probably the finest version of a very popular type, is so close to the face in the great picture in the Louvre [fig. 1] as to suggest that both likenesses derive from the same sitting. The same connection can be made in portraits of the queen. Our student would probably accept fewer surviving originals of her than of the king, for she became increasingly reluctant to sit. The first "type" produced by Van Dyck after his arrival [see cat. 62, fig. 1] was made to do duty, with very slight modifications, for the double portrait [cat. 62] painted to replace Mytens' at Somerset House; and the ravishing portrait of the queen in hunting costume [fig. 7] is possibly dependent on the same sitting as the exceptionally tender portrait [fig. 8], also painted in 1632, at Longford Castle. The links pointed out in this discussion may at least suggest that it was not always necessary, or perhaps possible, for Van Dyck to be given a sitting when a new portrait was wanted; and that he could have completed it without recourse to the sitter or, at the least, with a brief sitting at which to refresh his memory.

Such processes would have involved having ready access to an earlier portrait or perhaps retaining some prime record of a "type"; although there is no evidence that Van Dyck ever made an oil sketch of a sitter's head. On the contrary, all the evidence suggests that he painted a head straight onto the canvas. The only preparatory material for a new commission was a hurried drawing of a posture, or details therein, in which there is sometimes a vivid glimpse of a face. If versions or variants of a portrait were to be produced within a short space of time, the problems would not have been too difficult. Lord Wentworth, a perceptive and demanding patron, was probably aware of this when, in November 1636, he gave instructions about the two versions of the new portrait that Van Dyck was painting for him. The second version is as fine in quality as the first because Wentworth had instructed his agent to "minde Sr. Anthonye that he will take good paines upon the perfecting of this picture wᵗʰ his owne pensell";[10] and because the artist could have worked on the two canvases side by side as he was later able to do when commissioned to paint, in the last months of his life, two versions of a portrait of the newly married Princess Royal.[11] To rework a portrait type after a lapse of months or years would be more difficult. The head in the recently discovered portrait of Charles I [cat. 77], for example, may have been very carefully reworked from the more freely painted head in the full-length in state robes of 1636 [fig. 9]. This had probably been produced for the series of royal full-lengths in the Cross Gallery at Somerset House. When Van Dyck was commissioned by the king to paint full-lengths of the royal couple for Lord Wharton, he turned back to the same type for the portrait of the king,[12] slightly altering the pose, replacing the robes of state with armor, but copying the regalia from the three-quarter-length. The lines of production established in such a process—and it was repeated over and over again in Van Dyck's London years—had to be manned by a team of competent assistants. Some of them would have presumably been among the "servants" who, with Van Dyck, lodged with Norgate in the first weeks or months of Van Dyck's residence in London. Six servants were recorded in Van Dyck's household in a return of aliens living in London in 1634. Five were with him in Paris, at the very end of his life, when he was preparing to return to London. From the outset of his career at the English court Van Dyck's assistants must have been able to lay out his compositions, to paint areas over which Van Dyck could swiftly work in order to apply, in Jabach's words, "l'art & la verité que nous y admirons,"[13] and to produce independent copies that could give a plausible impression of an original.

No artist summoned to work at a foreign court can ever have carried out more conscientiously or more imaginatively his allotted task. No court painter illustrated with greater variety of scale or mood the different facets of a sovereign's personality

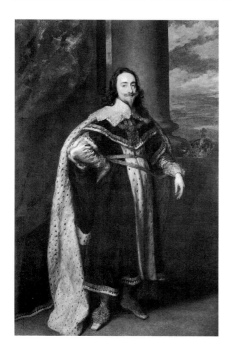

Fig. 9. Anthony van Dyck, *Charles I*, 1636, canvas, 248.3 x 153.77 (97³/₄ x 60¹/₂). Copyright reserved to H. M. Queen Elizabeth II

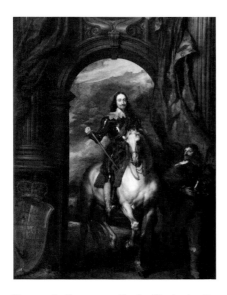

Fig. 10. Anthony van Dyck, *Charles I with M. de St. Antoine*, 1633, canvas, 368.4 x 269.9 (145 x 106¹/₄). Copyright reserved to H. M. Queen Elizabeth II

and position. Van Dyck's presentation of the king is, moreover, so subtle that we do not know, in looking at his portraits of him, that we are confronting someone "fundamentally unsuited for the task of kingship"; although the king had "the most sophisticated appreciation" of the representation of it.[14]

That Van Dyck frequently—inevitably—found himself reworking older formulas makes the apparent originality of so many of his English works the more impressive. He rearranged and redressed older ideas so magnificently, and with such variety, in the brilliance of his mature style, that they would have seemed to his patrons excitingly new and at the same time stimulating in their evocation of the great painters of the Renaissance: and often skillfully adapted, in execution and design, to the positions for which they had been specially composed. There is a change in style between the first portraits Van Dyck painted for the Crown and those he produced at the end of his life when he was sick both in mind and body: between, for instance, the ravishing *Henrietta Maria with Sir Jeffrey Hudson* [cat. 67] and the last important royal commission, the marriage portrait of the prince and princess of Orange.[15] In the earlier portrait the color is rich and silvery, the touch quick and sensitive throughout, the allusions to the queen's state precisely appropriate to the mood of the picture, the whole canvas alive with flickering light. The later composition is more pallid in tone, the touch decisive still but rather coarse, the paint more heavily impasted, the light less subtly cast; but characterization and drawing are as perceptive and accomplished as ever. This late style, seen very clearly on a large scale in *James Hamilton, 3d Marquis of Hamilton* [cat. 87], is one in which the studio "servants" were increasingly adept at working.

Although Van Dyck's technique was never quite so consistently brilliant in England, or the atmosphere in his works quite so tangible, as they had been in the pictures of his second Flemish period or in the remarkable group of works he painted during the spell in the Spanish Netherlands in 1634–1635, the refinement of handling, even in pictures painted on such a very big scale as the two equestrian portraits of the king [fig. 10], is remarkable. It is not easy to work out a chronology for the painter's English period because he worked in different manners, as well as at different pitches of inspiration, at any given moment. The handling of the flesh or the whites in the two masterpieces from the royal collection is very different: carefully worked in the triple study of the king [cat. 75 and fig. 5], nervous and free in the double portrait [cat. 62]. The English œuvre would be drastically pruned if it were to be restricted to portraits that revealed such areas of supremely fine painting as the armor in the portrait of Arundel and his grandson [cat. 76] or to works so inspired and so superbly handled, again in rather different ways, as *Sir Thomas Hanmer*, the *Countess of Bedford*[16] at Petworth, or the *Three Eldest Children of Charles I* [cat. 74]; the last without question the finest of the compositions in which the artist adapts handling and palette, both of unsurpassed refinement in this work, and the standard accessories to a group of little children as touching as they are grand.

The handling of the English portraits—their lustrous color, nervous draftsmanship, linear rhythms, and consummate elegance, the sense of strain or melancholy, and a nervous tension which they so frequently display—these qualities evoke the personality of the painter himself as we can recognize it from such fragmentary evidence as has come down to us: small, good-looking, charming in company, sensitive, ambitious and neurotic, delicate, fond of women, and enjoying a cultivated way of life in emulation of Rubens. Transformation of the appearance of his English patrons takes them into the eighteenth century, away from the early Stuart age. In earlier portraits of the king, by Pot or Mytens for instance, the king stands on an almost crudely defined stage. In Mytens' double portrait for Somerset House king and queen could be performing in an unusually grand Punch and Judy show. In Honthorst's huge canvas on the queen's staircase at Hampton Court the heavy forms are frozen in a "still" from a clumsily orchestrated masque. In Van Dyck's great royal portraits, on the other hand, his sinuous double portraits or the Pembroke family group at Wilton [see Brown, fig. 1], we are caught up in another world, full of poise, allusion, flickering light, and a palpable atmosphere: fascinated, in other words, by

stagecraft far more sophisticated, in which the king in particular is far more compellingly at the center of his stage and of his world.

It is, however, in a smaller canvas that Van Dyck's personality, his state of mind toward the end of his years at court, can be most vividly evoked: the exquisite *Cupid and Psyche* [cat. 85], which may have been painted for a scheme of decoration in the Queen's Cabinet at Greenwich, a welcome relief from the relentless demand for portraits. Certainly it would have been appropriate for a queen on whose behalf, when the scheme was being discussed, the king stipulated that in any picture painted for her the faces of the women were to be "as beautifull as may bee, y^e figures gracious and suelta."[17] The figure of Psyche is perhaps the most ravishing Van Dyck ever painted; her enchantingly pretty face may be that of his mistress in a perhaps uncharacteristic tranquil moment. If the composition is compared to *Rinaldo and Armida* [cat. 54] or to *Amaryllis and Mirtillo* [cat. 60], the delicate touch, reduced scale, and clear color can be seen as a final tribute to Titian and Veronese. It may be improper to compare too closely *Cupid and Psyche*, and the position it occupies in Van Dyck's development, with the *Toilet of Venus* by Velázquez, painted slightly later in the artist's career; but Velázquez, like Van Dyck, was steeped, at the time he was painting his Venus, in the work of Titian, Tintoretto, and Veronese.[18] The brilliance of Velázquez' handling dramatically transcends normal chronological constraints. *Cupid and Psyche* does not stand in so seminal a position; nor was Van Dyck ever to record a court with the unvarnished truth so remarkable in Velázquez. *Cupid and Psyche* still has the artifice of so much of Van Dyck's work, and of the culture of the Caroline court as a whole, but, for the painters of the rococo in France and for Gainsborough in England, this final distillation by Van Dyck of the manner of the great Venetians is notably significant.

NOTES

1. The payments are most conveniently printed in Hookham Carpenter 1844, 71, 72.

2. Note by Abraham Van der Doort in *Walpole Society* 37 (Glasgow, 1960), 174; elsewhere (184) he listed among the king's Titians the twelve emperors as at St James's, "one thereof being a copy."

3. References in this paragraph are to the following: Hookham Carpenter 1844, 29, 65; obituary notice by Baldwin Hamey (in the Royal College of Physicians, London); Brown 1983, 69–72; Public Record Office, London, Declared Accounts, A.O.i, 2427/64; E. Harris, *Velázquez* (Oxford, 1982), 193.

4. Versions, for example, of portraits of the king, queen, and prince of Wales were painted for the king of Spain; and rich presents to the king of Morocco in 1638 included "the king and queens picture drawne after the Vandikes originalls." See *Ceremonies of Charles I*, ed. A. J. Loomie (New York, 1987), 250.

5. Fully discussed in *Christian IV and Europe* [exh. cat. Museum pa Frederiksborg, Hillerod] (Copenhagen, 1988), 329.

6. Van der Doort 1960, 180. The full-length in the National Portrait Gallery in London (no. 1247) is painted against a fine perspective that is almost certainly by Steenwyck and may, in itself, record a lost image by Van Dyck.

7. *The Treasure Houses of Britain* [exh. cat. National Gallery of Art] (Washington, 1985), 132 (no. 56).

8. Glück 1931, 410.

9. Hookham Carpenter 1844, 67–68, 72–74. The painter's executors were still claiming, during the interregnum, arrears due to them.

10. *For Veronica Wedgwood These*, ed. R. Ollard and P. Tudor-Craig (London, 1986), 115.

11. The first version was sold at Christie's, London, 17 November 1989, no. 41, having earlier appeared at Sotheby's, 15 December 1976, no. 59.

12. Glück 1931, 390.

13. Cust 1900, 139.

14. L. J. Reeve, *Charles I and the Road to Personal Rule* (Cambridge, 1989), 173; K. Sharpe, *Politics and Ideas in Early Stuart England* (London, 1989), 46.

15. Glück 1931, 505.

16. Most conveniently reproduced and discussed in London 1982–1983, nos. 41, 37.

17. W. N. Sainsbury, *Original Unpublished Papers* (London, 1859), 217.

18. Harris 1982, 136–140; the court styles of Van Dyck and Velázquez are lucidly analyzed and compared in M. Levey, *Painting at Court* (London, 1971), ch. 4.

Reflections on Motifs in Van Dyck's Portraits

ZIRKA ZAREMBA FILIPCZAK

Fig. 1. Paulus Pontius after Anthony van Dyck, *Hendrick van den Bergh*, engraving, 35.8 x 29 (14 x 11 3/8). Private collection

Van Dyck creatively reused motifs he inherited from other portraitists, but he also devised new settings and situations for his sitters, and showed them with new props. Scholars have given little attention to several innovations Van Dyck made in these areas, innovations that his patrons permitted or chose to have him repeat, so that his novel images developed into new types.[1]

Because of the fashion set by Titian and other Venetians, curtains and columns, alone or in combination, had become common as backdrops for portraits. Van Dyck used this schema throughout his career, but characteristically his columns do not carry the same meaning from picture to picture. Whole, they usually are signs of status suggesting a palatial environment [cat. 43], though in rare instances they may function as metaphors presenting the sitter as a pillar of his profession [perhaps cat. 42].[2] Broken, they may signify death [cat. 84] or travel to places with classical ruins [cats. 33, 48]. The presence of only a column base in the portrait of *William Cavendish, Duke of Newcastle* (Duke of Portland, Welbeck Abbey) refers to the celebrated ongoing building project of Bolsover Castle.[3]

Van Dyck's most innovative settings began around 1630, when he introduced a new type in which stark natural elements, in the form of cliffs, caves, and boulders, dominate [cat. 83 and figs. 1–3]. The drab and irregular rock masses, however, articulate space in much the same ways as splendid columns and curtains.

Traditional outdoor settings that Van Dyck continued to use were greener and more pleasant. Sitters inhabit gardens [fig. 2] or countryside that refers to their travels (*Everhard Jabach*, Hermitage, Leningrad) or to land they possess (*James Stanley, Earl of Derby, with Charlotte de la Tremouille, His Wife, and Catherine, Their Daughter*, Frick Collection, New York). Most often, however, the glimpses of countryside recall paintings by Titian [cat. 29]. Costumes suggesting silk-clad shepherds or nymphs in verdant settings evoke the Arcadian environments that became fashionable in northern European literature, theater, and art in the early seventeenth century [cat. 63].

A scene in which stark stone dominates had different associations than more verdant environments. Cliffs and caves were traditional for such subjects as hermit saints living in the wilderness [cat. 2] or Andromeda chained to a rock.[4] In overtly allegorical contexts such as emblem books and friendship albums, bare rocks symbolized constancy.[5] Rocky masses were also traditional scenic devices in the theater, where they represented wilderness in which difficulties had to be overcome. In fact, they were such clichés in masques at the English court that in the performance of George Chapman's *Middle Temple* (1613), Plutus was given lines commenting on his setting. "Rockes? Nothing but Rockes in these masking devices? Is Invention so poore shee must needes ever dwell among Rocks?"[6] Rock masses were thus very familiar as settings, but not in portraits until introduced by Van Dyck.[7]

The significance of the rocky setting is most straightforward where it seems to refer to the sitter's professional activity. When Van Dyck piled boulders around *Sir John Suckling*, who stands in front of a silhouetted cliff [fig. 2], he recalled the stage setting of Suckling's play *Aglaura*, of which the playwright was inordinately proud.[8] Similarly, when in the *Iconography* he placed the painter Joos de Momper next to a cliff and in front of distant mountains, his etching identified the type of terrain De Momper commonly depicted.[9] Van Dyck's most frequent use of rocky settings in male portraits was for figures in armor. The earliest known example shows Hendrick van den Bergh, who was commander of the Spanish forces fighting in the Netherlands, hardly mountainous country (c. 1630; Prado, Madrid). Although the original painting was in the collection of Charles I of England,[10] Pontius' engraving after the portrait made it widely known [fig. 1]. It is likely that Van Dyck used a craggy setting for men in armor to symbolize heroic strength, and perhaps to evoke

the harsh conditions of war. This new setting created a continuity between sitter and context by emphasizing two kinds of hard surfaces, armor and rock. Van Dyck chose a hybrid setting for a double portrait in which only one figure wears armor, that of Thomas Howard, earl of Arundel [cat. 76], whose actual and rather inglorious performance as a military commander still lay in the future.[11] Whereas Arundel stands before a shadowy cliff, his silk-clad grandson, Lord Maltravers, is in front of a golden curtain.

Van Dyck's most unexpected and perplexing use of rocky settings was in portraits of women who vary in age, religious affiliation, marital status, and fecundity. The Anglican *Diana Cecil, Countess of Oxford,* for example, sits in front of a cliff wall resting her hands on a stone table [fig. 3]. Allegorical presentations were common throughout western Europe at this time, but nowhere more than at the English court. Van Dyck's English sitters were accustomed to having themselves and others take on symbolic guises in masques and in literature.[12] In their portraits by Van Dyck they occasionally assume overtly mythological or allegorical roles, and women frequently wear simplified, collarless, and thus more timeless versions of contemporary dress.[13] Thus all that stone around the countess of Oxford may well have carried allegorical connotations for contemporary viewers. Perhaps it symbolized her constancy (a virtue believed to be rare in women) or the hardness of her life (a childless widow for thirteen years, she wears black and holds a fading rose).[14]

Whatever other significance a rocky setting might have in a woman's portrait, usually it served as a visual contrast to her appearance, as in *Mrs. Endymion Porter* [cat. 83].[15] Although Van Dyck endowed his sitters with exceptional grace and elegance, he sometimes placed them in the starkest natural settings in the history of western portraiture. That contrast had hierarchical resonance. For example, in the writings of Kenelm Digby, a close friend of Van Dyck, rocks and earth were classified as the lowest level of nature; plants were ranked higher, and it was their "purer and nobler substance" which yielded flowers (such as the ubiquitous roses of Van Dyck's female portraits); human beings, of course, represented the highest level in this hierarchical ordering of nature.[16] Van Dyck's visual innovation was to juxtapose lowest and highest by using the rough drabness of rocks to heighten the graceful brightness of women, "the rarest workes of nature."[17]

Other artists borrowed the image of a sitter next to a rocky surface (such as Adriaen Hanneman, *Henry, Duke of Gloucester*, National Gallery of Art, Washington; Thomas Gainsborough, *Mrs. Baker*, Frick Collection, New York), but none used this setting as often, or as variously, as Van Dyck.

Van Dyck introduced into portraiture the motif of a woman about to dip her hand in a marble fountain.[18] Judging from his surviving works, he first used it for a Genoese noblewoman (*Marchesa Caterina Durazzo*, Palazzo Reale, Genoa) in the mid-1620s, when he showed it as part of a traditional setting of architecture and curtain. He then seems to have ignored the motif until the following decade, when he relocated it amid greenery to suggest a garden setting for an unidentified Fleming [fig. 4], and for an unusual Englishwoman, *Lucy Percy, Countess of Carlisle* (The Lord Egremont, Petworth).

Fountains associated with women had an extensive and varied history in western literature as well as art. In the famous classical fresco known as the Aldobrandini Wedding, which Van Dyck sketched in Rome, a woman dips her hand in a fountain.[19] A fountain could serve as a symbol of life, of love, of chastity, and was an attribute of both the Blessed Virgin and Venus.[20] In the seventeenth century the supposed biological differences between the sexes supported the continued association of woman and fountain: cold and wet humours were still believed to be dominant in women. Henry Percy, 9th earl of Northumberland [cat. 65] wrote, for example, that women's "Bodies you may perceive to be very tender out of extreme Humidytes, and this doe all our Physitians agree in."[21] Van Dyck did use a fountain once to refer specifically to wetness (namely, to identify a sitter as a "living fountain" of grief),[22] but that is not the theme of portraits in which a woman is about to dip her hand in a fountain. In his two examples from the 1630s [such as fig. 4] the fountain

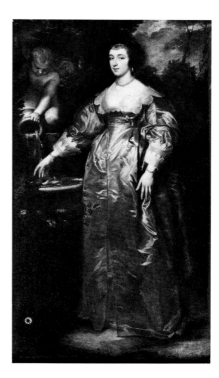

Fig. 2. Anthony van Dyck, *Sir John Suckling*, c. 1637, canvas, 216.5 x 130.3 (85 1/4 x 51 1/4). The Frick Collection, New York

Fig. 3. Anthony van Dyck, *Diana Cecil, Countess of Oxford*, 1638, canvas, 108 x 86 (42 1/2 x 33 7/8). Museo del Prado, Madrid

Fig. 4. Anthony van Dyck, *Unidentified Lady with a Dolphin Fountain*, c. 1635, canvas, 208.3 x 118 (82 x 46 1/2). Copyright reserved to H. M. Queen Elizabeth II

stands amid greenery and is crowned by a statue of a cupid. Its presence evokes a garden of love in which the sitter appears as a love-inspiring yet chaste presence.

The vase, another prop Van Dyck used in an innovative way, had an equally extensive history in western art. A few portraits, among them works by Rubens, included vases that contain garden plants, and on rare occasions Van Dyck himself used vases this way [cat. 67]. In several examples from the last years of his life, however, the vase stands empty. A rosebush grows near it, not from it, and a young woman stands next to both [fig. 5]. In these portraits the vase itself becomes a visual metaphor for a beautiful woman.

The source of this unusual motif seems to have been a book published in Florence in the mid-sixteenth century, Agnolo Firenzuola's "Dialogo delle belezze delle donne" (1548),[23] a copy of which belonged to Kenelm Digby.[24] Van Dyck probably did not know or did not appreciate the significance of this idea during the years he lived in Italy, for he did not introduce the motif of an empty vase into portraiture until a decade later, after Digby returned to England in 1637/1638. Perhaps Digby directed Van Dyck's attention to the little book by Firenzuola, which explicitly compares the figures of beautiful women to classical vases. The book includes a woodcut that contrasts well and ill-formed vases, both full and slim. The ideal full vase [fig. 6, second from right] looks like the one Van Dyck included in a portrait of *Anne Carr, Countess of Bedford* [fig. 5]. Firenzuola pointed out "the neck rising from the body of the vase, which is the bust of a woman rising from her hips … discern[s] that the hips must be very large and the bust rise from them shapely and slender; and that the shoulders and neck must be the same."[25] He even extended the analogy to a comparison between women's arms and the handles of vases.

In Van Dyck's portraits that make the same comparison between women and vases, the basic shape of the vase remains the same, but Van Dyck introduced telling changes nonetheless. In the portrait of Lady Anne Carr, for example, he juxtaposed her left profile with the right side of the vase. In the full-length portrait of *Jane Goodwin, Lady Wharton* (Coll. Major Malcolm Munthe, MC), her arms curve gracefully to echo the handles of the vase. Scalloping decorates and emphasizes the neckline of both woman and vase in *Lady Dorothy Sidney, Countess of Sunderland* (The Lord Egremont, Petworth).[26] Van Dyck was probably attracted to the motif because it conveyed a compliment in a directly visual way, through the shapes themselves.

Other artists had compared female figures, including both Venus and Mary, to

61

vases,[27] but to my knowledge, never in portraits. Van Dyck was unique in complimenting his sitters in this way. Many motifs existed for praising a woman's appearance, especially comparing her to a rose, but none, it seems, referred to shape.

Van Dyck developed the straightforward pairing of vase and woman into a subtly flexible motif. Each repetition refers to the beauty of form of the women in whose portraits it occurs. By varying the treatment of both vase and sitter, he subtly brought out differences among the women. These variations on a theme were known to Van Dyck's patrons, many of whom moved in the same social circles and saw his portraits in each others' houses. Their memories of how Van Dyck had used a motif in one portrait could help them perceive his emphasis in another.

The vase and fountain had an almost opposite reception outside the circle of Van Dyck's patrons at the English court. No subsequent portraitists, it seems, imitated his use of an empty vase as a visual metaphor, but the fountain was widely adopted, particularly in England and the Netherlands.[28] The fountain was easy to use, effectively combining several compliments, such as praise for the woman's purity and her capacity to inspire love. Perhaps Van Dyck himself used the fountain motif less frequently than did other portraitists because its significance depended more on well-established associations than on direct visual perception.

Friendship portraits are another area in which Van Dyck added to the repertoire of motifs he had inherited. This bond, the "sweet union or communion of mind,"[29] was a frequent and serious topic in literature during the early seventeenth century, as it had been in classical antiquity and again since the Renaissance.[30] Many artists (among them Raphael, Titian, Holbein, and Rubens) had recorded friendships by portraying two or more people together in one painting. Generally they had produced one, or at most two such portraits.[31] Van Dyck, however, returned to this subject again and again, painting at least ten portraits that can be described as friendship portraits.[32]

From the beginning of his career Van Dyck painted double portraits of husbands and wives [cat. 17] and of brothers [cat. 42], but his earliest work that can definitely be identified as a friendship portrait is *Sir Endymion Porter and Van Dyck* [cat. 73]. He painted it in England, where he was doubly foreign, being a Catholic and a Fleming. Its format makes this work unique among Van Dyck's double portraits. The shape of the canvas itself—an ellipse, which has two foci—aptly conveys the essence of friendship, which was often described as "two bodies in one soul."[33] Van Dyck located each man over one focus, which lies at his outer shoulder rather than the middle of his body;[34] this placement, whether intentional or intuitive, heightens the sense of the friends' closeness. The rock on which both men rest a hand symbolizes the durability of their relationship,[35] whereas the bare hand Van Dyck places on his own chest probably refers to his feelings, more enduring than even the rock beneath his gloved hand. The sentiment seems comparable to that expressed in a play of 1640: "The solid earth of a continued rock, May ... be Rent, and so divided; but true friends, are Adjuncts most inseparable."[36]

The example provided by this painting may have sparked the demand for other friendship portraits by Van Dyck, such as *Thomas Killegrew and Lord Crofts* [cat. 84]. The literature of the time gives ample evidence that a strong emphasis on friendship already existed in England before Van Dyck settled there. For example, in 1631 Richard Brathwaite published *The English Gentleman*, which includes an exceptionally long chapter about friendship and is dedicated to Thomas Wentworth, earl of Strafford [cat. 86].

Van Dyck not only produced an unprecedented number of friendship portraits for his English patrons, but also an unprecedented type of friendship portrait, that of women [fig. 7]. With the help of his studio, he painted as many such portraits of women as of men. He did so, moreover, at a time when women were repeatedly described as incapable of real friendship. The year after Richard Brathwaite had published *The English Gentleman*, which stresses the importance of friendship for men, he published a slimmer volume on *The English Gentlewoman*. It contains no corresponding chapter—not even a sentence—about women's friendships. Kenelm

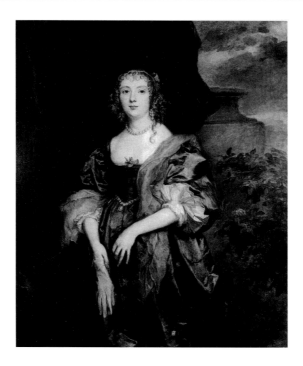

Fig. 5. Anthony van Dyck, *Anne Carr, Countess of Bedford*, c. 1638, canvas, 136.2 x 109.9 (53 5/8 x 43 1/4). Petworth House, Sussex—The National Trust

Fig. 6. Woodcut from *Prose de M. Agnolo Firenzuola Fiorentino* (Florence, 1548), 105

Digby was typical in blaming women's inconstancy for their inability to attain the "high and elevated" notions needed for real friendship, of which only men were capable.[37] Nevertheless, Van Dyck and his studio produced several portraits that pair two adult women—sisters, sisters-in-law, aunt and niece, or women with no family relationship.[38] Biographical data about several of the sitters suggests that even these family paintings can be classified as friendship portraits.

Traditionally, the placement of figures in a double portrait was not neutral, but carried hierarchical significance.[39] Thus in portraits of a man with his secretary [cat. 86], or of husbands and wives [such as cat. 51], the less powerful person was usually placed at the other's left. Such recognition of differences in status would, however, be contrary to the essence of friendship, and so Van Dyck avoided using this convention. He seems to have solved the delicate question of placement differently for men than for women. In the case of men, he gave the more important position to the older, even if he was of lesser rank. With women, precedence went to the one who was married, or had been married longer, even if she was younger and of lower rank, as in fig. 7. The weight given to marriage in this arrangement reveals contemporary attitudes toward women.[40] Most of the men's and women's friendship portraits by Van Dyck can be called portraits of occasion, the visual counterparts of poems of occasion. Mountjoy Blount, earl of Newport, and George, Lord Goring, probably commissioned two friendship portraits of themselves prior to a separation they had reason to fear might prove final (one work is in Petworth House, Sussex; the location of the other, which Lord Goring later took with him to Spain, is unknown).[41] Marriage of the woman on the viewer's right seems to have been the occasion for the commission of all but one of the women's friendship portraits.[42] In fig. 7 the seated Dorothy Savage, Viscountess Andover, is identified as a bride by her gown of saffron, believed to be the color worn by brides in antiquity.[43] In at least three cases the situation of the woman on our right was controversial. A letter written to Thomas Wentworth, earl of Strafford, summarizes the worst that accompanied the marriage on 10 April 1637 of Dorothy Savage, she of the saffron gown, to Charles, Lord Andover: "Never such an outcry was made about a marriage. ... Disinherited he must be, never looked in againe by any of his friends, no maintenance or house for them to live in, for also her mother hath commanded her from her house. ..." Why such intense opposition? Because they had been married by a Catholic priest without parental permission.[44]

Dorothy Savage's portrait uses extensive classical vocabulary. In addition to the color of the bride's dress, her sister Lady Elizabeth Thimbelby's gesture with a veil is classical as well: a pose used in antiquity to indicate a woman's chaste marital state.[45] There is also a winged cupid. Through these means the painting directed attention away from the issue of Catholicism, which would provoke conflict, to a more general statement about love and marriage. By pairing the bride with her sister it documents the bonds that linked them when friends and even family had turned away.

Roses appear in all the women's friendship portraits. Oliver Millar has noted that roses in Van Dyck's portraits can carry many meanings; here they are probably the roses that were "the chiefest grace of spouces on their Nuptial dayes."[46] The married woman, who is consistently placed more fully in the midst of nature, either points to the flowers already held by her companion, or provides her with these flowers, thus encouraging marriage. The portraits thus present friendship as a support for the marital state. In English literature of the time, however, women usually had to choose between friendship and marriage,[47] and a comparable fate may well have awaited Van Dyck's sitters. These portraits may actually be commemorations of a friendship at its high point, prior to the distancing resulting from the very marriage that the friendship had helped to promote.[48]

Seventeenth-century artists after Van Dyck continued to produce friendship portraits of men, but not, to my knowledge, of women. Peter Lely, for example, although influenced by Van Dyck's example, seems to have only imitated the surface of Van Dyck's innovative portrayals of pairs of women. He eliminated Van Dyck's complex continuity between the ties of friendship and marriage and returned to double portraits that simply juxtapose two sisters (such as *Mary Capel and Her Sister Elizabeth, Countess of Caernarvon*, The Metropolitan Museum of Art, New York).

The Neoplatonic comparisons between physical and spiritual beauty then current at the English court must have contributed to the growing interest in depicting beauty that is evident in Van Dyck's work from his English period. Agnolo Firenzuola's book was not the sole literary source from which he learned a new way of presenting a woman as beautiful. The other source was Franciscus Junius' *De pictura veterum* (Amsterdam, 1637; English translation, *The Painting of the Ancients*, London, 1638), in which Junius compiled statements from classical antiquity that pertain to painting. As Van Dyck's congratulatory letter of 19 August 1636 to Junius indicates, he had access to the manuscript prior to publication.[49] Its text included passages by Seneca and Aristaenetus about female beauty.[50] To be considered beautiful, women must have beautiful faces, but more beautiful still are those whose fair faces are the least fair part of their bodies. Aristaenetus said this was true of his own mistress, whom he identified as "my Limone": "though she hath a face faire beyond nature, yet putting off her cloathes seemeth to have no face at all, in regard of the other excellencies that were concealed." Van Dyck must have found this passage intriguing, for the name of Van Dyck's own mistress was Margaret Lemon, and it was she who probably served as his model for the figure of Psyche in *Cupid and Psyche* [cat. 85].[51]

Van Dyck ingeniously translated Aristaenetus' phrase "seemeth to have no face at all" into visual form by putting the face of Psyche into partial shadow while illuminating her unclothed body. By this selective use of light he stressed her beauty as well as her unconscious state. Shadowing the face while undraping the body was not, however, a motif Van Dyck could apply in portraits of beauties at the court of Charles I, for this king's standards of propriety were more formal than those of his son and successor Charles II. Instead, Van Dyck seems to have derived a safer motif from Junius' *Painting of the Ancients*, one that accorded with his tendency to link women and flowers. Stimulated by Junius' repeated mention of "a most famous picture" by Pausias, he portrayed several of his sitters as "a woman garland maker."[52]

The borrowings from Firenzuola and Junius suggest that especially during the last half-decade of his life Van Dyck experimented with different ways of representing women as beautiful. One strategy he seems to have explored was setting up

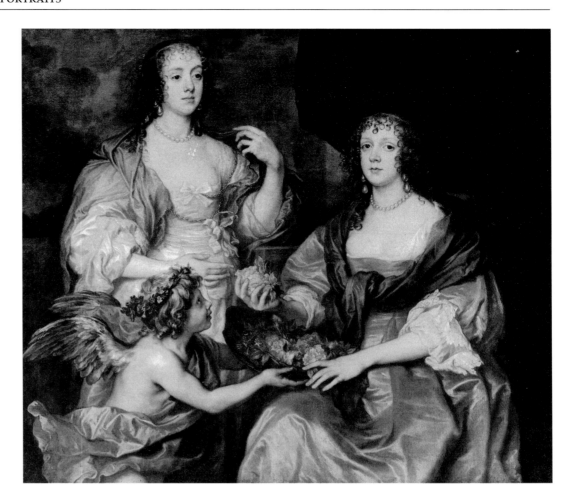

Fig. 7. Anthony van Dyck, *Lady Elizabeth Thimbelby and Dorothy, Viscountess Andover*, c. 1637, canvas, 131.2 x 149.5 (51 5/8 x 587/8). National Gallery, London

comparisons and contrasts. He enabled the viewer to analyze the various aspects of the woman's visual appeal by isolating them: here pointing out the similarities between roses and her coloring and the texture of her skin, there comparing the rightness of her shape to that of a classical vase, or, conversely, contrasting her beauty with the absence of any such loveliness in her rocky setting. Whatever other significance such portraits might have, they were always lessons in beauty. Different sections of the paintings illustrated different degrees and types of beauty, with the portrayed woman herself appearing as the summation of the beautiful.

The motifs considered here can also be examined indirectly, by noting the contexts in which they do not appear. When Van Dyck portrayed people together, whether family or friends, he gave them various indoor and outdoor settings, but not bare, rocky terrain.[53] Unlike his use of the column and curtain, he associated the rocky setting with people who are alone. Whether alone or not, however, reigning heads of state never appear before a rocky cliff. Only royal exiles do, and their rocky background may be symbolic, possibly referring to firmness of resolve, or even to the state of exile.[54]

The other innovative motifs considered here are likewise absent from the portraits of King Charles I and Queen Henrietta Maria [cats. 62, 67, 75, 77]. Neither is ever paired with a friend, for that would suggest that a sovereign is the equal of a person lower in station.[55] Henrietta Maria never stands next to an empty vase or a fountain (and never wears a more timeless, collarless dress), for to portray a monarch with the untraditional motifs Van Dyck used for courtiers might imply that courtiers and monarchs are comparable.

Van Dyck's innovations with setting, props, and situations varied over time, and according to the sitters' gender. Van Dyck inherited a much broader repertoire of motifs for depicting men than women. That may be why, throughout his career, he relied largely on creative reuse of existing male prototypes, supplementing them with 65

an occasional new motif for a specific portrait, such as in *George Gage with Two Men* [cat. 30]. (Whether this was also true of the poses and gestures he used for male sitters remains to be established.)[56] As was common, Van Dyck's portraits of women were less individualized than those of men. Yet especially in his portraits of Englishwomen from the 1630s, Van Dyck expanded the repertoire he had inherited by developing new types of images that refer to the appearance and the qualities of, and even the relationships between, women.

Van Dyck's depiction of beauty through visual comparison and contrast was characteristic, it seems, of his increasingly visual mode of thinking. A comprehensive study of Van Dyck's handling of subject matter would test what this limited study suggests. In the course of the roughly two dozen years that he painted portraits, Van Dyck expanded the range of situations in which he showed sitters, and he made formal elements such as shape, texture, and hue increasingly serve not only descriptive and aesthetic functions but act also as carriers of meaning.

NOTES

Much of this material was presented in lectures during the past year at the Art Department Faculty Colloquium, Williams College; The Daniel H. Silberberg Lecture Series at The Institute of Fine Arts, New York University; and Smith College. I am grateful to the colleagues who spoke with me on these occasions. I also found it helpful to discuss the material with students in my graduate seminar on Van Dyck at Williams College. My special thanks to E. J. Johnson for his comments on an earlier draft of this essay.

1. Novel ideas that Van Dyck did not repeat, such as the situation in *George Gage with Two Men* [cat. 30], will not be treated in this essay. During the decade prior to Van Dyck's departure for Italy, a new genre, depictions of collectors' galleries, originated in Antwerp. These scenes of people discussing artworks and other objects may have stimulated Van Dyck to portray three men gathered casually around a statuette.
2. For column as metaphor see Raupp 1984, 102. Rubens described Lucas van Leyden as *Sculptorum Columen* (a pillar, that is the foremost among engravers); Julius S. Held, *Rubens. Selected Drawings* (Oxford, 1986), 143, cat. 187.
3. P. A. Faulkner, *Bolsover Castle* (London, 1985), 11–15.
4. Van Dyck owned Titian's *Perseus and Andromeda* (Wallace Collection, London), which has a cliff setting. See Brown 1983, 71.
5. Richard Brathwaite, *A Strange Metamorphosis of Man, Transformed into a Wildernesse* (London, 1634), 8, "The Rocke ... a faire example and pattern to us of constancy and perserverence in vertue and a good life"; Huston Diehl, *An Index of Icons in English Emblem Books 1500–1700* (Norman, Oklahoma, and London, 1986), 174. For an example of this use in a friendship album see Jean Puraye, ed., *Album Amicorum Abraham Ortelius* (reprint Amsterdam, 1969), 21.
6. Allardyce Nicoll, *Stuart Masques and the Renaissance Stage* (London, 1937), 56–57. The grottoes that existed in gardens, which John Evelyn described as "agreeable places for solitude" (E. S. de Beer, ed., *The Diary of John Evelyn* [Oxford, 1955], 4:177), looked different, usually being ornamented (Roy Strong, *The Renaissance Garden in England* [London, 1979], 73–165). On English liking for paintings depicting great rock masses see Henry V. S. and Margaret Ogden, *English Taste in Landscape in the Seventeenth Century* (Ann Arbor, 1955), 36.
7. Even in the portrait of *Robert Devereux, 2d Earl of Essex* attributed to Marcus Gheeraerts the Younger (c. 1596; The Duke of Bedford, Woburn, and other versions), the cliff in the background is preceded and crowned by more greenery; Roy Strong, *The English Icon* (London, 1969), 297, cat. 300.
8. Thomas Clayton and L. A. Beaurline, eds., *The Works of Sir John Suckling* (1971), 1:LXII–LXIII, 2:262. Aspects other than the setting are discussed in Malcolm Rogers, "The Meaning of Van Dyck's Portrait of Sir John Suckling," *Burlington Magazine*, 120 (1978), 741–745.
9. Vergara 1983, 284–285. See there the engraved portrait of De Momper by Hendrick Hondius that Van Dyck used as a source but transformed, turning the

wall into a cliff, and the mountainous distance, with its town and a castle, into desolate terrain.

10. Oliver Millar in Royal Collection 1963, 107, cat. 178.

11. Howarth 1985, 164, 204–205.

12. Much has been published about the cultural climate of the Caroline court, including Perry 1981, and Strong 1972, especially chapters 4–7, and Strong 1973, 213–243. For the court's effect on Van Dyck's portraits, see Larsen 1972, 252–260, and Roskill 1987, 173–199.

13. That this small modification of costume changed the effect of the figures for contemporaries is suggested by a passage in Bellori 1931, 317. Bellori, who got his information about Van Dyck's English works from Kenelm Digby, described two women in such attire as "in habito di Ninfe." See also Oliver Millar in London 1982–1983, 30.

14. Arthur Collins, *Historical Collections of the Noble Families* (London, 1752), 266–268. I thank Egbert Haverkamp-Begemann for the idea that in women's portraits the rocky cliff may symbolize constancy.

15. Olivia Boteler, Mrs. Endymion Porter, wears a type of upward-flying cloak that is rare in Van Dyck's portraits, but which in his religious and mythological paintings seems to be associated with special moments, such as a supernatural vision [cat. 46] or falling in love [cat. 54]. The pose of this convert to Catholicism, an ardent proselytizer, is likewise exceptionally vital.

16. Kenelm Digby, *Of Bodies and of Mans Soul* (London, 1669; first publ. 1644), 156, 271, and his *A Discourse Concerning the Vegetation of Plants* (London, 1669), 216–218. See also P. M. Rattansi, "The Scientific Background," *The Age of Milton*, ed. C. A. Patrides and Raymond B. Waddington (Manchester, 1980), 202.

17. John Marston, *The Insatiable Countess* (London, 1631), act 3, scene 1.

18. Cust 1905, 41, and Strong 1979, 209. There was a dolphin fountain in the garden of Peter Paul Rubens in Antwerp (Muller 1989, 35).

19. Adriani 1940, 51–52.

20. The numerous sources include Diehl 1986, 102; Raimond van Marle, *Iconographie de l'Art Profane* (New York, 1971), 2:430–431; Friedrich Muthmann, *Mutter und Quelle* (Basel, 1975); Paul Watson, *The Garden of Love in Tuscan Art of the Early Renaissance* (Cranbury, N.J., and London, 1979), 70–72. See also n. 22.

21. Ian Maclean, *The Renaissance Notion of Woman: A Study in the Fortunes of Scholasticism and Medical Science in European Intellectual Life* (Cambridge, 1980), 34, 89. The quotation is from Edward Barrington, *Annals of the House of Percy* (London, 1887), 2:352.

22. In the double portrait of *Dorothy Percy, Countess of Leicester, and Lucy Percy, Countess of Carlisle* (Sudeley Castle, Winchcombe, Cheltenham) by Van Dyck and his studio, the widowed Lucy Percy points to water from a wall fountain. In symbolism common to literature but not to painting, the stream of water stands for tears of grief; the weeping woman is a "living fountain" (e.g., Henry Gladthorpe, *The Ladies Privilege*, [1640], 94; Henry Hawkins, *Parthenia Sacra* [1633], no. 19;

Rhodes Dunlap, ed., *The Poems of Thomas Carew* [Oxford, 1949], 108). Despite her characteristic tight smile, she is probably paired with her sister to suggest a shared sorrow at the absence of their husbands. In March of 1636 Lucy Percy's husband died, and in May of the same year Dorothy Percy's departed to serve as ambassador to France, where he remained for five years.

23. Agnolo Firenzuola, "Dialogo delle belezze delle donne," *Prose di M. Agnolo Firenzuola Fiorentino* (Florence, 1552), 337–430. Elizabeth Cropper was the first to discuss the influence of this book on Parmigianino and other artists, "On Beautiful Women, Parmigianino, 'Petrachismo,' and the Vernacular Style," *Art Bulletin* 58 (1976), 375–394. I thank Anna Blume for referring me to this article.

24. *Bibliotheca Digbiana, sive catalogus librorum quos post Kenelmum Digbeium eruditiss. Virum possedit Illustrissimus Georgius Comes Bristol* [auction cat.] (London, 1680), 75, no. 42. For Digby's biography, see T. Longueville, *The Life of Sir Kenelm Digby* (London and New York, 1896).

25. The original text is in Firenzuola 1552, 423. The English translation is from Agnolo Firenzuola, ed. and trans. C. Bell, *Of the Beauty of Women* (London, 1892), 145.

26. These portraits are reproduced in London 1982–1983, cat. 40 and cat. 52. Cat. 35 amusingly juxtaposes a woman with a pet dog and a vase with a carved lion.

27. Cropper 1976.

28. E. de Jongh, *Portretten van echt en trouw; huwelijk en gezin in de Nederlandse kunst van de zeventiende eeuw* (Haarlem and Zwolle, 1986), 91–94, and review by Hans-Joachim Raupp, *Simiolus* 16 (1986), 258.

29. Richard Brathwaite, *The English Gentleman* (London, 1631), 293.

30. See Laurens J. Mills, *One Soul in Bodies Twain* (Bloomington, Indiana, 1937).

31. Harold Keller, "Entstehung und Blütezeit des Freundschaftsbildes," *Essays in the History of Art Presented to Rudolf Wittkower* (London, 1967), 161–173.

32. They include: *George Digby, Earl of Bristol, and William Russell, Duke of Bedford* [see cat. 42, fig. 1]; and two versions of *Mountjoy Blount, Earl of Newport, and George, Lord Goring, with Page* (Petworth House, Sussex, and present location unknown). *Prince Charles Louis, Elector Palatine, and Prince Rupert* (Louvre, Paris) may belong in the category of a friendship portrait. It is equally possible that Charles I and Henrietta Maria simply wanted a double portrait of the two brothers before they left England. For friendship portraits of women, see n. 38.

33. Mills 1937, 11.

34. My thanks to Frank Morgan of the mathematics department, Williams College, and to others who described the structure of this form.

35. See n. 5.

36. Gladthorpe 1640, 94.

37. Kenelm Digby, Nicholas H. Nicholas,

ed., *Private Memoirs of Sir Kenelm Digby, Gentleman of the Bedchamber to King Charles the First. Writ by Himself* (London, 1927), 6–8, 276–276. On the general association of women with inconstancy see Maclean 1980, 55, 89. The dialogue form, common in secular poetry, especially pastoral poetry, during the Caroline period, was used between men or men and women, but not between women. Marianna Mays, "Some Themes and Conventions in Caroline Lyrics" (Oxford, Ph.D. thesis, 1965), 142.

38. Women's friendship portraits include: 1) fig. 7; 2) see n. 22 for an example that purports to be a friendship portrait; 3) *Anne, Lady Morton, and Cecilia Crofts, Mrs. Killigrew* (versions Wiltshire, Wilton House, earl of Pembroke, and Blenheim Palace, Woodstock, Oxfordshire). Both were ladies in the household of the queen. They were indirectly linked in a play by Cecilia Crofts' husband, Thomas Killigrew, who dedicated *Cicilia and Clorinda, or Love in Armes* (London, 1663), his only play that features his wife's name in its title, to "Lady Anne Villiers, Countesse of Morton"; 4) *Frances Stuart, Duchess of Portland, and Katherine Howard, Lady d'Aubigny* (formerly Hermitage, Leningrad, now perhaps in the Museum of Fine Arts, Moscow, according to Larsen 1988, 1: fig. 436), for more information see n. 44; 5) *Anne Rich, Countess of Manchester, and Isabella Rich, Lady Thynne* (formerly Los Angeles County Museum of Art; present location unknown); 6) so-called portrait of *Anne Dalkeith, Lady Morton, and Anne Kirke* (Leningrad, Hermitage). See also Hermitage 1963, no. 25, in which the identity of the sitters is uncertain (the double use of black for the woman on the right suggests mourning, or perhaps controversy over the marriage).

39. When husbands and wives were represented as donors in the religious works they commissioned, the husband would usually be situated to the right, the wife to the left, of the sacred figure(s) in the center; an example is Hugo van der Goes, *The Portinari Altarpiece* (Uffizi Gallery, Florence). Even when portraits had become independent secular images, that tradition of placement persisted through the seventeenth century in double, pendant, and family portraits. Examples include works by Rubens, Rembrandt, Frans Hals, but not always Van Dyck.

40. In his chapter on ethics, politics, and social writings in the sixteenth and seventeenth centuries, Ian Maclean noted that the "belief that woman cannot be considered except in relation to the paradigm of marriage is reinforced by the ethical and medical vision of marriage as a natural state." Maclean 1980, 57.

41. Goring was mistakenly reported killed at the siege of Breda, and mourned as such. See A. B. Gibbs, *Sir William Davenant* (Oxford, 1972), 387–388. This report must have made the two friends more aware, on the eve of new battle, of the possibility of death. For provenance, see Larsen 1980, no. 860.

42. For the exception see n. 22.

43. Killegrew 1663, 307, "Hymen's

yellow ..."; Shakerley Marmion, *Cupid and Psyche* (London, 1637), lines 247–248: "For Hymen's saffron weed, that should adorn/Young blushing brides."

44. *Recusant Records* 1961, 407. Also, W. Knowler, ed., *The Earle of Strafforde's Letters and Dispatches* (1739), 2:73–74. *Frances Stuart, Duchess of Portland, and Katherine Howard, Lady d'Aubigny* (Hermitage, Leningrad) pairs sisters-in-law, both of whom were likewise Catholic. Katherine Howard converted in 1637, prior to her secret marriage in 1638 to Lord George Stuart, Seigneur d'Aubigny, also a Catholic convert. Of the five Stuart siblings, Frances (born 1617) and George (born 1618) were closest in age. "Katherine Howard, but tis love that hath bin the principall agent in her conversion, for unknowne to her father, the Earl of Suffolk, she is, or wil be, maryed to the Lord d'Aubigny, ... he hath bin bred a Papist. ..." Clare Talbot, ed., *Catholic Records Society Miscellanea. Recusant Records* (Newport, Mon., 1961), 53:410. Two cousins are shown together in *Anne Rich, Countess of Manchester, and Isabella Rich, Lady Thynne*, which is largely a studio piece. In 1638/1639 Isabella Rich, daughter of the earl of Holland, married Sir James Thynne, wealthy but not of noble birth (Daphne Thynne, *Longleat from 1566 to the Present Time* [Liverpool, 1949], 16). In 1653 Dorothy Osborne wrote that "she had better have married a beggar than that beast with all his Estate" (G. C. Moore Smith, ed., *The Letters of Dorothy Osborne to William Temple* [Oxford, 1928], 100), but she does not indicate whether the marriage was problematical from the beginning or only became so later. See n. 22 about *Dorothy Percy, Countess of Leicester, and Lucy Percy, Countess of Carlisle*; Lucy Carlisle probably commissioned the work in response to questions about the propriety of her relationship with Thomas Wentworth.

45. Leo Steinberg, "Addendum to Julius Held's Paper," *Source* 8–9 (1989), 77–79.

46. Millar in London 1982–1983, 29. The quotation from Hawkins' *Parthenia Sacra* (1633), no. 18, is also cited by Millar.

47. Peter Erikson, *Patriarchal Structures in Shakespeare's Dramas* (Berkeley, 1985), 8, 36; Louis A. Montrose, "'Shaping Fantasies': Figurations of Gender and Power in Elizabethan Culture," in *Representing the English Renaissance*, ed. Stephen Greenblatt (Berkeley and London, 1988), 38–39.

48. I thank Susan Barnes for recognizing this irony.

49. Hookham Carpenter 1844, 55.

50. Junius 1638, 260–261.

51. Cust 1905, 136; London 1982–1983, 97–98, 112.

52. Junius 1638, especially 49. Surviving examples are *Anne, Lady Morton, and Cecilia Crofts, Mrs. Killigrew*; *Anne Carr, Countess of Bedford* (National Gallery of Art, Washington). Other examples can no longer be traced. William Sanderson, *Graphice* (London, 1658), 39, wrote about an unidentified sitter: "see how pretily she is busied to wreath her Lilly-flowr'd branch into a chaplet ..." (thanks to Jeffrey Muller for this reference), and Smith 1829–1843, 3:133, described Frances Stuart, countess of Portland, as taking a rose from a vase with one hand while holding a floral wreath in the other.

53. *A Family Group* (Detroit Institute of Arts) is a partial and perhaps telling exception, for the seven children shown here without adults may be orphans. Julius S. Held, *The Collections of the Detroit Institute of Arts. Flemish and German Paintings of the 17th Century* (Detroit, 1982), 37.

54. *Maria de' Medici* (1631, Musée des Beaux Arts, Bordeaux) records the exiled queen's visit to Antwerp, visible in the background across the Scheldt River. The cliff behind her does not record actual terrain, for the land there is quite flat. In the pendant full-length portraits of *Prince Charles Louis of the Palatinate* and *Prince Rupert of the Palatinate* (both Kunsthistorisches Museum, Vienna), Van Dyck introduced a rocky cliff behind the exiled heir to the throne, but placed architecture behind his younger brother.

55. Such a situation appears in Richard Edwards' *The Excellent Comedie of Two the Most Faithfullest Freendes, Damon and Pithias* (1571): "But you must forget you are king, for friendship stands in true equality." Quoted in Mills 1937, 143.

56. For a discussion of the poses Van Dyck favored in portraits of artists, see Raupp 1984, 98–103, 107–115.

"Death Moved Not His Generous Mind": Allusions and Ideas, Mostly Classical, in Van Dyck's Work and Life

J. DOUGLAS STEWART

Fig. 1. Anthony van Dyck, *The Crucifixion with Saints Dominic and Catherine of Siena* (detail), c. 1628, canvas. Koninklijk Museum voor Schone Kunsten, Antwerp

In his *Reflections on the Works of Sir Anthony Van Dyck*, Roger de Piles wrote: "his Mind was not of so large an extent, as that of *Ruben's* [sic].

"His *Compositions* were full, and conducted by the same Maxims, as were those of *Ruben's*; but his *Invention* was not so Learned, nor so Ingenious as his Master's. ..."[1] Since Rubens was probably the most learned painter who ever lived, one may readily agree with De Piles' statements. But they may be partly responsible for a tendency to exaggerate the differences between Rubens and Van Dyck and to see the latter as essentially unintellectual. Perhaps as a result of this, Van Dyck's use of symbols and allusions has often been ignored. A considerable sense of humor in these aspects of Van Dyck's art has also been overlooked.[2]

I have previously argued that the Fleming was deeply religious and employed symbolism, often of an erudite and witty sort, not only in his religious works, but also in his portraits.[3] Here Van Dyck's allusions and ideas from classical antiquity will be my subject. On the whole, personal works such as the 1628 *ex-voto* for his father, drawings, self-portraits, and others that are not likely to have been influenced by a patron are the most likely areas for this inquiry; however, I will also look at some commissions where the visual ideas appear to be the artist's and that support my argument that Van Dyck's interest in classical ideas seems to have extended beyond the professional level; for there is evidence, both visual and documentary, that Van Dyck was attracted to one of the strongest philosophical currents of his age, Neo-Stoicism.

During the time that Van Dyck was in Italy, his father died in Antwerp. The senior Van Dyck had been in the care of Dominican nuns, and apparently made a promise that his son would, on his return, paint an altarpiece for them. That picture, now in the museum at Antwerp, was presumably painted in 1628, and depicts the crucified Christ flanked by saints Dominic and Catherine of Siena. At the foot of the cross in that picture is a classical allusion: an inscribed rock [fig. 1], on which is seated a winged boy pointing to Christ. The boy holds an inverted torch, an ancient funeral symbol. Also on the rock is a lighted antique lamp. The symbolism indicates that earthly death (the inverted torch) can be overcome; Christ's sacrifice on the cross has given to mankind the chance of eternal life (the lighted lamp).[4] The inscription reads: "NE PATRIS MANIBVS/TERRA GRAVIS ESSET HOC/SAXVM CRVCI ADVOLVEBAT/ET HVIC LOCO DONABIT/ANTHONIVS VAN DYCK" (Anthony Van Dyck rolled this stone to the cross and presented it to this place so that the earth would not be heavy on the spirit of his father).[5] There seems to be a learned pun hidden in this inscription, the reference to the *manes* ("manibus"), the classical spirit of the departed. This shows familiarity with the classical epitaphs, as one of the commonest ancient epitaphs was *sit tibi terra levis* (may the earth sit lightly on you).[6] Van Dyck seems to have violated this last wish by painting a heavy stone, but of course it is only a painted stone. Moreover, by this painting Van Dyck has fulfilled his father's vow, and hence the earth won't be heavy on his father's spirit.

Did Van Dyck write this epitaph? Evidence that he read Latin can be found in a letter of 14 August 1636 in which the artist wrote to Francis Junius, Lord Arundel's librarian: "The Baron Canuwe [Conway] has returned me, by sea, the copy of your book 'De Pictura Veterum', which he values very highly, and considers it a most learned composition; I am confident it will be as acceptable to the public as any hitherto published, and that the Arts will be much elucidated by so remarkable a work, which must materially promote their regeneration, and ensure a great reputation and satisfaction to its author. ..." Van Dyck was commenting on the manuscript of Junius' *De pictura veterum*, a treatise on painting in antiquity, which was to be published in 1637. Presumably what Van Dyck read was the Latin version

Fig. 2. Anthony van Dyck, *The Continence of Scipio* (detail), c. 1620–1621, canvas. The Governing Body, Christ Church, Oxford

Fig. 3. Anthony van Dyck, *Self-Portrait with a Sunflower*, c. 1635–1636, canvas, 60 x 73 (23⅝ x 28¾). Collection Duke of Westminster, London

of this work, since the English and Dutch translations were not published until 1638 and 1641 respectively.[7]

A further reason for accepting Van Dyck's authorship of his father's Latin epitaph is the artist's use, from an early age, of discrete visual puns involving classical subjects. Perhaps the earliest example is the decorative wine ewer in the background of the Dulwich *Samson and Delilah* of 1619–1620 [cat. 11]. The ewer, which is decorated with grapes and whose handle is an ithyphallic satyr,[8] acts as a miniature "gloss" on the story, since it is through drunkenness and lust that Samson is brought to defeat.

Another visual pun involving a classical subject can be found in Van Dyck's portrait of George Gage and attendants [cat. 30]. Sir Oliver Millar, on the basis of the sitter's coat of arms, brilliantly identified the subject of this portrait.[9] He noted also that the crest of the Gage family is a ram. Van Dyck put a large ram's head not directly above the coat of arms, but at the corner of the plinth, thereby transforming the plinth into an antique altar decorated at the corners with rams' heads. Just what is being done on this "altar" cannot as yet be determined, because neither the antique statue in the picture nor the attendants have been clearly identified.

A third example appears in *The Continence of Scipio*. There a steeply foreshortened elephant in the rug beneath the feet of Allucius' betrothed [fig. 2][10] is almost certainly a symbol of Temperance, for Scipio exemplified that virtue in his refusal to take possession of her, as was his right as a conqueror. Normally the elephant is shown upright, not feet first as though his feet formed a pattern in the rug![11]

Among Van Dyck's self-portraits, the one that has been most discussed is the *Self-Portrait with a Sunflower* [fig. 3]. The picture has been interpreted as an emblem of the sitter's devotion to Charles I and the royalist cause on the basis of poems and emblem books in which the sunflower symbolizes the relationship between citizen and monarch.[12] Since the picture shows not only a sunflower but also a prominent gold chain, it has been suggested that Van Dyck meant to refer both to his royalism and to his profession as a painter.[13]

However, Bruyn and Emmens have noted a passage in a 1654 poem by Joost van den Vondel that provides the basis for a different interpretation: "Just as the sunflower, out of love, turns his eyes towards the heavenly canopy and follows with his face the all-quickening light of the sun who bestows color upon the universe and kindles trees and plants—thus the art of painting from innate inclination and kindled by a sacred fire, follows the beauty of nature."[14]

Van Dyck's *Sir Kenelm Digby* at Hawarden Castle [fig. 4] also contains a sunflower. Like Van Dyck's *Self-Portrait with a Sunflower*, the Hawarden picture has been given a royalist interpretation.[15] Inscribed above the sunflower is "OMNIS IN HOC SUM."[16] This inscription is from Horace's *Epistles*, 1.1, line 11: "Quid verum atque decens curo et rogo et omnis in hoc sum" (What is true and seemly [decorum] I am troubled about and question and I am totally involved in this).[17] Horace tells his patron Maecenas that he has given up Rome for retirement to the country; he has gone into retreat to consider philosophy and the meaning of things. Sir Kenelm, after the sudden and early death of his wife Venetia in 1633, grew a beard and went into retirement at Gresham College, London. He apparently spent two years doing scientific work and also special religious reading. By sometime in 1635, as a result of this reading, he returned from Protestantism, which he had embraced only in 1630, to his original faith, Catholicism.[18]

George Vertue saw, in the early 1730s, "at Althorpe Ld Sunderlands … Sr Kenelem Digby. ½ length with a sunflower at his side. at top OMNIS. IN HOC SUM."[19] More important, in 1725, in listing self-portraits by Van Dyck, Vertue noted "another having a Sun Flower, alluding to his imitation of the beautys of nature and flower, is said to follow the light of the Sun."[20]

Remarkably, Vertue's interpretation of the Van Dyck *Self-Portrait with a Sunflower* is almost a quotation of the 1654 Vondel poem. Yet it is unlikely that Vertue knew the Vondel passage, and both authors must have drawn their interpretations from a shared tradition. Vertue never associated Van Dyck's or Sir Kenelm's portraits with the sitters' royalism. Yet one can be virtually certain that Vertue, a Roman Catholic

Fig. 4. Anthony van Dyck, *Sir Kenelm Digby*, c. 1635–1639, canvas, 100 x 78.8 (39 3/8 x 31). Charles A. Gladstone, Esq., Hawarden Castle

born in 1688 and devoted to the memory of Charles I, would have been aware of such an interpretation had it existed.

The use of the term "royalist" (with its implied opposite "roundhead") for Englishmen of the mid-1630s is actually anachronistic, projecting the controversies of the 1640s back into the previous decade. Virtually everyone was a royalist in the mid-1630s. One might wish to change the king's policies, or those of his advisors; but, as a recent biographer has noted, "there was no alternative to the king. Or if there was, it was so unacceptable that Bishop Williams (who had no cause to love the personal rule) prayed, 'God send those men more wit who living in a monarchy rely on a democracy.'"[21] Van Dyck's *Self-Portrait with a Sunflower* might still be an expression of personal devotion to Charles I, possibly given to the king; yet there is no trace of it in the well-documented royal collection. It is further unlikely that the picture had been painted as an expression of personal gratitude to Charles I because Van Dyck omitted the royal portrait medal known to have been on the gold chain that the king presented to the painter.

Thus we may safely dismiss the idea that either the Hawarden *Sir Kenelm Digby* or Van Dyck's *Self-Portrait with a Sunflower* has anything to do with royalism. With our knowledge of the classical inscription and Digby's personal life around 1635, we can be almost certain that, in his portrait, the sunflower is a symbol of philosophical and religious significance, and that he probably commissioned the picture as a record of his becoming a Catholic again.

Van Dyck's *Self-Portrait with a Sunflower* may also carry the religious idea of turning to God, just as the sunflower does to the sun, but in his case there seems to be the added idea of the artist imitating the beauties of nature. But we know nothing of the circumstances surrounding the creation of this Van Dyck self-portrait; only that, from its distinctive oblong format, it would seem to have been designed with a specific location in mind, probably an over-door. Yet whatever the precise meaning of this image of Van Dyck, it is surely very significant that the painter chose to place an ancient symbol so prominently beside himself.[22]

Van Dyck and Sir Kenelm Digby were close friends,[23] which may have a bearing on the sunflowers in their pictures. Van Dyck's most highly symbolic portrait is his *Venetia Stanley, Lady Digby, as Prudence*, of which there are several versions, including a life-size one in the royal collection and a smaller one [cat. 64].[24] Digby doubtless had much to do with the subject matter of his wife's picture. But it also contains visual and iconographic aspects that seem to derive from the painter's, not the patron's, invention. Primary among these are the overall compositional concept and the existence of specific motifs that can be found in Van Dyck's earlier work. Van Dyck's composition, for example, is reminiscent of Rubens' allegorically figured book titles, such as that of Jacob de Bie's *Numismata Imperatorum Romanorum* ... (Plantin, 1617),[25] which Van Dyck clearly knew since it was produced while he was a member of Rubens' workshop. The bearskin worn by the two-faced figure of Fraud had appeared many years before draped over his figure of Samson in the Dulwich *Samson and Delilah* [cat. 11]. In both instances the fur was used to denote the vice of Luxuria.[26] Another link with earlier Van Dycks is the fallen figure of Profane Love, whose pose recalls those of the Christ Child in the Munich *Rest on the Flight into Egypt* of around 1630, and the child in the Vicenza *Ages of Man* [cat. 41].[27]

Lady Digby holds a serpent in her right hand; her left rests on one dove while another looks toward the first. The reference is to Christ's admonition to his apostles: "Be ye wise as serpents, and harmless as doves."[28] However, connections with this biblical text do not explain the presence of two doves (as opposed to one serpent), nor the different poses of the doves. *Lady Digby* may be, in part, an epitaph to Sir Kenelm's wife. On a tomb for a married couple, only one of whom was apparently dead when Rubens made the design about 1620–1625, is a very similar distinction between two doves.[29] One dove, like that under Lady Digby's hand, has outstretched wings; the other, representing the still-living husband, has, like the dove at the far right of Van Dyck's picture, folded wings. Van Dyck notably heightened the melancholy in his picture by surrounding the right-hand dove with darkness.

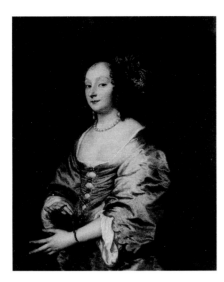

Fig. 5. Anthony van Dyck, *Mary Ruthven, Lady Van Dyck*, c. 1639–1640, canvas, 104 x 81 (41 x 31 7/8). Museo del Prado, Madrid

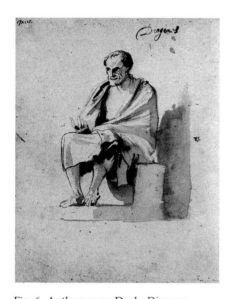

Fig. 6. Anthony van Dyck, *Diogenes*, Italian sketchbook, fol. 33v. Courtesy of the Trustees of the British Museum, London

On 27 February 1640 Van Dyck married Mary Ruthven, a granddaughter of the 1st earl of Gowrie.[30] In Van Dyck's portrait of Mary [fig. 5], she wears oak leaves in her hair, which have been taken to refer to her family crest.[31] I would suggest that here the oak also incorporates Christian meanings, especially Salvation. Indeed Van Dyck used the oak as a Christian symbol in several earlier works.[32] The oak is an attribute of the Virgin because of the prophetic reference in Isaiah 6:13; here that meaning seems especially appropriate since Mary is the sitter's name saint, and also she holds a rosary, a form of devotion to the Virgin.[33] The oak leaves representing these Marian ideas as well as Lady Ruthven's family crest are yet another example of Van Dyck's predilection for visual associations.

Van Dyck would have known that Raphael, in the *Stanza della Segnatura*, had portrayed the cardinal virtue Fortitude with oak leaves in her hair, and also perhaps that this attribute was sanctioned by the mythographer Valeriano.[34] Van Dyck may also have wished to use the oak leaves to refer to Fortitude, because as well as being a Christian virtue, it was equated by Neo-Stoics with Constancy. Van Dyck, true to the Neo-Stoic effort to synthesize Christian and Stoic ideas, may have deliberately mixed Christian and Stoic emblems by placing oak leaves in his wife Mary's hair.

Van Dyck's acquaintance with Stoicism is suggested by the broken column that appears prominently in his Leningrad *Self-Portrait* [cat. 33]. The broken column is a symbol of Constancy,[35] a central doctrine of the ancient philosophy; the Stoic wise man aims to achieve tranquility of mind, including avoiding the fear of death, which can only be attained by firmness and the pursuit of inner virtue.[36]

The Stoic revival, or Neo-Stoicism, had begun in 1584 with the publication of Justus Lipsius' *De Constantia*, a book that was a sort of Christianization of ancient Senecan Stoicism, and which quickly became known all over Europe, in learned and courtly circles and elsewhere. Indeed, Lipsius, it has been said, "was probably the most widely read and influential thinker of his time," and he was also widely translated. Lipsius (Joest Lips) was a Fleming, and his face appears in Rubens' *Four Philosophers* (Pitti Palace, Florence).[37]

Neo-Stoicism seems to have had a special appeal in this period because of the widespread uncertainties in religion and politics among Europeans. For the Stoic many of these "outward" beliefs and conformities could be seen as *adiaphora* (matters of indifference, because beyond the individual's control) compared to "inner virtue" (which each person could control).[38] It was a philosophy that was easy to grasp and one that, because of its ethical basis, was seen as complementary to Christianity.

Poussin, *le peintre philosophe*, was a Stoic. Rubens too is well known for his Stoic beliefs. That Van Dyck might have been a Stoic too may come as a surprise, yet evidence does suggest his sympathies with this philosophical outlook. Figure 6 is a drawing in Van Dyck's Italian sketchbook of a statue that was thought to represent Diogenes, the ancient Cynic philosopher.[39] Diogenes was a hero to ancient Stoic writers: as Anthony Blunt put it, he was "a sort of ne plus ultra of Stoic self-abnegation."[40] In the statue, Diogenes is shown with his right hand cupped, a gesture that presumably alludes to one of the most famous stories about him, his flinging away his last possession, a drinking bowl, after observing a boy drinking from a stream by cupping his hands. Van Dyck's drawing is, for him, careful and detailed; and he uncharacteristically identified it with an inscription. That the making of this drawing sprang from very personal interest we may be sure for two more reasons: the *Diogenes* was neither famous nor frequently copied; nor was a record of it likely to be of any direct use to Van Dyck in his future work.[41]

Another drawing from Van Dyck's Italian period is the *Saint Matthew and the Angel* [fig. 7]. It has been observed that Van Dyck's "surprisingly vigorous conception of the subject may reflect his study of the two versions of Saint Matthew and the Angel painted by Caravaggio which … he [Van Dyck] would have seen in Rome in the Giustiniani collection and in the Contarelli Chapel."[42] Indeed Van Dyck gave the head of Saint Matthew, as did Caravaggio in his first version, the features of Socrates—the bald head and squashed nose that are quite unlike the more refined features traditionally associated with the apostle. Caravaggio's reasons for using the

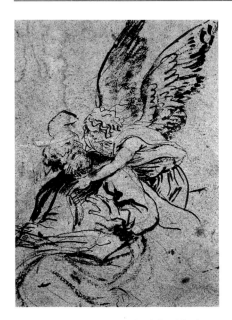

Fig. 7. Anthony van Dyck, *Saint Matthew and the Angel*, c. 1622–1625, pen, brush, and ink, 20.3 x 14.0 (8 x 5 1/2). Museum Boymans-van Beuningen, Rotterdam

features of Socrates have been explained by Irving Lavin in a brilliant piece of iconographical exegesis: Socrates, like Matthew, was divinely inspired, Socrates anticipated Christianity, and he was the wisest man of all.[43] As the father of ancient philosophy, and because of the manner of his death, Socrates, like Diogenes, was a Stoic hero.[44] Van Dyck may thus have consciously used the model of Socrates for similar reasons in this drawing.

We may perhaps fruitfully reexamine the *Lady Digby as Prudence* for evidence of Stoic ideas. Bellori, who was almost certainly given the information by Sir Kenelm Digby, tells us that the theme of the picture is based on a line from Juvenal's Tenth Satire: "Nullum Numen abeat si sit Prudentia" (No heavenly power is wanting where Prudence is present).[45] This satire has been described as "By all accounts the poem of Juvenal that is most deeply imbued with Stoicism."[46] The choice of the text must have been the patron's. However, the composition was certainly Van Dyck's, and Lady Digby's pose bears a striking resemblance to an emblem of the Stoic wise man "Sapientiae Libertas."[47] Like the Stoic wise man, she is shown on a plinth, serenely aloof, above her adversaries. It was an appropriate parallel for the image of his dead wife, which Sir Kenelm was trying to project as one whose virtue caused her to triumph over what he saw as the calumnies of the world.

On 4 December 1641 Van Dyck lay dying in his house in Blackfriars. The court for which he had labored was collapsing: a great patron, the earl of Strafford, had been executed in May; the London mobs were out.[48] Van Dyck had been married for less than two years, and had a five-day-old daughter; the painter himself was only forty-two. In these circumstances most men would have been terrified and bitter. But the will that Van Dyck made on that day shows otherwise. Despite being "weake in body," Van Dyck asked that "laude & praise be given to Allmightie God considering that there is nothing more certaine than death and nothing more uncertaine than the houre thereof." He went on to "commend my soule into the hands of Allmightie God my heavenly Father And my body to the earth to be Christianlike & Decently buryed in the Cathedrall Church of St. Paul in London.

"And soe cominge to the orderinge and disposinge of my temporall goods & estate which it hath pleased the Allmightie God to lend mee vpon earth. ..."[49]

The idea that one's possessions are lent is a Stoic one. It is, of course, entirely compatible with Christian principles such as stewardship. But put in this form, the idea is a Stoic formulation. Epictetus, one of the most famous and most rigorous of the later Stoics, said: "Never say of anything, 'I lost it,' but say 'I gave it back.' Has your child died? It was given back. Has your wife died? She was given back. Has your estate been taken from you? was this not given back? ..." And when a questioner asked how long he might be able to use Fortune's gifts, Epictetus replied: "Just as long as He who lent them wills."[50]

Five days after making his will, Van Dyck died. According to the poet Abraham Cowley, the painter met his end with tranquility, thereby passing the supreme Stoic test: "... Death moved not his generous mind."[51]

NOTES

1. Roger De Piles, *The Art of Painting and the Lives of the Painters ... Done from the French ...* (London, 1706), 304.
2. See Waterhouse 1953, 54; Ottawa 1980, 25; Waterhouse 1978, 82; London 1982–1983, 17; Brown 1982, 153; for opposing views see Lee 1963; Stewart 1981, 120–122; Stewart 1983, 57–68; J. Douglas Stewart, "Review of exhibition, Van Dyck in England," *Revue d'Art Canadienne/Canadian Art Review (RACAR)* 11 (1984), 159-161; Stewart 1986, 140-141;

J. Douglas Stewart in *Master Drawings from the National Gallery of Canada* [exh. cat. Vancouver Art Gallery] (Vancouver, 1988), 126–130; J. Douglas Stewart, "Rome, Venice, Mantua, London: Form and Meaning in the 'Solomonic' Column from Veronese to George Vertue," *Rome, Tradition, Innovation and Renewal. Proceedings of the June 1987 Canadian International Conference in Honour of Leonard Boyle and Richard Krautheimer* (forthcoming, 1991).
3. Stewart 1983, 57–68.

4. Glück 1932, 236; Lee 1963, 18; Held 1982, 81.
5. I am grateful to Ross Kilpatrick for this translation.
6. Richmond Lattimore, *Themes in Greek and Latin Epitaphs* (Urbana, 1942), 65, 90.
7. Hookham Carpenter 1844, 55–56 (the original letter is in Dutch; the translation is Carpenter's).
8. Stewart 1986, 141.
9. Stewart 1981, 121; London 1982–1983, 42–43.

10. London 1982–1983, 43–44; Stewart 1984, 161. Traditionally Buckingham, who certainly owned the picture, has been credited with its commission. But Arundel (who owned the classical relief depicted at the left of the painting) was a very learned, much-traveled man who in 1620 was thirty-five years old, when Buckingham, never noted for scholarship, was only twenty. For further commentary see Stewart 1991.

11. Cesare Ripa, *Iconologia* (1603), with an introduction by Erna Mandowsky (Hildesheim, 1970), 481; Helen F. North, *From Myth to Icon: Reflections of Greek Ethical Doctrine in Literature and Art* (Ithaca, 1979), 254–257.

12. Wark 1956.

13. J. Bruyn and J. A. Emmens, "The Sunflower Again," *Burlington Magazine* 99 (1957), 96–97.

14. J. Bruyn and J. A. Emmens, "De zonnebloem als embleem in een schilderijlijst," *Bulletin van het Rijksmuseum* 5 (1955), 3–9.

15. Wark 1956.

16. John Steegman, *A Survey of Portraits in Welsh Houses*, 2 vols. (Cardiff, 1957), 1:180.

17. Horace, *Q. Horati Flacci Epistvlae: The Epistles of Horace*, ed. Augustus S. Wilkins (London, 1886), 3. See also Ross S. Kilpatrick, *The Poetry of Friendship: Horace, Epistles* 1 (Edmonton, 1986), 2, 5, and 119, n. 3.

18. R. T. Petersson, *Sir Kenelm Digby: the Ornament of England 1603–1665* (Cambridge, 1956), 95, 106, 107, 337.

19. Vertue 1936, 38. This may be the Hawarden picture, or a version of it. See Vertue 1932, 107.

20. Vertue 1932, 107.

21. Charles Carlton, *Charles I: The Personal Monarch* (London, 1984), 157.

22. Bruyn and Emmens 1957, 26.

23. Bel+ Bellori 1976, 280.

24. London 1982–1983, 48-50.

25. Stewart 1984, 161. For the Rubens see *Rubens and the Book: Title Pages by Peter Paul Rubens*, ed. Julius S. Held [exh. cat. Williams College] (Williamstown 1977), 137–138, 255.

26. From pp. 17–18, 291, Guy de Tervarent, *Attributs et symboles dans l'art profane 1450–1600* (Geneva, 1958).

27. Stewart 1983, 61.

28. Matthew 10:16.

29. Julius S. Held, *Rubens and His Circle*, ed. Anne W. Lowenthal, Danid Rosand, and John Walsh, Jr. (Princeton, 1982), 84–85, and fig. VII.4.

30. London 1982–1983, 35.

31. London 1972, 47–48, with earlier references.

32. Stewart 1983, 60, n. 16.

33. Mirella Levi d'Ancona, *The Garden of the Renaissance: Botanical Symbolism in Italian Painting* (Florence, 1977), 250.

34. Tervarent 1958, 91.

35. Tervarent 1958, 106–107.

36. Blair Worden, "Constancy," Review of Gerhard Oestreich, *Neostoicism and the Modern State*, *London Review of Books* 5 (1983), 13.

37. Worden 1983, 13; Jason Lewis Saunders, *Justus Lipsius: The Philosophy of Renaissance Stoicism* (New York, 1955); W. Prinz, "The Four Philosophers by Rubens and the Pseudo-Seneca in Seventeenth-Century Painting," *Art Bulletin* 55 (1973), 410–428.

38. For the *adiaphora* see Marcia L. Colish, *The Stoic Tradition from Antiquity to the Early Middle Ages*, vol. 1, *Stoicism in Classical Latin Literature* (Leiden, 1985), 44, 48, 49.

39. Adriani 1940, 33v.

40. Anthony Blunt, *Nicolas Poussin*, 2 vols. (New York, 1967), 1:165.

41. The *Diogenes* does not appear in Francis Haskell and Nicholas Penny, *Taste and the Antique: The Lure of Classical

Sculpture 1500–1900* (New Haven, 1981), nor in Phyllis Pray Bober and Ruth Rubinstein, *Renaissance Artists & Antique Sculpture: A Handbook of Sources* (London, 1986).

42. Princeton 1979, 118.

43. Irving Lavin, "Divine Inspiration in Caravaggio's Two St. Matthews," *Art Bulletin* 56 (1974), 70–72.

44. Epictetus, *The Discourses and Manual*, ed. and trans. P. E. Matheson, 2 vols. (Oxford, 1916), 2:240, n. 4; Seneca, *Letters from a Stoic: Epistulae Morales ad Lucilium*, ed. Robin Campbell (Harmondsworth, 1969), 190, 192.

45. Bellori 1976, 280.

46. Colish 1985, 209.

47. *Sapientiae Libertas*, engraving from Otto van Veen, *Q. Horatii Flacci Emblemata* (1607). For commentary on the Horatian emblem see Maren-Sofie Røstvig, *The Happy Man: Studies in the Metamorphoses of a Classical Ideal*, vol. 1, 1600–1700, 2d ed. (Oslo, 1962), 16–18.

48. London 1982–1983, 35.

49. Hookham Carpenter 1844, 75–77.

50. Epictetus 1916, 1:129, 2:217. It is significant that Isabel Rivers, in her *Classical and Christian Ideas in English Renaissance Poetry* ... , under the section on Stoic ideas, cites part of the Epictetus passage on "lending"; (London 1979), 51.

51. "On the Death of Sir Anthony Vandike, The Famous Painter" (from Anthony Cowley, *Miscellanies*, 1656) in Abraham Cowley, *The Complete Works in Verse and Prose*, ed. A. B. Grossart, 2 vols. (New York, 1967), 1:138. The poet seems to have known the Van Dyck family. It is not known whether the Catherina Cowley whom Van Dyck made a guardian of his daughter Justiniana in his will was any relative of the poet's, for he had a sister Katherine. See Arthur H. Nethercot, *Abraham Cowley: The Muse's Hannibal* (New York, 1931), 67–68.

Chronology

ANTWERP
22 March 1599
Anthony van Dyck, the seventh child of the wealthy merchant Frans van Dyck and of Maria Cuypers, is born in the house "Den Berendans" on the Grote Markt near the cathedral of Antwerp. Several of his sisters will follow a religious calling: Susanna, Cornelia, and Isabella become Béguines and Anna an Augustinian nun. His younger brother Theodoor, called Waltman, will become a Norbertine canon at Saint Michael's Abbey and later a priest at Minderhout.

16 March 1607
Death of Maria Cuypers, who was well known for the beauty of her embroidery.

October 1609
Is registered with the Saint Luke's Guild as the apprentice (leerjonger) of Hendrik van Balen.

1613
Paints An Elderly Man [cat. 1].

3 December 1616 and 13 September 1617
Although still a minor, pursues legal proceedings on behalf of himself and his siblings to receive partial payment of the estate left by their grandmother.

11 February 1618
Registered as a master of the Saint Luke's Guild in Antwerp.

15 February 1618
With his father's consent, is declared to be of age by the tribunal (Vierschaar).

12 May 1618
Rubens writes Sir Dudley Carleton that the cartoons for the Decius Mus tapestry series are in Brussels to be woven. According to a 1661 document, Van Dyck executed the painted models for the cartoons.

1618
Paints several portraits including Portrait of a Man [cat. 4] and Portrait of a Woman [cat. 5].

29 March 1620
Rubens enters into an agreement with the Jesuit order in Antwerp that he will design thirty-nine ceiling paintings to be executed by Van Dyck and some of his other assistants for the new Jesuit church. The same agreement stipulates that Van Dyck may make a painting for one of the four side altars at a later time.

1620 or 1621
Van Dyck lives and works in a house called the "Dom van Keulen" in the Lange Minderbroederstraat, where he engages Herman Servaes and Justus van Egmont as assistants to make copies of his Apostles [cats. 19, 20].

17 July 1620
A letter to the earl of Arundel from Francesco Vercellini, who is visiting Antwerp with the countess of Arundel, relates that Van Dyck is still working with Rubens, that his work is almost as highly appreciated as Rubens', and that he will probably not want to leave Antwerp.

LONDON
20 October 1620
Thomas Locke writes William Trumbull from London: "Van Dyke is newly come to towne. ... I am tould my Lo: of Purbeck sent for him hither."[1]

25 November 1620
Toby Matthew writes Sir Dudley Carleton that King James I has given Van Dyck an annual stipend of £100, and that Van Dyck is living with George Geldorp.

16 February 1621
Receives payment of £100 "by way of reward for speciall service by him pformed for his Matie," James I.

ANTWERP
28 February 1621
Receives a travel pass and permit, signed by the earl of Arundel, for eight months' duration. Returns to Antwerp.

ITALY
October 1621
Leaves for Italy. Arrives in Genoa, at the house of Cornelis de Wael, probably by late November.

February–August 1622
In Rome. Paints Sir Robert Shirley [cat. 28] and Teresia, Lady Shirley [cat. 29] during their Roman stay between 22 July and 29 August. Fills his sketchbook with drawings from life and from works he admires in churches and collections.

August–October 1622
In Venice. Paints Lucas van Uffel [cat. 31], and probably meets the countess of Arundel. Visits collections there and in Padua.

October 1622–early 1623
Perhaps accompanies the countess of Arundel to Turin, and to Mantua and Milan en route. Also probably stops in Genoa, Florence, and Bologna before returning to Rome.

1 December 1622
Van Dyck's father dies in Antwerp.

1623
Paints Filippo Cattaneo [cat. 34] and Clelia Cattaneo [cat. 35] in Genoa.

March–October/November 1623
In Rome. Then, or on the previous visit, paints Cardinal Guido Bentivoglio (Pitti Palace, Florence). Meets Sir Kenelm Digby, the "English Resident" in Rome.

Fall 1623–Spring 1624
Probably in Genoa.

Spring–September 1624
In Palermo. Toward the middle of May, the plague strikes and the city is soon under quarantine. With discovery of her purported remains on Monte Pellegrino, Saint Rosalie's cult expands significantly, and Van Dyck receives commissions to represent her has an intercessor against the plague. He paints the Viceroy, Emmanuel Philiberto [cat. 38], who dies on 3 August 1624. On 12 July, Van Dyck visits the aged court painter Sofonisba Anguissola. Makes a drawing of her in his sketchbook along with notes of their conversation. Receives the commission for a major

altarpiece, the *Madonna of the Rosary* (Oratorio del Rosario, Palermo), and begins the painting but does not complete it before leaving Sicily.

Fall 1624–July 1625
Presumably in Genoa.

July 1625
Reputedly travels to Marseilles and Aix-en-Provence to visit Peiresc, whose portrait appears in the *Iconography*. Returns to Genoa at an unknown date.

12 December 1625
His brothers and sisters declare to the magistrate in Antwerp that he is abroad, as his brother-in-law had done on 27 November 1624.

ANTWERP
Autumn 1627 (?)
Returns to Antwerp, where his sister Cornelia dies on 18 September. He paints *Peeter Stevens* [cat. 45].

18 December 1627
Payment is made in Genoa by Giovanni Francesco Brignole to "Antonio fiamengo" for portraits of his son *Anton Giulio Brignole-Sale*, *Paola Adorno*, Anton Giulio's wife, and *Geronima Sale with Maria Aurelia Brignole-Sale*, Giovanni Francesco's wife and daughter. The paintings are all in the Palazzo Rosso, Genoa.

Spring 1628
In Antwerp paints *Anna Wake* [cat. 44] and *Saint Augustine in Ecstasy* [cat. 46].

6 March 1628
Makes his will in Brussels.

8 April 1628
The Confraternity of the Rosary in Palermo makes payment for the *Madonna of the Rosary*, "novamente fatto nella città di Genova," to Van Dyck's representative, Antonio della Torre.

27 May 1628
The earl of Carlisle writes from Brussels to the duke of Buckingham that he had not met Rubens at his home in Antwerp, but had met him the following day at "Monsr Van-digs."

1628
Van Dyck becomes a member of the Jesuit Confraternity of Bachelors "Sodaliteit van de bejaerde Jongmans" in Antwerp. For this confraternity he paints the *Virgin and Child with Saints Rosalie, Peter, and Paul* in 1629 and the *Mystic Vision of Herman-Joseph* in 1630 (both Kunsthistorisches Museum, Vienna).

December 1628
Receives a gold chain, worth 750 guilders, for a portrait of the Infanta Isabella.

5 July 1629
Writes Endymion Porter that his painting *Rinaldo and Armida* [cat. 54] for King Charles I had been handed over to his agent and that he had received £72 for it.

20 March 1630
The city of Antwerp issues a loan of 100,000 guilders; Van Dyck subscribes for 4,800 guilders.

27 May 1630
Van Dyck calls himself painter of Her Majesty ("schilder van Heure Hoocheyd", the Infanta Isabella) in a proxy for Pieter Snayers. He receives an annual salary of 250 guilders as painter to the court at Brussels, although he continues to live in Antwerp.

December 1630
Antwerp restorer J.-B. Bruno mentions Van Dyck's exquisite collection.

10 May 1631
Named godfather for Antonia, daughter of the engraver Lucas Vorsterman.

4 September–16 October 1631
The Queen Mother Maria de' Medici is in Antwerp, with her son Gaston, duke of Orleans. Van Dyck paints their portraits. In his travel record, J. P. de la Serre, secretary to the queen mother, notes his admiration for "le Cabinet de Titien" of Van Dyck.

16 December 1631
Balthasar Gerbier sends Lord Weston a *Virgin with Saint Catherine* by Van Dyck as a New Year's gift for Charles I. In a letter to George Geldorp in London, Van Dyck declares this work to be a copy. Gerbier writes to King Charles I on 13 March 1632 that Rubens considers the painting an original and that the seller, Noveliers, confirms this with a notarial certificate. Gerbier mentions that Van Dyck is in Brussels and is planning to travel to England.

Winter 1631–1632
Van Dyck travels from Flanders to the Netherlands. He works in The Hague at the court of Frederik Hendrik and Amalia van Solms, prince and princess of Orange, and at the court of Frederick of the Palatinate and his wife Elizabeth Stuart, the so-called "Winter King" and "Winter Queen." On 28 January 1632 Van Dyck paints the portrait of Constantijn Huygens, who writes in his diary, "Pingor a Van Dyckio. ..." Huygens writes three mottos for Van Dyck's *Iconography*.

LONDON
1 April 1632
Van Dyck is in London. Edward Norgate, brother-in-law of Nicholas Lanier, receives from this day 15 s. per day "for the dyett and lodging" of Van Dyck, who temporarily lives with him (according to Privy Seal Warrant, 21 May 1632). Van Dyck moves soon after to Blackfriars on the outskirts of London, beyond the jurisdiction of the Painter-Stainers' Company. He also stays at the royal summer residence at Eltham/Kent.

5 July 1632
Van Dyck is knighted and made "principalle Paynter in ordinary to their Majesties."

8 August 1632
Receives payment of £280 for ten commissions from Charles I.

1632
Paints *King Charles I and Queen Henrietta Maria* [cat. 62] and *Philip, Lord Wharton* [cat. 63].

20 April 1633
Receives a gold chain and a medal worth £110.

7 May 1633
Receives payment of £444 for nine portraits of Charles I and Henrietta Maria.

26 August 1633
Henrietta Maria tries to place Theodoor van Dyck, Anthony's brother, a Norbertine friar, as court chaplain in her service. Theodoor presumably comes to London, but stays only for a little while; on 14 March 1634 he is back in Flanders.

17 October 1633
Van Dyck is promised £200 as an annual salary.

1 December 1633
The Infanta Isabella dies in Brussels. Prince Thomas-Francis of Savoy-Carignan [cats. 71, 97] is named temporary governor.

Winter 1634
Van Dyck travels to Flanders.

28 March 1634
Acquires an interest in the estate Steen in Elewijt, the property that Rubens will buy in May 1635.

14 April 1634
Authorizes his sister in Brussels to administer his goods.

18 October 1634
Receives the highest honor that could be bestowed by the Saint Luke's Guild in Antwerp: he is elected Dean of the Guild *honoris causa* and his name is inscribed in capital letters in the list of members. Only Rubens had previously received this honor.

4 November 1634
Cardinal-Infante Ferdinand makes his entrance in Brussels as governor-general. Van Dyck paints his portrait (Prado, Madrid), which is mentioned on 16 December 1634 as "recently painted."

16 December 1634
Van Dyck stays in Brussels in the house "In 't Paradijs," behind the town hall.

1634
Paints *Cesare Alessandro Scaglia* [cat. 70], *Jacomo de Cachiopin* [cat. 69], *Princess Henrietta of Lorraine* [cat. 72], *Prince Thomas-Francis of Savoy-Carignan on Horseback* [cat. 71].

Spring 1635
Is again in London. In Blackfriars a road and a dock are made to establish a connection from his house to the Thames for King Charles I's visits to his studio in June and July.

1635
Paints *Three Eldest Children of Charles I* [cat. 74], *Charles I in Three Positions* [cat. 75].

14 August 1636
Requests Franciscus Junius, librarian for the earl of Arundel, for an appropriate inscription for the portrait of Kenelm Digby in the *Iconography* and highly praises Junius' new book *De pictura veterum*.

February 1637
The duke of Newcastle writes Van Dyck an appreciative letter in stylized and rhetorical terms.

23 February 1637
Receives payment of £1,200 from Charles I "for Certaine pictures by him delivered for our use."

1638
Paints *Thomas Killigrew and William, Lord Crofts* [cat. 84], oil sketch of *Charles I and the Knights of the Garter in Procession* [cat. 102] for Whitehall.

end of 1638 (?)
Lists in a memorandum to Charles I prices for 25 paintings for which he is unpaid and five years of arrears payments for his annual pension. On 14 December 1638 he receives the first payment of £1,603 and on 25 February 1639 a second payment of £305. The value of 14 paintings listed was reduced by the king.

1639
Marries Mary Ruthven, a noble lady-in-waiting for the queen.

26 June 1639
In a letter, Henrietta Maria requests a portrait bust of herself from Bernini, in the manner of the one he sculpted of Charles I. She promises to send him paintings by Van Dyck as models.

early 1640
The countess of Sussex writes Ralph Verney that Van Dyck wants to leave London.

30 May 1640
Rubens dies in Antwerp.

13 September 1640
The earl of Arundel obtains a passport for Van Dyck and his wife to visit the Continent.

23 September 1640
Cardinal-Infante Ferdinand writes Philip IV from Ghent that Van Dyck is expected on 18 October 1640 at the Saint Luke's celebration of the guild in Antwerp.

10 November 1640
Ferdinand writes Philip IV from Brussels that Van Dyck does not want to finish Rubens' unfinished paintings for the Torre de la Parada. He is, however, prepared to accept a new commission.

December 1640 (?)
In Paris tries to procure the commission for history paintings to decorate the Grande Galerie of the Louvre; Poussin, however, receives the commission and is summoned from Italy by King Louis XIII. Van Dyck returns to London.

19 March 1641
Charles I is forced to leave London for York. Henrietta Maria takes up residence in Paris with her brother, King Louis XIII.

12 May 1641
Marriage of Princess Mary with Willem II of Orange in London. Van Dyck may have painted the wedding portrait (Rijksmuseum, Amsterdam).

13 August 1641
The countess of Roxburghe writes from Richmond to Count Johan Wolfert van Brederode in The Hague that Van Dyck has been ill for a long time, but is now recovered. Within 10 to 12 days, she writes, he will travel to the Continent via Holland and will bring the promised painting.

October 1641
Van Dyck is in Antwerp.

16 November 1641
Sojourns in Paris. He is so ill that he has to postpone painting the portrait of "Monseigneur le Cardinal" (Richelieu or Mazarin). He requests a passport for travel to England.

1 December 1641
Daughter Justiniana is born.

4 December 1641
Makes another will.

9 December 1641
Van Dyck dies in Blackfriars and is buried on 11 December 1641 in the choir of Saint Paul's Cathedral, London. His tomb and his remains perish in the great fire of London in 1666.

NOTES

This chronology is based on one published in Antwerp 1960, 13–21.

1. We are very grateful to David Howarth for sharing this new document in advance of his publication of it. See cat. 17, n. 3.

Catalogue

1
An Elderly Man

1613
inscribed *Aetatis.Sue. 70 . Anno .*
1613.AVD.F.Aeta.Sue.14
canvas, 63 x 43.5 (23 x 17³/₈)

Musées Royaux des Beaux-Arts de
Belgique, Brussels, inv. no. 6858

PROVENANCE Joseph Antoine Borgnis,
Paris; his sale, 1804; Georges Cain, Paris;
Kleinberger, Paris; Charles Léon Cardon,
Brussels, by 1910; purchased in his sale,
1921, by S. Del Monte; acquired from his
sale, Sotheby's, London, 24 June 1959, lot
37, by the Musées Royaux

EXHIBITIONS Brussels, *Trésors de l'Art
Belge*, 1910; Vienna, *Drei Jahrhunderte
flämische Kunst*, 1930, no. 96

LITERATURE Van den Branden 1883, 696;
Rooses 1907, 1; *Trésors de l'Art Belge* 1
(1912), 142, ill. LXI; Rosenbaum 1928a, 5;
Gustav Glück, *La Collection del Monte*
(Vienna, 1928), 9, ill. VII; A. L. Mayer,
"Die Sammlung Del Monte in Brüssel,"
Pantheon 4 (1929), 442; Glück 1931, 75 ill.
527; "Nouvelles Acquisitions 1959,"
Bulletin Musées Royaux des Beaux-Arts 8
(Sept. 1959), 172, ill.; Müller Hofstede
1987–1988, 143, ills. 14, 16

It is fairly common to find inscriptions on Netherlandish and Italian portraits that
provide the information seen here, namely the date of the painting, the age of the
sitter, and the artist's initials—in this case, the interlocked monogram that Van Dyck
used later on his *Drunken Silenus* [cat. 12]. This inscription is remarkable, however, in
that the artist proudly included his own age as well, and that his age was a
precocious fourteen years. This portrait of an elderly man, probably Van Dyck's
earliest painting and surely the first dated one, was painted a mere four years after
Van Dyck had been apprenticed to Hendrik van Balen, dean of the painters' guild, in
1609. If the present painting does not show the direct influence of Van Balen's own
style, it displays, in the dry-brushed application of white paint, a sensitivity to
sixteenth-century Venetian painting that Van Balen may have given his young pupil.
Like many ambitious Netherlandish painters, Van Balen had studied in Italy, and he
was active in the Antwerp association of "Romanist" painters who elected him their
dean in the very year Van Dyck's portrait was made. On the other hand, Van Dyck
could also have gained the exposure to Venetian painting from Rubens himself,
whose studio he probably had joined in some capacity by about this time.

Also from this period, though undated, Van Dyck's first *Self-Portrait* [fig. 1] is far
more revealing of his gifts and his interests than this competent, conventional
likeness. There, both form and *facture* convey the impression of a highly original,
ambitious young talent. His sharply turned pose in bust-length is unusual in its
informality as well as in the tension and spontaneity it suggests. Also remarkable
when compared with other paintings of his time, but exemplary of Van Dyck's own
love of his medium, is the energy and daring with which he worked paint, pulling his
brush through thick, drying areas of impasto to create a rich, vibrant surface.

In 1926 Ludwig Burchard found a copy of the present painting in Milan; its
whereabouts are unknown today.

S. J. B.

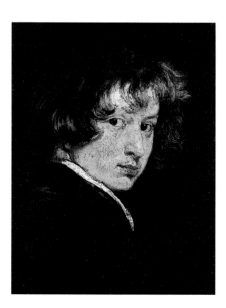

Fig. 1. Anthony van Dyck, *Self-Portrait*,
1613, canvas, 25.8 x 19.5 (10¹/₈ x 7⁵/₈).
Gemäldegalerie der Akademie der
bildenden Künste, Vienna

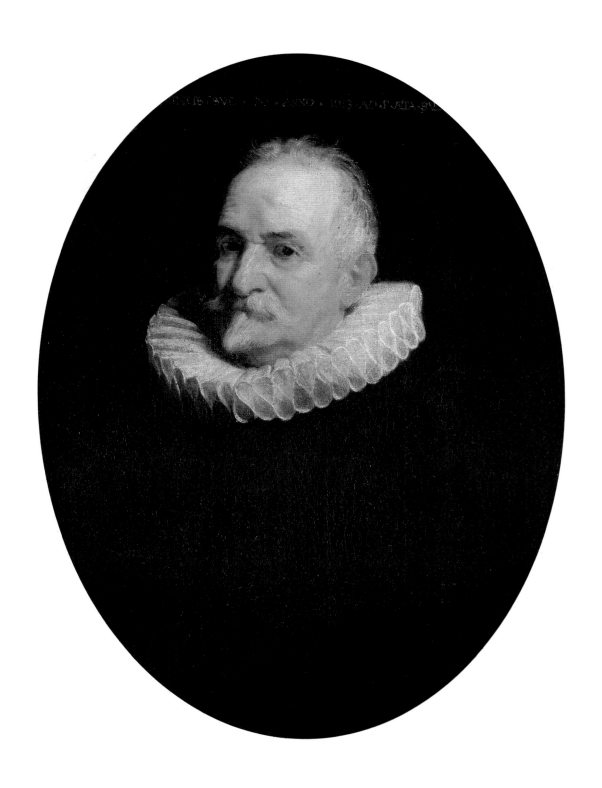

81

2
Saint Jerome

1615
canvas, 157.5 x 131 (62⅝ x 52)

Collections of the Prince of Liechtenstein, Vaduz Castle, inv. no. 56

PROVENANCE Acquired in 1701 by Prince Johann Dam from the dealer Marcus Forchoudt

EXHIBITIONS Lucerne 1948, no. 123; New York 1985–1986, no. 195, pl.

LITERATURE Liechtenstein 1780, 211–212 no. 648; Waagen 1866, 1:273; Guiffrey 1882, 251 no. 195C; Cust 1900, 13, 233 (as repetition of no. 13, Prado); Bode 1906, 262; Schaeffer 1909, 31 ill.; Rosenbaum 1928a, 46; J. Denucé 1931, 248–249, 252; Glück 1931, XXVII, 9 ill., 518; Glück 1933, 282, ill. 158; Van Puyvelde 1941, 182; Liechtenstein 1980, 157–158 no. 61, pl. 61; Ottawa 1980, 267, 295 ill. 63

1. On Rubens' versions see Hans Vlieghe, *Corpus Rubenianum Ludwig Burchard*, part 8, Saints 2 (London, 1973), nos. 120–121.
2. See Denucé 1932, 66, 156, 160–161, 164, 170, 357.

Fig. 1. Peter Paul Rubens, *Saint Jerome in the Wilderness*, 1613–1615, canvas, 236 x 163 (92⅞ x 64⅛). Gemäldegalerie, Dresden

Seated at the edge of a grotto, the grizzled, weatherbeaten Saint Jerome intently pens his Latin translation of the Scriptures. His back is rounded from the habitual posture of his scholarly pursuit and from age, which also marks the flesh that sags around his waist and furrows his brow. At his feet lie the books from which he is compiling the Vulgate and a sleeping lion whose faithful, docile companionship Jerome earned by removing a thorn from the animal's paw.

This first surviving large-scale religious painting of Van Dyck's œuvre typifies his youthful working method in one crucial respect: it shows him already intimately acquainted with and indebted to specific works in Rubens' studio, and at the same time to be aggressively seeking his own path, in competition with and reaction against those works. Van Dyck made three quite different known full-length interpretations of the theme of Saint Jerome between about 1615 and 1618. Although this painting depicts him as a scholar and the final one in Dresden [cat. 8] shows him penitent, both are set in the wilderness. Both refer clearly to Rubens' *Saint Jerome in the Wilderness* of c. 1613–1615 [fig. 1], and to Titian's *Saint Jerome* from Santa Maria Nuova, Venice (now Brera, Milan), which Van Dyck knew through Rubens' drawn copy, preserved today in studio replicas such as cat. 8, fig. 1. Van Dyck's second *Saint Jerome* (Museum Boymans-van Beuningen, Rotterdam; another version in Stockholm), which shows the saint seated frontally, writing, and accompanied by an angel, instead is based loosely on Rubens' earlier *Saint Jerome in His Study* of c. 1609–1610.[1]

Just as Rubens had looked to Titian as a model, so Van Dyck looked to Rubens. The adolescent painter followed his master in several respects, depicting shallow space framed with rocks and vegetation: the saint is in profile, simply draped in red, and the great golden head of the sleeping lion lies on the bare ground. His differences from Rubens are both striking and telling. As Baumstark pointed out, Van Dyck's iconography was innovative. By depicting Jerome writing outdoors rather than in his study, he blended the traditions of Jerome as scholar and Jerome penitent in the wilderness. Van Dyck also chose a very different physical type for his model and, one may say, a radically different technique. Although Rubens' Jerome is depicted with scrupulous attention to the details of skin, hair, and posture that convey his age, he is nonetheless a heroically muscular, ideal type. As such he represents the blending of naturalism and idealism, a principle and practice Rubens had adopted from the Carracci reform of painting. Van Dyck's *Jerome*, however, displays a complete rejection of the ideal in favor of a wildly exaggerated naturalism. This style, which Glück dubbed Van Dyck's "rough style," is seen in its vintage form here and in the Louvre *Saint Sebastian* [see cat. 3, fig. 1] and, already softened, in *The Martyrdom of Saint Peter* [cat. 3]. The three paintings have in common a simple palette of primary colors, a harsh clarity of light, and certain awkwardnesses of form and spatial relations that can be attributed to their direct, experimental means of creation as well as to the artist's inexperience. Most critics have linked these pictures to Caravaggism, and indeed they do share with that movement the use of very coarse physical types and an unflinching depiction of the ugly and the ravaged. Van Dyck's Saint Jerome even shows the contrast between the pale flesh of his back and the redness and wrinkles of face and hands more frequently exposed to the sun, which Caravaggio and his followers used with shocking effect to remind viewers that their models were common laborers.

What sets Van Dyck's *Saint Jerome* apart from all its sources is the technique, a reckless directness in composition and a violent expressionism in the application of paint, which contrasts most completely with the even, meticulous craftsmanship of Rubens' *facture*. While Van Dyck thinly if hastily washed oil paint in glazes over the light gray-beige priming coat in areas such as the lion's head, the cave at right, and the vegetation at left, he jabbed, slashed, and slathered it on thickly in others, such as the landscape vista, the saint's torso, and especially his head, hands, and arms. Not coincidentally, the latter areas, where the impasto is most pronounced, correspond to

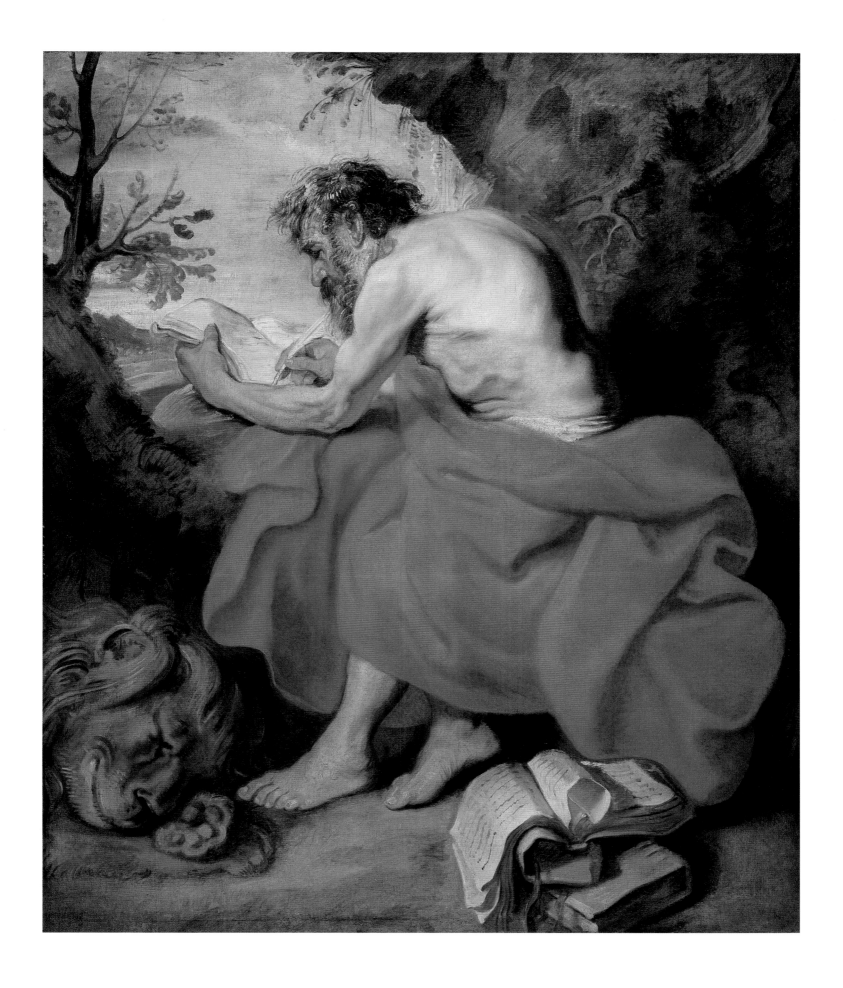

the emotional center of the picture—Saint Jerome's head and his work, which are also framed by the cave at right and tree at left. As Van Dyck matured he would employ again, as he did here, the animation of the painted surface to lead the eye to an area of importance, to enhance the meaning of his work. Later, however, he also conveyed those points through other elements in the compositional design, such as pose, glance, and gesture.

Van Dyck's working procedure in these first religious paintings is uncertain. Their apparent directness suggests a lack of preparatory studies, and indeed none specifically related to this *Saint Jerome*, the Louvre *Saint Sebastian*, or *The Martyrdom of Saint Peter* is known to survive. The feeling of simple spontaneity may be deceptive, however, as it is in the Minneapolis *Betrayal of Christ* [cat. 13] a few years later, whose rash, sketchy appearance belies numerous compositional drawings.

The daring directness and raw painterly power of Van Dyck's short-lived "rough style" had apparently no precedent in large-scale painting in Antwerp; the comparison that has been sought in Rubens' technique in oil sketches does not stand up to scrutiny. Subsequent full-size works that display the same approach, though in a hand tamed by maturity, are preparatory in nature, however, and include Van Dyck's twin *Head Studies* (Rockoxhuis, Antwerp) and some of his passages in the *Decius Mus* tapestry cartoons, such as Decius' own head in *Decius Mus Relating His Dreams* [see Wheelock, fig. 2]. Van Dyck's "rough style" also had a strong influence on the head studies of his colleague Jacob Jordaens a couple of years later.

The tempestuous boldness of *Saint Jerome* and its awkwardnesses have led most scholars to place it rightly at the very beginning of Van Dyck's activity. That date is usually set at 1616, though for no particular reason. Knowing Van Dyck's dated portrait of 1613 and the contemporary *Self-Portrait* in the Vienna Akademie, we can agree with Van Puyvelde's suggestion that this date be pushed back to 1615. A work painted so far in advance of Van Dyck's acceptance as a master in the guild should not have been made on commission. Like most of his early religious paintings, this must have been painted for himself and for an eventual private sale. Seventeenth-century documents suggest that *Saint Jerome* would have been a good subject for the open market. Frans Francken's painting of the picture gallery of Nicholas Rockox (Schleissheim Palace, Munich) shows a sixteenth-century *Saint Jerome in His Study* on the wall beneath a row of ancient marble busts. We know from Rubens' estate inventory that he possessed three of Van Dyck's *Saint Jerome*s. One of these probably ended up in Dresden [cat. 8]. Another went to Philip IV and eventually to Rotterdam. A decade later, there were six—three originals and three copies—listed in the 1653 inventory of Jeremias Wildens. At the end of the century, in 1691, Jan-Baptista Anthoine also had three of Van Dyck's *Saint Jerome*s.[2] The present picture, purchased in Antwerp in 1701 by Prince Johann Adam von Liechtenstein, might have come from any or all of these collections.

S. J. B.

3
The Martyrdom of Saint Peter

c. 1616
canvas, 204 x 117 (79½ x 45⅝)

Musées Royaux des Beaux-Arts de
Belgique, Brussels, inv. no. 215

PROVENANCE Probably identical with the
Saint Peter in the inventory of Jan Gillis,
Antwerp, 28–30 July 1682; sale H. J. Stier
d'Aertselaer, Antwerp, 29 July 1822, lot
10; bought by Rottiers; acquired from
Colonel Rottiers in 1830

EXHIBITIONS Antwerp 1899, no. 30; Ant-
werp 1949, no. 9; Genoa 1955, no. 9, ill.

LITERATURE Smith 1829–1842, 3:14, no.
38; Fromentin 1876, 138; Guiffrey 1882,
251 no. 207; Hymans 1899a, 235;
Hymans 1899b, 419; Cust 1900, 45, 210
no. 30, 240 no. 41; Schaeffer 1909, 27 ill.;
Rosenbaum 1928a, 46–47; Glück 1931,
XXVII, 7 ill., 518; Denucé 1932, 310; Glück
1933, 282–284; Van Puyvelde 1941, 182;
Van Puyvelde 1950, 123; Vey 1962, 92
(text vol.); Koninklijke Musea 1984, 96
no. 215 ill.

1. With due respect to Martin 1981, 393,
who has pushed the dating of the Louvre
Saint Sebastian toward 1617–1618 instead.
2. Glück 1933, 281–284. Others he in-
cludes in this group are: The Lamentation
(Glück 1931, 8), Samson and Delilah [cat.
11], Christ Carrying the Cross (Glück 1931,
11), and The Entry of Christ into Jerusalem
(Glück 1931, 55).
3. Walter Friedländer, Caravaggio Studies
(Princeton, 1955), 63; see Hans Vlieghe,
Corpus Rubenianum Ludwig Burchard, part
8, Saints 2 (London, 1973), no. 39.

This large, strong-colored canvas attests that Van Dyck's keen attention to Italian painting and his synthesis of influences as diverse as Titian's and Caravaggio's were characteristic from his very debut in history painting. Beneath the discolored varnish that partly obscures it, the intense cerulean blue, the signature color of Titian's middle years, forcefully frames the action of the story. We find the same simple bright palette and the same heavily worked surface in Van Dyck's *Martyrdom of Saint Sebastian* in the Louvre [fig. 1] and the slightly earlier *Saint Jerome* [cat. 2]. These three paintings, which may well predate the year 1616 to which they are usually assigned, are the earliest surviving large-scale religious subjects by Van Dyck.[1] Glück grouped them as works from Van Dyck's "rough" or "awkward" style.[2] The terms connote both their conscious naturalism and the fledgling artist's sometimes clumsy attempts at plausibly relating the human figure to others and to a setting. Nevertheless, all of these remarkable paintings bespeak Van Dyck's unbridled ambition at age sixteen, his formidable courage and originality, and his ability to create images of strong design, emotional power, and striking material presence.

Fromentin saw links between the early work of Jacob Jordaens and *The Martyrdom of Saint Peter*, which he termed "du Jordaens délicat et presque poétique." Jordaens, six years Van Dyck's senior, became a master of the Guild of Saint Luke, Antwerp, in 1615. Van Dyck's strong naturalism, his choice of coarse, old models whose aged, sagging flesh is rendered with thick, slashing strokes, does share characteristics with certain contemporary oil sketches by Jordaens, but the priority of influence is not clear. Jordaens' *Studies of a Man's Left Arm and Right Hand* (Fitzwilliam, Cambridge), for instance, are quite close to the technique seen here in Saint Peter's left arm. Jordaens' early finished paintings, however, have the smooth, enamellike surfaces we associate with Rubens' of the time, not the overtly roughhewn character of Van Dyck's.

Glück tied Van Dyck's early naturalism in general to northern Caravaggism, and it now is possible to identify a specific Caravaggist source for the present painting. The unattributed *Crucifixion of Saint Peter* in Leningrad, which Friedländer thought might be a copy of Caravaggio's lost first version of the subject, was recognized by Waagen as having inspired Rubens' painting of the 1630s for the church of Saint Peter, Cologne.[3] Some twenty years earlier it had most certainly also served Van Dyck, as the striking similarity between the models of the saint demonstrates conclusively.

A page of black chalk drawings for the hands of Saint Peter and the beadle at right was sold from the Oppenheimer collection by Christie's in 1936. Vey pointed out that two pen and wash compositional studies of the subject may relate distantly to this painting, but are really very dependent on Rubens' *Elevation of the Cross* in the Antwerp Cathedral.

S. J. B.

Fig. 1. Anthony van Dyck, *Saint Sebastian*,
c. 1615, canvas, 144 x 117 (56¾ x 46).
Musée du Louvre, Paris

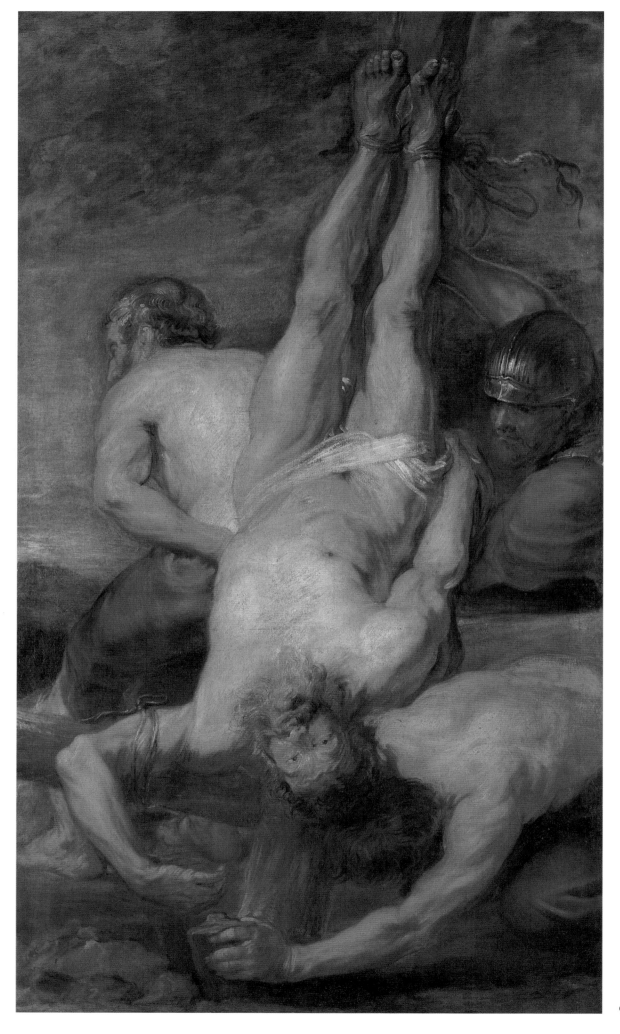

4·5
Portrait of a Man
Portrait of a Woman

Portrait of a Man, 1618
inscribed *A⁰ 1618. Aet. 57*
panel, 105.8 x 73.5 (41 1/4 x 28 5/8)

Collections of the Prince of Liechtenstein,
Vaduz Castle, inv. no. 70

PROVENANCE Acquired before 1712

EXHIBITIONS Lucerne 1948, no. 127;
Vaduz, *Flämische Malerei im 17.
Jahrhundert*, 1955

LITERATURE Liechtenstein 1780, 212
no. 649; Liechtenstein 1885, no. 70 (as
Rubens); Max Rooses, *Rubens' Leben und
Werke* (Stuttgart, 1890), 317 (as Rubens);
Liechtenstein 1896, 42–43; Bode 1906, 268
(as Van Dyck); Schaeffer 1909, 131 ill.;
Rosenbaum 1928a, 15–17; Rosenbaum
1928b, 332; Glück 1931, 81 ill., 528;
Baldass 1957, 253, ill. 2, 256–257, 259–260;
Ottawa 1980, 116; Schinzel 1980, 114–115,
130–131; London 1982–1983, 11 ill. 1;
New York 1985–1986, 309; Müller
Hofstede 1987–1988, 135–136, ill. 6

Portrait of a Woman, 1618
inscribed *A⁰ 1618. Aet. 58*
panel, 104.5 x 75.6 (41 x 29 1/2)

Collections of the Prince of Liechtenstein,
Vaduz Castle, inv. no. 71

PROVENANCE Acquired before 1712

EXHIBITIONS Lucerne 1948, no. 120;
Vaduz, *Flämische Malerei im 17.
Jahrhundert*, 1955; New York 1985–1986,
no. 196, ill.

LITERATURE Liechtenstein 1780, 217
no. 662; Liechtenstein 1885, no. 71 (as
Rubens); Max Rooses, *Rubens' Leben und
Werke* (Stuttgart, 1890), 317 (as Rubens);
Liechtenstein 1896, 42–43; Bode 1906, 268
(as Van Dyck); Schaeffer 1909, 131 ill.;
Rosenbaum 1928a, 15–17; Rosenbaum
1928b, 332; Glück 1931, 81 ill., 528;
Baldass 1957, 253, ill. 3, 256–257, 259–260,
ill. 2; Ottawa 1980, 7, 116, 270 ill. 2;
Schinzel 1980, 114–115, 130–131

1. In New York 1985–1986, 309.

Upon Van Dyck's registration as a master in the Antwerp Guild of Saint Luke on 11 February 1618, he was entitled to pursue his career as an independent artist working on commission. This could explain the sudden burst in 1618 of his activity as a portraitist, which had apparently lapsed following his precocious debut at age fourteen [cat. 1]. Although he had been active making history paintings for himself before 1618 while working in Rubens' studio, none of his portraits can be surely ascribed to the years between 1613 and 1618. This hiatus notwithstanding, Van Dyck's intense interest in individuals gave him a natural bent for portraiture, which he actively followed henceforth and which, of course, would become the field of his greatest renown.

This unnamed pair, along with another pendant pair in Dresden, is dated 1618. These four paintings form the nucleus of a group that can be assigned to that year, which includes also *An Elderly Man* [cat. 6], *Portrait of a Man* (The Metropolitan Museum of Art, New York), and *A Flemish Lady* (National Gallery of Art, Washington, Andrew Mellon Collection). In 1618 Van Dyck's activity as an assistant in Rubens' studio was also at its peak, and the master's influence on these first portraits was strong. Van Dyck followed Rubens' Flemish portraits, adopting the format developed by their countryman Anthonis Mor, who had been Europe's most prominent and influential portraitist in the later sixteenth century. The sitters are shown at about three-quarter length, standing against a dark, undifferentiated background, with their bodies turned at a slight angle to the viewer. In addition to their formal similarities, Van Dyck's early portraits bear such technical resemblance to Rubens' likenesses of the early 1610s that the authorship of some works, such as *Jean de Cordes* and *Jacqueline van Caestre* (Musées Royaux des Beaux-Arts de Belgique, Brussels), is still debated. Although the present pair along with cat. 6 were rightly given to Van Dyck by Bode in 1896, they share with Rubens' portraits their wooden support and the very manner in which the paint is applied. Emulating Rubens' own technique in this brief period, which Rosenbaum termed Van Dyck's "plastic style," Van Dyck modeled the flesh by juxtaposing many fine strokes of unblended color on top of a creamy flesh-colored layer. While the small, thick touches of red, cream, and black do give depth and volume to his sitters' faces and hands, Van Dyck's portraits of this time do not have the massive, sculptural quality of Rubens'. What they surrender in physical presence, however, they gain in psychological nuance.

If Van Dyck rooted himself in native portrait traditions, he immediately grew, and he blossomed at a remarkable pace. The development of his abilities and his ideas in 1618 is perceptible from work to work, even within this pair. Baumstark, noting differences between the more careful execution of the background in the *Portrait of a Man* and the greater assurance in the *Portrait of a Woman*, concluded that the man was painted first.[1] Other observations supporting this conclusion include the increased economy of means Van Dyck gained through the use of the streaky gray imprimatura as a middle tone in the woman's collar. The other dated pendants from 1618 are bust length and do not include the hands; these portraits, which may be Van Dyck's first that do, already display one of his trademarks, the important expressive role he gave to hands. The woman's elegant, bony fingers are beautifully articulated; they attest to her refinement and draw attention to her golden rings and bracelets. Although her husband's hands appear more labored and clumsy, they are equally expressive. Baumstark also suggested that the man's left hand (which was abraded, overpainted, and only recently revealed) might be artificial: long, flat, and lifeless, it rests on his thigh in the shadow. His right hand, clenched tightly around papers, shows a tension that belies the trace of vulnerability in his eyes.

<div align="right">S. J. B.</div>

A° 1618. ÆT. 57.

A.º 1618. ÆT. 52.

25

89

6
An Elderly Man

1618
inscribed (on back) *oudt 55 Jaren*
panel, 106.5 x 73.7 (42⅛ x 29⅛)

Collections of the Prince of Liechtenstein,
Vaduz Castle, inv. no. 95

PROVENANCE Since 1733 in the
Liechtenstein collection

EXHIBITIONS Lucerne 1948, no. 118;
New York 1985–1986, no. 197, ill.

LITERATURE Liechtenstein 1780, 218 no.
665; *Graphischen Künste* 1889, 39, ill.;
Bode 1906, 268; Adolf Kronfeld, *Führer
durch die Fürstlich Liechtensteinsche
Gemäldegalerie in Wien* (Vienna, 1927), 36
no. 95 (as Rubens); Rosenbaum 1928a,
16–17; Rosenbaum 1928b, 332; Glück
1931, XXXIII, 78 ill., 528; Liechtenstein
1943, ill. 44, 98; Baldass 1957, 256, ill. 6,
259–260

1. New York 1985–1986, 310–312.

Van Dyck's portrait of this resolute, dignified Antwerp burgher is uninscribed, but can be dated securely to 1618 through comparison with the dated *Portrait of a Man* [cat. 4], also in Vaduz. In fact, the similarities between the two are quite striking in that time of rapid change for Van Dyck. Comparisons of the handling in their costumes and in their faces suggest that they were made in quick succession, probably with only cat. 5, the pendant *Portrait of a Woman*, intervening. Painted on wood panel like the pendants, this work also clings to the three-quarter format traditional in the Netherlands. Here, however, Van Dyck's addition of a chair creates a certain spatial dimension. Rubens placed the same kind of chair behind the sitter in his 1616 *Portrait of Jan Vermoelen* [fig. 1]. Vermoelen's likeness was long attributed to Van Dyck because of this formal tie, and because in a small number of portraits [cats. 4, 5] Van Dyck's mimicking of Rubens' technique blurred distinctions between their œuvres. Baumstark recently set the record straight.[1]

Van Dyck soon largely forsook the wooden panel in preference for canvas, whose textural variations enhanced the surface effects he sought. Thanks to the stable support here, the workings of the artist's brush have been perfectly preserved for nearly four centuries. We see the lines of thick white paint, skillfully applied with a fine brush to trace the ruffled, figure-eight edges of the collar and the white hairs of the beard; the more boldly and broadly dashed grays, flecked with black, for the satin sleeve; the hasty and less skillful use of black washes and lines to suggest the embossed leather on the chair; the creamy yet agitated strokes of many colors that model the face and hands; and the ghostly pentimenti to the left of the head that betray Van Dyck's changes in the profile of the collar. The support has retained an important overall effect as well, namely the rich variety of palpable strokes, that spectacle of subtle surface lights with which Van Dyck drew attention to areas of focus such as the hands and face.

The lack of an inscribed date or of an identification for the sitter is unfortunately more the rule than the exception for the portraits Van Dyck made in his two periods of work in Antwerp and during his years in Italy.

S. J. B.

Fig. 1. Peter Paul Rubens, *Portrait of Jan Vermoelen*, 1616, panel, 127 x 97 (50 x 38¼). Sammlungen des Regierenden Fürsten, Liechtenstein

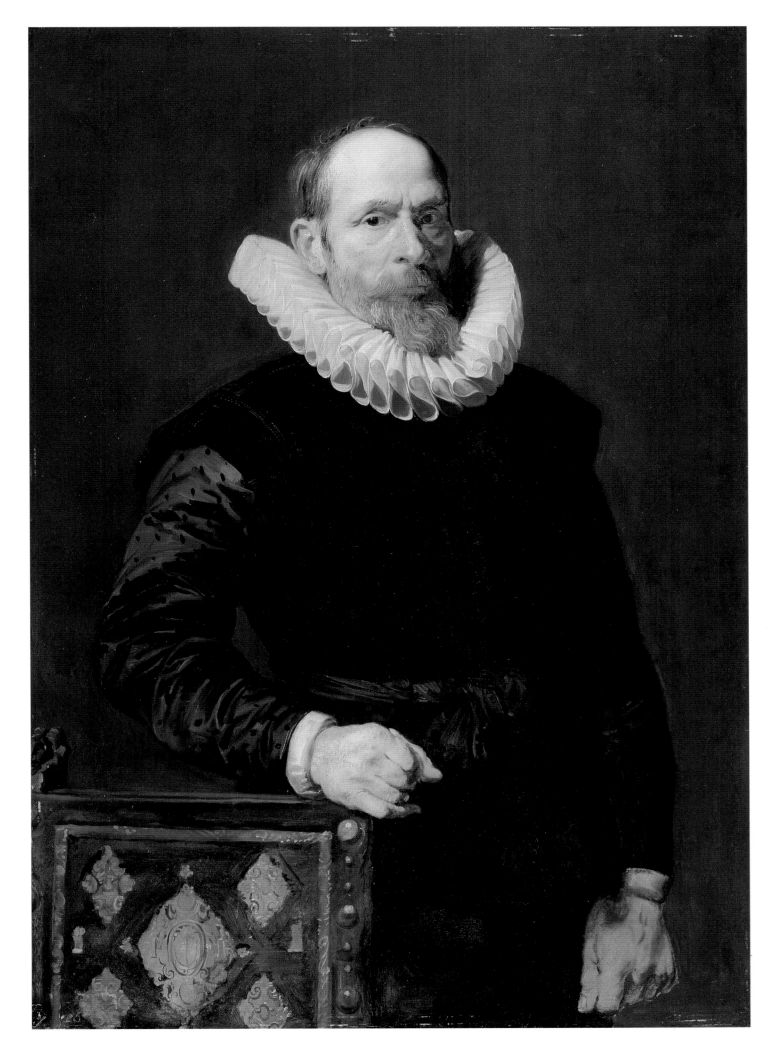

7
Man with a Glove

probably 1618
panel, 107 x 74 (41 3/4 x 28 7/8)
Gemäldegalerie Alte Meister der
Staatlichen Kunstsammlungen Dresden,
inv. no. 1023C

PROVENANCE In inventory Guarienti
(1747–1750), no. 18[1]

EXHIBITION Moscow 1989

LITERATURE Gemäldegalerie Dresden
1765, 67, no. 344; Smith 1829–1842, 3:54,
no. 189; Gemäldegalerie Dresden 1876,
220 no. 847 (as Rubens); Guiffrey 1882,
284 no. 1007; Cust 1900, 77–78, 236, no.
63; Gemäldegalerie Dresden 1905, no.
1023C, ill. (as Van Dyck); Schaeffer 1909,
139 ill.; Rosenbaum 1928a, 18–19; Glück
1931, XXXIII, 82 ill., 528; London
1982–1983, 11 ill. 2, 12; Barnes 1986, 1:79;
Gemäldegalerie Dresden 1987, 167 no.
1023C ill.; David Smith, " 'I Janus':
Privacy and the Gentlemanly Ideal in
Rembrandt's Portraits of Jan Six," Art
History 11, no. 1 (March 1988), 45, ill. 39

1. Pietro Guarienti was the "Inspector of
the Gallery" in Dresden.
2. Justus Müller Hofstede, "Höfische
und bürgerliche Damenporträts.
Anmerkungen zu Rubens' Antwerper
Bildnismalerei 1609–1620," Pantheon 41
(1983), 308–321.
3. See Hans Vlieghe, Corpus Rubenianum
Ludwig Burchard, part 19, Portraits 2.
Antwerp, Identified Sitters (London, 1987),
139–142.
4. Millar in London 1982–1983, 12.

This arresting image of an unidentified man in the act of putting on or removing his glove is pivotal in Van Dyck's development for two reasons. It marks the transition from Flemish types and traditions to Venetian ones in his portraiture. And it is the first manifestation of an interest in transitory movement, which would characterize Van Dyck's portraits henceforth.

The painting was made probably in 1618, surely in the few weeks or months after cats. 4–6. While retaining the wooden support and three-quarter pose of these, it shows Van Dyck's continuing development in several respects. He endowed this sitter with a greater sense of physical ease, particularly through the gesture of his hands and arms. Technically, he displays an ever-greater assurance and economy of means. Paint is applied thinly and rapidly throughout, and the prepared panel surface with its streaky gray imprimatura functions as a middle tone both in the man's collar and, particularly, in the foreshortened gloved hand, whose illusion is masterfully created with a few bold strokes. In the modeling of the flesh the numerous small touches of contrasting colors of the previous works are giving way to longer strokes of blended color.

The reintroduction of movement to portraiture was part of the sweeping current of naturalism that came to dominate western European painting in the seventeenth century. In the early sixteenth century artists such as Titian, Giorgione, and Lorenzo Lotto in Italy, or Joos van Cleve, Jan Gossaert, and Jan Cornelisz. Vermeyen in the Netherlands had painted portraits that implied the movement of the sitters. The second half of the sixteenth century, however, had brought an international fashion for formality and immobility in portraiture, typified by works of Mor in Spain and the Netherlands, and Bronzino in Florence. The reaction against this, expressed in greater informality of pose and setting with a return to suggestions of movement, appeared in the mid-1580s in Bologna in the wake of the Council of Trent as one manifestation of the Carraccis' reform of painting. In Rome it began from about 1595 with the Carracci circle, Caravaggio, and Ottavio Leoni, where it doubtless affected Rubens' portraits in Genoa and Spain. Seemingly spontaneously, as early as 1611 in Haarlem, Frans Hals began to show his portrait subjects in naturalistic ways including animated gestures. Hals visited Antwerp in 1616, but his contacts with artists there are unknown.

During his years abroad, 1600–1608, Rubens had created and left behind in Genoa and Spain portraits with such powerful dramatic action as the equestrian image of Giancarlo Doria (Palazzo Vecchio, Florence). Once back in Antwerp, however, he shunned portraiture apart from likenesses of his family and intimates, and put his vast inventive powers to work on stories from sacred and mythological history. Müller Hofstede has shown how, for those portraits Rubens was obliged to paint to satisfy the Hapsburg regents Archduke Albert and Archduchess Isabella Clara Eugenia and their courtiers in Brussels, he eschewed the full-length, patterned, iconic portrait types of the Spanish and Viennese Hapsburgs and employed instead the less imposing formulae for portraits of burghers.[2] Although they are relatively informal, like his rare contemporary portraits of Antwerp citizens they are not really concerned with movement. One exception is the c. 1615 Portrait of Michael Ophovius (Mauritshuis, The Hague), who was an important Dominican official who actively opposed Protestantism. He is shown with his hand outstretched to the viewer in an oratorical gesture known from Renaissance portraiture.[3]

For the gesture of donning a glove, Van Dyck had such precedents in northern Renaissance painting as Joos van Cleve's Portrait of Joris Vezeler (National Gallery of Art, Washington). As Millar wrote, however, his Man with a Glove attests the ascendency in Van Dyck's portraiture of the Venetian influence that had even earlier permeated his history paintings: "the ease and unstated authority, the combination of relaxation and grandeur, that 'certaine mooving vertue,' which he found again and again in the work of Titian."[4] The sitter's gesture and his gaze engage the spectator,

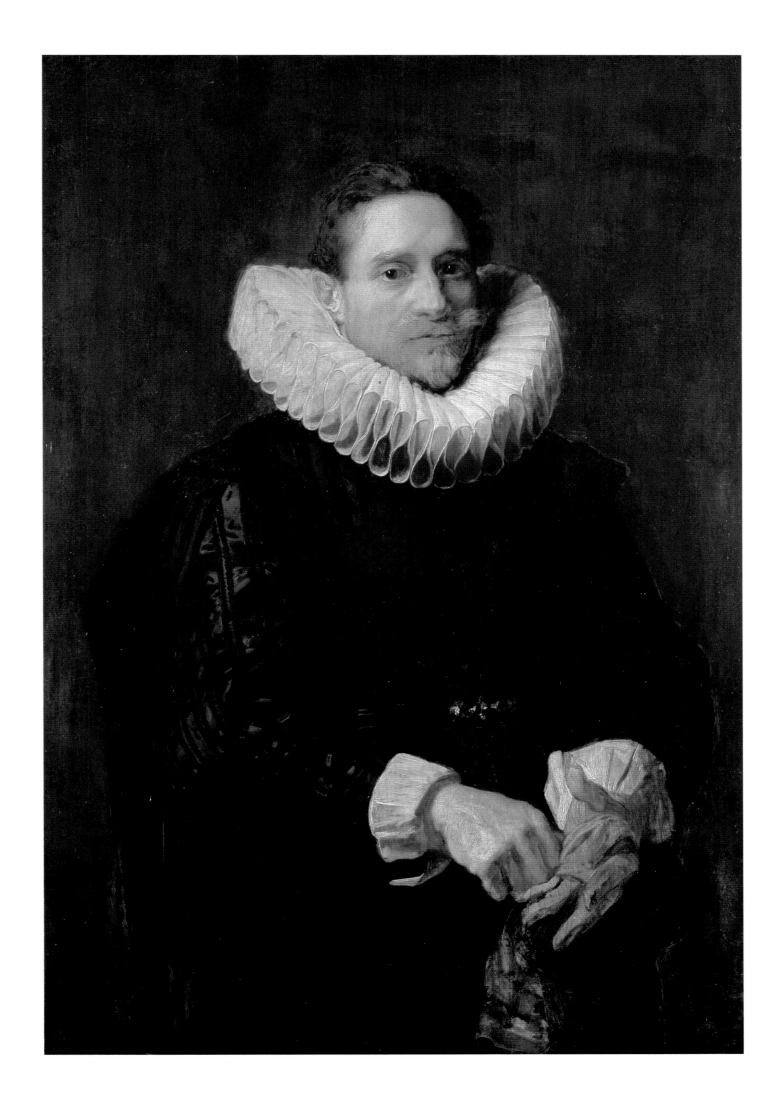

and both serve to convey the impression of a dignified yet forthright presence. As Smith has noted, such images, which embodied Renaissance courtly ideals set forth in Baldassare Castiglione's *Book of the Courtier*, had a later life in the Netherlands, in the work of Rembrandt among others. In the months and years after he painted *Man with a Glove*, Van Dyck would develop and refine his use of pose, gesture, and movement in creating the impact he sought for a particular portrait sitter. To the same end, very soon thereafter he also began to introduce more elaborate settings for his portrait subjects.

S. J. B.

8
Saint Jerome

c. 1618

canvas, 192 x 215 (74⁷/₈ x 83⁷/₈)

Gemäldegalerie Alte Meister der
Staatlichen Kunstsammlungen Dresden,
inv. no. 1024

PROVENANCE Probably in Rubens'
possession (inventory 1640); a picture
representing this subject was sold in the
collection of M. van Zwieten, The Hague,
1731;[1] Dresden, in inventory Guarienti
(1747–1750), no. 112, as Rubens[2]

LITERATURE Gemäldegalerie Dresden
1765, no. 501 (as Van Dyck); Smith
1829–1842, 3:55, no. 195; Cust 1900, 13,
233, no. 12 (as after Rubens); Bode 1906,
262, 264; Schaeffer 1909, 32, ill., 496;
Rosenbaum 1928a, 59; Glück 1931, xxx,
65, ill., 526; Denucé 1932, 66; Glück 1933,
286; Van Puyvelde 1941, 185; Ottawa
1980a, 267, 295, ill. 62; Gemäldegalerie
Dresden 1987, 168, no. 1024, ill.; Jeffrey
M. Muller, *Rubens: The Artist as Collector*
(Princeton, 1989), 134

1. "Catalogus van schilderyen van den
Heer van Zwieten, verkogt 12 April 1731
in 's Hage," no. 23, in Hoet 1752, 2:12.
2. Pietro Guarienti was the "Inspector of
the Gallery" in Dresden.
3. See Glück 1933, 286, and the catalogue
entry for the Althorp version in *Baroque
Paintings* [exh. cat. Colnaghi] (New York,
1984), 22.
4. No. 230 in Rubens' estate inventory
was described as "Un grand St. Jerosme à
genoux du mesme [Van Dyck]" (Denucé
1932, 66). Muller 1989, 134, has ques-
tioned whether the reference was to the
present painting or the version formerly
in Althorp, which I deem to be
unfinished. See below.
5. Exhibited and illustrated in London
1968a, no. 1, and in *Baroque Painting* [exh.
cat. Colnaghi] (New York, 1984), no. 9.
6. Quoted in *Exhibition of Old Master and
English Drawings* [exh. cat. Colnaghi]
(London, 1969), no. 37, ill.

Fig. 1. Peter Paul Rubens, studio after
Titian, *Saint Jerome in the Wilderness*,
c. 1605, chalk, ink, heightened with white
on blue paper, 49.7 x 34.9 (19⁵/₈ x 13³/₄).
Teylers Museum, Haarlem

In about 1618, Van Dyck made his third and apparently final full-length painting
devoted to Saint Jerome. It was by far his grandest, most ambitious, and most moving
treatment of the subject. While in earlier versions in Liechtenstein [cat. 2] and
Rotterdam he had shown the saint as a scholar at work in a summarily suggested
landscape, here Jerome kneels amid gnarled trees, ferns, and fungi, transfixed with
feeling as he gazes at a crucifix and meditates humbly on his sins.

As with the first version from about 1615, Van Dyck was here inspired and
challenged by works in Rubens' studio, including Rubens' own *Saint Jerome* [cat. 2,
fig. 1] and a painting by Titian that Rubens copied, known today through studio
drawings [fig. 1]. Titian's influence, more dominant here than before, can be seen in
the kneeling pose, the tilt of the head, and the emotional facial expression. The
similarities between Van Dyck's painting and the drawing after Titian extend even to
the strongly linear handling of the flesh, raising the question of Van Dyck's
authorship of the Teyler copy. Other sources that nourished the young artist's
invention include Caravaggio's *Madonna of the Rosary* (Kunsthistorisches Museum,
Vienna), then in Saint Paul's Church, Antwerp, from which he took the idea of
wrapping the great curtain around the tree, as well as the independent landscape
paintings that Rubens had begun to make during the decade.

The truly remarkable achievement of the present painting, however, transcends
specific sources. It lies in Van Dyck's successful assimilation of a fundamental lesson
from Venetian art, namely the sweeping expressive power that landscape could bring
to religious painting. How he could have learned this so early and well in Antwerp,
where his exposure to Venetian painting was limited to prints, copies, and works in
collections or on the market, remains a mystery. His success in that regard has led
scholars from time to time to date the painting after Van Dyck's first contact with
Italy.[3] Numerous other qualities place it indisputably in the years before Italy, how-
ever, including the overt emotion and harsh naturalism proper to 1615–1620. In ad-
dition, the palpable fretwork of slashing brushstrokes that deftly define the left hand
and arm recalls, if generally, the handling of flesh in the portraits of 1618 [cats. 4–6].

The large canvas support was pieced together from two nearly equal parts joined
with a vertical seam to the left of the center. Rather than mask its marked texture,
Van Dyck used the canvas weave to enhance the liveliness of the surface overall and
to accentuate the textural illusions in such areas of his composition as the vegetation
and the saint's flesh and beard. The excessive violence of the brushwork in the
earliest *Saint Jerome* is gone, as are the extreme contrasts between heavily and thinly
worked areas. The palette of primary colors is now enriched with a range of greens
and browns in the lush vegetation at left.

The painting is thought to have been one of three *Saint Jerome*s by Van Dyck in
Rubens' estate.[4] It was engraved by C. Galle and N. de Beauvais. *Saint Jerome* came to
Dresden by 1750 and was first listed as a work by Rubens himself, but was
recognized as Van Dyck's in the 1754 inventory. A somewhat smaller and markedly
more horizontal variant on canvas, once at Althorp, may have been Van Dyck's first
essay for the painting.[5] There he seems to have blocked out the composition with the
lion at right and started on the figure of Saint Jerome before abandoning the work
unfinished. The sky was apparently completed by another hand. A black chalk
drawing with touches of ink, known to me only from reproductions when it was on
the London market in 1969, is a variant on the final composition. It is more tightly
framed, and the book, crucifix, and curtain are suppressed. Jaffé suggested it was a
preparatory study for an unexecuted engraving.[6]

S. J. B.

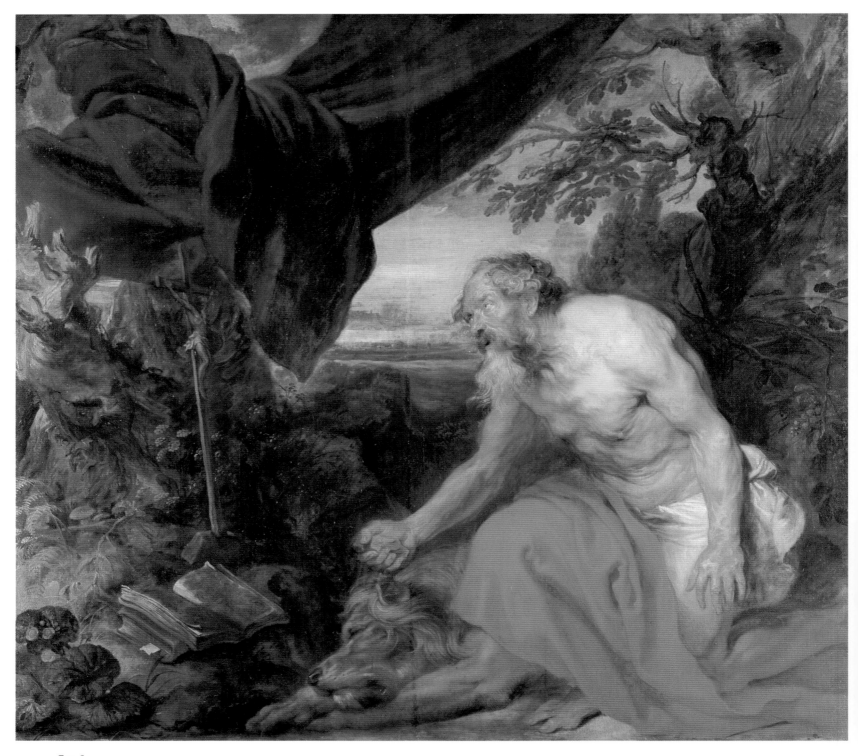

Cat. 8

9
Portrait of a Family

1619
canvas, 113.5 x 93.5 (44³/₄ x 36⁷/₈)

The State Hermitage Museum,
Leningrad, inv. no. 534

PROVENANCE In the gallery of the
collector M. La Live de Jully, Paris, who
bought it in 1762; in his sale 2–14 March
1770; bought by Mrs. Groenbloedt,
Brussels; acquired in 1774

EXHIBITIONS Brussels 1910, no. 117, ill.
57; Leningrad, State Hermitage Museum,
1938, no. 33; Montreal, International Fine
Arts Exhibition, Expo, *Terre des Hommes,
Exposition Internationale des Beaux-Arts/
Man and His World*, 1967, no. 65, ill.;
Leningrad, State Hermitage Museum,
1972, no. 331; Washington 1975–1976, no.
17, pl.; Leningrad, State Hermitage
Museum, 1978, no. 9; Vienna,
Kunsthistorisches Museum, *Gemälde aus
der Eremitage und dem Puschkin-Museum*,
1981, 34–37, ill.; Rotterdam 1985, no. 32,
pl.; New York 1988a, no. 37, pl.

LITERATURE *Catalogue historique du cabinet
de peinture et sculpture française de M. de
Lalive* (Paris, 1764), 114–115 (as "célèbre
peintre Sneyders" and his family); Smith
1829–1842, 3:88 no. 300, and 9:382 no.
51; Blanc 1857, 1:165; Hermitage 1864,
149; Hermitage 1870, 76–77 no. 627;
Guiffrey 1882, 278 no. 847 (as Snyders
and his family); Cust 1900, 18, 236, no. 56
(as possibly Jan Wildens and his family);
Rooses 1904, 116; Schaeffer 1909, 160 ill.,
501; Rooses 1911, 45–46; Réau 1912, 474;
Glück 1931, 108 ill.; Hermitage 1958, 152,
241, no. 218; Hermitage 1963, 100–101 no.
5, ills. 10–15B; Hermitage 1964, no. 15,
pl.; Ottawa 1980a, no. 72, ill. (not exhib-
ited); Brown 1982, 50–51, ill. 41; London
1982–1983, 12 ill. 3; Barnes 1986, 1:122,
2: ill. 107

Van Dyck's development as a portraitist proceeded apace beginning in 1618 [cats. 4–7], and before the end of 1619 he had created a series of lively images with innovations based on sixteenth-century Venetian prototypes. Typically these show figures in a setting that may include a column, a curtain, furniture, or a view outdoors. Such portraits quickly set new fashions and conventions for portraiture in Antwerp, which were followed by Cornelis de Vos and to less an extent by Jacob Jordaens. Burchard characterized their importance to the history of Netherlandish portraiture: "the spell which had held all the portrait groups of the sixteenth century was broken: representation is softened by familiarity, ceremonial dignity is gone."[1]

This engaging, informal portrait represents Van Dyck's earliest known family group, and the only surviving one from the first Antwerp period.[2] Although he remained a bachelor until he was forty, Van Dyck had a remarkable sense about children, and his images of them number among his most important and moving enrichments to the history of portraiture. The painting has power and charm along with certain awkwardnesses that place it among his first experiments with complex settings, probably around 1619. The relationship of the sky to the curtain is unresolved; the figures are hemmed in by the chair at left, and the space seems too small to contain them. The shallowness of the space and the frontality of the figures actually look back to the painting's source, Rubens' *Jan Brueghel the Elder and His Family* [fig. 1], from about 1613. With only one child to paint, however, Van Dyck reversed Rubens' triangular composition, putting the baby girl at the apex on the lap of her mother and letting the child form a link between her parents through the upturned gaze at her father.

Van Dyck's conceptual innovations that distinguish this painting so markedly from those of the previous year are matched by technical changes, also inspired by Venetian painting, but which are absolutely Van Dyck's own in practice. Rather than the smooth wooden support of 1618, Van Dyck chose a canvas whose coarser warp threads, running vertically, became an active part of the surface texture. Using the grain as a foil, he quickly applied, in broad, sometimes long and agitated strokes, paint that was thick and nearly dry. Impasto is more pronounced. Gone in the flesh areas are the many fine touches of modeling color. With the conceit of outdoor light, the scene is strongly lit, the shadows either washed out or very deep. Faces and hands are drawn, almost sculpted, and colored with the same rapid and deftly applied strokes of paint. Colors are brighter and more varied than before. Strong reds, blue, and greens have been added to the black, white, and gold palette of 1618.

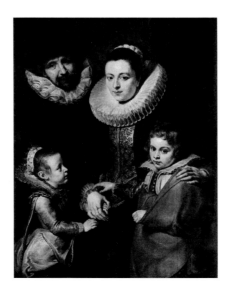

Fig. 1. Peter Paul Rubens, *Jan Brueghel the Elder and His Family*, 1612–1613, panel, 124.5 x 94.6 (49 x 37¹/₄). Courtauld Institute Galleries (Princes Gate Collection), London

1. Burchard 1938a, 26.
2. One formerly on the London art market (Glück 1931, 112), perhaps identical with the version that was recently on loan to the Rubenshuis from the Dulière Collection, is the work of an imitator.
3. On the Snyders, see Van der Stighelen 1987, 37–48.
4. Also, the Wildens' first child was born in August 1620, after this painting was made. See Hans Vlieghe, *Corpus Rubenianum Ludwig Burchard*, part 19, Portraits 2. *Antwerp, Identified Sitters* (London, 1987), figs. 234, 236 for the Wildens portraits.
5. See Hermitage 1963, 100, ill. When and why Van Dyck made this change is uncertain, but it may well have been done to simplify an overloaded composition (New York 1988, 82).

Once more the sitters are unnamed. From the time the picture was in La Live de Jully's collection it was thought to represent Frans Snyders with his wife and child; but the faces of Snyders and Margaretha de Vos, who were childless and older than this couple they only vaguely resemble, are known from Van Dyck's dazzling pendant portraits of them in the Frick Collection.[3] That they might be the family of the landscape painter Jan Wildens—as Cust suggested, and McNairn and Brown among others have accepted—does not hold up either when the likeness here is compared with Rubens' and Van Dyck's later portraits of their colleague.[4] It is interesting, and perhaps only coincidental, that both suggestions are of sitters from the artistic milieu. Costume may play a role in that association, since the man wears the same flat, lace-trimmed collar as Snyders in the Frick and Wildens in Vienna (Glück 1931, 120); pentimenti and radiographs show that he originally had the fluffy millstone collar of other contemporary sitters.[5] In addition, the technical roughness of the painting, quite bold and original in its time, may signal that it was commissioned by a patron who was open to experimentation and innovation, a quality presumably found sooner in a fellow artist than in others.

Cust listed copies of the painting in the Staatsgalerie, Stuttgart, and in the collection of Mrs. Culling Hanbury, Bedwell, Hertfordshire. According to McNairn, the last, which was exhibited at the Van Dyck tercentenary at the Royal Academy in 1900, was with Ian MacNichol, Glasgow, in 1951. It may also be the picture recently recorded in the Friementhal Collection, England.

S. J. B.

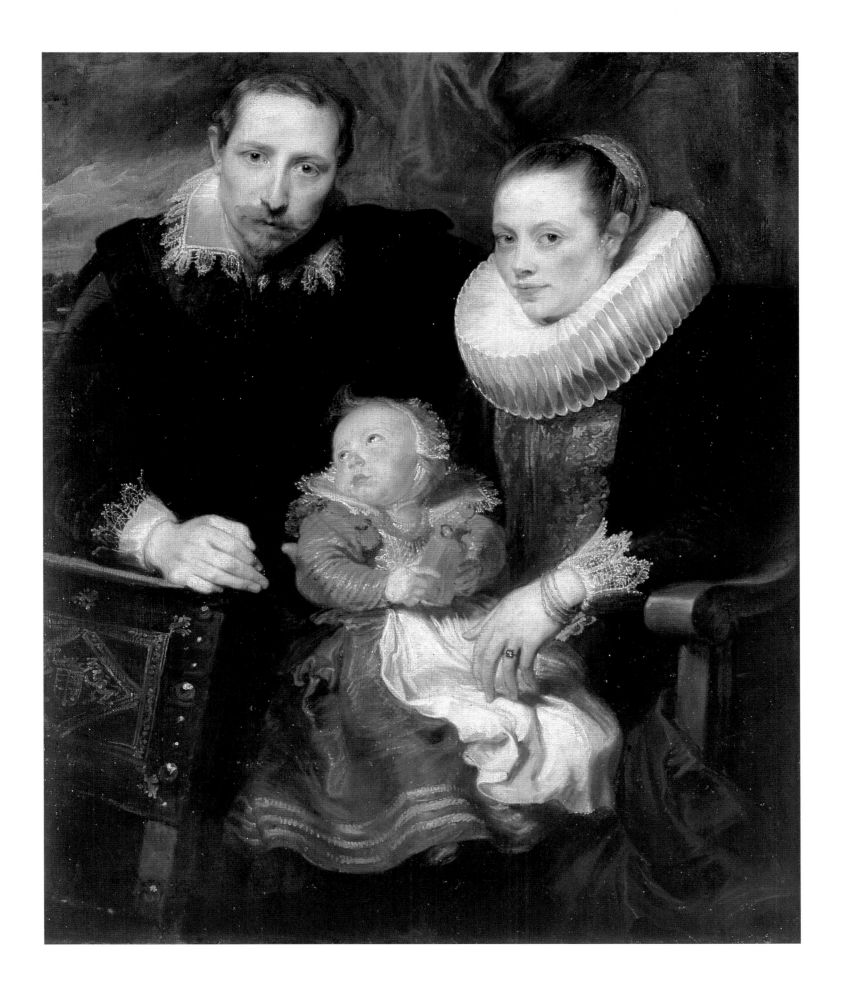

1619–1620
canvas, 149 x 113.2 (58 5/8 x 44 5/8)

The Trustees of the National Gallery,
London, inv. 50

PROVENANCE Probably P. P. Rubens,
sale Antwerp 1640, lot 233; in the Roger
Harenc sale, Langford, 1 March 1764, lot
50; in collection Lord Scarborough
(1725–1782) and bought from his heir by
Hastings Elwyn; first recorded in
Elwyn's possession, 29 December 1785;
Elwin sale (by private contract), January
1787, lot 17 (not sold); still in Elwyn's
possession, 13 April 1799; sold to J. J.
Angerstein by 1807, when lent by him to
the British Institute for copying;
purchased with the Angerstein
Collection, 1824

EXHIBITIONS London, Whitechapel Art
Gallery, 5 Centuries of European Painting,
1948, no. 12; Ottawa 1980, 7, 15, no. 35,
ill.

LITERATURE John Young, A Catalogue of
the Celebrated Collection of Pictures of the
Late John Julius Angerstein, Esq. (London,
1823), no. 2, ill. (etching); Passavant 1836,
1:44 no. 3; Smith 1829–1842, 3:76 no.
252; Guiffrey 1882, 250 no. 161; Cust
1900, 13, 233 no. 10; Bode 1906, 263;
Rosenbaum 1928a, 58; Glück 1931, XXVIII,
18 ill., 519; Glück 1933, 281; A. J. J.
Delen, Het Huis van P. P. Rubens (Diest,
1940), 61; Van Puyvelde 1950, 50–51 (as
Rubens); Vey 1956, 174; National Gallery
London 1970, 29–34 no. 50; Hans
Vlieghe, "National Gallery Flemish
Pictures" (book review of National
Gallery London 1970), Burlington
Magazine 116 (1974), 47–48; Vienna 1977,
78; Brown 1982, 30–31, ill. 19; Glen 1983,
48; Martin 1983, 39, ill., 40; Millar 1983,
308; Stewart 1986, 139–140; Barnes 1986,
1:34–37; National Gallery London 1987,
72–73, pl. 30; Larsen 1988, no. 253, ill.
110; Jeffrey M. Muller, Rubens: The Artist
as Collector (Princeton, 1989), 134–135

Spiritual authority triumphs over political authority in this encounter between the Roman emperor Theodosius (c. 346–395; emperor from 379) and Saint Ambrose (c. 340–398), archbishop of Milan from 374, told in the *Golden Legend*. Theodosius ruled a far-flung empire threatened on all sides by barbarian tribes. When a rioting mob in Thessalonica murdered one of his generals, he authorized a massacre of those responsible. Saint Ambrose responded by barring him from entry to the cathedral of Milan. Theodosius accepted this, and performed the public penance demanded by the archbishop in recompense for his sin.

This painting has long been recognized as Van Dyck's smaller, "free copy" of a large, handsome work on panel by Rubens in Vienna [fig. 1].[1] The Vienna painting is generally dated to c. 1618 because of similarities with the tapestry cartoons for *Decius Mus* [see Wheelock, fig. 2], which were completed before May 1618, and *The Last Communion of Saint Francis* of 1619. Van Dyck was one of Rubens' assistants on the *Decius Mus* series, and Oldenbourg, among others, credited him with the execution of the Vienna picture as well.[2] The present painting probably dates to 1619 or 1620.

Pentimenti, some visible to the naked eye, show that Van Dyck copied Rubens' composition before making his changes and additions.[3] This in itself is quite anomalous in his practice, as indeed is the fact of making so close a variant. We have several other pictures in this exhibition in which Van Dyck began with a subject that Rubens had treated [cats. 2, 8, 11, 12, 15, 19, 22], but in each of those cases he displaced the model with his own vision from the first sketch. Here we find the customary general differences of support, and of style and mood found in other cases: the Vienna panel represents Rubens' monumental, serene sculptural style, while the London canvas shows Van Dyck's linear, "nervous" approach, with the figures set on a more narrow, spatially compressed stage. However, Van Dyck's actual modifications to Rubens' composition are so minor that at first glance they might seem insignificant. Oliver Millar has noted that Van Dyck's painting is quite a bit smaller, being less than half the size of the original.[4] Three specific alterations include the shift of the architectural backdrop to the left; the change in Theodosius' face, which is now beardless, and based loosely on Rubens' drawn copy of an ancient bust of the emperor Galba;[5] and the inclusion of Nicholas Rockox's portrait among the attendants of Saint Ambrose.[6] The rest of the changes are concentrated at the left edge of the painting, where a menacing spear and halberd have appeared along with a dog, and where the soldier at left has become a young man of haughty bearing.

Gregory Martin recognized that Van Dyck's addition of the hound signaled his introduction of another episode in the story, based on a new edition of Surius' *De*

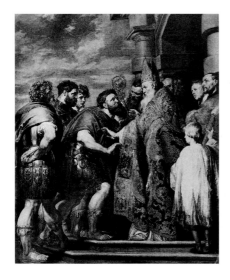

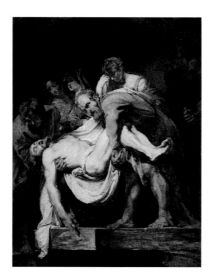

Fig. 1. Peter Paul Rubens, *Theodosius and Ambrose*, c. 1618, panel, 362 x 246 (142 1/2 x 96 7/8). Kunsthistorisches Museum, Vienna

Fig. 2. Peter Paul Rubens after Caravaggio, *The Entombment*, 1614, panel, 88.3 x 66.5 (34 3/4 x 26 1/8). National Gallery of Canada, Ottawa

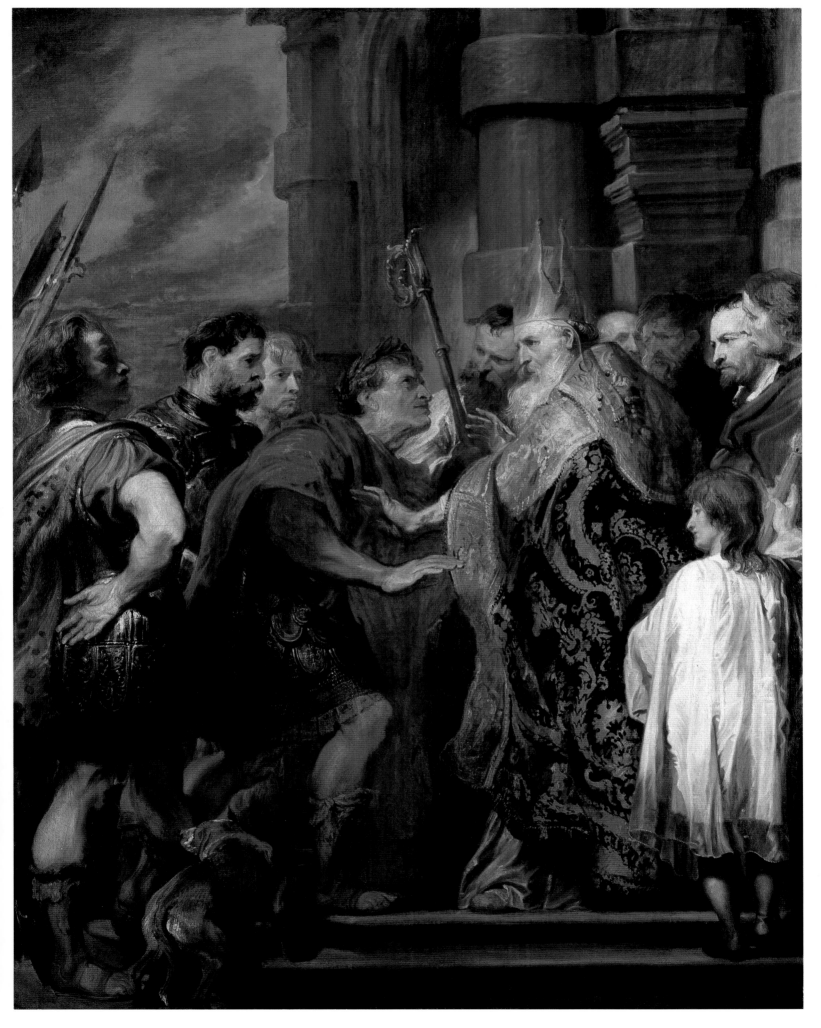

1. Only Glück thought it was a preparatory study. Van Puyvelde was the lone dissenting voice on the attribution of the present painting, which he inexplicably gave to Rubens.

2. Rudolf Oldenbourg, *Peter Paul Rubens* (Stuttgart, 1921), 462 n. 191, cited Rubens' studio drawings in Copenhagen, copied after the Vienna painting, with annotations indicating Van Dyck's authorship (Martin in National Gallery London 1970, 32 n. 5, described the drawings). Martin seems to have believed, as he thought that Bode and Glück did, that the Vienna painting was Van Dyck's invention as well as his execution. For a full discussion of the attribution of that painting, see Vienna 1977, 78–79, whose authors interestingly conclude that Van Dyck had no part in the painting at all.

3. The pentimenti are fully detailed by Martin in National Gallery London 1970, 29: "The features of Theodosius, the acolyte with the candle and the spectator to his right have been altered; the head of the soldier on the left was first placed more to the right (and may have been different); the drapery on his shoulder and on Theodosius' shoulder has been altered; a baton held by the soldier on the left has been suppressed; the outer edge of Ambrosius' cope originally fell in a straight line away from him; the position of his hands and Theodosius' right hand have also been slightly altered, and the inner column of the central doorway was first narrower, while the entrance on the right had a more pronounced arch."

4. Millar 1983, 308.

5. Martin in National Gallery London 1970, 31.

6. As Rooses was the first to recognize in *L'Oeuvre de Rubens*, 6 vols. (Antwerp, 1886–1892), 1888, 2: no. 387. Compare the profile portrait by Rubens (Oldenbourg 1921, 85), the wing of *The Doubting Thomas* (Koninklijk Museum voor Schone Kunsten, Antwerp). Martin's "tentative suggestions" (1970, 31) that Van Dyck had also portrayed contemporary artists in the crowd have not been supported (Hans Vlieghe, "National Gallery Flemish Pictures," *Burlington Magazine* 116 [1974], 48).

7. Martin in National Gallery London 1970, 29–30.

8. With due respect to Stewart 1986, 139.

9. Rosenbaum (1928a, 52) pointed out that this was characteristic of the young Van Dyck.

10. For Rubens' copy after Parmigianino, see Michael Jaffé, *Rubens and Italy* (Ithaca, N.Y., 1977), fig. 62.

11. The sketchbook drawings typify Van Dyck's work in competition with Italian painters. See Barnes 1986, 1:38–43.

12. Rubens' estate inventory included "Un *S. Ambroise* du mesme [Van Dyck]" (Denucé 1932, 66), which some have taken to mean the Vienna painting. For the state of this question see Martin in National Gallery London 1970, 33, n. 30, and *Peter Paul Rubens* (Vienna, 1977), 78. In his new study of Rubens' collection, Jeffrey Muller leans toward identifying the picture in the artist's collection with the London version.

Vitis Sanctorum, published in 1618.[7] In that account Ruffinus, who was Theodosius' master of knights, tried to intervene with the bishop on behalf of the emperor. Saint Ambrose rebuked Ruffinus thus: "Thou hast no more shame than a hound." Martin rightly concluded that Van Dyck had identified the man at the far left as Ruffinus by placing the hound at his feet.

By including this episode, Van Dyck introduced a new, overtly hostile dimension to the tale, embodied in the defiant pose of Ruffinus and the weapons behind him. Antagonism lends complexity and tension to the drama by presenting a challenge to the authority of Saint Ambrose in contrast with Theodosius' humble submission.[8] That challenge provokes Ambrose's rebuke to Ruffinus, likening him to a dog. Van Dyck's making the faces of Ruffinus and Theodosius beardless better enables us to perceive the nuances of their expressions. Likewise, his extension of the church facade serves to emphasize the division in the company assembled before it; the acquiescent Theodosius submits to ecclesiastical dominion and remains in the arms of the Church, while the contemptuous Ruffinus stands apart and outside the faith.

We find a similar juxtaposition of extremes for dramatic effect in the Minneapolis and Prado versions of *The Betrayal of Christ* [cat. 13 and cat. 13, fig. 1], where the raging mob contrasts with the serenity of Christ.[9]

Neither the function of the painting nor Van Dyck's purpose in creating this unique close variant has been addressed. Rubens often painted free copies of works he admired, such as Caravaggio's *Entombment* [fig. 2] or *Cupid Sharpening His Bow* by Parmigianino, among many others, altering them to suit his own interpretive ideas.[10] Van Dyck usually made such variant interpretations in hasty pen drawings, as seen in his Italian sketchbook; this painted work is exceptional.[11] The small size and sketchy technique of his version suggest that it may have been an exercise carried out for himself and for Rubens, in whose collection the painting probably remained.[12] Rubens would well have appreciated his young assistant's ability to so transform the meaning of a painting with a few small alterations. Particularly witty is the tour de force wrought on the man at left, whom Van Dyck metamorphosed from a soldier at rest to a rebel by the simple elimination of his baton.

<div align="right">S. J. B.</div>

11
Samson and Delilah

1619–1620
canvas, 149 x 229.5 (58 1/8 x 89 1/2),
including an added strip at the top about
5 in. deep

Dulwich Picture Gallery, London,
inv. no. 127

Restored with the generous support of
the Hambland Foundation

PROVENANCE David Armory, Amster-
dam, 1711; Armory sale 23 June 1722,
no. 1; Sir Gregory Page before 1767;
anonymous (Page) sale, at Bertels,
London, 26 [or 28?] May 1783, lot 76,
perhaps bought by Desenfans;
Desenfans private sale 8 April 1786, lot
174 (as Rubens), not sold; bequeathed by
Desenfans to Sir Francis Bourgeois, 1807;
on insurance list 1804, no. 99 (as
Rubens); Bourgeois bequest 1811, to
present owner

EXHIBITIONS London 1938, 21, no. 68,
ill.; London, National Gallery exhibition
of Dulwich Gallery works, 1947, no. 13;
London 1953–1954, no. 228

LITERATURE Hoet 1752, 1:259 no. 1;
Thomas Martyn, *The English Connoisseur*
(London, 1766), 59; Hymans 1899a, 228;
Cust 1900, 69, 246 no. 3; Schaeffer 1909,
21 ill., 496; Rosenbaum 1928a, 56; Glück
1931, XXVII, 13 ill., 518; Glück 1933, 282,
ill. 160; H. G. Evers, *Rubens und sein
Werk, neue Forschungen* (Brussels, 1943),
165; Vey 1958, 43–60; Brussels 1965, 298;
Madlyn Kahr, "Delilah," *Art Bulletin* 54
(1972), 296, n. 53; Princeton 1979, 57 ill.
13, 58; Dulwich 1980, 53–54 no. 127, ill.
127; Ottawa 1980a, 56, 285, ill. 36; Brown
1982, 32–34, pl. 22; London 1982–1983, 13
ill. 6 (intr.); John Rupert Martin in
RACAR 1983, 38, ill. 3; Washington
1985–1986a, 20, 21, ill.; Stewart 1986, 138;
J. Douglas Stewart, review of David
Freedberg, *The Life of Christ after the
Passion* (Oxford, 1984) *RACAR* 15, no. 1
(1988), 74; Larsen 1988, no. A38, ill. 72 (as
an eighteenth-century copy)

1. Included in this exhibition are *Moses
and the Brazen Serpent* [cat. 15], *Susannah
and the Elders* [cat. 16], the series of
Apostles [cats. 19, 20], *Drunken Silenus*
[cat. 12], *Saint Jerome* [cats. 2, 8], and
Saint Sebastian Bound for Martyrdom [cat.
22].
2. See Kahr 1972, 286–292, figs. 8–13.
3. Oldenbourg suggested that
Tintoretto's painting had inspired
Rubens' composition ("Die Nachwirkung
Italiens auf Rubens und die Gründung
seiner Werkstatt," *Jahrbuch der Kunsthis-
torischen Sammlungen des Allerhöchsten
Kaiserhauses* 34, no. 5 [1918], 184–185). H.
G. Evers, *Rubens und sein Werk, neue
Forschungen* (Brussels, 1943), 151,
accepted that suggestion, as have the
authors of the Corpus Rubenianum
(verbal communication).
4. Vey 1958, 48; and in Antwerp 1960, 40.
5. Martin 1983, 38.
6. Stewart 1986, 140.

When Van Dyck was active in Rubens' studio, he closely studied the works that were
unsold and kept in stock. On several occasions, in the healthy spirit of competitive
emulation that nurtures creative growth, he took one of these as a point of departure
for a painting of his own.[1] *Samson and Delilah* (National Gallery, London), arguably
Rubens' most significant private commission of the decade for his home city, was
painted shortly after his return from Italy in 1609 for Nicholas Rockox, an important
collector and civic leader in Antwerp and one of Rubens' greatest patrons. The large,
dark, sensual *Samson and Delilah* hung over the mantelpiece in Rockox's salon from
about 1610 on. Sometime before 1620, Van Dyck decided to undertake a version of
this subject as well.

Van Dyck drew on many sources to develop his *Samson and Delilah*. His two
known preparatory studies—a study in pen and wash, once in Bremen (destroyed),
and a pen and ink drawing, squared for transfer (Kupferstichkabinett, Berlin)—
indicate that he referred to the Matham engraving after Rubens' painting and to
Rubens' own preparatory studies. For instance, the labored hatching of shadows in
the Berlin drawing, remarked on in the Princeton catalogue (1979), is an exaggeration
of the treatment in Rubens' compositional drawing (collection Van Regteren-Altena,
Amsterdam), which Van Dyck must have had before him.

As was customary in paintings that Van Dyck based on Rubens', however, he
charted a distinct course from the very beginning. He made formal changes such as
extending the length of the composition, as he did with *Moses and the Brazen Serpent*
[cat. 15], and reversing the direction, which now follows the print. Fresh from his
direct experience of Caravaggio's painting in Italy, Rubens had placed his action in
Delilah's boudoir, lit by candles. Although there were precedents for an interior
setting, such as a print by Brosamer (Bartsch 1) and Marten van Heemskerck, others
by Lucas van Leyden and Dürer had shown Samson and Delilah outdoors.[2] Van
Dyck followed Venetian models, such as Boldrini's print after Titian and the painting
by Tintoretto [fig. 1] that had been the source for Rubens' figure group, in choosing
an open loggia for his scene,[3] which he filled with light and with the clear, bright
colors he also took from Titian and from Veronese.

If Van Dyck's choice of setting is traditional, his narrative is decidedly not. When
artists represented this scene from the life of Samson, they usually showed the Old
Testament hero either while his hair was being shorn (as Rubens had) or once the act
was accomplished. These depictions are lacking in the kind of dramatic tension that
appealed to the young Van Dyck. He instead selected the climactic moment just
before the locks are cut, which is fraught with danger and suspense. As we know
from the text in Judges 16:4–19, three times Delilah had pried from Samson a
purported secret of his superhuman strength. Thrice she had tried to render him to
the Philistines for the promised cash reward, only to find that Samson had fooled her.
Astonishingly gullible in light of her previous treacheries, Samson has finally

Fig. 1. Tintoretto, *Samson and Delilah*,
c. 1590, canvas, 158.75 x 225 (62 1/2 x
88 5/8). Chatsworth Collection, Duke of
Devonshire

7. Flavius Josephus, *Jewish Antiquities*, v. 306–308; see Kahr 1972, 286, 292.
8. Evers 1943, 160; Kahr 1972, 296.
9. Larsen's recent suggestion that the painting is an eighteenth-century copy is absurd.
10. Brown 1982, 34; Millar in London 1982–1983, 13.

entrusted Delilah with the true source of his power and been lulled by love and drink to sleep on her lap. Once his hair is cut, he will be impotent; for now, though, he is as menacing as a great slumbering beast. The Philistines stand nervously in the wings. Delilah, still bare-breasted from Samson's caresses, cautions her anxious attendants to be silent. She delicately draws back the cloth from Samson's head and waits for the deed to be done.

Studies in the last generation have shown that Van Dyck enriched the meaning of his painting with mythological references from ancient and sixteenth-century art. Vey noted that Samson's pose had two likely sources: Rubens' drawing of the *Borghese Hermaphrodite* (The Metropolitan Museum of Art, New York) and Boldrini's print of *Sleeping Cupid* after Titian.[4] Both have a poignant relevance to Samson's own story. Martin pointed out that without his herculean force, Samson will be as if emasculated.[5] The sleeping Cupid, on the other hand, ironically suggests Samson's childlike innocence in trusting his love to Delilah, and recalls Rubens' use of a sculpture of Cupid blindfolded to make a similar point in his painting. When Van Dyck returned to the story of Samson a decade later [fig. 2], he relied on yet another ancient source, using the agonized pose and expression of the Laocoön to convey the tragedy of Samson's capture.

These particular symbolic meanings are veiled as allusions. However, Stewart only recently recognized one so flagrant and central that it should have been seen long ago.[6] Directly above Samson's head, silhouetted against the cerulean blue sky, is a beautiful golden pitcher, with a cluster of grapes on the side and a handle in the shape of an ithyphallic faun. This bacchic ornamentation graphically describes the two sources of Samson's undoing: intoxication and concupiscence. Samson was a Nazarite and forbidden to drink alcohol. Although the Bible does not mention his drunkenness, Josephus did, and it became part of the visual tradition. Josephus was also responsible for the notion that Delilah was a harlot.[7] Johann de Brune's twenty-second emblem in *Emblemata oder Sinnesprüchen* (Amsterdam, 1624) shows that "Delilah's lap" was synonymous with a whore's.[8] The air of illicit eroticism in Rubens' painting already suggests such an interpretation, but he signaled it explicitly, and Van Dyck followed suit, by including a procuress type as Delilah's attendant. Probably to reinforce the same idea, Van Dyck bedecked Delilah in extravagant finery—the kind the Philistines' reward will help to support—with gold and pearls adorning her dress, her hair, and the voluptuous brocaded drape around her.

Although the painting was auctioned in 1722 as "een Kapital Konstig Stuk" by Van Dyck, in the course of the eighteenth century it was assigned to Rubens' œuvre where it remained for more than a hundred years. Roughly a century ago, Bode, followed by Rooses, Hymans, and Cust, reclaimed the Dulwich *Samson* for Van Dyck.[9] Bode thought the painting belonged with very early "rough" works such as the first *Saint Jerome* [cat. 2], and so did Glück. Since then scholarly opinion about the date has rightly moved further along toward the year 1620, which Brown recently asserted and Millar implied.[10]

S. J. B.

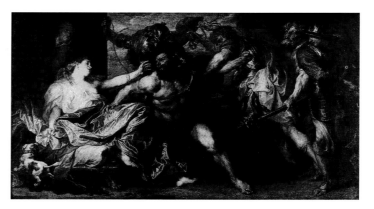

Fig. 2. Anthony van Dyck, *Samson and Delilah*, c. 1630–1632, canvas, 146 x 254 (57 1/2 x 100). Kunsthistorisches Museum, Vienna

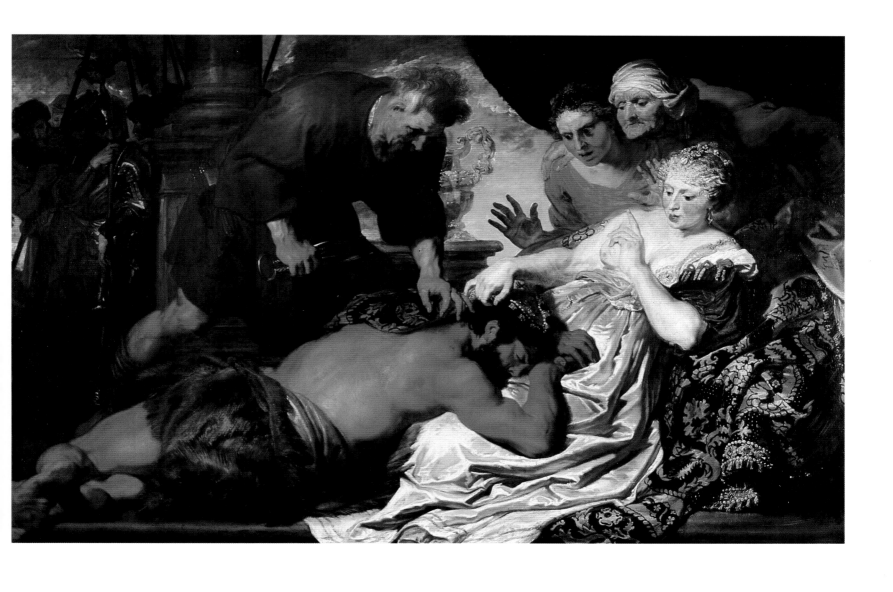

12
Drunken Silenus

c. 1620
monogrammed on the pitcher *AVD*
canvas, 107 x 91.5 (41 3/4 x 35 5/8)

Gemäldegalerie Alte Meister der
Staatlichen Kunstsammlungen Dresden,
inv. no. 1017

PROVENANCE Archduke Leopold
Wilhelm; purchased by the painter
Antoine Pesne for Augustus III;[1] in
inventory of 1722[–1728], no. A79

EXHIBITIONS Tokyo, National Museum
of Western Art, *Meisterwerke der
europäischen Malerei aus der Gemäldegalerie
alte Meister Dresden*, 1974–1975, no. 38,
pl.; Washington 1978–1979, no. 548, ill.;
Ottawa 1980a, no. 68, ill.

LITERATURE Gemäldegalerie Dresden
1765, 65 no. 335; Smith 1829–1842, 3:55
no. 193; Guiffrey 1882, 144, 253 no. 267;
Cust 1900, 14, 44–45, 233 no. 15;
Gemäldegalerie Dresden 1905, 329 no.
1017; Bode 1906, 257; Schaeffer 1909, 54,
ill., 497; Valentiner 1910, 226; Rosen-
baum 1928a, 55, 57; Glück 1931, XXXII, 67
ill., 526; Glück 1933, 286; Van Puyvelde
1941, 182, 183 ill. IIB; Damm 1966,
140–144 no. 30, ill. 9; Van Puyvelde 1950,
43, 47, 67, 123; Vey 1962, no. 99, ill. 139;
Brussels 1965, 60–61, under no. 58;
Roland 1983, 25; Roland 1984, 220, ill. 60;
Gemäldegalerie Dresden 1987, 166 no.
1017, ill., pl. 39; Brown 1982, 27, ill. 18

1. This was contradicted by Woermann
in Gemäldegalerie Dresden 1905.
2. *Metamorphoses* 11, 85–193, as pointed
out in Ulla Krempel's catalogue entry for
Rubens' *Drunken Silenus* [fig. 1] in Alte
Pinakothek 1986, 459. The caption reads:
"Ebrietas mentis membrorumque impedit
usum,/ Sileni ut scite fabula prisca
docet// esaurit nummos, Veneris,
Martisque furores/ Escitat, et mortem
provocat ante diem" (Drunkenness
hampers the use of the limbs and the
intellect, as the old fable of Silenus
recounts; it squanders money, stimulates
the blind passions of Venus and Mars,
and causes premature death). That stern
moralizing message seems not to have
been intended for most of the paintings,
which exhibit a good-natured debauch-

Of Van Dyck's two early paintings of the Drunken Silenus, this version is most
closely related to a group of works that were executed in the Rubens studio in about
1617–1620. A clue to their common textual source comes from the inscription on an
engraving by Schelte à Bolswert after a Rubens drawing, which seems to refer to the
following episode from the Midas story in Ovid.[2] Silenus, foster father and tutor of
the god of the vine Dionysus, lost his way one day in a drunken daze. Found by
Phrygian peasants who crowned him with vine leaves, he was carried to their king
Midas, as we see here. The story continues with Midas' recognition of Silenus, whom
he entertained, then led back to the grateful Dionysus; in reward Midas was granted
the fateful wish that gave him the golden touch.

Rubens' first silenic procession, painted in about 1617–1618, was a half-length
composition on panel showing Silenus flanked by an old peasant woman and faun at
left and a black man and a white man at right. This composition, the source for Van
Dyck's, was enlarged at the bottom and the sides by Rubens in about 1626 to the
form we see today in Munich [fig. 1].[3] A horizontal, three-quarter-length version of
another composition (National Gallery, London) was executed in Rubens' studio in
about 1620 with assistance, including Van Dyck's unmistakable touch in the face of
the satyr just behind Silenus.[4] Still another, the lost painting from Berlin (Glück 1931,
15), which Glück believed Van Dyck had entirely executed from Rubens' *modello*, was
a full-length, horizontal version of the subject based closely on Rubens' first;[5] it
included charming children in the foreground rather than the repellent unconscious
woman later added to that painting.

Van Dyck knew well all of Rubens' Silenuses, some of which he had helped to
paint and one of which [fig. 1] was the model for this composition. Yet in a decidedly
competitive twist, Van Dyck's own *Drunken Silenus* displays a different technique, a
different cast of characters, and an altogether different mood from any of those. The
heavy canvas here whose texture is selectively covered and Van Dyck's fluid,
palpable application of paint contrast with Rubens' smoothly planed and evenly
coated wooden support. Van Dyck's technique recalls other Venetian-inspired works
of his own from 1620–1621, such as *The Betrayal of Christ* [cat. 13] or *Susannah and the
Elders* [cat. 16]. His changes to the characters include giving Silenus the animal legs
that betray his descent from Pan, and depicting him with an unflinching realism that
harks back to the earlier paintings of *Saint Jerome* [cats. 2, 8]. Most important to the
change of mood and meaning he sought was Van Dyck's replacement of Rubens' old
peasant woman with a beautiful bacchante at left, whose long, flowing hair and
wide-eyed gaze hint at the frenzy for which the maenads were known. This
compelling woman, who is the focus of the painting, gives it both a tender and an
erotic dimension. She is at once the caring companion of Silenus, whom she gently
supports, and the willing object of desire of the peasants who accompany them. It
may be a measure of Van Dyck's pride in his painting that he signed it with an

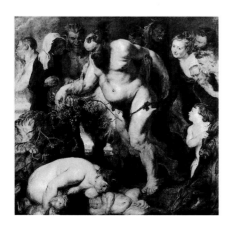

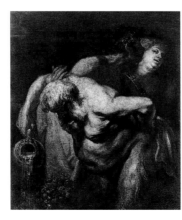

Fig. 1. Peter Paul Rubens, *Drunken
Silenus*, 1617/1618–1626, panel, 205 x 211
(80 3/4 x 83 1/8). Alte Pinakothek, Munich

Fig. 2. Anthony van Dyck, *Drunken
Silenus*, c. 1618, canvas, 133.5 x 109.5
(52 1/2 x 43 1/8). Musées Royaux des
Beaux-Arts de Belgique, Brussels

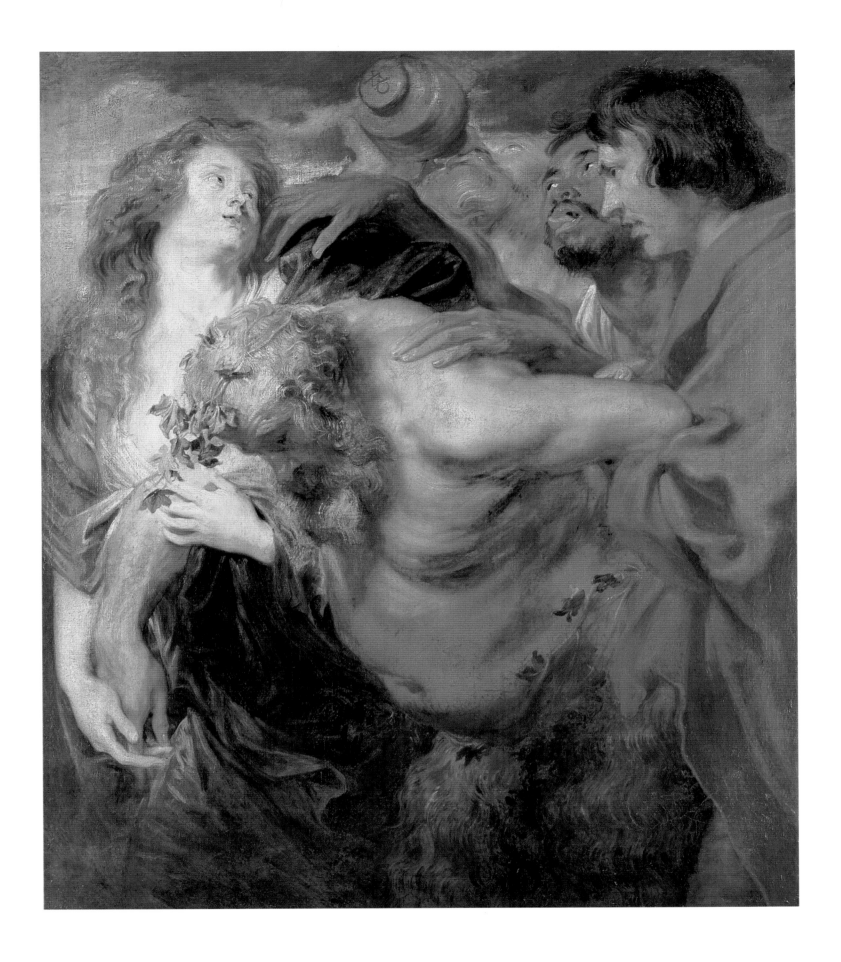

ery. Only the last, the expanded Munich version with prominence given to the prone inebriated woman, stresses the unsavory consequences of drink.

3. Krempel in Alte Pinakothek 1986, 459–460. See also Hubert von Sonnenburg and Frank Praesser, *Rubens: Gesammelte Aufsätze zur Technik* (Munich, 1979), 4, 6, ill. 10.

4. For the attribution history of the painting see Martin in National Gallery London 1970, 217–218.

5. Burchard believed the painting was also Van Dyck's invention (notes, Burchard archive, Rubenianum Library, Antwerp).

6. Roland (1984, 220, n. 67) summarized a century of opinions concisely, save Rosenbaum's, which implied a date at the end of the first Antwerp period.

7. In 1984 Roland repeated the conclusions of her doctoral study (Damm 1966, nos. 30, 31), placing the Dresden *Silenus* two years before the version in Brussels, which she dates 1621. Although Prof. Roland is certainly correct in moving the Brussels painting toward 1620 from the early date that Glück implied by grouping it with the Louvre *Saint Sebastian* and the Liechtenstein *Saint Jerome*, the Dresden picture's advances over it, discussed here, leave no doubt which came first.

8. Vey 1962, no. 99, ill. 139.

interlocked monogram, wittily placed on the bottom of the upturned jug as if it were a potter's mark.

In previous generations there was considerable disagreement about the date of the painting and its chronological relation to the version in Brussels [fig. 2].[6] With the exception of Roland, all current scholars agree that the Brussels version was first, and that the present one falls c. 1620–1621.[7] Everything in this poignant and masterful painting speaks for such a conclusion. Technically it is a brilliant display; the paint seems to have flowed effortlessly from Van Dyck's brush, here in thick marks that give light and texture to Silenus' head, there in evanescent washes that suggest drapery in the shadow. Beneath the discolored varnish that covers the painting, the palette is finely modulated to include a whole spectrum of greens: some pure, some mixed with blue to near iridescence, and others with silver or gray. These colors are closest to those (also masked by heavy varnish at present) in the Prado *Betrayal of Christ*, giving further support to the date of 1620–1621. Most telling for the date, however, is Van Dyck's refinement and focus of emotional content, conveyed here as in *The Continence of Scipio* [see cat. 22, fig. 2] and the Edinburgh *Saint Sebastian Bound for Martyrdom* [cat. 22] through sensitively conceived and captured hand gestures and facial expressions. In the present painting, they link the tightly grouped figures in a sinuous embrace.

On a lost sheet of studies, known from a copy in Braunschweig, Van Dyck sketched a preliminary compositional design for the *Drunken Silenus*.[8] The painting was engraved by Schelte à Bolswert and Franciscus van Steen.

S. J. B.

Bulletproof your systems before you are hacked

The Hardening series shows you how

Hardening Windows® Systems
Roberta Bragg
0-07-225354-1
$39.99

Hardening Linux
John H. Terpstra, Paul Love, Ron Reck,
Geoff Silver, Tim Scanlon
0-07-225497-1
$39.99

Hardening Network Infrastructure
Wesley J. Noonan
0-07-225502-1
$39.99

Hardening Code
Nishchal Bhalla & Kartik Trivedi
0-07-225651-6
$39.99

OSBORNE DELIVERS RESULTS!

McGraw Hill Osborne
www.osborne.com

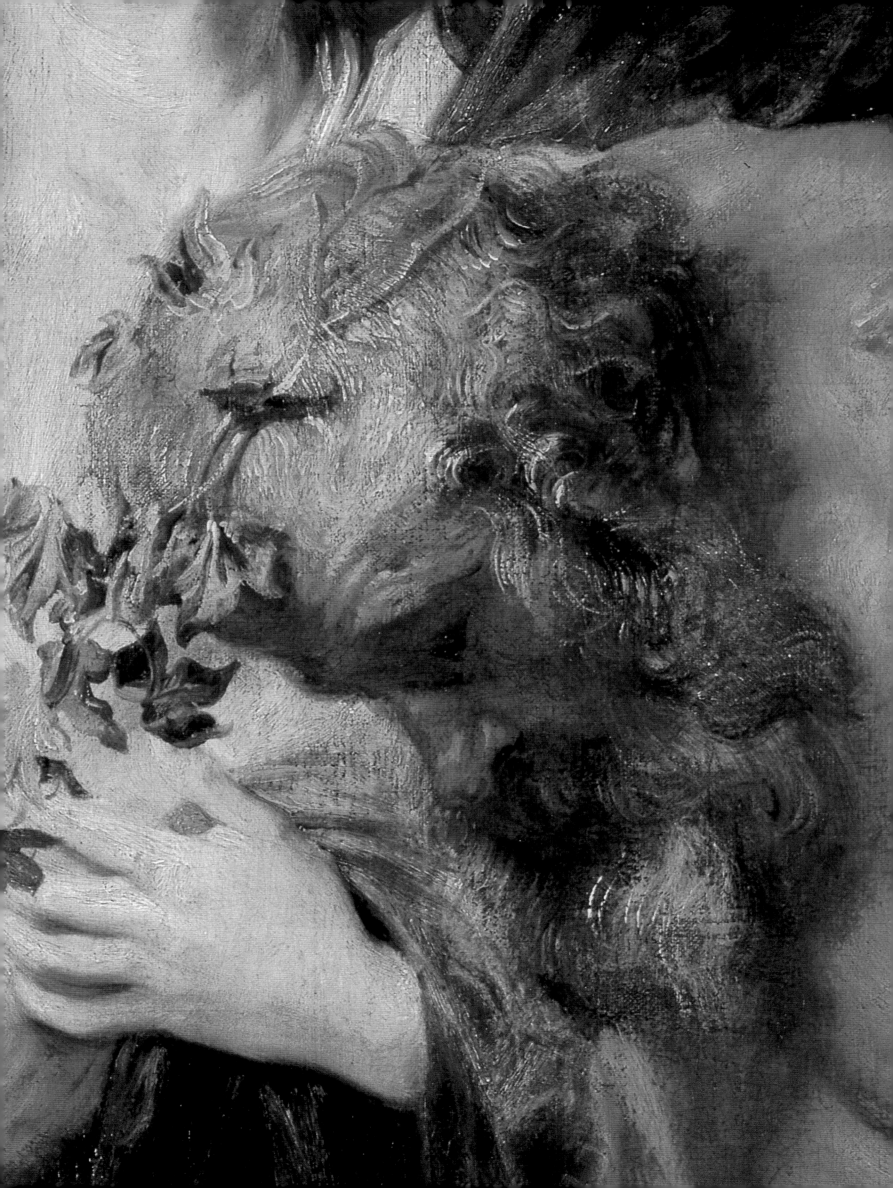

The Betrayal of Christ

c. 1620
canvas, 141.92 x 113.03 (55⁷/₈ x 44¹/₂)

Lent by The Minneapolis Institute of
Arts, The William Hood Dunwoody,
Ethel Morrison Van Derlip, and John R.
Van Derlip Funds, inv. no. 57.45

PROVENANCE Lord Egremont by 1896;¹
sold in that year to Sir Francis Cook,
Bart., Doughty House, Richmond,
Surrey; purchased through Rosenberg
and Stiebel, New York, 1957

EXHIBITIONS Antwerp 1899, no. 10;
London 1900, no. 85; The Toledo
Museum of Art, *Masterpieces from the Cook
Collection*, 1944–1945, no. 250, ill.; London
1953–1954, no. 218; New York, Knoedler,
*Masters of the Loaded Brush, Oil Sketches
from Rubens to Tiepolo*, 1967, 73–75, no. 53,
ill. 53; Princeton 1979, no. 24, ill.; Ottawa
1980a, 20, no. 45, ill. 45

LITERATURE Hymans 1899a, 230;
Hymans 1899b, 418–419; Cust 1900, 31,
208 no. 10, 221 no. 85, 237 no. 4;
Friedländer 1900, 169; Bode 1906, 261;
Schaeffer 1909, 39 ill.; Rosenbaum 1928a,
65–66; Glück 1931, XXXII, 71 ill., 527;
*Abridged Catalogue of the Pictures at
Doughty House, Richmond, Surrey, in the
Collection of Sir Herbert Cook, Bart*
(London, 1932), 35 no. 250; Delâcre 1934,
63, 70, ill., 83–85; Pierre Bautier,
"Tableaux de l'école flamande en
Roumanie," *Revue Belge d'Archéologie et
d'Histoire de l'Art* 10 (1940), 45; Vey 1956,
168, 169 ill. 1, 203, n. 7; Vey 1958, 180,
196–197, 202, n. 5; Stechow 1960, 4–17,
ill. 1; Minneapolis Institute 1970, no. 75,
ill.; Brown 1979, 145 ill. 3; Brown 1982,
39; Keyes 1983, 196–197, ill. x; Martin
1983, 41 ill. 9; Barnes 1986, 1:27, n. 9, 29
n. 14, 33 n. 30

1. Stechow (1960, 15–16 n. 1) has refuted
the connection with the painting in
Smith 1829–1842, 3:5 no. 17, which

Bearing torches, spears, and swords, a tumultuous band of soldiers and citizens surges through the moonlit night, storming the garden of Gethsemane. The swelling crowd has come to capture Christ, whom Judas, draped in treacherous yellow, identifies with an embrace. In the left foreground beside an overturned lamp, the apostle Peter lunges over the prone Malchus, the servant of the high priest, and cuts off his ear with a sword. The blazing torch held aloft by a red-faced young man illumines faces and bodies twisted with fury. Frenzied arms flailing ropes reach out and up to seize Jesus. He, having passed the night in the garden wrestling with his destiny, stands serenely resigned in face of the traitor and the throng.

Van Dyck has depicted the betrayal and arrest of Christ according to the Gospel of John 18:1–12, who alone described "a band of men and officers from the chief priests and Pharisees ... with lanterns and torches and weapons" and named Peter as the assailant of Malchus.² This large but very sketchy oil is surely, as is generally agreed, the first of three versions Van Dyck painted of this subject at the end of his first Antwerp period.³ Very close to it in configuration is the monumental canvas in the Prado [fig. 1] that Philip IV purchased from Rubens' estate. More than twice the size of this, it is also extended vertically in format so that the trees fill nearly half the picture and tower over the figures. Below, the crowd is arranged nearly identically in the two versions, with the exception of Peter and Malchus, who in the Prado version are turned so that the thrust of their movement conforms with that of the group behind. Because of the close similarities between the two paintings, the Prado picture has been thought to follow the present one directly, leaving the third version, at Corsham Court [cat. 14], for last. The sequence of the three is not so evident, however, and is discussed in the entry for the Corsham version.

Vey among many remarked that the brilliant, seemingly spontaneous execution here demonstrates a "furia del pennello" reminiscent of very late Titian or of Tintoretto. Such technical freedom on a large scale, unprecedented in Flemish painting before the young Van Dyck and extraordinary even for him, belies the thoughtful preparation of the subject attested by many preparatory drawings, including six surviving compositional studies.⁴ Van Dyck's first drawing (Kupfer-stichkabinett, Berlin), which may be separate from the studies for the paintings, was reproduced in a print by Soutman. Horizontal in format, it depicts Christ, dejected after his capture, bound and brought along in a procession. In the remaining drawings, which all seem related to the paintings, the narrative moment shifts to the climactic instant before Christ's arrest. The last-known of these [fig. 2], in pen and

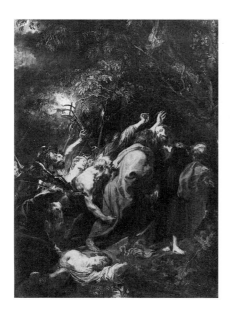

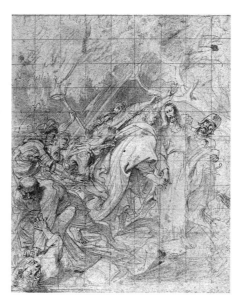

Fig. 1. Anthony van Dyck, *The Betrayal of
Christ*, c. 1620, canvas, 344 x 249
(135³/₈ x 98). Museo del Prado, Madrid

Fig. 2. Anthony van Dyck, *The Betrayal of
Christ*, c. 1620, chalk, reworked with pen
and chalk and squared in chalk,
53.3 x 40.3 (21 x 15⁷/₈). Hamburger
Kunsthalle, Hamburg

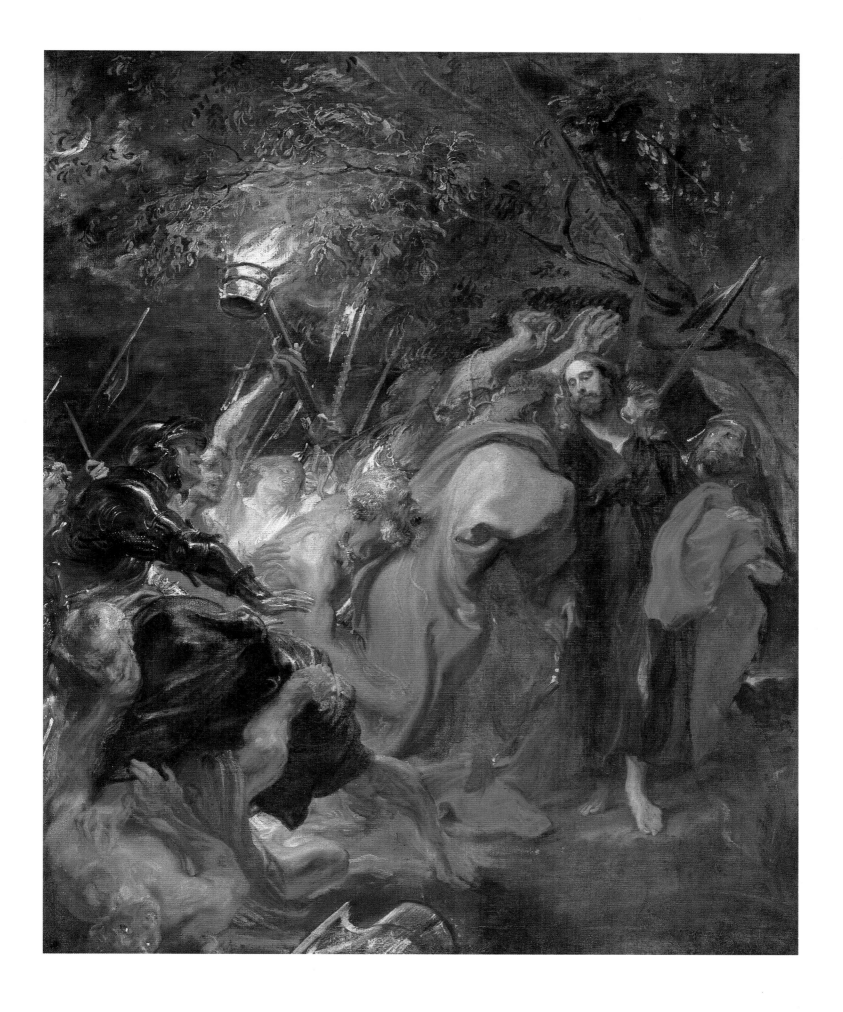

belonged to Chevalier S. Erard, and was part of his Paris sale in 1832, noting that the Erard painting as catalogued for the sale was much larger (about 265 x 227 cm) than the Minneapolis version, and its description matched the Prado version.

2. As noted by Stechow 1960, 5.

3. There are two dissenting voices: Delâcre thought the Prado version was the first (1934, 84), as Vey believed the Corsham picture to be (1958, 180, and in all his subsequent writings). Larsen suggested the present painting is a reduction of the Prado painting.

4. First described and discussed as a group by Delâcre, the drawings were catalogued and studied carefully by Vey (1958). See also discussions in Stechow 1960, Vey 1962, nos. 62, 79–86, Princeton 1979, 103–113, and Ottawa 1980a, 100–107.

5. In Princeton 1979, 106.

6. Glück 1931, 527; Martin 1983, 41.

7. As Keyes recently suggested.

8. In Ottawa 1980a, 108.

9. Vey 1958, 180.

10. See Bautier 1940.

11. Ann Tzeutschler Lurie, "Jacob Jordaens' *The Betrayal of Christ*," *Bulletin of the Cleveland Museum of Art* (March 1972), 71.

chalks and squared for transfer, is usually called the *modello* for the painting. The many small changes between the drawing and painting suggest, however, that the drawing was only an outline that Van Dyck fleshed out in form and content on the canvas. The changes include: the completion of the landscape, additions and deletions to the background figures and their weapons, alterations in the poses of Peter and Malchus, and the replacement of the beardless hatted type just to the left of Judas with a model resembling that for Saint Jerome. Although the figure types are tall and lean, many of the people also have broader faces and more substantial bodies in the painting than in the drawing; this is most important in Christ, who gains in presence considerably thereby.

Martin and Feigenbaum noted that Van Dyck diverged from traditions of pictorial iconography for the Betrayal in his preparatory studies: for example, in the Louvre drawing, he followed the account in the synoptic gospels rather than visual precedents, by showing the disciples asleep at the time Christ is taken.[5] Stechow pointed out Van Dyck's debts to Dürer's Passion cycles and to three drawings by Marten de Vos for his final interpretation. The most striking comparison among these is the pen and wash sheet, signed by De Vos [fig. 3], which influenced both the Minneapolis and Prado versions in the overall scheme, in the pose and expression of the Christ-Judas group, and in accessory figures such as the Düreresque man in armor at left. Van Dyck seems to have returned to the same sheet for inspiration when he sought to change the Peter-Malchus group in the Prado version. In addition to earlier northern sources, Van Dyck included figures from contemporary paintings, too. His own *Saint Jerome* (Glück 1931, 68), as mentioned above, and *Judas Thaddeus* (Glück 1931, right) flank Christ; and Rubens' prostrate figure in the foreground of *The Miracles of Saint Ignatius* (Kunsthistorisches Museum, Vienna) reappears as the wretched Malchus.[6]

Notwithstanding this Netherlandish ancestry, Van Dyck's *Betrayal of Christ* has a marked north Italian appearance. Roughhewn peasant types suggest a Caravaggist naturalism that Van Dyck had adopted in his earliest religious paintings [cats. 2, 3], and here it is matched with Caravaggist chiaroscuro. The tenebrism also recalls the late Titian or Tintoretto, as does the heavily textured canvas across which paint is broadly, dryly applied. Other paintings that share these qualities can be grouped in the same period of 1619–1621: two like versions of *Saint Sebastian* (Alte Pinakothek, Munich; Chrysler Museum of Art, Norfolk); *Susannah and the Elders* [cat. 16]; and the two versions of *Drunken Silenus* (Musées Royaux des Beaux-Arts de Belgique, Brussels; [cat. 12]).

Their strong Italianate traits led Glück to assign many of those paintings to Van Dyck's Italian years, but not *The Betrayal*.[7] Martin and Feigenbaum were correct that Glück's implied placing of the pictures between March and October 1621 is generally accepted, but only the Prado version indisputably warrants such a date, with its unprecedented mastery of scale, composition, and color. The Minneapolis and Corsham versions would not have come much earlier, probably within a year, but we have seen how much a few months could mean in Van Dyck's early development.

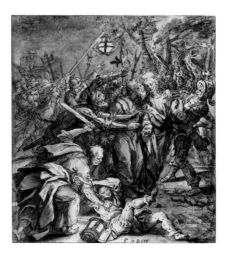

Fig. 3. Marten de Vos, *Betrayal*, pen and wash. Musées Royaux des Beaux-Arts de Belgique, Brussels

No consensus has emerged on the original function of this version, because of its unique combination of qualities. Stechow summarized the dilemma: it is too sketchy to have been a traditional presentation *modello*; too large and complete to have been made as an artist's working sketch; and too bold and advanced in technique for one to imagine it commissioned as an independent painting in 1620 Antwerp. McNairn maintained it was the *modello* for the Prado canvas.[8] Vey was closer when he called it a preparatory painterly experiment, a "private work."[9] Martin and Feigenbaum reminded us of Van Dyck's youthful tendency to make two versions of a subject, one sketchy and the other more finished.

The focus on finish can be misleading, particularly because Van Dyck's early œuvre embraces a wide range of techniques and "finish," even in portraiture [see cats. 4, 5, 9], which sets him apart from his contemporaries in Antwerp. Moreover, the question of finish is bound up with function and with patronage, two areas about which we know little, particularly for Van Dyck's history paintings. In fact, of the dozen paintings that comprise the versions of *The Betrayal of Christ, The Crowning with Thorns, The Martyrdom of Saint Sebastian,* and *Saint Martin and the Beggar,* we have the original location for only one—*Saint Martin and the Beggar* at Saventhem. Those that came from Rubens' estate have been assumed, without supporting evidence, either to have been commissioned by him or to have been gifts from Van Dyck. Some could have been made for the open market, however, and left for sale with Rubens' own stock to the many collectors who visited Rubens' studio. The greater smoothness and finish of the Corsham and Prado versions of *The Betrayal* are often faulted, by modern writers, when compared with the boldness of the present painting. If we put aside the prejudices of our own time, however, we recognize those qualities as less radical challenges to established taste in 1620 Antwerp.

A copy of the present painting, which was shown *hors catalogue* in Princeton 1979, is currently on the art market in New York. Another weaker painted copy was once with the king of Romania.[10] Jacob Jordaens' drawn copy in chalk, pen, watercolor, and body color (Mr. and Mrs. Michael Jaffé, London) was a source for his own much later painting of the subject.[11]

<div align="right">S. J. B.</div>

14
The Betrayal of Christ

c. 1620

canvas, 274 x 222 (106⁷/₈ x 86¹/₂)

City of Bristol Museum and Art Gallery

PROVENANCE Possibly Alexander Voet, Antwerp (inventory 1689); purchased by Sir Paul Methuen (1672–1757) in 1747 for £100 from George Bagna (the receipt, dated 22 May 1747, exists at Corsham), Grosvenor Square, London; in 1757 inherited by his cousin and godson, Paul Methuen (1723–1795), who had bought Corsham Court in 1745; moved from Grosvenor Square to Corsham, c. 1761; inherited by his son, Paul Cobb Methuen (1752–1816); acquired in lieu of duty after the death of the 4th Lord Methuen in 1984

EXHIBITIONS London, British Institution, 1857, no. 12; London 1877, no. 109; London 1887, no. 125; Antwerp 1899, no. 9; London 1900, no. 30; Washington 1985–1986, no. 264, pl.

LITERATURE Britton 1801, 289; Smith 1829–1842, 3:5, no. 16; Waagen 1838, 3:102–103; Waagen 1857, 395; Guiffrey 1882, 31, 247 no. 92B; Lord Methuen, *Corsham Court* (Corsham, 1891), no. 274; Hymans 1899a, 230; Cust 1900, 30–31, 67, 68 (opp.), ill., 205 no. 125, 208, no. 9, 218, no. 30, 247, no. 12; Friedländer 1900, 169; Lord Methuen, *Corsham Court* (Corsham, 1903), no. 227; Bode 1906, 260; F. M. Haberditzl, *Kunstgeschichtliche Anzeigen* (1909), 62; Schaeffer 1909, 38 ill., 496; Rosenbaum 1928a, 66; Vertue 1930–1955, 2:10–11;[1] Glück 1931, XXXII, 70 ill., 527; Delâcre 1934, 83; Tancred Borenius, *A Catalogue of the Pictures at Corsham Court* (London, 1939), 68–69 no. 119, ill. 1; Pierre Bautier, "Tableaux d'école flamande en Roumanie," *Revue Belge d'Archéologie et d'Histoire de l'Art* 10 (1940), 45; Lord Methuen, *An Historical Account of Corsham Court, The Methuen Collection of Pictures and the Furniture in the State Rooms* (Corsham Estates, 1958), 6; Vey 1958, 180, 197, 201, n. 3, 201–204, no. 4; Antwerp 1960, 79–82; Stechow 1960, 14, ill., 12, 16 n. 7; Princeton 1979, 102 ill. 25; Brown 1982, 39 ill. 29; Keyes 1983, 196; Martin 1983, 41, n. 14; *A Catalogue of the Pictures at Corsham Court* (Corsham, 1986), VIII

1. "At Sr. Paul Methuens ... a fine painting on stained Cloth in (guazzo) or size colour, our Saviour before Pontius pilate. the Perspective composition. good. but the Out lines & Airs of heads prodigious fine. & Natural of good tast."
2. Vey 1958, 201 n. 4.
3. In Princeton 1979, 102.

Paradoxically, this version of *The Betrayal of Christ*, long known and referred to in monographs and studies on Van Dyck, has rarely been seen outside Corsham Court and never discussed at length in the literature. Cust knew the painting and published it as a later reworking of the subject, after Van Dyck returned from Italy. Its authenticity was then questioned by Haberditzl and Rosenbaum, who had not actually seen it. Nor had Glück or Stechow, though they both defended it. Cust and his generation were the last to see the picture exhibited with others by the artist, when it was lent to the great tercentenary celebrations in Antwerp and London at the turn of the last century. It has left Corsham Court only once since, to represent grand tour Augustan collecting taste in *Treasure Houses of Britain* at the National Gallery of Art, Washington, in 1985. Five years later it is reunited with other masterpieces from Van Dyck's œuvre, including the first version of the subject.

Larger in size than that sketchy painting in Minneapolis [cat. 13] whose early collection history is unknown, yet smaller than the monumental version [see cat. 13, fig. 1] that went to Spain from Rubens' estate, this painting may well be the "autaerstuck" of *The Betrayal* listed in the 1689 inventory of Alexander Voet in Antwerp.[2] We ignore whether this work, whose size and format are appropriate for an altarpiece, was actually painted as such, or whether the term "autaerstuck" was just meant to suggest its large size. Vey doubted that the painting was intended for a private collection.

The significant differences in finish and in composition between this version and the other two, specifically the elimination of the group of Peter and Malchus, have led specialists to separate them in time. Cust put it nearly a decade later than they. Although everyone now agrees that all three fall in the same period, Vey, who first spoke to the subject of their sequence in recent times, believed this to be the first version. When Stechow studied the Minneapolis painting thoroughly, he discussed the other versions in passing. Not having seen this one, he raised with circumspection the questions of its order within the versions and its date. His strong suggestion that it was the last was echoed by Martin and Feigenbaum.[3]

Stechow's reasoning is clear, concise, and compelling. The Minneapolis painting follows the scheme laid out in the squared Hamburg drawing [see cat. 13, fig. 2], with only small changes. These were carried over into the Prado painting, a more resolved stage of creation that includes the reconfiguration of the Peter and Malchus group better to conform with the rest of the composition. The revised poses for Peter and Malchus, based on northern models including Dürer and Marten de Vos [see cat. 13, fig. 3], had been worked out through intervening figure studies that survive. In the Corsham version Van Dyck eliminated the Peter and Malchus group entirely, making a more balanced, tightly framed, and concentrated composition. Stechow concluded that such a departure from the other paintings and from the surviving studies must stand apart from and follow them.

Tempting as such a conclusion may be, we know very little about Van Dyck's methods and purposes in making multiple large-scale versions of the same subject. This practice, peculiar to his early career, was concentrated in the years around 1619–1621. In addition to three versions of *The Betrayal of Christ*, we have two known versions each of *Saint Martin and the Beggar* (Saventhem; Windsor) and *Christ Crowned with Thorns* (Berlin [destroyed]; Prado, Madrid), and three different interpretations of *Saint Sebastian Bound for Martyrdom* [see cat. 22]. No systematic study of these pictures as a group has been undertaken, nor have surviving versions been brought together. Even without such a study it is apparent that no generalization applies. For example, while the *Saint Sebastian* types are nearly identical in size and configuration, with one being more sketchy than the other, there are significant compositional changes between the two *Saint Martins* and the two *Crowning with Thorns* versions. Pentimenti in the Prado *Crowning with Thorns* show that Van Dyck repeated the standing soldier at left from the Berlin painting, and then painted him out entirely. In short, however

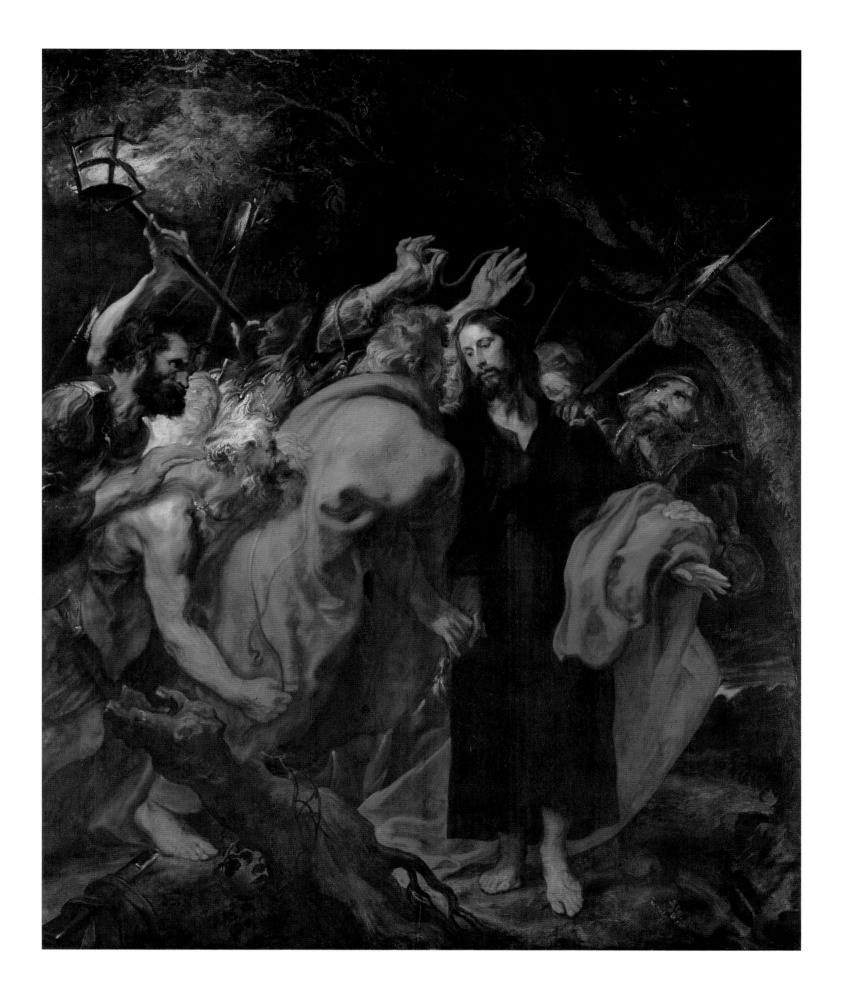

commanding or "finished" they may appear to be, as the Prado *Crowning with Thorns* indeed seems, each is potentially a stage in an ongoing process. Van Dyck seems to have moved between these large-scale paintings almost with the same freedom and experimentation that he might had they been drawings.

The present exhibition permits a comparison between two versions of *The Betrayal of Christ* that may help us better understand their relation to one another. In the meanwhile, along with the suggestions advanced by Vey and Stechow, we should keep open the third alternative for the present painting, namely that Van Dyck made it between the other two. Although Stechow stated that most of the details here conform to the Minneapolis and Madrid versions, they actually are closest to the Minneapolis painting and to the Hamburg drawing. Apart from the elimination of the deep foreground and the replacement of Peter's leg with the tree stump, moving from right to left in the paintings the compositions are identical up to the "Saint Jerome" type behind Judas. There the composition is stopped, leaving Christ and Judas nearly at the center. The face of the blond young man holding the torch is brought more closely in; the swarthy, bearded soldier is added to balance the leering helmeted man at right. For Christ himself, here as in the Minneapolis painting, his extended left foot makes him seem weightless; in the Prado version, that foot is planted firmly. Christ's face here resembles neither of the other painted versions, but has the longer, finer, more ascetic look of the Hamburg drawing.

Whenever the present painting was made relative to the others, Van Dyck sought to create a mood and focus different here from that in the Minneapolis and Prado versions. There he contrasted extremes, pitting the large frenzied mob and the struggling Peter and Malchus, rendered in brilliant chiaroscuro and palpable surface lights, against the smoothly clad immobile pair of Judas and Christ. The Corsham painting, on the other hand, represents a reduction and simplification of the scene, which focuses the drama on the confrontation of the two principal players. Although twice the size of the Minneapolis version, it contains fewer figures. They are more tightly framed, and loom larger within the space. A gnarled tree stump now serves as a *repoussoir* in place of the distracting conflict of Peter and Malchus. Other peripheral action from the crowd has been eliminated or condensed. The scene is more evenly illumined and more smoothly painted. Christ and Judas have been brought closer to the viewer. They now dominate the composition completely by their size, their central placement, and the large unbroken areas of color in their costumes. All eyes, all activity now revolve around Christ in the moment of betrayal.

S. J. B.

15
Moses and the Brazen Serpent

1620–1621
canvas, 205 x 235 (80 x 91⅝); strips have
been added to the top and bottom, and it
appears that the canvas was trimmed on
the right side[1]

Museo del Prado, Madrid, inv. no. 1251

PROVENANCE In the Spanish Royal
Collection by 1666 (inventory, as Rubens)

LITERATURE Guiffrey 1882, 38
(reattributed to Van Dyck); Hymans
1899a, 228; Max Rooses, L'Oeuvre de
Rubens (Antwerp, 1886), 1:141–142 (as by
Van Dyck); Cust 1900, 13, 232 no. 1;
Adolf Rosenberg, P. P. Rubens (Stuttgart
and Leipzig, 1905), 180 ill. (as Rubens);
Bode 1906, 263 (as Van Dyck); Schaeffer
1909, 25 ill., 496; Rosenbaum 1928a, 65;
Glück 1931, XXXII, 73 ill., 527; Glück 1933,
26, 161, 306, 390; Antwerp 1949, 47
(under no. 73); Vey 1958, 152–177;
Antwerp 1960, 60–63 (under nos. 23, 24,
25); Vey 1962, 111–119; Prado 1975, 81
no. 1637, ill.; Ottawa 1980a, 12, 265, 287,
ill. 42; Brown 1982, 45, pl. 36

1. These alterations could explain the
discrepancy among inventory measure-
ments before and after the Alcázar fire
of 1734.
2. See Delâcre 1934, Vey 1962, Ottawa
1980a.
3. See Egbert Haverkamp-Begemann and
Carolyn Logan, Creative Copies. Inter-
pretative Drawings from Michelangelo to
Picasso [exh. cat. The Drawing Center]
(New York, 1988), 87, 89.
4. The first drawing was lost in the
Second World War from the Kunsthalle,
Bremen (Vey 1962, 1:113, 2: fig. 59). The
second is in the Musée Bonnat, Bayonne
(Vey 1962, 1:116, 2: fig. 62).
5. In Ottawa 1980a.
6. J. B. Knipping, Iconography of the
Counter-Reformation in the Netherlands:
Heaven on Earth (Nieuwkoop, 1974).
7. According to Díaz Padrón in Prado
1975, Conde de Maule (Viaje de España,
Francia, et Italia, 11:20) had recognized
Van Dyck's hand even before Guiffrey
did.
8. Radiographs revealing the presence
of a Netherlandish type of the Trinity
Crowning the Virgin of the Apocalypse
beneath the copy suggest it was made
before the original left Flanders. I am
grateful to Pietro Marcheselli, whose
research on this painting brought the one
beneath it to light, and to Suzanne
Stratton for sharing her expertise on
scenes of the Virgin.

The rays of light and hornlike wisps of hair on the head of one of the men at left identify him as Moses. From the right, afflicted people surge and stumble together toward the tree whose broken branches support a metal serpent. The Book of Numbers 21:4–9 tells how God sent a plague of serpents to attack the Israelites who had become disaffected on their arduous journey across the desert. When, bitten and dying, they repented to Moses and pleaded for help, the Lord told Moses to set up a pole with a bronze serpent upon it; all those who beheld it would be cured of their wounds.

Eleven surviving drawings on nine sheets show the evolution of Van Dyck's ideas in creating this composition.[2] His point of departure was Rubens' somewhat smaller vertical painting on panel from about 1610 [fig. 1], from which he retained the elongated, wiry figures and a palette of clear, strong colors. Van Dyck's final rendition, in a horizontal format in oil on canvas, is a rather different interpretation, however, that incorporates his response to other Netherlandish and Italian artistic sources and may possibly contain a message timely in the Counter-Reformation.

Michelangelo rendered this Old Testament tale, with its dense web of writhing, heroically muscled bodies, on a spandrel above the Last Judgment on the Sistine Chapel ceiling. That famous work had inspired many painters including Palma Giovane, Tintoretto, Marten van Heemskerk, and Frans Floris by the time Rubens visited Rome and made his variant drawing after the fresco (British Museum, London).[3] Shortly after returning from Italy to Antwerp, Rubens painted the subject, still with a strongly Michelangelesque character, but structured to conform with the narrative clarity that the Council of Trent had mandated in reaction against the kind of paintings made by his predecessors.

Besides Rubens' drawing after Michelangelo and his painting, which Van Dyck clearly knew, other important works of art informed Van Dyck's preparatory drawings and his painting of the Brazen Serpent. Vey noted that the figure group in one of Van Dyck's studies quotes a detail from Raphael's Death of Ananias, while in another we see figures from Rubens' variant painting of Caravaggio's Entombment.[4] Most of the drawings were executed in pen or brush with ink washes and concerned the configuration of the large group of Israelites, with a suggestion of the overall composition. Despite the many changes between the drawings, including several characteristic reversals of direction, some salient features of the final scheme were set in the first surviving study, a pen and ink drawing in Rotterdam [fig. 2]. There Van Dyck established the horizontal format and the asymmetrical nature of the composition, placing the serpent at one end, and he introduced the man who rushes toward the serpent with outstretched arms, the gesture that gives such forceful movement to the scene. Since none of the drawings includes the dark-haired woman at right for whom we have the only surviving individual figure study [fig. 3], McNairn suggested that the ultimate compositional sketch is lost.[5] Such a work might have been squared up, as were the final drawings for The Betrayal of Christ. A stirring oil sketch in Vienna [see cat. 89, fig. 1], which could be taken for Mary Magdalen, depicts the head of the blond woman fallen to her knees at right.

Van Dyck carried out his final design on a smoothly prepared canvas, with bravura and economy of means, using the richly varied palette of colors he preferred in 1620–1621, including purple, peacock blue, salmon, and assorted other blues and greens. Some foreground figures and drapes he painted thickly, though in one passage with material so fluid that it came down in rivulets still visible in the lower right corner; other areas, such as the faces in the background, he lightly sketched with the brush against the pale gray ground. Van Dyck's choice of a long, lean figural canon strongly links his Brazen Serpent with Rubens' own, and with other paintings by the master from about 1610. Certain compositional features, however, show Van Dyck's deep familiarity with the paintings that Rubens was designing in 1616–1620 and producing with the help of his young assistant. The shallow space and friezelike arrangement of figures on a stone ledge owe to Abraham and Melchisedek (Musée des

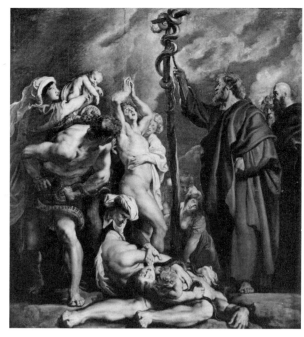

Fig. 1. Peter Paul Rubens, *Moses and the Brazen Serpent*, c. 1609–1610, panel, 159 x 144 (62 5/8 x 56 5/8). Courtauld Institute Galleries (Princes Gate Collection), London

Fig. 2. Anthony van Dyck, *Study for the Brazen Serpent*, pen and ink with wash over chalk, 21.1 x 26.2 (8 1/4 x 10 1/4). Museum Boymans-van Beuningen, Rotterdam

Fig. 3. Anthony van Dyck, *Woman with Outstretched Arm*, c. 1620, chalk, 45.8 x 28.5 (18 x 11 1/4). Statens Konstmuseer, Stockholm

Fig. 4. After Van Dyck, *Moses and the Brazen Serpent*, canvas, 141 x 210 (55 x 81). Private collection

Beaux-Arts, Caen), for instance, and recall *Emperor Theodosius Refused Entry into Milan Cathedral*, of which Van Dyck made a variant [cat. 10]. The pose of the woman at far right repeats that of the Franciscan supporting the kneeling Saint Francis in Rubens' *Last Communion* (Koninklijk Museum voor Schone Kunsten, Antwerp), as Vey noted. The same picture shows the overlapping heads of people tightly grouped and aligned to give diagonal thrust leading to the main point of pictorial focus, just as they are in Van Dyck's *Brazen Serpent*.

From the Middle Ages on, the story of the Brazen Serpent had been understood as a prefiguration of the Crucifixion, based on a reference in the Gospel of John 3:14. According to Réau, the double entendre by which the serpent of the Fall becomes the serpent of redemption lay behind the popularity of the subject in visual art well into the Renaissance. Rubens made this symbolism rather explicit, wrapping the serpent around a cruciform staff. Van Dyck, whose inscription "Ave Maria gratia plena," written on a sheet of studies for the painting (ex-Kunsthalle Bremen, destroyed in World War II), suggests his own association of the tale with Christian faith conveyed principally through the gestures and attitudes of the Israelites. In that regard we may recall his using figures from a *Deposition* as a source. Unlike others who painted the scene, Van Dyck depicted no people who continue to suffer or who have died. All of them come to embrace salvation; the sense of redemption received is palpable in the upturned face of the blond woman being carried toward the staff. Knipping asserted that Flemish artists in this period had considerable freedom in interpreting sacred stories, which would particularly apply if no patron were involved, as seems likely here.[6] It is tempting to speculate that in the waning days of the Twelve Years' Truce the devout young Van Dyck, whose homeland had been rent by the Protestant defection, meant also through this scene of reconciliation with the Almighty to encourage the faithless to return to the fold.

The early history of the painting is unknown. Although it is large enough for an altarpiece, the horizontal format makes that unlikely. Its appearance as early as 1666 in Spain suggests that Van Dyck painted it for the open market. Rubens was credited with the authorship of the picture in the 1666 inventory, when it hung in the Alcázar, and thenceforth until Guiffrey correctly gave it to Van Dyck; Rooses soon concurred.[7]

When the false inscription "P.P. Rubens F.ct." was added to the ledge at bottom right is uncertain, but it does not figure in a recently discovered copy [fig. 4], apparently made in Flanders in the seventeenth century; the copy also seems to show the extent of the composition before the right side was trimmed to eliminate the face of the person whose upstretched arm remains.[8]

S. J. B.

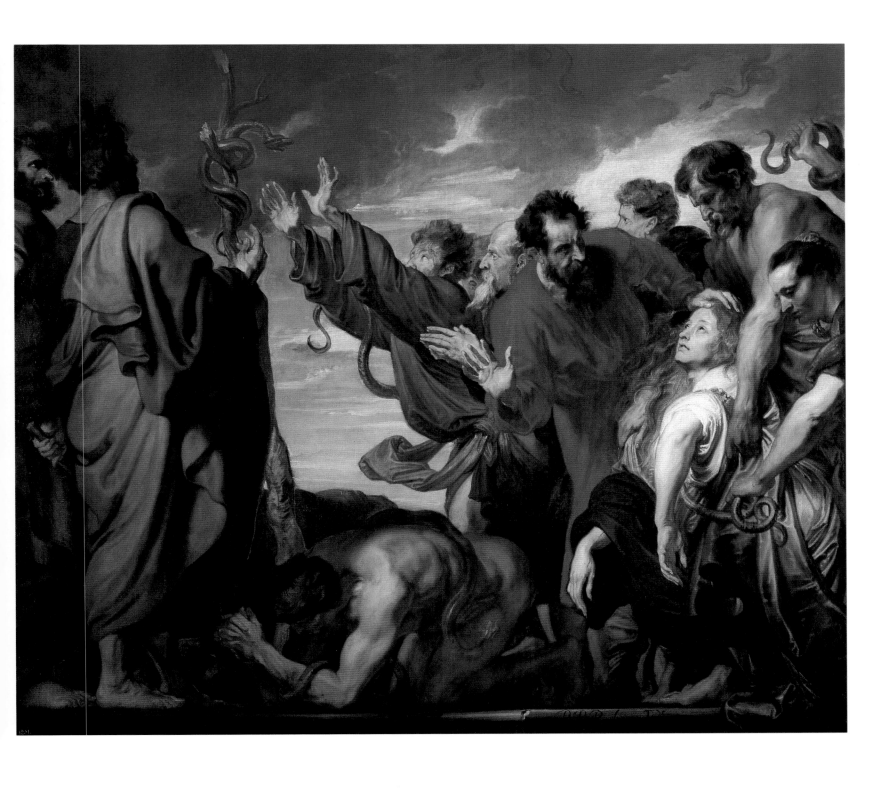

16
Susannah and the Elders

1620–1621
canvas, 194 x 144 (75 5/8 x 56 1/8)

Bayerische Staatsgemäldesammlungen,
Munich, inv. no. 595

PROVENANCE Collection Elector Johann
Wilhelm of the Palatine (ruled
1690–1716), Düsseldorf Gallery; in 1836
from the Hofgarten Gallery to the Alte
Pinakothek

EXHIBITIONS Amsterdam 1948, no. 46, ill.
67; Genoa 1955, no. 13, ill.

LITERATURE Van Gool 1750, 2:554;
Smith 1829–1842, 3:22, no. 69; Horace
Walpole, *Anecdotes of Painting in Italy*, ed.
Rev. James Dalloway (London,
1826–1828), 2:195–196; Cust 1900, 12, 232,
no. 2; Bode 1906, 264; Schaeffer 1909, 26,
ill.; Rosenbaum 1928a, 55, 60; Glück
1931, XXXV–XXXVI, 135, ill., 534; Glück
1933, 286; Alte Pinakothek 1974, 95;
Brown 1982, 98, ill. 89; Alte Pinakothek
1986, 187–188, no. 595, ill., pl. 7; Larsen
1988, no. 473, ill. 145, pl. 8

1. Although this need not be the case, as
Elizabeth McGrath has shown in her
illuminating article, "Rubens's *Susanna
and the Elders* and Moralizing Inscriptions
on Prints," in *Wort und Bild in der
niederländischen Kunst und Literatur des 16.
und 17. Jahrhunderts* (Erftstadt, 1984),
81–85, Rubens' two different prints on
the theme from the early 1620s were
inscribed with verses of divergent
meanings. Vorsterman's engraving,
which Rubens dedicated to Anna Roemer
Visscher, was an allegory of virtue, while
the one engraved by Pontius carried the
motto *Turpe Senlis Amor*.
2. The painted versions of these two may
have existed, but are today unknown.
See note 3 below.
3. Max Rooses, *L'Oeuvre de Rubens*
(Antwerp 1886–1892), 1: no. 133. For the
drawing, see Vey 1962, 1: no. 167; for
the print by Pontius, see *Rubens in der
Grafik* [exh. cat. Kunstsammlung der
Universität] (Göttingen, 1977), no. 45,
whose authors correctly refuted the idea

The text from the apocryphal thirteenth chapter of the Book of Daniel (1–64) tells of
the "beautiful and devout" Susannah, wife of Joakim, who was unjustly accused of
adultery and nearly put to death, but saved by the wisdom and courage of young
Daniel. Two visual traditions for depicting the story of Susannah, corresponding to
different moments in the narrative and to different intentions, were firmly established
in the sixteenth century. One shows Susannah in peaceful reverie, innocent and
unaware that the elders are observing her naked beauty from a distance. In that
tradition, gloriously exemplified by Tintoretto's painting in Vienna [fig. 1], the
moralizing aspects of the tale are eclipsed by the celebration of the nude, and what
Fragonard termed "les hasards heureux du bain." The other, more common tradition,
which Van Dyck chose, represents the moment of confrontation that focuses upon
the issues of virtue and justice associated with the story.[1]

Many sixteenth-century northern prints and paintings of Susannah and the Elders
share the general compositional features that Van Dyck's painting displays, with the
dramatis personae grouped together in the foreground of the picture. Between 1609
and 1620, Rubens himself produced several compositions on the theme, at least two
of which survive in paintings and two others in prints.[2] One of the prints was
engraved twice, first by Michel Lasne in about 1620 and then again in 1624 by Paul
Pontius, after a drawn *modello* (Louvre, Paris), which has been attributed to Van
Dyck.[3] We can see relationships between all of these compositions and the present
painting, but it is clear that Van Dyck was engaged most directly with Rubens'
powerful painting of c. 1609–1610 [fig. 2]. Van Dyck's *Susannah* thus joins the group
of paintings from about 1619–1621 that he executed in direct competition with
Rubens' works of nearly a decade previous.[4]

Painted shortly after his own return from Italy, Rubens' *Susannah and the Elders* is
an early synthesis of Italian traditions, incorporating the dramatic tenebrism of
Tintoretto with the monumental figure types of the Carracci school. Indeed, his
painting may owe both to a print by Annibale [fig. 3] and a painting, known through
copies such as Lanfranco's (Galleria Doria-Pamphili, Rome). Like Rubens, whose
composition he reversed, Van Dyck contrasted the stormy ambient darkness with the
brilliant light that seems to emanate from Susannah. Van Dyck also followed Rubens
in juxtaposing the two advancing, draped, heavy forms of the elders with the bare
flesh of the recoiling Susannah.

Within these broad similarities, however, the two interpretations differ markedly
and tellingly in the detailed machinations of the account. Rubens' narrates in grand,
broad terms, through forceful gestures and unambiguous facial expressions. Van
Dyck's, on the other hand, is writ in finer features that chillingly convey the complex,
insidious nature of Susannah's dilemma. When the elders, who long had desired her,

Fig. 1. Tintoretto, *Susannah and the Elders*,
1555–1556, canvas, 146.6 x 193.6
(57 3/4 x 76 1/4). Kunsthistorisches
Museum, Vienna

Fig. 2. Peter Paul Rubens, *Susannah and
the Elders*, c. 1610, panel, 198 x 218
(78 x 85 7/8). Real Academia de Bellas
Artes de San Fernando, Madrid

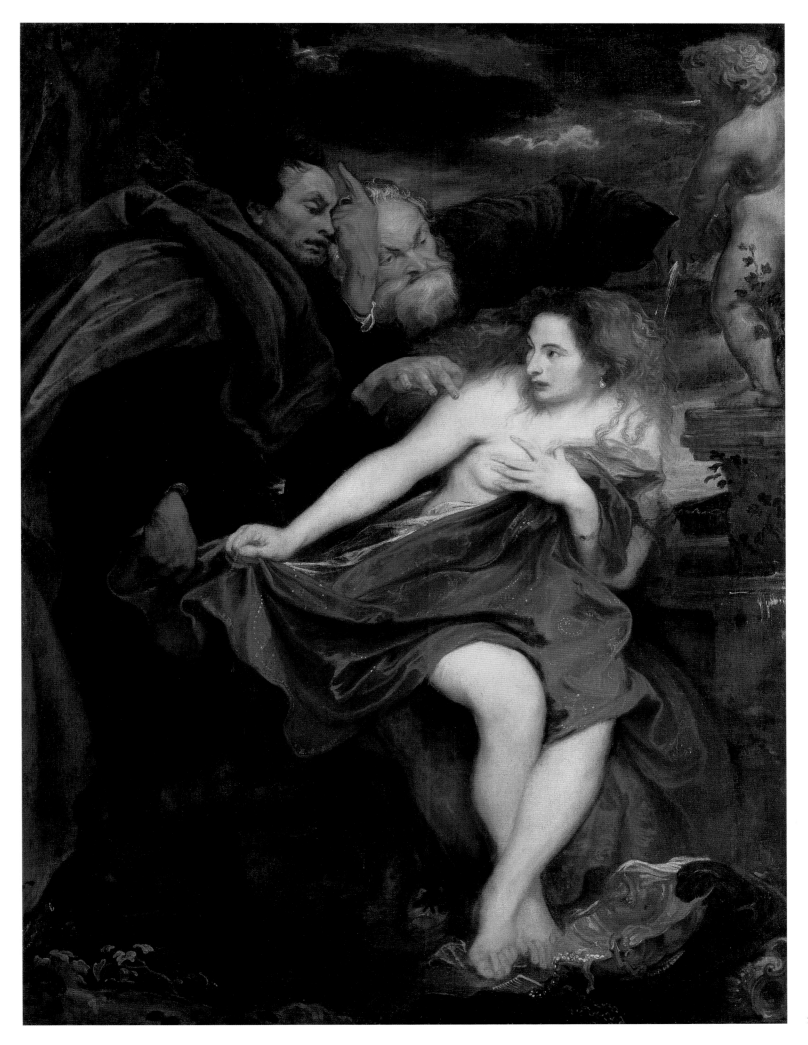

that the print reproduces Rubens' c. 1614 workshop painting in Stockholm (Rudolf Oldenbourg, *Peter Paul Rubens* [Stuttgart and Berlin, 1921], 75 ill.). The print by Lasne carried the same dedication of Anna Roemer Visscher as did the print by Vorsterman (see n. 1 above).

4. See cats. 15, 19, 20, 22.

5. Bruce M. Metzger, ed., *The Apocrypha of the Old Testament. Revised Standard Version* (New York, 1965), 214.

6. Glück 1933, 286. In 1926, Glück still subscribed to the theory advanced by Rooses (1906) that Van Dyck had made a first short trip to Italy, traveling directly from England in February 1621, that he had been recalled to Antwerp in 1622 by his father's mortal illness and remained for several months before returning to Italy for the rest of his sojourn. This theory was devised to explain the presence in Van Dyck's Italian sketchbook of studies that were related to paintings (properly) dated before his departure, and which Rooses grouped in this interval between the "first" and "second" Italian voyage: *The Betrayal of Christ* (Prado, Madrid); *Saint Martin and the Beggar* (Saventhem; Windsor Castle); and *Christ Crowned with Thorns* (Prado, Madrid; Berlin, destroyed). In 1926, Glück thought that the present painting was made during the second Italian stay.

7. By then, Glück had also absorbed Vaes' magisterial study of Van Dyck's Italian sojourn, published in 1924, which put to rest the two-voyage theory. See Glück 1931, XXXII.

8. "*Beijm Admiralen habe ich gesehen die schöne Susanne vom Van Dyck, so sehr viel aestimiret wirdt*" ("Den Första Italienska Rsean," in Osvald Sirén, ed., *Nicodemus Tessin D. Y: S. Studierersor* [Stockholm, 1914], 82).

managed to catch Susannah alone bathing in her garden, they threatened her thus: "The garden doors are shut, no one sees, and we are in love with you; so give your consent, and lie with us. If you refuse, we will testify against you that a young man was with you, and this was why you sent your maids away."[5] Van Dyck devised a composition whose claustrophobically intertwining parts are a metaphor for Susannah's entrapment. He then let the plot permeate every detail of the three characters' bearing, their subtle facial expressions, and the carefully delineated movements of their hands. As they explicate their threat point by point, the elders loom over the crouching Susannah with the certainty and deliberation of beasts of prey contemplating a fresh kill. Terrified and helpless, the virtuous heroine still bravely engages the eyes of her assailants, struggling to keep her drape clutched around her, as she makes her decision to risk judgment and death rather than surrender her virtue. The scene, taut with the anxiety of impending doom, shows Van Dyck's maturity as a narrator and his deep human understanding. It is one of his most intricate dramatic achievements.

Everyone agrees on the strongly Italianate quality of Van Dyck's *Susannah*, but its origins have divided opinion on the dating of the painting. Cust, Bode, and Schaeffer all agreed that the painting fell within Van Dyck's first Antwerp period; for Bode it was evident that Van Dyck would have seen many Venetian works in Rubens' own collection, and in other places as well. Glück first concluded that the painting was made in Italy, years after 1621, because the Tintoresque tenebrism and technique of these paintings could only be the fruit of Van Dyck's long contact with Venetian art on Italian soil.[6] He grouped it with the *Drunken Silenus* [cat. 12], the Munich *Saint Sebastian* [see cat. 22, fig. 1], and *The Penitent Magdalen* (Rijksmuseum, Amsterdam)— all painted before 1622 in my opinion—as well as with such undisputed Italian-period works as *The Ages of Man* [cat. 41] and *The Madonna of the Rosary* [see cat. 46, fig. 4]. Rosenbaum's eloquent and convincing arguments for the place of *Susannah* in Van Dyck's œuvre around 1620–1621 may have swayed Glück somewhat. In the Klassiker der Kunst (1931) he wrote that *Susannah* and *Saint Sebastian* "followed closely" after works painted in Antwerp, but because of their coarse canvas supports he kept them with the Italian œuvre.[7] Glück was the last person to raise the question of the date, and his conclusions have been accepted by the curators of the Alte Pinakothek and by Brown. In fact, however, *Susannah* displays the undigested Venetianism typical of Van Dyck's œuvre before Italy. The thick impasto, the strong chiaroscuro, the brightly lit, unmodeled flesh, all of which Rosenbaum rightly likened to Van Dyck's portraits of about 1620 (see cat. 33, which also has a coarse canvas support), all disappear in his Italian work.

Crucial to the understanding of Van Dyck's development, particularly after 1618, is a definition of chronology that is independent of questions of style. Rubens prized Van Dyck's assistance precisely because he could freely imitate the master's style in executing paintings to satisfy the voluminous commissions for the studio in those years. For his own work, both youthful and mature, from time to time Van Dyck consciously emulated the techniques of other painters he admired. The virtuosity that enabled him to command diverse visual languages let him choose a style that was

Fig. 3. Annibale Carracci, *Susannah and the Elders*, c. 1590/1595, etching and engraving, 35.1 x 31.0 (13 3/4 x 12 1/4). National Gallery of Art, Washington

suitable to the mood of the stories he was depicting, and that would support their meaning.

Once one removes the stylistic grounds for grouping the tenebrist works mentioned above and arranges them according to criteria such as their mastery of form in space, or color, or their emotional and narrative sophistication, clear distinctions emerge between them that suggest a chronological span of years rather than months. The anatomical clumsiness of *The Penitent Magdalen* and her angel, and their awkwardness in relation to their setting, link that painting with the Rotterdam *Saint Jerome* in about 1617–1618. Despite the laudable ambition of the Munich *Saint Sebastian*, its unconvincing spatial relationships and fragmented narrative focus put it closer to 1619 than to 1621. That painting and *Susannah*, more than the others, share a range of colors, a stark chiaroscuro, and a fascination with such details of handling as the skillful scumbling of thick, dry white paint over the dark ground, all of which Van Dyck derived from Tintoretto. Notwithstanding those technical and stylistic similarities, the two paintings are separated by many months. In that intervening time Van Dyck grew to the threshold of mastery as a painter and of maturity as an interpreter of religious history, which brought forth *Susannah and the Elders*.

The painting was first recorded in the collection that was amassed between the 1680s and 1716 for Elector Johann Wilhelm of the Palatinate and housed in the Düsseldorf Gallery, which he constructed. Its collection history previous to that is not known. Believing it to have been painted in Italy, Larsen has suggested it was in the Neapolitan collection of Gaspar de Roomer in 1630. However, in the summer of 1687, Nicodemus Tessin visited Antwerp and remarked in his travel diary on a highly esteemed *Susannah* by Van Dyck.[8] Since this canvas is his only extant treatment of the theme, this text might also refer to the present painting.

<div align="right">S. J. B.</div>

17
Sir George Villiers and Lady Katherine Manners as Adonis and Venus

late 1620–early 1621
canvas, 223.5 x 160 (88 x 63)

Harari & Johns Ltd., London

PROVENANCE Frank Hall Standish (1799–1840), Seville, and Duxbury Hall, Chorley, Lancashire; by bequest to Louis-Philippe, king of France; Musée Standish in the Louvre, Paris, until the revolution of 1848; in the personal collection of Louis-Philippe until his death; Standish Collection sale, Christie's, London, 28–30 May 1853, lot 37 (as "A Portrait of Rubens and his Wife"); T. A. Houghton, Armsworth House, Alresford, Hampshire; sale Christie's, London, 29 July 1918, lot 79; purchased by "Van Slochem"

LITERATURE Michael Jaffé, "'Venus and Adonis' Painted by Van Dyck in England 1620–21," *Burlington Magazine* 132 (October 1990)

1. The annotation reads: "Hertoginne van Bochengem." See *Die Rubenszeichnungen der Albertina, zum 400. Geburtstag* [exh. cat. Albertina] (Vienna, 1977), no. 40 ill.
2. Randall Davies, "An Inventory of the Duke of Buckingham's Pictures, Etc., at York House in 1635," *Burlington Magazine* 10 (1906–1907), 379.
3. British Library, Trumbull Manuscripts, Miscellaneous Correspondence vol. 11, fol. 144 seq. David Howarth very kindly informed me of this exciting and timely find in advance of its publication. See his article, "The Arrival of Van Dyck in England," *Burlington Magazine* 132 (October 1990).
4. As Derek Johns pointed out.
5. See Arnout Balis, *Rubens Hunting Scenes* (London and Oxford, 1986), figs. 9 and 23.

This daring portrait of a couple in the guise of Venus and Adonis, which was discovered only recently, is the most remarkable addition to the known œuvre of Van Dyck that has appeared in some time. Although the painting is not documented at all and has never before been included in the literature on Van Dyck before the last century, there can be no doubt that it is an authentic work by the artist painted during the time he spent in England between mid-October 1620 and mid-February 1621.

Lacking the early history for the portrait and in the absence of a costume that might link the sitters to Flanders or England, one might question where it had been painted. But the couple, who during the nineteenth century were thought to be Rubens and his wife, can be identified with certainty as George Villiers, then marquess (later the 1st duke) of Buckingham (1592–1628), and Lady Katherine Manners (d. 1649), daughter of the earl of Rutland, whom Buckingham married in May 1620. The identification is based less on the generalized facial features of Buckingham than on the likeness of Katherine Manners, whose head Van Dyck appears to have painted from life directly onto the canvas. It can be compared closely with the face in a chalk drawing by Rubens [fig. 1], to which a later hand has added Katherine Manners' title as duchess of Buckingham.[1] Rubens' drawing, a study for his painting in the Dulwich College Picture Gallery, must have been made after Buckingham's death, while Rubens was on a diplomatic mission to London in 1628–1629. Although nearly ten years separate Van Dyck's portrait from Rubens', the woman's face is recognizably the same in the eyes, nose, chin, and neck, as well as in the high forehead and the hanging curls fluffed along either side of the face. Also identical between the two are the jewelry, a choker necklace and pendant earrings made of large pearls.

With *The Continence of Scipio* [see cat. 22, fig. 2] and the bust-length portrait of *Thomas Howard, 2d Earl of Arundel* (J. Paul Getty Museum, Malibu), this brings to three the total number of paintings known from Van Dyck's four-month first visit to England. Surviving letters and documents from the period show that Arundel and Sir Dudley Carleton both were interested in bringing Van Dyck to England, and that the king had given the artist a retainer once he was there. Buckingham's patronage of *The Continence of Scipio* has been deduced because the first item in the 1635 inventory of his collection reads: "Vandyke.—One great Piece being Scipio."[2] The absence of the present portrait from that inventory has yet to be explained. Nevertheless, its

Fig. 1. Peter Paul Rubens, *Lady Katherine Manners*, 1629 or 1630, chalk with white heightening, 36.8 x 26.3 (14 3/8 x 10 1/4). Albertina, Vienna

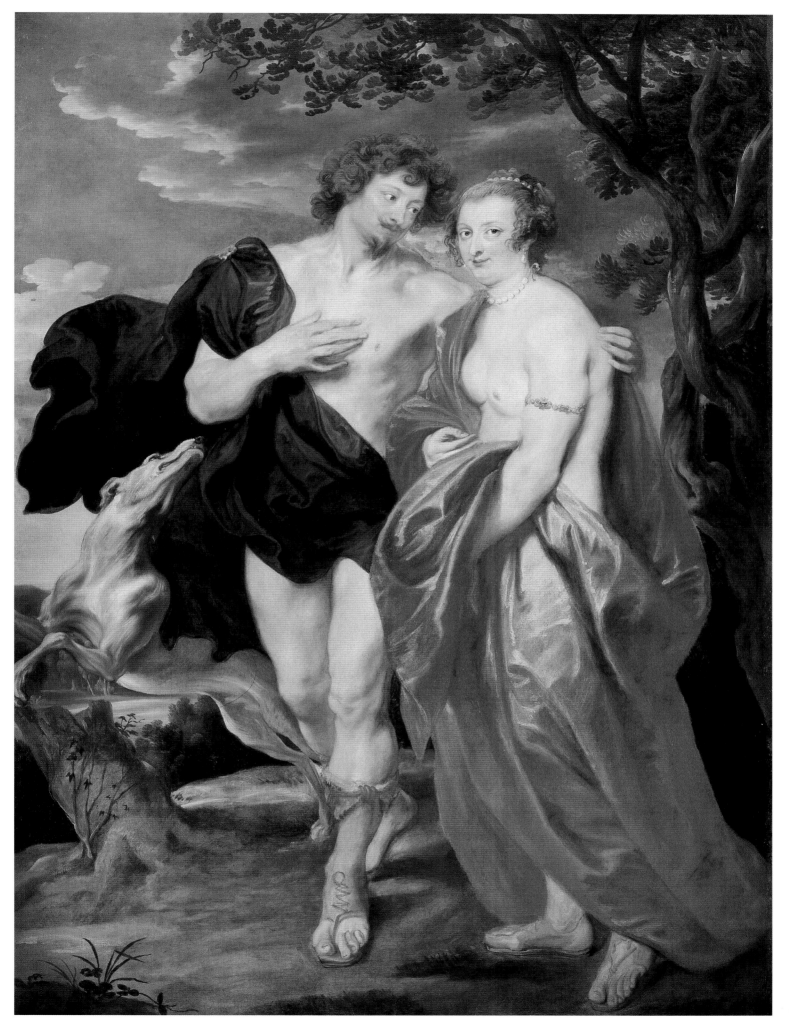

existence suggests that Buckingham loomed large indeed among Van Dyck's early English patrons. That hypothesis is strengthened by another contemporary document, a letter of 20 October 1620 fortuitously brought to light by David Howarth.[3] The letter from Thomas Locke to William Trumbull gives us two important new facts about this passage in Van Dyck's career. It establishes that Van Dyck was "newly come" to London by 20 October, a full month sooner than has been known. It also states "I am tould my Lo: of Purbeck sent for him hither." Viscount Purbeck was John Villiers, Buckingham's brother.

The portrait was painted about halfway along the path of Buckingham's meteoric career at the English court. Introduced to James I in 1614, he rapidly became the darling of the king, whose favor elevated him steadily from knighthood the following year to a dukedom in 1623. Buckingham was the most powerful and one of the richest men in the realm, and with his appointment as lord high admiral of England in 1619 he entered the field of international politics. During the next decade, while he was indulged and protected by James I and, on his death in 1625, by Charles I, Buckingham's shifting alliances and his reckless initiatives led to a string of military failures for English troops and finally to his own assassination in 1628.

Buckingham is known to have been as decisive in his collecting instincts as in his political exploits, but far more discerning. The 330 pictures included in the aforementioned inventory show that his taste was focused: he tended to collect works of individual artists in depth. There is particular strength in sixteenth-century Venetian painting—the names of Titian, Tintoretto, Veronese, and Bassano appear often—but Mabuse, Rubens, and Fetti are also represented in number. Buckingham's legendary daring in public life is borne out also in the imaginative conceit of the present picture, whose unconventional nature assures it would have been reserved for the couple's private chambers, while *The Continence of Scipio* was hung proudly in the Great Hall. Although symbolic and allegorical portraits abounded in Elizabethan painting, such an image as this, with sitters unclad, is apparently without precedent in either Flemish or English painting. The classical mythological allusions of this *portrait historié*, which distinguish it from the recondite references to indigenous literature found in Tudor allegorical portraiture, exemplify the change of taste at the Jacobean court toward ancient and modern Mediterranean culture.

Van Dyck's highly charged and original work draws on some traditional sources as well as his own recent experience. His compositional structure looks back to images of the Promenade, found in the prints of Lucas van Leyden (Bartsch 144–145) and Dürer (Bartsch 94). Dürer's design, in which death hovers ominously behind the tree, is otherwise close enough to have been a direct inspiration for the painting.[4] Cranach's print of *Venus and Cupid* (Bartsch 113) could have been a source as well, particularly for Venus' hair style and adornment, although they coincide remarkably with Katherine Manners' own, even in later years, as Rubens' drawing demonstrates. Among the features that suggest contemporary Flemish influence is the dog, a joyous, elastic version of the wiry, ferocious hounds Snyders painted in scenes such as *Deer Hunt* (Musées Royaux des Beaux-Arts, Brussels) or *Boar Hunt*, which he executed with Van Dyck (Gemäldegalerie, Dresden).[5] Also very Flemish in character is the landscape, from the Joos de Momper-like icy blue tone of the distant woods at left to the type of tall, thin, twisting tree at right, which goes back to Pieter Bruegel's drawings and appears in Rubens' landscape paintings, such as *The Farm at Laeken* (Buckingham Palace) of about 1618.

Van Dyck forged these components into a creation distinctly his own, remarkable in its sense of movement and its bold invention. There is a certain awkwardness to the female figure, the probable result of joining a precise portrait face with an imagined physique. Nevertheless, Van Dyck achieved a dramatic cohesion in his composition, and infused it with a tenderness found in other works of this time, such as *The Continence of Scipio* and *Saint Sebastian Bound for Martyrdom* [cat. 22]. Buckingham and Lady Katherine are knitted together by his embrace, which is echoed in the curving leap of the hound. The canopy of oak branches that shelters them extends upward from two trunks, not one; the intertwining trunks can be seen as a visual metaphor of the couple's union.

S. J. B.

Suffer Little Children To Come unto Me

1620–1621

canvas, 131.4 x 199.4 (52 3/4 x 77 3/4)

National Gallery of Canada, Ottawa, inv. no. 4293

PROVENANCE Purchased by John Churchill, 1st duke of Marlborough (1650–1722) at auction;[1] by descent in the family, at Blenheim Palace; sale Christie's, London, 24 July 1886, lot 64 (as Rubens); bought by Bertram Wodehouse Currie, Minley Manor, Hants., through Charles Fairfax Murray (as Rubens); by descent to Bertram Francis George Currie, Minley Manor; sale Christie's, London, 16 April 1937, lot 125 (as Van Dyck); bought by Heather; with Bottenwieser (dealer), London; Asscher & Welker (dealers), London; acquired in 1937

EXHIBITIONS Chicago 1954, 34, ill., 35 ill.; McIntosh Memorial Gallery, University of Western Ontario, *Loan Exhibition 15th-16th-17th Century Flemish Masters*, 1957, ill. (n.p.); Art Gallery of Hamilton, Ontario, *Old Masters, An Exhibition of European Paintings from the Sixteenth, Seventeenth and Eighteenth Centuries, from North American Collections*, 1958, no. 33, ill. 33; Princeton 1979, no. 21, ill.; Ottawa 1980a, 12, 16, 17, 19, 21, 22, no. 71, ill.

LITERATURE *New Oxford Guide* (1759), 100 (as "scholar of Rubens"); W. Hazlitt, *Sketches of the Principal Picture Galleries in England* (1824), 171 (as Rubens); Smith 1829–1842, 2:249, no. 845 (as Diepenbeck); Waagen 1854, 3:125 (as Rubens); G. Scharf, *Catalogue of the Pictures in Blenheim Palace* (London, 1862), 54–55 (as Rubens); W. B. [Wilhelm von Bode], "Die Versteigerung der Galerie Blenheim in London," *Repertorium für Kunstwissenschaft* 10 (1887), 61 (photogr. reprint 1968); Max Rooses, *L'Oeuvre de P. P. Rubens* (Antwerp, 1888), 2:421 (as Adam van Noort); Bode 1906, 264 (as Van Dyck); M. MacFall, *Catalogue of the Collection of Works at Minley Manor*, 1908, 7 (as Rubens); Burchard 1938, 25–30, 27 ills.; Garas 1955, 189–200, ill. 1–2, 191; A. Pigler, "Gruppenbildnisse mit historisch verkleideten Figuren und ein Hauptwerk des Joannes van Noordt," *Acta Historiae Artium* (Budapest, 1955), 172 ill. 173–174; Vey 1962, 102 (text vol.); Waterhouse 1978; Brown 1982, 46, 50, ill. 40; Urbach 1983, 19; Roland 1983, 25; National Gallery Canada 1987, 1:99–101 (text vol.), 128 ill. (pl. vol.); Jeffrey M. Muller, *Rubens: The Artist as Collector* (Princeton, 1989), 148, n. 2

1. According to a note from Blenheim; see n. 2 below.
2. Burchard's first transcription, made in the British Museum, reads: "'Marlborough Jewels and Pictures' [1718?]; transcript from original at Blenheim, in Coxe papers, vol. 48, B.M. Addit. MSS 9125] fol. 6*v*:

Fifty years ago when Ludwig Burchard's study commemorating the acquisition of the painting by the National Gallery of Canada was published, *Suffer Little Children To Come unto Me* was known only by the family of the dukes of Marlborough who had owned it for nearly two centuries and by the visitors to Blenheim where it had hung. Waagen and Hazlitt had hailed "the truth of nature, the felicity of execution" of the work that both believed was by Rubens, but it was not really examined or studied. In a complete reversal of that long oblivion, the last half century has seen the painting widely exhibited and subjected to thoughtful research by eminent scholars, beginning with Burchard and including Garas and Waterhouse. These last two elaborated on Burchard's published conclusions, identifying the family depicted in the painting as Rubens' own. Burchard also continued to gather information after his article was published, and he found notes of two records from Blenheim that shed light on the early collection and attribution history of the painting. Burchard's transcriptions of these records, preserved with his notes in the Rubenianum Library in Antwerp, are here published for the first time.[2] Let us traverse the familiar ground of opinions about the painting, introducing new evidence and new arguments as they are relevant.

The story of Christ blessing the children is recounted in all three synoptic Gospels (Matthew 19:13–15; Mark 10:13–16; Luke 18:15–17). Depicted several times in the early sixteenth century by Lucas Cranach the Elder, it was also a popular subject in seventeenth-century Flanders.[3] Most versions show a group of adults and children with generalized features, as Van Dyck did in a drawing in Angers [fig. 1].[4] In his painting, however, he departed from that tradition: Van Dyck was apparently the first to represent the supplicants as a single family of actual people.[5] In this early *portrait historié*, one of two that Van Dyck is known to have painted prior to 1622 [see cat. 17], he skillfully and imaginatively married the genre of religious history with that of the family group portrait. At the same time, within the painting he used several subtle pictorial conventions and devices to distinguish between the spiritual and temporal realms. Appropriately, he represented Christ and the disciples with generalized facial features and otherworldly expressions; then he wrapped them in warm light and dramatic chiaroscuro that set them clearly apart from the family crowded together before them. The family members, on the other hand, are shown in bright, natural light. Their faces and gestures are highly individualized and lifelike, and the emotional responses they display are profoundly human.[6]

All specialists agree with Burchard's published suggestion that the painting was made to commemorate the confirmation and first communion of the young boy. While Burchard did not venture a guess on the identity of the family, Klara Garas used Rubens' own paintings and drawings of himself and his family to argue that Van Dyck had depicted Rubens and Isabella Brant with their three known children, Clara Serena (1611–1623), Albert (1614–1657), and Nicholas (1618–1655), and another baby lost to history. Waterhouse agreed with this hypothesis, which he expanded by suggesting that the painting had come to the duke of Marlborough with two other family portraits from Rubens' estate, *Helena Fourment with Her Son as a Page* (Louvre, Paris) and *Rubens, Helena Fourment, and Their Eldest Child* (The Metropolitan Museum of Art, New York). Despite the apparent appeal of this theory, it has not been universally embraced.[7] Now, the Blenheim documents reveal that the painting was already thought to represent Van Dyck's painting of the family of Rubens when it entered the Marlborough Collection in the early eighteenth century, but that it had been purchased by the duke and duchess at auction rather than from Rubens' family.[8]

Since the earlier of the two documents brings us within a century of the painting's origins, it should strengthen the case for the Rubens identification; but for this writer insurmountable problems remain. The ages and order of the children simply do not jibe, for instance. The young boy being blessed appears to be the eldest child in the

" 'The Family of Rubens done by VanDike of Ten figures bought at Mr. Talmashes Auction, half by my Lady and half by my Lord Duke, cost Two hundred fifty-five pounds.' "

The second transcription comes from an old piece of paper inserted after page 54 in the copy of G. Scharf, *Catalogue Raisonné; or List of the Pictures in Blenheim Palace* (London, 1861 [not the usual 1862 edition, notes Burchard]). The piece of paper was a list, belonging to Lord Churchill, copied by Col. the Hon.ble Robert Spencer, and received by G. Scharf on 15 June 1877. The list contains Blenheim portraits, but also Van Dyck subject pictures at Blenheim. One item of the list reads:

"Our Saviour & his Apostles/ with Rubens & his family by Van Dyck/ This picture John Duke of Marlborough paid £225 [or 255, on diff. transcription] for."

3. On Cranach's pictures, see Christine Ozarowska Kibish, "Lucas Cranach's *Christ Blessing the Children*: A Problem of Lutheran Iconography," *Art Bulletin* 37 (1955), 196–203. Pigler 1956 (1974 ed., 301–303) gives a long list of later sixteenth- and seventeenth-century depictions of the subject. Jordaens' c. 1616 version on panel (The Saint Louis Art Museum) is illustrated by Waterhouse, and in Princeton 1979. See Ottawa 1980, 153, for a discussion of the literature on Adam van Noort's version.

4. Vey 1962, no. 32.

5. He was not the first to include actual portraits, however. Perry Chapman (in Princeton 1979, 90) cited a 1602 painting by Hieronymus Francken in a 7 May 1947 sale at Fisher, Lucerne, which contained four rows of portrait heads.

6. Van Dyck wisely softened the contrast between the two realms by giving the family generalized costumes (Chapman, in Princeton 1979, 90).

7. Held refuted it (1957), as did Brown (1982). McNairn (Ottawa 1980a) repeated it with a curious lack of enthusiasm, and Chapman (Princeton 1979) pointed out the problem of the unknown fourth child. Most recently, Muller (1989) has doubted the identification.

8. Remember that the transcribed document includes "1718?" for the date. That year is well along in the construction of Blenheim (1705–1724), and during the lifetime of John Churchill, 1st duke of Marlborough (d. 1722), who built the palace and furnished it.

9. Although the auction catalogue listed the artist as Rubens, the reporter for *The Times* (July 1886, 415) wrote: "it was now pretty generally admitted to be an early work of Van Dyck, as stated by Mr. Woods [the auctioneer]." Bode's account of the sale (1887) affirmed the attribution to the young Van Dyck, though he identified the family as Snyders'.

10. Neither Smith's suggestion of Van Diepenbeck's authorship, nor Rooses' of Adam van Noort's, was ever taken up.

Fig. 1. Anthony van Dyck, *Christ and the Children*, pen and washes, 175 x 195 (68⁷/₈ x 76³/₄). Musées d'Angers

Fig. 2. Cat. 18, infrared reflectograph, detail

painting, while Albert Rubens was a full two years younger than Clara and only four years older than Nicholas. As is often mentioned, Rubens and Isabella Brant had three children; any baby who died in infancy would at least have been recorded through its baptism. Finally, beneath their fashionably similar hair and beard styles, the parents do not really resemble Rubens and his wife. Particularly telling in that regard are two depictions of Isabella Brant both close in time to the present painting, neither of which can be mistaken for the woman there. Rubens' drawing of *Isabella Brant* [cat. 23, fig. 1], and Van Dyck's painted portrait [cat. 23] show that her face was dominated by large eyes, set fairly far apart and framed with thin, broadly arched eyebrows, and that she had long, narrow lips, characteristically pursed in a wide half-smile. Our unknown mother has smaller eyes, set closer together beneath heavier, shorter, flatter brows, and a smaller mouth with fuller lips.

One question that has not been adequately explored is the significance of the pentimento of a woman's head visible today between the parents' heads. Waterhouse was surely correct in assuming that this was a first thought for the mother's head, and not meant to be an additional adult. Nevertheless, the original pose with downturned eyes and head, which is apparent from infra-red reflectographs [fig. 2], suggests that the mother was gazing on her other children and did not then have the baby in her arms. This raises the interesting possibility that the painting was begun before the birth of the last child and completed some months afterward, with changes to accommodate that family addition.

It has been thought that Van Dyck's name was originally attached to *Suffer Little Children* only when it came to the auction block in 1886.⁹ The first published notice of the painting, the *New Oxford Guide* of 1759, assigned it to "a scholar of Rubens," and in the nineteenth century it was given to Rubens himself by both Hazlitt and Waagen.¹⁰ Accordingly, the painting was assumed to have carried those names in the collection inventories. Burchard's discoveries show, instead, that Van Dyck was known to be the author of the painting when it was purchased, and that the attribution was lost subsequently.

While Burchard's published study implied a date of about 1618 for the painting, Waterhouse leaned strongly toward 1620–1621, citing the reuse of various apostles, such as the figure of *Saint Simon* (Kunsthistorisches Museum, Vienna) from the Böhler series for the disciple at far left. More reliable comparisons might be made with other portraits: the 1621 portrait of *Frans Snyders* (Frick Collection, New York), for instance, whose cloak has a sculptural fullness similar to that here, or *Susanna Fourment and Her Daughter* [cat. 21] of about the same time, whose handling and coloring of feminine and youthful flesh is similar. This painting can also be compared with *The Continence of Scipio* [see cat. 22, fig. 2] in the chromatic richness of the palette as well as the elegance and poignancy of gestures and facial expressions. *The Continence of Scipio* was painted between November 1620 and February 1621. If the present painting was indeed begun and completed in two separate stages, it is tempting to think that the interval between them coincided with that four-month sojourn in England. Such a conclusion would force the issue unnecessarily, however. A date of 1620–1621 is quite plausible given the comparisons, and sufficiently late to explain the accomplishment with which Van Dyck conceived and carried out this fusion of the timeless with the temporal.

S. J. B.

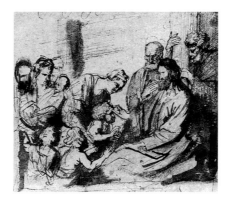

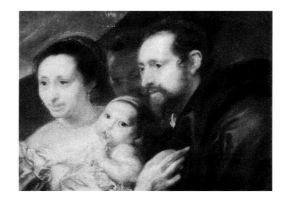

128

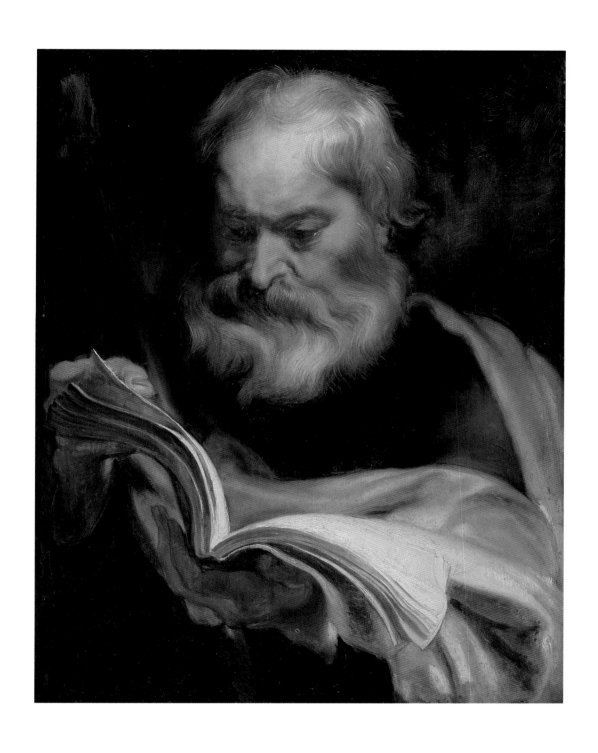

Rubens" to mean that Van Dyck was living with his master.[12] Jan Brueghel had testified Van Dyck lived in the "Dom van Keulen" when he painted the *Apostles*. Vercellini's phrasing is ambiguous, however, and could as easily mean Van Dyck was still with Rubens in the sense of their working together. I would be more comfortable with a date just before or after Van Dyck's English sojourn, 1620 or 1621. Let me also suggest that the "studio" could be a less formal arrangement than we have supposed, and that it probably involved Van Dyck's enlisting the aid of friends in completing a commission when he was overcommitted between assisting Rubens and maintaining his burgeoning independent career.

S. J. B.

21
Susanna Fourment and Her Daughter

1620 or 1621
canvas, 172.7 x 117.5 (68 x 46 1/4)

National Gallery of Art, Washington, Andrew W. Mellon Collection, 1937.1.48

PROVENANCE Gaillard de Gagny (receiver of finances), Grenoble; Dauphin, France; his sale, Paris, 29 March 1762, no. 9 (for 2,050 livres); purchased by Jean-Henri Eberts for Markgravine Karoline Luise von Baden; her sale, Amsterdam, 6 March 1769, no. 3;[1] Etienne-François, duc de Choiseul et d'Amboise; his sale, Paris, 6–10 April 1772, no. 1 (for 7,380 livres); purchased by Prince Alexander M. Galitzine for Catherine II, empress of Russia, for the Imperial Hermitage Gallery, Saint Petersburg, where it remained until March 1930; sold as Rubens, to Andrew W. Mellon Collection, 1937; gift, 1937

LITERATURE Pierre Rémy, Catalogue raisonné des Tableaux du Cabinet de M. Gaillard de Gagny (Paris, 1762); Pierre-François Basan, Recueil d'Estampes gravées d'après les Tableaux du Cabinet de Monseigneur le Duc de Choiseul (Paris, 1771), 8, pl. 83; Jean-François Boileau, Catalogue des Tableaux qui composent le Cabinet de Monseigneur le Duc de Choiseul (Paris, 1772); Blanc 1857, 1:191; Hermitage 1864, 149, no. 635 (as Van Dyck); Guiffrey 1882, 287 no. 1095; Claude Phillips, "The Van Dyck Exhibition at Antwerp," The Nineteenth Century [London] (November 1899), 743 (as Van Dyck); Max Rooses, L'Oeuvre de Rubens (Antwerp, 1886–1892), 4:181 (as Rubens, "Susanna Fourment and her Daughter"); Cust 1900, 17, 234, no. 22 (as Van Dyck); A. Somof, Catalogue de la galerie des tableaux (Saint Petersburg, 1901), 366–367, no. 635 (as Rubens); Adolf Rosenberg, P. P. Rubens (Stuttgart and Leipzig, 1905), 317 ill. (as Rubens); Schaeffer 1909, 155 ill., 525, 544; Burchard 1929, 336 (as Van Dyck); Glück 1931, 111 ill., 531, 584 (as Van Dyck); Glück 1933, 144, 145 ill. 8, 165, 390; Tolnay 1941, 193 ill. 24, 195 (as Van Dyck); Jan Lauts, "Einiges über Markgräfin Karoline Luise von Baden als Gemäldesammlerin," Jahrbuch der Staatlichen Kunstsammlungen in Baden-Württemberg 15 (1978), 49, 53, 54 ill. 3, 55–56; National Gallery Washington 1985, 143, no. 1937.1.48, ill.; Barnes 1986, 1:75, n. 37, 79, 122, 2: ill. 100; Larsen 1988, no. 82, ill. (as "Unknown lady with her daughter")

1. Lauts 1978, 49.
2. For biographical data on the Brant and Fourment families, see P. Génard, P. P. Rubens. Aanteekeningen over den grooten meester en zijne bloedverwanten (Antwerp, 1877), 408–411.
3. Noted in Hans Vlieghe, Corpus Rubenianum Ludwig Burchard, part 19, Portraits 2. Antwerp, Identified Sitters(London, 1987), 105 n. 1. See also Vlieghe 1987, 103–105, for other biographical data on Susanna Fourment.

The presumed portrait of *Susanna Fourment and Her Daughter* announces Van Dyck's brilliance in a portrait type for which he remained an innovator throughout his career, the double portrait of an adult and child. Several later examples of the type also exhibited here [cats. 37, 43, 49, 50, 76] demonstrate the vitality of Van Dyck's invention in depicting the subtle and shifting relations of dependence and independence between offspring and their parents. Although *Susanna Fourment and Her Daughter* is his first surviving full-length example of the type, painted when the artist was about twenty-one, it is already a mature masterpiece. The painting is both the portrait of two charming individuals and the depiction of their relationship to one another. In the *Portrait of a Family* [cat. 9], Van Dyck's ambition in introducing elaborate background settings had somewhat outstripped his ability, resulting in a fresh, direct, but slightly fragmented whole. This painting, made within eighteen months of that, shows his command in orchestrating all of the components of the picture. Here every detail, from the smallest gesture to the shape and color of each part of the surroundings, combines to create a quiet, integrated image of sheltering, nurturing motherhood.

Van Dyck's authorship of the painting was never questioned during the eighteenth century as it passed from one private collection to another and into the Hermitage, where it was also attributed to him throughout the nineteenth century. Then, when preparing his magisterial study of Rubens, Rooses correctly recognized the close affinities between this portrait and the *Portrait of Isabella Brant* [cat. 23], which had always been given to Rubens; but he erred in concluding that both were from the brush of that master. For nearly forty years thereafter, the painting was claimed by partisans of each artist. Cust, Bode, Schaeffer, Glück, and Burchard maintained Van Dyck's authorship, while many joined Rooses in speaking for Rubens, including other authors of Rubens monographs and the curators of the Hermitage. Thus as a Rubens it was purchased by Andrew Mellon and entered the National Gallery in 1937, but soon it was returned to Van Dyck.

Rooses also first claimed that the subject of the painting was Susanna Fourment. Born in 1599, the same year as Van Dyck, Susanna was already related to Rubens' wife Isabella Brant through the marriage of her eldest brother Daniel (1592–1648) to Clara Brant, Isabella's sister.[2] Susanna would have seen the ties between her family and Rubens' further strengthened through marriage had she lived into her forties, as we once believed she did. Carl van de Velde recently discovered that she died in 1628, two years before her younger sister Hélène became Rubens' second wife;[3] in 1641 her daughter Clara del Monte, the one probably depicted here as a girl of two or

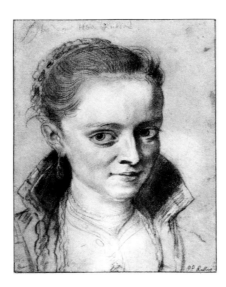

Fig. 1. Peter Paul Rubens, *Susanna Fourment*, c. 1626–1627, chalk with white heightening, 34.4 x 26.0 (13 1/2 x 10 1/4). Albertina, Vienna

4. For documents regarding Clara's life, see P. Génard, "Clara del Monte en Deodatus van der Mont," *Rubens Bulletijn* 5 (1910), 1–8. Clara was baptized on 1 April 1618 in the church of Onze Lieve Vrouwe; Génard gave no further details about Raimond del Monte.

5. See Vlieghe 1987, 105–110, for Rubens' portraits of Susanna Fourment.

6. Glück 1933, 144.

7. Lunden was an important collector. See Hans Vlieghe, "Une grande collection anversoise du dix-septième siècle: le cabinet d'Arnold Lunden, beau-frère de Rubens," *Jahrbuch der Berliner Museen* 19 (1977), 172–204. For the estate inventory of Clara del Monte and Albert Rubens see Max Rooses, "Staet ende Inventaris van de Sterffhuyse van Mynheer Albertus Rubens ende vrouwe Clara del Monte," *Rubens Bulletijn* 5 (1910), 11–59.

8. Gaillard de Gagny sale, Grenoble, 29 March 1762. The paintings were listed together under catalogue 9: "L'un de ces deux Tableaux représente un homme ayant sa barbe & des cheveux, la tête découverte et une fraise au col; il est vêtu de noir & assis dans un fauteuil, prenant un papier sur la table qui est devant lui, couverte d'un tapis de Turquie. … Un rideau & du paysage fait le fond du haut de ces deux Tableaux." Jan Lauts (1978, 55) reprinted this text, which brought to light this lost episode in the history of our painting.

9. Rijksbureau voor Kunsthistorische Dokumentatie, The Hague, according to Lauts 1978, 49.

10. *Abecedario de P. J. Mariette*, 6 vols. (Paris, 1853–1854), 2:207.

11. *Nicholas Rockox* does have the same width as *Susanna Fourment and Her Daughter*, and the sale catalogue description is written as if it had the same length as well (Lauts 1978, 55).

three, married Rubens' oldest son Albert. Despite the brevity of her life, Susanna married twice herself and had three children. Raimond del Monte, whom she wed on 29 January 1617, left her a widow by 1621, with a single child, Clara (born 1618).[4] Another daughter, Catherine (1625–1656), and a son, Arnold, who died young, were born after her second marriage on 8 March 1622 to Arnold Lunden, a merchant and master of the Antwerp mint.

Rooses' proposed identification of Susanna, both in the present painting and Rubens' misnamed *Chapeau de Paille* (National Gallery, London), rests on their resemblance to the woman in a red and black chalk drawing by Rubens in Vienna [fig. 1]; the annotation running across the top of that sheet, "Suster van Heer Rubens," added after Rubens' death, most likely refers to Susanna.[5] Bode would not accept such thin supporting evidence for the naming of the sitter here, nor would Glück, who furthermore refuted the resemblance point by point.[6] Their doubts, which were shared by Burchard and cannot be completely dismissed, preclude our naming this mother and child with absolute certainty. We must also note that in neither the inventory of Susanna's widowed husband Arnold Lunden, nor that of her daughter Clara del Monte, a painting such as this one is described.[7] In favor of the identification are: a measure of resemblance with the woman in Rubens' drawing, particularly the high forehead and the slightly guarded quality of the glance; the known contacts among Rubens, Van Dyck, and Susanna Fourment; and the fact that the apparent ages of the mother and child in the painting correspond to those of Susanna Fourment and Clara del Monte when the painting was made in 1620–1621.

The mother and child we see form such a balanced, self-sufficient group that they do not suggest a missing pendant. The fact that one was listed and sold separately in the Gaillard de Gagny sale in 1762 proves to be misleading. In the sale catalogue the detailed description for that unnamed portrait precisely fits that of the *Portrait of Nicholas Rockox* (Hermitage, Leningrad).[8] Fortunately, two independent contemporary references coincide to confirm this match: an annotated copy of the sale catalogue names "Vatelet" as the purchaser;[9] and Mariette, who knew the sitter's identity from the inscribed print by Vorsterman, tells us that the *Portrait of Rockox* was in the collection of M. Watelet.[10] Rockox was widowed in 1619, and Van Dyck's portrait of 1621 had no pendant. Nor, in any case, would his half-length image have been made as a companion for our full-length one.[11] Their anachronistic pairing, made by Gaillard de Gagny or a previous collector, had a certain logic given the proximity in time and the similarities in design of the two paintings.

S. J. B.

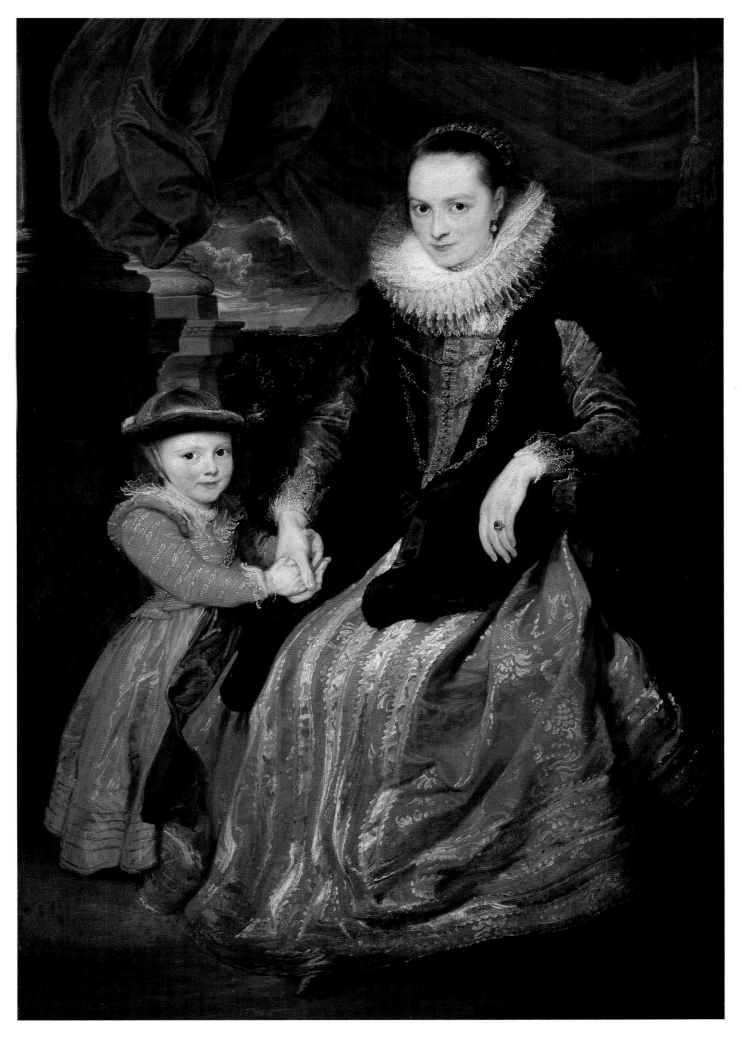

1620 or 1621
canvas, 226 x 160 (88 1/8 x 62 3/8)

National Galleries of Scotland,
Edinburgh, inv. no. 121

PROVENANCE Possibly inherited by
Caterina Giustiniani, wife of Bartolomeo
Saluzzo (c. 1705), and sold by their son
Alessandro Saluzzo to Costantino Balbi;[1]
first recorded in a 1724 inventory of the
collection of Costantino Balbi (1676–1740),
Genoa, and in a 1740 inventory (no. 46)
of the same collection in Palazzo Balbi,
Via Balbi 6; by descent to Costantino's
son Giacomo Balbi; by descent to
Giacomo's son Costantino Balbi, from
whose daughters, the Marchesa
Violantina Spinola and the Marchesa
Tommasina Adorno, it was purchased for
the Royal Institution, Edinburgh, in 1830

LITERATURE Ratti 1780, 197; Guiffrey
1882, 252 no. 215B; Cust 1900, 47–48, 240
(as repetition of no. 44, Munich); Glück
1931, 526 (note to 66); Glück 1933, 276;
National Gallery Scotland 1957, 77 no.
121; Thompson 1961, 318, 319, ills. 29–31;
London 1968, 13, 19; Thompson 1975, 1,
no. 4, 3, 5, ill., 4, 6–7; Ottawa 1980a, 26,
284 ill. 34; Martin 1981, 393–400; Brown
1982, 43, ill. 32; Glen 1983, 49; Boccardo
1987, 79, 85 n. 41; Boccardo and Magnani
1987, 65, 86 no. 46, 88 n. 131; Piero
Boccardo, "Materiali per una storia del
collezionismo artistico a Genova nel XVII
secolo," unpublished Ph.D. thesis, Milan,
Università degli Studi, 1989, 131 no. 46

1. As proposed by Piero Boccardo
(personal communication, January 1990).
On the question of Costantino Balbi's
purchases from the Saluzzi, see Piero
Boccardo, Ph.D. thesis, 122–129. Balbi's
1724 inventory is transcribed there,
129–132. I am most grateful to Dr.
Boccardo for sharing his findings with
me.

One of the characteristics unique to Van Dyck's youthful œuvre was the practice of creating variant versions of an important religious narrative. We have seen how in three canvases of *The Betrayal of Christ* [cats. 13, 14] he continued to work on his interpretation of the subject at full scale, making alterations that reflect his evolving thoughts. The variants differ in size, but we assume that they were made fairly closely in time. There, as with the two versions of *The Crowning with Thorns* (Prado, Madrid; ex-Kaiser-Friedrich-Museum, Berlin), the changes between the variants involve the number and reactions of secondary characters; the central focus—Judas and Christ in the *Betrayal*, and Christ alone in the *Crowning*—remains unchanged.

Van Dyck's paintings of Saint Sebastian are another case. In the space of about six years, he returned to the subject three separate times, making three distinct interpretations of the theme of the saint being bound for martyrdom. For each of the three he made at least two large versions of roughly equal size. One of the two is more sketchy than the other, but otherwise there are no real differences between them. Consensus identifies the stocky sulking *Sebastian* in the Louvre [see cat. 3, fig. 1] as the first interpretation, although the date proposed ranges from c. 1615 to 1617.[2] The second version of this first composition was discovered through radiograph to be concealed beneath the present picture.[3] This painting in Edinburgh and its more tightly painted twin in the Alte Pinakothek have been thought to represent Van Dyck's second interpretation of the theme, and have been dated between 1620 and 1623.[4] The remaining rendition, with versions in Munich [fig. 1] and in the Chrysler Museum, Norfolk, has been considered as the last and placed in Van Dyck's Italian period.

Glück established this generally accepted chronological sequence for Van Dyck's *Saint Sebastians* fifty years ago, based on his assumptions about the impact of Italy on the artist's style and technique. However, the Munich and Norfolk *Saint Sebastians* share a markedly Tintoresque flavor more with first-Antwerp-period works such as *The Betrayals* of Christ and *Susannah and the Elders* [cats. 13, 14, 16] than with any Van Dyck created in Italy. In addition, Van Dyck's voracious assimilation of Venetian influences in the early years is now well established. Finally, his stylistic facility undermines our using style as the sole basis for establishing a chronological order.

Van Dyck's *Saint Sebastians* span the period of his most rapid maturation as a narrator in paint, and it is the development of his narrative ability from one to the next that holds the key to their sequential arrangement. Like the Louvre *Saint*

Fig. 1. Anthony van Dyck, *The Martyrdom of Saint Sebastian*, c. 1619–1620, canvas, 199.9 x 150.6 (78 3/4 x 59 1/4). Alte Pinakothek, Munich

Fig. 2. Anthony van Dyck, *The Continence of Scipio*, late 1620–early 1621, canvas, 182.8 x 232.4 (72 x 91 1/2). The Governing Body, Christ Church, Oxford

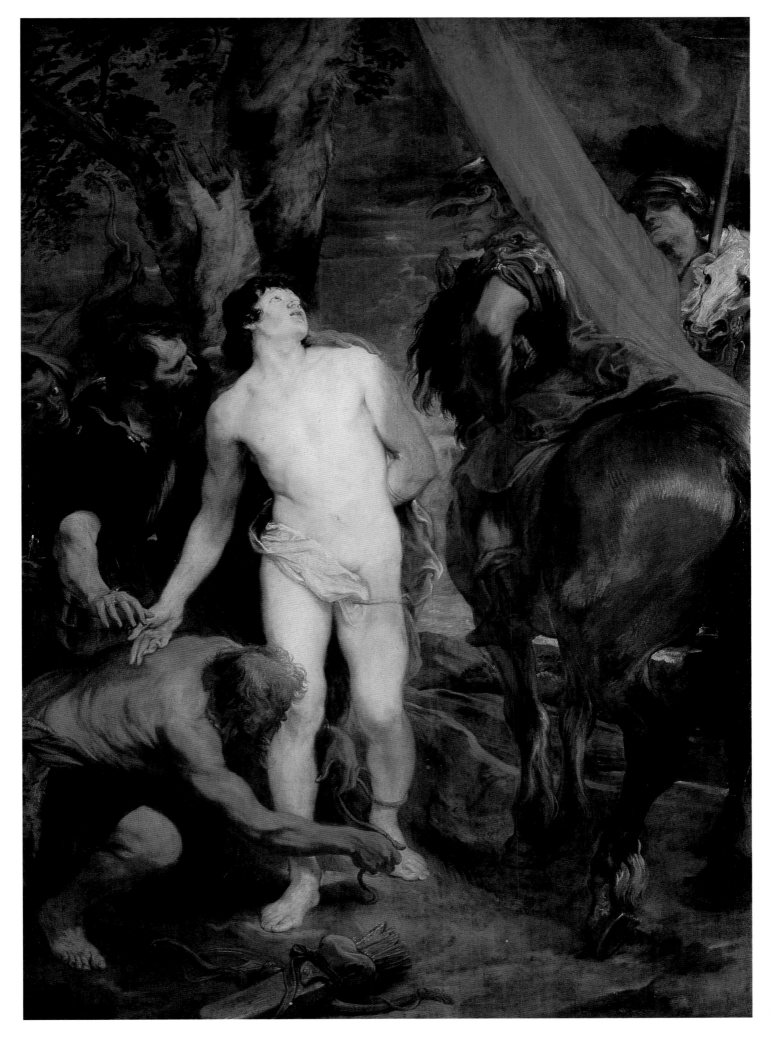

2. Glück 1933, 286, suggested the earlier year, while Martin 1981, 393, thought it might be up to two years later.

3. Thompson 1961, 318.

4. Glück ignored the Edinburgh version, but in 1926 he placed the version in Munich after contact with Italy (published in Glück 1933, 176), then (Glück 1931, 526, no. 66) late in the first Antwerp period. Keepers at the National Gallery of Scotland have gone back and forth between these two dates: Thompson (1975, 7), rightly comparing their painting with *The Continence of Scipio*, dated it to 1621, but in the revised *Shorter Catalogue* he wrote with Brigstocke (1978, 31), he suggests it was painted in Genoa in 1621–1623, probably because of its Genoese provenance.

5. Thompson (1961, 318) noted Van Dyck's use of the horse from *Le Coup de Lance*.

6. Millar 1951, 125, n. 9; Thompson 1975, 7.

7. Glück 1933, 276.

Sebastian, the rendition in Munich and Norfolk, which I would place second in the sequence of three, shows the saint standing, partly bound. He faces the viewer, once brooding, once almost coy, and shows no resistance and little reaction to the charging, lunging, jeering men around him. In both these interpretations the landscape is summarily rendered and serves more as a backdrop than a setting. Van Dyck added figures in the Munich/Norfolk version, and massed them in an ambitious way to the right of the saint. But this addition disperses the narrative focus between the saint and two aligned figures at right, and the horseman and the frightened fair-haired youth below him.

The Edinburgh *Saint Sebastian*, in contrast, is a painting whose parts have been brought harmoniously together to convey a single theme, the transcendent power of Christian faith. Men and horses, more gracefully and calmly rendered than before, comfortably occupy a landscape whose new level of mastery owes to the study of Rubens' *Coup de Lance* (Koninklijk Museum voor Schone Kunsten, Antwerp) of about 1620, on which Van Dyck is generally agreed to have worked.[5] The character of the landscape also recalls Rubens' own *Saint Sebastian* (Gemäldegalerie, Berlin). Beyond his technical maturity, Van Dyck's sheer dramatic achievement here marks this as the culminating work of the three. As in the earlier interpretations, Sebastian is at the center. But rather than look outward, he faces his maker, whose spiritual presence animates the saint's countenance and through him affects the entire assembled company. Sebastian's captors look toward him with awe and bemusement. The soldier at his side, ready to seize him, pauses, and his gesture becomes ambiguous, delicately poised between threat and tenderness. The painting can be dated with certainty to 1620 or 1621. It is startlingly close in palette and in the handling of many details to *The Continence of Scipio* [fig. 2]. Millar first remarked on the strong similarities between them, which Thompson and others have echoed.[6] The sure dating of *The Continence of Scipio* in Van Dyck's brief first English visit from November 1620 to February 1621 makes it a rare chronological benchmark in these years, whose absence from this exhibition is keenly felt.

Glück first noted that rather than showing Sebastian already pierced with arrows, as was customary, Van Dyck had depicted him being prepared for martyrdom.[7] Martin discovered that Wenzel Cobergher's *Saint Sebastian* (Musée des Beaux-Arts, Nancy), once in the Antwerp cathedral, was a source both for this narrative choice and for the motif seen here of the beadle kneeling at left to bind Sebastian's legs. There are several copies of the present composition: one in the Museum Wuyts in Lier, one in the Louvre (RF 1961-84), and one that passed from Christie's on 4 April 1986 to the art market in Brescia. In my opinion, none of these is an autograph sketch, as each has been claimed to be at one time or another.

S. J. B.

23
Isabella Brant

1621
canvas, 153 x 120 (60 1/4 x 47 1/4)

National Gallery of Art, Washington,
Andrew W. Mellon Collection, 1937.1.47

PROVENANCE Pierre Crozat (1665–1740);
by descent to his nephews, Louis-Fran-
çois Crozat, baron de Châtel (1691–1750),
and [on his death without a male heir] to
Louis-Antoine Crozat, baron de Thiers
(1700–1770); purchased in 1772, through
Diderot as an intermediary, by Catherine
II (1729–1796), empress of Russia, for the
Imperial Hermitage Gallery, Saint Peters-
burg (Leningrad), where it remained
until 1932; sold to Andrew W. Mellon in
1937; gift, 1937

LITERATURE Probably Félibien
1666–1688; de Piles 1708; probably
Arnold Houbraken, De Groote Schouburgh
der Nederlantsche Konstschilders en
Schilderessen (Amsterdam 1718),
1:182–183; Crozat 1755, 47 (as Rubens);
Hermitage 1774, 101 (as Rubens); G. F.
Waagen, Die Gemäldesammlung in der
kaiserlichen Ermitage zu St. Petersburg
(Munich, 1864), 140, no. 575 (as Rubens);
Walpole 1876, 1:317; Max Rooses,
L'Oeuvre de Rubens (Antwerp, 1886–1892),
4:131, 136, no. 900 (as Rubens); A.
Somof, Catalogue de la galerie des tableaux
(Saint Petersburg, 1895), 2:63, no. 575 (as
Van Dyck); Max Rooses, "Addenda en
Corrigenda," Rubens Bulletijn 1895, 284
(as Rubens); Cust 1900, 24, 235, no. 31
(as Van Dyck); A. Somof, Catalogue de la
galerie des tableaux (Saint Petersburg,
1901), 2:365–366, no. 575 (as Rubens);
Rooses 1905, 496–497 (as Rubens);
Ricketts 1905, 83–84 (as Van Dyck); Bode
1906, 268–269 (as Van Dyck); Rooses,
"Van Dyck's leer-en-reisjaren II," Onze
Kunst 6 (2d half 1907), 41–44, 43, ill. (as
Rubens); Schaeffer 1909, 167 ill., 502, 525;
Glück 1931, 114 ill., 531 (as Van Dyck);
Glück 1933, 96, 100, 102, 144, 163 (as Van
Dyck); Leo van Puyvelde, "Les Portraits
des Femmes de Rubens," Revue de l'Art,
3d period, 71, no. 376 (April 1937), 5–7
(as Van Dyck); Van Puyvelde 1940a, 2–9,
ill. on 2 (as Van Dyck); Tolnay 1941, 194,
ill. 25, 195 (as Van Dyck); Henry S.
Francis, "'Portrait of Isabella Brant' by
Peter Paul Rubens," The Bulletin of the
Cleveland Museum of Art 34, no. 10
(December 1947), 248 (as Rubens); Jan
Albert Goris and Julius Held, Rubens in
America (New York, 1947), 45 (as Van
Dyck); Larsen 1967, 4–5 (as Van Dyck);
Crozat 1968, 104, no. 386, ill. (as Rubens);
Ottawa 1980a, 12, 17, 272 ill. 7; National
Gallery Washington 1985, 143, no.
1937.1.47, ill.; Barnes 1986, 1:75, n. 37;
Hans Vlieghe, Corpus Rubenianum Ludwig
Burchard, part 19, Portraits 2. Antwerp,
Identified Sitters (London, 1987), 58;
Jeffrey M. Muller, Rubens: The Artist as
Collector (Princeton, 1989), 148

1. See P. Génard, "Het Laatste
Testament van P. P. Rubens," Rubens
Bulletijn 4 (1896), 139. For Rubens'
inventory, see Denucé 1932, 56–71.

According to Félibien, when Van Dyck left Rubens' studio to travel to Italy in 1621, he made a gift to his mentor of the portrait of Rubens' first wife, Isabella Brant. Because the terms of Rubens' will provided that the portraits of himself and of his wives were set aside for the family, they were not itemized in the estate inventory.[1] Nor do we know the collection history of the present painting before the middle of the eighteenth century, when it appeared in the Crozat Collection with an attribution to Rubens. Nevertheless, from the time that Bode first gave Isabella Brant to Van Dyck, it has been linked to the one mentioned by Félibien.[2] There is every reason to believe that as magnificent a painting as this would have been remembered and described for Félibien's benefit. Van Dyck's radiant portrait of Rubens' first wife celebrates her as the proud mistress of a new lordly estate. At right, the sweeping, fantastically colored view shows the recently completed Italianate stone gateway to her garden in Antwerp. This architectural landmark was part of Rubens' large campaign of classicizing additions to their Flemish-style house, including a wing for the studio.[3] Undertaken between 1617 and 1621, these transformations gave Rubens' Antwerp property the character of an Italian villa.[4]

Isabella Brant is one of a stunning group of master portraits made by Van Dyck during 1620 and 1621, both in Antwerp and in England [see cats. 17, 21]. In contrast to his earlier Antwerp portraits, several of their subjects are known, and were prominent citizens of Antwerp. The fact that some of his sitters were from the artistic milieu, such as Frans Snyders and his wife Margaretha de Vos (whose portraits are in the Frick Collection, New York), as well as Rubens' wife Isabella Brant, may foretell the interest that led Van Dyck in later years to carry out an ambitious project immortalizing many Antwerp artists along with other distinguished people through a series of engraved portraits known as the Iconography.[5]

Van Dyck knew Isabella Brant well, having literally grown up in and around Rubens' house and studio.[6] His portrait represents her as a great lady in an imposing setting. In tribute to her, Van Dyck took liberty with the house's sculptural decoration, moving the statue of Minerva from atop the garden screen to a fictive position behind Isabella's shoulder, suggesting a link between his subject and the goddess of wisdom.[7] Van Dyck's study for the garden portal was recorded in Antwerp in the 1689 inventory of Alexander Voet. Rubens' chalk drawing of his wife's head [fig. 1] is often wrongly cited as the model for this painting.[8] There her face is shown completely frontally; the warm good humor written in her sparkling eyes and deeply dimpled cheeks mirrors her intimacy with the artist. The drawing, which probably dates to the same time as our painting, was the model for Rubens' own

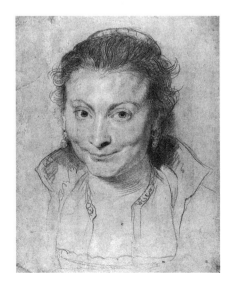

Fig. 1. Peter Paul Rubens, Isabella Brant,
c. 1622, chalk with washes on paper,
38.1 x 29.5 (15 x 11 5/8). Courtesy of the
Trustees of the British Museum, London

Rubens' portraits of Susanna Fourment were not listed either, but were sold with other works from the estate to her widowed husband (Denucé 1932, 77–78, nos. LVI, LXIII, LXIX, LXX).

2. Bode's attribution, reflected in Somof's 1895 catalogue of the Hermitage, was refuted by Rooses (1895, 284). This apparently persuaded Somof to change his mind in the revised edition four years later, where he returned both *Isabella Brant* and *Susanna Fourment and Her Daughter* to Rubens. Although most scholars correctly followed Bode, even after the painting came to the National Gallery of Art it remained officially attributed to Rubens until the 1970s.

3. The house and garden suffered during the eighteenth and nineteenth centuries. Plans to restore it, developed in the late nineteenth century, were carried out in the 1940s. For a history of the property see Paul Huvenne, "Het Rubenshuis," *Openbaar Kunstbezit in Vlaanderen* 26, no. 4 (1988). On the decoration of the house see Elizabeth McGrath, "The Painted Decoration of Rubens's House," *Journal of the Warburg and Courtauld Institutes* 41 (1978), 245–277; and most recently, Jeffrey M. Muller, *Rubens: The Artist as Collector* (Princeton, 1989), 25–47.

4. See Muller 1989, 37.

5. The prints comprising Van Dyck's *Iconography* were catalogued by Mauquoy-Hendrickx, 1956. For the relation of this series to the Italian tradition of the *Uomini illustri*, see Susan J. Barnes "The Uomini Illustri ... ," *Cultural Differentiation and Cultural Identity in the Visual Arts*, Studies in the History of Art 27 (1989), 81–92.

6. For a discussion of Van Dyck's work with Rubens, see my essay in this publication.

7. For the role of Minerva and Hermes in Rubens' decorative program, see Muller 1989, 26–29.

8. Rooses first made the connection, thinking that both the drawing and the painting were by Rubens, but Ricketts refuted it early on (1905, 84).

9. Hans Vlieghe, *Corpus Rubenianum Ludwig Burchard*, part 19, Portraits 2. Antwerp, *Identified Sitters* (London, 1987), 58.

10. Ch. Ruelens, *Correspondance de Rubens*, 6 vols. (Antwerp, 1887–1909), 3:446.

portrait of his wife in the Uffizi, which Vlieghe believes he painted after her untimely death on 20 June 1626.[9]

As is so often the case for women of the past, Isabella Brant's history and character are veiled. One poignant testimony survives from Rubens' correspondence, his response of 15 July 1626 to a letter of condolence from Pierre Dupuy. The document is uniquely revealing of the artist's feelings about her and about their conjugal life. Rubens wrote of his late wife: "In truth I have lost an excellent companion. How to express it, one had to cherish her—with reason—because she had none of the faults of her sex: never moody, no feminine weaknesses, nothing but goodness and thoughtfulness. Her virtues made her dear to everyone during her lifetime, and have caused universal grief since her death. Such a feeling of loss as I have seems justified to me, and because the sole remedy for all such ills is time, I must doubtless look to time for my relief. But it will be difficult for me to separate the pain that her loss makes me suffer from the memory I will guard all my life of this cherished and venerated woman."[10]

S. J. B.

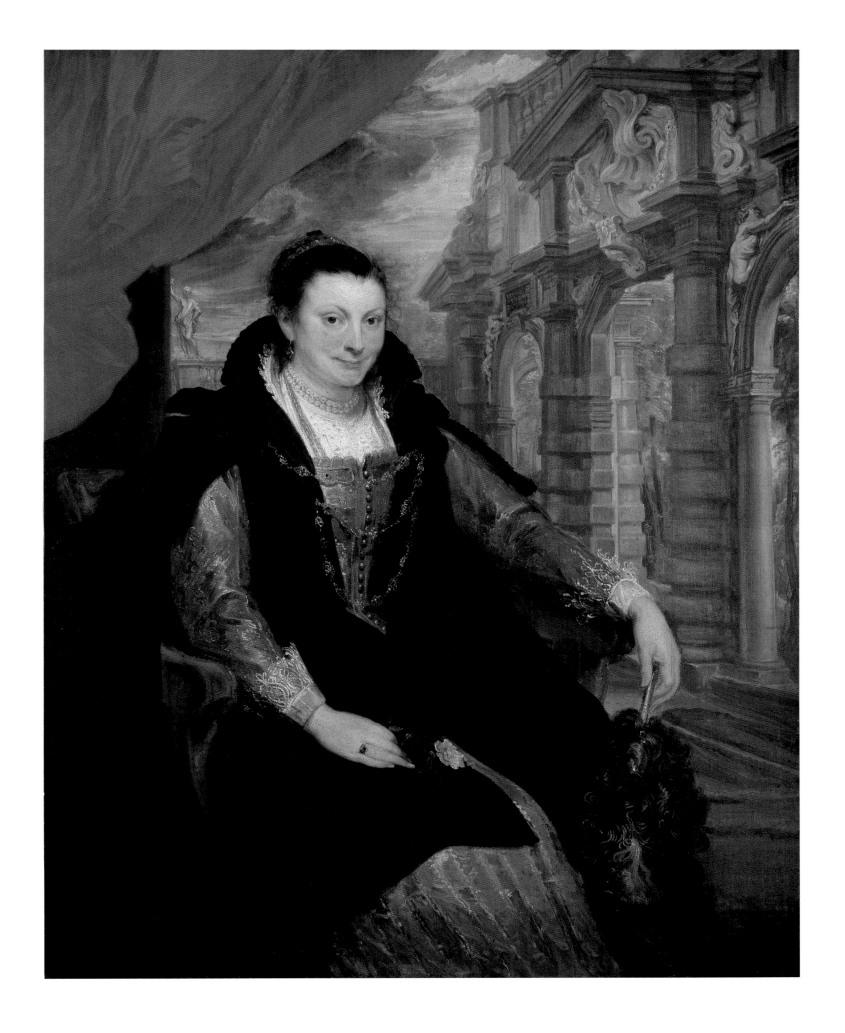

late 1621 or early 1622

canvas, 183 x 122 (72 x 48)

National Gallery of Art, Washington, Andrew W. Mellon Collection, 1937.1.49

PROVENANCE Balbi family, Genoa, until c. 1819; sold by Giacomo Balbi to Baron J. B. Heath, British consul at Genoa (c. 1805–after 1842); sold in 1836 by the latter, in London, to Robert Stayner Holford (1802–1892), Dorchester House, London, and Westonbilt, Gloucester; by inheritance to his son, Sir George Lindsay Holford, K.C.V.O. (1860–1926); purchased in February 1926 from his estate by Lord Duveen of Millbank; sold to Andrew W. Mellon, 1926

EXHIBITIONS London, British Institution, 1836, no. 103; London, British Institution, 1862, no. 35; London, *Old Masters at the Royal Academy*, 1870, no. 26; London 1887, no. 77; London 1900, no. 70; London, Grosvenor Gallery, 1913–1914, no. 100 ill.

LITERATURE Smith 1829–1842, 9:395, no. 96; Waagen 1854, 2:200; Guiffrey 1882, 257 no. 365; Cust 1900, 42, 203, 220, 241 nos. 64, 65; Schaeffer 1909, xx, 198 ill.; Glück 1931, 196 ill., 540; Royal Cortissoz, *An Introduction to the Mellon Collection* (privately printed, 1937), 37–38; Reder 1941, 10, ill. 13; Tolnay 1941, 197, ills. 29, 30; G. Balbi, "Fatti e misfatti di un Palazzo Balbi," *Genova* 35, no. 8 (1958), 28 ill., 29 n. 7; Jaffé 1965, 43; Erich Hubala, *Die Kunst des 17. Jahrhunderts* (Berlin, 1970), 58; National Gallery Washington 1985, 143; Barnes 1986, 1:101, 304–305, 2: ill. 212; Boccardo and Magnani 1987, 79 n. 13

1. They are: an equestrian portrait of young *Anton Giulio Brignole-Sale*, a full-length of his new wife *Paola Adorno*,

Although the names of most of Van Dyck's Genoese patrons are not known to us, documents show that two families, the Brignole-Sale and the Balbi, gave him multiple commissions. For the Brignole-Sale we have a rare payment notation showing that the three family portraits today in the Palazzo Rosso, Genoa, were commissioned together at the end of 1627.[1] The story is more complicated for the Balbi, who were more numerous, and who both commissioned works during Van Dyck's lifetime and collected them for a century after his death; it begins in Antwerp. In the later sixteenth century the Balbi were as prolific and enterprising as they were prosperous and prominent. At least one of Nicolò Balbi's five sons, Bartolomeo, went to live for a period in Antwerp, representing the family's economic interests there. He married a native of the city, Lucrezia Santfort. Their son Gio. Agostino also resided in Antwerp, where he was said to have founded the Convent of the Minorites of Saint Francis of Paul in 1615.[2] Gio. Agostino had a single illegitimate child, Ottavia, who by the terms of her father's will gained her inheritance if she married one of the family. Accordingly, she wed her father's first cousin, Bartolomeo, nephew of the first Bartolomeo who had lived in Antwerp.

It seems highly likely that Van Dyck or his family had some contact with the Balbi in Antwerp, if only because of the important commissions they awarded him in Genoa. He painted at least three, and probably four major portraits of members from two branches of the family. Three were listed in the 1647–1649 inventory of Bartolomeo Balbi, Ottavia's husband.[3] Two of these have not been identified: an equestrian of *Bartolomeo Balbi* himself, and the portrait of *Gio. Agostino*. The third, which is known—indeed infamous—is another equestrian, of Bartolomeo's younger brother *Giovanni Paolo Balbi* [fig. 1]. Many years after the portrait was painted, Giovanni Paolo conspired with the French to conquer Genoa. Discovered, tried, convicted, and sentenced to death in absentia, he was stricken from the Libro d'Oro of the Genoese nobility in 1648. Because of this disgrace, we learn from Bartolomeo's inventory made just then that his portrait had been removed from the house, "for being unworthy to be there."[4] Another younger cousin, Francesco Maria, who had not been portrayed by Van Dyck, had a practical solution to the problem: he took the handsome equestrian image of his discredited relative, commissioned an artist to paint his own face over Giovanni Paolo's in the later seventeenth century, and displayed the portrait proudly.[5] The probable fourth Balbi portrait is the stunning family group in the Palazzo Durazzo-Pallavicini called "*La Dama d'Oro*" [fig. 2], which

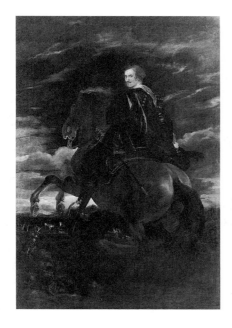

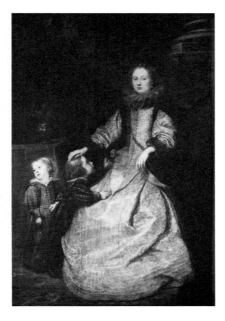

Fig. 1. Anthony van Dyck, *Portrait of Giovanni Paolo Balbi*, c. 1625, canvas, 370 x 263 (145 5/8 x 103 1/2). Fondazione Magnani Rocca, Parma

Fig. 2. Anthony van Dyck, "*La Dama d'Oro*," *Battina Balbi* (?) *with Two of Her Children*, c. 1622, canvas, 218 x 146 (85 7/8 x 57 1/2). Palazzo Durazzo Pallavicini, Genoa

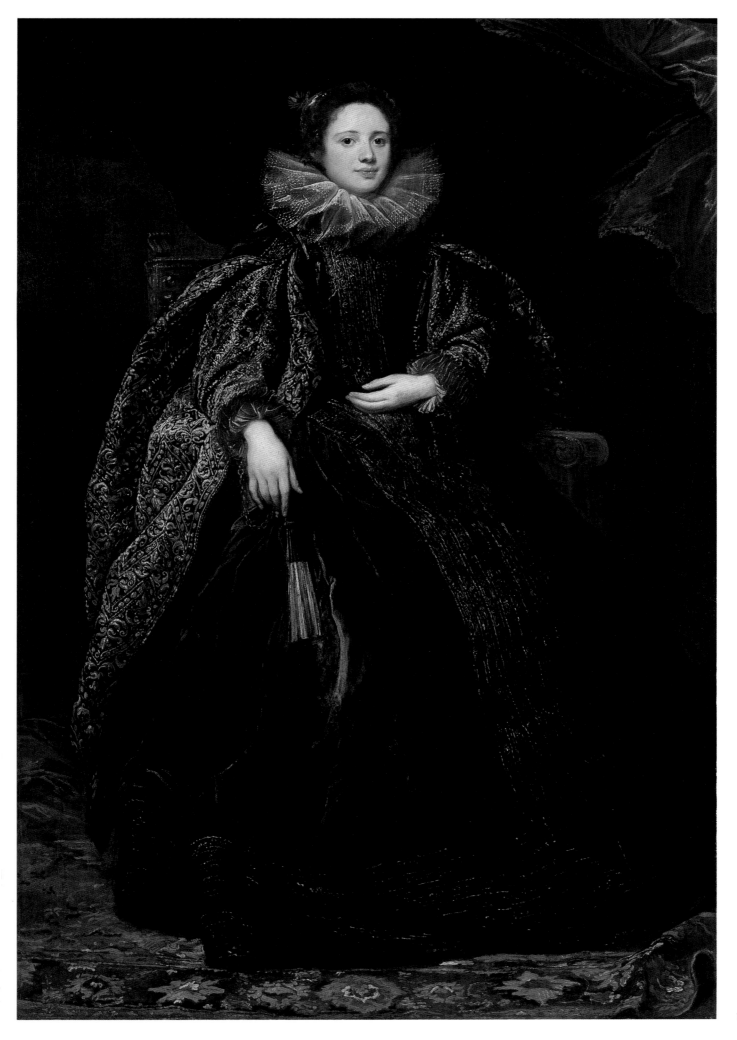

and another of his mother and sister, *Geronima Sale, Marchesa Brignole, and Aurelia Brignole-Sale.* Laura Tagliaferro discovered and kindly shared with me a payment in Gio. Francesco Brignole's personal account books, on 18 December 1627, referring to all three works (Barnes 1986, 1:20–21, 204).

2. Longhi, "Familigie Nobili," ms. 473, fol. 511, Archivio di Stato, Genoa.

3. Boccardo and Magnani 1987, 78, n. 11.

4. Because of his censure, the sitter was not named even in this document, but his identity can be deduced from the description: "Il ritratto di N. a cavallo del detto [Van Dyck]—levato di casa per essere indegno di starci" (Boccardo and Magnani 1987, 78, n. 11).

5. The painting remained this way in the Balbi family until its recent acquisition by the Fondazione Magnani-Rocca. They ascertained through radiographs that there was indeed another face beneath, and carefully removed the additions to reveal it for the first time in three centuries.

6. Her second husband was Ippolito Invrea, whose grandson Ippolito Settimio Invrea sold the painting to the Durazzo; interestingly, the terms of the sale included the making of a copy (D. Puncuh, "L'Archivio dei Durazzo, marchesi di Gabiano," *Atti della Società ligure di storia patria,* n.s. vol. 21 no. 2 [1981], 189–190). I would identify the copy as the painting of the woman alone in the Virginia Museum of Fine Arts, Richmond (Barnes 1986, 1:193–194).

7. On Costantino's collection, see Boccardo and Magnani 1987, 64–65.

in my opinion depicts the sister of Bartolomeo and Giovanni Paolo, Battina Balbi, with the two sons from her first marriage to Giovanni Durazzo.[6]

Because of its early nineteenth-century provenance in the collection of Giacomo Balbi, the present painting has been called "Marchesa Balbi." Recently, Lauro Magnani and Piero Boccardo published the impressive fruit of their research on the patronage and collecting of the Balbi, and made the interesting suggestion that she is Ottavia Balbi (c. 1610–1648), daughter of Gio. Agostino and wife of Bartolomeo. Although the many family connections Ottavia would have had to Van Dyck, outlined above, make this seem logical, there are reasons to doubt it. The certain stylistic dating of the picture to 1621 or 1622, described below, means that the sitter would have been younger by several years than the woman we see here. From the point of view of the documents, the painting is absent from Ottavia's husband's 1647–1649 inventory, which includes all of the works from her late father's collection as well as their own. In addition, it came in the early nineteenth century from Giacomo Balbi's collection, which was put together by his father Costantino (1676–1740), who, not being the first-born son in his family, seems not to have inherited any Balbi family portraits.[7] Finally, and most surprisingly, our portrait was not included in the 1780 edition of Ratti, who described Giacomo Balbi's collection with such care that we can recognize many of the paintings today, including three others included in this exhibition [cats. 22, 26, 27].

The doubts about our noblewoman's identity reflect not at all on the beauty and interest of this painting, both as a portrait and as a work of art. Clearly it was created on Van Dyck's first stay in Genoa, and in response to two of Rubens' Genoese masterpieces. Van Dyck quickly eschewed such iconic, static forms and strong contrasts of light and dark, to pursue his interests in naturalism and movement in portraiture. Here, however, he was totally under the sway of Rubens' stunning, nearly identical portraits of *Veronica Spinola-Doria* [fig. 3 and Staatliche Kunsthalle, Karlsruhe] in depicting his sitter in an imposing frontal view and in dramatically lit surroundings. The pattern of scintillating light on the golden brocade of her dress and on her lace collar form a kind of mandorla around her, increasing the sense of her magical presence in the penumbra. An early dating for the painting is confirmed by certain technical details such as the shimmering, energetically scumbled highlights on the curtain at left and down the front of the skirt, which are like similar effects in the 1622 *Portrait of Lucas Van Uffel* [see cat. 31, fig. 1].

S. J. B.

Fig. 3. Peter Paul Rubens, *Veronica Spinola-Doria,* c. 1607, canvas, 225.5 x 138.5 (88³/₄ x 54¹/₂). Staatliche Kunsthalle, Karlsruhe

25
Agostino Pallavicini

late 1621 or early 1622
signed on the right near the back of the
chair *Ant.us Van Dyck f* [ecit]; the
inscription on letter in sitter's right hand
is now illegible
canvas, 216 x 141 (85 1/8 x 55 1/2)

The J. Paul Getty Museum, Malibu,
inv. no. 68.PA.2

PROVENANCE[1] Agostino Pallavicini;
inherited by his son, Ansaldo Pallavicini,
resident from 1650 onward in the Palazzo
a Pellicceria, Genoa, which passed with
its contents through the following hands:
Ansaldo's son and heir Agostino
Pallavicini took holy orders, leaving
everything to his sister Anna Maria, wife
of Girolamo Doria; their son Paolo
Francesco Doria died in 1732, and his
sister Maddelena, wife of Nicolò Spinola
di San Luca, inherited; their son Paolo
Francesco Spinola died in 1824,
whereupon the palace and collections
went to Giacomo Spinola di Luccoli;
purchased through Andrew Wilson, 1841; sold
to Sir Joseph Hawley, Bart.; owned by
Sir Henry Hawley, Brighton, in 1879; M.
Colnaghi (dealer), London, 1887; sold to
Arthur Pemberton Heywood-Lonsdale,
Shavington, Shropshire, in 1887; passed
to H. H. Heywood-Lonsdale, Shavington,
Shropshire, and then (1968) to Lt. Col. A.
Heywood-Lonsdale; purchased through
Thos. Agnew and Sons, London, in 1968

EXHIBITIONS London, Royal Academy,
1879, no. 168; London, Royal Academy,
1894, no. 125; London 1900, no. 47;
Liverpool 1959, no. 5 (as probably
Agostino Pallavicini); on loan to the
National Gallery, London, 1962–1968;
London 1968, no. 21, ill. 21 (as "Andrea
Spinola"); Minneapolis 1972, no. 27,
ill. 27

LITERATURE Bellori 1672, 256; Ratti 1780,
140; Allan Cunningham, *The Life of Sir
David Wilkie* …, 3 vols. (London, 1843),
2:420, 429, 430, 439, 448–449, 474,
480–482, 494–495 (as a half-length that
had been later expanded); Cust 1900, 42
(opp.), ill., 43–44 (as "Andrea Spinola,"
probably by a Genoese follower of Van
Dyck), 219, no. 47, 244, no. 123;
Friedländer 1900, 169; Laban 1901, 204,
n. 1; Schaeffer 1909, 434, ill., 518 (as
"Andrea Spinola"); Burchard 1929, 336;
Glück 1931, 204, ill., 541 (as "Andrea
Spinola"); W. N. Hargreaves-Mawdsley,
*A History of Legal Dress in Europe until the
End of the Eighteenth Century* (Oxford,
1963), 10; Getty 1972, no. 87, ill. (as "a
Member of the Pallavicini Family");
Sarasota 1984–1985, 213, ill.; Barnes 1986,
1:102–103, 229–232, no. 32, 2: ill. 229;
Boccardo 1987, 62, ill., 66, 68; Larsen
1988, no. 366, ill. 170 ("a member of the
Pallavicini family [?] or [preferably]
Andrea Spinola"); Marzia Cataldi Gallo,
"Ritratto e costumi: status symbol nella
Genova del Seicento," *Bollettino Ligustico
per la Storia e la Cultura Regionale*, n.s. 1
(1989): 83, 86

When the eighteenth-century writer Ratti saw this imposing painting, he understood that it was the portrait of a civic official. He mistook the scarlet gown for that worn by the doge, however, and since he was in a palace of the Spinola family, and a bit vague on the dates of Van Dyck's Genoese œuvre, he reckoned that the sitter was Andrea Spinola, doge from 1629 to 1631.[2] The portrait carried that name for nearly two hundred years as it traveled from the Spinola collections and through others. In 1959 the author of the Liverpool catalogue recognized the Pallavicini arms in the curtain behind the sitter, and proposed that the portrait was the one mentioned by Bellori (1672) as showing the future Doge Agostino Pallavicini in his official garb as ambassador from Genoa to the Holy See.[3] That attractive hypothesis was received with due caution by the curators of the Getty, who accepted only that the man was from the Pallavicini family.[4] Fortunately, we can now confirm the identification absolutely by comparison with an engraved portrait, which commemorates Agostino Pallavicini's next and most important civic role, his election as doge in 1637 [fig. 1].[5] If we wonder how Ratti could have mistaken the crimson satin robes he wears in the present portrait for the ermine cape and royal crown seen in the engraving, it is because Pallavicini had eschewed the traditional ducal garments of his predecessors. Pretending that the Genoese possession of Corsica had been a kingdom in ancient times, Agostino Pallavicini became the first Genoese ruler to give himself a royal coronation and to don those trappings, complete with scepter. He also renamed the ducal residence the Palazzo Reale.

The portrait must date from Van Dyck's first stay in Genoa, between late November 1621 and February 1622. Earlier in 1621, from late May to early June, Agostino Pallavicini had traveled to Rome as one of a delegation of four on behalf of the Genoese Republic to pay respects to the new pope, Gregory XV. Van Dyck's arrival was fortuitous; it allowed the politically ambitious Pallavicini to record that honor and service to the republic in the same manner as he would his election as doge, by commissioning a portrait. Van Dyck showed him seated, and holding in his hand the paper that signified his mission. The seated pose befitted an ambassador. It also is consistent with Italian tradition and with Van Dyck's own later images of civic and religious officials, such as the unnamed senator [cat. 26], *Cardinal Bentivoglio* [fig. 2], and the *Roman Clergyman* [cat. 32]. That consistency typifies Van Dyck's respect for the decorum of the day, the sense that portraits should conform to shared conventions of representation. As he was well aware, the late sixteenth-century Italian painter and theorist G.-P. Lomazzo had admonished portraitists to depict the costume, the attributes, the pose, and the gestures appropriate to their subject's position in society. Beyond that, he charged the artist to invest the sitter with the proper bearing for his role, even if the painter had to invent it.[6]

Fig. 1. Frontispiece, *Applausi della Liguria nella Reale Incoronatione del Serenissimo Agostino Pallavicino* (Genoa, 1638)

1. We owe a great debt to Piero Boccardo (1987), whose masterful work in the Genoese archives enables us now to trace the entire history of the painting.
2. The later addition of the ducal red beret to the table beside Pallavicini would have strengthened the impression that the sitter was in fact a doge.
3. Regulations governing the dress of Genoese officials did not specify the color of an ambassador's robes beyond restricting against their being black (Luigi Volpicella, ed., "Il Libro dei ceremoniali della Repubblica di Genova," *Atti della Società ligure di storia patria* 49, fasc. 2 [1921], 113). We may speculate whether Agostino Pallavicini chose to wear the color so closely associated with the office to which he must have aspired. For the biography of Agostino Pallavicini, see Luigi Levati, *I Dogi biennali di Genova dal 1528 al 1699* (Genoa, 1930), 34–46. Marzia Gallo (1989) has published entries in Pallavicini's account books pertaining to this costume.
4. Larsen inexplicably denied the evidence of the coat of arms (1988, no. 366).
5. The engraving by Gilles Rousselet, after Domenico Faisella's painted portrait (Gallerìa Nazionale di Palazzo Spinola, Genoa), was published as the frontispiece of *Applausi della Liguri nella reale incoronazione del serenissimo Agostino Pallavicini Duce della Republica* [sic] *di Genova* (Genoa, 1638).
6. Giovanni Paolo Lomazzo, *Trattato dell'arte della pittura, scultura, et architettura*, 3 vols. (Rome, 1844), 2:370–372.
7. Cunningham 1843.

We can only guess how Pallavicini and Van Dyck came to meet. His reputation as Rubens' prized assistant had surely preceded him in the city where Rubens had left such a strong mark. Among the works Rubens had painted during visits to Genoa during his own Italian years were a most impressive series of full-length portraits [see cat. 24, fig. 3], as well as *The Circumcision* (Sant' Ambrogio, Genoa), painted for the main altar of the Jesuit church. In the years just previous to Van Dyck's arrival the Genoese had commissioned other important works from Rubens, among them the tapestry designs for the *Life of the Consul Decius Mus* [see Wheelock, fig. 2] in whose execution Van Dyck had an important role, and *The Miracles of Saint Ignatius*, also for the Jesuit church. Nicolò Pallavicini, the godfather and namesake of Rubens' son who was responsible for the latter commission, was also a distant cousin of Agostino Pallavicini.

Sir David Wilkie's impression that the portrait had been expanded from half-length to full-length by a later hand was mistaken,7 as was Cust's doubt (1900) about the authorship of the painting. A copy made by one of the Piola family is in the Palazzo Bianco, Genoa.

S. J. B.

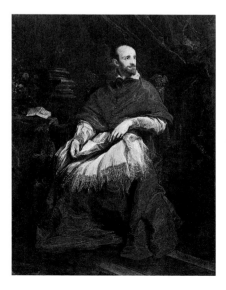

Fig. 2. Anthony van Dyck, *Cardinal Bentivoglio*, 1622 or 1623, canvas, 196 x 145 (77 1/8 x 57 1/8). Pitti Palace, Florence

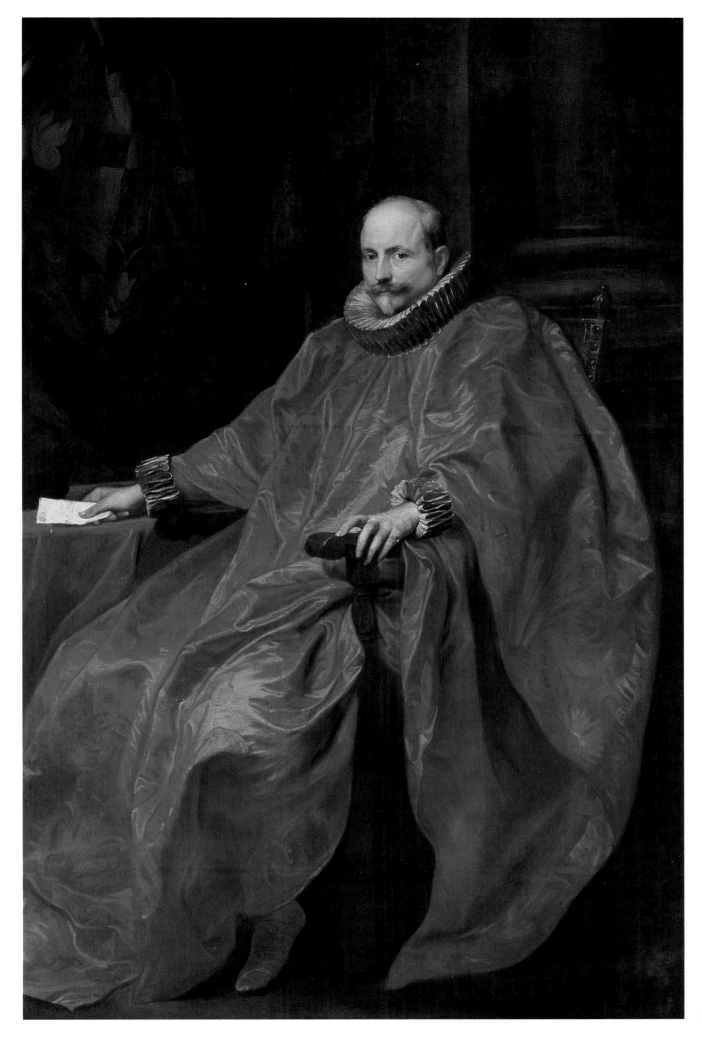

A Genoese Senator, 1621–1623
canvas, 200 x 116 (78 x 45 1/4)

Staatliche Museen Preussischer
Kulturbesitz, Gemäldegalerie, Berlin,
inv. no. 782B

PROVENANCE Possibly inherited by
Caterina Giustiniani, wife of Bartolomeo
Saluzzo (c. 1705), and sold by their son
Alessandro Saluzzo to Costantino Balbi
in 1706;¹ first recorded in a 1724
inventory of the collection of Costantino
Balbi (1676–1740); inherited by his son,
Giacomo Balbi, and Giacomo's wife,
Violante Durazzo; inherited by their son,
Costantino Balbi; on his death in 1823,
when the collection was divided between
two surviving daughters, the pendants
passed to Violante Balbi and her husband
Giacomo Spinola; purchased in 1828 by
the English painter David Wilkie for Sir
Robert Peel, London, whose collection
went chiefly to the National Gallery in
1871; acquired at sale of Sir Robert Peel
Heirlooms, 10 May 1900, at Willis,
London, lot 266–267

EXHIBITION London, British Institution,
1829, no. 18

LITERATURE G. Brusco, *Description des
beautés de Gênes et de ses environs* (Genoa,
1773), 66; Ratti 1780, 195; Smith
1829–1842, no. 179; Allan Cunning-
ham, *The Life of Sir David Wilkie …*, 3 vols.
(London, 1843), 2:420 (as "Old Lady
and Gentleman"), 429, 430, 439, 449, 474,
480–482, 494, 3:2, 12; C. M., "Collection
de Sir R. Peel," *Le Cabinet de l'amateur et
de l'antiquaire* (1845–1846), 4:68, no. 50;
Guiffrey 1882, 287, no. 1076; Cust 1900,
26, 242, no. 88; Laban 1901, 200–206, ill.
opp. 200; Schaeffer 1909, 196, ill., 503;
*Beschreibendes Verzeichnis der Gemälde im
Kaiser-Friedrich Museum* (Berlin, 1921), 130,
no. 782B; Glück 1931, XXXVII, 174, ill.,
539; Brown 1982, 88–89, 90, ill. 80;
Gemäldegalerie Berlin 1986, 29, 228, ill.
489; Barnes 1986, 1:104, 280, no. 54, 2: ill.
196; Boccardo 1987, 84, n. 41; Boccardo
and Magnani 1987, 65, 86, no. 22, ill. 65;
Piero Boccardo, "Materiali per una storia
del collezionismo artistico a Genova nel
XVII secolo," unpublished Ph.D. thesis,
Milan, Università degli Studi, 1989, 125,
128–129, n. 30, 130, no. 22

A Genoese Lady, 1621–1623
canvas, 200 x 116 (78 x 45 1/4)

Staatliche Museen Preussischer
Kulturbesitz, Gemäldegalerie, Berlin,
inv. no. 782C

PROVENANCE See above

EXHIBITION London, British Institution,
1829, no. 23

LITERATURE *Description* 1773; Ratti 1780,
196; Smith 1829–1842, 3:52, no. 180;

The large number of known Italian portrait sitters in this exhibition belies the fact that the names of Van Dyck's patrons in Italy usually have been lost to us. Van Dyck painted most of his Italian portraits in Genoa, where many remained through the eighteenth century. Only then, in a French guidebook of 1773 and Ratti's of 1766 and 1780, were they described summarily for the first time in their locations, and only an exceptional few were given with the names of their subjects. During the 150 years since Van Dyck's departure, the pictures had moved and the names had been forgotten. As Boccardo's newly reconstructed provenance of the portrait of *Agostino Pallavicini* [cat. 25] demonstrates, inheritance might have taken a palace and its contents through several families by the time Ratti's comprehensive 1780 edition was published. In addition, as the fortunes of individual members of the Genoese patriciate fell, they sold assets, including family portraits; paintings by Van Dyck were valuable capital. Quantities of paintings and tapestries were purchased by others, whose fortunes had risen, to decorate the expansive walls of their palaces.² Occasionally these works were the object of a serious collector.

Such was the case with the paintings owned by Costantino Balbi (1676–1740) in whose collection the portraits of this Genoese senator and his wife were first recorded in 1724. Because the couple were not named in that inventory and since fourscore men held the office of senator during Van Dyck's years in Italy, it seemed doubtful that their identities would be discovered. The traditional name for the senator given in the Peel sale was Bartolomeo Giustiniani, which Laban rejected for lack of evidence. But in new research, Boccardo has come back to the Giustiniani name with the discovery that Alessandro Saluzzo, whose mother Caterina Giustiniani was universal heir in her family, had sold a number of paintings to Costantino Balbi. Boccardo hypothesized that the couple might be Senator Luca Giustiniani and his wife.³

The pendants probably were painted in the first part of Van Dyck's Italian sojourn. The woman's pose, the disposition of her hands, her long, boneless fingers, and the general design of the composition recall Van Dyck's seated portraits of women from 1620–1621, such as *Susanna Fourment* [cat. 21] and others that should be dated to the earliest years of the artist's activity in Italy.⁴ The composition of the senator's portrait also is close to works of 1621–1623: the early sketch for the portrait of *Cardinal Bentivoglio* [fig. 1], and the painted portrait of *Agostino Pallavicini*. Like the

Fig. 1. Anthony van Dyck, *Sketch for Cardinal Bentivoglio*, 1622 or 1623, chalk and ink with wash on paper, 39.7 x 26.8 (15 5/8 x 10 1/2). Petit Palais, Paris

Allan Cunningham, *The Life of Sir David Wilkie* ..., 3 vols. (London, 1843), 2:420, 429, 430, 439, 449, 474, 480–482, 494, 497, 3:2, 12 (as "Old Lady and Gentleman"); C. M., "Collection de Sir R. Peel," *Le Cabinet de l'amateur et de l'antiquaire* (1845–1846), 4:68, no. 51; Guiffrey 1882, 288, no. 1111; Cust 1900, 26, 242, no. 89; Laban 1901, 200–206, ill. opp. 200; Schaeffer 1909, 196, ill., 503; Glück 1931, XXXVII, 175, ill., 539; *Beschreibendes Verzeichnis der Gemälde im Kaiser-Friedrich Museum* (Berlin, 1921), 131, no. 782C; Burchard 1929, 336; Gemäldegalerie Berlin 1971, 62, 224; Gemäldegalerie Berlin 1978, 146, no. 782B, ill.; Brown 1982, 88–89, 90, ill. 81; Gemäldegalerie Berlin 1986, 29, 228, ill. 490; Barnes 1986, 1:104, 306–307, no. 69, 2: ill. 215; Boccardo 1987, 84, n. 41; Boccardo and Magnani 1987, 65, 86, no. 16, ill. 66; Piero Boccardo, "Materiali per una storia del collezionismo artistico a Genova nel XVII secolo," unpublished Ph.D. thesis, Milan, Università degli Studi, 125, 128–129, n. 30, 130, no. 22, 130, no. 16

1. As proposed by Piero Boccardo (personal communication, January 1990). On the question of Costantino Balbi's purchases from the Saluzzi, see Boccardo, "Materiali per una storia del collezionismo artistico a Genova nel XVII secolo," unpublished Ph.D. thesis, Milan, Università degli Studi, 122–129. Balbi's 1724 inventory is transcribed there, 129–132. I am most grateful to Dr. Boccardo for sharing his findings with me. See also Boccardo and Magnani 1987, 64–65, where Costantino Balbi's 1740 inventory is also transcribed, 85–87 n. 128.

2. Thus, as we now know, the Durazzo purchased groups of paintings from different sources, including several portraits by Van Dyck, to decorate the palace on the via Balbi that they purchased in the early eighteenth century (D. Puncuh, "L'Archivio dei Durazzo, marchesi di Gabiano," *Atti della Società ligure di storia patria*, n.s. vol. 21, no. 2 [1981], 189, for instance).

3. Personal communication; see also Boccardo thesis, 128–129, n. 30.

4. For example, the portraits of unidentified Italian noblewomen in The Metropolitan Museum of Art, New York ("Marchesa Durazzo," inv. 14.40.615), in the Musée des Beaux-Arts, Strasbourg (Schaeffer 1909, 210 ill.), and in a private collection in Scotland. See Barnes 1986, 1: nos. 65–67.

5. Apparently unfinished is the V-shaped area between the collar and the waist of her dress, which is bare but for the gray underpaint. Although it is not clear how Van Dyck intended to complete it, this surface resembles the areas in his Leningrad *Self-Portrait* [cat. 33], where the artist created the illusion of the shirt beneath his slit-sleeved jacket by laying a few strokes of white on the gray-primed canvas. The pedestrian rendering of the proper right sleeve in the Berlin painting, and the shiny flatness of the curtain at left, both of which betray the hand of another artist, may signal areas that were damaged or also left unfinished.

6. Ludwig Burchard (notes, Rubenianum Library, Antwerp); Davis' painting was exhibited in *Works of Art from Midland Houses* [exh. cat.] (Birmingham, 1953), no. 11.

senator, both men were officials, as conveyed by their seated poses and by the papers they hold. In contrast to the pendant portraits of Sir Robert and Lady Shirley [cats. 28, 29] painted in 1622, the senator and his wife at first appear to be in the same surroundings. There are subtle differentiations, however, which are appropriate distinctions according to their gender. The architecture framing the senator has an institutional severity, with rectilinear pilasters and a bare stone floor, and it opens at right onto a view of the sky, while his wife is in an enclosed interior, with such softening, domestic features as an oriental rug, a curtain, and a rounded column.

Van Dyck's execution of the woman's head includes delicate highlights that animate her countenance, giving the impression of a vivacious and penetrating intelligence. In other areas, however, the painting seems to have been left unfinished, and in some parts it may have been worked over by a later hand.[5] Van Dyck represented the pair as two strong, individual personalities. Writing about the *Senator*, the painter David Wilkie noted Van Dyck's remarkable achievement: "Feebleness, gouty stiffness, and dignity mixed in a way I have never seen before, save in Vandyck."

John Scarlett Davis' painting *The Interior of the British Gallery* shows the pendants as they were hung in the exhibition of 1829.[6] Both were copied by Piola (Palazzo Rosso, Genoa). According to the Berlin catalogue of 1921, there was also a full-length copy of the *Senator* in the collection of Humphrey Ward, London, and a half-length with Principe S. Fautino in the Palazzo Barberini.

S. J. B.

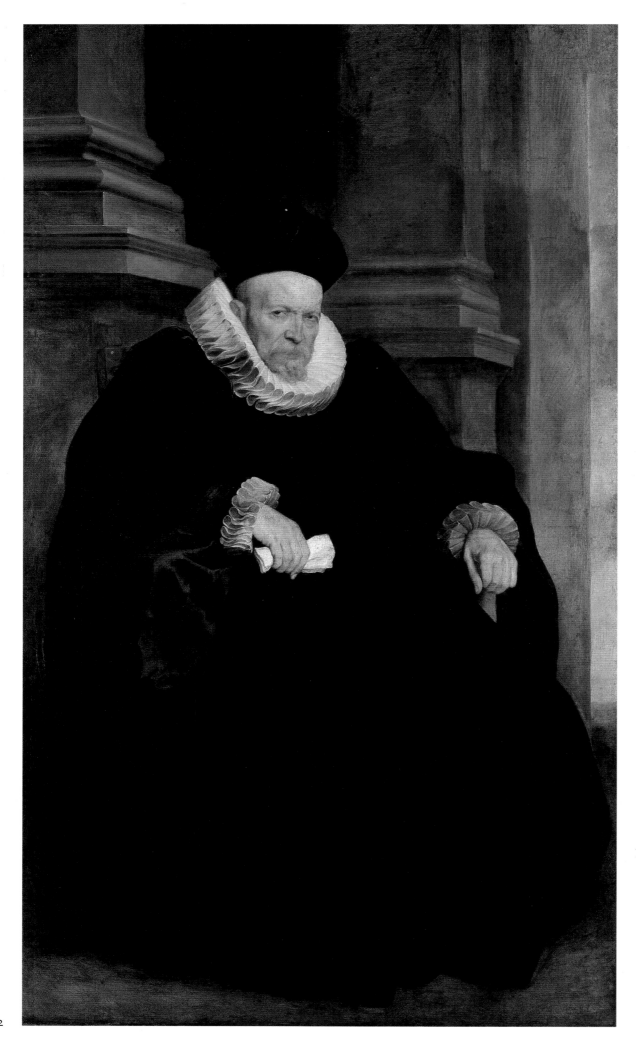

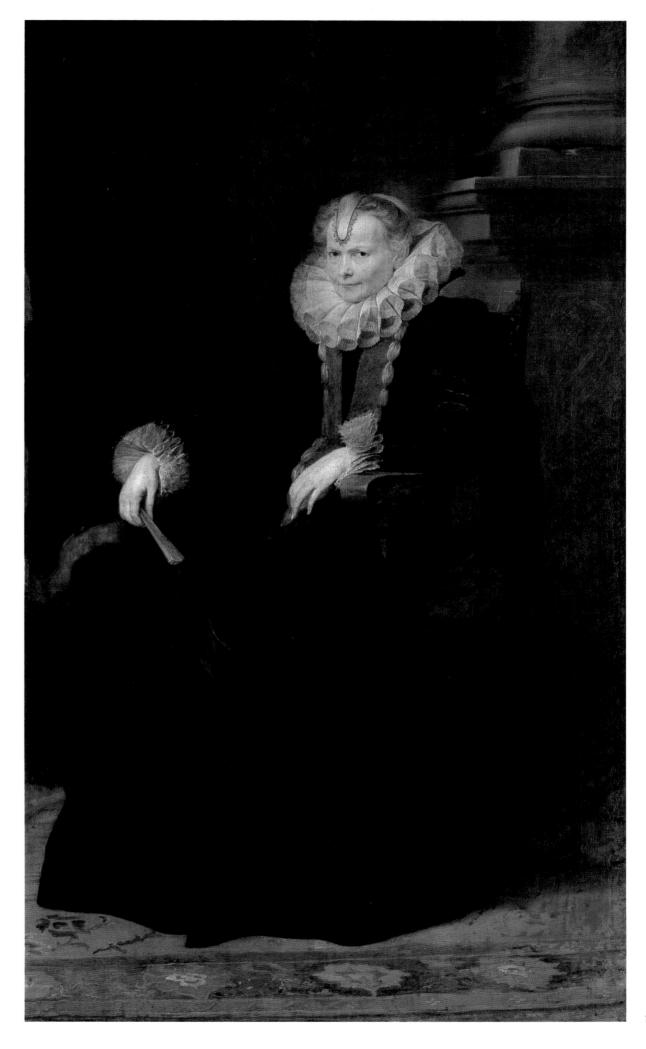

28·29
Sir Robert Shirley
Teresia, Lady Shirley

Sir Robert Shirley, 1622
inscribed *SIR ROBERT SHIRLEY.*
canvas, 200 x 133.4 (84¼ x 51¾,
originally 78 x 51)

The National Trust, Petworth House
(Egremont Collection), inv. no. 38

PROVENANCE Owned by the Shirleys;
tradition at Petworth suggests that the
pictures might have been bought at a
sale of the Shirley property at Wiston,
Steyning, though no sale catalogue is
recorded; earl of Egremont by 1815

EXHIBITIONS London 1955, no. 38;
London 1968a, 9, no. 17; London
1982–1983, no. 4, ill.

LITERATURE Bellori 1672, 55; Smith
1829–1842, 3:154, no. 545; Waagen 1854,
3:40 ("too feeble in drawing and too
heavy in colour for Vandyck"); Walpole
1876, 1:330; Baes 1878, 64; Cust 1900, 29,
36, 243, no. 117 (as 1623); C. H. Collins
Baker, *Catalogue of the Petworth Collection
in the Possession of Lord Leconsfield*
(London, 1920), 28, no. 96; Vaes 1924,
202–203 (as 1622); Vertue 1930–1955,
20:105; Glück 1931, 510, ill., 577–578;
Adriani 1940, 56; Petworth 1954, 13,
no. 96; Ellis K. Waterhouse, "Artists in
Seventeenth-Century Rome," *Burlington
Magazine* 97 (1955), 222; Millar 1930, 314;
Julius S. Held, "The Polish Rider,"
*Rembrandt's 'Aristotle' and Other
Rembrandt Studies* (Princeton, 1969), 57, n.
46 (as early example of "fancy dress" in
portraiture); Larsen 1975a, 56–57; Brown
1982, 64–65 pl. 52, ill. 54; Barnes 1986,
1:242–244, no. 37, 2: ill. 163

Teresia, Lady Shirley, 1622
inscribed *LADY SHIRLEY.*
canvas, 200 x 133.4 (84 x 51¾, originally
81 x 51¾)

The National Trust, Petworth House
(Egremont Collection), inv. no. 39

Contemporary documents establish with remarkable precision the subjects of these pendant portraits as well as the place and date they were painted. An inscribed drawing in Van Dyck's own hand, a study for the painting, tells that the man in cape and turban was "Ambasciatore di Persia in Roma," who was Sir Robert Shirley [see fig. 3]. Thanks to a Vatican diarist discovered by Vaes, we know that Sir Robert Shirley visited Rome only briefly, between 22 July and 29 August 1622.[1] Sir Robert was traveling with his wife on a mission from the shah of Persia to Pope Gregory XV.[2] He arrived a few days before the departure of his countryman and contemporary George Gage, who had completed his own diplomatic assignment to the Vatican. In the close circles around the papal court one can well imagine that they met, and that Gage, who knew Van Dyck and whose own portrait was also painted by him [cat. 30], recommended the young painter to Sir Robert.

The Shirleys were a very exotic pair, and the commission to do their portraits was an extraordinary opportunity. In addition to making a compositional sketch for each [figs. 1, 2], Van Dyck took care to record the forms and colors of Sir Robert's lavish costume in drawings made from life [fig. 3].[3] He drew them in the sketchbook he carried about, which he otherwise filled with drawings after works of art or with life studies not directly related to his own paintings. The Shirley paintings themselves are sumptuous in their color and light—dazzling in the case of *Lady Shirley*. That they were most likely made in haste, given the short stay of the Shirleys in Rome, helps to explain the weakness of drawing, which troubled Waagen. Van Dyck executed the paintings with virtuosity in handling of paint and with real economy of means, letting the warm brown ground tone stand for most of the dark areas in both compositions. Against that tone, he created a rich surface texture through the application of thick, dragged paint. This was a technique Van Dyck had developed in emulation of Venetian painting long before coming to Italy. Here, on the eve of his first trip to Venice, he applied that technique with unbridled bravura and almost for the last time. The Cattaneo family portraits, painted in Genoa in 1623 [cats. 34–36], show Van Dyck already relinquishing the extreme surface lights of the Shirley portraits. His interest in Venetian portraiture shifted from the handling of the brush and toward color, compositional designs, and the psychology of the sitter.

In creating marriage pendant portraits from about 1620 on, Van Dyck distinguished in ways small and large between the activities and everyday environments of men and of women. The extreme differences here suggest the trappings and customs of another culture, as he noted on the drawing of Lady Shirley, "habito et maniera di

PROVENANCE Owned by the Shirleys; in the collection of Charles I, Greenwich; sold by order of the Commonwealth, 23 October 1651, to Murray; a contradictory tradition at Petworth suggests that the pictures might have been bought at a sale of the Shirley property at Wiston, Steyning, though no sale catalogue is recorded; earl of Egremont by 1815

EXHIBITIONS London, British Institution, 1815, no. 61 (lent by the earl of Egremont); London 1955, no. 39; London 1968a, 9, no. 18; London 1982–1983, no. 5, pl. 1

LITERATURE Bellori 1672, 255; Vertue 1757, no. 18 (in collection of Charles I as "The lady Shirley in fantastick habit [supposed to be a Persian habit] by Vandyke"); Smith 1829–1842, 3:154, no. 544; Waagen 1854, 3:40 ("too feeble in drawing and too heavy in colour for Vandyck"); Walpole 1876, 1:330; Baes 1878, 64; Phillips 1896, 121; Cust 1900, 29, 36, 243, no. 119 (as 1623); C. H. Collins Baker, *Catalogue of the Petworth Collection in the Possession of Lord Leconsfield* (London, 1920), 28–29, no. 97; Vaes 1924, 202–203 (as 1622); Glück 1931, 511, ill., 577–578; Adriani 1940, 55; Petworth 1954, 13, no. 97; Ellis K. Waterhouse, "Artists in Seventeenth-Century Rome," *Burlington Magazine* 97 (1955), 222; Millar 1955, 314; Julius Held, "The Polish Rider," *Rembrandt's 'Aristotle' and other Rembrandt Studies* (Princeton, 1969), 57, n. 46 (as early example of "fancy dress" in portraiture); Brown 1982, 64–65, 67, pl. 53; Barnes 1986, 1:245–247, no. 38, 2: ill. 165

1. Paul Alaleoni, *Barberini latini*, no. 2818, *Diarium Pauli Alaleonis*, fol. 13, 14, 16 (Vatican Library), as discovered by Vaes (1924, 202).
2. For facts about the Shirleys see London 1955, no. 38; on himself and his brothers, *The Encyclopaedia Britannica*, 11th ed., 29 vols., 1911, 24:990.
3. Oliver Millar noted that Shirley wears the same costume in an unattributed English portrait at Berkeley Castle (London 1982–1983, no. 4).

Persia." He painted Lady Shirley bathed in light and surrounded by opulent woven and embroidered textiles, seated with her pet monkey outside a tent, and set slightly incongruously against the Roman landscape. Sir Robert, in contrast, beturbaned and armed curiously with a bow and arrow, glows in his golden cape from within a dark, indeterminate interior setting.

Like his older brother, Sir Anthony (1565–c. 1635), Robert Shirley (c. 1581–1628) spent his life as a diplomat between the courts of Europe and Persia. Reared in England, Robert accompanied Anthony on his first trip to the court of Shah Abbas in 1598. He remained there until the shah sent him to negotiate with James I in 1607, seeking trade agreements as well as support for a campaign against the Turks. By that date Robert was married to Teresia, a Christian who was the daughter of Ishmael Kahn, a noble Circassian. En route to England during the year 1609, Sir Robert visited a succession of Continental courts where he was honored: Rudolf II knighted him at Prague; in Florence the grand duke gave him a golden chain; in Rome, where he embellished the turban he always wore with a golden crucifix, Paul V received him in audience, and named him Count of the Sacred Palace of the Lateran. After eighteen months' negotiation in Madrid, he arrived to a warm reception by James I in England in 1611. The Shirleys' only child, a son, was born then, and christened Henry in honor of his godfather, Henry, prince of Wales. Shirley's second European mission for the shah kept him in Spain from 1617 to 1622 as an honored guest of the crown. After his brief stop in Rome in 1622, he went on to England. His fortunes changed on his return to Persia in 1627: he found himself out of favor and died soon, on 13 July 1628. Lady Shirley retired to Rome thereupon and passed the remaining forty years of her life in a convent attached to Santa Maria della Scala.

It is not known how the pendants were separated, as they appear to have been, and then reunited. Since the Shirleys went directly to England from Rome, they may have left the paintings there with Sir Robert's family, who also kept their son. By 1639 the portrait of Lady Shirley had come alone into the collection of Charles I. That would seem to contradict Vaes' assumption that Bellori had seen both paintings in Rome with Lady Shirley after 1628. Bellori might have heard about the portraits from Sir Kenelm Digby, who told him much about Van Dyck. In 1815 *Lady Shirley* was sent alone from Petworth for exhibition; the first record of the two paintings' being together again at Petworth comes with Smith.

S. J. B.

◁

Fig. 1. Anthony van Dyck, compositional sketch for *Sir Robert Shirley*, Italian sketchbook, fol. 63r, 1622, pen and ink. Courtesy of the Trustees of the British Museum, London

Fig. 2. Anthony van Dyck, compositional sketch for *Teresia, Lady Shirley*, Italian sketchbook, fol. 60v, 1622, pen and ink. Courtesy of the Trustees of the British Museum, London

Fig. 3. Anthony van Dyck, study for costume of Sir Robert Shirley, Italian sketchbook, fol. 62r, 1622, pen and ink. Courtesy of the Trustees of the British Museum, London

Robert Shirley.

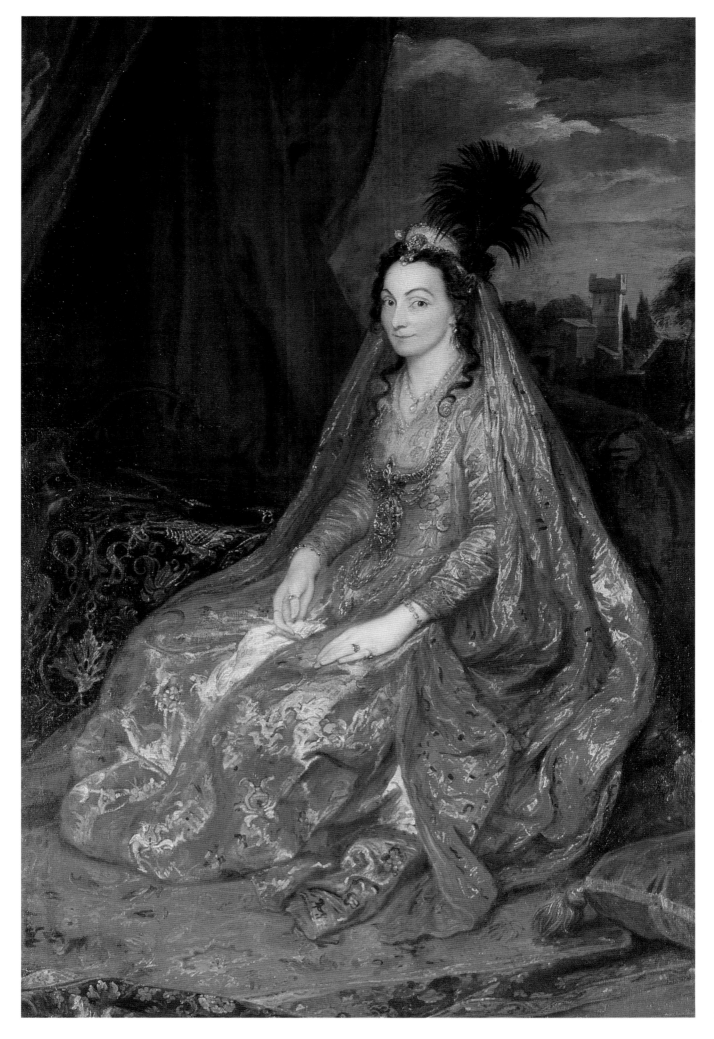

30
George Gage with Two Men

1622 or 1623

canvas, 115 x 113.5 (44⁷/₈ x 44¹/₄)

The Trustees of the National Gallery, London, inv. no. 49

PROVENANCE Sir Joshua Reynolds sale, 17 March (fourth day) 1795, lot 73;[1] bought by John Julius Angerstein; purchased with the Angerstein Collection, 1824; National Gallery, London

EXHIBITIONS London 1972–1973, no. 8 ill.; London 1982–1983, no. 1 ill.; Oxford 1985–1986, no. 63, ill.

LITERATURE John Young, *A Catalogue of the Celebrated Collection of Pictures of the Late John Julius Angerstein ...* (1823), no. 24; [Peter George Patmore], *British Galleries of Art* (1824), 27–28; Smith 1829–1842, 3:92, no. 318; *The National Gallery of Pictures* (London, 1838), no. 43; Waagen 1854, 1:352, no. 2; C. G. V. Schneevoogt, *Catalogue des Etampes gravées ... après P. P. Rubens* (1873), 163, no. 78; Cust 1900, 245, no. 145; Algernon Graves and William Vine Cronin, *A History of the Works of Sir Joshua Reynolds P.R.A.*, 4 vols. (London, 1901), 4:1630, no. 73; Schaeffer 1909, 220 ill.; F. M. Haberditzl, *Kunstgeschichtliche Anzeigen* (1909), 64 (perhaps depicts Cornelis Saftleven, but probably an *amateur*); Vaes 1924, 205; Glück 1931, 129 ill., 533; H. G. Evers, *Rubens und sein Werk, neue Forschungen* (Brussels, 1943), 343, fig. 369 (as portrait of Rubens); Van Puyvelde 1944, 3–8, ill. 1 (depicts Van Dyck and Bernini); Millar 1969, 414, 417, ill. 2 (depicts George Gage, 1620–1621); National Gallery London 1970, 58–61 (as "After [?] Van Dyck, *Portraits of Three Men*," 1620s, Van Dyck); Michael Jaffé, review of National Gallery London 1970, *Art Bulletin* (1973), 463; Harris 1973, 529; Larsen 1975a, 56, n. 86; Larsen 1980, 1: no. 386 ill. ("an artist," perhaps Rubens himself, 1622); London 1982–1983, 12, 40; Brown 1982, 74 (Italian period), ill. 62; Brown 1984, 123, ill. 2; Howarth 1985, 157, 158, ill. 108; Barnes 1986, 1:124–125, 218 no. 29, 2: ill. 143; National Gallery London 1987, 78, 79, pl. 33; Larsen 1988, 370, ill. 156, pl. 7 (may depict Rubens)

1. Graves and Cronin 1901: "As originally printed it was Saturday, March 8th, 1794; altered in ink to March 14th, 1795, and afterwards in Christie's own copy to Tuesday, March the 17th, 1795."
2. Martin listed the other names that have been proposed (1970, 59).
3. *Patronage and Collecting in the Seventeenth Century. Thomas Howard, Earl of Arundel* [exh. cat. Ashmolean Museum] (Oxford, 1985–1986), no. 63.
4. Stewart 1986, 140.
5. Howarth (1985, 157–158) has proposed to read the scene as an actual event, identifying the black man as Lady Arundel's own servant, the other man as Daniel Nys, and the sculpture as one belonging to the Arundels.

In the eighteenth century, when this wonderfully imaginative portrait of an art *amateur* was in the collection of Sir Joshua Reynolds, the principal person was thought to be Rubens, whom we now can see he does not resemble. Other suggestions have been made, but there can be no doubt that he is George Gage (1582?–1638), as Oliver Millar deduced twenty-odd years ago.[2] Millar recognized the saltire and sun in splendor from the Gage family arms, as well as the ram's head from the Gage crest, which Van Dyck had placed prominently in the relief decoration of the sculpted pedestal. Martin's reservations about Millar's discovery were as uncharacteristically mistaken as his doubts about the painting's authorship. A survey of Van Dyck's œuvre quickly reveals that such specific references are not coincidental. Van Dyck used sculptural allusions sparingly but purposefully; another contemporary example is *The Continence of Scipio* [see cat. 22, fig. 2], painted for Buckingham, where he depicted a fragment of a frieze from Pergamon that Buckingham had acquired.[3] The allusions may have a witty moral, as does the salacious faun in *Samson and Delilah* [cat. 11].[4] Van Dyck's sense of humor is apparent here, as well, when one thinks of the formulaic coats of arms often clumsily added to portraits in family galleries. By including the Gage arms in his own composition, Van Dyck anticipated and preempted such meddling.

Among Gage's business concerns was his activity as agent for Sir Dudley Carleton's art collecting, and the painting seems to involve negotiations for a piece of antique sculpture. The image is so lifelike and matter-of-fact that we must be reminded how very unusual it was at that time to depict a person in the course of his daily affairs. Gage's business transaction is a bold and original conceit; it creates a kind of narrative pretext that stretches the conventions of portraiture to include a new range of human interaction.[5]

Recent opinion holds that the painting was made in Italy, rather than in England or Antwerp in 1620–1621 as Millar proposed.[6] Strong evidence points to its creation in Rome in 1622 or 1623. The Louvre manuscript biography mentions a Roman portrait of Gage.[7] Gage was in Rome for long periods during 1621–1622 and again in 1623, as he negotiated secretly, on behalf of James I, the papal dispensation for the Protestant prince of Wales to marry the Infanta Maria of Spain. His documented stays in Rome overlap those we presume for Van Dyck by a total of eleven months.[8] When Gage and Van Dyck met there they may have renewed an acquaintanceship perhaps begun in England or in Rubens' Antwerp studio, which Gage had visited some years earlier on a mission for Carleton.

Stylistic evidence also points to a Roman origin for the painting. As *Lucas van Uffel*

Fig. 1. Anthony van Dyck, sketch after Titian, *Portrait of Paul III Farnese and His Cardinal Nephews*, Italian sketchbook, fol. 108r, 1622 or 1623, pen and ink. Courtesy of the Trustees of the British Museum, London

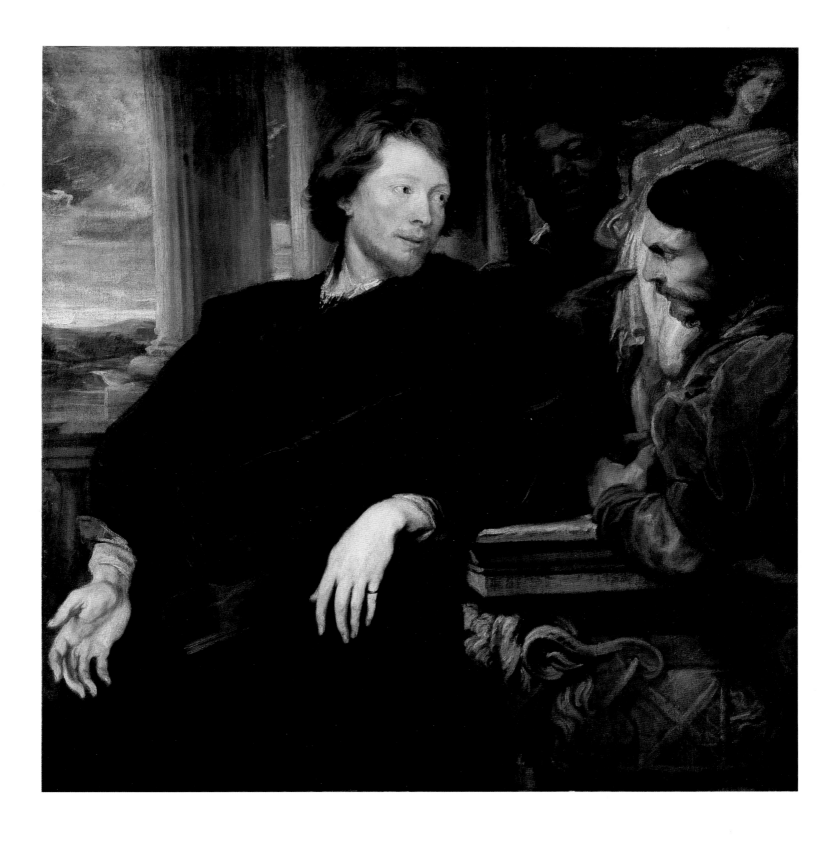

6. Brown 1982; Howarth 1985; Barnes 1986.
7. Larsen 1975a, 56.
8. The source for Gage's life and travels is Philippa Revill and F. W. Steer, "George Gage I and George Gage II," *Bulletin of the Institute of Historical Research* 31 (1958), 141–147. For Van Dyck's Roman sojourns, see Larsen 1975a, 53–58.

[see cat. 31, fig. 1, datable to 1622] demonstrates, Van Dyck continued his Antwerp techniques for many months after arriving in Italy. Thus the broad, sometimes rough handling, the taste for thick impasto, and the coarse canvas support of this painting could as easily belong to 1622 as to 1620. This work does display major advances over the most accomplished of Van Dyck's portraits of the first Antwerp period, being more complex compositionally, psychologically, and in the representation of movement. These advances owe in part to the study of sixteenth-century Italian examples, such as Titian's triple portrait of *Paul III Farnese and His Cardinal Nephews* (Capodimonte, Naples), rich in intrigue, which Van Dyck sketched [fig. 1] in the Farnese Palace in Rome, or Titian's *Jacopo Strada* (Kunsthistorisches Museum, Vienna), which equally influenced the New York portrait of *Lucas van Uffel*. Another painting from Rome, Van Dyck's *Portrait of a Roman Clergyman* [cat. 32], shares with George Gage the "informal, 'conversational' air" that Millar noted, and which in the seventeenth century was also admired in the portraits of the prominent Roman painter Ottavio Leoni. Even George Gage's architectural setting is Italian, with fluted columns like those in the portrait of *Elena Grimaldi* [cat. 36], inspired by Veronese.

James I had chosen Gage for a sensitive mission to the Holy See because his Catholic upbringing and extensive travels in Italy over the years caused him to feel at home there. Van Dyck depicted him in just that way, with the ease, the grace, the aplomb—in sum, the *sprezzatura*—that was the essential quality of the Italian courtier.

S. J. B.

31
Lucas van Uffel

1622
canvas, 108.5 x 90 (42 3/8 x 35)
Herzog Anton Ulrich-Museum,
Braunschweig

PROVENANCE Herzog Anton Ulrich,
Galerie Salzdahlum (by 1776); taken by
Napoleonic troops to France, 1806, and
exhibited at the Louvre, then returned in
1815

EXHIBITIONS Genoa 1955, no. 63 ill.;
Brussels 1965, no. 61 ill.

LITERATURE C. N. E. Eberlein, *Verzeichniss
der herzoglichen Bilder-Galerie zu Salzthalen*
(Braunschweig, 1776); *Notice des tableaux
exposés dans la Galerie du Musée* (Paris,
1814), no. 264 (as "Portrait of a General");
A. Riegel, *Beiträge zur niederländischen
Kunstgeschichte* (Berlin, 1882), 2:107
(identified the sitter as the same in the
duke of Sutherland's painting [now The
Metropolitan Museum of Art, New York]);
Guiffrey 1882, no. 1017; Cust 1900, 245, no.
143; Schaeffer 1909, 215 ill., 504; Vaes
1924, 181 n. 2; Marquet de Vasselot,
Répertoire des catalogues du Louvre (Paris,
1927), no. 133; Rosenbaum 1928a, 35–36
(among the first works Van Dyck painted
in Italy); Heil 1930, lxxxi; Glück 1931, 126
ill., 533; Burchard 1933, 412–413; Baldass
1957, 265–266; Jaffé 1967, 161; Rudiger
Klessman, *Herzog Anton Ulrich-Museum*
(Braunschweig, 1987), 56, 57 ill., 260;
Brown 1982, 78; Metropolitan Museum
1984, 1:58, ill. 12; Barnes 1986, 1:87,
250–251, no. 40, 2: ill. 170

1. Different impressions of Vaillant's
engraving after the portrait of the same
man in The Metropolitan Museum of Art
[fig. 1] carry different annotations. One
in the Rijksprentenkabinet, Amsterdam,
is inscribed with the name of Van Uffel,
while one in the Bibliothèque Nationale
says "Mr. de Nys Amatoor." In addition,
a letter of 1738, written by Antonie
Rutgers to Wilhelm VIII, landgrave of
Hesse-Kassel, describes the Metropolitan
painting as "le Van Uffelen de Van Dijk"
(Metropolitan Museum of Art 1984, 1:57).
2. Larsen 1975a.
3. On Van Uffel, see Vaes 1924, 178–182,
and Vaes 1925, 160–164.
4. For a more complete interpretation of
these attributes, see in Metropolitan
Museum of Art 1984, 1:58.
5. There is a similar background in the
*Portrait of a Lady Called the Marchesa
Durazzo*, 1621–1622 (The Metropolitan
Museum of Art, New York, inv.
no. 14.40.615).
6. Specifically, for instance, the highly
original pose of Lucas van Uffel in the
Metropolitan painting seems to have
been the model for one of Rembrandt's
Syndics of the Drapers Guild (Rijksmuseum,
Amsterdam). This would be a piece of
evidence in support of the Van Uffel
identification, since Rembrandt attended
the auction of Van Uffel's collection in
Amsterdam on 9 April 1639. See
Metropolitan Museum of Art 1984, 1:57,
60, n. 8, and Barnes 1986, 1:254.

Although eighteenth-century evidence has attached the names of both Daniel de Nys
and Lucas van Uffel to this man, a consensus seems to have emerged that he is Van
Dyck's friend and patron Van Uffel.[1] Like Van Uffel, De Nys was from the
Netherlands and living in Venice. Like Van Uffel, he had an important art collection,
which Van Dyck included in a list of Venetian art attractions in his sketchbook. But
Van Dyck had special ties to Van Uffel, who was later termed his "patrone et
singularissimo amico" (patron and most particular friend) in the dedication on
examples of Van Dyck's etching after *Titian and His Mistress*. Even when Van Dyck
was first in Italy, Van Uffel seems to have had some concern about his activities,
because Cornelis de Wael kept him abreast of them in letters now lost that formed
the basis for a rather detailed account of the artist's travels from 1621 through 1624 in
the eighteenth-century biography of Van Dyck in the Louvre.[2]

Van Dyck painted two portraits of Van Uffel when he visited Venice during the
fall of 1622. Both depict him as a man of intelligence, elegance, and action; but
though the heads and costumes are the same in the two half-lengths, they show Van
Uffel in separate surroundings that represent different aspects of the man's character
and interests.[3] The present portrait, with its distant view of ships in a harbor, points
out Van Uffel's business concerns as an arms merchant and shipowner. The portrait
in The Metropolitan Museum of Art [fig. 1], which was unable to travel to this
exhibition, instead suggests his life as an intellectual and *amateur* of the arts, through
the papers, celestial globe, recorder, and antique bust that adorn his desk.[4]

What caused Van Dyck to create two complementary images is uncertain; it is the
only such case known in the artist's Italian œuvre. Both have their origins in the
portraits of Titian, to which typologically they look back; however, one of them looks
forward as well. This portrait includes a curtain and cut-away view outdoors that
emulate portrait forms employed in the sixteenth century by Titian and Tintoretto,
artists whose works Van Uffel admired and collected. We have seen how in 1619–1621
Van Dyck fashioned such portrait settings, which had enlivened and modernized
portrait types in Antwerp [cats. 9, 21, 23]. In Italy, however, where such conventions
would have been familiar, and even old-fashioned, he seems only to have used them
for a few months, up through his Venetian stay.[5] The Metropolitan version has a
warm brown interior setting and a brilliant, buttery scumbling of paint throughout
that owes to Titian. It is also animated with a dynamic sense of movement that we
associate with Titian's *Jacopo Strada* (Kunsthistorisches Museum, Vienna) or Lorenzo
Lotto's *Andrea Odoni* (Her Majesty the Queen). Reestablishing that dynamism is where
Van Dyck looked forward; his depiction of movement of all kinds, in formal and
informal portraits alike, would have an untold impact in Italy and the Netherlands as
well as England.[6]

S. J. B.

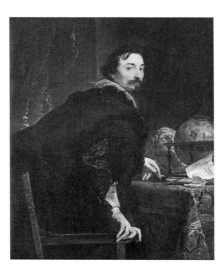

Fig. 1. Anthony van Dyck, *Lucas van Uffel*
(1583?–1637), 1622, canvas, 124.5 x 100.6
(49 x 39 5/8). The Metropolitan Museum of
Art, New York, Bequest of Benjamin
Altman, 1913 (14.40.619)

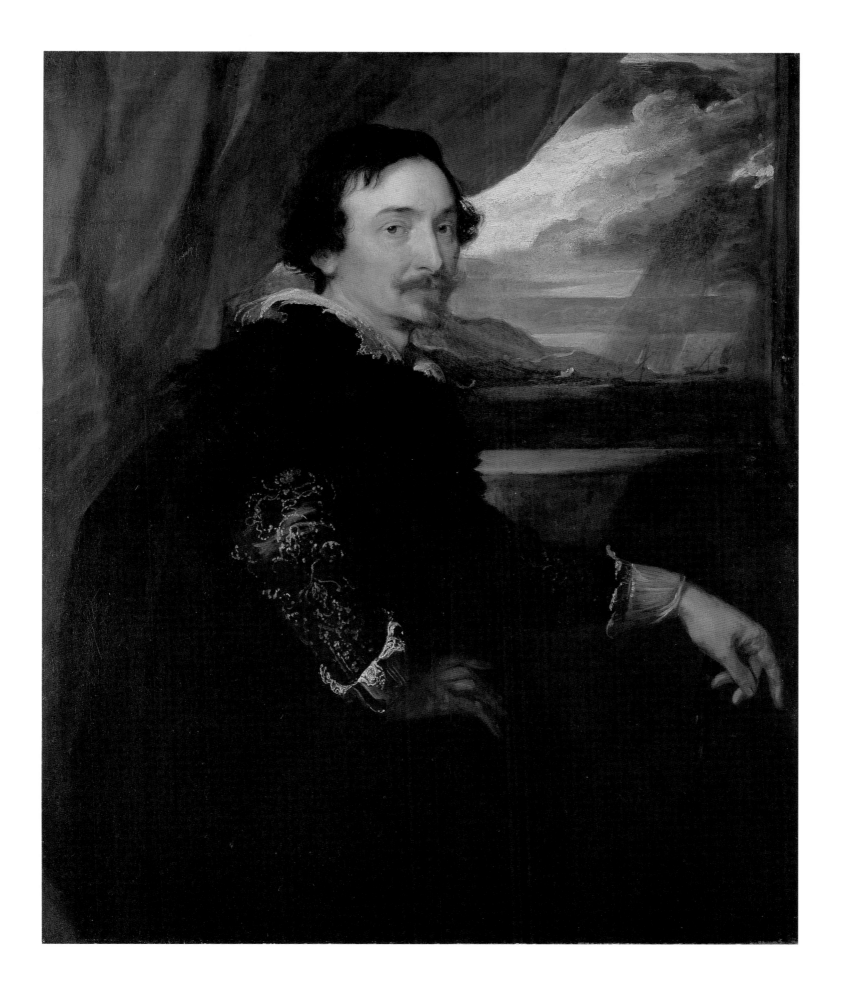

1622 or 1623
canvas, 104 x 86 (40 ¹/₂ x 33 ¹/₂)

The State Hermitage Museum, Leningrad

PROVENANCE Boyer (by 1703); in Crozat
Collection, Paris, by 1740 inventory;
acquired for the Hermitage from the
Crozat Collection by Catherine the Great

LITERATURE *Recueil des plus beaux
tableaux du cabinet de M. Boyer, seigneur
d'Aguilles* (Aix, 1709); Crozat 1755, 5;
Smith 1829–1842, 3:151, no. 535, and 229,
no. 818, 9:394, no. 94; Hermitage 1870,
2:78, no. 632; A. Somof, *Ermitage
Impériale. Catalogue* (1895), 73–74, no. 632
(as *Lazarus Maharkyzus*); Cust 1900, 257
no. 69; Schaeffer 1909, 242 ill. (as *Lazarus
Maharkijzus*, second Antwerp period);
Glück 1931, 281 ill., 550 (*Lazarus Mahar-
kyzus*, second Antwerp period); O. I.
Panifilowa, "Eskis Van-Dijka k portretu
Kardinala Bentivoglio," *Bulletin du Musée
de l'Hermitage* 8 (1955), 36–37, ill.;
Hermitage 1958, 2:56 no. 552, fig. 49; H.
Gerson and E. H. ter Kuile, *Art and
Architecture in Belgium, 1600 to 1800*
(Baltimore, 1960), 56, ill. 49; Hermitage
1964, no. 16, ill. (*Portrait of a Man*, c.
1623); Crozat 1968, 97, no. 335, ill.;
Barnes 1986, 1:272–273, no. 50, 2: ill. 188

1. The nature of Van Dyck's relationship
with this important figure is uncertain.
Before being created cardinal in 1621,
Guido Bentivoglio had served as papal
nuncio to Flanders (1607–1615), where he
might have known Van Dyck or his
father. The seventeenth-century
biographer Bellori tells us that Van Dyck
frequented the magnificent palace on the
Quirinal where Guido Bentivoglio lived
with his brother Enzo. Enzo's role as
art advisor to successive papal families,
both Paul V Borghese (1605–1621) and
Gregory XV Ludovisi (1621–1623), made
him one of the most powerful figures in
the Roman art world. But apart from the

Van Dyck is thought to have visited Rome briefly in 1622 and for about eight months in 1623. This informal, engaging portrait of an unknown cleric, painted there, holds clues that illumine two different aspects of his portraiture in the papal city.

Some years ago the curators of the Hermitage (1964) correctly deduced from a combination of technical and stylistic evidence that this portrait had been painted in Rome, rather than later in Antwerp, as an erroneous inscription on an engraving by Sebastian Barras had led scholars to believe. They saw the resemblance of the portrait to other early Italian works by the artist. Critical proof was furnished by radiographs that Panifilowa had published revealing a sketch for the portrait of Cardinal Bentivoglio underneath the painted surface [fig. 1]. The magnificent *Cardinal Bentivoglio* [see cat. 25, fig. 2], which sadly is absent from this exhibition, was painted in Rome in 1622 or 1623. Van Dyck's practice in portraiture was usually to work directly on the canvas, not to make preparatory oil sketches. Apparently Bentivoglio, who was from a family of art connoisseurs and himself an important person at the papal court, had asked Van Dyck to make the sketch, a presentation *modello*, so that he could approve the young artist's idea for the portrait before it was undertaken.[1] After that, the sketch being of no further purpose, Van Dyck reused the canvas, expanding it with an addition of several centimeters on the left side to accommodate the present composition. The unnamed man depicted here, whose collar identifies him as a man of the cloth, may have been a member of the cardinal's entourage.[2]

It now is apparent that the form of the portrait itself and the animated quality it conveys are quintessentially Roman, that they evince Van Dyck's response to portrait traditions proper to that city and particularly evident in the work of Ottavio Leoni (c. 1578–1630). Although Leoni's name had come down to us through contemporary literature as the leading portraitist of his time, his œuvre has only recently begun to be studied and brought to light.[3] His drawings and prints show his sitters informally, at bust or half length. Leoni counted among his subjects popes, princes, and generals—the most important people in Rome. He and his father Ludovico both were known for the speed with which they rendered portrait subjects having seen them only once. Some of Ottavio's works, such as the 1620 dated drawing of *Tommaso Salini* [fig. 2], convey that instantaneous quality by capturing sitters in motion.

A few years before coming to Italy, Van Dyck had begun to experiment with depictions of arrested movement in his *Man with a Glove* [cat. 7]. Leoni's œuvre, of which we may assume Van Dyck was aware, can only have encouraged him to pursue those experiments in the present painting and in others from the same time,

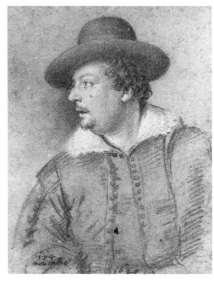

Fig. 1. Cat. 32, X-ray, detail

Fig. 2. Ottavio Leoni, *Tommaso Salini*, November 1620, chalk, 22.5 x 17.2 (8⁷/₈ x 6³/₄). The Metropolitan Museum of Art, New York, Gift of Mrs. Charles Slatkin, 1954 (54.612.1)

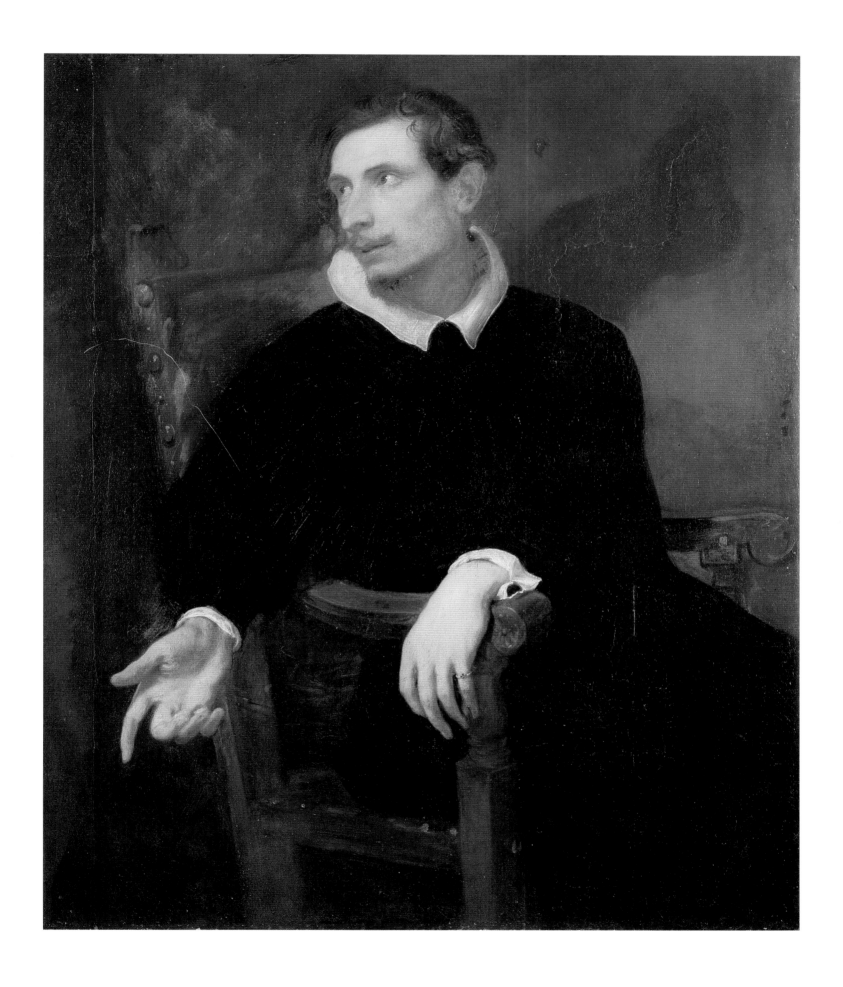

Portrait of Cardinal Bentivoglio, we have no evidence that Van Dyck benefited from that patronage.

2. Compare the collars in Maratta's *Clement IX* (Rospigliosi Collection, Rome), and in the *Portrait of an Ecclesiastic* attributed to Velázquez (Capitoline, Rome; E. Harris, *Velázquez* [Oxford, 1982], fig. 68).

3. John Spike reawakened us to his importance with "Ottavio Leoni's Portraits *alla macchia*," in *Baroque Portraiture in Italy: Works from North American Collections* [exh. cat. The John and Mable Ringling Museum of Art] (Sarasota, 1984), 12–16. On Leoni's printed portraits, see Susan J. Barnes, "*The Uomini Illustri ...*," *Cultural Differentiation and Cultural Identity in the Visual Arts*, Studies in the History of Art 27 (1989), 81–92. C. Roxanne Robbin is currently preparing a dissertation on Leoni's paintings for the University of Santa Barbara.

especially the striking *Portrait of Lucas van Uffel* [see cat. 31, fig. 1], painted in Venice between Van Dyck's two trips to Rome. Both of these portraits are quite revolutionary in seizing the sitter in a motion or action that involves turning in space. It is typical of Van Dyck, however, that the character of their movements differs in ways that express their respective roles. The Roman cleric is seated, consistent with decorum for members of the clergy, with a searching glance and rhetorical gesture that befit his calling. Lucas van Uffel, merchant and connoisseur, is depicted as the worldly man of action we know him to have been, rising from his desk and turning swiftly to face the viewer with a steady, self-contained gaze.

S. J. B.

33
Self-Portrait

c. 1623
canvas, 116.5 x 93.5 (45 3/8 x 36 1/2)

The State Hermitage Museum,
Leningrad, inv. no. 548

PROVENANCE Possibly Jan-Baptista
Anthoine, Antwerp (1691 inventory); in
Crozat Collection (Crozat Inventory,
1740, no. 69); acquired for the Hermitage
in 1772 from the Crozat Collection, Paris

EXHIBITIONS Leningrad, State Hermitage
Museum, 1938, no. 36; Leningrad, State
Hermitage Museum, 1972, no. 333;
Moscow 1972, 51, 62 [no. 60?];
Leningrad, State Hermitage Museum,
1978, no. 12; Ottawa 1980a, no. 77, ill.
(not in exhibition); Vienna 1981, 38–41,
pl.; Tokyo, National Museum of Western
Art, 1983, no. A; Rotterdam 1985, no. 106,
pl.; New York 1988a, no. 39, pl.

LITERATURE Crozat 1755, 7 (as
self-portrait); Smith 1829–1842, 9:395 no.
98; Guiffrey 1882, 280, no. 905 (as
self-portrait, painted in England); Claude
Phillips, "The Van Dyck Exhibition of
Antwerp," *The Nineteenth Century*
[London] (November, 1899), 740; Cust
1900, 19, 235 no. 42 (first Antwerp
period); Schaeffer 1909, 171 ill.; Bode
1921, 348; Glück 1931, 122 ill., 532 (first
Antwerp period); possibly Denucé 1932,
356, no. 61; Glück 1933, 310; Glück 1934,
195 (dating after Italy); Speth-Holterhoff
1957, 25; Hermitage 1958, 152, 153, pl.,
241, no. 219; H. Gerson and E. H. ter
Kuile, *Art and Architecture in Belgium*
(Baltimore, 1960), 121; Hermitage 1963,
110–112, no. 11, ills. 28–29; Hermitage
1964, no. 17, pl.; Brown 1982, 52 (as 1620
or 1621); Millar in London 1982–1983, 15,
ill. 13 (as before Italy); Metropolitan
Museum 1984, 68, ill. 15; Barnes 1986,
1:215–217, no. 28, 2: ill. 141

1. Metropolitan Museum 1984, 1:68.
2. See Alte Pinakothek 1986, 185–186,
no. 405.
3. As Arthur Wheelock also concluded,
in *Masterworks from Munich. Sixteenth- to
Eighteenth-Century Paintings from the Alte
Pinakothek* [exh. cat. National Gallery of
Art] (Washington, 1988), 95.
4. Denucé 1932. Speth-Holterhoff (1957)
had suggested that the description could
refer to any one of the three paintings
under discussion, but only the Munich
version has one hand.
5. Hermitage 1964, no. 17.

Between the ages of about fourteen and twenty-four, Van Dyck painted several self-portraits of varying formats. By far the earliest is a bust [see Barnes, fig. 2], dating from about 1613, and executed with the same daring, densely wrought impasto as his first known history paintings, including the Liechtenstein *Saint Jerome* [cat. 2]. Three others —one in Munich, one in New York [fig. 1], and the present painting—came later.

The half-length portrait in The Metropolitan Museum of Art is generally agreed to date from about 1620, and Walter Liedtke has revived Cust's attractive suggestion that it was painted in England.[1] The Munich version, bust-length like the Vienna picture, was expanded all around and repainted extensively.[2] These later alterations, which include the addition of the golden chain, have been associated with the presumed gift of the chain to Van Dyck from the duke of Mantua, but their appearance makes dating the painting more problematic than the literature would indicate. For this viewer the coloration and handling in the face, which was not apparently changed, indicate that it was the first of these three, rather than the last as some would have it. The combination of thick impasto highlights on the forehead and the rosy and opalescent carnation glazed with Rubensian blue-gray shadows point to a date as early as 1618.[3] It could well be the *Portrait of Van Dyck with a Cape and One Hand* that was in the collection of Jan-Baptista Anthoine in Antwerp at the end of the seventeenth century.[4]

The curious fact that the angle of the artist's head is repeated in the three paintings has led to the general belief, first expressed by Glück, that they are based on the same lost head study. We may also assume that Van Dyck needed no two-dimensional model from which to create his own likeness. The paintings have even been called variants of one another.[5] When one studies them closely, however, slight physical differences do appear, such as the thickening of the chin in the Leningrad painting, that may reflect the passage of a few years' time. The present painting has been given the widest range of dates—from the first Antwerp period, where Cust and Glück at first grouped it closely with the other two, to the years after Italy, the late 1620s or early 1630s, as Glück later proposed and as the curators in Leningrad believe. For this writer it clearly belongs to the Italian years, probably about 1623. Beneath the darkened varnish the painted surface is well preserved and retains stylistic peculiarities, such as the vestiges of an impasto highlight on the forehead, that link it both to works of the last years in Antwerp and to early ones in Italy, such as the portrait of *Filippo Cattaneo* [cat. 34]. Elsewhere it is quite thinly painted, however, and in other respects the portrait bespeaks the maturity that Van Dyck acquired south of the Alps. Both his mastery of the integrated pose and his ability to convincingly depict a turned form in space with minimal artistic means are much advanced over the Metropolitan *Self-Portrait* and even over the figure of *George*

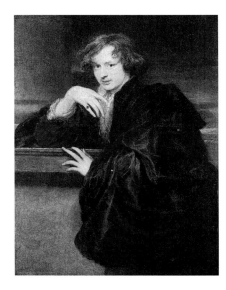

Fig. 1. Anthony van Dyck, *Self-Portrait*,
c. 1619–1620, canvas, 119.7 x 87.9
(47 1/8 x 34 5/8). The Metropolitan Museum
of Art, New York, The Jules Bache
Collection, 1949 (49.7.25)

Gage [cat. 30], where the bodies seem relatively flat. The use of the fullness of costume and gesture to enhance the plasticity of form and the pose itself recall the portrait of a young man by Raphael, which Van Dyck drew on fol. 109*v* of his Italian sketchbook [fig. 2].

Here, although he is still young in face at age twenty-four, Van Dyck presents himself as one come into his own. He is the confident, worldly young gentleman who made such an impression on his fellow artists in Rome and whom Bellori described: "He was still young, with very little beard, but his youth was coupled with a grave spiritual modesty and noble aspect, despite his small stature. His manners were more of an aristocrat than of a common man, and he was resplendent in his rich dress and accessories. Being of Rubens' school and accustomed to the company of noblemen, and being of an elevated nature himself and desirous of distinction, in addition to wearing fine stuffs he adorned his head with feathers, he wore golden chains across his breast, and went about with a retinue of servants. Thus imitating the splendor of Zeuxis and attracting the attention of all who saw him. ..." The broken column at left in this painting, which suggests antique architecture, gives further evidence for placing the work about or just after Van Dyck's Roman visits in 1622 and 1623.

S. J. B.

Fig. 2. Anthony van Dyck, sketch after Raphael's *Portrait of an Unknown Man*, Italian sketchbook, fol. 109*v*, 1622, pen and ink. Courtesy of the Trustees of the British Museum, London

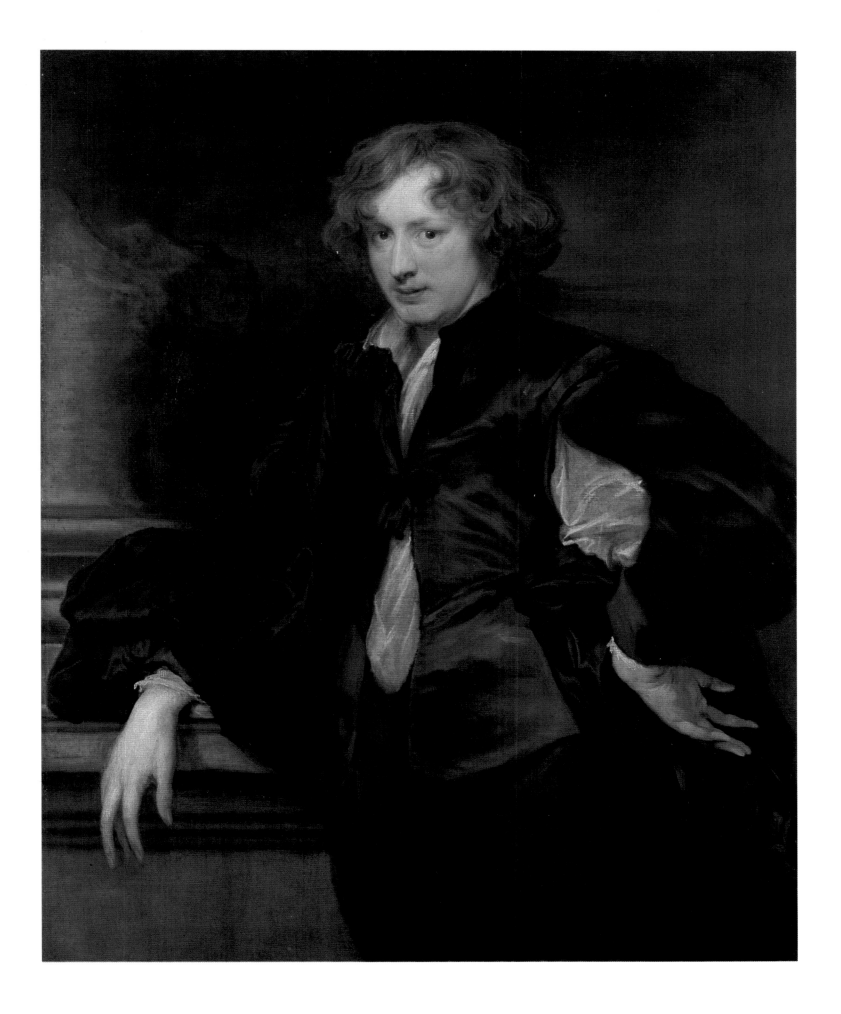

Filippo Cattaneo, 1623
inscribed (on pilaster at left) A^o 1623
Aet. 4.7
canvas, 122 x 84 (48 1/2 x 33 1/8)

National Gallery of Art, Washington,
Widener Collection, 1942.9.93

PROVENANCE Nicola Cattaneo, Genoa
(by 1828); Cattaneo della Volta
Collection, Genoa (until 1906); P. & D.
Colnaghi & Co., London; M. Knoedler
& Co. to P. A. B. Widener (1908); by
descent to Joseph Widener

EXHIBITION New York 1909, no. 5

LITERATURE Allan Cunningham, *The Life
of Sir David Wilkie ...*, 3 vols. (London,
1843), 2:494–495; Alizeri 1846–1847,
1:422–423; Cust 1900, 242 (portraits not
individually specified, but grouped as
nos. 73–80, based on unpublished
catalogue by Menotti); Holmes 1908, 316,
pl. 3; W. Walton and L. Cust, "Exhibition
in New York of Portraits by Van Dyck,"
Burlington Magazine 16 (1909–1910), 301;
C. J. Holmes, *Notes on the Art of
Rembrandt* (London, 1911), 180, n. 1;
Widener 1913, no. 51 ill.; Valentiner 1914,
208–209, 239 no. 14; Lelia Wittler, "The
Cattaneo-Lomellini Van Dycks,"
International Studio (August 1928), 38, 41
ill.; Glück 1931, 188 ill., 540; B. Berenson,
C. Hofstede de Groot, W. Valentiner, and
W. Roberts, *Pictures in the Collection of
Joseph Widener at Lynnewood Hall,
Philadelphia* (1931), n.p. ill.; Vey 1962,
1:62; Waterhouse 1978, fig. 11; Brown
1982, 93–95, pl. 83; National Gallery
Washington 1985, 146 ill.; Barnes 1986,
1:132, 133, 134, 210–212, no. 26, 2: ill. 139

Clelia Cattaneo, 1623
inscribed (on pillar at left) 1623 *Aet* 2.8(?)
canvas, 122 x 84 (48 1/2 x 33 1/8)

National Gallery of Art, Washington,
Widener Collection, 1942.9.94

PROVENANCE Genoa, Cattaneo della
Volta Collection (until 1906); P. & D.
Colnaghi & Co., London; M. Knoedler &
Co. to P. A. B. Widener (1908); by
descent to Joseph Widener

EXHIBITION New York 1909, no. 3

LITERATURE Allan Cunningham, *The Life
of Sir David Wilkie ...*, 3 vols. (London,
1843), 2:494–495; Alizeri 1846–1847,
1:422–423; Cust 1900, 242 (portraits not
individually specified, but grouped as
nos. 73–80, based on unpublished
catalogue by Menotti); Holmes 1908, 316,
pl. 3; W. Walton and L. Cust, "Exhibition
in New York of Portraits by Van Dyck,"
Burlington Magazine 16 (1909–1910), 301;
C. J. Holmes, *Notes on the Art of
Rembrandt* (London, 1911), 180, n. 1;
Valentiner and Hofstede de Groot 1913,
no. 52 ill.; Valentiner 1914, 208–209, 239,
no. 13; Lelia Wittler, "The Cattaneo-

Van Dyck's first paintings of children with their parents announced his special gifts
as a portraitist of young people [cat. 9]. In Italy he began to paint children individu-
ally, and in groups without adults. These types were apparently unprecedented in
Genoa, but they gave form to the dynastic concerns of the Genoese patriciate and
evoked images of the Spanish nobility whom they sought to emulate. In the process,
however wittingly, Van Dyck also built a repertoire that would serve him very well with
young aristocrats in the future, particularly the children of Charles I [cats. 74, 100].

The charming pendants of a brother and sister seen here are the only matched
pair of children surviving in Van Dyck's corpus. Painted in 1623, near the beginning
of his Genoese œuvre, they were probably inspired in form by Cornelis de Vos'
pendants of *Jan Vekemans* and *Cornelia Vekemans* (Museum Mayer van den Bergh,
Antwerp). Their other ties to Van Dyck's first-Antwerp-period portraits are apparent
when they are compared with the later Genoese *Boy in White* [fig. 1]. For example, as
he had in Antwerp pictures, Van Dyck depicted the Cattaneo children slightly from
above, making their faces larger and bringing them nearer the viewer. This gives us a
sense of intimacy with them, which is enhanced by the openness of their facial
expressions, by their simple poses and settings, and by the disarming device of
Filippo's basset puppy. That small dog, one of the most adorable and beautifully
painted creatures in all the history of portraiture, shows at once Van Dyck's tender
humor and his sense of metaphor, for boy and pup alike will outgrow their youthful
clumsiness to reach maturity. *The Boy in White* is the portrait of a very different kind
of child. It shares with Van Dyck's later portraits of Genoese children a *di sotto in su*
perspective whose lower point of view distances the viewer from the subject. The boy
is more self-contained and aloof than the Cattaneos, and his surroundings and
demeanor are far more imposing. Titian's influence is strongly evident in the loaded
brush technique of both the Cattaneo pendants and in the white translucent texture
of Clelia's dress. More quietly and more profoundly, however, the two share a human
language with Titian's own portraits of children—with *Ranuccio Farnese* [fig. 2], for
example, and with *Clarice Strozzi* [fig. 3]—that shows Van Dyck to be in this respect,
as in others, Titian's true heir.

When the pendants came to the Widener Collection with the magnificent
full-length portrait of their mother [cat. 36], they were said to depict Filippo and
Clelia Cattaneo, the children of Alessandro Cattaneo and Elena Grimaldi. Archival

Fig. 1. Anthony van Dyck, *Boy in White*,
c. 1625, canvas, 149 x 100 (58 5/8 x 39 3/8).
Palazzo Durazzo Pallavicini, Genoa

Lomellini Van Dycks," *International Studio* (August 1928), 38, 40 ill.; Glück 1931, 189 ill., 540; B. Berenson, C. Hofstede de Groot, W. Valentiner, and W. Roberts, *Pictures in the Collection of Joseph Widener at Lynnewood Hall, Philadelphia* (1931), n.p., ill.; Vey 1962, 1:62; Brown 1982, 93–95, pl. 84; National Gallery Washington 1985, 146 ill.; Barnes 1986, 1:131, 132, 134, 213–214, no. 27, 2: ill. 140

1. "Nobilium Civitatis Genue ...," Biblioteca Berio, Genoa.
2. Antonio Maria Buonarroti, "Alberi genealogici di diverse famiglie nobili ...," 1750, 2: fol. 117, Biblioteca Berio, Genoa.

evidence lends strong but inconclusive support to the traditional name for the boy. A man called Filippo Cattaneo was inscribed in the Libro d'Oro of the Genoese nobility on 5 December 1640 at the age of twenty-three; his parents were Giacomo Cattaneo and Elena Grimaldi.[1] "Elena" was an unusual given name in the Grimaldi family, and seems to have belonged to only one woman of this period who married a Cattaneo.[2] The fact that the names of mother and son (if not the father), which were preserved by verbal tradition, match the names of persons in documents of the proper period suggests that the Filippo Cattaneo of the archives and the one of the portrait are the same. A slight discrepancy appears in the ages, however. The painting is dated 1623, and gives the age of the boy as 4.7, presumably four years and seven months: he would have been born either in 1618 or 1619. Filippo Cattaneo, on the other hand, was born in 1617, if he correctly stated his age for the Libro d'Oro. The case for identifying the sitter with the documented Filippo Cattaneo thus rests on the compelling coincidence that names traditionally given to the paintings reappear together in archival documents for people of approximately the same age.

Thus far the archives have not yielded a child called Clelia in the same family. On the whole, girls leave fewer traces than boys. They appear in the Libro d'Oro of the nobility as the mothers of boys being registered, for instance, but never in their own right. The other known children of Giacomo Cattaneo and Elena Grimaldi were Gio. Giacomo, Geronima, and Maddelena, whose names were culled from documents in the notarial archives, particularly wills, by eighteenth-century genealogists. If we are correct in matching the family of Giacomo Cattaneo and Elena Grimaldi with these children and the woman in cat. 36, the little girl may simply not have lived long enough to appear in the notarial documents, or she may have been named Geronima or Maddelena and her name lost in time to be supplanted by "Clelia."

S. J. B.

Fig. 2. Titian, *Ranuccio Farnese*, 1542, canvas, 89.7 x 73.6 (35 1/4 x 29). National Gallery of Art, Washington, Kress Collection

Fig. 3. Titian, *Clarice Strozzi*, 1542, canvas, 115 x 98 (45 1/4 x 38 5/8). Gemäldegalerie, Berlin

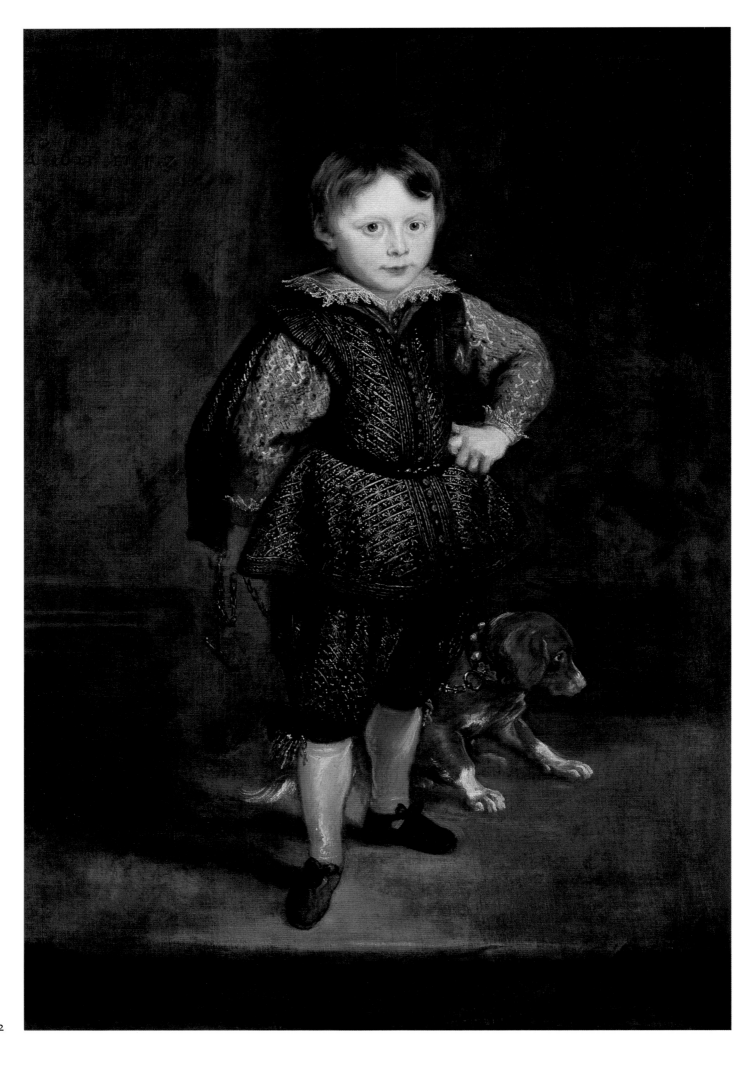

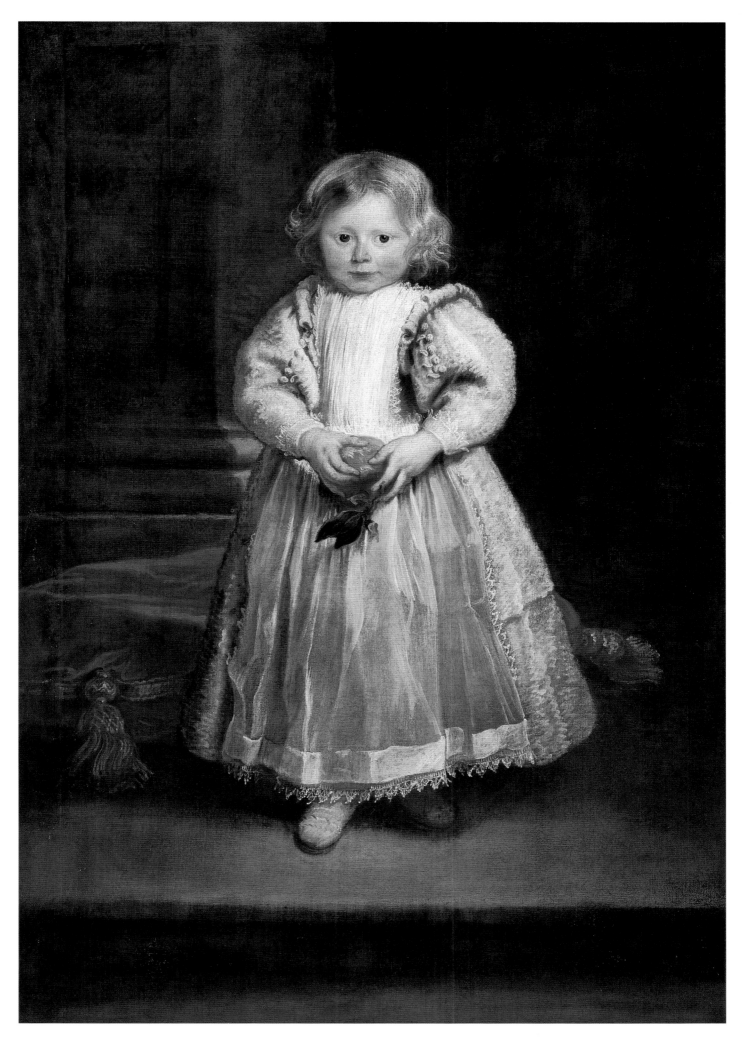

36
Marchesa Elena Grimaldi

1623
canvas, 246 x 173 (97 x 68)

National Gallery of Art, Washington, Widener Collection, 1942.9.92

PROVENANCE Giambatista Cattaneo, Genoa (by 1780); Nicola Cattaneo, Genoa (by 1828); Cattaneo della Volta Collection (until 1906); P. & D. Colnaghi & Co., London; M. Knoedler & Co. to P. A. B. Widener (1908); by descent to Joseph Widener

EXHIBITION New York, *Exhibition of Portraits by Van Dyck from the Collections of Mr. P. A. B. Widener and Mr. H. C. Frick*, 1909, no. 4

LITERATURE Ratti 1780, 106; Allan Cunningham, *The Life of Sir David Wilkie ...*, 3 vols. (London, 1843), 2:494–495, 3:38–39; Alizeri 1846–1847, 1:422–423; Cust 1900, 242 (portraits not individually specified, but grouped as nos. 73–80, based on unpublished catalogue by Menotti); W. Suida, *Genua* (Leipzig, 1906), 166; Roberts 1907, 44, 47; E. Modigliani, "The Cattaneo Van Dycks and the Italian Law," *The Connoisseur* 18 (1907), 174; Holmes 1908, 316; Walton and Cust 1909–1910, 296, 301, 302; C. J. Holmes, *Notes on the Art of Rembrandt* (London, 1911), 180, n. 1, pl. 45; Widener 1913, no. 50 ill.; Valentiner 1913, n.p., ill.; Valentiner 1914, 208–210, ill.; Wittler 1928, 37–38; Burchard 1929, 321, 323, 324, 344, pl. 3; Glück 1931, 187 ill., 540; B. Berenson, C. Hofstede de Groot, W. Valentiner, and W. Roberts, *Pictures in the Collection of Joseph Widener at Lynnewood Hall, Philadelphia* (1931), n.p., ill.; Fell 1938, 99; E. Waldmann, "Die Sammlung Widener," *Pantheon* 22 (1938), 335–343; Vey 1962, 1:62; Licia Ragghianti Collobi, *Disegni della Fondazione Horne in Firenze* [exh. cat.] (Florence, 1963), 61 (no. 249); Jaffé 1965, 43, ill. 15; Müller Hofstede 1973, 156, 157 ill.; Frances Huemer, *Corpus Rubenianum Ludwig Burchard*, part 19, *Portraits I* (London, 1977), 37; Brown 1982, 93, pl. 82; Kaplan 1982b, 14, fig. 14; National Gallery Washington 1985, 146 ill.; Barnes 1986, 1:112–115, 122, 124, 222–226, no. 30, 2: ill. 144

When Ratti described the collection of Giambatista Cattaneo in the palace beside the church of saints Cosmas and Damian in Genoa, among several portraits by Van Dyck he singled out for praise this "most particular" beauty. Indeed, *Marchesa Elena Grimaldi* was Van Dyck's most brilliant and accomplished invention to date, based on a remarkable synthesis of observations from nature, of precedents in the portraits of Titian and Rubens, and of devices from religious history painting. As obvious and natural as it seems to us today, the gentle forward stride of Elena Grimaldi introduced a new chapter in the history of full-length portraiture; at the same time, the light, the color, and the architectural setting of the painting were a clarion call for the seventeenth-century appreciation of Titian and Veronese.

Portraiture was a minor aspect of Rubens' work in Antwerp. He studiously avoided it, painting only those images of loved ones he wanted to do and of courtiers he was obliged to do. Thus, with the exception of *Alatheia Talbot, Countess of Arundel, and Her Train* (Alte Pinakothek, Munich), in whose execution he probably assisted, Van Dyck had limited exposure to the extraordinary inventive powers Rubens could apply to the genre of portraiture. Rubens had painted the most prodigiously imaginative and powerful portraits of his career during the eight years he spent abroad: the equestrian portraits of the *Duke of Lerma* (Prado, Madrid) and of *Giancarlo Doria* (Palazzo Vecchio, Florence), as well as a stunning series of full-length portraits of women. The majority remained in Genoa. There they greeted Van Dyck with a challenge he would have seized on his own—but in which he was supported by Genoese patronage—namely to rival Rubens' portraits with his own.

As Burchard first pointed out, *Elena Grimaldi* was directly inspired by Rubens' *Portrait of Brigida Spinola-Doria*, painted in 1606 [fig. 1]. Both a preparatory drawing and Lehnert's nineteenth-century lithograph [fig. 2] record the original extent of Rubens' great masterpiece as Van Dyck knew it, before it was cut down. They show the portrait at its full length and width, including an important lost element of the setting, a terrace balustrade and view across it to the open sky. When Ludwig Burchard's fundamental study of Rubens' Genoese portraits first established Van Dyck's debt to Rubens, the painting of *Brigida Spinola-Doria* was still lost, and his comparisons, based on the print, understandably minimized the differences that now are apparent between the two paintings. In addition, we can now understand that the striking similarities between the two paintings attest to Van Dyck's engagement in direct competition with Rubens' painting, and to his striving to surpass it in the spirit of Artistic Imitation.[1]

Fig. 1. Peter Paul Rubens, *Brigida Spinola-Doria*, 1606, canvas, 152.2 x 98.7 (59⅞ x 38⅞). National Gallery of Art, Washington

Fig. 2. Paul Lenhert after Rubens, *Brigida Spinola-Doria*, 1848, lithograph. Courtesy of the Trustees of the British Museum, London

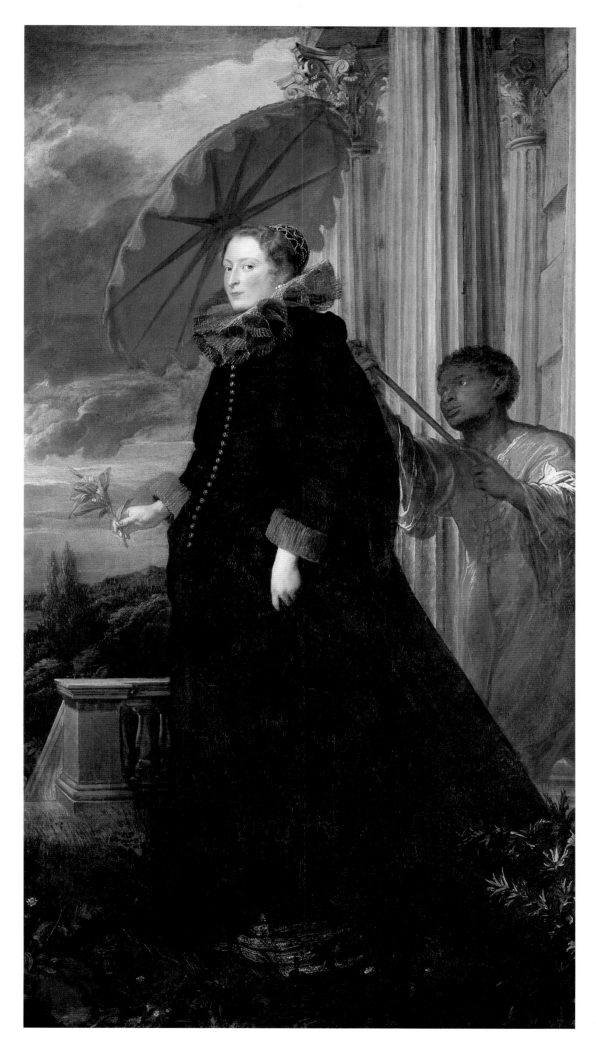

1. See *The Tribute Money* [cat. 40].
2. Erwin Panofsky wrote about Titian's "transplantation" of classical schemata for portraiture (*Problems in Titian, Mostly Iconographic*, 1969, 74–77), and Johannes Wilde described the ways Titian introduced facial expressions, poses, and expressions of telling emotions from his own religious and mythological paintings into his portraits (*Venetian Art from Bellini to Titian* [Oxford, 1974], 212–223). J. Müller Hofstede noted the similarity between the organization of the background in Rubens' *Brigida Spinola-Doria* and his altarpiece for the Gonzaga ("Bildnisse aus Rubens' Italienjahren," *Jahrbuch der staatlichen Kunstsammlungen in Baden-Württemberg* 2, 1965, 139), while Michael Jaffé cited Raphael's Vatican fresco of *Gregory IX Giving the Decretals* as Rubens' source for the background of *Veronica Spinola-Doria* (*Rubens and Italy* [Ithaca, 1977], 26–27).
3. According to John Onians (personal communication), the fluted Corinthian columns were particular to architecture in Verona during this period.
4. Paul Kaplan, "Titian's 'Laura Dianti' and the Origins of the Motif of the Black Page in Portraiture," *Antichità Viva* no. 1 (1982), 11–18, and no. 4 (1982), 10–18.
5. This was also from Titian; see Van Dyck's Italian sketchbook, fol. 107. Because the artist used the same expression for a child in "*La Dama d'Oro*" (Palazzo Durazzo-Pallavicini, Genoa), I would have to disagree with Kaplan's (*Antichità Viva* no. 4 [1982], 14) characterization of "fawning subservience" in this character, who has a beauty and an other-worldly quality instead.
6. Antonio Maria Buonarroti, "Alberi genealogici di diverse famiglie nobili ...," 5 vols., 1750, 2: fol. 117, Biblioteca Berio, Genoa.
7. Agostino Della Cella, "Famiglie di Genova, Antiche e Moderne ...," 3 vols., 1782–1784, 2: fol. 148r, Biblioteca Berio, Genoa.
8. See Rosita Levi-Pisetzky, *Storia del costume in Italia* (Milan, 1966), 3:434.

Fig. 3. Anthony van Dyck, drawing of a Roman woman walking, Italian sketchbook, fol. 112v, 1622 or 1623, pen and ink. Courtesy of the Trustees of the British Museum, London

176

The most obvious difference between *Brigida Spinola-Doria* and *Elena Grimaldi* is the change of type, from a single portrait to a double portrait with the addition of a servant. Other differences evince fundamental changes in the history of art that transpired in the generation separating the two paintings. For example, Rubens' reduced palette and strong chiaroscuro typify the Caravaggist tenebrism of the first decade of the century, while Van Dyck's brighter, primary hues and glowing, even light reflect his prescient revival of sensibilities based on Titian and Veronese that would dominate painting in Rome, Antwerp, and Madrid in the later 1620s, 1630s, and 1640s.

Van Dyck's typological innovation over Rubens' *Brigida Spinola-Doria* was, in a very literal sense, to take the next step: to bring his figure out with a graceful forward movement. The poses and gestures of Elena Grimaldi and her servant that convey that movement were apparently informed by studies from Van Dyck's sketchbook. Two, from life, show people walking: a man with an outstretched leg (fol. 8r) and a woman with a trailing skirt [fig. 3]. The third, a copy of Titian's *Lavinia as a Bride*, part of a sheet of several sketches [see cat. 43, fig. 2], captures the fine gestures of a lady as she walks, raising slightly the object she holds in one hand and gathering her skirt in the other.

Van Dyck had also learned from Titian and from Rubens that he could quietly aggrandize his portrait sitters with trappings from paintings of religious history.[2] The soaring fluted Corinthian columns behind Elena Grimaldi, for example, whose soft curving rhythms match those of her collar, cuffs, and fashionable red parasol, owe more to Veronese's setting for *The Marriage at Cana* [see cat. 43, fig. 1] than to the actual palaces of Genoa; those buildings did not include this grand architectural order.[3] Titian's "*Laura Dianti*" (Thyssen Collection) was the first portrait to include an African page, a tradition Van Dyck revived here and in his later *Princess Henrietta of Lorraine* [cat. 72]. According to Paul Kaplan who charted this tradition, Titian's portrait, like Veronese's grandiose biblical scenes peppered with young black servants, reflected the actual popularity of such domestic slaves in sixteenth-century Italian courts.[4] The Genoese were quite active in the trade of African slaves and had black house servants then and in Elena Grimaldi's day. Even so, Elena's page seems at least partly an invention. This is signaled in a number of ways: by his timeless costume; his sharply pointed ear; the curious maturity of his face and body mixed with his diminutive height; and above all the reverent expression on his face, which also is derived from history painting.[5] That expression functions in the painting to exalt his mistress to an almost supernatural status.

The traditional identification of our lady as Elena Grimaldi is circumstantially supported by archival references to her son, Filippo [see cat. 34]. We learn from Buonarroti's mid-eighteenth-century genealogical tables about the place of Elena Grimaldi in her family trees—as the daughter of Gio. Giacomo Grimaldi, the wife of Giacomo Cattaneo, and the mother of four children.[6] Her brother Geronimo was created cardinal in 1643, and their father Gio. Giacomo elected senator in 1606.[7] But no data about her own life have been found. The remarkable fact that her name came down to us in connection with the present portrait, preserved only by memory through three centuries, surely owes to the extraordinary image that Van Dyck created for her.

This most strikingly Venetian of Van Dyck's Italian portraits probably dates, with the pendant portraits of her children, to late 1623. Van Dyck's later depictions of the graceful processional movement inaugurated here include the portrait of *Anne, Countess of Clanbrassil* (Frick Collection, New York), and the design for an unrealized monumental tapestry depicting *Charles I and the Knights of the Garter in Procession* [cat. 102]. An oil sketch on canvas of Elena Grimaldi's head [see Christensen, fig. 3] was probably made from life for use in completing the picture in the studio; radiographs of the sketch show the first idea was to place a flower behind Elena's right ear. Two variant drawings of the composition have been ascribed erroneously to Van Dyck. One is in the Fondazione Horne, Florence. The other, in the Museo Lazaro-Galdiano, Madrid, shows the addition of a little girl standing beside the balustrade, and can be dated to the middle of the seventeenth century by the child's costume.[8]

S. J. B.

A Genoese Noblewoman with Her Child

c. 1623–1625
canvas, 217.8 x 146 (84⁷/₈ x 56⁷/₈)

The Cleveland Museum of Art,
Gift of the Hanna Fund, 54.392

PROVENANCE Possibly Benedetto
Spinola, Genoa (Ratti 1780); Du Pré
Alexander, 2d earl of Caledon, purchased
through George Augustus Wallis in
Florence (March 1829); sale earl of
Caledon, New York, American Art
Association, 1895; New York, Sedel-
meyer, 1895; J. Pierpont Morgan, London
and New York, by 1902; M. Knoedler &
Co., New York

EXHIBITIONS London, British Institution,
1832, no. 46; London, British Institution,
1854, no. 62; London, Royal Academy,
1902, no. 102; Brussels 1910, no. 110, ill.
60; New York, The Metropolitan
Museum of Art, A Loan Exhibition of Mr.
Morgan's Paintings, 1913; The Cleveland
Museum of Art, Venetian Tradition 1956,
no. 13, ill. 16; The Cleveland Museum of
Art, Style, Truth and the Portrait, cat. by
Rémy G. Saisselin, 1963, no. 24, ill.

LITERATURE Possibly Ratti 1780, 289;
Smith 1829–1842, 9:395, no. 97; Waagen
1857, 151; Guiffrey 1882, 278, no. 858;
Sedelmeyer Gallery, Second Hundred, New
York, 1895, ill.; T. Humphrey Ward and
W. Roberts, Pictures in the Collection of
J. Pierpont Morgan at Prince's Gate & Dover
House (London, 1907), n.p.; Schaeffer
1909, 188 ill.; Dumont-Wilden 1910, 21,
ill., 26; Rooses 1911, 42–43, ill.; Guy Pène
du Bois, "The Old Masters in the
Morgan Collection," Arts and Decoration 3
(May 1913), 235–236, 234, ill.; Graves
1914, 4:1502, 1504, 1523; Glück 1931, 205
ill.; Helen Comstock, "The Connoisseur
in America," Connoisseur 113 (March
1944), 40, ill.; Francis 1955, ill. on cover,
115–117, ills.; Jaffé 1965, nos. 1–2, 42, 47,
ills. 5, 6; Ostrowski 1981, 54, ill. 59;
Cleveland Museum 1982, 11–13, ill. 5;
Brigstocke 1982, 21–22, 39, 489; Barnes
1986, 1:331–333, no. 82, 2: ill. 241

1. Valentiner (letter, Museum files, cited
in Cleveland Museum 1982, 13) proposed
the name of Geronima Doria, wife of
Filippo Spinola, for the mother. That is
the name traditionally given to the
full-length woman in Berlin-Dahlem
(Glück 1931, 191). For this viewer the
resemblance with this subject, which is
partly created by their similar poses, does
not hold up under close scrutiny. The
Cleveland woman has a fuller face and
wider mouth than does her counterpart
in Berlin.
2. Jaffé 1965, 47, ill. 5.

The fact that this splendid portrait was identified as "Marchesa Spinola" as early as its 1832 showing at the British Institution suggests that it came from a Spinola collection. It could be the painting of an unnamed mother and child from the Benedetto Spinola Collection, which Ratti (1780) called "bellissimo." No verifiable identification has been made for this charming woman and her son or daughter, and it is doubtful that one will be found.[1]

In most of Van Dyck's family group portraits the mother is shown seated, but here she stands in the same three-quarter view Van Dyck employed in standing single por- traits such as the one mistakenly called Paola Adorno in the Frick Collection [fig. 1]. Pentimenti in the skirt of the Cleveland woman show that Van Dyck first completed the dress so that the lower hem was undulating almost identically to that woman's and to the real Paola Adorno's (Palazzo Rosso, Genoa). Other pentimenti in the face of our woman show that changes were also made there, to lift her eyes slightly without changing their direction.

The bold simplicity of the design, which joins the towering figure of the mother to the tiny child, succeeds in keeping the child from being eclipsed through a balance of line, color, light, and human interest. Van Dyck's alteration of the dress from a waving profile to a flat one reflects the delicacy of that equilibrium. Although Van Dyck had used architectural elements to create a separate sense of space and scale for children in earlier double portraits, such as Susanna Fourment and Her Daughter [cat. 21], as he would in such later ones as A Genoese Noblewoman and Her Son [cat. 43], here he accentuated the presence of the child through other means. A swath of softly brushed silvery paint illumines the area behind and above the toddler who is clad in deep ultramarine trimmed with gold. The youngster's enchanting face and sponta- neous, touching gesture in reaching for the mother's hand draw further attention.

Alfred Joseph Wollmer's painting, Interior of the British Institution (1833, Yale Center for British Art, New Haven), depicts the installation of the 1832 exhibition, but he took liberties in reproducing the present painting whose direction he reversed and from which he eliminated the child. Ostrowski has shown the direct influence of Van Dyck's composition on a portrait by his Genoese follower, Giovanni Bernardo Carbone (private collection, Genoa). A sketch of the head, published by Jaffé as an autograph preparatory work, is not by Van Dyck in my opinion.[2]

S. J. B.

Fig. 1. Anthony van Dyck, Portrait of a Genoese Noblewoman, c. 1623–1625, canvas, 230.8 x 156.5 (90⁷/₈ x 61⁵/₈). The Frick Collection, New York

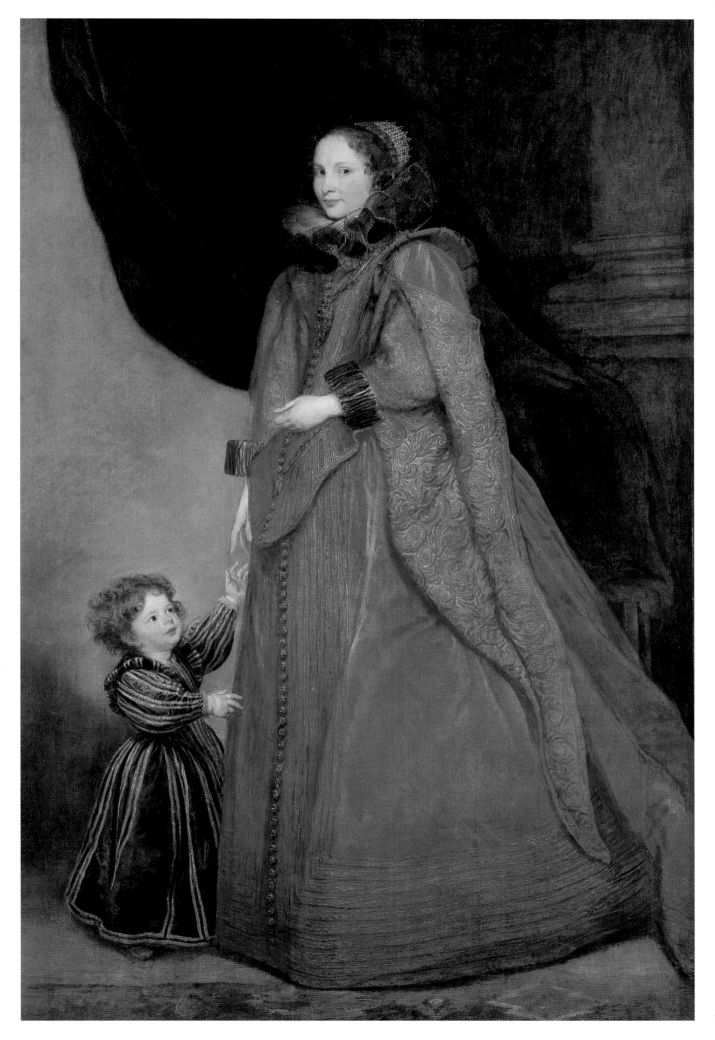

38
Emmanuel Philiberto of Savoy

1624
canvas, 126 x 99.6 (49⅝ x 39¼)

By permission of the Governors of
Dulwich Picture Gallery, London,
inv. no. 173

PROVENANCE Painted in Palermo,
summer 1624; sale V. Donjeux, Paris, 29
May 1793, lot 132; bought by Desmarets;
Bourgeois Bequest, 1811 (1813 inventory
as Duke D'Alva)

EXHIBITIONS London, British Institution,
1828, no. 113 (as "Portrait in Armour");
London, *Special Exhibition of Pictures from
Dulwich at the National Gallery*, 1947, no.
12; London 1953–1954, no. 153;
Washington 1985–1986, no. 6, pl.

LITERATURE Bellori 1672, 257; Smith
1829–1842, 3:197, no. 682 and 232, no.
831; Waagen 1854, 2:342, no. 3 (as "The
portrait of a General in rich armour, here
called the Archduke Albert"); Walpole
1876, 2:318; Guiffrey 1882, 284 no. 986;
Baes 1878, 67; Schaeffer 1909, 436, ill.,
518 (as "Portrait of a knight"); Claude
Phillips, "Rubens or Van Dyck?," *Art
Journal* (1911), 237–240, ill.; Albert van de
Put, "The Prince of Oneglia by Van
Dyck," *Burlington Magazine* 21 (1912), 310,
ill., 311–314 and 25 (1914), 59; Vaes 1924,
217; Glück 1931, 171, ill., 538; Sterling
1939, 53; Larsen 1975a, 61; Brown 1982,
82, pl. 71; Barnes 1986, 1:14, 240–241, no.
36, 2: ill. 161

1. Although Bellori (1672, 257) and
Soprani implied that he went on his
own, the Louvre biographer asserted he
was called there by Emmanuel Philiberto
(Larsen 1975a, 61). According to Baes
(1878, 67), Van Dyck was accompanied to
Sicily by the Chevalier Vanni. The
younger Brueghel's trip to Palermo is
known from his father's letters to
Cardinal Federico Borromeo, archbishop
of Milan (Giovanni Crivelli, *Giovanni
Brueghel, pittor fiammingo, o sue lettere a
quadretti esistenti presso l'Ambrosiana*
[Milan, 1868], 323, 328).
2. See Van de Put 1912 for the biography
of the prince.
3. Van de Put 1912, 313.
4. "... ogni re e principe vuol mestà, ed
avere un'aria a tanto grado conforme, sì
che spiri nobiltà e gravità. ..." (G. P.
Lomazzo, *Trattato dell'arte della pittura,
scultura ...*, 3 vols. [Rome, 1844], 3:370).
5. It is not clear whether this is the same
sketch mentioned by Glück (1931, 538) as
being in the Josephson collection,
Sweden, which he judged to be
autograph.
6. Ludwig Burchard documentation,
Rubenianum Library, Antwerp.

In the spring of 1624 Van Dyck traveled to Palermo. He may have gone on the
invitation of the viceroy, Emmanuel Philiberto of Savoy, or of another patron, or
simply on his own, as his friend Jan Brueghel the Younger had done the year before.[1]
In mid-May, probably shortly after Van Dyck's arrival, the plague broke out. Before it
subsided thousands had died, including the viceroy himself.

Van Dyck painted this portrait during that summer. Albert van de Put recognized
that the palm and crown motifs on the armor were from the house of Savoy; he
identified the sitter as Emmanuel Philiberto, and the painting as the one mentioned
by Bellori. Emmanuel Philiberto (1588–1624), son of Carlo Emmanuel I, duke of Savoy,
and of Catherine, daughter of Philip II of Spain, had spent his life in service to the
Spanish crown. Created prince of Oneglia by his father in 1620, he was named
viceroy of Sicily at the end of 1621. Van Dyck depicted him just before his untimely
death on 3 August 1624.[2] Van de Put intimated that the portrait is the one mentioned
in the posthumous biography of the prince, written by his surgeon Gianfrancesco
Fiochetto, as having been made to send to his fiancée Princess Maria Gonzaga in
preparation for the marriage that had been arranged in a treaty of 16 May. Fiochetto
reported that the prince returned to his quarters after Mass to find his portrait had
fallen face down, and that he had taken it as a portent of his death.[3]

The portrait depends closely on Titian's lost state portrait of *Charles V in Armor*,
known to Van Dyck as it is to us through Rubens' painted copy and the Vorsterman
engraving after the copy [fig. 1]. This formal anachronism, which caused Phillips to
attribute the work to Rubens' Italian period, functions to establish visually the
continuity of authority between the late Holy Roman Emperor and his
great-grandson, Emmanuel Philiberto, whom Philip III had chosen to govern
Hapsburg Sicily. Within the constraints imposed by the prototype, Van Dyck
exercised his considerable talents both as a painter and as an interpreter of the inner
workings of men. He lavished attention on such details as the rich pattern of the
damascened armor, the lace collar and cuffs, and the plumed helmet only to
subordinate them to the quietly commanding hands and intelligent countenance of
the prince. In the previous decade Van Dyck had made portraits of burghers and
patricians, artists and *amateurs*, parents and children, and of a cardinal, a senator, and
an ambassador. But this was his first portrait of a ruler. Here, the artist whose
greatest fame would come as a portraitist to the king of England displayed his firm
grasp of the refinements of the image of power. In the dignity, the gravity, the
nobility of his bearing, *Emmanuel Philiberto of Savoy* is the ideal likeness of the
Renaissance ruler.[4]

Two paintings known to me only in photographs may be autograph preparatory
works: an oil sketch of the head, once in the Lamm collection;[5] and a scaled-down
version of the whole composition, rendered sketchily, that might have served as a
presentation *modello*. A painting that Burchard thought to be a period copy was sold
from the collection of the late R. W. Cater, Christie's, London, 6 March 1936, lot 151.[6]

S. J. B.

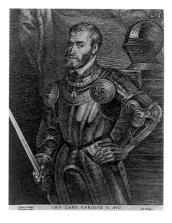

Fig. 1. Lucas Vorsterman after Titian,
(lost) *Charles V in Armor*, engraving,
41.3 x 31.8 (16 x 12⅜). The Baltimore
Museum of Art, Garrett Collection,
1946.112.15346

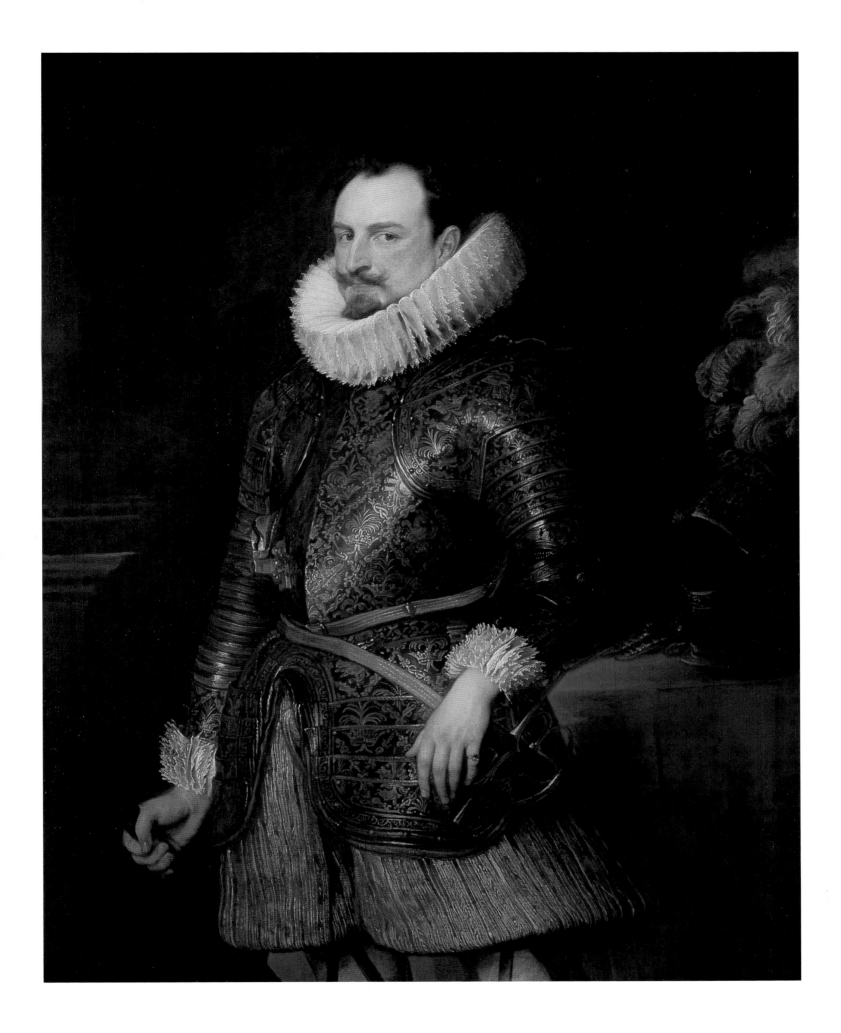

39
Vertumnus and Pomona

c. 1625
with the assistance of Jan Roos
canvas, 142 x 197.5 (55 3/8 x 77)

Galleria di Palazzo Bianco, Genoa

Restored with funds given in memory of
Patricia Toomey

PROVENANCE Doria family, Palazzo
Doria in Via Garibaldi, Genoa (by 1846);
bequest of Marchese Ambrogio Doria in
memory of his brother, Gustavo

EXHIBITIONS Genoa, *Mostra della pittura
del '600 e '700 in Liguria*, 1947, no. 24;
Genoa 1955, no. 58, ill.

LITERATURE F. Alizeri, *Guida illustrativa
per la città di Genova* (Genoa, 1875), 2:447
(as "una thema mitologico del Wandik");
Alizeri 1875, 195; Wilhelm Suida, *Genua*
(Leipzig, 1906), 166 (as *Jupiter and Ceres*);
Millar 1955, 314; Horst Vey, "Eine
Satyrszene von Van Dyck," *Pantheon* 20
(1962), 182 (as *Vertumnus and Pomona*);
Lee 1963, 20–21, pl. x, 11; Damm 1966,
no. 62; London 1982–1983, 15, ill. 7;
Barnes 1986, 1:46–47, 179–180, no. 16,
2:ill. 73

1. Morassi realized (in Genoa 1947) that
the draped head of the old woman is
based on the vendor in the central
foreground of Titian's *Presentation of the
Virgin* [see Brown, fig. 8].
2. Morassi, in Genoa 1947.

Evident in Van Dyck's history paintings from 1618 onward was his growing concern for the expression of intense personal emotion, whether in religious subjects, like *Saint Sebastian Bound for Martyrdom* [cat. 22] and *Moses and the Brazen Serpent* [cat. 15], or mythological ones, like *Drunken Silenus* [cat. 12]. This stream in his work, which deepened and widened thenceforth, was fed in Italy by his exposure to artists who shared that concern, both from early in the previous century, such as Titian and Correggio, and from a time nearer his own, such as Cigoli and Barocci.

Tenderness fills his interpretation of *Vertumnus and Pomona*, a story from Ovid's *Metamorphoses*, of love unperceived at a distance, offered in disguise, finally recognized and returned. Pomona, the beautiful wood nymph, showered affection on the plants she tended, but ignored the suitors who gathered outside her locked garden gate. Most devoted of them all was Vertumnus, a god whose power over the changing seasons enabled him to alter his physical form. He presented himself to Pomona in many charming guises, none of which she entertained until he came one day dressed as an old woman. Admitted to the garden in this cloak, he spoke to Pomona of her own beauty and of the love she should share with the worthy Vertumnus. And he won her heart.

Like Goltzius in versions of the subject painted in 1613 and 1615, and in harmony with Ovid's narrative, Van Dyck seated his figures on the ground. Far and away his greatest debt is to Titian, however, whose mythological paintings he had studied and recorded at length in Italy [fig. 1]. Several paintings by and after Titian lie behind this *Vertumnus and Pomona*, two of them appropriately devoted to a theme of love.[1] The most important is *Danaë* [fig. 2], which Van Dyck would have seen in the Farnese Palace in Rome, and from which he adopted the pose of Pomona as well as the pictorial stage. Over and above these formal borrowings, Van Dyck sought to emulate the style and the content of Titian's love pictures, to re-create the air of sensuality and amorous rapture in the *Danaë*. Lee recognized this when he grouped *Vertumnus and Pomona* with Van Dyck's "finest *poesies*," the term Titian used for the mythological subjects, some from Ovid, that he painted for Philip II. Lee also noted that Van Dyck had captured a nostalgia that "is something very personal yet at the same time profoundly evocative of the sentiment of Giorgione and early Titian," and that looks forward to Van Dyck's Titianesque masterpiece *Rinaldo and Armida* [cat. 54].

Contrary to the hypothesis that Van Dyck had a large "studio" of assistants in Italy, *Vertumnus and Pomona* is one of his rare Italian works that evinces the assistance of other artists. Another is *The Boy in White* [fig. 3]. In both these paintings Van Dyck carried out a practice of the Rubens studio, engaging a specialist to paint the still life.

Fig. 1. Anthony van Dyck, studies after Titian's Venuses, Italian sketch-book, fol. 114r, c. 1622, pen and ink. Courtesy of the Trustees of the British Museum, London

Fig. 2. Titian, *Danaë*, 1545–1546, canvas, 120 x 172 (47 1/4 x 67 3/4). Gallerie Nazionali, Capodimonte, Naples

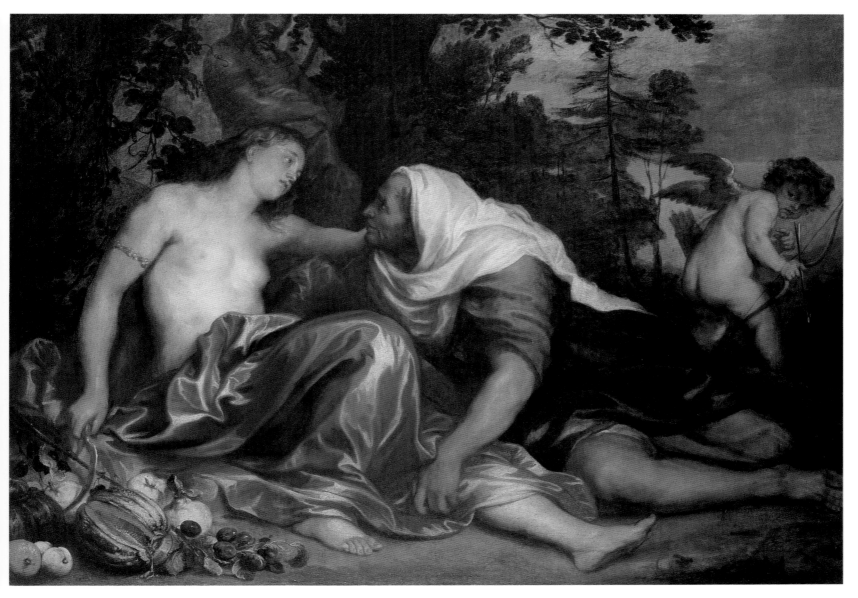

Photographed during conservation treatment

Morassi suggested the work was done by another Antwerp expatriate, Jan Roos, whose name appears often in Genoese inventories and guidebooks as Van Dyck's collaborator.[2] That suggestion is borne out by comparisons made possible in the recent reinstallation of galleries in the Palazzo Bianco, which has brought together this painting with some attributed to Roos. A surviving drawing that appears to be a working studio *modello* [fig. 4] gives clues to the process by which the collaborative image was generated. There, in a drawing exceptionally finished for Van Dyck, all the figures and the landscape are thoroughly represented in black chalk, wash, and gouache. The area in the left foreground is blank, however, suggesting that it was left for Roos to fill once the design was translated to canvas. Another less talented assistant may have helped to do that, and even to execute the drapery over Pomona's lap, which is more mechanical than one would expect from Van Dyck's own brush.

The figure of Vertumnus is similar in facial type and in the modeling of the swarthy flesh to the Pharisee in the foreground of *The Tribute Money* [cat. 40], which, like *Vertumnus and Pomona*, was painted between 1624 and 1627. The subject of the present picture was mistaken for *Jupiter and Ceres* until Vey correctly identified it. Cupid's pose is reversed from a drawing in Van Dyck's sketchbook (fol. 113*v*) after a painted copy after Titian's *Blinding of Cupid*. In addition to the drawing mentioned above, there is a pen and ink compositional sketch in Berlin.

This painting was restored by Gianfranca Carboni and Antonio Silvestri and photographed by Enrico Polidori.

S. J. B.

Fig. 3. Anthony van Dyck with Jan Roos, *Boy in White*, detail, c. 1623–1625, canvas. Palazzo Durazzo Pallavicini, Genoa

Fig. 4. Anthony van Dyck, *modello* for *Vertumnus and Pomona*, chalk and wash with white heightening. Whereabouts unknown

184

40
The Tribute Money

c. 1625
canvas, 142 x 119 (55 3/8 x 46 3/8)

Galleria di Palazzo Bianco, Genoa

Restored with funds given in memory of
Patricia Toomey

PROVENANCE Possibly collection of
Chianetta Gentile;[1] Brignole-Sale
Collection, Genoa, by 1748 (inventory);
by descent through the Brignole-Sale
family; bequest of Maria De Ferrari
Brignole-Sale, duchess of Galliera, to the
city of Genoa in 1874

EXHIBITIONS Genoa, *Mostra d'arte antica*,
1892, no. 60; Genoa 1955, no. 24

LITERATURE *Pitture e quadri del Palazzo
Brignole, detto volgarmente il Palazzo Rosso
di Strada Nuova in Genova* (Genoa, 1756),
13; Charles-Nicolas Cochin, *Voyage d'Italie*
(Paris, 1758), 258; C. G. Ratti, *Intruzione di
quanto può vedersi di più bello in Genova in
pittura, scultura et architettura* (Genoa,
1766), 233; Ratti 1780, 257; William
Buchanan, *Memoirs of Painting* (London,
1824), 2:132; Smith 1829–1842, 3:50–51
no. 172; Allan Cunningham, *The Life of
Sir David Wilkie ...*, 3 vols. (London,
1843), 2:447; Alizeri 1846–1847, 2:392;
Jakob Burckhardt, *Der Cicerone* (Leipzig,
1869), 3:1042; Guiffrey 1882, 45, 246, no.
83; Cust 1900, 46, 237, no. 1; Wilhelm
Suida, *Genua* (Leipzig, 1906), 164
(compares to Titian's *Tribute Money* in
Dresden); Schaeffer 1909, 61 ill.; O.
Grosso, *Catàlogo della Galleria di Palazzo
Rosso e Bianco* (Genoa, 1912), 34; Glück
1931, 142 ill.; C. Marcenaro,
"Precisazione sulla pala vandyckiana di
S. Michele di Rapallo," *Bulletin de
l'Institut historique belge de Rome* 18 (1937),
210, 213, ill. 4; L. van Puyvelde, "Van
Dyck a Genova," *Emporium* 122 (1955),
106–107, ill. 8 (first Antwerp period);
Millar 1955, 314; Ostrowski 1981, 12;
Brigstocke 1982, 80, 82, 93, 99, 107, 422,
488; Barnes 1986, 1:39, 158–159, no. 9, 2:
ill. 47

1. As per the ms. notation of L. A.
Cervetto, "Elenco di quadri. ..." Genova,
Biblioteca Berio, m.r. XVII, 351. Piero
Boccardo brought this to my attention.
2. On Van Dyck and Imitation, see
Barnes 1986, 1:30–48. See also Quintilian,
Instituto Oratoria, x.ii; Eugenio Battisti, "Il
Concetto d'Imitazione nel Cinquecento
da Raffaello a Michelangelo," *Commetari* 7
(1956), 86–104, 249–262; E. de Jongh,
"The Spur of Wit: Rembrandt's Response
to an Italian Challenge," *Delta* 12, no. 2
(summer 1969), 49–67; and Jeffrey Muller,
"Rubens's Theory and Practice of the
Imitation of Art," *Art Bulletin* 64 (1982),
229–249.
3. Suida thought Van Dyck's model was
Titian's Dresden *Tribute Money*, but
McNairn recognized the proper source
(Ottawa 1980a, 18–19). Another example
of a "reconstruction" by Van Dyck can
be found in his Italian sketchbook on
fol. 15. There he drew the group of the

One particular aspect of Van Dyck's working method was his practice of creating a work of art in dialogue with another one he admired. Several paintings in this exhibition show how, as a young man in Antwerp, he often took a composition by Rubens as a point of departure and made his own very different interpretation of the same subject [cats. 11, 15]. The differences between Van Dyck's paintings thus conceived and those by Rubens reflect both the fundamental differences in the personalities and interests of the two artists and Van Dyck's healthy spirit of rivalry. The desire he displayed to assimilate the greatest achievements of others and to strive to surpass them has always been an attitude fundamental to learning and to the quest for excellence. In ancient and Renaissance theory and procedure the practice was known as *imitatio*. In current studies it is called Imitation.[2]

Van Dyck had early been drawn to the works by Titian, Tintoretto, and Veronese that he had seen in collections in Antwerp and England, and he had emulated them from the standpoint of technique and color. In Italy he also discovered the extent to which Titian was his true spiritual forebear. Drawings in the sketchbook he carried during the years 1621–1624 make apparent his intense absorption in the forms and ideas of Titian's œuvre, especially the mythological and religious paintings. In this respect Van Dyck was a harbinger of tastes guiding later seventeenth-century Roman painting: first Poussin, then Pietro da Cortona. Van Dyck's Imitation of Titian, seen in *The Tribute Money* and in *Vertumnus and Pomona*, is quite different from his Imitation of Rubens. Whereas he had systematically distanced himself from Rubens' style, in works such as these he almost completely absorbed himself in emulation of his model, taking over Titian's technique, compositions, figure types, and most of all the feelings that pervade the paintings.

The Tribute Money is a fascinating case in Van Dyck's study and Imitation of Titian. His painting appears to be both a reconstruction and a partial reinterpretation of a painting that he knew only through prints.[3] Titian's *Tribute Money*, now in London, had been commissioned by Philip II. It was in Spain, and Rota's engraving [fig. 1] was Van Dyck's source. The direction of Van Dyck's painting is the reverse of the print's, as indeed he might have thought Titian's original painting was. In many respects, Van Dyck's *Tribute Money* re-creates Titian's. They have the same format and general composition, and share the figural type and pose of the Pharisee in the foreground. Van Dyck worked from his knowledge of other paintings by Titian to infuse his painting with the Titianesque light, color, and modeling that we see. The result, rather than being like Titian's loose late manner in the London painting, is the crisper mode of an earlier period. Notwithstanding these similarities, Van Dyck reinterpreted the interaction of Christ with the Pharisee. Whereas Titian's two figures were closely interlocked, Van Dyck's Christ stands clearly apart from his tempter. He

Fig. 1. Martino Rota after Titian, *Tribute
Money*, engraving, 27.6 x 22.8 (107/8 x 9).
Courtesy of the Trustees of the British
Museum, London

Virgin and Child from the woodcut after Titian's painting *Il Doge Gritti Adora la Vergine*, which had been destroyed by fire in 1574. Rather than copy the harsh style of the reproductive print, Van Dyck gave these figures a Titianesque aspect (Barnes 1986, 1:38).
4. McNairn (Ottawa 1980a) dated the painting to about 1617.

conveys his moral distance and his message (Matthew 22:15–16, 21), "Render unto Caesar that which is Caesar's and unto God the things that are God's," through the upward-pointing gesture from one of Raphael's apostles in *The Death of Ananias*.

Van Puyvelde and McNairn dissent from common opinion to place the painting in Van Dyck's first Antwerp period, because of the Pharisees' Rubensian qualities.[4] The same character led Ostrowski to assign it to an early date in the Italian years. For this writer it comes somewhat later. Another version of the subject, whose description indicates it might be a copy of this painting, was sold by the Trustees of the Duke of Grafton (London, Christie's, 13 July 1923, no. 145, not illustrated).

This painting was restored by Gianfranca Carboni and Antonio Silvestri and photographed by Enrico Polidori.

S. J. B.

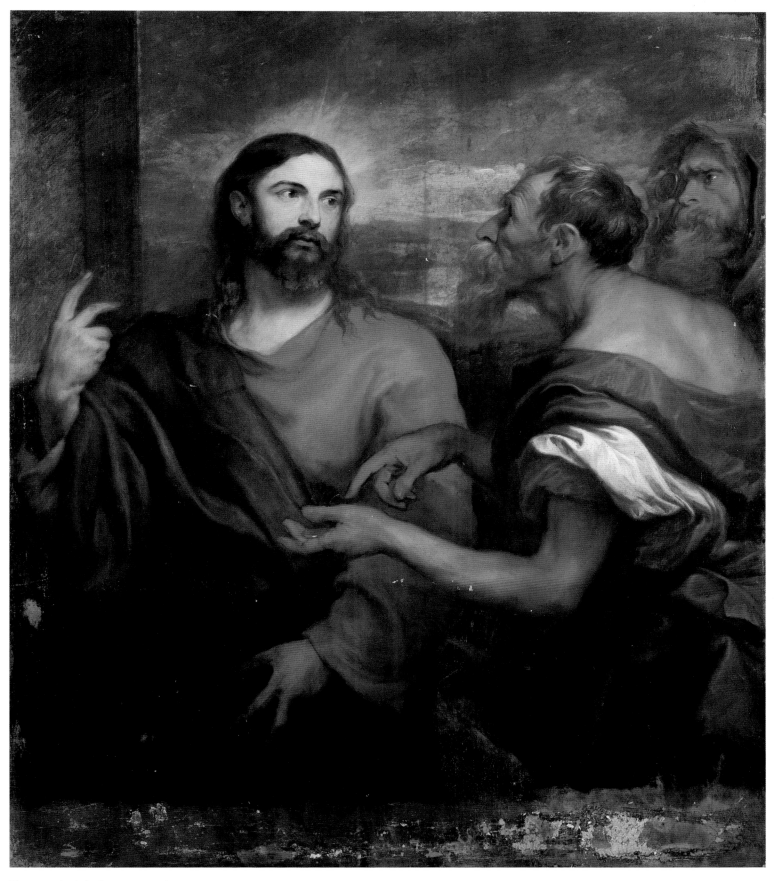

Photographed during conservation treatment

41
The Ages of Man

c. 1625
canvas, 120 x 165 (46 1/2 x 64 1/2)

Museo Civico d'Arte e Storia, Vicenza,
inv. no. A228

Restored with funds given by Giuseppe
Roi in memory of Gino Barioli

PROVENANCE In the collection of Carlo
II, duke of Mantua, in his inventory of 10
November 1665 (d'Arco) and until 1711
(*Raccolte*); bequest of Paolina Porto-Godi
in 1826

EXHIBITIONS Venice, *I Capolavori dei
Musei Veneti*, by Rodolfo Pallucchini,
1946, no. 277 ill.; Genoa 1955, no. 49 ill.

LITERATURE Antonio Magrini, *Il Museo
Civico di Vicenza solennemente inaugurato il
18 agosto 1855* (Vicenza, 1855), 54 (by
Rubens); Carlo d'Arco, *Delle Arti e degli
artifici di Mantova* (Mantua, 1857), 2:184,
186; Schaeffer 1909, 58 ill.; C. Frizzoni,
"Die Städtische Gemäldegalerie zu
Vicenza," *Zeitschrift für bildende Kunst* 24
(1913), 193 ill.; Karl Woermann, *Geschichte
der Kunst aller Zeiten und Völker*, 6 vols.
(Leipzig and Vienna, c. 1915–1922),
5:261; Glück 1931, XXXVI, 146 ill., 535;
Glück 1933 [1926], 286; Theodor Hetzer,
Tizian: Geschichte seiner Farbe (Frankfurt,
1935), 229; Ludwig Justi, *Giorgione*
(Berlin, 1936), 2:282–285, pl. 5; G. Fasolo,
Guida del Museo cìvico di Vicenza (Vicenza,
1940), 168, 169 ill.; Millar 1955, 314;
Pinacoteca Vicenza 1962, 2:246–248;
*Raccolte di quadri a Mantova nel sei-sette-
cento. Fonti per la storia della pittura* (Mun-
zambano, 1976), 4:47, 59, 71, 72; Brown
1982, 97, ill. 87; Stewart 1983, 60–61, ill. 5;
Barnes 1986, 1:184–185, no. 18, 2: ill. 83

1. Wethey reasoned that a reproductive
drawing or painting in Antwerp was the
source for the drawing of the amorous
couple in the Chatsworth sketchbook
that Jaffé attributed to Van Dyck (Jaffé
1966a, 2:59r). Van Dyck also would have
seen either the original or a good painted
copy when he visited the Aldobrandini
collection in Rome in 1622 or 1623. For
the versions of *The Ages of Man*, see
Harold Wethey, *The Paintings of Titian, III.
The Mythological and Historical Paintings*
(London, 1975), 182–184, and the
discussion of the Aldobrandini painting
on 183, under nos. 5 and 6.
2. On the lost *Emperors*, see Wethey 1975,
no. L–12; Saedler's engraving of
Augustus is fig. 35.
3. Carlo Ridolfi, *Le maraviglie dell'arte ...*,
(Venice, 1648), 81–83; Justi used Ridolfi's
text and the present painting to
reconstruct the lost Giorgione (Justi 1936,
282–285).

The only allegorical painting known to survive from Van Dyck's Italian period shows him steeped in the subjects and styles of sixteenth-century Venetian painting. In the early years of that century, Titian and Giorgione had begun to treat the theme of the changing interests and attitudes of man in his successive stages of life. This is one level of meaning embodied in Giorgione's intriguing *Three Philosophers* (Kunsthistorisches Museum, Vienna), where each of three men—young, middle-aged, and old—represents a different stage of thought and activity. We find it again in Titian's late triple portrait (National Gallery, London), known as the *Allegory of Prudence*, where the faces of youth, middle age, and old age are conjoined. In his early painting of *Three Ages of Man* from about 1515 [fig. 1], Titian cast the theme rather differently, showing figures in the extreme states of infancy, youth, and old age scattered about in a beautiful pastoral landscape. The infants doze, unaware of the experiences that await or of the fledgling love that dances around them; old age has withdrawn into a meditation on death; only the young shepherd partakes of life, through passion with his enraptured shepherdess.

Van Dyck knew about Titian's *Ages of Man* even before he left for Italy.[1] Like Titian, Van Dyck depicted the prime of maturity through the amorous interaction between the sexes, but Van Dyck's commander in armor is far more mature and self-assured than Titian's shepherd. Stewart has suggested that Van Dyck's couple allude to the theme of Mars and Venus, that is of force tempered by love. Frizzoni passed on Gronau's interesting idea that the man in armor was derived from one of Titian's eleven paintings of Roman emperors, presumably *Augustus*, which adorned the Gabinetto dei Cesari of the ducal palace in Mantua, and which Van Dyck could have seen on his visit in about 1623.[2] Van Dyck was probably inspired to represent maturity as a man in armor by Giorgione's lost painting of the "Vita humana" that Ridolfi recorded in the Cassinelli Collection in Genoa, as Justi proposed. According to Ridolfi's description, Giorgione's multi-figured composition included four ages, with an infant at a nurse's breast, a young man in conversation with scholars, a powerful man in armor, and a stooped elderly one, contemplating a skull.[3] Justi hypothesized, and Glück agreed, that Van Dyck's painting was more strongly indebted to Giorgione's than seems likely, given the differences detailed by Ridolfi. Van Dyck's *Ages of Man* certainly typifies his assimilation of the vernacular of cinquecento Venetian painting, and it displays a worldly wise yet tender humanity, and a grace and fullness of gesture that he has made his own. His compositional invention, with the gently turning, interwoven poses of the male figures, conveys a beautiful conceit about life as a perpetual cycle, a revolving stage on which one passes smoothly and inevitably from childhood to old age.

Glück first linked this painting with one dubbed "le quattro età" in the 1665 Gonzaga inventory published by d'Arco; he was proven correct when the 1711 sale list was printed in the *Raccolte* with a full description that matches in all details. Despite the centuries-old tradition that the painting represents four ages, which persists in Vicenza even today, we clearly have Three Ages of Man, as observant critics, including Justi, Frizzoni, and Stewart periodically have noted.

S. J. B.

Fig. 1. Titian, *Three Ages of Man*,
c. 1512–1515, canvas, 90.2 x 151.2
(35 1/2 x 59 1/2). Duke of Sutherland
Collection, on loan to the National
Gallery of Scotland, Edinburgh

c. 1626

canvas, 120 x 101 (46³/₄ x 39³/₈)

Pinacoteca Capitolina, Rome

PROVENANCE De Wael family, Antwerp; inventory of the estate of knight and postmaster Jan-Baptista Anthoine, deceased in Antwerp on 27 March 1691, no. 63; in sale of count de Fraula, Brussels, 21 July 1738, no. 261; Vincenzo Nelli; given to Camera Apostolica 21 March 1822 by Nelli, in partial payment of a debt incurred; transferred to Capitoline Gallery in 1824

EXHIBITIONS Brussels 1910, no. 119; Genoa 1955, no. 62 ill.; Rome, Palazzo Barberini, *Dipinti fiamminghi di collezioni romane*, 1966, 22 [unnumbered], ill. 34; Genoa, Museo di Sant' Agostino, *Il Tempo di Rubens*, 1987, no. 25

LITERATURE Hoet 1752, 1:541, no. 261; Smith 1829–1842, 3:85, no. 289; Jakob Burckhardt, *Der Cicerone* (Leipzig, 1869), 3:1043; Xavier Barbier de Montault, *Les Musées et galeries de Rome. Catalogue général* (Rome, 1870), 39; Guiffrey 1882, 42–43, 56, 282, no. 941; Bertolotti 1887, 16; Pinacoteca Capitolina 1890, 50–51; Fernand Donnet, "Van Dyck inconnu," *Bulletin de l'Académie royale d'archéologie de Belgique* (1898), 394, n. 1; Hymans 1899b, 409; Cust 1900, 53–54 (opp.) ill., 244, no. 137; Wilhelm Waetzoldt, *Die Kunst des Porträts* (Leipzig, 1908), 274; Schaeffer 1909, 217 ill., 504; *Katalog der königlichen Gemäldegalerie zu Kassel* (Berlin, 1913), 19; F. J. van den Branden, "28 Maart–10 April 1691 Inventaris vande goederen compterende den sterffhuyse van ritter Joan Baptista Anthoine, Riddere ende Postmeester binnen dese stadt, overleden op 27 Maart 1691," *Antwerpsch archievenblad* 22, 80; Vaes 1924, 230; Vaes

Cornelis de Wael (1579–1667), son of the painter Jan de Wael and a contemporary of Rubens, grew up and was trained in Antwerp. After moving to Genoa in his thirties, he lived out his long life in Italy as a painter of battle scenes, marines, and moralizing genre cycles, and as a dealer in Flemish paintings. With his brother Lucas (1591–1661), who joined him there for most of the 1620s, he was at the center of the community of Netherlandish artists that included Jan Roos, Vincent Malò, Jan Hovaert, and of course their family friend Van Dyck. The presence of the De Waels in Genoa must have made life there more welcoming to the young Van Dyck, who appears to have made the city his home base in Italy. Cornelis, who was twenty years older than Van Dyck, kept track of his travels in his correspondence with their mutual friend Lucas van Uffel [cat. 31]. Those letters, now lost, were indispensable sources informing the account of Van Dyck's Italian sojourn in an anonymous eighteenth-century manuscript biography of the artist (Larsen 1975a; Bibliothèque du Louvre, Paris). According to the unknown author, when Van Dyck made his final departure from Genoa, he gave several pictures to the brothers, including this double portrait.[1]

Cornelis and Lucas de Wael is Van Dyck's first double portrait of a type he developed to spectacular effect during his English years. The portrait of siblings represents two people of equal status. As such it poses a challenge different from the double portrait of parent and child, or of a person with an aide or servant. It calls for a composition of an inexplicit balance, one that favors the individuality of each sitter but gives pride of place to neither. Some of Van Dyck's most memorable images fall into this category, including two masterpieces of aristocratic hauteur from the English period, *George, Lord Digby, and William, Lord Russell* [fig. 1] and *Lord John Stuart with His Brother, Lord Bernard Stuart* (National Gallery, London), both regrettably absent from this exhibition.

In the portrait of the De Wael brothers Van Dyck already found the devices that would serve him in such later works; he set the brothers apart with light and dark clothing, and differentiated them through their divergent movements and glances. In the mature masterpiece *George, Lord Digby, and William, Lord Russell*, the sitters are shown officially, at full length, with suggestions of the surroundings and accoutrements of their class. *Cornelis and Lucas de Wael*, on the other hand, are presented at half length against a neutral background, simply and directly, but with dignity. Their portrait has an artless informality and naturalism that would seem to deny a painted

Fig. 1. Anthony van Dyck, *George, Lord Digby, and William, Lord Russell*, c. 1637, canvas, 242.5 x 155 (95¹/₂ x 61). Collection of Lord Spencer, Althorp

Fig. 2. Raphael, *Self-Portrait with Fencing Master*, 1518–1519, panel, 99 x 83 (39 x 32¹/₂). Musée du Louvre, Paris

1925, 152–155; Glück 1931, 157 ill., 537; Denucé 1932, 357, no. 63; Glück 1933, 312; Theodor Hetzer, *Titian* (Frankfurt am Main, 1935), 228; Adriani 1940, 8; Leo van Puyvelde, *La Peinture flamande à Rome* (Brussels, 1950), 168, pl. 72; C. Pietrangelli, "Revisioni d'attribuzioni nella Pinacoteca Capitolina," *Bollettino dei musei communali di Roma* 1 (1954), 59; Jaffé 1965, 43; Larsen 1975a, 61–62, n. 95; Pinacoteca Capitolina 1978, 48–49, no. 103 ill; Brown 1982, 61, pls. 49–50; Barnes 1986, 1:125–126, 258–260, no. 43, 2: ill. 176

1. Larsen 1975a, fol. 46–47: "Avant de partir il donna un beau témoignage/ de la reconnaissance qu'il devait à l'amitié des frères De Wael. Il les peignit l'un et l'autre sur une même toile. ..."
2. We learn from the document that Nelli gave four paintings to the Camera Apostolica on 21 March 1822, in partial payment for a debt he incurred in October 1820. They included: "due del Vandich rappresentante ciascuno due ritratti di celebre artisti Fiamminghi [the De Wael brothers, and Pieter de Jode and his son]" as well as a Saint Francis by Rubens and a Holy Family by Luca Cambiaso. The two portraits by Van Dyck were evaluated at 1,000 zecchini, the Rubens at 300 zecchini (Rome, Archivio di Stato, Fondo Camerlengato, titolo IV, busta 43, fasc. 273, 21 March 1822).

precedent. Still, the resemblance to Raphael's *Self-Portrait with Fencing Master* [fig. 2] is striking enough to suggest it was an inspiration to Van Dyck.

Hollar's engraving was perhaps based on an oil sketch in Kassel made after the painting. The inscription on the engraving, along with the De Wael family presence, helped keep alive the memory of the sitters' names in the north, where the painting had traveled by the late seventeenth century. In Italy, however, where it returned by the early nineteenth century, their identities were progressively lost: the document of transfer to the Camera Apostolica in 1822 calls them "due celebri artisti fiamminghi";[2] for Barbier de Montault (1870) they were unknown gentlemen; and by the late nineteenth century they had been rechristened Thomas Killigrew and Thomas Carew (Pinacoteca Capitolina 1910). Not until the 1950s did the Pinacoteca Capitolina restore their proper identification.

S. J. B.

43
A Genoese Noblewoman and Her Son

c. 1626
canvas, 189 x 139 (74 1/2 x 55)

National Gallery of Art, Washington,
Widener Collection, 1942.9.91

PROVENANCE George Grenville
(1746–1816), 2d earl of Brooke and
Warwick (from 1773), Warwick Castle,
before 1802, probably by 1787;[1] by
descent to Francis Richard Charles Guy
(1853–1929), 5th earl of Warwick; sold in
1909 by M. Knoedler & Co., Paris, to
P. A. B. Widener

EXHIBITIONS London, British Institute,
1862, no. 36 (as "A Lady and Child");
London 1871, no. 155 (as "Countess of
Brignole and Child"); London, Royal
Academy, 1878, no. 158; London 1887,
no. 18; New York 1909, no. 2; London,
Grafton Gallery, National Loan Exhibition
of Old Masters, 1910, no. 55

LITERATURE Richard Warner, A Tour
Through the Northern Countries of England
and the Borders of Scotland (London, 1802),
240 (as Lady Brooke sitting; painter
unknown); J. N. Brewer, The Beauties of
England and Wales (London, 1801–1818), 18
vols., 2:215 (as Lady Brooke with a boy);
Smith 1829–1842, 3:179, no. 617; Waagen
1838, 3:213; H. T. Cooke, An Historical
and Descriptive Guide to Warwick Castle
(Warwick, 1851), 47 (as Brignole family
members); Waagen 1854, 3:213; Guiffrey
1882, 259, no. 412; Cust 1900, 40, 200,
241–242, no. 72 (Marchesa Brignole-Sale);
Mrs. F. Nevill Jackson, "Lace of the Van
Dyck Period," Connoisseur 2 (January–
April 1902), 106; Schaeffer 1909, 503,
under no. 177; Walton and Cust 1910,
301 ill.; Widener 1913, n.p., no. 50 ill.;
Graves 1914, 1506, 1512, 1514, 1532;
Glück 1931, xxxvii, 181 ill., 540; Reder
1941, 10, n. 5; Brown 1982, 88, ill. 77;
Millar in London 1982–1983, 15, ill. 10;
National Gallery Washington 1985, 145,
no. 1942.9.91 (as Portrait of an Italian
Noblewoman and Her Son); Barnes 1986,
1:128–129, 334–335, no. 83, 2: ill. 242;
David Buttery, "George Romney and the
Second Earl of Warwick," Apollo 124,
no. 294 (August 1986), 108, 109, n. 36, 38,
ill. 13

1. Buttery 1986, 109, n. 36.
2. On the document, see cat. 24, n. 1.
3. David Buttery, personal communi-
cation, National Gallery of Art curatorial
files.
4. He used a nearly identical setting in
the portrait of an unknown woman,
formerly in the Balbi di Piovera
collection (Barnes 1986, 1:316, no. 74,
2: ill. 226).

Van Dyck painted scores of portraits for the Genoese, but in the sixty-odd paintings surviving today not half the sitters can be identified even tentatively. Because of the human instinct to inquire about the people in portraits, however, names and histories have accrued to many of these unknown personages over the centuries. For instance, this grand lady became an imaginary ancestor of the house of Brooke and Warwick when she acquired the title of Lady Brooke sometime before 1802. Then, near the middle of the nineteenth century, and probably in recognition of her Genoese origins, the name of Brignole became attached to her. That identity alternated with Lady Brooke's until Cust (1900) named her Marchesa Brignole-Sale, Paola Adorno, which held until 1983. The first Marchesa Brignole-Sale (and the only one of Van Dyck's day) was indeed Paola Adorno, who married Anton Giulio Brignole-Sale late in 1625. Van Dyck's documented portrait of Paola in the Palazzo Rosso, painted at the end of his sojourn in 1627, shows her to be a different, and far younger woman than depicted here.[2] Furthermore, Paola Adorno and her husband could not have had a child the age of the boy seen here before Van Dyck's departure from Italy. Unfortunately, no clue to the real identity of this mother and child has come to light. The records at Warwick have not yielded the name of the Genoese collection from which it came;[3] nor, probably because it had already been sold, was it included in Ratti's 1780 guide to the art treasures of the city.

The massive columns at right surround the mother in a shadowy, almost sepulchral interior environment. At the left, however, behind her son, the background suddenly changes: the edge of a portico roof, the balustrade, and the great expanse of sky we see suggest a stepped-down extension of the house and a terrace overlooking a garden below. Many of Van Dyck's Genoese patrons would have lived in the late Renaissance palaces built on the steep terrain of the via Balbi and the strada Nuova. Nevertheless, this is the kind of fictive setting that he had created since 1620–1621 [cats. 9, 21, 26, 27] to suit the varied purposes of his art.[4] Those he designed for this and other Italian portraits recall the architecture in sixteenth-century monumental history paintings [fig. 1] and fresco decorations, and were employed along with a di sotto in su perspective to enhance the presence of his sitters, making them much grander than life. Beginning in Antwerp, Van Dyck invented settings that also helped articulate the roles of the characters in a double portrait. With Susanna Fourment and Her Daughter [cat. 21], for instance, the mother and her young child are knitted together by the curtain and columns that surround them, and are set as a cozy pair in a safe haven against a distant stormy sky. Here, however, the architecture is used to very different effect. The shift in scale from the monumental order around his mother

Fig. 1. Paolo Veronese, The Marriage at Cana, 1562–1563, canvas, 699 x 990 (275 1/4 x 389 3/4). Musée du Louvre, Paris

to the smaller components behind the boy both lends him physical stature and distinguishes between him and his mother by creating a dichotomy between their worlds. There is a contrast between her dark, interior surroundings and the place he is destined to occupy, perhaps even to command, which opens wide behind him. Although his hand is in his mother's, his manly stance and even gaze leave no doubt about who is in charge.

The mother's unusual full-profile pose, which is related to a sketchbook study after Titian [fig. 2], makes her intriguingly, majestically, and even hauntingly aloof. It evokes the profile portraits of rulers seen on medals and coins and of the dead on tomb sculpture. Van Dyck's animating device of the little leaping dog, here at the side of his young master, had an afterlife in English portraiture, as can be seen in Sir Joshua Reynolds' *Portrait of Mrs. Mathews* [fig. 3].

S. J. B.

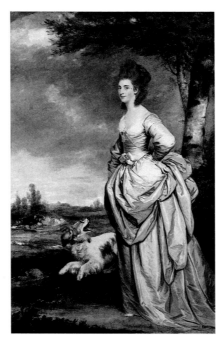

Fig. 2. Anthony van Dyck, studies of portraits after Titian, Italian sketchbook, fol. 104v, c. 1623, pen and ink. Courtesy of the Trustees of the British Museum, London

Fig. 3. Joshua Reynolds, *Portrait of Mrs. Mathews*, 1777, canvas, 239.4 x 146.7 (94 1/2 x 57 3/4). The Museum of Fine Arts, Houston

194

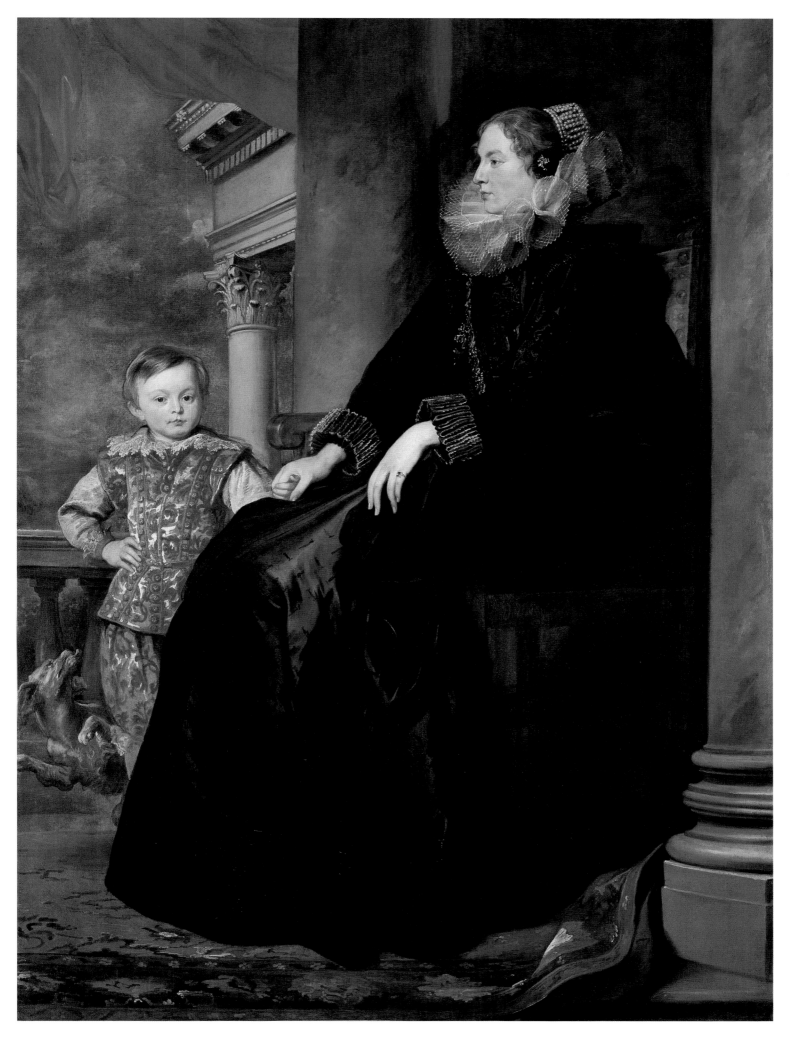

44·45
Anna Wake
Peeter Stevens

Anna Wake, 1628
signed *AET.SVAE. 22 AN 1628 Ant.º van
dyck fecit*
canvas, 113 x 98 (44 1/8 x 38 1/4)

Koninklijk Kabinet van Schilderijen
"Mauritshuis," The Hague, inv. no. 240

PROVENANCE Peeter Stevens, Antwerp,
1628–1668; Govert van Slingelandt, The
Hague, 1752–1768; Willem V, The Hague,
1768–1795; Louvre, Paris, 1795–1815;
Koninklijk Kabinet van Schilderijen, The
Hague, 1815; Koninklijk Kabinet van
Schilderijen "Mauritshuis," 1821

EXHIBITIONS Brussels 1910, no. 99;
Antwerp 1949, no. 47, ill. 29

LITERATURE Hoet 1752, 2:404; Smith
1829–1842, 3:38, no. 135; Cust 1900, 58
(as "Wife of Sir … Sheffield"), 261, no.
126; Schaeffer 1909, 225, ill., 504–505;
Glück 1931, 284, ill., 550; Leveson Gower
1910, 74–76; Speth-Holterhoff 1957, 15;
Van Gelder 1959, 47–48; B. Brennink-
meyer-de Rooij, "De schilderijengalerij
van Prins Willem V op het Buitenhof te
Den Haag (2)," *Antiek* 11 (1976), 162, no.
23; Drossaers and Lunsingh Scheurleer
1974–1976, 3:207, no. 23; Smith 1982,
87–88, ill. 35; Mauritshuis 1985, 174, no.
28, 175, pl., 360, no. 240, ill.; Mauritshuis
1987, 119–125, no. 21, pl.; Larsen 1988,
618, ill. 207

Peeter Stevens, 1627
signed *AET.SVAE 37 1627 Ant.º van Dijck.
fecit*
canvas, 113 x 98 (44 x 38 1/4)

Koninklijk Kabinet van Schilderijen
"Mauritshuis," The Hague, inv. no. 239

PROVENANCE Peeter Stevens, Antwerp,
1627–1668; Govert van Slingelandt, The
Hague, 1752; Willem V, The Hague,
1768–1795; Louvre, Paris, 1795–1815;
Koninklijk Kabinet van Schilderijen, The
Hague, 1815; Koninklijk Kabinet van
Schilderijen "Mauritshuis," 1821

EXHIBITIONS Brussels 1910, no. 98, ill.
64; Antwerp 1949, no. 46, ill. 28

LITERATURE Hoet 1752, 2:404; Smith
1829–1842, 3:38, no. 134; Schaeffer 1909,
224, ill., 504–505 (as "Sir Sheffield");
Cust 1900, 195, 259, 108, 259–260, no. 108
(as "Sir Scheffield"); Leveson Gower
1910, 73–76; Hofstede de Groot 1916, 68;
Glück 1931, 285, ill., 550 (as "The Maece-
nas Peter Stevens"); Speth-Holterhoff

Throughout his life Van Dyck had close contacts with artists, connoisseurs, and patrons of the arts, many of whom he depicted in sympathetic and revealing ways, both in paintings and in images for his *Iconography.* Peeter Stevens was one such acquaintance. Van Dyck's pendant portraits of him and his wife Anna Wake, painted in Antwerp after his return from Italy, are among his most tender images. The warmth of Peeter Stevens' expression as he looks toward Anna Wake and the ease with which he gestures in her direction with his extended left hand, sheathed in an elegantly decorated leather glove, seem so natural that one forgets how radically innovative are both the mood and pose within portrait conventions. The Anna Wake whom he presents is elegantly dressed, complete with expensive jewelry and an ostrich fan that she holds open before her in her left hand. Although her pose is more conventional than that of Peeter Stevens,[1] Van Dyck conveys both her grace and strength of character as she gazes at the viewer in her wedding portrait. Her engagement and wedding rings are proudly displayed on her left thumb.[2]

While such expressions of affection are often found in double portraits[3] and family portraits [see cat. 9], pendant portraits traditionally maintained a more formal relationship between the subjects than evident here. As in Van Dyck's pendant portraits from his first Antwerp and Italian periods [cats. 4, 5, 26, 27], sitters' poses complemented each other but did not suggest physical or emotional contact between the individuals.

One other fascinating departure from tradition in these pendants is that Van Dyck has placed Peeter Stevens to Anna Wake's left, thus reversing the positions normally reserved for the male and female. This arrangement suggests a new dynamic between husband and wife, replacing the traditional hierarchical associations inherent in the dexter-sinister portrait format with ones that suggest a partnership built upon reciprocity and mutual respect, an attitude toward marriage that was increasingly stressed at this time.[4]

Van Dyck's innovations in these portraits have not been sufficiently appreciated, in part because it has occasionally been thought that the works were not conceived as pendants.[5] This argument is founded on the fact that the portraits are dated in different years and on the assumption that the dexter-sinister rule in pendant portraits was inviolate.[6] Van Dyck's pendant portraits from the Louvre [cats. 49, 50], painted only shortly after these works, show that the latter assumption is invalid, at

Fig. 1. Willem van Haecht, *The Cabinet of
Cornelis van der Gheest,* 1628, panel,
104 x 139 (40 3/4 x 54 3/4). Rubenshuis,
Antwerp

1957, 14–19; Van Gelder 1959, 47–48; B. Brenninkmeyer-de Rooij, "De schilderijengalerij van Prins Willem V op het Buitenhof te Den Haag (2)," *Antiek* 11 (1976), 162–163, no. 24; Drossaers and Lunsingh Scheurleer 1974–1976, 3:208, no. 204; Smith 1982, 87–88, ill. 36; Mauritshuis 1985, 360, no. 239, ill.; Mauritshuis 1987, 119–125, ill.; Larsen 1988, 617, ill. 208

1. Her pose, including the position of the fan, is virtually a mirror image of a *Portrait of a Lady*, 1627, by Paulus Moreelse in the Mauritshuis (inv. no. 655), as was first noticed by W. Martin, *De Hollandsche schilderkunst in de zeventiende eeuw* (Amsterdam, 1936) 1:82–84, figs. 47–48. The wearing of the rings on the thumb is unusual in Flemish marriage customs of this period, but commonly seen in English portraits from the late sixteenth and early seventeenth centuries. Anna Wake was the daughter of an English merchant living in Antwerp. For depictions of rings on the thumb in English portraiture, see Royal Collection 1963, cats. 47, 48. I would like to thank Martina Friedrich for drawing my attention to this English practice, which was also adapted by the Dutch later in the seventeenth century.
2. For the symbolism of the square cut diamond and importance of the double rings, see Bianca M. du Mortier, "Costume in Frans Hals," in Seymour Slive, *Frans Hals* [exh. cat. Royal Academy of Art] (London, 1989), 46.
3. See Rubens' *Self-Portrait with Isabella Brant* (Alte Pinakothek, Munich) and Frans Hals' marriage portrait of *Isaac Massa and Beatrix van der Laen* (Rijksmuseum, Amsterdam).
4. For ideals of reciprocity in marriages at that time see Sherrin Marshall, *The Dutch Gentry, 1500–1650: Family, Faith, and Fortune* (New York, 1987), 163–164.
5. Mauritshuis 1987, 124.
6. Eddy de Jongh, *Portretten van Echt en Trouw* [exh. cat. Frans Halsmuseum, Haarlem] (Zwolle, 1986), 195, no. 40; 231–235, no. 52; 236–237, no. 53.
7. That the betrothal date was of great significance at this time is evident from the inscription Rembrandt made on a silverpoint drawing of Saskia (Kupferstichkabinett, Berlin), where he referred to her as his "huysvrou" after their engagement on 8 June 1633. The couple were married in June of the following year. See Walter L. Strauss and others, *The Rembrandt Documents* (New York, 1979), 100–101; for a comparable situation within Van Dyck's œuvre see his full-length portraits of Philippe le Roy and Maria de Raet in the Wallace Collection, London.
8. This interdiction was stressed by Jacob Cats, *Hovwelyck* (Middelburgh, 1625), fol. 24r. I would like to thank Bianca du Mortier for drawing my attention to this reference.
9. For one interpretation of the symbolic meaning of the fan in this painting, see Smith 1982, 87–88.
10. For a discussion of the duties of the Aalmoezeniers situated in Amsterdam, which would not have been significantly different from those in Antwerp, see Sheila D. Muller, *Charity in the Dutch Republic: Pictures of Rich and Poor for*

least for Van Dyck. The fact that *Peeter Stevens* is dated 1627 and *Anna Wake* 1628 is also no reason to conclude, given Peeter Stevens' pose and longing expression, that these works were not conceived as pendants. Although their actual wedding day was 12 March 1628, such a socially prominent couple would clearly have been engaged for some time.[7] Indeed, convention dictated that the betrothed woman's portrait could not be painted until the wedding had actually taken place.[8]

Peeter Stevens' gesture seems to suggest that he is, indeed, presenting his new wife to the viewer. Van Dyck had used this gesture in two full-length portraits of mothers accompanied by their daughters during his Italian period (Glück 1931, 185, 195). The elegant fan that she holds so proudly may be a wedding present from her husband. Perhaps specific symbolic meanings were attached to it and the position in which it was held; unfortunately the language of fans is not fully understood today.[9]

At the time of his marriage Peeter Stevens was thirty-seven years old, the son of Adriaen Stevens and Maria Bosschaerts, whose portraits Van Dyck painted in 1629 (now in the Pushkin Museum, Moscow, where they are on loan from the Hermitage). Peeter Stevens and his father both were Aalmoezeniers (almoners), and highly respected for their piety and charity.[10] Peeter Stevens worked closely with a number of Antwerp churches and served as trustee of the "Tafels van de H. Gheest en de Camer van den Huysarmen." He was responsible for the financial obligations that were incurred by that organization in its function of feeding and caring for the poor.[11] Anna Wake, who was baptized on 19 February 1606, was the eldest child of Lionel Wake, an English merchant who settled in Antwerp and became actively involved in the cultural life of that city. Wake, for example, was well acquainted with Rubens and helped expedite the exchange of paintings and sculptures between the artist and Sir Dudley Carleton, the British ambassador in The Hague.[12] Little is known of Anna other than that she bore eight children between 1628 and 1641. The date of her death is not known.

By the time he sat for Van Dyck, Peeter Stevens was already recognized as a man of discriminating taste, a collector and connoisseur. In 1628, the year of his marriage, he was prominently included in Willem van Haecht's exceptional painting *The Cabinet of Cornelis van der Gheest* [fig. 1]. In this work, a document of the social prestige that Van der Gheest and his collection enjoyed, Stevens is portrayed in the center of the composition, leaning on a table covered with bronzes and peering intently at a small portrait in his hand. In Van Haecht's composite record of distinguished visitors to Van der Gheest's collection, Stevens belongs to an exalted company, including Albert and Isabella, regents of the southern Netherlands, Wladislas Sigismund, the future king of Poland, Rubens, and Van Dyck, as well as other distinguished artists and connoisseurs.[13]

Stevens, who was an active collector, purchased a number of important paintings, including works by Jan van Eyck and Quentin Metsys, from Van der Gheest's

PETRVS STEVENS

Fig. 2. Lucas Vorsterman after Van Dyck, *Petrus Stevens*, *Iconography*, etching and engraving, 23.2 x 15.7 (9 3/16 x 6 3/16). National Gallery of Art, Washington

197

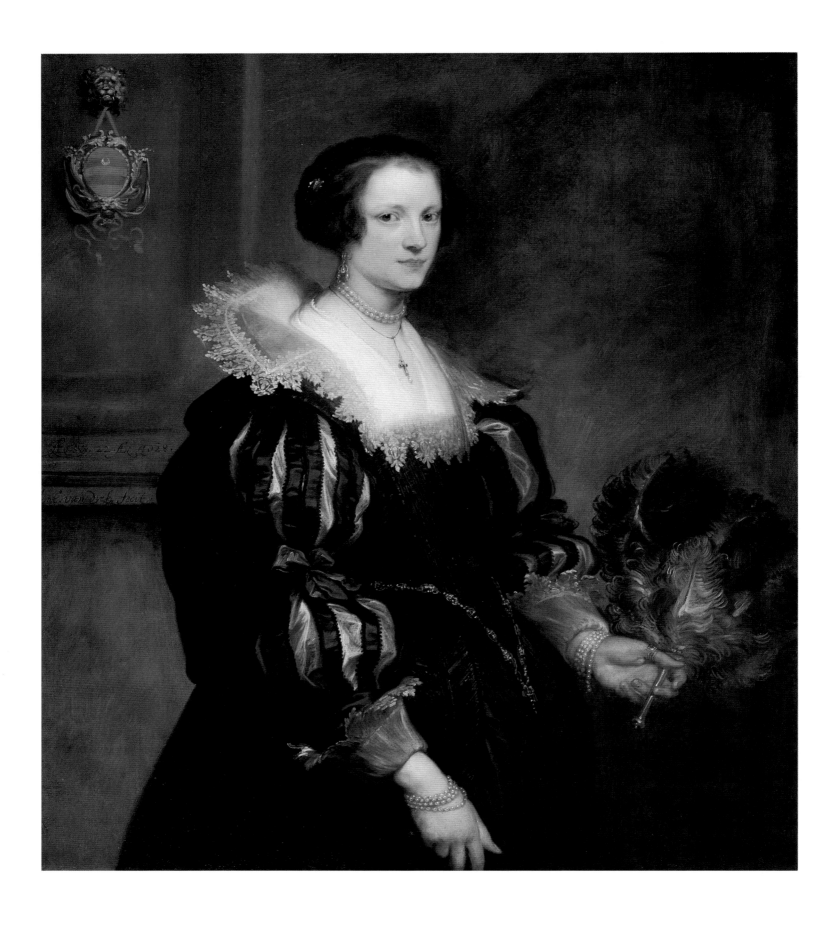

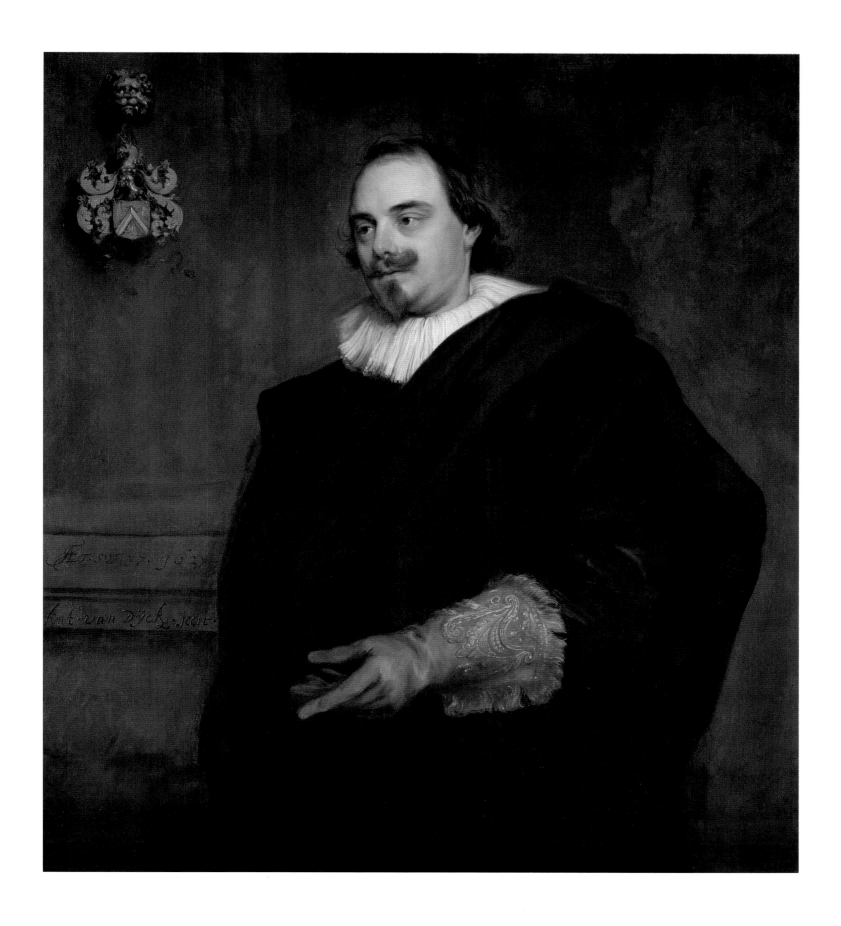

199

Charitable Institutions (Ann Arbor, 1987), 76–77.

11. For further biographical information on Stevens, see J. Briels, "De Antwerpse kunstverzamelaar Peeter Stevens (1590–1668) en zijn Constkamer," *Jaarboek van het Koninklijk Museum voor Schone Kunsten Antwerpen* (1980), 137–226; and Mauritshuis 1987, 123.

12. For further biographical information, see Mauritshuis 1987, 119–120.

13. A great deal of literature has been devoted to this painting. See, for example, Held 1957, 53–84.

14. For an account of the collection, see Speth-Holterhoff 1957, 14–19; and Briels 1980 (see n. 10 above).

15. Leveson Gower 1910, 73–76.

collection after the latter's death in 1638. He also inherited paintings, including the Van Dyck portraits of his parents. The four Van Dycks are mentioned in the catalogue of the sale of his remarkable collection after his death in 1668.[14]

Despite the presence of the prominent coats of arms, the identity of the pair was forgotten as early as 1752 when they were in the G. van Slingelandt Collection in The Hague. When the paintings were catalogued in the collection of Willem V in the late eighteenth century it was thought that the coat of arms in the male portrait was that of a Sir Sheffield, duke of Buckingham, an opinion that lasted until 1910 when the correct identification was finally made.[15] As is so often the case, the presence of Peeter Stevens in Van Dyck's *Iconography*, where he was included among the *Kunst-liefhebbers* (art lovers), helped establish the sitter's identity [fig. 2]. This engraving by Lucas Vorsterman was based on an oil sketch now in the collection of the duke of Buccleuch.

<div align="right">A. K. W.</div>

46
Saint Augustine in Ecstasy

1628

canvas, 389 x 227 (156 x 90)

Kunsthistorische Musea—City of
Antwerp

PROVENANCE Commissioned by the
church of Saint Augustine in 1628;
transferred to the Louvre (1795?) and
returned to the church of Saint
Augustine, Antwerp, 1815

EXHIBITIONS Antwerp 1899, no. 26;
Antwerp 1949, no. 14, ill. 1; London
1953–1954, no. 132

LITERATURE Houbraken 1753, 1:184;
Descamps 1753–1754, 2:16; Smith
1829–1842, 3:3–4, no. 5; Cust 1900, 60
(opp.), ill., 61, 181, 209, no. 26, 249, no.
56; Schaeffer 1909, 89, ill., 499;
Buschmann 1916, 47–48; Glück 1931, 237,
ill., 544; Millar 1954, 42; Vey 1956, 176;
Antwerp 1960, 156–158 (under no. 124);
Brown 1979, 145; Princeton 1979,
136–137, ill. 37; Larsen 1975a, 66–68;
Brown 1982, 114–116, ill. 105; Larsen
1988, no. 658, ill. 204

1. The meanings of various attributes of
the putti are described by Bellori 1672,
258: "The scepter with an eye represents
Providence, the olive branch is peace;
the serpent biting its tail is eternity; one
putto contemplates the Sun of Justice
and other sublime mysteries."
2. The fact that the patron had himself
depicted in a guise of Saint Nicholas of
Tolentino, a thirteenth-century friar of
the Order of Saint Augustine, was made
clear by the anonymous eighteenth-
century biographer of Van Dyck in the
Louvre manuscript. See Larsen 1975a,
67–68.
3. F. Peeters, L'Eglise Saint-Augustin à
Anvers (Antwerp, 1931), 116–117, quoted
from an account found in the Diarium
Augustinum: "1628. Hoc anno procurata
est pictura admodum elegans S.
Augustini in exstasi contemplantis divina

In this, one of Van Dyck's most inspired altarpieces, Saint Augustine gazes upward in
ecstasy at a vision of the Holy Trinity situated above a lively band of putti. These
hold emblematic attributes representative of God's almighty power, unity, and
eternity.[1] The saint is supported by two angels, one of whom gestures above to
announce the vision to the donor, Father Marinus Jansenius, who is seen here in the
guise of Saint Nicolas of Tolentino.[2] To the left the saint's mother, Saint Monica,
stares reverently in wonderment at the miraculous image.

Van Dyck completed the *Saint Augustine in Ecstasy* in 1628 for the altar on the left
aisle of the church of Saint Augustine in Antwerp.[3] The circumstances of this major
commission so soon after his return from Italy are not known, but it may well have
come at the suggestion of Peter Paul Rubens who had been asked to paint the main
altarpiece for the church, *Madonna and Child Adored by Saints* [fig. 1]. A third altarpiece,
devoted to *The Martyrdom of Saint Apollonia* [fig. 2], was commissioned from Jacob
Jordaens and was installed across from Van Dyck's altarpiece.[4] The altarpieces thus
respectively honored the Virgin and Saints, to whom the church was dedicated; Saint
Apollonia, whose relic was preserved in the church; and Saint Augustine, the patron
saint of the order.[5] The program for the altarpieces was undoubtedly connected with
the decision made in Brussels in 1625 that in May of 1628 the provincial chapter of
the Augustinians would convene at the recently constructed Augustinian church in
Antwerp.[6]

This unique ensemble of altarpieces provides a marvelous opportunity to compare
the different artistic personalities of these masters. Rubens' magisterial creation
pulsates with energy and strength, as a rich array of idealized saints leads insistently
to the enthroned Madonna and Child. This composition culminates more than two
decades of work in which Rubens had forged a new vocabulary of religious imagery
that fused the physical and spiritual into a consistent whole. Neither Van Dyck nor
Jordaens, whose early careers had been so dependent on the great master, had freed
themselves from Rubens' overpowering influence, yet their distinctive personalities
are clearly evident in these remarkable paintings. Jordaens' composition is dense and
his figures massive as he strove to emphasize the brutality of Saint Apollonia's
martyrdom. Van Dyck's image, on the other hand, is more joyous and spontaneous in
feeling, as he focused on figures' expressions to evoke their emotional responses to
the mystical vision.

The reaction to Van Dyck's altarpiece, according to Descamps, was enthusiastic on
the part of his fellow artists, who were convinced that Van Dyck's experiences in Italy
had "embelli sa maniere de peindre, & qu'il avoit achevé de prendre des grands

Fig. 1. Peter Paul Rubens, *Madonna and
Child Adored by Saints*, 1628, canvas,
564 x 401 (222 x 1577/8). Church of Saint
Augustine, Antwerp, on loan to
Koninklijk Museum voor Schone
Kunsten, Antwerp

Fig. 2. Jacob Jordaens, *The Martyrdom of
Saint Apollonia*, 1628, canvas, 409 x 213
(161 x 837/8). Church of Saint Augustine,
Antwerp, on loan to Koninklijk Museum
voor Schone Kunsten, Antwerp

attributa, a Domino Van Dyck depicta. Constitit 600 florenis."

4. D'Hulst and Vey in Antwerp 1960, 156, cat. 124, noted that Van Dyck and Jordaens both conceived their works so that the saints faced a window, as though they were being illuminated by a natural source of light.

5. For the iconographic relationships between these three paintings, see Princeton 1979, 136.

6. C. van de Velde, "Archivalia betreffende Rubens' Madonna met Heiligen voor de kerk der Antwerpse Augustijnen," *Jaarboek van het Koninklijk Museum voor Schone Kunsten Antwerpen* (1977), 231.

7. Descamps 1753–1754, 2:13–14.

8. Cust 1900, 61, had already noted compositional similarities to Titian's *Assumption of the Virgin* in the church of the Frari in Venice, Raphael's *Transfiguration* in the Vatican, and Guido Reni's paintings.

9. Larsen 1975a, 66. Van Dyck's anonymous biographer was particularly fond of the putti. "Ils présentent des attitudes/si gracieuses, si variées, une facilité de pinceau si étonnante, que l'on peut assurer que Rubens, qui peignait supérieurement les enfans, n'a jamais rien produit qui surpassât cette partie du tableau."

10. For a fuller discussion of the episode, commonly referred to as the Vision at Ostia, see Princeton 1979, 138. Saint Augustine's vision at Ostia, however, was not specifically of the Trinity. Van Dyck has here conflated that episode with the trinitarian doctrine found in Saint Augustine's later treatise *De Trinitate*. See Antwerp 1960, 157.

11. Princeton 1979, 139. See, for example, Lodovico Cigoli's *The Ecstasy of Saint Francis*, c. 1596, Uffizi, Florence.

12. See Peeters 1931, 116–117 (see n. 3 above).

13. Houbraken 1753, 1:184.

14. Weyerman 1729, 1:301–302.

15. Descamps 1753–1754, 2:16.

16. Larsen 1975a, 67.

17. See Antwerp 1949, 19, cat. 14.

Maîtres ce qui lui restoit à acquérir."[7] While compositional elements do call to mind Titian, Raphael, Guido Reni, and Annibale Carracci,[8] isolating specific Italian influences in this work is difficult, so fully is it conceived within Rubens' own idiom. The most influential prototype is the altarpiece Rubens brought back with him from Italy in 1609, which had been rejected for Santa Maria in Vallicella in Rome and placed above an altar in the Abbey of Saint Michael in Antwerp in memory of Rubens' mother [fig. 3]. The impact of that image, whose composition had so influenced Van Dyck's altarpiece for the Oratorio del Rosario in Palermo [fig. 4] of 1624–1627, is evident here in the way the saint looks aloft at this miraculous vision. Reflections of Van Dyck's own Palermo altarpiece, moreover, are also seen here in the playful attitudes of the putti and the prayerful expression of Saint Monica as she gazes upward with crossed arms.[9]

Saint Monica's presence is crucial to the specific iconography associated with the ecstasy of Saint Augustine. Van Dyck's scene is based upon an episode in Augustine's *Confessions*, 9:10, in which he and his mother converse about the mystery of eternal life.[10] Their meditations transported them to an exalted state in which they were no longer aware of their physical being. The ideal of total immersion in one's religious experience, a fundamental concept of the Counter-Reformation, thus underlies the thematic concept for this altarpiece. Van Dyck here strengthens this message by depicting Saint Augustine in an attitude that resembles that of Saint Francis of Assisi in ecstasy as he receives the stigmata.[11]

Van Dyck received six hundred guilders for his altarpiece, in comparison to the three thousand received by Rubens for his.[12] Legend has it, however, that Van Dyck's payment did not come without some resistance on the part of the church fathers. Houbraken wrote that they were not pleased with the expression of the saint, who looked "drunk" as he peered upward.[13] Campo Weyerman recounted that the church fathers insisted that Van Dyck paint the robes of Saint Augustine black instead of the white he had intended for the figure, a decision that all later authors who reported the story regretted.[14] Finally, according to Descamps, Van Dyck received his payment only after he presented the church an additional painting of a Crucifixion.[15] The anonymous biographer in the Louvre manuscript does not deny that these difficulties existed, but says that the issues concerned Van Dyck and his patron Marinus Jansenius and not the Augustinians.[16] Weyerman's account that Van Dyck originally conceived the robes of Saint Augustine as white seems to be supported by the white robe seen in both the oil sketch he prepared for this work [see cat. 94] and in the engraving made after it by Pieter de Jode the Younger [fig. 5]. Radiographs, however, have not revealed a layer of white below the black.[17] The subject must have had special significance to Van Dyck as is evident from the dedication of the print to his sister Suzanna, who was a member of the religious association of the Béguines in Antwerp.

A. K. W.

Fig. 3. Peter Paul Rubens, *Saint Gregory, Pope, Surrounded by Saints*, c. 1606–1608, canvas, 477 × 288 (187 3/4 × 113 3/8). Musée de Grenoble

Fig. 4. Anthony van Dyck, *Madonna of the Rosary*, 1624–1625, canvas, 397 × 278 (156 1/4 × 109 1/2). Oratorio del Rosario, Palermo

Fig. 5. Pieter de Jode the Younger after Van Dyck, *Saint Augustine in Ecstasy*, engraving, 52 × 30.2 (20 1/2 × 11 7/8). Museum Plantin Moretus en Prentenkabinet, Antwerp

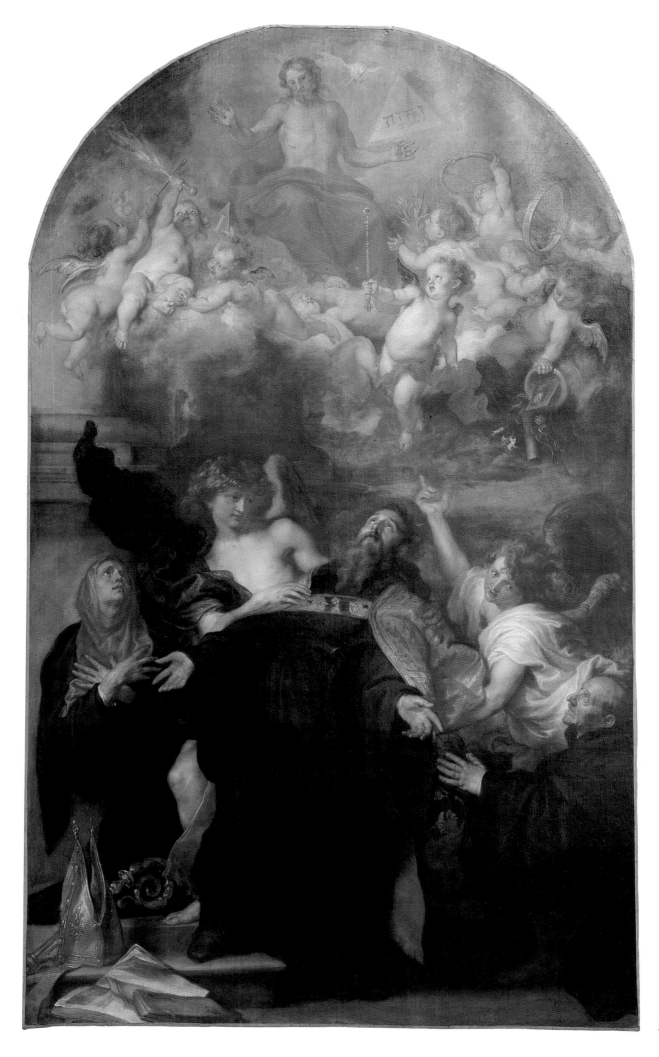

203

47
The Virgin as Intercessor

1628–1629

canvas, 1.18 x 1.02 (46 1/2 x 40 1/4)

National Gallery of Art, Washington, Widener Collection, 1942.9.88

PROVENANCE P. van de Copello, Amsterdam; sold to Henry Hope, Amsterdam, 26 January 1774 for £5,000; Henry Philip Hope, London; Thomas Hope; Henry Thomas Hope; Mrs. Henry Thomas Hope; Lord Francis Pelham Clinton-Hope; Asher Wertheimer, London, 1898; P. A. B. Widener, Philadelphia, 1899; Joseph Widener

EXHIBITIONS London, British Institution, 1815, no. 120; London, British Institution, 1847, no. 25; London, British Institution, 1865, no. 16; London, British Institution, 1881, no. 132; London, South Kensington Museum, 1891, no. 68; Princeton 1979, no. 36, ill.

LITERATURE Joshua Reynolds, *The Works of Sir Joshua Reynolds, Knight* (London, 1801), 2:359; Passavant 1836, 1:226; Smith 1829–1842, 9:400; Waagen 1857, 2:114; Guiffrey 1882, 249, no. 155C; Cust 1900, 249, no. 52; *Catalogue of Paintings Forming the Private Collection of P. A. B. Widener, Part 1: Modern Paintings* (Ashbourne-near Philadelphia, 1900), ill. no. 153; Widener 1913, ill.; Valentiner 1914, 240; Glück 1931, 230, ill., 543; Sterling 1939, 54, n. 14; Hermitage 1955, 36, under no. 110; Vey 1956, 194; Antwerp 1960, 160; Matíaz Díaz Padrón, "Thomas Willeboirts Bosschaert, Pintor en Fuensaldaña, Nuevas obras identificadas en Amberes y Estocolmo," *Archivo Español de Arte* 178 (1972), 96, ill. 7; Martin G. Buist, *At spes non fracta: Hope & Co., 1770–1815, merchant bankers & diplomats at work* (Amsterdam, 1974), 491; J. W. Niemeijer, "De kunstverzameling van John Hope," *Nederlands Kunsthistorisch Jaarboek* 32 (1981), 179; National Gallery Washington, 1985, 144; Larsen 1988, no. 690, ill. 690

1. The exact meanings of the paper held aloft by the angel in the upper right and the white shroud used as a headdress by the angel beneath it are not known. For discussion of these and other issues, see Martin and Feigenbaum in Princeton 1979, 132–135.
2. This iconographic interpretation was first suggested by Laura Gilbert in 1977.
3. As quoted by J. B. Carol, O.F.M., in "Our Lady's Part in the Redemption According to Seventeenth-Century Writers," *Franciscan Studies* 24 (n.s. 3):1 (March, 1943), 16–17.
4. See Niemeijer 1981, 179.
5. This information was kindly provided by Dr. J. van den Nieuwenhuizen, archivist at the Stadsarchief, Antwerp (letter in curatorial files, 20 July 1977).
6. The fate of the painting Happaert owned is uncertain. It may be the *Assumption of the Virgin* that was in the Marlborough Collection at Blenheim Palace in the nineteenth century (Smith

In this devotional image, the Virgin, with upturned eyes, open gesture, and bent knee, is presented frontally to the viewer. Situated within the heavenly sphere, she is surrounded by ten putti, many of whom hold instruments of Christ's Passion, including the crown of thorns, the cross, and the bloodstained scourge of the flagellation.[1] Although this painting has always been identified as an Assumption, that title is inadequate. The stylistic character and iconographic attributes of this scene differ markedly from traditional depictions of the Assumption of the Virgin, such as those seen in large-scale altarpieces by Rubens or that found in Van Dyck's oil sketch [cat. 96], where the Virgin rises dramatically through the sky to the astonishment of the crowd around her empty sarcophagus. In this painting no evidence of her earthly entombment is suggested nor is any upward movement implied, either through the Virgin's pose or through the pattern of folds in her loosely fitted white garment. While the varied activities and even playful attitudes of the putti enliven the scene, the Virgin appears quiet and serene, her gaze suggesting the fullness of her piety.

Van Dyck in this work has transformed a narrative scene into a devotional image representing the Virgin as she presents herself to God as intercessor for man's redemption. She assumes this role not only by virtue of her participation in Christ's Passion, but also through her own mystical death.[2] This theological concept, which was well established in the seventeenth century, was articulated by Franciscus Guerra, a member of the Franciscan Order, in 1659: "Christ our Lord ... deigned to admit His Mother to a congruous cooperation in that same redemption. First, by offering up her Son; secondly, by offering up herself. ... Because of this [twofold] oblation ... she became the Redemptrix of the human race together with our Redeemer."[3]

Seventeenth-century sources do not explicitly connect Mary's death with her role as redemptrix, but theologically these concepts reinforce one another. The Virgin's Assumption recalls Christ's Ascension, and hence the promise of redemption. Thus Van Dyck's allusions to the Virgin's Assumption in this work reinforce his primary theme, the Virgin as mediator and intercessor.

No commission for this painting is known, but its scale and intimate character suggest that it was intended for a private chapel. By the 1670s, however, it must have been owned by an Antwerp collector, for it figures prominently in a gallery picture (Musée Girodet, Montargis) by Hieronymus Janssens, where it hangs above the fireplace [fig. 1]. It remained in Antwerp at least until 1717.[4] What appears to be a more finished version of this composition was engraved after Van Dyck's death by Lucas Vorsterman the Younger (1625–c. 1667) [fig. 2]. This painting, according to the inscription on the engraving, was owned by Joannes Philippus Happaert. Happaert

Fig. 1. Hieronymus Janssens, *Galerie de Tableaux visitée par des amateurs*, c. 1670, canvas, 120 x 172 (47 1/4 x 67 3/4). Musée Girodet, Montargis

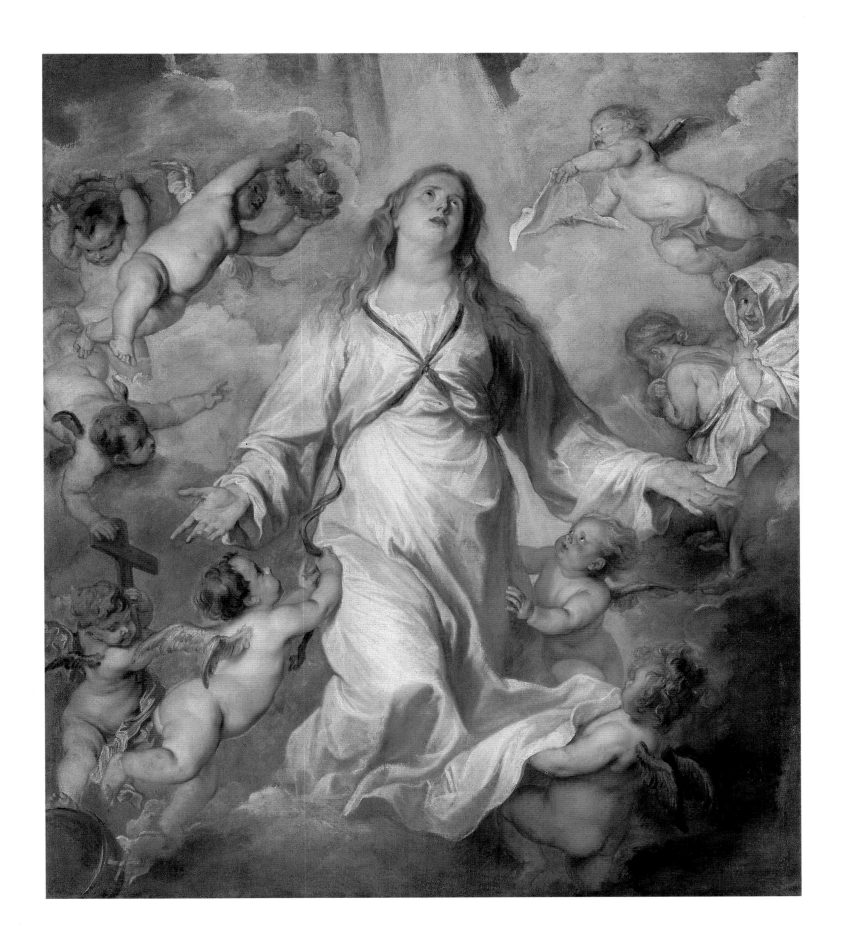

1829–1842, 3:80, no. 264). By 1861, however, the painting must have been sold since it is not recorded in Blenheim 1861. That painting, or a copy of it, belonged to the New York collector Samuel Hartveld in the 1940s. This painting was not included in the sale of his estate: Parke-Bernet, New York, 15 November 1950, no. 1196. It probably is the same painting, however, that sold at Sotheby's, London, 21 February 1962, no. 17. An inscription on the verso of a photograph in the photo archives at the National Gallery indicates that this painting was once in the possession of "A. L. Nicholson London." No further confirmation of his ownership, however, has been established.

7. Other versions have also been recorded in the literature, although none are known today. Charles Bagot exhibited an *Assumption* at the British Institution in 1834 (Graves 1914, 4:1503). Cust 1900, 249, no. 52, mentioned an *Assumption* in the collection of Arthur Hugh Smith Barry of Marbury. Smith Barry exhibited his painting at Grosvenor Gallery in 1887; the catalogue (reprinted in Cust 1900, 202, no. 61) gives the dimensions as 27 x 17 in., about half the size of the exhibited version. Glück, in a handwritten note on the back of a photograph in the National Gallery photo archives, mentioned a copy sold by Dubois-Eymael that was published in *Cercle Artistique*, Antwerp, in March 1924.

8. The only authors who have situated this painting differently within Van Dyck's œuvre are Valentiner 1914, 240, who placed it in Van Dyck's Italian period, and Dobroklonsky in Hermitage 1955, no. 110, who dated it 1624 on the mistaken assumption that the painting represents Saint Rosalie and that Van Dyck executed it in Palermo. Dobroklonsky's argument is part of his attempt to demonstrate that a drawing in the Hermitage is Van Dyck's preparatory study for this painting (see also Dobroklonsky 1931, 238).

9. For a discussion of this painting, see Metropolitan Museum 1984, 1:43–48.

was a city magistrate in Antwerp in 1646, 1647, and 1651 and, after 1652, a canon at the Antwerp cathedral.[5] The compositions of the two works are virtually identical,[6] although in the version engraved by Vorsterman the putto on the left who holds the top of the cross in his right hand points to the cross with his left hand. In the National Gallery's painting he points to the Virgin.

Even though Vorsterman's engraving records the Happaert version of the scene, there seems no doubt that the National Gallery's painting is the earlier.[7] Free and spontaneous in execution, it exhibits all the delicacy of Van Dyck's touch. Numerous pentimenti exist. Van Dyck eliminated a putto to the left of the Virgin and then filled that space with the pointing gesture of a putto touching the cross with his right hand. This putto had originally gestured toward the cross with his left hand, as is seen in Vorsterman's engraving [see fig. 2]: Van Dyck also made changes to the crown of thorns in the upper left. In a number of instances, moreover, he modified the contours of the Virgin's robes to give her a more slender profile.

Van Dyck executed this work about 1628–1629.[8] Stylistically it represents the full appreciation and mastery of Titian's brushwork so evident in Van Dyck's religious paintings from this period. The broken character of the brushstrokes and suggestive modeling of forms reinforces the feeling of lightness and translucency that pervades the scene. The whimsical attitudes of the putti attending the Virgin are also comparable to such figures in Van Dyck's majestic *Saint Augustine in Ecstasy* from 1628 [cat. 46]. Indeed, the putto holding the Virgin's blue ribbon is identical to the one on the far left of that tumultuous group.

As is so often the case in paintings of the late 1620s, Van Dyck developed a strikingly new compositional type to convey the spirituality of his devotional image. His transformation of the Assumption of the Virgin iconographic tradition into an image of the Virgin as Intercessor almost certainly came as a result of his depiction of Saint Rosalie. In his *Saint Rosalie Borne up to Heaven by Angels* [fig. 3], for example, Rosalie, surrounded by putti, intercedes on behalf of the plague victims from the city of Palermo.[9] Just as in the *Assumption of the Virgin*, rays of heavenly light illuminate her form while a putto reaches upward to crown her with a wreath of roses. While the roses refer to Rosalie's name, they also have a broader meaning, signifying heavenly love.

The prominence of the wreath of roses in this painting almost certainly was meant to be seen in this light, but the implicit associations with Saint Rosalie were also important. In May 1628 Van Dyck joined the Confraternity of Bachelors in Antwerp, a religious society run by the Jesuits who were instrumental in promoting the cult of Saint Rosalie in Flanders. The plague that had devastated Palermo in 1624 was threatening Antwerp. Isabella Brant, Rubens' wife, who apparently died of the plague in 1626, was only one of many victims. The confraternity eventually arranged to have the saint's relics brought to Antwerp in August 1629, and had them installed in their chapel in the Jesuit church that year. It may well be that this threat of death through the plague underlies the unusual iconography found in this painting.

A. K. W.

Fig. 2. Lucas Vorsterman the Younger after Van Dyck's *The Virgin as Intercessor*, engraving. Musée du Louvre, Paris, Cabinet des Estampes

Fig. 3. Anthony van Dyck, *Saint Rosalie Borne up to Heaven by Angels*, 1624, canvas, 100.3 x 74.4 (39 1/2 x 29 1/4). The Metropolitan Museum of Art, New York

48
Nicholas Lanier

1628
canvas, 111.5 x 86 (43 1/2 x 33 1/2)

Kunsthistorisches Museum, Vienna, inv. no. 501

PROVENANCE King Charles I; acquired by Lanier at the dispersal of the royal collection, 2 November 1649; in 1720 in the Stallburg, Vienna

EXHIBITIONS Antwerp 1930, 79, ill. 52 (as "Portrait de jeune homme"); Amsterdam 1947, no. 52; Brussels 1947, no. 34, 78 ill. (as "Portrait d'un homme à barbe blonde"); London 1972–1973, no. 74 ill.; London 1982–1983, no. 6

LITERATURE Vertue 1757, 90, no. 34; Kunsthistorisches Museum 1783, 109, no. 21; Smith 1829–1842, 3:233, no. 834; Phillips 1896, 36; Kunsthistorisches Museum 1896, 2:114, no. 1032; Cust 1900, 52–53, 86, 259, no. 96; Schaeffer 1909, 201, ill.; Glück 1931, 349, ill., 557 (as "Portrait of a Man"); Glück 1936, 148–153, ill.; Hevesy 1936, 153; Antwerp 1949, 56; Antwerp 1960, 132; Kunsthistorisches Museum 1963, 51, no. 148; Gaunt 1980, 92, 93, ill.; Brown 1982, 137, pl. 137; Kunsthistorisches Museum 1987, 194, 195, pl.; Larsen 1988, no. 898, ill. 351

1. *The Letters of Peter Paul Rubens*, trans. and ed. Ruth Saunders Magurn (Cambridge, Mass., 1955), 269.
2. Concerning the sale of the Mantuan treasures, see H. Trevor-Roper, *The Plunder of the Arts in the Seventeenth Century* (London, 1970), 29; Alessandro Luzio, *La Galleria dei Gonzaga Venduta all' Inghilterra nel 1627–28* (Rome, 1974); and Parry 1981, 214–216.
3. Walpole 1876, 1:330–332.
4. The painting has been dated to the beginning of Van Dyck's English period (c. 1632–1634) by Glück 1931, 557, no. 349; d'Hulst and Vey in Antwerp 1960, 132; and Nora de Poorter in Vienna 1987, 194. Brown 1982, 139, dated it 1630. Van den Wijngaert 1943, 148, 149, and Millar in London 1982–1983, 45, placed it in 1628 at the time of Lanier's stop in Antwerp.
5. Further evidence that the work predates Van Dyck's English period comes from Abraham van der Doort's catalogue of King Charles I's collection, where it is noted that the painting was "Done by Sr Antho: Vandike Beyond ye Seas" (Millar 1960a, 7). See Vertue 1757, 90, no. 34.
6. Howarth 1985, 246, n. 18, noted that Lanier christened one of his children Arundel in honor of his friend, but the child (baptized 10 December 1633) was that of Nicholas Lanier's brother, Jerome. See F. Lanier Graham, "The Earlier Life and Work of Nicholas Lanier," Ph.D. diss., Columbia University, 1955, 128, no. 4.10.
7. Not only was Van Dyck an acquaintance of Lanier's colleague Daniel Nys, but he was also present in Mantua when the sale of the Gonzaga collection was

On 15 June 1628 Peter Paul Rubens wrote from Antwerp to his friend Pierre Dupuy that "the English gentleman who is taking the art collection of Mantua to England has arrived here. He tells me that everything is now well on the way and that he expects any day the arrival of the greater part of it in this city. This sale displeases me so much that I feel like exclaiming, in the person of the Genius of that state: *Migremus hinc!* (Let us depart hence!)."[1]

The English gentleman to whom Rubens referred was Nicholas Lanier (1588–1666), Master of the King's Music for Charles I and one of the agents sent by the king to Italy to help acquire art treasures for the royal collection. Although the news of this stunning acquisition distressed Rubens, it heralded the Caroline court as a major artistic center, bringing to England great masterpieces by Mantegna, Raphael, Giulio Romano, Andrea del Sarto, Caravaggio, Correggio, Tintoretto, and, above all, Titian. It demonstrated throughout Europe the strength and vitality of the English court, and the serious patronage of the arts that could be expected from the young king, who only two years previously had ascended to the throne.

Lanier's role in the protracted transactions was secondary to that of Daniel Nys, agent of Charles I who became involved in the negotiations for acquiring these art treasures soon after Duke Vincenzo had contacted the countess of Arundel in 1623 about the possible sale of the Mantuan collection.[2] Lanier was sent to Italy in 1625 by Charles I to help arrange for the transport of the paintings to England.

Van Dyck's striking portrait of Lanier almost certainly was painted at the time Lanier was passing through Antwerp on his triumphant return to England with his precious cargo. He is stylishly dressed as a courtier in a white satin blouse whose split sleeves are lined in red. His left hand rests on the hilt of his sword, while his right hand at his hip is covered by a black cape thrown over his shoulder. His pose, which Van Dyck worked out in a striking preliminary drawing [fig. 1], is assured yet relaxed as he peers down at the viewer with a somewhat haughty expression. Van Dyck placed Lanier in an outdoor setting, juxtaposing him against a roughhewn stone wall beyond which extends a gentle landscape vista.

Every indication exists that Van Dyck considered this an important commission and that he worked to convey successfully the elegance and refinement of his patron. Walpole later related that "Sir Peter Lely told Mrs. Beale, that Laniere assured him he had sat seven entire days to him, morning and evening, and that notwithstanding Vandyck would not once let him look at the picture till he was content with it himself."[3] The careful modeling and sensitive characterization of the sitter, which attest to the attention he gave this work, also account for the confusion that has surrounded the date of this painting.[4] It is frequently placed in the early years of Van Dyck's English period (1632–1634), yet the loose handling of the brushwork in the costume is very close to Van Dyck's technique during his Italian period.[5]

Van Dyck's effort to reach this level of artistic achievement may well have stemmed from a preexisting friendship with Lanier. Lanier, a talented musician, was born in London, the son of a musician from Rouen who had been attached to the court of Henry II in France. Lanier served under Henry, prince of Wales, for whom he designed, composed, and performed in masques at court. He was named Master of the King's Music by Charles I in 1625. He seems to have been close to the earl of Arundel, who was also active in the artistic circles of Henry's court, and Arundel could well have introduced the young Van Dyck to Lanier on the artist's first visit to England.[6] Van Dyck would also have had the opportunity to meet Lanier during the latter's Italian travels, which coincided with Van Dyck's stay in Genoa.[7] That there existed a long-standing friendship might also explain why Van Dyck stayed with Edward Norgate, Lanier's brother-in-law, when he eventually moved to London some four years later.

Whatever the nature of the personal associations, knowing that Lanier intended to present the portrait to Charles I upon his return to England would also have been an

first broached to the countess of Arundel.
8. Walpole 1876, 1:332.
9. Millar 1960a, 7. The identity of this portrait of Liberti is not certain, but in all likelihood it is the painting now in the Alte Pinakothek, Munich, inv. no. 375.
10. Kunsthistorisches Museum 1896, 2:114, no. 1032.
11. Glück 1936, 153, on the basis of a suggestion first made by André de Hevesy, *Rembrandt* (Paris, 1935), 224, n. 27.
12. Bellori 1672, 262.

inducement for Van Dyck to spend an inordinate amount of time perfecting the image. Being fully aware of Charles' predilection toward Venetian art, Van Dyck conveyed in this work the full range of his knowledge of Titian's achievement. Not only are the fluid brushwork in Lanier's costume and the Arcadian character of the landscape reminiscent of this great Venetian master, but the pose is as well. Van Dyck's achievements were appreciated by the king. Lely later related that "This was the portrait that determined the king to invite him to England a second time."[8]

Whether or not Lely exaggerated the importance of this work to Van Dyck's future, the portrait was prominently hung in the Bear Gallery in Whitehall next to Van Dyck's portrait of another prominent musician, the Antwerp organist Henri Liberti.[9] After the king's death in 1649, Lanier bought back his portrait for £10 in the Commonwealth sale. By 1720, when the painting is first recorded in the Hapsburg collection in Vienna, the identity of the sitter had been lost. When Christian von Mechel published the first catalogue of the Kaiser's collection in 1783 (109, no. 21), he identified the sitter as Charles I, perhaps because of the CR branded on the back of the painting from the time it was in the royal collection. Later it was proposed that the sitter represented Count Rhodokanakis;[10] only in 1936, when Glück made the association between the facial characteristics in this work and those in an engraving by Lucas Vorsterman after a lost portrait of Lanier by Jan Lievens, was the sitter correctly identified.[11]

Van Dyck, according to Bellori, painted another portrait of Lanier during his English period, this one "in sembianza di Dauide che suona l'arpa auanti Saule."[12] This painting is now lost.

A. K. W.

Fig. 1. Anthony van Dyck, *Nicholas Lanier*, 1628, chalk with white heightening, 39.2 x 28.5 (15 3/8 x 11 1/4). National Gallery of Scotland, Edinburgh

209

A Woman with Her Daughter
A Man with His Son

A Woman with Her Daughter, 1628–1629
canvas, 204 x 136 (79 ¹/₂ x 53)

Musée du Louvre, Paris, Département
des Peintures, inv. no. 1243

PROVENANCE Eberhard Jabach; acquired
for Louis XIV from the Jabach collection

EXHIBITION Gilberte Martin-Méry, *La
Femme et l'Artiste de Bellini à Picasso* [exh.
cat. Musée des Beaux-Arts] (Bordeaux,
1964), no. 34

LITERATURE Louvre 1793, 97, no. 499;
Louvre 1799, 61, no. 254; Smith
1829–1842, 3:44, no. 153; Louvre 1852, 2:
no. 149; Cust 1900, 78, 261, no. 134;
Schaeffer 1909, 282, ill.; Louvre 1922, 31,
no. 1974; Glück 1931, 338, ill., 556;
Louvre 1979, 1:52, ill.; Larsen 1988, no.
595, ill. 274

A Man with His Son, 1628–1629
canvas, 204 x 137 (79 ¹/₂ x 53 ¹/₂)

Musée du Louvre, Paris, Département
des Peintures, inv. no. 1242

PROVENANCE Eberhard Jabach, acquired
for Louis XIV from the Jabach collection

LITERATURE Louvre 1793, 95, no. 490;
Louvre 1799, 60, no. 253; Smith
1829–1842, 3:45, no. 154; Louvre 1852, 2:
no. 148; Cust 1900, 78, 261, no. 133;
Schaeffer 1909, 283, ill.; Louvre 1922, 33,
no. 1973; Glück 1931, 339, ill., 556;
Louvre 1979, 1:52, ill.; Larsen 1988, no.
594, ill. 275

1. Michiels 1882, 262, n. 1, was the first
to note that the man did not correspond
in age with any of Rubens' brothers.

Van Dyck's genius for conveying both warmth and dignity in his sitters is nowhere more evident than in his portraits of parent and child. His remarkable achievements with this portrait type, which are found in all periods of his career [cats. 9, 21, 37, 43, 76], demonstrate an endless variation in pose and concept as Van Dyck sought to satisfy his patrons' specific demands. Here, while no physical contact links father to son and mother to daughter, the close rapport and affection among family members are suggested through pose, gesture, and the sympathetic expression on the faces of the sitters.

These magnificent images are the only extant full-length pendants with parent and child by Van Dyck, yet remarkably the identities of the sitters are not known. When these paintings, which had been acquired by Louis XIV in 1671, were catalogued by Le Brun in 1683, they were described as representing respectively Rubens and his son and the wife of Rubens and her daughter. It was soon realized that this identification was not tenable. De Bailly in his inventory of 1709 at Versailles suggested that the paintings were by Rubens and depicted Rubens' brother and his brother's wife. While the attribution to Rubens found no lasting support, the idea that they represented the family of Rubens' brother seems to have persisted until 1852 when it was reiterated by Villot in his catalogue of the Louvre collection.[1]

Although the names of the sitters are not known it seems clear from their dignified bearing and elegant clothes that they were wealthy members of Antwerp society. The costumes are difficult to date precisely, but their styles are consistent with those from about 1628–1629. The jeweled cross hanging from a black cord under the woman's lace collar identifies her as a Catholic, but little else in the portraits helps place them more specifically within the social framework of their day.

Without knowing anything about the specifics of the commission, one needs to be cautious about interpreting the nature of the relationship Van Dyck has suggested in the paintings; nevertheless, it is clear that he has carefully conceived the two works in relation to each other. As with the portraits of *Anna Wake* and *Peeter Stevens* [cats. 44, 45], he has reversed the traditional positions of the male and female. Once again a standing husband gestures in such a way as to present his wife, here resplendently seated in an armchair with a golden drapery hanging behind her. As if taking a cue from his father, his young son, dressed in a rich full-length costume and wearing a cross and a gold chain draped over his shoulder, likewise gestures toward his mother and sister. The latter, older than her brother, stands demurely and somewhat behind her mother as she looks out at the viewer with a disarming expression.

The subtle differences between the two images are meant to convey both the honor due to the female and the strength and activity of the male. This same sense is reinforced in the differences in the architectural settings. With the male portraits, the flat vertical planes behind the figures and the horizontal step on which the father and son are standing provide an aura of stability against which are juxtaposed the active gestures of the protagonists. In the pendant the architecture is less evident, partially obscured by the chair, drapery, and figures. Its more softly lit and rounder forms reinforce the controlled, self-contained disposition of the figures.

A. K. W.

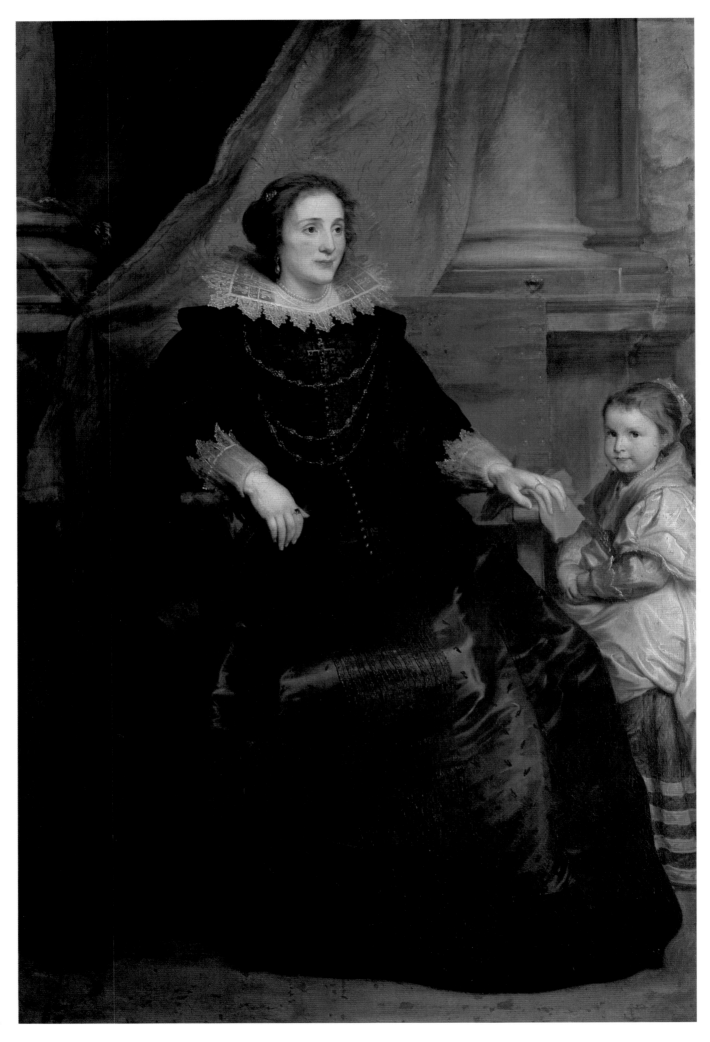

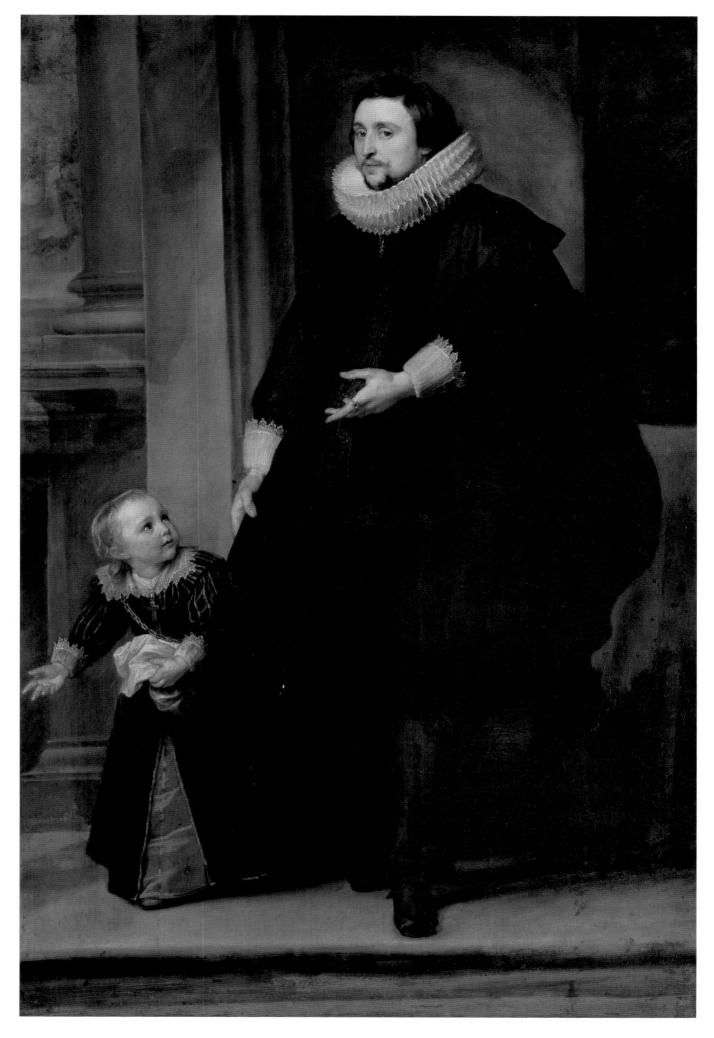

51
Jan de Wael and His Wife

1629
canvas, 125.3 x 139.7 (49 1/4 x 54 3/4),
added strip of 3.5 cm on top, and 4 cm at
the bottom

Bayerische Staatsgemäldesammlungen,
Alte Pinakothek, Munich

PROVENANCE Collection Gisbert van
Ceulen; purchased from him by Elector
Max Emanuel of Bavaria, 17 September
1698; in 1781 taken from Schleissheim to
the Hofgarten Gallery; in 1836 moved to
the Alte Pinakothek, Munich

EXHIBITIONS Amsterdam 1948, no. 47, ill.
68; London 1949, no. 4

LITERATURE Smith 1829–1842, 3:22–23,
no. 72 and 9:369, no. 6; Cust 1900, 16,
235, no. 45; Schaeffer 1909, 163, ill., 502;
Glück 1931, 304, ill., 552; London 1968,
40; Alte Pinakothek 1974, 95; *Kurfürst
Max Emanuel, Bayern und Europa um 1700*,
2 vols. (Munich, 1976), 1:223, 230, ill.;
Alte Pinakothek 1986, 190–191, no. 596,
ill.; Larsen 1988, no. 525, ill.

1. Vey 1962, no. 248, pl. 301.
2. The date can be established from a
partial copy of this painting, which
represents only Jan de Wael, and which
is inscribed AETAT SVAE 71, 1629. The
painting was in the Prague art market in
the 1930s. This information, which was
found in the Rijksbureau voor Kunst-
historische Dokumentatie, is noted in the
files on this painting at the Alte Pinako-
thek. I am grateful to Dr. Konrad Renger
for making these files available to me.
3. Comparable differences of attitude can
be seen when one compares the pendant
portraits of *Anna Wake* and *Peeter Stevens*
[cats. 44, 45] with those of Stevens'
parents.
4. Soprani 1674, 305.
5. Alte Pinakothek 1986, 190.

Within Van Dyck's *Iconography* few images command the viewer's attention as does that of Jan de Wael [fig. 1]. With his austere countenance and piercing gaze he projects strength and assurance quite extraordinary for a man in his seventy-first year. Van Dyck made an etching of this work, one of the few he actually executed himself, basing it on a drawing made from life (Cabinet Edmond de Rothschild, Louvre, Paris).[1] The same drawing must have served for this equally powerful image in this double portrait with his wife. Although no preliminary drawing for Gertrude de Jode is known, he undoubtedly made one of her as well and combined the two studies. Van Dyck must have followed this procedure frequently in his group portraits, but here he has exploited the process to emphasize the distinctive individuality of these two formidable beings. Unlike others of Van Dyck's double portraits of man and wife, these two do not hold hands or otherwise touch; rather their bond and pride in each other is manifest in gesture and expression.

Van Dyck executed this work in 1629 as a sequel to the double portrait he had painted in Genoa of their sons Cornelis and Lucas [cat. 42].[2] The difference in style in these two portraits, the informal, relaxed atmosphere of the sons and the austere, formal character of the parents, demonstrates Van Dyck's sensitivity to the attitudes and aesthetics of different generations.[3] In this painting he has adapted a traditional schema for pendants of husband and wife by depicting the man standing and the woman seated.

Van Dyck must have known De Wael from his childhood since Soprani said that when Van Dyck came to Italy he wanted to visit Genoa to see his friend Cornelis de Wael.[4] De Wael, who had left Antwerp in 1610 when Van Dyck was only eleven years old and had lived in Genoa since 1613, welcomed Van Dyck into his house when he arrived there in November of 1621. Van Dyck stayed with Cornelis and his brother Lucas during his years in Genoa.

Little is known of Jan de Wael's artistic career. After an apprenticeship with Frans Francken I he lived for a period of time in France. In 1584 he was named deacon of the Guild of Saint Luke in Antwerp. He apparently specialized in religious works, although none survive. He was president of the guild of the militia group "van den Ouden Voetboghe," whose lozenge-shaped badge decorated with a crossbow appears on his sleeve.[5] Gertrude de Jode, whom he married in 1588, was the sister of the engraver Pieter de Jode the Elder (1570–1634), whose son Pieter de Jode the Younger (1606–1674) was also an engraver. The artistic circles in Antwerp were small and families of artists often intermarried. Van Dyck painted a double portrait of the two Pieter de Jodes during these years (Glück 1931, 271); both engraved Van Dyck's compositions and each appeared in the *Iconography*.

Even though Van Dyck's schema for this double portrait follows Flemish portrait conventions, his figures, particularly that of Jan de Wael, are conceived with a richness of modeling that demonstrates his complete assimilation of Titian's style of portraiture. Whether consciously or not, he posed this aged artist in a manner that brings to mind Titian's famous *Self-Portrait* of c. 1660 in the Uffizi. De Wael's pose and gesture, which relate to a number of portraits Van Dyck painted during his second Antwerp period, essentially derive from a lost Titian prototype, as can be seen in a drawing Van Dyck made in his Italian sketchbook [fig. 2]. Van Dyck here used the gesture of De Wael's left hand as a device to present his wife to the viewer. It is an effective use of this motif, for it brings a sense of movement to this formal portrait type without distracting from the essential severity of the composition or of the sitters themselves.

A. K. W.

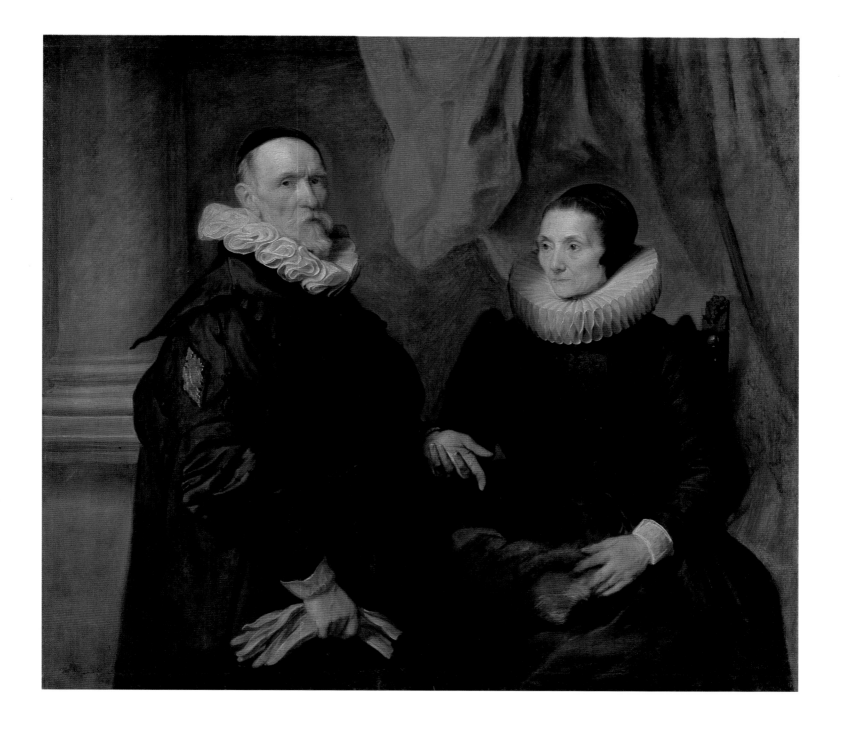

IOANNES DE WAEL

ANTVERPIÆ PICTOR HVMANARVM FIGVRARVM.

Fig. 1. Anthony van Dyck, *The Artist Jan
de Wael*, c. 1626–1641, etching and
engraving, 25 x 17.6 (9 13/16 x 6 15/16).
National Gallery of Art, Washington

Fig. 2. Anthony van Dyck, sketches after
Titian portraits, Italian sketchbook,
fol. 104r, 1622–1625, pen and ink.
Courtesy of the Trustees of the British
Museum, London

52
Maria Louisa de Tassis

1629
canvas, 129 x 92.8 (51 1/8 x 36 3/4)

Collections of the Prince of Liechtenstein, Vaduz Castle, inv. no. 58

PROVENANCE Acquired in 1710 by Prince Johann Adam from the Antwerp dealer Jan Pieter Bredael

EXHIBITIONS Lucerne 1948, no. 122, ill. 29; Vaduz 1967; Bregenz, Künstlerhaus Palais Thurn und Taxis, *Meisterwerke der Malerei aus Privatsammlungen im Boden-seegebiet*, 1965, no. 32, ill. 59; Vaduz 1974; New York 1985–1986, no. 200, pl.

LITERATURE Liechtenstein 1767, 75, no. 374; Liechtenstein 1780, no. 650; Smith 1829–1842, 3:33, no. 113; Waagen 1866, 1:272; *Graphischen Künste* 1889, 39; Cust 1900, 75–77, 76 (opp.), ill., 260, no. 118; Schaeffer 1909, 294, ill.; A. Kronfeld, *Führer durch die Fürstlich Liechtensteinische Gemäldegalerie in Wien* (Vienna, 1927), 21, no. 58; Glück 1931, XLI, 333, ill., 556; Liechtenstein 1943, pl. 7, 98; Baldass 1957, 265, ill. 16, 267–268; Liechtenstein 1980, 159–160, no. 65, pl. 65; Brown 1982, 106, ill. 96; M. Lorandi, "Le Poste, le armi, gli onori, i Tasso e la committenza artistica. Internazionalità del potere, internazionalità dell' arte," in *Le Poste dei Tasso, un' impresa in Europa* [exh. cat.] (Bergamo, 1984), 91, 124, no. 27, ill. 54; Larsen 1988, no. 521, ill. 273

1. Cust 1900, 75.
2. The biographical information is taken here from the excellent entry on this painting by Reinhold Baumstark in New York 1985–1986, 315. His information on the Tassis family was based on that found in the exhibition catalogue *Le Poste dei Tasso: un' impresa in Europa* (Bergamo, 1984). Earlier publications had identified Maria Louisa as the daughter of Maximilian de Tassis, brother of Antonio, who was the imperial postmaster in Antwerp. The Tassis family, who originated from Bergamo, had by the end of the fifteenth century established the first postal system in Europe, which by the seventeenth century had spread throughout the Continent. Maria Louisa was an only child. Her mother, Maria Scholiers, died in 1613, and her father never remarried.
3. On the engraving made after this portrait for Van Dyck's *Iconography* is the inscription: "Picturae, Statuariae, nec non omnis Elegantiae amator et admira-tor" (lover and admirer of paintings, sculptures, and all that is particularly elegant). This translation is taken from New York 1985–1986, 316.
4. Baumstark, in New York 1985–1986, 315–316, has noted that Van Dyck first intended to "adorn the cream colored fabric with a pattern of scattered flowers" that still can be seen through the upper layers of paint.

One of the most memorable experiences of visiting the princely collection at Vaduz is to encounter the captivating gaze of Van Dyck's *Maria Louisa de Tassis*. Rarely have the sensitivity of artist and sitter been more compatible. Her warmth and natural ease radiate as she stands before us in her elegant costume. The fluid and caring touch of the artist's brush, evident in the delicate flesh tones, the opalescence of the pearls, and in the subtle variations in the sheen of the satin sleeves, helps bring the portrait alive. Cust rightly described it as "among the principal triumphs of van Dyck," an assessment that has never been questioned.[1]

Maria Louisa de Tassis, who was born on 2 July 1611, was nineteen when Van Dyck painted this portrait, presumably as a pendant to the artist's portrait of her widowed father Antonio de Tassis (Sammlungen des Regierenden Fürsten, Liechtenstein).[2] Her father, after an earlier career in the military, was ordained in 1629, and he served as a canon at the Antwerp cathedral. It may have been this appointment that prompted him to commission his portrait from Van Dyck. While depicted in the robes of a canon, the book he holds in his right hand indicates that he is a man of learning. He was a noted connoisseur, and at his death in 1651 he left behind a remarkable art collection.[3]

Despite his ecclesiastical profession, Antonio de Tassis seems not to have been averse to providing Maria Louisa with the most fashionable of wardrobes. Her wide, flat lace collar, which so effectively sets off her charming face, the gold accents on her satin dress, and the pink ribbons tied around her waist and arm, give her a splendor unmatched by sitters in other of Van Dyck's portraits from this time.[4] Even her cross pendants are examples of elaborate craftsmanship, in which gold and precious jewels have been wrought to form exquisite pieces of jewelry.

Van Dyck based his pose for Maria Louisa on his portrait of Anna Wake [cat. 44], which he painted as a pendant to her husband Peeter Stevens [cat. 45] in 1628. Although the poses are reversed, all of the components are the same, with the exception of the direction in which Maria Louisa holds her ostrich feather fan. Because the similarities between these two works are so striking, they reveal the subtle evolution in Van Dyck's style during his Antwerp years. In *Anna Wake* he did not integrate elements of the figure's anatomy in the fluid way that he did in *Maria Louisa de Tassis*. The relationship of head to neck to shoulders is more natural in the latter portrait and the manner in which Maria Louisa brings her right hand holding the fan before her makes Anna Wake's comparable gesture seem relatively contrived. Also better integrated is the character of the brushwork. In the painting from 1628 Van Dyck modeled the face with delicate touches of the brush whereas he defined the costume, particularly the slashed sleeves, with bold strokes; in *Maria Louisa de Tassis* the character of the brushwork is freer in the features and more subtle in the drapery.

Despite her youthful beauty and vibrancy, Maria Louisa's life was not to be a long one. She died in 1638, shortly before her twenty-seventh birthday. Only two years previously she had married Henri de Berchem.

A. K. W.

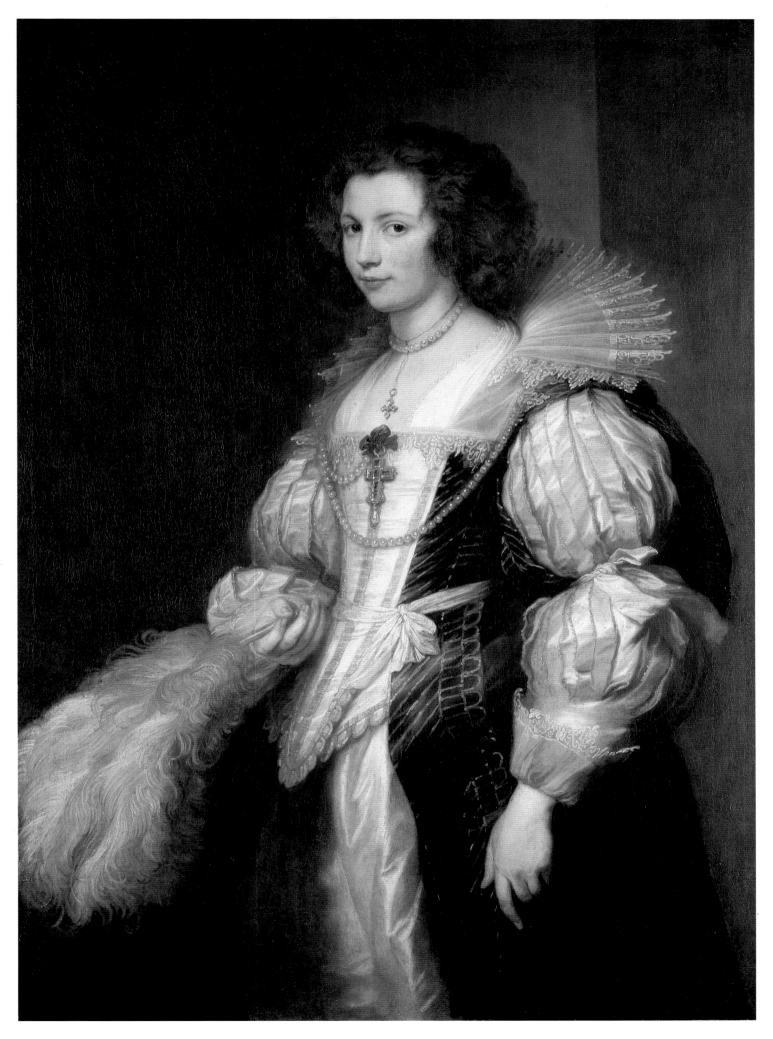

1629
canvas, 185 x 157 (72 1/8 x 61 1/4)

Pinacoteca di Brera, Milan, inv. no. 701

PROVENANCE Acquired in 1813 through an exchange with the Louvre

EXHIBITION Genoa 1955, no. 75, ill.

LITERATURE Smith 1829–1842, 3:16, no. 44; Cust 1900, 46, 58 (opp.), ill., 62, 239, no. 35; Schaeffer 1909, 104, ill., 499; Glück 1931, 222, ill., 542; Brera 1950, 126–127, no. 701; Larsen 1975a, 39; Brera 1977, 55, ill.; Larsen 1988, no. 656, ill. 229

1. Descamps 1753–1754, 2:25.
2. Larsen 1975a, 39. "[Descamps] nous donne encore comme [pour] original de Vandyck le tableau de l'église de l'hôpital de Vilvorde tandis que ce/tableau n'est que la copie du St Antoine de Padoua que l'infante Isabelle a possedé et qui se voit aujourd'hui à Versailles."
3. This painting, however, may also be the work described as the Virgin and Child with Saint Francis that was sold in 1809 in Paris from the collection of Pierre Grand-Pré (sale: Langlier and Pailler, 16 February 1809, no. 65). Although the size seems slightly smaller (70 x 58 p.; approximately 176 x 147 cm) than the Brera version, the description of the painting is identical. The following would seem to indicate that Grand-Pré had acquired the painting outside France: "Le défunt en a fait l'acquisition dans l'étranger après une longue correspondance, désirant depuis longtemps un Morceau de renommée pour former la tête de la galerie qu'il projetait."
4. See in particular: P. Beda Kleinschmidt, Antonius von Padua in Leben und Kunst, Kult und Volkstum (Düsseldorf, 1931).
5. Shortly after his death in 1231 Anthony of Padua was canonized by Pope Gregory IX, who declared him to be a Teacher of the Church.

In a composition that is monumental in its grandeur and yet deeply moving in its intimacy, Saint Anthony of Padua, dressed in his Franciscan robe, kneels reverently before the Virgin and Child. As the Virgin gently lifts her son toward the saint, the young Jesus reaches out to touch Anthony's upturned face. The exchange of gesture and glance, which is so quietly moving, captures the essence of Van Dyck's religious sensitivity during his years in Antwerp after his return from Italy.

Nothing is known about the commission for this devotional piece. It may be the work described in Descamps in 1754 as: "A l'Hôpital de Vilvorde, un beau Tableau représentant S. Antoine de Padoue, la Vierge & l'Enfant Jesus."[1] The anonymous eighteenth-century biographer of Van Dyck, however, who was extremely critical of Descamps, emphatically stated that this painting was only a copy and that the original, which had been with the Infanta Isabella, was at that time in Versailles.[2] This information may well be correct, for in 1813 The Vision of Saint Anthony was in the Louvre, at which time it was sent to the Brera in Milan in exchange for a number of Italian paintings.[3]

An altarpiece devoted to Saint Anthony of Padua, one of the most important of the early Franciscans, would have appealed to the Infanta Isabella, who, after the death of her husband, Archduke Albert of Austria, had decided to don the black habit of the Order of Saint Francis as evidence of her devotion to the Virgin. Saint Anthony had attracted a cult during the sixteenth century that continued to flourish during the seventeenth, of which the most visible manifestation in Antwerp was the construction of the church of Saint Anthony in June 1614. Anthony, who was born in Lisbon at the end of the twelfth century, was well known as a persuasive teacher and the first professor of theology within the Franciscan order. Through his ministry he was reputed to have performed many miracles that helped convert the heathen to Christianity. These miracles were widely recorded in sculpture and painting.[4] One of the most frequently represented miracles was that recorded by a monk who had witnessed the Christ Child perched on a book Saint Anthony had been reading. The book lying on the ground in Van Dyck's painting is a reference to this miracle.[5]

This legend, which seems to have developed at the end of the sixteenth century, was understood by Counter-Reformation theologians to parallel the Virgin's presentation of the child to Simeon.[6] It was popular in part because it stressed the importance of the saint as an intermediary between the earthly and the spiritual.

The fusion of Franciscan iconography with that of Saint Anthony would be consistent with Capuchin ideals since the lives of the two saints were so closely intertwined. Rubens had received at least three commissions for altarpieces during

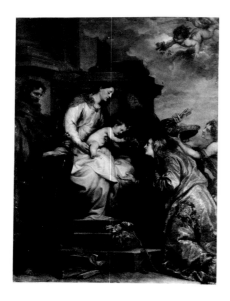

Fig. 1. Anthony van Dyck, Virgin and Child with Saints Rosalie, Peter, and Paul, 1629, canvas, 275 x 210 (108 1/4 x 82 5/8). Kunsthistorisches Museum, Vienna

Fig. 2. Anthony van Dyck, sketch after Titian, Madonna and Child with Donor, Italian sketchbook, fol. 28v, 1622–1625, pen and ink. Courtesy of the Trustees of the British Museum, London

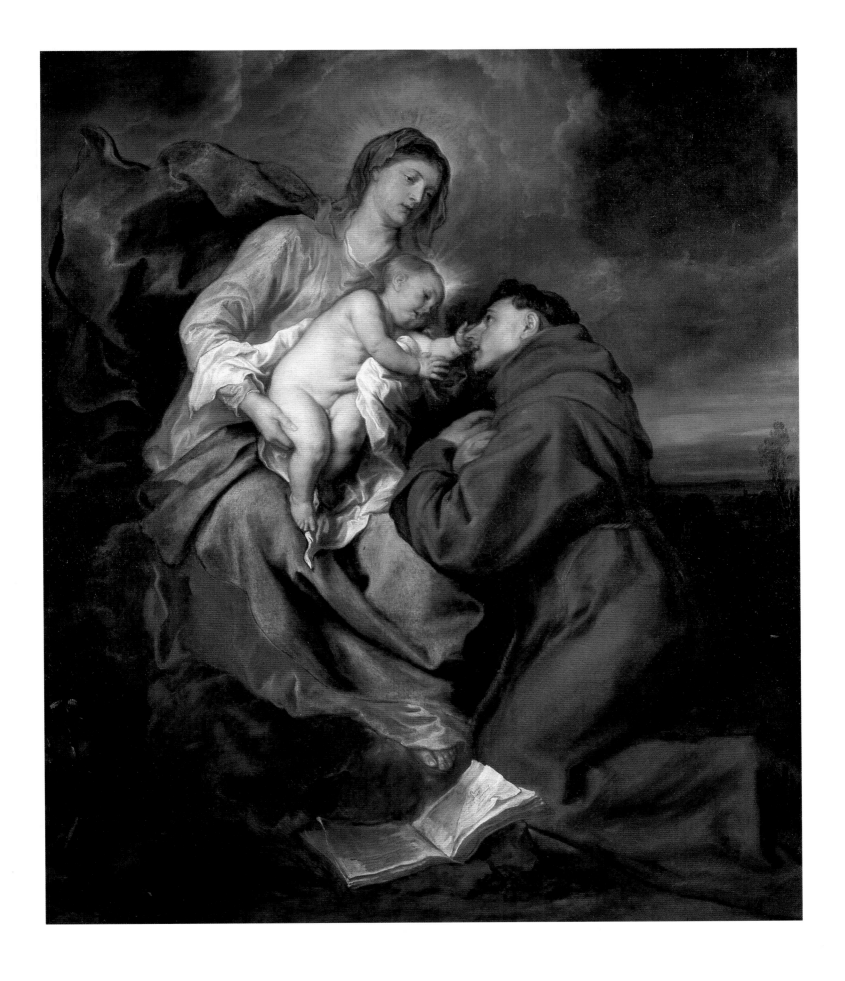

6. Glen 1977, 171.
7. Hans Vlieghe, *Corpus Rubenianum Ludwig Burchard*, Part 8, Saints 1 (London, 1972), 1:145–150, cats. 94, 95, 96.
8. See Adriani 1940, fol. 12r. Van Dyck also used the motif of the Christ Child reaching out to touch the cheek of a donor in his large painting of *The Virgin and Child with Two Donors* in the Louvre (Glück 1931, 245).

the second decade of the seventeenth century in which Saint Francis received the Christ Child.7 Van Dyck, who would have known these works, used Rubens' compositional ideas for this separate but related subject.

Stylistically this work parallels Van Dyck's 1629 altarpiece *Virgin and Child with Saints Rosalie, Peter, and Paul* [fig. 1], and thus a date of the same year should be postulated. Not only are the attitudes of the saints comparable, but also the extremely statuesque Virgin. In both altarpieces an active Christ Child reaches out in joyous acknowledgment of the saint's presence. This motif is one he recorded in a number of variations in drawings after Titian's paintings in his Italian sketchbook [fig. 2].8

A. K. W.

54
Rinaldo and Armida

1629
canvas, 236.5 x 224 (93 x 90)

The Baltimore Museum of Art,
The Jacob Epstein Collection, 1951.103

PROVENANCE Commissioned by
Endymion Porter for King Charles I and
completed by December 1629; bought by
Col. William Webb on 27 October 1649 at
the Commonwealth sale for £80; bought
by the duke of Newcastle; from 1754
until 1756 owned by Thomas Holkes
Pelham, duke of Newcastle; through
descent in collection of dukes of
Newcastle, Clumber Park, Nottingham-
shire; bought from Willian Cavendish,
duke of Newcastle, by dealer Arthur
Sulley, London, 1913; purchased from M.
Knoedler & Co., New York, by Jacob
Epstein, Baltimore, 1927

EXHIBITIONS Manchester 1857, no. 126;
London, Royal Academy, 1879, no. 126;
London 1887, no. 19; London 1900,
no. 67

LITERATURE Hookham Carpenter 1844,
24–25; Waagen 1857, 511; Phillips 1896,
121; Cust 1900, 70, 84 (opp.), ill., 85, 89,
112, 200, no. 19, 220, no. 67, 251, no. 94;
Schaeffer 1909, 117, ill.; Singleton 1929,
181–182, 183, ill.; Glück 1931, XXIII, XL,
265, ill., 548; Baltimore Museum of Art
1939, entry and ill.; Rosenthal 1946, 3–7,
ill.; Pigler 1956, 2:450; Whinney and
Millar 1957, 68; Quandt 1959, 4–8, ill.;
Lee 1963, 12–26, ill. 13; Mathews and
Van Schaack 1968, 8, ill., 9–15, 75–76;
London 1970, 10, 11, ill. 2; Gaunt 1980,
92, ill.; Brown 1982, 137, pl. 136; London
1982–1983, 17–18, 19, ill. 15; Larsen 1988,
no. 740, ill. 254; "Diamond of the
Month," *The Baltimore Museum of Art*
(January 1989), cover, pl., ill.

1. See Lee 1963, 12–26, for an excellent
essay on Van Dyck's various representa-
tions of Rinaldo and Armida. See also the
same author's *Ut Pictura Poesis: The
Humanistic Theory of Painting* (New York,
1967), 48–56, for a discussion of the
interpretations of this theme by Poussin
and others (reprinted from an article that
appeared in *Art Bulletin* 22 [1940],
242–250). For this entry I have also bene-
fitted from an excellent seminar paper on
this painting written by Shirley K.
Bennett at the University of Maryland
in 1982.
2. Torquato Tasso, *Godfrey of Bulloigne* or
The Recoverie of Ierusalem, trans. Edward
Fairefax (London, 1600), book 14, verse
62, reprinted as *Jerusalem Delivered*
(Carbondale, Ill.), 1962, 366. Mathews
and Van Schaack 1968, 9–15, have demon-
strated that the notes on the paper held
by the water nymph form a coherent
musical notation. They speculate that the
music may be based on Claudio
Monteverdi's lost opera, *Armida*, which
was first performed in Mantua in 1628.
Van Dyck may have learned of the opera
through Nicholas Lanier [see cat. 48],
who was living in Mantua in 1628 before

The power of love, a theme that constantly recurs in Van Dyck's mythological scenes, is nowhere more beautifully realized than in this painting. Based upon an episode in Torquato Tasso's *Gerusalemme Liberata*, Van Dyck's richly sensuous image conveys all of the lyricism of this poet's account of Armida's love for Rinaldo at the moment she gazes upon the face of this sleeping Christian knight. Although the theme of Tasso's epic poem, first published in 1581, was the siege and eventual capture of Jerusalem by the crusaders, an event that symbolized the victory of the church militant over its enemies, the love story of Rinaldo and Armida interwoven into that epic was the primary source of fascination for Van Dyck and his contemporaries.[1]

The scene that Van Dyck represented is situated on an island in the Orontes River, where Rinaldo has been serenaded by the sweet strains of a water nymph. Her song pleads with him not to toil for "glory vain or virtue's idle ray" for "Who followeth pleasure he is only sage."[2] Loosened from his Christian vigil by the nymph's seductive words, golden tresses, and sensuous appearance, Rinaldo sleeps defenseless against the power of the sorceress Armida who, in alliance with the forces of the underworld, had laid this ambush to kill the knight and prevent him from reaching Jerusalem. Gazing upon Rinaldo's sleeping face, however, her hatred turns to passion and her foe becomes her lover. The tenderness of her expression as she gently envelops Rinaldo is evidence enough of her feelings, but her inner passion is also suggested by the turbulence of her robes. As she leans over Rinaldo she encircles him with a garland of flowers.

The garland that Armida wraps around Rinaldo is described by Tasso as: "wood-bines, lilies, and … roses sweet,/Which proudly flower'd through that wanton plain,/All platted fast, well knit, and joined meet,/She fram'd a soft but surely holding chain,/Wherewith she bound his neck, his hands, and feet."[3] Thus bound she abducted him in her dragon-drawn coach and took him to the Fortunate Isle. There, in a land that is "fresh, pleasant, sweet, and green," and basks "in perpetual, sweet, and flow'ring spring,/She lives at ease, and 'joys her lord at will."[4] Eventually Rinaldo is rescued by his friends and released from the spell of the sorceress with the aid of a magic shield. He returns to battle and his Christian duty. Rinaldo and Armida meet again, and after further adventures, Armida finally joins the Christians in their battle against the heathen.

This complicated story of love and hatred, of Christian duty and bewitching sorcery, of exotic islands removed from the cares and troubles of war and pestilence, has resonances in pastoral literature that reach back to antiquity, to the spell cast upon Ulysses on an enchanted island or to Diana falling in love with the sleeping Endymion.[5] The impact of this epic poem in the early seventeenth century, however, was so great because its Christian gloss made it particularly relevant to a period not only beset by religious wars but also fascinated with Christian Neoplatonism, where beauty became associated with purity and love.

Tasso's epic poem had an especially great impact on the English court after the publication in 1600 of Edward Fairfax's English translation, which was dedicated to Elizabeth I. Charles I was so fond of Tasso's epic that he took a copy of Fairfax's translation with him during his imprisonment.[6] Within the epic the story of Rinaldo and Armida was particularly admired. Its imagery and its setting struck responsive chords in the Jacobean and Carolinian courts, just as it did on the wider society of the period. Many of these same themes are found in the court masques, particularly those created by Ben Jonson.[7] In these spectacles, in which the whole court participated, kings and queens were beset by witches and demons who threatened to undermine their peaceful rule. The overriding theme, however, was that England was a "blest isle."[8] In Britannia the sun shone and the climate was temperate; within its boundaries strife, so rampant in the rest of the world, was unknown because of its just and virtuous rulers.

The associations with the Arcadian world to which Rinaldo was brought by

he traveled to England via Antwerp.

3. Tasso 1600, book 14, verse 68.

4. Tasso 1600, book 14, verses 70 and 71.

5. The connections between these themes in Van Dyck's mind become particularly clear when one compares the composition and mood in his drawing of *Diana and Endymion* from about this date in the Pierpont Morgan Library. See Felice Stampfle, *Rubens and Rembrandt in Their Century* (New York, 1979), cat. 30.

6. Lee 1963, 12.

7. For an excellent assessment of the meanings of the masques in the Stuart court, see Parry 1981.

8. Parry 1981, 46.

9. Parry 1981, 56, 57.

10. These documents are among the papers of Endymion Porter, Domestic State Papers at the Record Office, London. They are quoted in full in Hookham Carpenter 1844, 24–26.

11. Hookham Carpenter 1844, 24.

12. Phillips 1896, 36.

13. Hookham Carpenter 1844, 24. After the sale the painting was depicted in a gallery picture executed by P. Neefs and G. Coques, a photograph of which is in the files at the Baltimore Museum of Art.

14. See Adriani 1940, 46, fol. 37; 75, fol. 113v. A particularly close comparison that is interesting as well for its thematic connections is Paolo Veronese's *Venus and Adonis* in the Prado, Madrid. This comparison was suggested to me by Shirley K. Bennett.

15. A reduced version of this painting (187.5 x 147 cm) is in Sanssouci, Potsdam (Götz Eckardt, *Die Gemälde in der Bildergalerie von Sanssouci* [Potsdam-Sanssouci, 1975], no. 53). A grisaille oil sketch in Brussels (Koninklijke Musea 1984, 95, no. 3781) is the preparatory study for an engraving by Pieter de Balliu (reversed).

Armida, the Fortunate Isle, are nowhere more clear than in the title of the last masque Jonson wrote for King James: *The Fortunate Isles and Their Union.* Charles was a participant in the masque when it was performed in 1625. His role was that of an ancient hero, and the celebration of his betrothal to the French princess, "joining the bright lily and the rose," was the climactic moment of the performance.[9] It would not have escaped Charles' awareness that precisely the same flowers were used by Armida to bind the sleeping Rinaldo.

Van Dyck's masterpiece was ordered for King Charles I, although no document outlining the commission is known. The first reference to the painting is a letter dated 5 December 1629 from Van Dyck to Endymion Porter indicating that the painting had been finished and had been given to M. Pery to be delivered.[10] On 25 March 1630 Charles I ordered Endymion Porter [see cat. 73], "one of the grooms of his Majesties Bedchamber," to be paid seventy-eight pounds sterling for one picture of the story of Rinaldo and Armida bought by him of "Monsieur Vandick of Antwerpe."[11] The painting was greatly admired while in the royal collection, and traditionally has been viewed as one of the works that persuaded Charles to invite Van Dyck to England to work at his court.[12] The painting remained in the royal collection until it was sold for eighty pounds in the Commonwealth sale on 27 October 1649.[13]

Van Dyck's interpretation of the scene from *Gerusalemme Liberata* may well have benefited from discussions with Endymion Porter, who almost certainly had witnessed Jonson's masque *The Fortunate Isles* first-hand. What Van Dyck did not need from Endymion Porter, however, was a reminder that he should paint this work for Charles I in a Venetian mode. The rich colors, broad brushwork, and *di sotto in su* perspective capture the lush, sensuous character of the allegories of love by both Titian and Veronese that Van Dyck would have seen in Italy.[14] The singing water nymph is a distant relative of the nude figure in Titian's *Sacred and Profane Love,* which Van Dyck copied in his Italian sketchbook [see cat. 56, fig. 2], and several cupids are similar to those in Titian's *Worship of Venus*: the small cupid peering out from behind Armida, for example, is seen in reverse in Titian's great masterpiece [fig. 1].

These references to his Venetian predecessors, however, in no way account for the magnificence of this composition and the surety with which Van Dyck translated this poetic idyll into paint. It was a subject that sparked Van Dyck's imagination and allowed his strengths as an interpreter of literary subjects to come to the fore. In the gentle intertwining of these two mythic characters is found the sense of grace, beauty, and ideal love with which he, as no other artist, could infuse his scenes.[15]

A. K. W.

Fig. 1. Titian, *The Worship of Venus,* 1518–1519, canvas, 172 x 175 (67³/4 x 68⁷/8). Museo del Prado, Madrid

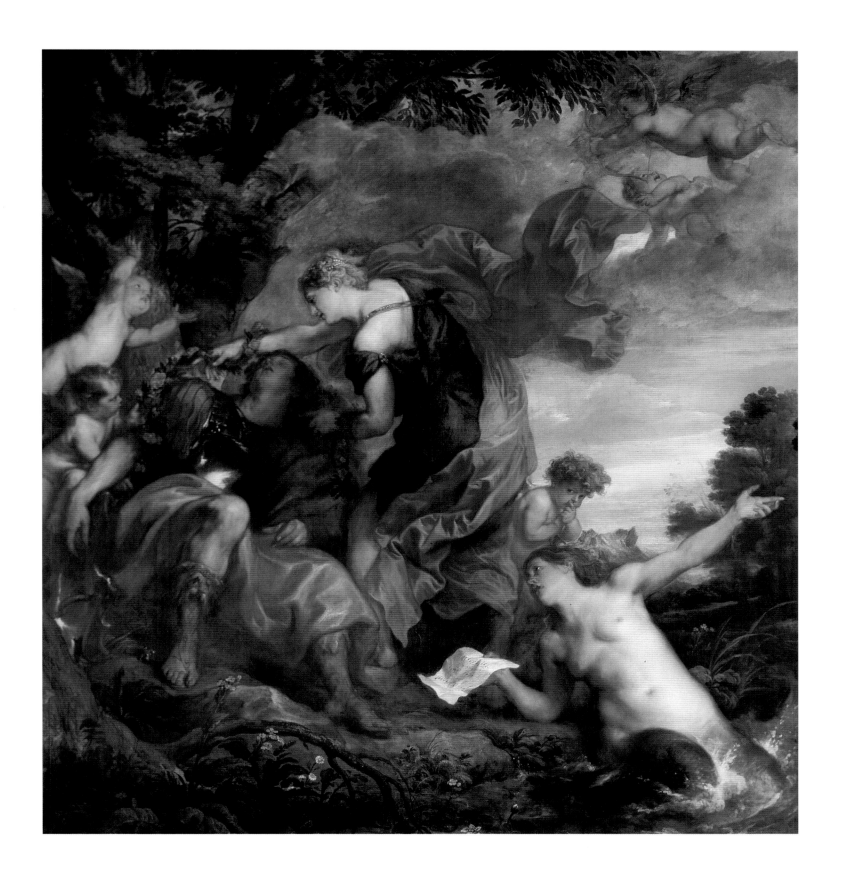

55
The Mystic Marriage of Saint Catherine

1630
signed *A VAN DYCK.*
canvas, 126.4 x 119.4 (49¼ x 46½)

H. M. Queen Elizabeth II

PROVENANCE Acquired in 1802 from the De Bustancy family, Brussels, by the Chevalier de Burtin (d. 1818), who imported it into England, apparently with the intention of offering it to George IV; not in the De Burtin sale, Christie's, 22 July 1820; bought for George IV by Sir Charles Long (afterward Lord Farnborough), and apparently received at Carlton House in September 1821; hung in the Blue Velvet Room at Carlton House and later in the Picture Gallery at Buckingham Palace

EXHIBITIONS London, British Institution, 1826, no. 53; London, British Institution, 1827, no. 80; London 1900, 46; London 1946–1947, no. 290; London 1953–1954, no. 451; London 1968, no. 13; London 1988–1989, no. 20, ill.

LITERATURE Burtin 1808, 2:187–189; Smith 1829–1842, 3:69-70, no. 234 and 9:398, no. 107; Royal Collection 1841, no. 169; Waagen 1854, 2:3, no. 3; Cust 1900, 46, 239, no. 36; Schaeffer 1909, 77, ill. 498; Glück 1931, 231, ill., 543; Royal Collection 1963, no. 162, ill. 86; Larsen 1988, no. 663, ill. 473

1. Saint Catherine of Alexandria was a third-century saint of noble birth and great beauty. After she succeeded in converting to Christianity many of the great philosophers in the realm of Maximim II, including his wife, the emperor ordered Saint Catherine to be martyred by being bound between four spiked wheels and torn to death. A lightening bolt from heaven destroyed the wheels before the sentence could be carried out. She was then beheaded with a sword.
2. This account of the legend is taken from George Ferguson, *Signs & Symbols in Christian Art* (New York, 1959), 66.
3. Royal Collection 1963, 103, cat. 162. The documents are published by Hookham Carpenter 1844, 57–64.
4. One would also imagine that Gerbier would have described the scene as the "Mystic Marriage of Saint Catherine." Van Dyck did paint a *Virgin and Child with Saint Catherine* that is now at The Metropolitan Museum of Art (Metropolitan Museum 1984, 1:79–84). This painting is not likely to be the work sent by Gerbier either, unless it was returned to Antwerp, for it was in the church of the Recolets in Antwerp in the eighteenth century.
5. Notice of this image was first made by Millar in Royal Collection 1963, 101, cat. 162.

The Christ Child takes Saint Catherine's hand to place on her finger a ring signifying their celestial marriage. As the child and the saint gaze tenderly into each other's eyes, the Virgin looks down with a quiet yet approving countenance while she holds a crown of flowers for her son's bride.

Van Dyck's intimate portrayal of this scene is similar in many respects to his *Vision of Saint Anthony* [cat. 53], painted about 1629, although a comparison between the works also reveals striking differences. In that altarpiece Van Dyck stressed the mystical character of the encounter by the flowing drapery of the Virgin, the radiant light emanating from Christ's head, and the nimbuslike effect of the clouds. In this devotional painting, on the other hand, the mood is more somber and restrained in acknowledgment that Saint Catherine's acceptance of this ring and commitment to fulfilling her vows would lead to martyrdom and death. Indeed, as she prepares to accept the ring, her left hand rests on the spiked wheel, the instrument by which she would be tortured, and she grasps the palm branch signifying her victory over death.[1]

The Mystic Marriage of Saint Catherine was widely represented because it reinforced in Catholic dogma the importance of baptism, one of the seven sacraments. The legend surrounding the Mystic Marriage is that before Catherine was baptized she had a dream in which she saw the Virgin Mary holding the Christ Child in her arms. When the Virgin asked the child to allow Catherine to serve him, he averted his head and said that she was not beautiful enough, even though she was renowned for her beauty. Then, tormented about what she should do to make herself more appealing to the Christ Child, she allowed herself to be baptized. When she once again had the dream, the Christ Child offered her the ring, which she found on her finger when she woke.[2]

Around 1620, Van Dyck had depicted this same subject in a much more statuesque manner (Prado, Madrid). The differences in concept between the two versions, executed some nine or ten years apart, demonstrate the degree to which Van Dyck has managed to define his own artistic personality apart from the powerful influences of Rubens and Titian. In the Prado version the Mystic Marriage is a public ceremony, witnessed by three introspective attendants, in which little emotion is shown. In this painting, on the other hand, the experience is a private one. Van Dyck may have derived this concept from a now-lost work by Titian, which he copied in his Italian sketchbook [fig. 1]; yet the graceful disposition of the figures and emotional energy in their expressions are aspects of Van Dyck's style that cannot be traced to an external source.

Fig. 1. Anthony van Dyck, sketch after a lost Titian, *Mystic Marriage of Saint Catherine*, Italian sketchbook, fol. 12r, 1622–1625, pen and ink. Courtesy of the Trustees of the British Museum, London

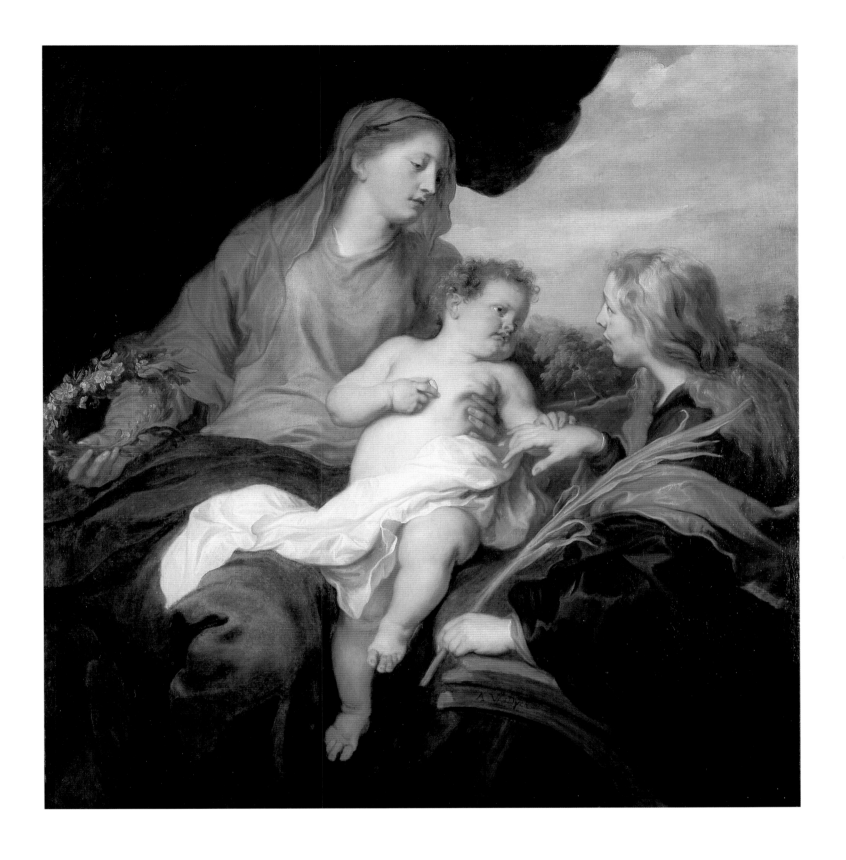

Although the circumstances under which this work was commissioned are not definitely known, *The Mystic Marriage of Saint Catherine* has been associated with one of the most bizarre set of documents in the Van Dyck literature.[3] In December 1631, Balthazar Gerbier, Resident of Charles I at the court of the Infanta Isabella in Brussels, wrote to the Lord Treasurer Weston to inform him that he had just purchased "a very beautiful Virgin and St. Catherine, by the hand of Van Dyck." He sent the painting to England as a New Year's gift for either the king or the queen. Gerbier continued that the painting was "one of the best pictures Van Dyck has executed. ..." The painting was sold to Gerbier by Salomon Nobliers, a painter who lived in Brussels. Nobliers had told Gerbier that the Infanta Isabella had briefly hung this work in her court in the chapel reserved for Maria de' Medici after her arrival in the summer of 1631.

Van Dyck, however, wrote to his friend George Geldorp in London that the painting was a copy, a letter that was then shown to Weston purportedly in an effort to discredit Gerbier. Gerbier then wrote an anguished letter to Weston defending the authenticity of the painting, partly by citing Rubens' opinion that it was by the hand of Van Dyck. He then attributed the whole problem to "the malice of Van Dyck" and indicated that although Gerbier had spoken to the Infanta Isabella and Maria de' Medici about Van Dyck's proposed trip to England "a sudden caprice has come into his head that he will not enter on the voyage."

Whatever the circumstance that led to this unseemly squabble, there is no assurance that this painting is the one sent to England by Gerbier. Aside from the fact that there can be no dispute over the attribution of this work, one of Van Dyck's most beautiful religious paintings from this period of his career, no painting by Van Dyck of the Mystic Marriage of Saint Catherine is recorded in the royal collection in the seventeenth century.[4] While the earliest secure reference to this work is 1802, it may be the version included in Willem van Haecht's *Interior of a Picture Gallery* in the marquess of Bute's collection.[5]

For a discussion of the oil sketch Van Dyck used as a preliminary study for the head of the Virgin, see cat. 95.

A. K. W.

56
Venus at the Forge of Vulcan

1630–1632
canvas, 220 x 145 (86 1/2 x 57), with an addition at the top

Musée du Louvre, Paris, inv. no. 1234

PROVENANCE Entered the collection of Louis XIV between 1684 and 1715; in 1709/1710 in the Petite Galerie of the Palais du Luxembourg, Paris

EXHIBITION Antwerp 1949, no. 22, ill. 13

LITERATURE Louvre 1793, 31, no. 143; Louvre 1799, 61, no. 259; Smith 1829–1842, 3:39–40, no. 140; Louvre 1852, 2: no. 140; Cust 1900, 70, 252, no. 106; Schaeffer 1909, 120, ill.; Louvre 1922, 12, no. 1965; Glück 1931, XL, 267, ill., 548; Damm 1966, no. 52, ill. 17; Louvre 1979, 1:1, 51, ill.; Louvre 1987, 408, pl.; Larsen 1988, no. 748, ill. 259

1. Virgil, *Aeneid*, trans. H. Rushton Fairclough (Cambridge, Mass., 1940), book 8, lines 370–453.
2. Julius S. Held, *The Oil Sketches of Peter Paul Rubens*, 2 vols. (Princeton, 1980), 1:172. For a full discussion of the series see also E. Haverkamp-Begemann, *The Achilles Series*, Corpus Rubenianum Ludwig Burchard, 10 (Brussels, 1975).
3. Held 1980, 1:179–181, cat. 125, discusses the oil sketch for this design. A somewhat larger version is in the Musée de la Ville, Pau (illustrated by Held, fig. 70).

The seductive power of women over men, a theme Van Dyck frequently returned to in his mythological paintings, is nowhere more forcefully expressed than in this representation of *Venus at the Forge of Vulcan*. The scene, drawn from book 8 of Virgil's *Aeneid*, depicts the interchange between Venus and Vulcan as she pleads with her husband, the god of fire, to craft arms to protect her warrior son Aeneas in his forthcoming battle against Taunus, king of the Rutulians.[1] Venus knew that Vulcan was wary of interfering in human affairs, and used her feminine guile to persuade him to aid her cause. When she addressed him she breathed "into her words divine love," and reminded him of the times he had relented to others' tears. Then, as Vulcan faltered, she threw "her snowy arms around and about him and fondle[d] him in soft embrace." "At once he caught the wonted flame; the familiar warmth passed into his marrow and ran through his melting frame. ... His consort knew it, rejoicing in her wiles, and conscious of her beauty." Deep within the cave on the island of Hiera, Vulcan then commanded his Cyclopean workers to put aside the chariot with flying wheels they were constructing for Mars and forge instead arms "for a brave warrior." Then they "with mighty force, now one, now another, raise[d] their arms in measured cadence, and turn[ed] the metal with gripping tongs."

Van Dyck captured the full scope of this drama, the seduction and passion of Venus and Vulcan and the searing heat and brute force that yields fine armor from red-hot metal. Some of Aeneas' armor, including his shield, lies on the ground, as the muscular Vulcan grasps the breastplate. While Cupid flies overhead after having shot his arrow, one cherub urges Venus on and another hefts Aeneas' sword over his shoulder.

Unfortunately nothing is known about the commission for this powerfully evocative painting. To judge from the low vantage point from which the figures are seen it must have hung high, perhaps over a hearth, for Vulcan had allegorical associations with fire. The choice and character of the subject must have had broader associations that are now lost. One possibility is political. Aeneas, the legendary founder of Rome, was greatly admired as an intrepid warrior whose worthy cause was abetted by the interference of Venus on his behalf. It is more probable, however, that this episode from the lives of the gods was chosen for its sensual overtones and for the contrasts it provided between Venus' beauty and Vulcan's muscular but deformed body.

The massiveness of Van Dyck's figures, which is quite exceptional in his paintings from his second Antwerp period, is reminiscent of Rubens' style around 1630–1632, after his return to Antwerp from his diplomatic mission in England. At this time

Fig. 1. Peter Paul Rubens, *Thetis Receiving the Arms of Achilles from Hephaestus*, 1630–1631, panel, 44 x 51.5 (17 3/8 x 20 1/4). Museum Boymans-van Beuningen, Rotterdam

Fig. 2. Anthony van Dyck, sketch after Titian, *Sacred and Profane Love*, Italian sketchbook, fol. 113r, 1622–1625, pen and ink. Courtesy of the Trustees of the British Museum, London

Rubens was engaged in designing a major tapestry series on the Life of Achilles, perhaps in anticipation that it would appeal to Charles I.[2] One episode of this series depicted *Thetis Receiving the Arms of Achilles from Hephaestus* [fig. 1],[3] a theme that parallels closely *Venus at the Forge of Vulcan*. Compositionally, Rubens' design finds many echoes in Van Dyck's painting: not only the pose of Hephaestus, which is similar to that of Vulcan, but also the presence of the Cyclops in the background. Even the cupids have taken on a more Rubensian character than the waifs that populate Van Dyck's religious and mythological paintings from the late 1620s [see cats. 47, 54].

The world Van Dyck evokes in his painting, however, is far different than that in Rubens' episode in the life of Achilles, partly because of the change in subject, but also because of the different temperaments of the artists. Van Dyck was more interested in the sensual and psychological interaction of the two figures than in the narrative. Van Dyck's Venus, moreover, has the sensuality of Titian's rather than Rubens' nudes. Her proportions and attitude are not far removed from the image of profane love in Titian's *Sacred and Profane Love* (Borghese Gallery, Rome), which Van Dyck recorded in his Italian sketchbook [fig. 2], or from Andromeda in Titian's *Perseus and Andromeda* (Wallace Collection, London), which he owned.

The way Van Dyck has juxtaposed the seated Vulcan with the standing Venus also suggests that he was responding to a third source, which combined elements of both masters, Rubens' copy of Titian's *Fall of Man* (Prado, Madrid). Rubens, who made this copy in 1629 when he was in Madrid, brought it back with him when he returned to Antwerp, and thus it must have been known to Van Dyck. Thematic as well as compositional parallels relate these works, for both stories concern a temptress who persuades an unwilling partner to submit to her desires.

At an early point in its history this painting was extended at the top by 26 cm (10 in.). As far as is known this addition occurred before the painting was acquired by Louis XIV.

A. K. W.

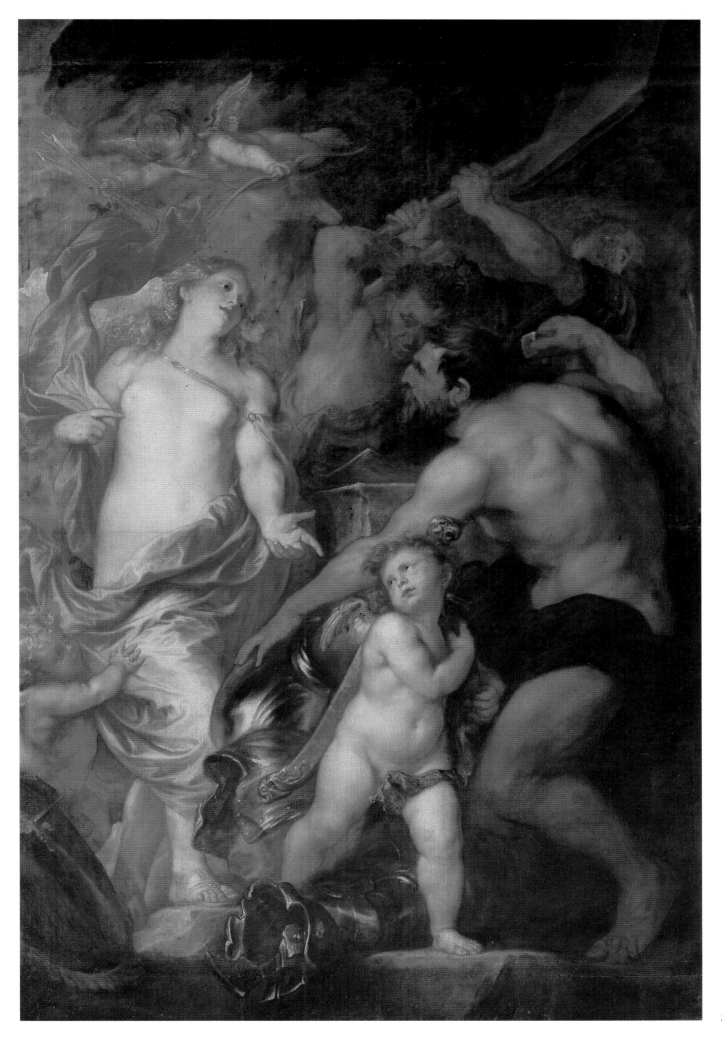

229

57
Time Clipping Cupid's Wings

1630–1632
canvas, 182.5 x 125.5 (71 1/8 x 49)

Institut de France-Musée
Jacquemart-André, Paris

PROVENANCE Estate of Jeremias Wildens,
Antwerp, 30 December 1653; collection of
the House of Orange by 1707; inven-
tories of Palace Het Loo in 1712 and
1713; sale of paintings from Het Loo, 26
July 1713, Amsterdam, lot 2; Electeur
Palatin (?); M. Cocklers 1789 (?); dukes
of Marlborough, Blenheim Castle; Marl-
borough sale, Christie's, London, 24 July
1886, lot 13; sale Sir John Millais,
London, 1 May 1897, lot 100; P. and D.
Colnaghi & Co., London, October 1899;
Madame Edouard André, Paris

EXHIBITIONS London, Royal Academy,
1882, no. 125; London, Royal Academy,
1895, no. 113 (lent by Sir J. E. Millais);
Antwerp 1899, no. 37 (lent by Colnaghi,
London); Paris 1977–1978, no. 39

LITERATURE Hoet 1752, 1:149, no. 2;
Smith 1829–1842, 3:79, no. 262; Waagen
1854, 3:122; Blenheim 1861, 28; Cust
1900, 70, 82, 210, no. 37, 251–252, no. 101;
Schaeffer 1909, 122, ill., 500; *Antwerpsch
Archievenblad/Bulletin des Archives d'Anvers*
21 (1931), 383; Glück 1931, 269, ill., 548;
Musée Jacquemart-André 1948, 36,
no. 419; Van Gelder 1959, 77; Drossaers
and Lunsingh Scheurleer 1974–1976,
1:677, no. 846, 699, no. 97; Brown 1982,
126, ill. 121; Larsen 1988, no. 737, ill. 261

1. The inventory, made by Cornelis Cock
on 30 December 1653, is published in
Antwerpsch Archievenblad 21 (1931),
381–395. It lists paintings by room, and is
very precise concerning attribution and
subject matter. Of great interest is that
copies and originals hung side by side,
which suggests that while such attri-
butive distinctions were made, both
copies and originals were deemed wor-
thy to be hung in a collector's cabinet.
This attitude probably reflects the im-
portance placed upon subject matter in
seventeenth-century collections. Since
most of the paintings in the *schilderscamer*
(painter's room) are listed as "naer ..."
(after), it is also possible that Jeremias
Wildens earned a living by painting
replicas of other artists' works. Jeremias
may have inherited many of his
paintings by Rubens, Van Dyck, Wildens
and other early to mid-seventeenth-
century Antwerp masters from his father.
2. This painting appears in the interior of
a collector's cabinet, which may well be
that of Jeremias Wildens in a work
attributed to Frans Francken III, *Musical
Party in a Collector's Cabinet*, illustrated in
D. Bax, *Hollandse en Vlaamse schilderkunst
in Zuidafrika* (Capetown and Pretoria,
1952), fig. 10. I would like to thank
Martina Friedrich for this reference.
3. Otto van Veen, *Amorum Emblemata*,
facsimile ed. (New York, 1979), 236–237.
Jacques Foucart in Paris 1977–1978, cat.
39, on the other hand, identifies the

At his death in 1653 the painter Jeremias Wildens possessed one of the most extensive collections of seventeenth-century Flemish paintings of his day. Jeremias was the son of Jan Wildens, a landscape painter who collaborated with Rubens, and he owned a large number of paintings by both Rubens and his father. Van Dyck, who was a colleague and friend of Jan Wildens, was also extremely well represented: Wildens owned no less than fifty-two of his paintings (and fourteen copies of his works), many of which cannot be identified today.[1] One that can, because of its distinctive subject, is "Een schilderye daer den Tyt Cupido syn vleugelen cort, van van Dyck" (a painting in which Time shortens the wings of Cupid by Van Dyck).[2]

This remarkable painting is the only known representation of this theme by Van Dyck. Its unique character strongly suggests that Van Dyck painted it for a specific commission, perhaps for his friend Jan Wildens. Whoever commissioned the work, however, must have been familiar with emblematic literature, for the theme is drawn directly from Otto van Veen's *Amorum Emblemata*, first published in Antwerp in 1608 [fig. 1].[3] The English text accompanying the poem explains the meaning of the image in the following manner:

Loues harte is euer young.
Tis onlie tyme that can the winges of Cupid clip,
And make him fly more low then he was wont to doo,
But Tyme clips not away his good will thereunto,
The aged carter loues to heare the lashing whip.

The image of Father Time, Chronos, as an aged winged figure wrapped only in a loose loincloth was well established by the seventeenth century. His attribute, the scythe, which derived from his associations from antiquity with the god Kronos, underscored his role as the destroyer of all things temporal.[4] Time, as the emblem and the painting demonstrate, also affects the power of Love. While it can clip Love's wings to limit its flight, however, Time cannot stymie Love's will to fly, for Love's heart is ever young.

The large scale and richness of the image relate it to Van Dyck's *Venus at the Forge of Vulcan* in the Louvre, which the artist executed c. 1630–1632 [see cat. 56]. In both of these works Van Dyck managed to combine the vigor of Rubens' figure types with the visual poetry of Titian's brushwork. Van Dyck's figure of Time, which features a muscular body, large wings, and a full white beard, resembles Rubens' image of Time in his oil sketch of *The Victory of Eucharistic Truth over Heresy*, c. 1626 (Prado, Madrid) executed for the tapestry series *The Triumph of the Eucharist*.[5] As with his *Venus at the Forge of Vulcan* in the Louvre, Van Dyck, in adapting Rubens' image, limited his narrative to focus on the interactions of the two main protagonists. He then enlivened the surface with rich brushwork and strong chiaroscuro effects.

Fig. 1. Otto van Veen, *Amorum Emblemata* (Antwerp, 1608). Library of Congress, Washington, Prints and Photographs Division

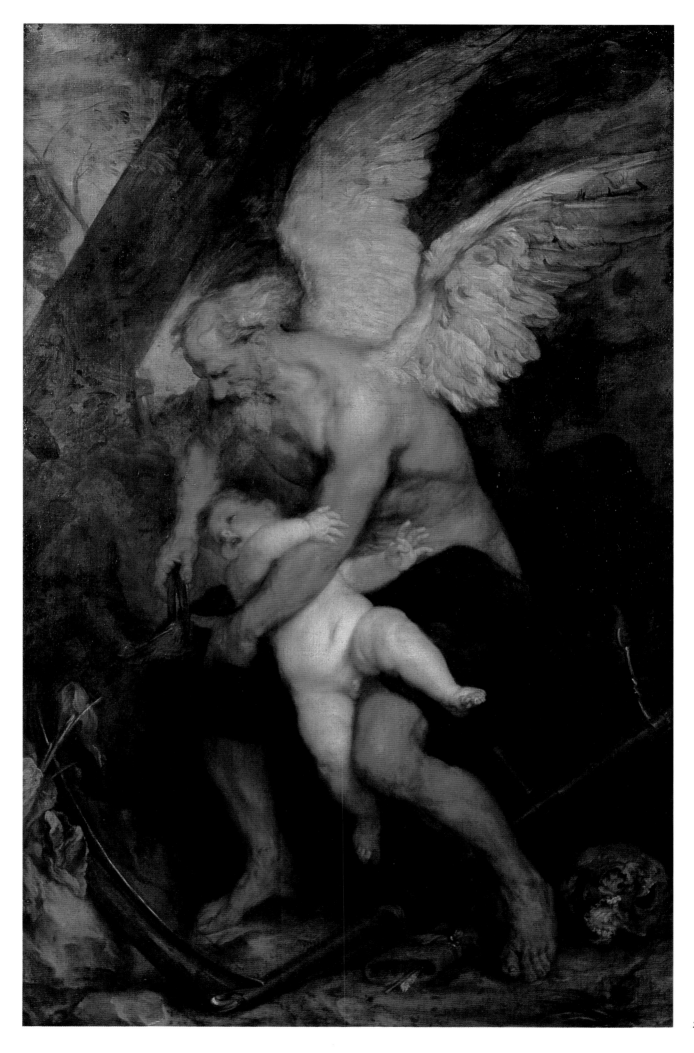

theme with an Ovidian text that appears on a seventeenth-century print by Perrier of the same subject: "Omnia Vincit Amor, mox tempus Amorem."

4. For a discussion on the evolution of the concept of Father Time, see Erwin Panofsky, *Studies in Iconology: Humanistic Themes in the Art of the Renaissance* (New York, 1972), ch. 3 (first published in 1939).

5. Julius S. Held, *The Oil Sketches of Peter Paul Rubens*, 2 vols. (Princeton, 1980), 1: cat. 100.

6. Nordenfalk 1938, 47.

7. For a list of these see the entry on this painting by Foucart in Paris 1977–1978, cat. 39.

8. Descamps 1853–1854, 2:27, listed among the Van Dyck paintings in the collection of "l'Electeur Palatin" "le temps qui coupe les aîles de l'amour." Smith 1829–1842, 3: no. 262, mentioned that a painting of this subject was in the collection of M. Cocklers in 1789.

9. Gérard Mabille, "Une terre cuite de Corbet: Le Temps coupant les ailes de l'Amour," *Revue du Louvre* (1977), 89–93.

As with other mythological paintings from this period, this painting appealed to the taste of the House of Orange and entered into the collection of that family at the end of the seventeenth century.[6] Various copies of this work are known,[7] some of which may have been mistakenly associated with the provenance of this painting.[8] Van Dyck's composition apparently influenced the sculptor Charles-Louis Corbet (1758–1808) in a work executed in 1776, presently in the Louvre.[9]

A. K. W.

58
Venus at the Forge of Vulcan

1630–1632
canvas, 116.5 x 156 (46 x 61 1/2)

Kunsthistorisches Museum, Vienna,
inv. no. 498

PROVENANCE Archduke Leopold
Wilhelm, 1659, no. 113

EXHIBITIONS Amsterdam 1947, no. 53;
Brussels 1947, no. 37

LITERATURE Kunsthistorisches Museum
1783, 107, no. 14; Smith 1829–1842, 3:27,
no. 89; Kunsthistorisches Museum 1896,
2:115, no. 1035; Cust 1900, 69–70, 252,
no. 105; Schaeffer 1909, 119, ill.; Glück
1931, XL, 263, ill., 547; Vey 1956, 197;
Kunsthistorisches Museum 1963, no. 149;
Damm 1966, no. 56, ill. 18; Brown 1982,
126–127, ill. 120, 122, 123; Kunsthisto-
risches Museum 1987, 192, 193, pl.;
Larsen 1988, no. 747, ill. 258

1. This painting was enlarged at some
point in its history. The extensions,
which are visible in old photographs of
the painting, measure 7 cm (2 3/4 in.)
along the top and 16 cm (6 1/4 in.) on the
right.
2. Götz Eckhardt, *Die Gemälde in der
Bildergalerie von Sanssouci* (Potsdam-
Sanssouci, 1975), no. 62.
3. Drossaers and Lunsingh Scheurleer
1974–1976, 1:285, no. 1232. It also
appeared in the inventory made in 1673
(Drossaers and Lunsingh Scheurleer
1974–1976, 1:317, no. 737), where it hung
in the Galerie "in 't Oude Hoff in 't
Noorteynde" along with other paintings
by Van Dyck, including his portrait of
Frederik Hendrik [see cat. 59].
4. As noted in Antwerp 1960, cat. 74, the
attitude of Venus resembles that in Van
Dyck's drawing of *The Judgment of Paris*,
Gemeente Musea, Verzameling Fodor,
Amsterdam.
5. This motif was subsequently used by
Ferdinand Bol in his *Venus and Sleeping
Mars*, c. 1660, Herzog Anton Ulrich-
Museum, Braunschweig. See *Gods, Saints
and Heroes: Dutch Painting in the Age of
Rembrandt* [exh. cat. National Gallery of
Art] (Washington, 1980), 172, cat. 40.

During the late 1620s and early 1630s Van Dyck turned to a variety of literary sources for paintings of mythological subjects, but whether his sources were Ovid, Virgil, Guarini, or Tasso, he invariably dwelled upon love relationships rather than on heroic conquest through physical confrontations. By this time he had come to recognize that his strengths as a narrative artist were quite different from those of Rubens. He could convey far more emotion through facial expression than through figures in action. He also had a talent for introducing humor into his scenes, particularly through the playful interaction of whimsical cupids, who often assist but occasionally mock the purported seriousness of the main protagonists.

All of these components meant that Van Dyck's mythological paintings were far more appropriate for private viewing than public display. Indeed, he seems never to have designed large narrative subjects, including ceilings or tapestry series, that might be deemed "serious subjects" with allegorical implications, such as those that were so often demanded of Rubens.

One of the most delightfully whimsical of all of Van Dyck's mythological scenes is this version of *Venus at the Forge of Vulcan*, in which Venus makes herself all the more irresistible to Vulcan by holding against herself the breastplate he had crafted for Aeneas [for the story see cat. 56]. The stark contrast of hard metal against soft flesh, coupled with the longing expression in her eyes, would be enough to excite Vulcan's passion, but with the assistance of one of Venus' cupids who draws aim on the god of fire, he has completely succumbed to her charms. He reaches out to her, as though he is pleading with her to stay, but, as is clear from the attitudes of her small attendants who gather Aeneas' sword, shield, and helmet, it is time for them to depart to deliver the arms to Venus' warrior son.

As with Van Dyck's other interpretation of this subject in the Louvre [cat. 56], nothing is known about the commission for this work.[1] It is first mentioned in 1659, when it is recorded in the collection of Archduke Leopold Wilhelm in Brussels. Another version of this composition, presently in Sanssouci, Potsdam,[2] was in the collection of Amalia van Solms by 1654.[3] The fact that Amalia van Solms owned that painting raises the possibility that the subject, where a figure of one sex dons the clothing of the other, appealed to the court in The Hague for the same reasons that did Van Dyck's *Amaryllis and Mirtillo* [cat. 60] and its pendant, *Achilles among the Daughters of Lycomedes* [see cat. 60, fig. 1]. The patron who commissioned the Vienna *Venus at the Forge of Vulcan* may have taken a similar delight in this mythological narrative.

Fig. 1. Peter Paul Rubens,
*Achilles Recognized among the
Daughters of Lycomedes*,
1630–1632, panel, 45.5 x 61.5
(17 7/8 x 24 1/4). Museum
Boymans-van Beuningen,
Rotterdam

233

As with the Louvre version of *Venus at the Forge of Vulcan*, Van Dyck drew from both Rubens and Titian in conceiving his scene. Venus' attitude is particularly close to that of profane love in Titian's allegory of *Sacred and Profane Love* [see cat. 56, fig. 2].[4] The connections to Rubens' Life of Achilles series, once again, are also strong. Van Dyck has here reversed the composition of *Thetis Receiving the Arms of Achilles* [see cat. 56, fig. 1], changed its subject and emotional content, but adapted many of the same elements, including the juxtaposition of steel against flesh and the idea of putti carrying away armor. The delightful motif of the putto wearing the oversize helmet in Van Dyck's painting was probably suggested by another episode from Rubens' series, *Achilles Recognized among the Daughters of Lycomedes* [fig. 1], where Achilles, dressed as a woman, tries on a helmet.[5] This incongruity of dress and helmet may have brought to Van Dyck's mind the Renaissance motif of a putto wearing the enormous helmet of the sleeping Mars (see, for example, Botticelli's *Venus and Mars*, National Gallery, London).

A. K. W.

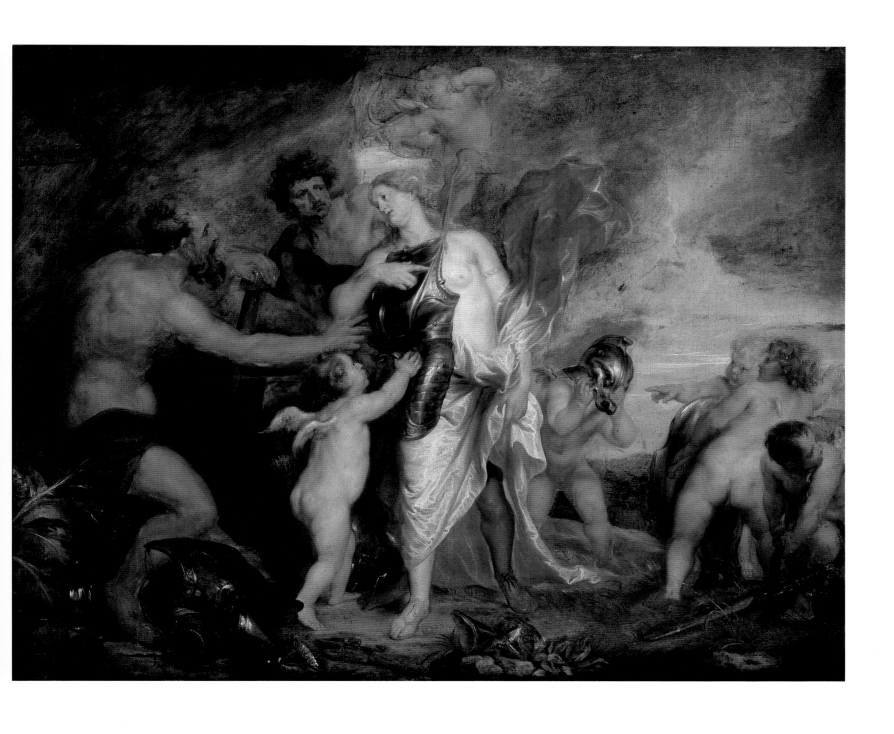

1631–1632
canvas, 114.3 x 96.52 (45 x 38)

The Baltimore Museum of Art: The Mary
Frick Jacobs Collection, BMA 1938.217

PROVENANCE Listed in the "Dispo-
sitieboek" of Amalia van Solms
Braunfels, wife of Prince Frederik
Hendrik, in 1673, no. 735; inherited by
Henriëtte-Catherina, wife of George,
prince of Anhalt-Dessau in 1675; duke of
Anhalt-Dessau (inventory 1709, no. 51),
Woerlitz, Germany; by inheritance in the
Anhalt-Dessau ducal family until
acquired by Duveen Brothers, New York,
February 1930; Mary Frick Jacobs

EXHIBITIONS London, Victoria and
Albert Museum, *The Orange and the Rose*,
1964, 30, no. 8; The Denver Art Museum,
Baroque Art, Era of Elegance, 1971, 80,
ill., 81

LITERATURE Cust 1900, 82, 255 (as
repetition of the portrait in the Prado);
Schaeffer 1909, 507 (note to 272); Glück
1931, 556 (note to 336); *The Collection of
Mary Frick Jacobs* (Baltimore, 1938), no. 64,
ill.; *Duveen Pictures in Public Collections of
America* (New York, 1941), no. 187, ill.;
Van Gelder 1959, 46, ill. 1; Drossaers and
Lunsingh Scheurleer 1974–1976, 1:317,
no. 735; Tiethoff-Spliethoff 1978, 106–107;
Larsen 1988, no. 554, ill. 208a

1. Van Dyck was named court painter
for the Infanta Isabella in May 1630.
2. Houbraken 1753, 1:185.
3. Cust 1900, 81, on the other hand,
argued that Van Dyck would already
have visited The Hague by then. The
earliest known contact between Van
Dyck and The Hague is a power of
attorney that he sent to the painter
Lenaert von Winde on 12 February 1631
in relation to the payment for certain
paintings delivered. This document,
however, merely confirms that Van
Dyck's paintings were known and
esteemed in the Netherlands, but does
not prove that he had made a trip by
that time.
4. Houbraken 1753, 1:185.
5. Jacob Smit, *De Grootmeester van Woord-
en Snarenspel: Het Leven van Constantijn
Huygens* (The Hague, 1980), 167.
6. The portrait of Amalia van Solms was
sold from the Norton Simon Museum,
Pasadena, California, at auction
(Sotheby's, London, 12 December 1973).
With the exception of Tiethoff-Spliethoff
1978, 106–107, most authors date all three
portraits c. 1628, as a result of
Houbraken's statement that Van Dyck
traveled to The Hague shortly after
completing the Augustinian altarpiece.
Tiethoff-Spliethoff argued that
the portraits of Frederik Hendrik and
Amalia van Solms should be dated 1632
because they do not appear in the
inventory of the stadhouder's collection
made in that year. That inventory,
however, was made in August, some
months after Van Dyck's visit. She

236

Van Dyck, unlike Rubens, undertook no diplomatic role in the disputes that racked
European society throughout his lifetime. This striking dissimilarity between these
two great artists is largely due to the differences in their personalities, but it also
reflects attitudes born from different generations. Van Dyck spent his youth in a
period of relative peace and prosperity thanks to the Twelve Years' Truce that began
in 1609. After the end of the truce in 1621 Van Dyck was in Italy, and hence saw little
of the renewed hostilities that raged between Flanders and the Netherlands. After his
return to Antwerp in 1627 he remained essentially apolitical, in part, it seems, because
he wanted to be a court artist and to be free to travel from one court to another. In
this he succeeded. Indeed, even with the hostilities between Flanders and the
Netherlands, Van Dyck was invited to work for both Infanta Isabella, the regent of
the southern Netherlands, and the leader of the United Provinces, Frederik Hendrik,
the prince of Orange.[1]

Traditionally Van Dyck is thought to have made two trips to the Netherlands, one
in the winter of 1628–1629 and a second in the winter of 1631–1632. This theory,
however, is based on a misinterpretation of Arnold Houbraken's life of the artist.[2]
According to Houbraken, Van Dyck was invited to The Hague to paint for Frederik
Hendrik shortly after he had completed his altarpiece for the Augustinian church
[cat. 46], that is, by June 1628, and before he painted his altarpiece for the Capuchins
in Dendermonde. The assumption has been made that the altarpiece for the
Capuchins referred to by Houbraken was Van Dyck's *Christ on the Cross Surrounded by
the Virgin and Saints* of 1629–1630 (Glück 1931, 242). Thus, Houbraken's assertion has
been interpreted quite literally to mean that Van Dyck was in The Hague in the
winter of 1628–1629. The altarpiece Houbraken mentioned, however, could as well
have been *The Adoration of the Shepherds*, which Van Dyck painted for the Capuchins
in Dendermonde in 1631–1632 [see cat. 61]. Whereas no supporting documentation
confirms a visit to The Hague in the late 1620s, specific evidence exists for a trip in
the winter of 1631–1632.[3]

The length of the trip is not precisely known. Houbraken indicated that shortly
before Van Dyck's departure for England (March 1632) he made his (possibly
apocryphal) visit to the studio of Frans Hals in Haarlem.[4] That he was in The Hague
at the end of January 1632 is clear from Constantijn Huygens' entry in his diary on
the twenty-eighth of that month, where he indicated that Van Dyck visited him on
the precise day that a tree in his backyard fell on his house.[5] Although Van Dyck
must have made a number of his portrait studies of Dutch artists, as well as that of
Huygens, for his *Iconography* during this period, nothing is known of his actual
itinerary.

For political and documentary reasons it also seems that the portraits of Frederik
Hendrik, Amalia van Solms, and Willem II that Houbraken says Van Dyck painted on
his trip to The Hague were painted in the early 1630s.[6] Van Dyck portrayed Frederik
Hendrik (1584–1647) in his role as commander of the forces of the States General. He
stands alertly in his armor, his left hand holding a staff, the other resting on the hilt
of his sword. Beside him on a table rests his helmet, which is surmounted by an
enormous plume. The roughhewn wall behind him lends conviction to his stature as
a forceful and stolid leader.

Frederik Hendrik had assumed his role as leader of the House of Orange only in
1625, after the death of his brother Maurits, but quickly sought to expand his powers
within the political structure of the Dutch Republic. The hostilities with Spain had
gone badly for the Dutch in the last years of Maurits' reign, the nadir being the
surrender of Breda in 1625, and the republic was prepared to give greater authority to
the new prince of Orange to drive back the enemy forces. By 1627 his prowess as a
military leader had become recognized and after the victorious battle of Groenlo the
offensive was taken by the Dutch. After the successful siege on 's-Hertogenbosch,
Frederik Hendrik's political position within the Dutch Republic was particularly

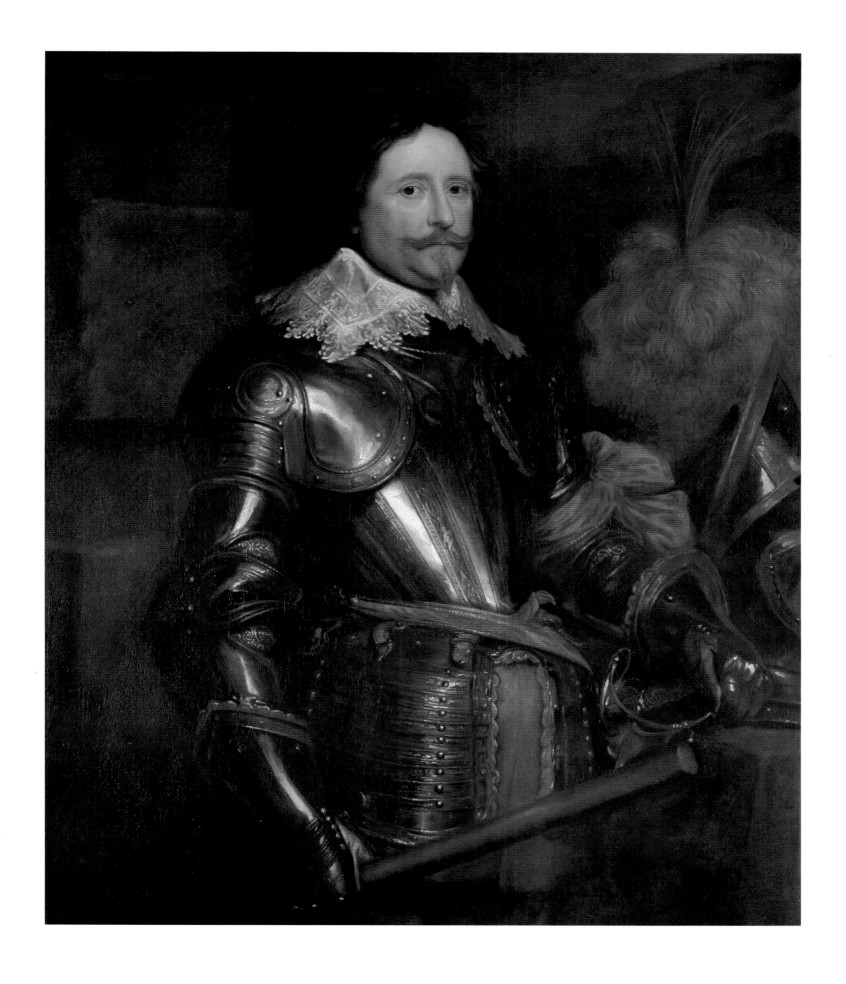

wrongly believes that they are studio pieces made after oil sketches Van Dyck prepared for his *Iconography*. The painting of Willem II is thought to be the portrait of a child now in Mosigkau, Dessau. Willem II was born on 27 May 1626. He would be rather old to be represented, as is the boy in the Dessau painting, in a child's dress, but such clothing was frequently worn until a boy's sixth birthday.

7. Van Dyck based his portrait of Frederik Hendrik on a formula devised by Michiel van Mierevelt as early as 1610 (Stadhuis, Delft), and the seated portrait of Amalia van Solms on Rubens' portrait of Anne of Austria, c. 1625 (Prado, Madrid).

8. Autograph replicas are in the Prado, Madrid (inv. nos. 1482 and 1483). Van Gelder 1959, 45, has suggested that these were the paintings made for Charles I upon his request and for which Van Dyck was paid on 8 August 1632. See Cust 1900, 99. They eventually passed into the collection of Isabella Farnese (inventory of 1746), whence they passed to the Prado.

9. For a discussion of Frederik Hendrik's patronage, see C. Willemijn Fock, "The Princes of Orange as Patrons of Art in the Seventeenth Century," *Apollo* 110 (1979), 466–475.

10. Constantijn Huygens, *Mijn jeugd*, trans. C. L. Heesakkers (Amsterdam, 1987), 79. Van Dyck, nevertheless, was listed among the successful history painters known by Huygens rather than praised as a portrait painter.

11. See Van Gelder 1959, 53–56; Drossaers and Lunsingh Scheurleer 1974–1976, 1:147–149.

12. Drossaers and Lunsingh Scheurleer 1974–1976, 1:317, no. 735. Van Dyck's portrait of Amalia is no. 736.

13. The full history is described by Van Gelder 1959, 45.

14. Mauquoy-Hendrickx 1956, no. 151, p. 310.

strong. It was probably at this point that he invited Van Dyck to his court to paint official portraits of himself and Amalia van Solms, ones that could serve as models to be sent to friends and allies. Even though the pendant portraits of Frederik Hendrik and Amalia van Solms were rather conventional in type,[7] they must have pleased the couple since a number of replicas of them exist. The fact that Van Dyck presented replicas of the portraits of the prince and princess of Orange and their son to King Charles I in 1632 is certainly evidence that these paintings had been only recently executed. Van Dyck would hardly have presented the king with replicas of portraits originally painted two or three years earlier.[8]

The foundations for Frederik Hendrik's ideals of patronage are not well known, but they may stem from his early childhood experiences at the court of Henry IV in France or from his exposure to the Jacobean court at the time of the coronation of James I.[9] Later in 1627 he had an opportunity to visit the court of Charles I when he was made a Knight of the Garter. His taste, however, must have also been strongly affected by that of his wife Amalia van Solms-Braunfels (1602–1675), whom he married in 1625. Amalia, a German noblewoman by birth, came to The Hague in 1621 as part of the retinue attached to the "Winter Queen," Elizabeth Stuart, sister of Charles I. Her interest in the arts probably stemmed from her experiences in the elaborate court life that Elizabeth and her husband Frederick of the Palatinate established during their exile in The Hague.

Particularly important for establishing the nature of the cultural life at the court of Frederik Hendrik was Constantijn Huygens, secretary to the prince of Orange. Huygens was a great admirer of Rubens, but he also praised Van Dyck's talents as a painter in his autobiography.[10] Huygens, who may have met Van Dyck when they were both at the court of James I in the winter of 1620–1621, would certainly have been aware of the esteem in which Van Dyck's portraits were held and the prestige that his sitters gained from the images painted by his hand.

Frederik Hendrik, with the encouragement of both Amalia van Solms and Constantijn Huygens, patronized some of the finest artists of his day, Dutch and Flemish, particularly those who worked in a classicizing style or who specialized in Arcadian images. It is well known that he had a marked preference for Rubens and owned six history paintings by this great master by August 1632, when the first inventory of his collection was made. Less noticed is that he also owned at least eleven paintings by Van Dyck. Eight of these paintings, including four portraits, are listed in the 1632 inventory. The portraits of Frederik Hendrik, Amalia van Solms, and Willem II mentioned by Houbraken, however, are for some reason not included.[11] They are first mentioned among Amalia van Solms' possessions in the gallery at her palace Noordeinde in The Hague in 1673,[12] and remained in the family until they were sold to Duveen in 1936.[13] Efforts to reunite the two works for this exhibition have unfortunately not been successful, but one hopes these two fine paintings will once again be able to hang side by side.

Van Dyck's portrait of Frederik Hendrik served as a model for Paulus Pontius' engraving of the prince of Orange for the *Iconography*.[14]

A. K. W.

60
Amaryllis and Mirtillo

1631–1632
canvas, 120 x 135 (46³/₄ x 52⁵/₈)

Graf von Schönborn, Pommersfelden

PROVENANCE In the Orange inventory
of the Stadhouderlijke kwartier en
Noordeinde, The Hague, of 1632; c.
1694/1695 a large number of paintings
were taken to Het Loo, which were
appraised in December 1712 by Jan van
Beuningen and J. P. Zomer; sale 26 July
1713, under no. 5 (as "van Dyck. 't
School der Liefde."), sold to the painter
Jost de Cossiau for 3,600 guilders for
Elector Lothar Franz von Schönborn,
Pommersfelden; catalogued at
Pommersfelden since 1719

LITERATURE Bellori 1672, 314;
Archivalische Belege, Archiv Wiesentheid,
Correspondence Lothar Franz, 2 July
1717; Nordenfalk 1938, 36; Van Gelder
1959, 58; Antwerp 1960, 166; Damm
1966, 67; Drossaers and Lunsingh
Scheurleer 1974–1976, 1:182, no. 25;
Larsen 1975a, 90–91; Van Gelder 1978,
237, ill. 13, 243–246; Brown 1982, 128,
130; Kettering 1983, 12, 109, 182, 193, ill.
164; Lohse Belkin 1987, 143–152; Brown
1987, 164; Larsen 1988, no. 735, ill. 212

1. Two excellent studies on *Il Pastor Fido*
and its influence are Van Gelder 1978,
227–263, and Kettering 1983, 107–119.
2. *A Critical Edition of Sir Richard
Fanshaw's 1647 Translation of Giovanni
Battista Guarini's Il Pastor Fido*, ed. Walter
F. Staton, Jr., and William E. Simeone
(Oxford, 1964), 24, lines 569–572,
"Your woe shall end when two of Race
Divine/Love shall combine:/And for a
faithlesse Nymphs apostate state/A
faithfull Shepherd supererogate."
3. Guarini 1964, 44, lines 1321–1326.
4. Van Dyck need not have painted it in
The Hague, but could well have brought
it with him or had it sent separately. For
the argument that Van Dyck only made
one trip to the court of Frederik Hendrik
and not two as is generally thought, see
cat. 59.

This pastoral idyll situated within a woodland glade is the most sensual of all of Van Dyck's paintings. Seated beneath a golden brocade draped over the branches of the trees is the beautiful nymph Amaryllis, who is about to be crowned with a wreath of flowers by her admiring suitor Mirtillo. The tenderness of this gesture is noted by a number of his female companions, although others, embracing and kissing, remain oblivious to everything except themselves. The moment's significance, however, is not lost upon the small cupids who fly overhead as one aims an arrow directly down at the heroine.

Van Dyck's scene is drawn from Giovanni Battista Guarini's late sixteenth-century tragi-comedy *Il Pastor Fido*, a pastoral that glorified Arcadian life and had far-ranging effects in art and literature in France, Flanders, and the Netherlands.[1] From a plot no less convoluted than that of Tasso's *Gerusalemme Liberata* [see cat. 54], Van Dyck has represented an episode that captures the lyricism of Guarini's remarkable fantasy.

In Arcadia, where the scene takes place, an oracle has decreed that the land would be fraught with plagues until two of its inhabitants, a faithless nymph and a faithful shepherd who were offspring of the gods, would be joined together.[2] The faithless woman, the nymph Amaryllis, descendant of Pan, has been bequeathed by her father to Silvio, descendant of Hercules, in hopes that the oracle could be satisfied. Silvio, however, has no interest beyond the hunt, whereas the shepherd Mirtillo is entranced by Amaryllis. When Amaryllis, at the beginning of book two, orders a "kissing warre" among the nymphs, with her assuming the role of judge, Mirtillo brazenly disguises himself as a woman to take part in the contest. As he describes the event in the play, Mirtillo was the last to approach the nymph.

When our two mouthes snapt like a bone well set, …
Then, then I felt the sharp sweet dart,
The amorous sting piercing my heart.[3]

Mirtillo is an easy winner and receives from Amaryllis a floral crown signifying his victory. The moment that Van Dyck has depicted is when Mirtillo gallantly removes the crown to place it on Amaryllis' head. The story eventually unfolds that Mirtillo is the lost brother of Silvio, and thus likewise stems from the lineage of Hercules. The eventual marriage of Amaryllis with this faithful shepherd, a descendant of the gods who is blessed with all human virtues, thus fulfills the conditions of the oracle and assures that the curse over the land shall be broken.

Van Dyck almost certainly painted his scene of the crowning of Amaryllis in the winter of 1631–1632 for the occasion of his visit to the court of Frederik Hendrik in

Fig. 1. Anthony van Dyck, *Achilles among the Daughters of Lycomedes*, c. 1628–1629, canvas, 123 x 137.5 (48³/₈ x 54¹/₈). Collection of Graf von Schönborn, Pommersfelden

Fig. 2. Anthony van Dyck, sketch after Titian, *Mars and Venus*, Italian sketchbook, fol. 106r, 1622–1625, pen and ink. Courtesy of the Trustees of the British Museum, London

5. Drossaers and Lunsingh Scheurleer 1974–1976, 182, n. 25. In the 1632 inventory the painting was described as "eene schilderije van verscheyde vrijagien." In the inventory of 1712/1713 it was known as "'t soetste kusje'." It was auctioned under the title "'t school der Liefde'" on 26 July 1713, no. 5.

6. Van Gelder 1978, 244–245.

7. Huygens was intimately familiar with Guarini's work and composed various works based upon the Italian poet. See Van Gelder 1978, 243, and Jacob Smit, *De Grootmeester van Woord- en Snarenspel: Het Leven van Constantijn Huygens* (The Hague, 1980), 124.

8. Nordenfalk 1938 identified the Göteborg version as the original. That painting, however, which is signed "Ant. Van Dyck eques fec.," must have been painted after 1632, when Van Dyck was knighted by Charles I. I believe it is a later copy, and not by Van Dyck's hand. Van Gelder 1959, 58–59, believed that the Turin version, which came to the Galleria Sabauda from the collection of Prince Eugene of Savoy, was the original. Van Gelder noted that the Turin version had certainly been in the Netherlands, because Jan de Bisschop made a drawing after it that is now in the Rijksmuseum, Amsterdam (it is distinguishable from the other versions because it lacks the eagle in the tree in the upper right). Van Gelder 1978, 245–246, amended his opinion and considered the Pommersfelden painting to be the original. He then suggested that the prince of Savoy had acquired the Turin version from the art dealer J. P. Zomer. This sequence of events, argued Van Gelder, explains why Zomer, who evaluated the collection at the Palace Het Loo in 1712, questioned the attribution of the version in the House of Orange collection. Brown 1982, 130, maintained that the Göteborg version was painted first, but in Brown 1987, 164, he changed his earlier opinion and considered the Turin painting the original. In any event, at the sale in 1713 *Amaryllis and Mirtillo* sold for 3,600 guilders, 500 guilders more than the *Achilles*, perhaps because the latter was already in a worse state of preservation. Both paintings were bought by the painter Jost de Cossiau for Count Lothar Franz von Schönborn. Although *Amaryllis and Mirtillo* was attributed to Van Dyck

The Hague [see cat. 59].4 An inventory of the stadhouder's collection taken in 1632 listed eight works by the artist, five of which hung prominently in the residence. Among those works were three mythological and pastoral subjects, including *Amaryllis and Mirtillo*.5

Amaryllis and Mirtillo hung above a fireplace in the prince's dressing room,6 a location indicative of the twofold appeal of its subject: its sensuality and its glorification of a virtuous hero. Frederik Hendrik, who was as well known in his early years for his delight in the pleasures of life as for his military exploits, would have empathized with the shepherd Mirtillo, who through constancy but also cunning achieved his amorous intentions. The subject expressed the pastoral ideals of love and courtship that pervaded the court, ones that, for example, are found not only in Constantijn Huygens' poetry, but also in the lyrics he wrote for his music.7 Indeed it is likely that Huygens was influential in determining the character of the decorative scheme for the prince's living quarters.

The story also drew upon another interest of the period: a fascination with transformations and metamorphoses. In the same dressing room hung seven tapestries illustrating *Vertumnus and Pomona*, a love story drawn from Ovid's *Metamorphoses* that also involved a man dressing as a woman so that he could come into her presence. In a nearby bedroom ("nieuwe slaepcamer") hung another painting of identical size by Van Dyck in which a male is dressed as a female, this one drawn from a classical source: *Achilles among the Daughters of Lycomedes* [fig. 1]. In this instance, Achilles, who is discovered because of his fascination with the weapons hidden among the jewelry admired by the women, probably served as a warning against the shirking of one's military responsibilities.

Both *Amaryllis and Mirtillo* and *Achilles among the Daughters of Lycomedes* are presently in the collection of Graf von Schönborn in Pommersfelden and have been since they were bought in the 1713 sale of paintings from the Orange collection. Notwithstanding a long and uninterrupted provenance that dates back to the inventory of 1632, a great deal of confusion has arisen concerning the attribution of *Amaryllis and Mirtillo*. The problem stems from the existence of two other versions of this subject, in the Galleria Sabauda, Turin, and in the museum in Göteborg. Throughout most of this century one or the other of these two latter paintings has been identified as the original by Van Dyck.8 Close examination of this work, however, confirms that it is an exquisite example from Van Dyck's hand. His brushwork and sense of color are evident not only in the shimmering drapery but also in the sensitive renderings of gestures and facial expressions.

Given the fascination of Amaryllis and Mirtillo for Dutch theater and literature, it is surprising that Van Dyck's is the first painted representation in the Netherlands.9 For inspiration he turned to Titian. As Christopher Brown has pointed out, he derived his lovers in the lower right from Titian's *Mars and Venus*, a painting he had seen in Italy and had partially copied in his Italian sketchbook [fig. 2].10 Van Dyck's primary source, however, was Titian's famous bacchanal *The Andrians* [fig. 3], a painting he

Fig. 3. Titian, *The Andrians*, c. 1523–1525, canvas, 175 x 193 (687/8 x 76). Museo del Prado, Madrid

Fig. 4. Anthony van Dyck, sketch after Titian, *The Andrians*, Italian sketchbook, fol. 56r, 1622–1625, pen and ink. Courtesy of the Trustees of the British Museum, London

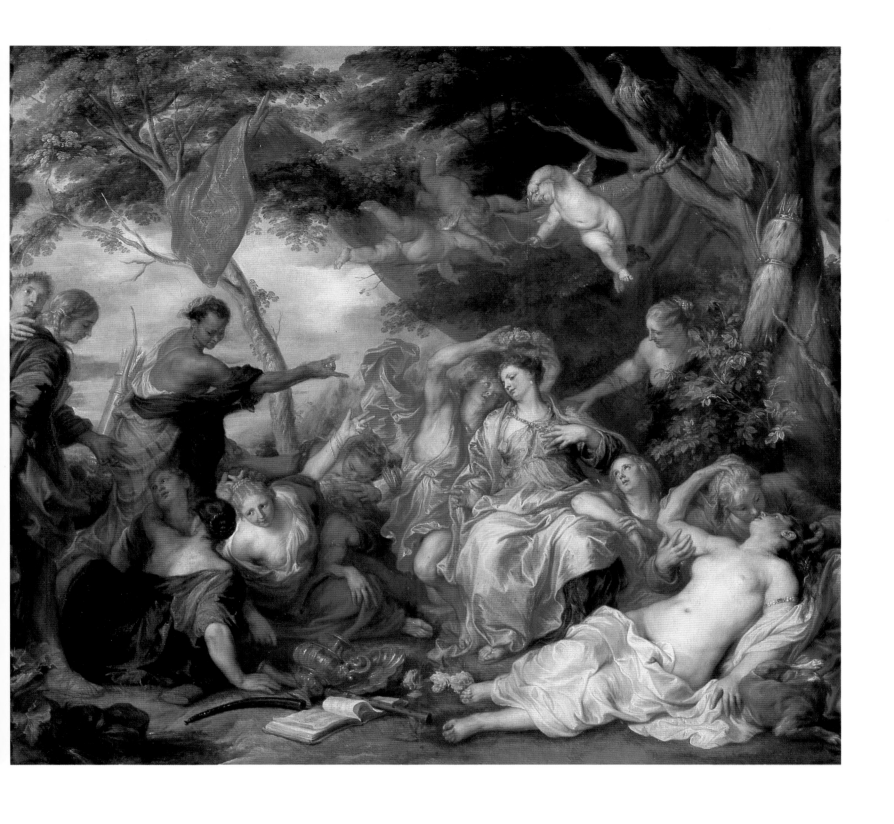

241

in catalogues at Pommersfelden in 1719 (no. 2), 1746 (no. 23), 1774 (no. 176), doubts about its attribution persisted into the nineteenth century. In the catalogue of 1857 (no. 47) the painting was given to Van Dyck's pupil Remigius Langain; in 1894 the attribution was changed to Jan van Boeckhorst, under whose name the painting is still catalogued at Pommersfelden.

9. Van Gelder 1978, 246.
10. Brown 1987, 159.
11. Van den Branden 1883, 720–721.
12. Van Dyck's apparently free copy after Titian was recorded in 1696 in the inventory of Everhard Jabach (no. 267), a banker and collector from Cologne whom Van Dyck depicted in a memorable portrait now in the Hermitage, Leningrad (Glück, 1931, 355). See F. Grossman, "Holbein, Flemish Paintings and Everhard Jabach," *Burlington Magazine* 93 (1951), 25. Van Dyck may have painted this copy from the original when he saw it in Italy. It seems more likely, however, that he painted it around 1628–1630 from a copy of *The Andrians* by another artist that he would have seen in Antwerp or even owned himself. Nordenfalk 1938, 46, was the first to suggest that Van Dyck must have based *Amaryllis and Mirtillo* on a painted copy.
13. Despite the arguments of Lohse Belkin 1987, 143–152, I doubt that Rubens based his composition on a Van Dyck copy.

had first seen in Rome at the Palazzo Ludovisi and had copied in his Italian sketch-book [fig. 4]. Indeed, Van Dyck may well have owned a copy of this masterpiece. When Maria de' Medici visited Van Dyck in Antwerp in 1631 she, according to her secretary, marveled at "le cabinet de Titien; je veux dire tous les chefs d'œuvre de ce grand maistre."[11] An old inventory even suggests that Van Dyck painted a copy after Titian's *The Andrians*.[12] Whether or not executed by Van Dyck, the existence of a painted copy of *The Andrians* in Antwerp in the late 1620s seems certain since Rubens' copy after this work (now in Stockholm) must have been painted c. 1628, when he was in Flanders.[13]

Before executing his involved composition of *Amaryllis and Mirtillo*, Van Dyck worked out his ideas in a quite-finished oil sketch, which nevertheless varies in certain details from the final version [fig. 5]. One major change has been to bring Mirtillo forward so that he is not obscured by Amaryllis. In his final composition Van Dyck also eliminated various figures and included the three putti directly above the central couple to emphasize the placing of the crown on Amaryllis.

A. K. W.

Fig. 5. Anthony van Dyck, *Amaryllis and Mirtillo*, c. 1628–1629, panel, 23.1 x 35.5 (9 1/8 x 14). Ecole Nationale Supérieure des Beaux-Arts, Paris

61
The Adoration of the Shepherds

1631–1632
canvas, 244 x 172 (95 1/8 x 67)

Kerkfabriek Onze-Lieve-Vrouw,
Dendermonde

PROVENANCE Commissioned by Cornelis
Gheeroffs for the Onze-Lieve-Vrouwkerk
in Dendermonde; taken by the French in
1795 and returned to Dendermonde in
1815

EXHIBITION Antwerp 1899, no. 3

LITERATURE Cust 1900, 96, 208, no. 3,
246, no. 6 (as "The Nativity"); Blomme,
1898–1901, 425–426; Schaeffer 1909, 115,
ill., 500; Glück 1931, 255, ill., 546; Vey
1956, 180; Antwerp 1960, 165 (under no.
131); Brussels 1965, 53 (under no. 50),
299 (under no. 316); Brown 1982, 162;
Larsen 1988, no. 682, ill. 241

1. Cust 1900, 96, referred to a letter from
Van Dyck dated 21 November 1631 that
identifies the patron for the commission.
His suggestion, followed by Brown 1982,
162, that the painting was only com-
pleted in 1635 is based on a misunder-
standing of the nature of the account
book in which Van Dyck's payment is
recorded. Blomme 1898–1901, 425–426,
explains that payments between 3
August 1630 and 6 November 1635 were
all combined in one book (Kerkrekening
1630–1635). This painting may well be the
altarpiece for the Capuchins in
Dendermonde to which Houbraken 1753,
1:185, referred [see also cat. 59].
2. In this painting Rubens included a
kneeling barefoot shepherd similar in
concept to the young shepherd in Van
Dyck's altarpiece. The original of this
motif goes back to Caravaggio's Madonna
di Loreto in Sant' Agostino in Rome, a
painting Van Dyck, as well as Rubens,
would have known.
3. Bellori 1672, 264.
4. Critics have in the past praised the
conception of this work, but questioned
the execution. Michiels 1882, 449–450, has
been the harshest. He believed that it
was largely painted by a Van Dyck pupil
Jean de Reyn after the master's design
and then retouched by the master.
Michiels' opinion, however, was based
on the false assumption that the painting
was executed in 1635, when Van Dyck's
manner of execution was quite different.
5. Glen 1977, 127, likened the revealing
of Christ's body in Rubens' adoration
scenes to the elevation of the host in the
Mass. This and the presence of wheat, he
argued, give Rubens' paintings a strong
eucharistic character. While these
components are not absent from Van
Dyck's painting, they do not seem to
play as central a role. The wheat is a
background element and not a primary
one in Van Dyck's portrayal. More
important is the association of Christ's
sacrifice through the image of the lamb
brought to the child by the young
shepherd.
6. See Antwerp 1960, 164–165, cat. 131.

With a gentle sweep of her arm the Virgin lifts her blue cloak from the sleeping
Christ Child to reveal him to the adoring shepherds. As the star that has guided the
shepherds to the Holy Family shines overhead, the aged Joseph looks upward to
witness the arrival of angels who hold aloft a ribbon banner proclaiming "Gloria [in]
Eccel[cis] De[o]." To the left an ox and an ass peer over the Virgin's shoulder, the
only reference to the humble surroundings in which the child was born.

Van Dyck received the commission for this altarpiece in November 1631 from
Cornelius Gheeroffs, an alderman of the Onze-Lieve-Vrouwkerk in Dendermonde,
where the painting still hangs.[1] Van Dyck was paid 500 guilders for the painting, 100
guilders less than he had received in 1629 for the larger and more complex altarpiece
he executed for the Augustinian church in Antwerp [see cat. 46].

For an artist who was at that time so much in demand for devotional paintings, it
seems remarkable that this commission was the first Van Dyck had received for this
traditional religious theme. Van Dyck's conception for his image, as one might expect,
reflects the powerful impact of Rubens' many altarpieces devoted to this subject from
the 1610s, works that Van Dyck may actually have helped execute while he was a
member of Rubens' workshop. The connections with Rubens' paintings of *The
Adoration of the Shepherds* can be found in virtually every component of Van Dyck's
composition: the motif of the Virgin revealing the child, the excited postures of the
shepherds as they witness for the first time the sleeping infant, and the flying putti
who carry the banner. Even the young shepherd's gift of a lamb to the baby Jesus, a
reference to Christ's own sacrifice for our salvation, is a traditional motif that is found
in Rubens' altarpiece for the Jesuit church in Neuburg of 1619 [fig. 1].[2]

The dependence of Van Dyck's concept on a visual vocabulary devised by Rubens
raises fascinating questions about Van Dyck's creative capacities. Since the time of
Bellori (1672) his subject paintings have been found lacking in matters of artistic
invention whereas his portraits have been greatly acclaimed. Although Bellori
admired the harmony of his colors in his religious and mythological paintings, he
criticized Van Dyck's compositions for lacking the spirit and sense of grandeur felt
before a painting by Rubens. Van Dyck's paintings, according to Bellori, were not
conceived with a conviction that brought their individual components into a unified
whole.[3] Bellori's criticism would not have had such a lasting impact in Van Dyck
literature if it did not encapsulate feelings others have had when comparing Van
Dyck's paintings to those of his former master. That criticism, however, is too severe,
for it overlooks the transformations in mood and spiritual energy that occur in Van
Dyck's distinctive interpretations of religious and mythological themes.

Compared to any of the altarpieces Rubens devoted to *The Adoration of the
Shepherds* between 1608–1620, Van Dyck's composition is, without question, more
tender and intimate. Van Dyck shifts focus from the dramatic public presentation of
the Christ Child found in Rubens' interpretation of the scene to a private, devotional
experience. The loving bond between mother and child as she looks down at him and
holds him to her, for example, is unparalleled in the older master's work. Although
an aura of divinity radiates from Christ's head, he does not give forth the blinding
light that creates the powerful chiaroscuro contrasts or expressive gestures seen in
Rubens' paintings. The shepherds, who have come to honor the Christ Child,
genuflect reverently before him; they react to the strong emotions aroused by seeing
him rather than to the heavenly light that so emphatically announces his divinity. As
is fitting in a church devoted to the Virgin, Van Dyck stresses Mary's nurturing and
supportive role in her son's life. Implicit also in her gesture is that she is the one who
will serve as an intercessor for those who wish to come into his presence.

The shift in emphasis in Van Dyck's rendering of the scene also parallels liberties
he has taken with the traditional iconography. Only two shepherds and a woman are
portrayed, whereas three shepherds are the norm. The large classical columns in the
background and stone step on which the Virgin and child are seated provide no

reference to the stable in which the child was born. These architectural elements do, however, provide a dignified setting for the adoration, one that harkens back to representations of the Virgin and Child Enthroned and Adored by Saints, as in Rubens' recently completed altarpiece in the Augustinian church in Antwerp [see cat. 46, fig. 1]. These modifications to the story did not occur because Van Dyck was unable to compose his work along the idiom developed by Rubens, as Bellori's critique of his history paintings might suggest, but rather because his focus was on the devotional rather than the narrative.[4] Van Dyck's emphasis on the quiet, meditative character of the scene also signals a movement away from the strict tenets of Counter-Reformation thought, where adherence to the biblical text was given the highest priority.[5]

Van Dyck executed a related composition, which is now in the Kunsthalle, Hamburg [fig. 2]. Although various oil sketches are known for this latter version, no sketches have survived for the Dendermonde altarpiece.[6]

A. K. W.

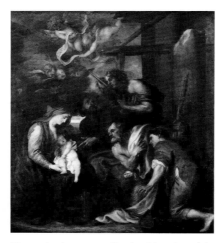

Fig. 2. Anthony van Dyck, *Adoration of the Shepherds*, c. 1626–1628, canvas, 228 x 198 (89 3/4 x 78). Hamburger Kunsthalle, Hamburg

Fig. 1. Peter Paul Rubens, *Adoration of the Shepherds*, altarpiece for the Jesuit church in Neuburg, 1619, canvas, 475 x 270 (187 x 106 1/4). Alte Pinakothek, Munich

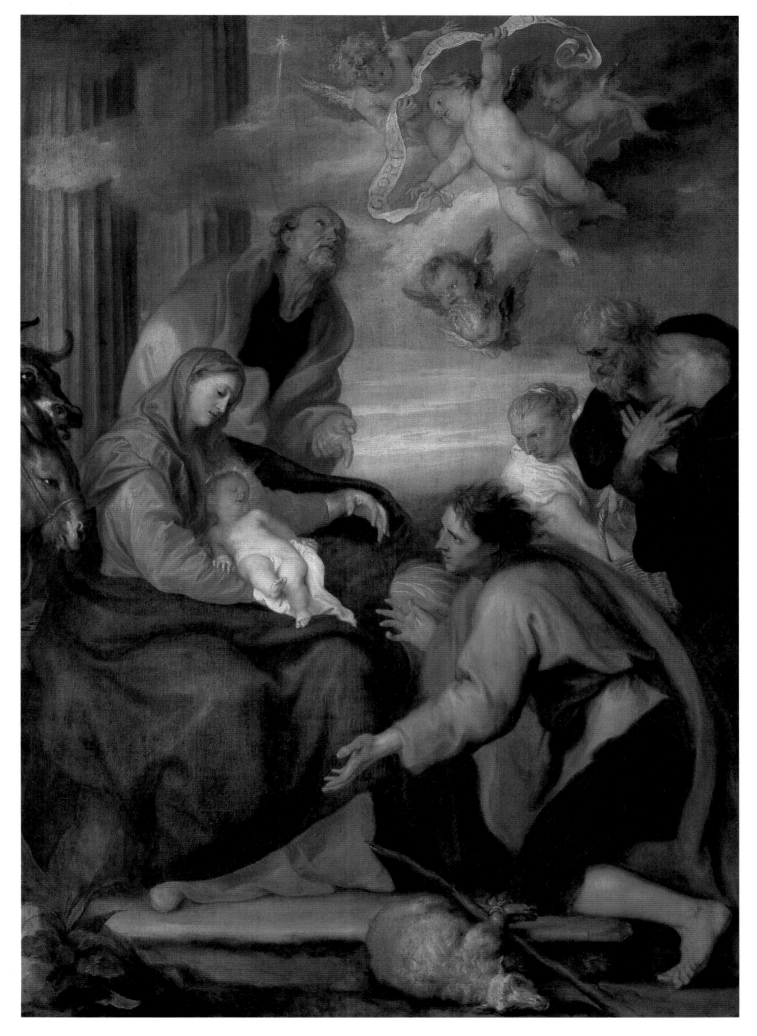

62
King Charles I and Queen Henrietta Maria

1632
canvas, 113.5 x 163 (44 1/4 x 63 1/2)

Státní Zámek, Kroměříz, Czechoslovakia

PROVENANCE Royal Collection, Commonwealth sale, September 1649, sold to John Jackson, an agent for various collectors; Inventory of Franz and Bernhard von Imstenraed, Cologne, 1673; Bishop Earl Karl von Liechtenstein, Olomouc

LITERATURE Millar 1962, 329, ill. 7; Eduard A. Safařík, "The Origin and Fate of the Imstenraed Collection," *Sborník Prací Filosofické Fakulty Brnenské University* 13 (1964), 176; Uměleckohistorické Muzeum, *Obrazárna Kroměřízského Zámku* (Kroměříz, 1964), 55, no. 0 406, 112 ill.; Parry 1981, 220; Cleveland Museum 1982, 15, ill. 6b; Wiemers 1987–1988, 263–264, ill.; Larsen 1988, no. 806, ill. 291

1. Cust 1900, 97.
2. Of the many excellent biographies of Charles I, particularly useful is Richard Ollard, *The Image of the King: Charles I and Charles II* (New York, 1979); Pauline Gregg, *King Charles I* (London, 1981). For an understanding of the court of Charles I, see in particular Parry 1981.
3. For biographical information on Henrietta Maria, see Carola Oman, *Henrietta Maria* (London, 1936, repr. London, 1951); Quentin Bone, *Henrietta Maria: Queen of the Cavaliers* (Urbana, 1972). For the importance of Henrietta Maria's Catholicism and its relationship to the queen's Neoplatonic ideals, see Erica Veevers, *Images of Love and Religion: Queen Henrietta Maria and Court Entertainments* (Cambridge, 1989).
4. As quoted in Bone 1972, 22.
5. For excellent analyses of this painting, see Millar 1962, 329; and Parry 1981, 220.
6. Millar 1962, 329, has also emphasized that the symbolic gifts relate to the contrasting character of the ancestry of the king and queen. The olive branch offered by Charles I represents the peacemaking activities of his father, James I; whereas the wreath of victory has associations with the warrior king Henry IV, father of Henrietta Maria. The fusion of these two traditions in their marriage was celebrated as well in Ben Jonson's masque, *Loves Wel-come ... at Bolsover*, 1634.
7. The original form of Mytens' composition is preserved in a copy at Welbeck Abbey. For a discussion of Mytens' painting and its relationship to Van Dyck's image see Millar 1962, 329. For an illustration of this work see also Royal Collection 1963, fig. 12.
8. Royal Collection 1963, 97, cat. 147.
9. The quotation is taken from Millar 1960a, 105.
10. For Mytens, see Ter Kuile 1969, 1–23.
11. Millar 1962, 329.
12. Safařík 1964, 171–182.
13. The inventory is published in Mary F. S. Hervey, *The Life, Correspondence and Collections of Thomas Howard, Earl of*

None of Van Dyck's remarkable achievements match the impact he has had on history's perception of the character of the court of Charles I and Henrietta Maria. With his arrival in London in the spring of 1632, the monarchy, which had been searching for a unifying visual image that would convey not only its divine right rule but also the ideals of peace and harmony that underlay its philosophy of government, found an artist whose gifts perfectly matched its needs and aspirations. In this remarkable double portrait of the king and queen, painted shortly after Van Dyck had become painter to the court, their transformation from mere mortals to romantic heroes "with an indefinable look of destiny" in their eyes was immediate and complete.[1]

The circumstances that led to Van Dyck's decision to go to England, a move that had import for both the artist and the history of English painting, have never been totally understood. Relationships between the artist and those close to Charles I had become so intertwined that no single influence can be given full credit. Undoubtedly the friendship and support he had received from the earl and countess of Arundel ever since the earl had first brought Van Dyck to England in 1620 were important, particularly because Arundel had regained political favor after the assassination of the duke of Buckingham in August 1628 [see cat. 76]. When Van Dyck moved to England in March 1632, he lived with Edward Norgate, an artist and writer in the service of Arundel. Norgate was also the brother-in-law of Nicholas Lanier [cat. 48], a relationship that suggests that Lanier, who had presented his portrait by Van Dyck to the king, would have looked favorably upon Van Dyck's arrival. Influential too was Endymion Porter, who, as one of the Grooms of His Majesty's Bedchamber, had been instrumental in commissioning Van Dyck's imposing *Rinaldo and Armida* for the king in 1629 [see cat. 54]. Sir Balthasar Gerbier, who was in the employ of the Lord Treasurer Richard Weston as an agent in Brussels, seems also to have discussed with Van Dyck the possibility of his coming to England [see cat. 55]. Even the queen mother of France, Maria de' Medici, probably added to his reputation. Cust speculated that she may have recommended the artist to her daughter Henrietta Maria after Van Dyck had painted the queen mother in Antwerp during her exile at the court of the Infanta Isabella in Brussels. Whatever the causes, Van Dyck's association with the English court of Charles I and Henrietta Maria constitutes one of the most fortuitous patron-donor relationships in history.

The England to which Van Dyck came in the spring of 1632 was a prosperous and peaceful realm. It was ruled by a monarch whose love of art and awareness of its propagandistic potential had transformed the English court into one of the leading cultural centers of Europe. The remarkable life of Charles began on 19 November 1600 at Dunfermline Palace, twelve miles outside Edinburgh.[2] His Scottish heritage remained extremely important to him throughout his life even though he was brought to London in 1604, shortly after his father James VI, king of Scotland, became King James I of England. Sickly and small of stature as a child, he grew up in the shadow of his older brother Henry. Henry, however, died in 1612; and Charles, who stammered badly and was painfully shy, was soon thrust into a role for which he seemed ill-suited.

The court of James I, which was often coarse and crude, held little attraction for the idealistic young prince of Wales. With his brother dead and his sister Elizabeth married to Frederick, elector of the Palatinate, he felt quite alone. Soon, however, one of James' favorites, George Villiers, befriended Charles, and the two became inseparable companions. Villiers, good-looking, charming, and ambitious, and who later was elevated to the title of duke of Buckingham, epitomized Castiglione's ideal of the courtier. Under Buckingham's influence, Charles began to develop his sense of style, his love of art and adventure. His remarkable escapade to Madrid in 1623, where he traveled incognito and on horseback with Buckingham and two other companions to try to woo the Infanta Doña Maria, underscores the chivalrous

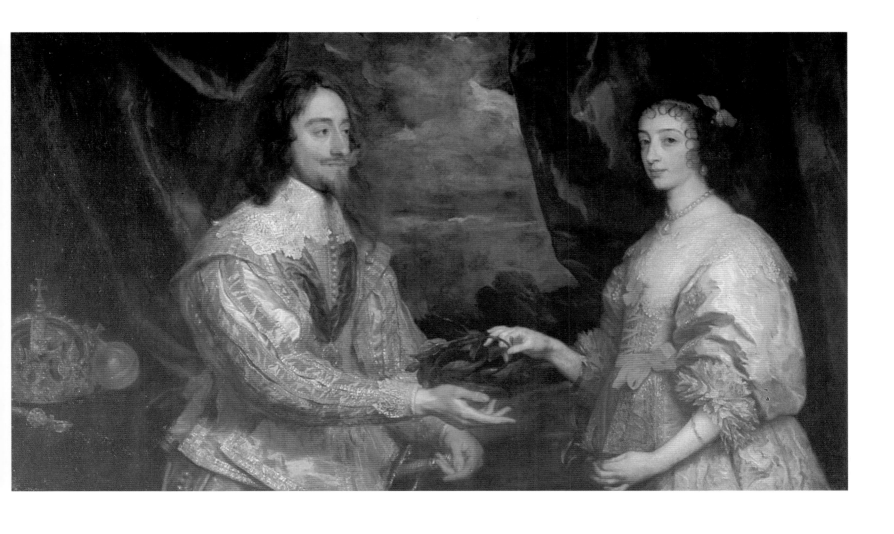

Arundel (Cambridge, 1921), appendix v, 473–500. The double portrait is no. 123 of the inventory. The connection between this painting and the Arundel collection was first made by Safarík 1964, 176.
14. The best-known version is owned by the duke of Grafton at Euston Hall. See Glück 1931, 374. A reduced copy, perhaps by Gonzales Coques, is in the Victoria and Albert Museum, London (45.78.5, Townshend Bequest). A fragmented version depicting the king only is in The Cleveland Museum of Art (inv. no. 16.1039).

idealism that became such an integral part of Charles' concept of the Divine Right monarch. The adventure was in part politically motivated, for he hoped that his marriage to the Infanta would be tied to an agreement with Spain to help restore the Palatinate to his sister and her husband. But, as often would be the case during his reign, his ideals were not grounded in reality. No Catholic monarch would have agreed to restore these lands to a Protestant ruler, whatever the complexities of the political arena of Europe.

With the failure of the Spanish match, inquiries were made with the queen mother of France to see whether a marriage contract could be arranged between the prince of Wales and the young Henrietta Maria. Henrietta Maria, born on 26 November 1609 and the only remaining unmarried daughter of Maria de' Medici and the late Henry IV, was an obvious, though, because of her Catholic religion, politically problematic choice.[3] She had close familial relations with many of the important figures in Europe. Her older brother was King Louis XIII of France; another brother was Gaston, duke of Orleans; her sister Elizabeth was married to King Philip IV of Spain; and her sister Christine was the wife of the powerful duke of Savoy. Her mother was a member of the Medici family and continued to have close ties with Italy. Reports to Charles, moreover, emphasized Henrietta Maria's charm and wisdom. Small of stature, she was said to be "the sweetest creature in France."[4] While England could gain no assurance during the marriage negotiations that France would come to the aid of Frederick and his wife Elizabeth, the match did serve English interests sufficiently to meet the approval of the king and Parliament.

The problematic aspect of the match, Henrietta Maria's Catholicism, was an issue that continued to stir the passions of Charles' countrymen throughout her reign. She had been given a dispensation by the pope to marry a Protestant prince with the understanding that she should be a guardian for Catholics in England, that she should raise her children in the Catholic faith, and that she should work for the conversion of her husband. She felt strongly about her religion and, indeed, surrounded herself with Catholic advisors when she moved to London. Undoubtedly Van Dyck's strong religious belief was one of the reasons the queen accepted him so easily into her circle of intimates.

The marriage ceremony, in which Charles participated by proxy, took place in Paris on 1 May 1625, shortly after the death of James I. The reign of Charles I thus coincided almost exactly with his union with this fifteen-year-old princess, who at this early age assumed the role of queen in a new land whose subjects not only spoke a different language, but also vilified her religion. For many reasons, including Charles' close friendship with Buckingham, the first years of their marriage were difficult. By the time Van Dyck created this magnificent double portrait in 1632, however, the king and queen had entered into a period of domestic harmony that gave strength to them both and direction to their rule. These qualities are captured here with a rare intimacy that makes this work one of the most moving of all of Van Dyck's images of the couple.

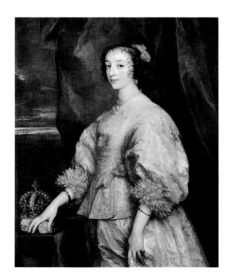

Fig. 1. Anthony van Dyck, *Henrietta Maria*, 1632, canvas, 108.6 x 86 (42 3/4 x 33 7/8). Copyright reserved to H. M. Queen Elizabeth II

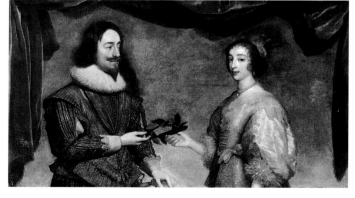

Fig. 2. Daniel Mytens, *Charles I and Henrietta Maria*, 1634, canvas, 95.3 x 175 (37 1/2 x 68 7/8). Copyright reserved to H. M. Queen Elizabeth II

In this tender image Charles gestures toward Henrietta Maria as she holds in her left hand an olive sprig he has just handed her. She, in turn, reaches out to hand him a laurel wreath.[5] The symbolism is clear. Their loving union, which is so evident in the gaze of Charles as he looks longingly at Henrietta Maria, will insure that the gifts of peace and victory they exchange will benefit the entire realm, signified by the landscape behind them.[6]

The informality and naturalism of the attitudes and gestures of the king and queen, qualities that give the image such conviction, are all the more remarkable when it is discovered that Van Dyck has here, as is so often the case with his portraits, adapted the compositional device of another artist. Daniel Mytens (c. 1590–1647), who was Dutch in origin but who had been court painter for Charles I since 1625, had executed a similar double portrait of the king and queen, which had been placed at Somerset House just prior to Van Dyck's arrival in England.[7] Mytens' comparatively stiff portrayal, however, must have appeared decidedly outmoded after Van Dyck painted his initial images of the king and queen in 1632 [fig. 1]. The figure of the queen in Mytens' double portrait was ordered painted over in a Van Dyckian style [fig. 2]. Perhaps because this "improvement" to Mytens' painting was deemed unsuccessful, Van Dyck was apparently commissioned to create a totally new painting for Somerset House. Although Van Dyck must have asked the king to sit anew, he based Henrietta Maria's pose on the half-length portrait of the queen that had served as the model for the reworking of Mytens' painting [fig. 1].[8] Van Dyck's double portrait replaced Mytens' painting at Somerset House, where it hung "above the Chimney in the wth drawing-roome otherwise Called the great Cabbonett."[9] The consequences for Mytens were disastrous. The humiliation signaled the end of his tenure in England, and by 1634 he had returned to the Netherlands to work at the court in The Hague.[10]

The exhibited painting's history since the early 1630s is not precisely known. It was valued at £60 in the Commonwealth sale in September 1649, which was held after the king's death, and sold to John Jackson, an agent who acquired 116 pictures on behalf of various clients. In 1672 Jaspar Duart of Antwerp petitioned Charles II for the discharge of certain goods, including this painting, that had been secured by his brother James.[11] Whether or not the painting was available at that late date is debatable, for in 1673 it was listed in the inventory of the brothers Franz and Bernhard von Imstenraed when their collection was acquired by the Bishop Earl Karl von Liechtenstein from Olomouc.[12]

In 1691 Liechtenstein bequeathed the collection to the bishopric of Olomouc where it was housed in the bishop's palace. Somewhat later much of this collection was transferred to Kroměříz, where it has remained ever since. Just where the Von Imstenraeds acquired the painting is a matter of dispute. They were friends of Eberhard Jabach from Cologne and may have attended the sale of the king's collection with him in 1649. It is also known that they purchased paintings from the countess of Arundel. The fact that there existed in the 1655 inventory of the Arundel collection a double portrait of the king and queen has raised the possibility that this painting came through the Arundel family.[13] Since the earl and countess of Arundel, however, had left England in the early 1640s and lived in exile thereafter, it seems unlikely that the countess, a widow after 1646, would have purchased works of art at the Commonwealth sale of 1649. Most likely the painting in the Arundel inventory of 1655 was one of the many copies of this composition that are still known to exist.[14]

A. K. W.

63
Philip, Lord Wharton

1632
inscribed (lower left) *P. Sr Ant: vandike*
and (lower right) *Philip Lord
Wharton/1632 about ye age/of 19.*
canvas, 133 x 106 (52$^1/_2$ x 41$^7/_8$)

National Gallery of Art, Washington,
Andrew W. Mellon Collection, 1937.1.50

PROVENANCE Philip, Lord Wharton
(1613–1696), Winchendon, near
Aylesbury, Buckinghamshire; purchased
from his heirs in 1725 by Sir Robert
Walpole (1676–1745), 1st earl of Orford,
Houghton Hall, Norfolk; inherited by his
grandson George (1730–1791), 3d earl of
Orford; acquired by Catherine II,
empress of Russia, in 1779 with the
Walpole Collection; Hermitage,
Leningrad; purchased in 1932 by
Andrew Mellon

EXHIBITIONS Amsterdam, Rijksmuseum,
Orange-Nassau Exhibition, 1898; Ant-
werp 1899, no. 85; London 1900, no. 61

LITERATURE Houghton Hall 1752, 52;
Walpole 1876, 1:322, 329; Hermitage
1864, 150, no. 616; Hermitage 1870, 73,
no. 616; Pol de Mont, *Antoine Van Dijk:
choix de 60 phototypies* (Haarlem, 1899), 4,
pl. 2; Cust 1900, 121, 213, no. 85, 286, no.
222; Rooses 1900, 81–82; Schaeffer 1909,
509, no. 303; Réau 1912, 474, ill. 475;
Hermitage 1923, ill. 240; Vertue
1930–1955, 22:11–12; Glück 1931, XLIV,
ill., 397; Tolnay 1941, 197; Van Puyvelde
1946, 66; Van Puyvelde 1950, 173;
National Gallery Washington 1975, 118,
no. 50; Brown 1982, 202, pl. 207; London
1982–1983, 101, ill. 47; National Gallery
Washington 1985, 144; Larsen 1985, 195,
no. 152; Larsen 1988, no. 1029, ill. 325

1. Lord Wharton eventually played an
active role in England's tumultuous
political events around mid-century.
During the 1640s he became a strong
parliamentarian and supporter of
Cromwell. He spent forty-six years in
Parliament (from 3 November 1639 to 15
May 1685) and was speaker of the House
of Lords from 1642–1645. He was also
summoned to Cromwell's House of
Lords 10 December 1657, and to Richard
Cromwell's Parliament 27 January
1658–1659. When Charles II returned to
England, Lord Wharton went to meet the
king at the landing, even though he
sided with the opposition in Parliament.
As a result of these political activities, he
was imprisoned in the Tower of London
for 18 months in 1676–1677. In 1688 he
was one of the first to support the prince
of Orange as king of England. He died in
1696.
2. Brown 1982, 165.
3. Vertue 1930–1955, 18:29, 109;
22:11–12. By the early eighteenth
century, during the life of Lord
Wharton's son, the marquess of
Wharton, the gallery was extremely
imposing and quite famous. Houbraken
1753, 1:147, noted that the collection
consisted of thirty-two paintings by Van

Philip, Lord Wharton looks alertly out at the viewer with steadfast gaze as he stands
before a shimmering green drapery that hangs, somewhat incongruously, over a rock
cliff behind him. The setting, Lord Wharton's clothing, and the casual ease with
which he assumes his stance as he encompasses the *houlette* in the crook of his arm
give an Arcadian character to the portrait, one, however, that is aristocratic in
essence. Every facet of it, from the refined grace of the pose to the elegant collar,
stylish cut, and expensive materials of the plum-colored velvet doublet jacket,
reinforces the sense of refinement and breeding so evident in Wharton's handsome
young face.

Philip, the 4th Lord Wharton, born 18 April 1613, was the eldest son of Sir Thomas
Wharton (1587–1622) and his wife, Philadelphia Carey (d. 1654), daughter of Robert,
1st earl of Monmouth. During the 1630s Philip was a prominent member of the court
and was on good terms with the king and queen.[1] As late as 1638 King Charles had
commissioned portraits of himself and Queen Henrietta Maria to be given to Lord
Wharton.[2] These were undoubtedly intended for a special gallery of portraits that
Philip constructed in his house at Winchendon near Aylesbury after his second
marriage, to Jane, daughter and heiress of Arthur Goodwin, in 1637. Vertue wrote
that in his gallery were twelve full-length and six half-length portraits by Van Dyck.[3]
Indeed, during the late 1630s Lord Wharton was one of Van Dyck's most important
patrons.

Philip, Lord Wharton's identity as well as the date of the painting and the sitter's
age are inscribed in the lower right.[4] Although this inscription as well as that in the
lower left identifying the artist as Van Dyck is old, it was only added after Van
Dyck's lifetime. The identity and dates provided, however, are undoubtedly correct.
In all probability this portrait was commissioned to commemorate Philip's marriage to
his first wife, Elizabeth, daughter of Sir Rowland Wanderford of Pickhill, Yorkshire, in
September 1632.

The portrait must have been one of the earliest private commissions Van Dyck
received after he arrived in England in March 1632. Although his fame as "Principal
Painter in Ordinary to their Majesties" was fully established by July of that year when
he was knighted at St James's, during his first months in London he was preoccupied
with portraits of the king and queen, images that convey the studied informality and

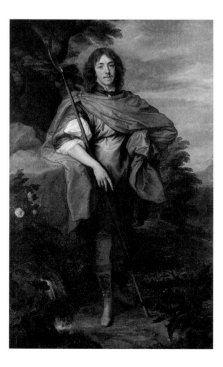

Fig. 1. Anthony van Dyck, *Lord George
Stuart*, c. 1638, canvas, 218.4 x 133.4
(86 x 52$^1/_2$). National Portrait Gallery,
London

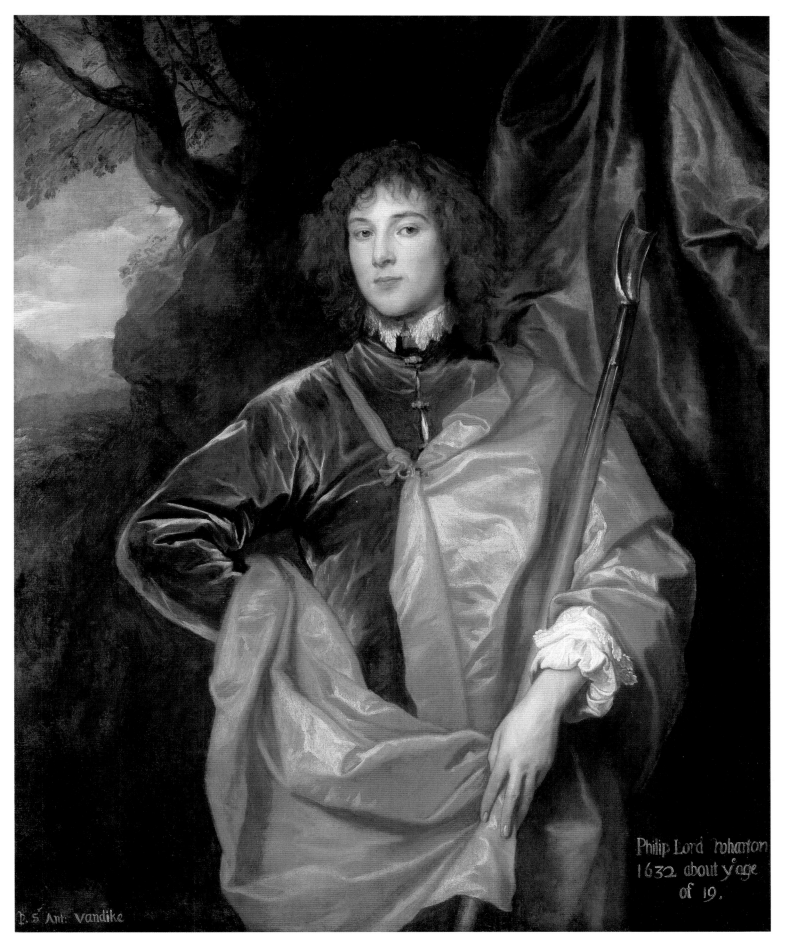

Philip Lord Wharton
1632 about y' age
of 19.

P. S. Ant: Vandike

Photographed during conservation treatment

Dyck, including fourteen full-length portraits.

4. This same type of inscription appears on other paintings owned by Lord Wharton. See Millar in London 1982–1983, cats. 51, 52, 55, 56.

5. This association was made explicit by Van Dyck some years later in *Lord George Stuart* [fig. 1], which also seems to have been commissioned to commemorate a marriage. In this painting the Latin phrase ME FIRMIOR AMOR is inscribed on the rock, while roses and a thistle, symbolic of love and constancy, grow from the ground.

grace characteristic of the Caroline court [see cat. 62]. This elegant portrait of Lord Wharton captures another aspect of the underlying philosophy of that court, the association of the Neoplatonic ideals of beauty and idyllic love with an Arcadian existence.[5]

Philip, Lord Wharton's pose has no direct prototypes in Van Dyck's œuvre, but the artist drew upon conventions he had been developing during his second Antwerp period. For example, Van Dyck portrayed Nicholas Lanier [cat. 48] in a similar manner, and this painting, which was in Charles I's collection, would certainly have been known to Lord Wharton. Van Dyck's portraits of Prince Charles Louis and Prince Rupert of the Palatinate [see cat. 70, fig. 1], the sons of Elizabeth, the sister of Charles I of England, and her husband the elector Frederick, also possess the studied nonchalance and dignity of character projected by Lord Wharton.

Despite these similarities, the portrait of Lord Wharton has a different mood. It possesses a gentleness and softness in which the figure and landscape are brought into harmony. The rich colors and sensitive modeling, which have been further revealed during the recent restoration of the painting, are among those qualities admired by the many critics who consider this one of Van Dyck's major achievements of his English period. Indeed, seldom has Van Dyck seemed more in sympathy with his sitter and with the philosophical concepts underlying his portrait.

A. K. W.

64
Venetia Stanley, Lady Digby, as Prudence

1633

canvas, 100.9 x 80 (39 3/4 x 31 1/2)

National Portrait Gallery, London

PROVENANCE Sir Kenelm Digby;
probably in collection of Cardinal
Mazarin (in his inventory 1661, no. 1235);
Thomas Walker; Mr. Skinner; Sir Eliab
Harvey, Rolls Park, Essex; Robert Fane;
Mrs. B. Gibbs; Christie's, 29 June 1962,
lot 69; private collection, England

EXHIBITIONS London, Agnew's (King's
Lynn Festival Fund), 1963, no. 23;
London 1968a, no. 43, ill. 43; London
1972–1973, no. 107; London 1982–1983,
no. 9

LITERATURE Bellori 1672, 261; Smith
1829–1842, 3:186, no. 636; Walpole 1876,
1:323; Glück 1931, 563 (under n. 399);
Vertue 1930–1955, 22:141, and 26:179;
Royal Collection 1963, 107–108, under no.
179; De Jongh 1975–1976, 69–97; Gaunt
1980, 106; Larsen 1988, no. A 219/4

1. For a discussion of masques in the
court of Charles I, see Parry 1981,
184–229.
2. These putti were taken over by David
Teniers in his allegorical painting of *Faith*
(Hermitage, Leningrad). See De Jongh
1975–1976, 78–79 ill.
3. Bellori 1672, 261.
4. The program as described by Bellori
may reflect the program given to Van
Dyck by Digby rather than the somewhat
reduced allegory the artist actually
executed.
5. The translation is taken from Royal
Collection 1963, 107.
6. After the poet's death in 1637, Digby
undertook to publish his writings in
1640–1641.
7. See De Jongh 1975–1976, 96–97, for a
discussion of Ripa's text. De Jongh also
argued that the pearls around Lady
Digby's neck symbolize the virtue of
chastity.
8. It appeared in his inventory of 1661,
no. 1235 (measurements given were
36 x 29 in.). See Comte de Cosnac, *Les
Richesses du Palais Mazarin*, Paris, 1884,
337–338.
9. Vertue 1930–1955, 22:141.
10. Quoted from Giles Waterfield's fine
entry on Van Dyck's painting *Lady Vene-
tia Digby* in Washington 1985–1986a, 54.
11. See Washington 1985–1986a, 56, for
excerpts from an elegy written by Ben
Jonson.
12. Walpole 1876, 1:323, n. 3, also
describes a sculpted monument Digby
had erected in her memory.
13. See Glück 1931, 398, for a version of
this composition.
14. For an argument that this painting is
a posthumous representation of Venetia
Digby, see J. Douglas Stewart's essay in
this catalogue.
15. For further information on Digby, see
Brown 1982, 144–150.

Within the masques of the Caroline court, an elaborate vocabulary had developed by the early 1630s for alluding to the virtues of love and purity that were embodied in the enlightened rule of Charles I and Henrietta Maria. The intellectual and philosophical climate that fostered these literary and dramatic productions also affected the visual arts, specifically this portrait of Venetia Digby (1600–1633) as Prudence. In an allegorical image so complicated that its program almost certainly stemmed from Venetia Digby's husband, Sir Kenelm Digby (1603–1665), Van Dyck sought to portray the triumph of Venetia's prudence and chastity over the evils of deceit and unrestrained passion.

Conceptually, the relationships between this painting and the masques are many. Just as in performances held at Whitehall where the king and queen joined with other members of the court as actors in the dramas, so here has Venetia Digby assumed the lead role in this allegory as she calmly holds a snake in one hand and rests the other on a turtledove. The form of the masque, as developed by Ben Jonson and evident in *Love's Triumph through Callipolis* and *Chloridia*, both of which were performed in 1631, was that the heroes would overcome evils personified in an anti-masque. In *Chloridia*, for example, which glorified an ideal world where earth was made coequal with heaven, the anti-masque presented the revolt of Cupid and the unleashed passions of jealousy and anger. After unruly love, in the guise of Cupid, had been subdued by Juno, goddess of marriage, the queen appeared as Chloris, goddess of the earth. The landscape setting changed to a colorful springtime vista signaling that earth now equaled heaven in its splendor.[1] In this painting Venetia likewise sits in a calm, Arcadian landscape, having conquered unrestrained passion (the figure of Eros, whom she suppresses under her foot) and Deceit (the crouched male figure who wears a mask on his head). Overhead three putti mark her victory with a wreath of laurel.[2]

The specific program for a larger version of this composition was recounted by Bellori as it was told to him by Sir Kenelm Digby in the mid-1640s.[3] Although the description does not accord precisely with the image as it is known today, the message in both instances is the same.[4] Van Dyck, according to Bellori, had depicted Venetia Digby "as Prudence, sitting in a white dress with a coloured wrap and a jewelled girdle. Under her hand are two white doves, and her other arm is encircled by a serpent. Under her feet is a plinth to which are bound, in the guise of slaves, Deceit with two faces; Anger with furious countenance; meagre Envy with her snaky locks; Profane Love, with eyes bound, wings clipped, arrows scattered and torch extinguished; with other naked figures the size of life. Above is a glory of singing Angels, three of them holding the palm and the wreath above the head of Prudence as a symbol of her victory and triumph over the vices, and the epigram, taken from Juvenal, NULLUM NUMEN ABEST SI SIT PRUDENTIA [The prudent will not look in vain for Heaven's help]."[5]

Digby, who was a close friend of Ben Jonson, may well have spoken to the poet and playwright about the allegorical concept for this visual ode to his wife's constancy.[6] Underlying the iconographic program was clearly the admonition in the Book of Matthew 10.16: "Behold, I send you out as sheep in the midst of wolves; so be wise as serpents and innocent as doves." Digby and Van Dyck must also have consulted emblem books, specifically Cesare Ripa's *Iconologia* from which they drew emblematic references from both Castita and Prudenza: from Chastity are taken the turtledoves and from Prudence the snake.[7] Van Dyck drew upon his combined experiences in portraiture and mythological painting to translate Digby's conception into an effective pictorial image. Guiding him in this respect was certainly the visual vocabulary devised by Rubens for the Maria de' Medici series as well as Rubens' allegorical representation of Charles I and Henrietta Maria in his *Landscape with Saint George and the Dragon*, which he had executed in London in 1630 and had brought back with him to Flanders.

The large painting of Venetia Digby as Prudence so pleased Van Dyck, according to Bellori, that he made a reduced version, which is the work here exhibited. Bellori also added that both the large and small versions were taken to France during the Civil War, almost certainly by Digby when he served as chancellor to Queen Henrietta Maria when she was in exile in Paris. Indeed, this small version of the composition seems to have been owned by Cardinal Mazarin by 1661.[8] It had been returned to England by the mid-eighteenth century, having been seen in the collection of Thomas Walker by Vertue in 1748.[9]

The circumstances that prompted Digby to commission this allegorical painting from his friend Van Dyck can be deduced from Digby's passionate defense of his wife's constancy in his *Private Memoirs* (published in 1827). Venetia Digby was born Venetia Stanley in 1600, the daughter of Sir Edward Stanley and Lady Lucy Percy. In her youth she was said to have been romantically involved with more than one nobleman, and her reputation was such that Digby's family opposed the marriage, which occurred secretly in 1625. In his *Private Memoirs* Digby went to some length to rebut the rumor about her loose morals, "that monster which was begot of some fiend in hell. …"[10] From all accounts, Venetia Digby was exceptionally beautiful, witty, and noted for "the sweetness of her disposition." She was beloved by those who knew her and mourned deeply at her sudden and premature death in May 1633.[11] Sir Kenelm was so devastated at her death that he asked Van Dyck to draw her on her deathbed.[12] His tender painting depicts Venetia lying peacefully as though asleep with only a rose, whose petals have been pulled from the stem, signifying that her life had been so abruptly ended in its prime [fig. 1]. It has been assumed that the allegorical painting of Venetia Digby as Prudence was also commissioned after her death. In this instance, Van Dyck could have used as a model the image of Venetia Digby in his portrait of the Digby family he had painted in 1632.[13] As the allegory contains no overt allusion to death, it is also possible that it was conceived and executed during her life, and thus prior to May 1633.[14]

Digby, who was a Catholic, remained a close friend of Van Dyck.[15] He sat to Van Dyck for a portrait in 1633, but also commissioned a number of religious and allegorical paintings that are now unfortunately lost. These works include a *Descent from the Cross*, a *Saint John the Baptist*, a *Magdalene*, a *Crucifixion*, and a *"Brown Lady" Dressed as Paris*. Had these paintings survived, they would provide a far different image of Van Dyck's creative endeavors during the 1630s than is now known through the many commissioned portraits that have come to represent the achievements of his English period.

A. K. W.

Fig. 1. Anthony van Dyck, *Venetia Stanley, Lady Digby, on Her Deathbed*, 2 May 1633, canvas, 74.3 x 81.8 (29 1/4 x 32 1/4). Dulwich Picture Gallery, London

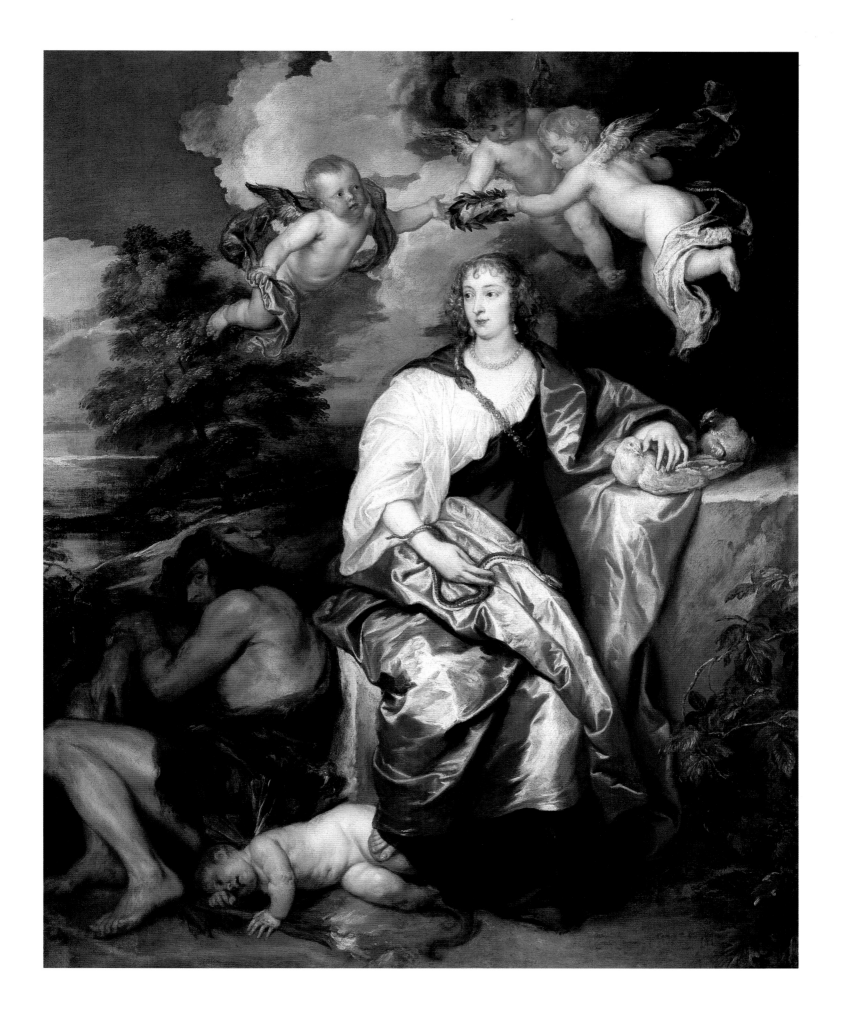

Henry Percy, 9th Earl of Northumberland

1633
inscribed *Henry Earl of/Northumberland*
canvas, 137.2 x 119.4 (54 x 47)

The National Trust, Petworth House
(Egremont Collection)

PROVENANCE Commissioned by the
sitter's son, Algernon Percy, the 10th earl
(1602–1668); his son Joscelyn, the 11th
earl of Northumberland (1644–1670); his
daughter, Elizabeth Percy (1667–1722),
who married Charles Seymour, 6th duke
of Somerset (1662–1748); his son
Algernon, 7th duke of Somerset and earl
of Northumberland and Egremont
(1684–1750); his nephew Charles
Wyndham, 2d earl of Egremont
(1710–1763); his son George O'Brien
Wyndham, 3d earl of Egremont
(1751–1837); his son George Wyndham
(1789–1869), Lord Leconfield; 3d Lord
Leconfield; as of 1947 The National Trust

EXHIBITIONS London, British Institution,
1815, no. 135; London 1982–1983, no. 13,
ill.

LITERATURE Peter George Patmore,
British Galleries of Art (London, 1824), 87;
Smith 1829–1842, 3:176, no. 608; Waagen
1854, 3:34–35; Walpole 1876, 1:330; Cust
1900, 120, 279, no. 143; Petworth 1920,
29, no. 223; Petworth 1954, 14, no. 223,
20 (opp.), ill.; Brown 1982, 201–202, ill.
205; London 1982–1983, 54; Peacock
1985, 139–157; Larsen 1988, no. 928,
ill. 928

1. Waagen 1854, 3:34–35.
2. London 1982–1983, 54.
3. London 1982–1983, 54.
4. *Dictionary of National Biography* 44
(1895), 411–413.
5. G. R. Batho, "The Wizard Earl in the
Tower," *History Today* 6 (1956), 345–351.
6. John William Shirley, "The Scientific
Experiments of Sir Walter Raleigh, The
Wizard Earl, and The Three Magi in the
Tower 1603–1617," *Ambix* 4 (1949), 52–65.
7. The poem is quoted in Peacock 1985,
142.
8. For excellent studies on Melancholia,
see L. Babb, *The Elizabethan Malady* (East
Lansing, Michigan, 1951); and Roy
Strong, "The Elizabethan Malady:
Melancholy in Elizabethan and Jacobean
Portraiture," *Apollo* 79 (1964), 264–269.
9. Reproduced in Strong 1964, 264.
10. The text reads: DIS …/QUID …/VERO
AD …/RATIO GRAVIOR …/EADEM SIT DISTA
…/GRAVE APPENDITIVR ADDISTANTIA/IN
QVA GRAVIVS FIET AEQVILIBM. The text
and diagram have been persuasively
analyzed in Peacock 1985.
11. Batho 1956, 350.
12. Peacock 1985, 150, reported that
Arundel welcomed Northumberland in
"a most public and it would seem
symbolic fashion" upon his release from
the Tower in 1621.

The indefatigable Gustav Waagen, who had a keen appreciation of Van Dyck, was greatly moved by this portrait when he saw it for the first time in 1850 at Petworth House: "This picture belongs in every respect to the great masterpieces of Vandyck. The noble and melancholic features tell the tragic history of a whole life, and the spectator hardly needs to be told that this nobleman was confined for 16 years in the Tower."[1] Indeed, the haunting quality of this brooding image, which seems especially forceful among Van Dyck's graceful portraits of members of the Caroline court, reveals an aspect of his genius that Van Dyck was only rarely allowed to express fully.

The persuasive character of the portrait is all the more remarkable in that Van Dyck almost certainly never met Henry Percy, who died on 5 November 1632 at Petworth where he had lived the last years of his life. It seems unlikely that the artist, who only arrived in England in March and who was kept busy with large commissions from the royal family, would have had the opportunity to travel so soon to Petworth. Moreover, the earl was sixty-eight at his death, far older than the rugged features in the portrait would indicate. As early as 1652 a source notes that the painting was based on an earlier prototype. The observation was made by Richard Symonds when on 27 December of that year he saw the painting at Northumberland House: "Another of his Ancestors an old man sitting in a Gowne & leaning on a Table, done by an old picture."[2]

Depicting ancestors on the basis of old pictures was a task faced by many portrait painters, particularly at this time when families were determined to assert their ancient prerogatives. Van Dyck had already had at least one such commission in Genoa, when he was asked to paint Raphael Racius (National Gallery of Art, Washington), an early sixteenth-century ancestor of the Racius family. In England he was called upon at least two other times to paint ancestral portraits, for the royal family (portraits of James I and Henry, Prince of Wales) and for the earl of Pembroke.[3] In no other instance, however, did Van Dyck so completely capture a sense of the living presence of the sitter, an achievement that certainly reflects far more his empathy with Henry Percy's character than the artistic merits of the lost portrait upon which he based his interpretation.

Henry Percy's cruel fate was being suspected as a conspirator in the "gunpowder plot" when it was revealed on 5 November 1605. Although he had protested the persecution of Catholics, it seems unlikely that he was actively involved in an attempted overthrow of the government. By 1605 he had returned from court to his country home to devote himself to private pursuits, including his gardening and scholarly interests. Nevertheless, he was tried and found guilty in 1606. He was fined and sent to the Tower where he remained until he was released in July 1621.[4]

Percy's quarters in the Tower were less austere than one might think. He actually had a large suite of rooms, and for a while as many as twenty servants to attend him. He had visitors and entertained them with festive meals. Most important, however, he was able to bring to the Tower large portions of his library so that he could read and converse with friends, among them the noted mathematician and astronomer Thomas Harriott, who was in his employ, and Sir Walter Raleigh, who was also confined to the Tower.[5] The books in his library, which included mathematical treatises and those on the occult, as well as the scientific experiments he undertook during these years, earned him the designation "The Wizard Earl."[6]

Henry Percy's fascination with finding the underlying truths of nature in mathematical and occult studies had developed during the 1590s, as is evident in a poem dedicated to him in 1593 by George Peele at the occasion of his investiture as Knight of the Garter and in a fascinating emblematic image painted in miniature by Nicholas Hilliard [fig. 1].[7] In the miniature he is portrayed as a young scholar reclining in a symbolic garden, resting his head on his hand. His pose and attitude are consistent with images of Melancholia, an attitude associated in Elizabethan

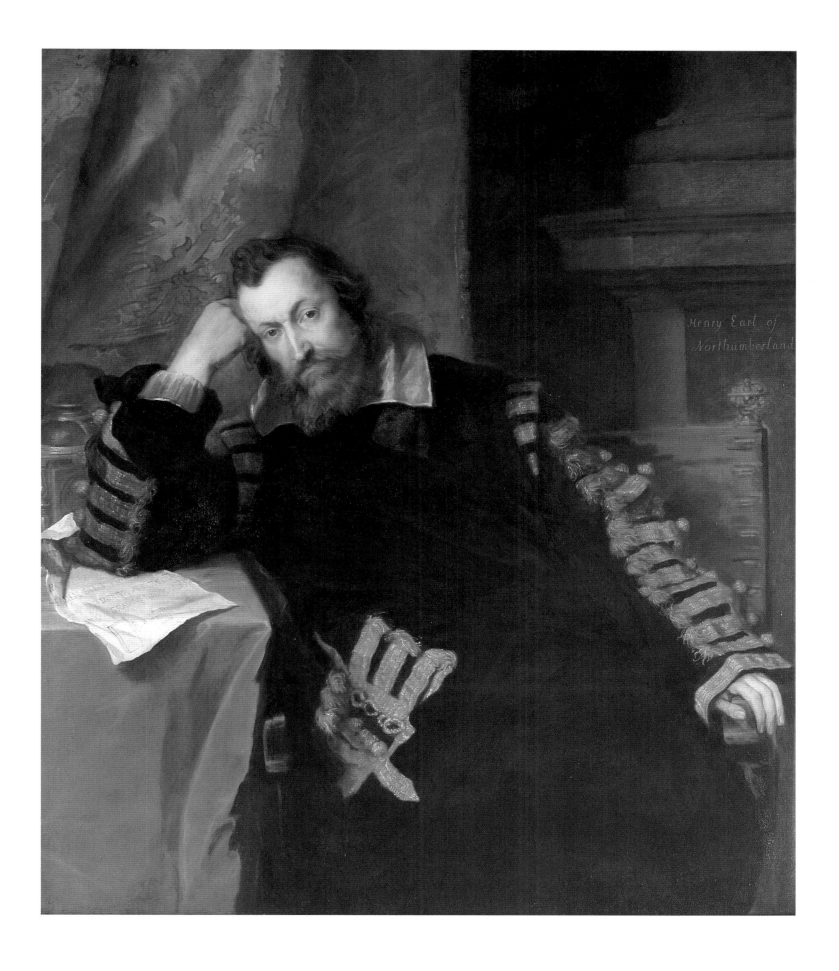

257

times with intellectual acumen and profundity, often achieved through divine inspiration.[8]

Van Dyck's image is essentially a restatement of Hilliard's miniature, with a much greater focus on the psychological characteristics of the sitter. The associations of a scholar at his desk resting his head in his hand with melancholia were by then well established in both literature and painting. Comparable figures, for example, are found in the title page to Robert Burton's *The Anatomy of Melancholy* (London, 1628),[9] and in Jan Davidsz. de Heem's painting *Man Seated at a Table*, 1628 (Ashmolean Museum, Oxford).

The specific concerns that have weighed on Percy's mind are suggested here by the clock on the table and the text and diagram visible on the paper crumpled beneath his elbow. The earl's interest in horology was well known, a study that had practical, theoretical, and moral implications. The practical is evident in the clock itself; the theoretical in the text and diagram. These are drawn from Archimedes and concern the counterbalancing of unequal weights.[10] The moral messages to be derived from this combination of elements are essentially twofold. The first is that life must be conducted with temperance, with a measured cadence that balances the extremes of reason and passion, of good and evil. The second is that life is transitory, and that even with temperance death is assured.

The complex associations found in this work, which are so different from those in Van Dyck's other portraits, suggest that he conferred closely with those familiar with the 9th earl of Northumberland. He must have studied the text and diagrams in Guido Ubaldo del Monte's Latin *Paraphrasis* of Archimedes, which was in Percy's library; likewise, he must have seen his black robe laced with gold, which the earl is known to have worn during his imprisonment.[11] Van Dyck may have received guidance from the earl's son, Algernon Percy, 10th earl of Northumberland, for whom this work was painted, but he could also have spoken with some of the subject's intimates, although both Harriott and Robert Hues, a geographer who was another of his pensioners, had died. It is not beyond the realm of possibility that Van Dyck spoke about this commission with Henry Percy's cousin who was a fellow patron of the arts and participant in a wide range of intellectual endeavors, the earl of Arundel [see cat. 76].[12]

A. K. W.

Fig. 1. Nicholas Hilliard, *Henry Percy*, 1590–1595, vellum, 25.7 x 17.3 (10 1/8 x 6 3/4). Rijksmuseum-Stichting, Amsterdam

1633
canvas, 215.9 x 127.6 (85 x 50 1/4)

The Metropolitan Museum of Art, New
York, Gift of Henry G. Marquand, 1889,
Marquand Collection, inv. no. 89.15.16

PROVENANCE Sir Paul Methuen,
Corsham Court, Chippenham, Wiltshire
(1672–1757); Paul Methuen (1723–1795);
Paul Cobb Methuen (1752–1816); Paul
Methuen, 1st Baron Methuen of Corsham
(d. 1849); Frederick Henry Paul Methuen,
2d Baron Methuen, until 1886; Henry G.
Marquand, New York, 1886–1889

EXHIBITIONS London, British Institution,
1835, no. 15; London, Royal Academy,
1877, no. 138; New York, The Metropoli-
tan Museum of Art, *Loan Collection of Old
Masters and Pictures of the English School,*
1888, 15, no. 18; Paris 1936, 21, ill.

LITERATURE H. Walpole, *Catalogue of the
Collections of Pictures of the Duke of
Devonshire, General Guise, and the late Sir
Paul Methuen* (Strawberry Hill, 1760), 30;
Britton 1801, 2:291; Corsham Court 1806,
no. 174, 96; Smith 1829–1842, 3:172, no.
594; Passavant 1836, 2:88; Waagen 1857,
396; Cust 1900, 117–118, 173, 278, no.
123; Schaeffer 1909, 371, ill., 514; British
Museum 1923, 2:67, under no. 54; Glück
1931, XLIV, 411, ill., 564–565; Metropolitan
Museum 1931, 370, v28–1; Genoa 1955,
44, under no. 93; Millar 1955, 315;
Antwerp 1960, 133–134, under no. 96;
Vey 1962, 288, under no. 214, 215;
Brussels 1965, 67, under no. 67, 303–304,
under no. 326; Edith Standen and
Thomas Folds, *Masterpieces of Painting in
the Metropolitan Museum of Art* (New
York, 1970), 40, pl.; Denys Sutton, ed.,
Letters of Roger Fry, 2 vols. (New York,
1972), 1:255; Metropolitan Museum 1980,
1:52, 3, 381, ill. 89.15.16; Brown 1982,
192, ill.; Held 1982, 334, 337, ill. no. 744;
London 1982–1983, 91; Metropolitan
Museum 1984, 1:50–54, 2: pl. 5, 38, ill.;
Müller Hofstede 1987–1988, 178; Larsen
1988, no. 968, ill. 347

Serenely self-confident, James Stuart, duke of Lennox, assumes a pose of relaxed
informality, with one hand resting on his hip and the other on a large but fawning
greyhound. Prominently displayed on his cloak is the embroidered cross of Saint
George surrounded by an aureole of silver rays signifying his membership in the
Order of the Garter. A light green ribbon with its red and gold pendant, the Lesser
George, hangs around his neck. The garter itself is visible above his left stocking.

James Stuart was elected to the Order of the Garter on 18 April 1633 to fill the
vacancy created by the death of Henry Percy, 9th earl of Northumberland [see cat.
65], and was formally installed on 6 November of that year.[1] It was almost certainly
this prestigious honor that occasioned this remarkable portrait by Van Dyck.

The Order of the Garter was an honor particularly prized in the court of Charles I.
Almost immediately upon ascending the throne, Charles had instituted certain
changes in the order to enhance its prestige, which had somewhat deteriorated since
the time of Elizabeth I. He expanded the occasions upon which knights could wear
the escutcheon as testimony to their being "persons of the highest honour and
greatest worth."[2] In 1629 he added the aureole around the cross of Saint George, in
imitation of the ensign of the French Order of Saint Esprit, an addition that not only
gave the escutcheon far greater visual prominence, but also a more pronounced
religious aspect.[3] The enormous symbolic importance Charles laid upon the order is
nowhere more strikingly evident than in his own decision to pose as a knight of the
Order of the Garter [fig. 1].

The election of James Stuart to the Order of the Garter was not unexpected.
Cousin to Charles I, Stuart had succeeded his father Esmé as duke of Lennox in
1624.[4] Following Scottish customs, Stuart's uncle, King James I, as the nearest male
relative, became his tutor and guardian. When Charles succeeded James I and
ascended to the throne in 1625, he appointed his cousin Gentleman of the Bed-
chamber and knighted him in 1630. After his studies at Cambridge and a period of
travel in Italy, France, and Spain, he was named privy councilor. James Stuart
remained close to Charles I throughout his life. When Stuart married Mary Villiers
[cat. 78], daughter of the duke of Buckingham, in 1637, the king gave away the bride.
In 1641 he was made 1st duke of Richmond. Loyal to the king throughout the Civil
War, he was nevertheless known for his equanimity and lack of enemies, even among
those opposed to Charles. He was buried in Westminster Abbey after his death
in 1655.

Van Dyck carefully planned his portrait to convey the sitter's aristocratic and quiet
demeanor. Stuart is silhouetted against a rich green drapery that acts as a foil for the

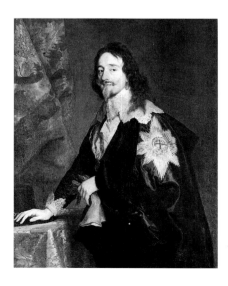

Fig. 1. Anthony van Dyck, *Charles I,*
1632, canvas, 123 x 96.5 (48 3/8 x 38).
Gemäldegalerie, Dresden

Fig. 2. Anthony van Dyck, *James
Stuart, 4th Duke of Lennox*, c. 1633,
chalk with white heightening,
47.7 x 28.0 (18 3/4 x 11). Courtesy of
the Trustees of the British Museum,
London

Fig. 3. Titian, *Charles V with a Hound,*
1533, canvas, 192 x 111 (75 5/8 x 43 3/4).
Museo del Prado, Madrid

1. George Frederick Beltz, K.H., *Memorials of the Most Noble Order of the Garter, from Its Foundation to the Present Time* (London, 1841), CLXXXVIII, no. 434.
2. Beltz 1841, XCIII.
3. See cat. 102 for a discussion of the pageant associated with the Garter Festival held on each Saint George's Day. For further discussion of Charles I's interest in the Order of the Garter see Strong 1972, 58f.
4. The following biographical information is taken from the excellent entry on this painting by Liedtke in Metropolitan Museum 1984, 1:50–54.
5. See Held 1982, 334.
6. Cust 1900, 117.
7. For a listing of copies and versions of this work see Metropolitan Museum 1984, 1:51–52. For a recent attribution see Müller Hofstede 1987–1988, 178.

long blond locks surrounding his face. At the same time the pronounced vertical in the wall at the right denotes strength of character. Most significant, however, is the devoted pose of the greyhound at his side. In preparation for this painting Van Dyck made chalk studies of both Stuart [fig. 2] and the dog (British Museum, London).

The juxtaposition of a nobleman with a dog has a long tradition in portraiture, one with which Van Dyck was extremely familiar, since Titian's magnificent portrait of *Charles V with a Hound* [fig. 3] was at that time in the collection of Charles I. In this work the large hound peers up at Charles V in much the same attitude as does the greyhound in Van Dyck's painting. Although Van Dyck may well have painted this portrait in response to the painting by Titian, the mood in the two works is very different. Whereas in the Titian the poses of the sitter and dog suggest strength and forcefulness, in the Van Dyck they convey elegance and devotion, a comparison that has led Held to a negative assessment of Van Dyck's achievement.[5]

The transformation of this motif by Van Dyck, however, should be understood as much in terms of the sitter as the artist. When painting this portrait type under different circumstances Van Dyck varied the character of the image enormously. For example, in his *Portrait of Herzog Wolfgang Wilhelm von Pfalz-Neuburg* (Alte Pinakothek, Munich), the relationship of dog to master is, in different ways, every bit as indicative of the sitter's strength and control as in Titian's portrait of Charles V. James Stuart was not a ruler but a courtier, and a young one at that, in a court that demanded allegiance and deference on the part of those associated with it. The desire for peace and harmony so prevalent in that court, even among the knights of Saint George, is underscored in this portrait and accounts for its distinctive character.

In a subsequent less formal portrait of James Stuart [fig. 4], Van Dyck once again included the greyhound. The dog in this instance may indicate James Stuart's love of the hunt, but its presence in both portraits may give some credence to an old legend that James Stuart had a special attachment to him. He is said to have saved his master's life during his travels on the Continent.[6] A number of other portraits of James Stuart, including one in the guise of Paris (Louvre, Paris), have been traditionally ascribed to Van Dyck.[7]

A. K. W.

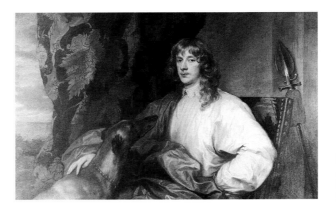

Fig. 4. Anthony van Dyck, *James Stuart, 4th Duke of Lennox and 1st Duke of Richmond*, c. 1636, canvas, 99.5 x 160 (39 1/8 x 63). Iveagh Bequest, Kenwood

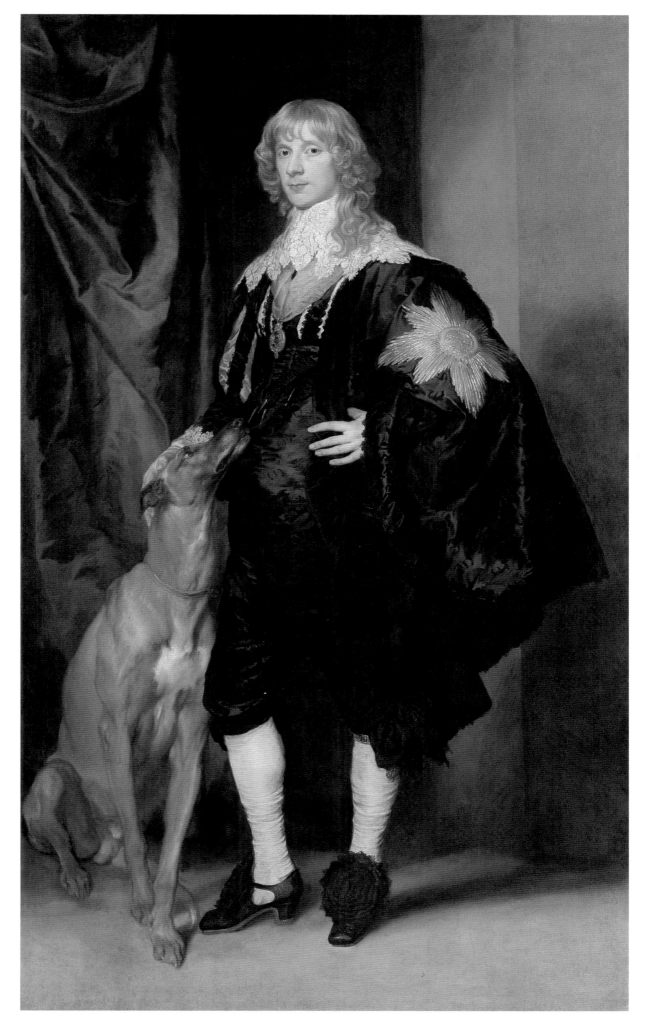

Queen Henrietta Maria with Sir Jeffrey Hudson

1633
canvas, 219.1 x 134.8 (86 1/4 x 53 1/8)

National Gallery of Art, Washington,
Samuel Kress Collection, 1952.5.39

PROVENANCE Earls of Bradford
(Newport family); by descent to Thomas,
4th earl of Bradford (d. 1762); by descent
to his sister, Diana, countess of Mount-
rath, widow of Algernon Coote of Ireland,
6th earl of Mountrath; by descent to
their only son, Charles Henry, the 7th
and last earl of Mountrath (d. 1802);
Joseph Dramer, 1st earl of Dorchester (d.
1798); by descent to Henry John, 3d earl
of Portarlington (1822–1889), Emo Park,
Queens County, Ireland; passed by
exchange in 1881 into the possession of
Thomas George, 1st earl of Northbrook
(1826–1867); by descent to Francis
George, the 2d earl of Northbrook
(1850–1946), Stratton, Micheldever,
Hampshire, until 1927; sold by Duveen
to William Randolph Hearst (1863–1951),
San Simeon, California; M. Knoedler and
Co., New York; Samuel Kress, 1952

EXHIBITIONS London, Royal Academy,
1878, no. 166; London 1887, no. 15 or 35;
London 1927, no. 146; Detroit 1929, no.
42; New York, Century Club, Masters of
Portraiture, 1938, no. 10; San Francisco,
Masterworks of Five Centuries, Golden Gate
International Exposition, 1939, no. 92; New
York, M. Knoedler and Co., A Loan
Exhibition of Allied Art for Allied Aid, 1940,
no. 3; New York, Art Objects and Fur-
nishings from the William Randolph Hearst
Collection, Saks Fifth Avenue, Gimble
Brothers, Hammer Galleries, 1941, 29;
Philadelphia Museum of Art, Diamond
Jubilee, 1951, no. 31; Berlin, Staatliche
Museen, Bilder von Menschen in der Kunst
des Abendlandes, 1980, 216, no. 9

LITERATURE James W. H. Weale, A
Descriptive Catalogue of the Collection of
Pictures belonging to the Earl of Northbrook
(London, 1889), 92, no. 130, ill.; Cust
1900, 108, 265, no. 24; Schaeffer 1909,
307; W. R. Valentiner, ed. with Ludwig
Burchard and Alfred Scarf, Unknown
Masterpieces in Public and Private
Collections (New York, 1930), 1:47, ill.;
Glück 1931, 44, ill. 373; Van Puyvelde
1950, 172; W. E. Suida and F. R. Shapley,
Paintings and Sculpture from the Kress
Collection, Acquired by the Samuel H. Kress
Foundation 1951–1956 (Washington, 1956),
70, no. 24; Bernard G. Hughes, "A Dwarf
of Royal Reknown," Country Life (March
1961), 635, ill.; Vey 1962, 280, no. 206;
Jaffé 1965, 43, 46, ill. 4; Douglas J.
Stewart, "Pin-ups or Virtues? The
Concept of the 'Beauties' in Late Stuart
Portraiture," English Portraiture of the 17c
and 18c. Papers Read at a Clark Library
Seminar (April 1973), University of
California, Los Angeles, 3–43, 41, 7b, ill.;
Kress 1977, 116, no. K1911, figs. 106, 107;
Brown 1982, 180, ill. no. 177; Washington
1985, 147; Larsen 1988, no. 864, ill. 296

Queen Henrietta Maria is reported to have sat for Van Dyck no less than twenty-five times between 1632 and 1640, but none of his portraits capture to such a degree the complex personality of this extraordinary person. In this majestic painting the queen, sumptuously clothed in a blue hunting dress, stands on a stone step of an imposing architectural structure. Her crown occupies a ledge behind her, almost camouflaged by the elegant gold drapery in which it is nestled.[1] She is accompanied by Sir Jeffrey Hudson, a dwarf, whose small monkey, perched on his left arm, playfully paws his hair. As the queen looks demurely out at the viewer, she rests her hand on the monkey's back and belt in a manner that suggests an easy familiarity with both Hudson and the pet.

Although the early history of this painting is not known, its approximate date can be determined by a document of October 1633 that records a payment of £40 made by King Charles I to Van Dyck for a painting of "our dearest Consort the Queene" that was delivered as a gift to Thomas Wentworth[2] [see cat. 86]. This painting, which still is at Wentworth Woodhouse, seems, however, to be a replica of the National Gallery of Art version, which must also have been ordered by the king as a gift to one of his loyal courtiers.[3]

Van Dyck's image of the queen dressed for the hunt follows a long tradition of such royal portraits. In 1617 Paul van Somer depicted Anne of Denmark, wife of James I, in similar apparel while holding the leash of her hunting dogs [fig. 1].[4] Shortly before Van Dyck's arrival in England Daniel Mytens depicted Charles I and Henrietta Maria together as they prepared for the hunt [fig. 2]. While their horses await their departure, Hudson is seen restraining a pair of hunting dogs who eagerly look forward to the day's adventure. Despite the impression conveyed by Mytens' painting, it does not seem that Henrietta Maria shared her husband's enthusiasm for the hunt. While she spent much time in the royal palaces surrounding London, she had a greater interest in flowers and gardening. Perhaps for this reason Van Dyck has altered the traditional image of the queen attired for the chase by eliminating all references to hunting dogs, horse, and groom.

Henrietta Maria had great love for the exotic, which she viewed as part of the trappings of royalty. A contemporary reference notes that when the queen traveled about the countryside she included within her caravan dogs, dwarfs, blacks, and monkeys.[5] The most notable dwarf attached to the court was Sir Jeffrey Hudson, whose fair countenance and ready wit endeared him to the queen. Sir Jeffrey, the son of John Hudson, was born in 1619 at Oakham, not far from Burley on the Hill, the home of the Villiers family. According to Vertue, Jeffrey was brought to the duke of Buckingham when he was about seven or eight years old and only eighteen inches

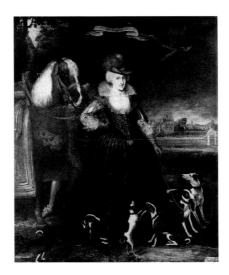

Fig. 1. Paul van Somer, Queen Anne of
Denmark, 1617, canvas, 265.4 x 208.3
(104 1/2 x 82). Copyright reserved to
H. M. Queen Elizabeth II

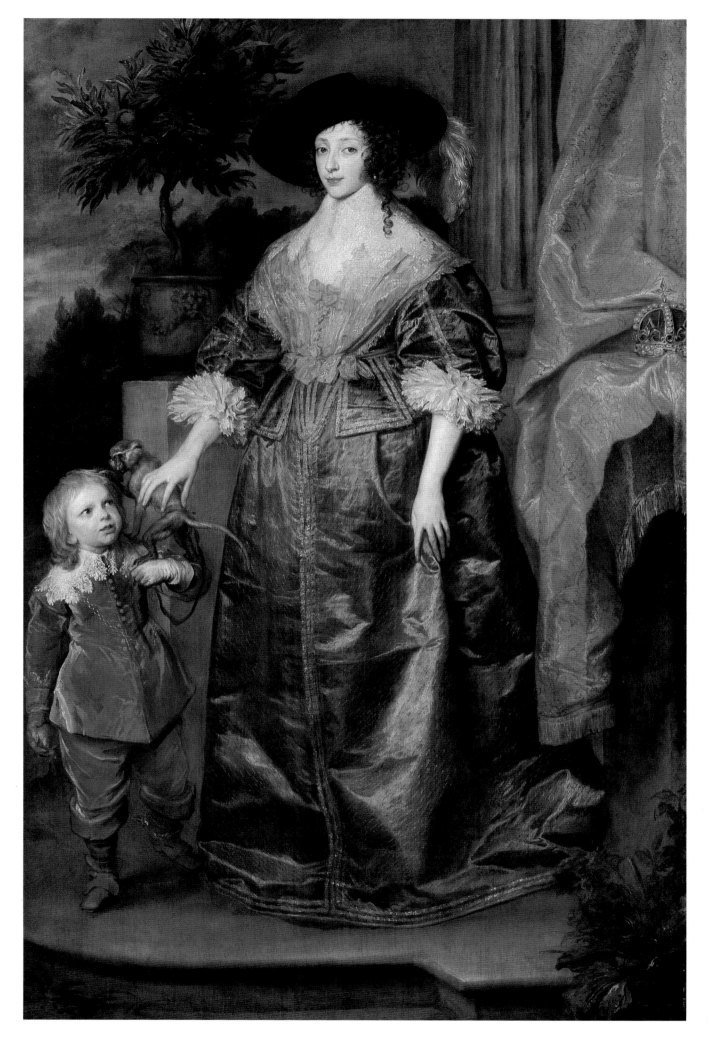

1. Henrietta Maria was, in fact, never crowned. When it became clear that she could not receive the crown from the hands of a Catholic priest, she refused to attend the coronation of Charles I. See Carola Oman, *Henrietta Maria* (London, 1936, repr. London, 1951), 42.

2. Hookham Carpenter 1844, 75–76. Van Dyck received £40 for this painting. See also n. 7, below.

3. Earlier writers considered the Wentworth Woodhouse painting to be the original version, in large part because the National Gallery version was not known until the 1860s. Recent critics, however, have been unanimous in their opinions about the primacy of the Washington version. Kress 1977, 117, suggested that Mountjoy Blount, earl of Newport, may have been the original owner of the National Gallery version.

4. See Royal Collection 1963, cat. 105.

5. Cited from the Calendar of State Papers Domestic, 1636, by Oman 1951, 83.

6. Vertue 1930–1955, 18:25.

7. Lionel Cust, *Notes on Pictures in the Royal Collections* (London, 1911), 88. Mytens received £80 each for these three paintings. The document reproduced in Hookham Carpenter 1844, 75–76, indicates that Van Dyck only received £40 in 1633 for the double portrait with Sir Jeffrey Hudson that the king presented to Thomas Wentworth. This relatively low price may well reflect the fact that it was a replica and not a first version. Mytens also painted a full-length painting of Hudson in 1630 (see Royal Collection 1963, 88, cat. 125).

8. Sir Jeffrey, who had an adventurous career, remained loyal to the queen throughout his life. Vertue 1930–1955, 18:78–79, gives a poignant description of the duel in which he killed Captain Crofts; of the time he was taken by Turkish pirates and sold "a slave to Barbary"; of the physical growth that occurred as a result of the imprisonment he endured; of being made a captain in the king's army in the Civil War; of his exile with the queen in Paris; his imprisonment on suspicion of being involved in the "popish plot"; and his death at the age of sixty-two or sixty-three in 1682. For an entertaining account of Jeffrey Hudson's life, see Edward J. Wood, *Giants and Dwarfs* (London, 1868), 277–284.

9. Vertue 1930–1955, 18:78.

10. Kress 1977, 116, cat. K1911.

11. Roy Strong, *Art and Power: Renaissance Festivals 1450–1650* (Woodbridge, Suffolk, 1984), 160–170.

12. Henry van Oosten, *The Dutch Gardener: Or, the Compleat Florist* (London, 1711), 206.

13. Kress 1977, 117, n. 2. The orange was also symbolically associated with the Medici family.

14. Vey 1962, 279–280, cat. 206.

tall. This remarkable being was then presented to the queen shortly after her marriage to Charles when the royal couple visited Burley on the Hill during the king's progress. Jeffrey made his appearance "served up to the table in a Cold pye."[6] That he immediately ingratiated himself with the queen is evident from the fact that Daniel Mytens was commissioned to paint at least three portraits of Queen Henrietta Maria with Sir Jeffrey Hudson in 1628 to be given as gifts.[7] Since one of these was presented to the queen of Bohemia, Van Dyck may well have seen it when he was in The Hague in 1632.

A double portrait of the queen and her dwarf undoubtedly served a purpose beyond demonstrating the queen's delight in his company.[8] One possible appeal was that the juxtaposition enhanced the queen's stature by making her appear taller than she was. Vertue, who remarked on how well Mytens had indicated the relative heights of the king and queen in his portrait of them preparing for the hunt, also noted that "it is observable that Vandyke in several of the pictures of this Queen which he has done at len: he contrivd secretly to show the Queen rather taller than shee was."[9] Van Dyck reinforced this effect by the low vantage point, which also was one particularly flattering to her long face with its prominent features.

The role of the monkey perched on Sir Jeffrey Hudson's arm is one of the most fascinating if ultimately inexplicable aspects of this painting. He is said to be "Pug," who was the queen's monkey and inseparable from the dwarf,[10] and his presence may reflect no more than her delight in this exotic pet. Monkeys, however, have many symbolic associations, and it is unlikely that in the Neoplatonic climate of the English court no allegorical meanings were brought to bear upon its presence. Monkeys were traditionally associated with erotic passion, and a chained monkey embodied a soul enslaved by the forces of sensuality. Henrietta Maria, by gently laying her hand on the monkey and clasping his belt, may well signify her control over the passions that he represents. She would then assume a role here akin to that reserved for her in the Caroline masques, where she embodies the Neoplatonic ideals of beauty and virtue and reigns over unrestrained passion.[11]

Symbolic of the peace and harmony brought about by the enlightened rule of Charles and Henrietta Maria was the cultivated and orderly garden portrayed in the culminating scene in Charles' masque of 1631, *Love's Triumph through Callipolis*, which was written by Ben Jonson and designed by Inigo Jones. This image reflected reality, for in these years the queen had begun to effect the transformation of English gardens into a new Italianate style. She sent to France for fruit trees and plants,

264

Fig. 2. Daniel Mytens, *Charles I and Henrietta Maria*, c. 1630–1632, canvas, 282 x 408.3 (111 x 160 3/4). Copyright reserved to H. M. Queen Elizabeth II

among them orange trees such as the one growing prominently in the urn in Van Dyck's portrait. Orange trees were greatly prized for the lasting pleasure that they provided. As one early eighteenth-century botanist wrote: "There is not a Day in the Year when Orange-Trees, may not, and indeed ought not, to afford matter of Delight; whether it be in the Greenness of their Leaves, or in the Agreeableness of their Form and Figure, or in the pleasant Scent of their Flowers, or in the Beauty and Duration of their Fruit."[12] Aside from the aesthetic and sensual satisfaction it provided, the orange tree had abstract associations to love and constancy. It was a symbol of purity, chastity, and generosity, and associated with the Virgin, Henrietta Maria's holy patron.[13]

Van Dyck made a study of Henrietta Maria's dress [fig. 3].[14] A copy of the painting by Charles Jervas (1675–1739) is still preserved at Petworth.

A. K. W.

Fig. 3. Anthony van Dyck, *Study of a Dress*, 1633, chalk with white heightening on blue paper, 41.9 x 25.7 (16 1/2 x 10 1/8). Ecole Nationale Supérieure des Beaux-Arts, Paris

1634
inscribed *Robert Rich 2ⁿᵈ Earle/Warwick Uncle to Lady Mary/Countess Breadalbane*
canvas, 208 x 128 (81⅞ x 50⅜), with added strip at top 213.4 x 128 (84 x 50⅜)

The Metropolitan Museum of Art, New York, The Jules Bache Collection, inv. no. 49.7.26

PROVENANCE John, 2d marquess and 5th earl of Breadalbane, Taymouth Castle, Aberfeldy, Perthshire (d. 1862); his sister Lady Elizabeth Pringle (d. 1878); her daughter the Hon. Mrs. Robert Baillie-Hamilton, Langton, Duns, near Berwick (d. 1912); her sister, Magdalen, Lady Bateson Harvey (d. 1913); the great-nephew by marriage of Sir Robert Bateson Harvey, the Hon. Thomas George Breadalbane Morgan-Grenville-Gavin, Langton, Duns (1913–1925; sale Christie's, London, 6 July 1917, lot 68); Duveen Brothers, New York, 1925; Jules S. Bache, 1949

EXHIBITIONS London, Royal Academy, 1877, no. 209; London, Royal Academy, 1893, no. 126 (as "Charles Rich, Earl of Warwick"); Detroit 1921, no. 41; The Detroit Institute of Arts, *British Paintings of the Late Eighteenth and Early Nineteenth Centuries*, 1926, no. 50; New York World's Fair, *Masterpieces of Art*, 1939, no. 106; London 1972–1973, no. 99, ill.

LITERATURE Walpole 1876, 1:332; Cust 1900, 221, no. 101, 285, no. 220; Edouard Brandus, "La Collection des tableaux anciens de M. Jules S. Bache, à New York," *Renaissance* 11 (May 1928), 187, ill., 194–196, ill.; *A Catalogue of Paintings in the Collection of Jules S. Bache* (New York, 1929), entry, ill.; Walter Heil, "The Jules

Van Dyck's close association with the court of Charles I meant that his patronage was normally drawn from those who, if not actually members of the court, were sympathetic to Charles and his undertakings. Robert Rich, however, had a complex relationship to the court, for, by the mid-1630s, when Van Dyck painted this portrait, he had already voiced strong opposition to the policies of the king. Given the sitter's political stance, Van Dyck's portrait takes on more than usual significance and raises questions about the independence he enjoyed while acting as court artist to His Majesty.

Robert Rich was a leading member of the Puritan Party, and was opposed to policies that restricted the rights of individuals without due cause.[1] For him the break with the king came in the late 1620s, during the tempestuous years when Charles was under the increasing influence of the duke of Buckingham. In 1628 Rich spoke out in Parliament in the debates surrounding the Petition of Rights, which declared among other issues that imprisonment without cause and taxation without parliamentary consent were illegal.[2] Throughout the 1630s he continued his political activities in opposition to the king, and after the dissolution of the Short Parliament in 1640, the king ordered his arrest. He subsequently became an active participant in the Civil War on the parliamentarian side. In 1642 he was appointed Admiral of the Fleet and shortly thereafter placed the navy at Parliament's disposal. In 1643 he was appointed Lord High Admiral and served with distinction until 1645 when he resigned to "serve the great cause of religion and liberty" in other capacities.

The decision of Parliament to place Robert Rich in charge of the navy may have been based on his earlier experiences at sea as a privateer. As early as 1616 he received commissions from the agent of the duke of Savoy to embark on privateering in the East Indies. In 1627 he obtained further commissions from Charles I for privateering against the Spanish. He seems to have genuinely loved the adventure of battle and was described as "never sick one hour at sea, and [he] would as nimbly climb up to top and yard as any common mariner in the ship; and all the time of the fight was as active and as open to danger as any man there."[3] Given this attitude it is not surprising that Van Dyck has included a naval engagement in the background of his portrait of this dashing figure. Armor and a baton, symbols of command, lie just behind him on the ground.

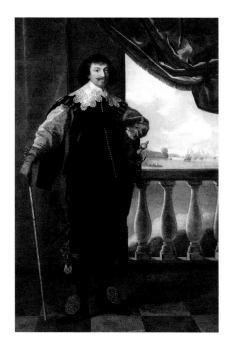

Fig. 1. Daniel Mytens, *Robert Rich*, 1632, canvas, 221 x 139.7 (87 x 55). National Maritime Museum, Greenwich

Fig. 2. Daniel Mytens, *Charles I*, 1628, canvas, 219.1 x 152 (86¼ x 59¾). Copyright reserved to H. M. Queen Elizabeth II

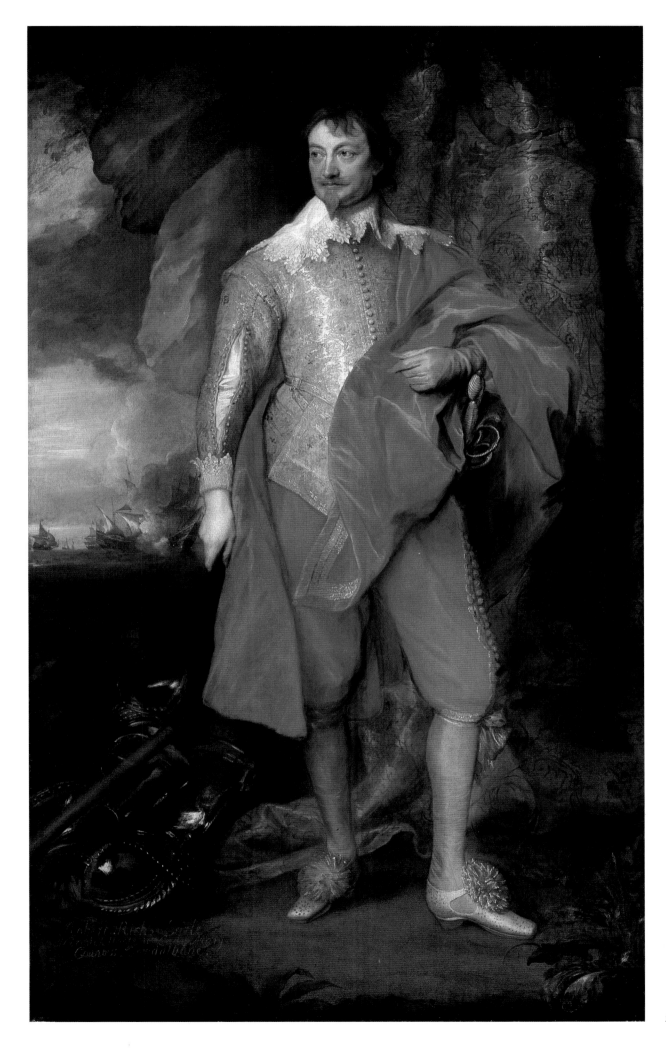

Bache Collection," *Art News* 27 (27 April 1929), 4, 32, ill.; Glück 1931, XLIV, 395, ill., 562; *Duveen Pictures in Public Collections of America* (New York, 1941), no. 188, ill.; Van Puyvelde 1946, 145; Whinney and Millar 1957, 71, ill. 15; Metropolitan Museum 1980, 1:52 and 3:381, ill. 49.7.26; Brown 1982, 203, 206, ill. 209; London 1982–1983, 23, ill. 22, 24; Metropolitan Museum 1984, 1:72–74 and 2: ill. 30; Larsen 1988, no. 1028, ill. 327

1. *Dictionary of National Biography* (London, 1896), 48:128–133, provides an excellent account of his life and is the basis for the biographical information found here.
2. J. P. Kenyon, *The Stuarts: A Study in English Kingship* (Glasgow, 1978), 67–68.
3. *Dictionary of National Biography* 1896, 48:129.
4. J. H. Hexter, *The Reign of King Pym* (Cambridge, Mass., 1941), 76–84.
5. Cicely V. Wedgwood, *The King's Peace* (London, 1955), 146–153.

As his elaborate and colorful costume indicates, Robert Rich, despite his taste for adventure, had a distinguished lineage. He was the eldest son of Robert, Lord Rich, and Penelope Devereux. Created Knight of the Bath in 1603, he succeeded to his father's title, the earl of Warwick, in 1619. Although he was associated with court life during the reign of James I, he increasingly turned away from it and became involved in the developing colonies in the new world. These enterprises, which ranged from Massachusetts to the West Indies, were both financially and religiously motivated. Around 1630 Puritans developed colonization schemes as a means for insuring freedom of worship, and the earl of Warwick was prominently involved in a number of them.[4]

Neither these activities nor his objections to Charles' policies of taxation, however, seem to have alienated him totally from the court in the early 1630s. After the dismissal of Parliament in 1629, no forum existed for the acrimonious debates that had occurred in that body in 1627–1628, which meant that firm positions of opposition did not develop. Robert Rich's relation to the court was also colored by the role of his younger brother, Henry Rich, earl of Holland, who was a member of the King's Council, and who helped further his brother's interests at court.[5]

Van Dyck's portrait manages to convey the striking individuality of the earl of Warwick while at the same time acknowledging Rich's dependence upon the king. His alert expression and dynamic pose, as though he is about to stride through the landscape, are those of an active, decisive leader fully prepared to undertake military responsibilities. At the same time, however, there is implicit recognition that the role of commander has only been possible through the good graces of the king.

Van Dyck's characterization of the sitter's personality through his pose as well as through his expression transformed British portrait traditions. With his arrival in England in the spring of 1632 the career of the then-favored court artist Daniel Mytens quickly floundered. An excellent comparison between their works is Mytens' 1632 portrait of Robert Rich [fig. 1] and the painting exhibited. Where the one is contrived and static, the other is fluid and energetic. The differences in character between the portraits, however, may also reflect the growing distance between Robert Rich and the court of Charles I. In Mytens' portrait the pose and setting are modeled after those in the artist's portrait of Charles I, 1628 [fig. 2], whereas in Van Dyck's image the pose stresses Warwick's independence and dynamism.

A. K. W.

69
Jacomo de Cachiopin

1634
canvas, 111 x 84.5 (43 ¼ x 33)

Kunsthistorisches Museum, Vienna,
inv. no. 503

PROVENANCE by inheritance to Jan-Bapt.
Cachiopin, Antwerp, in whose inventory
the painting is listed on 2 May 1662;
since 1720 in the Stallburg, Vienna

EXHIBITIONS Amsterdam 1947, no. 56;
Brussels 1947, no. 38, ill. 77

LITERATURE Smith 1829–1842, 3:233, no.
835; Kunsthistorisches Museum 1896,
2:116, no. 1041 (as "Portrait of a Young
Man"); Cust 1900, 261, no. 145; Schaeffer
1909, 253, ill. (as "The Painter Frans
Snyders"); Glück 1931, 340, ill., 556;
Denucé 1932, 230; Kunsthistorisches
Museum 1963, 2: no. 154, ill. 69;
Kunsthistorisches Museum 1987, 186,
187, pl.; Larsen 1988, no. 502, ill. 283

1. Precise reasons for his decision to
leave are not known, nor is it clear if he
intended to stay in Flanders. Family
considerations may have played a great
role. In August of 1633 Queen Henrietta
Maria had asked Van Dyck's brother,
Theodoor van Dyck, to become head
chaplain in her service, presumably at
the artist's request. Nothing is known
about Theodoor's tenure in England
other than that it had already ended by
14 March 1634 when he and his brother
were back in Antwerp. Shortly thereafter
Anthony acquired some property on the
country estate Steen at Elewijt. Within
three weeks, however, he had given his
sister Suzanna the power of attorney to
administer it in his absence, an indication
that he had little intention of retiring to
the country at this point in his life.
2. The political situation worked against
a consistent court style since the court
lacked a strong leader who could
establish a code of conduct such as had
Charles I. The Infanta Isabella had died
in December 1633 and Flanders was
awaiting its new governor, Cardinal-
Infante Ferdinand, who would make his
triumphant entry into Brussels only on
4 November 1634. For an assessment of
earlier portrait conventions in Flanders
see J. Müller Hofstede, "Höfische und
bürgerliche Damen-porträts:
Anmerkungen zu Rubens' Antwerpener
Bildnismalerei 1609–1620," Pantheon 41
(1983), 300–321.
3. Many of these portraits may have
been conceived with an eye toward the
publication of the Iconography.
4. For a short biographical account, see
Szwykowski 1859, 31. According to
Szwykowski, Cachiopin's country house
and its treasures were destroyed in the
war (no date given), after which he
returned to Antwerp. He was said to
have died "grief-stricken and depressed"
in 1642. Whether this assessment is
based on actual fact or on the basis of
Van Dyck's portrait is not known.
5. Carlo Ridolfi, Le Maraviglie Dell' Arte

In March 1634 Van Dyck took leave of his responsibilities as court artist for Charles I and returned to Antwerp. This chapter in Van Dyck's life lasted only about a year. It is not well understood for it has been frequently subsumed under Van Dyck's so-called English period.[1] The character of the portraits he painted during this year, however, is remarkably different from that evident in his English portraits of the preceding years. In large part the differences resulted from the specific social milieu of the Flemish court. The aristocrats he portrayed in Brussels [see cats. 70, 71, 72] did not conduct themselves with the same refined elegance that was practiced and admired in the court of Charles I. His portraits of nobility attached to the court in Brussels, consequently, have a directness that contrasts with the flattering images he created of English gentry.[2] Another major difference was that during this year Van Dyck received commissions to paint portraits of artists and art collectors, often friends and acquaintances, which were more private in character than the court portraits he had produced in England.[3]

Jacomo de Cachiopin (1575–1642), a passionate collector of Van Dyck's paintings, was one such friend. The son of a merchant, Cachiopin studied in the Jesuit school in Antwerp before attending the university in Louvain. After working for a while in his father's business, he retired to the country where he built a house for his collection. Although no inventory of his collection has survived, it is known that he devoted an entire room in his country house to portraits by Van Dyck.[4] As he also collected paintings by Titian, he must have had much to share with Van Dyck, including his love for Venice.[5] This portrait was paired with a portrait of Cachiopin's wife, which, unfortunately, has disappeared.[6]

Van Dyck's haunting image of Cachiopin can be fairly accurately dated 1634 on the basis of a drawing he made of the sitter that same year [fig. 1].[7] Although Cachiopin's wistful mood is quite different from the alert countenance of the sitter in the drawing, his age appears to be the same in both images. Cachiopin probably sat for Van Dyck before the artist moved to the court in Brussels in the fall of 1634.

The differences in attitude between the drawing and the painting relate to their different functions. The drawing was a preliminary study for Lucas Vorsterman's etching of Cachiopin for Van Dyck's Iconography [fig. 2], and thus it was conceived as a public image. The painting, on the other hand, with its half-length format, was a private one. The simplicity of dress and setting focus the painting on Cachiopin's melancholic state of mind. The heavy eyes, tousled hair, and wan complexion all add

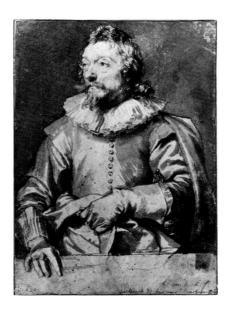

Fig. 1. Anthony van Dyck, *Jacomo de
Cachiopin*, 1634, chalk and wash,
25.3 x 17.6 (10 x 6⅞). Musée du Louvre,
Paris, Cabinet des Dessins, Collection
Rothschild

(Rome, 1965), 1:198–199, lists a large number of Titian's paintings Cachiopin brought from Venice to Antwerp, including many from Lucas van Uffel [see cat. 31], which Van Dyck presumably had seen when he was in Venice.

6. The two portraits are listed in the inventory of Jan-Bapt. Cachiopin on 2 May 1662. See Denucé 1932, 230.

7. For a discussion of the drawing, see Vey 1962, no. 273.

8. For studies of melancholia, see L. Babb, *The Elizabethan Malady* (East Lansing, Michigan, 1951). See also n. 4.

9. For a study of the social position of collectors in Antwerp at this time, see Filipczak 1987, 51–57.

to this effect. As an admirer of Van Dyck's work, Cachiopin would have been aware of the artist's innate ability to suggest a sitter's mood through gesture and expression, and must have agreed to be portrayed in this way. His attitude, as in Van Dyck's earlier portrait of Henry Percy [see cat. 65], may have been conceived to suggest Cachiopin's intellectual and artistic concerns, which were often associated with melancholia.[8]

Cachiopin's love of art is indicated in a different way in the *Iconography*, in an inscription beneath his portrait that reads "Amator Artis Pictoriae Antwerpiae." This designation only appeared on four of the eighty prints to appear in *Iconography* when it was published in Antwerp by Martin van den Enden, probably between 1636 and 1644 [see also cats. 44, 92]. Art lovers and collectors had never been so honored before Van Dyck's publication, but then again collecting by merchants and burghers was a new phenomenon in the history of art.[9]

A. K. W.

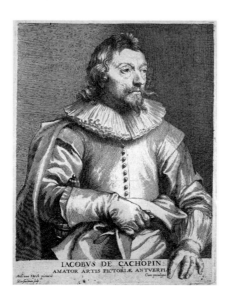

Fig. 2. Lucas Vorsterman the Younger after Van Dyck, *Jacomo de Cachiopin*, 1634, engraving, 24.13 x 17.78 (9 1/2 x 7). National Gallery of Art, Washington

270

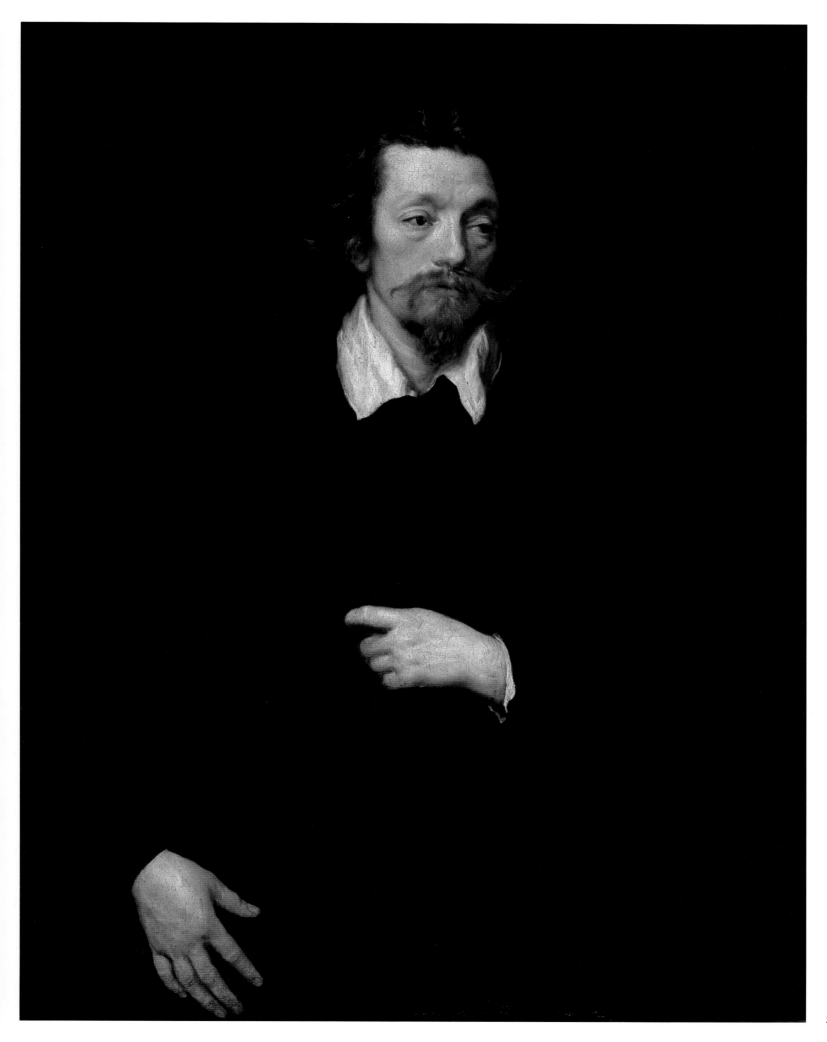

70
Cesare Alessandro Scaglia, Abbé of Stafforda and Mandanici

1634
canvas, 200.6 x 123.2 (79 x 48¹/₂)

The Viscount Camrose

PROVENANCE Presented by the Abbé
Scaglia to the church of the Recolets at
Antwerp; sold in 1641 after his death; in
collection of La Court van der Voort,
father and son, Leiden, sale of collection
of Allard de la Court's widow, Catharina
Backer, Leiden, 8–9 September, no. 3; Sir
Thomas Baring, Bart. by 1815; Robert
Stayner Holford (1808–1892) by 1851; by
descent to Sir George Lindsay Holford
(1860–1926); Holford sale, Christie's 17
May 1928, no. 61

EXHIBITIONS London, British Institution,
1815, no. 11; London, British Institution,
1839, no. 3; London, British Institution,
1851, no. 6; London, British Institution,
1862, no. 2; London 1887, no. 54;
Antwerp 1899, no. 73; London 1900, no.
66; London, Thomas Agnew & Sons,
1922, no. 37; London 1927, no. 133;
Antwerp 1930, 82–83, ill. 57; Paris 1936,
20, ill.; London 1938, 22, no. 86, ill.;
Antwerp 1949, no. 49; London 1953–1954,
no. 155; London 1982-1983, 34, no. 17, ill.

LITERATURE Hoet 1752, 3:542; Smith
1829–1842, 3:87, no. 295 and 9:37, no.
10; Waagen 1854, 2:200; Cust 1900,
93–94, 94 (opp.), ill., 202, no. 54, 213, no.
73, 220, no. 66, 259, no. 104; Schaeffer
1909, 317, ill., 510; Glück 1931, XLII, 426,
ill., 566–567; Brown 1982, 158, ill., 159,
161; Larsen 1988, no. 989, ill. 374

1. National Gallery London 1970, 50, n. 1.
2. Brown 1974, 4.
3. Martin in National Gallery London
1970, 49, explained that the specific
events centered around the success of
the French armies in Piedmont and the
settlement of Cherasco made by Victor
Amadeus I with the French in 1631.
4. Quoted in National Gallery London
1970, 50, n. 3.
5. National Gallery London 1970, 51,
n. 16.
6. Van Dyck's preliminary drawing
depicts Scaglia in quite a different
attitude. He is shown seated with his left
hand on a paper resting on a ledge
(Institut Néerlandais, Paris).
7. This observation was first made by
Millar in London 1982–1983, 58. Given
the rapidity with which he completed his
portraits, and the information we have
on his schedule for his sitters (see Cust
1900, 138–139), it seems that Van Dyck
must have come to design his paintings
in this manner as a matter of course in
his later years. For a similar aura around
the head see his portrait of the duke of
Hamilton [cat. 87].
8. See National Gallery London 1970, cat.
4889; and Brown 1974.
9. Brown 1974, 5.
10. Elewijt 1962, 122–123, cat. 41.

In Abbé Scaglia, Van Dyck must have found a compatible patron, a religious yet worldly-wise man of noble birth. To judge from the weary eyes of his handsome face, he, like Van Dyck, possessed a sensitivity that left him vulnerable to the opinion of others. The Abbé Scaglia was a fascinating figure whose multifaceted diplomatic career during the 1620s and early 1630s touched on many of the complex political controversies of the day, but his career was not free from disappointment and failure. Although by 1634, when Van Dyck painted this magnificent image, Scaglia had overcome his earlier adversities and was once again reinstated in a position of wealth and prestige, the cares that had burdened him remained etched on his face.

Cesare Alessandro Scaglia, who was the second son of Filibert, count of Verruax and marquis of Calussi, followed in his father's footsteps as an ambassador for the House of Savoy. He served under successive dukes, Charles Emmanuel I and his son Victor Amadeus I, and was an effective advocate for this small principality when he was stationed in Rome (1614–1623). His tenure in Paris (1625–1627), however, ended in bitterness both because of the designs of France on territories, including Montferrat, claimed by the duke of Savoy, but also because of Richelieu's refusal to elevate Scaglia to the rank of cardinal.[1] Scaglia then became involved in the complex negotiations of the duke of Savoy to help achieve peace between England and Spain. In this process he corresponded with and met Rubens, who was also actively engaged in diplomatic ventures to bring about peace on behalf of the Regent Isabella. From all accounts Rubens and Scaglia had great admiration for each other, although surprisingly Rubens never seems to have painted for him.

After the successful peace negotiations Scaglia was appointed ambassador in London. Philip IV of Spain granted him a second abbacy, that of Mandanici in Sicily, and asked him to act as his representative in the English court.[2] Political events in Europe overtook him. Before the year was out he fell into disfavor with the duke of Savoy because the latter's new-found friendship with the French collided with Scaglia's fervent anti-French feelings.[3] His depressed state was noted by Giovanni Soranzo, the Venetian ambassador in London, who wrote that Scaglia "is suffering from bodily indisposition in addition to his mental troubles, and is very little seen. The talk about his departure is uncertain, but the soundest conjecture is that he him-self does not know whither to turn, as he is on bad terms with France and his mas-ter, and to all present appearance does not enjoy the confidence of Spain, where he hoped to make his fortune. He is not on very good terms with the duke himself. ..."[4] Scaglia retired the following year and moved to Brussels.

When Scaglia sat for Van Dyck's full-length portrait two years later he had left retirement and had entered into the service of Victor Amadeus' brother, Prince Thomas of Savoy [cat. 71], who had recently arrived in Brussels as commander of the Spanish forces in the Netherlands. Even though Scaglia had never returned to favor with the duke, the dashing young prince came to depend on the abbé's advice and to value his vast diplomatic experience.[5] It must have been his return to political power that induced Scaglia to commission this imposing painting.

Van Dyck chose as a portrait type one he had used two years previously when he was in The Hague and was asked by the "Winter King" Frederick V and his wife Elizabeth to paint portraits of their sons, Prince Charles Louis and Prince Rupert [fig. 1]. The differences in treatment between the portraits of Scaglia and Prince Rupert are subtle, but in the slight turn of the head and increased angularity of forms Van Dyck conveys a whole range of worldly experiences with Scaglia that the young prince has yet to encounter. As is so often the case with Van Dyck, the ultimate source for the pose is to be found with Titian, whether his forceful portrait of *Benedetto Varchi*, now in the Kunsthistorisches Museum in Vienna [fig. 2] or a lost portrait that Van Dyck recorded in his Italian sketchbook [see cat. 51, fig. 2].[6]

Van Dyck, as was his custom, began by painting Scaglia's head, which is clear from the aura surrounding it, before executing the body and background.[7] His

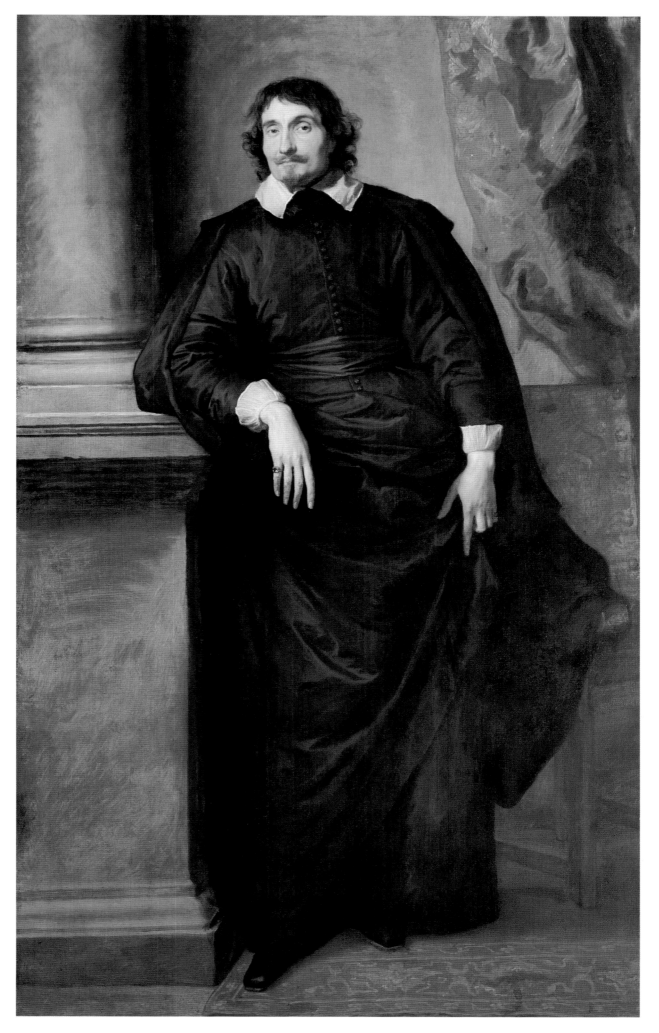

portrait served as a *modello* (oil on panel, 24 x 21 cm, Alte Pinakothek, Munich) for Paulus Pontius' engraving of the sitter for Van Dyck's *Iconography*.

Scaglia commissioned two other paintings from Van Dyck at this time, *The Abbé Scaglia Adoring the Virgin and Child* (National Gallery, London),[8] and *The Lamentation* [cat. 79]. He commissioned the latter painting for the Franciscan church of the Recolets in Antwerp. It was to hang above the altar he was having constructed in the Chapel of Our Lady of the Seven Sorrows. It must have been in place by 1637 when the altar was consecrated. In 1639 the Abbé Scaglia moved to Antwerp to be near the monastery, but he also continued on good terms with artists in that city, in particular Rubens, Frans Snyders, and Jacob Jordaens.[9] After his death in May 1641 a replica of this portrait was given to the Franciscans to hang above his tomb in his chapel in the church of the Recolets (Koninklijk Museum voor Schone Kunsten, Antwerp).[10]

A. K. W.

 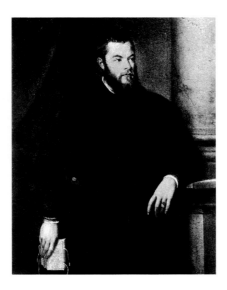

Fig. 1. Anthony van Dyck, *Portrait of Prince Rupert*, c. 1630–1631, canvas, 175 x 95.5 (68⅞ x 37⅝). Kunsthistorisches Museum, Vienna

Fig. 2. Titian, *Benedetto Varchi*, c. 1540, canvas, 117 x 91 (46 x 35⅞). Kunsthistorisches Museum, Vienna

1634
canvas, 315 x 236 (122⁷/₈ x 92)

Galleria Sabauda, Turin

PROVENANCE Executed in Brussels for
the prince; given at the beginning of the
eighteenth century by Prince Victor
Amadeus Carignan to Prince Eugène of
Savoy Soissons in Vienna; inherited by
Marie-Anne-Victoire, niece of Eugène,
who sold it to Charles Emmanuel III,
king of Sardinia in 1742; by descent to
Charles-Albert, king of Sardinia, in
whose palace it hung in Turin

EXHIBITION Turin 1989, 24

LITERATURE Smith 1829–1842, 3:53, no.
182; Baudi di Vesme 1885, 27–41; Cust
1900, 91, 259, no. 102; Schaeffer 1909,
321, ill., 510; Glück 1931, XXIV, XLV, 421,
ill., 566; Van Puyvelde 1946, 150;
Sabauda 1968, 91, ill. no. 17, 94–96;
Sabauda 1969, 15, ill. 74; Brown 1982,
153–155, ill. 156; London 1982–1983, 33,
ill. 35, 34; Tardito Amerio 1982, pl. on
cover, 12, no. 22, 100, ill., 101–105, ills.;
Larsen 1988, no. 986, ill. 361

1. Royal Collection 1963, 108–109,
cat. 184, identified this medal on the
half-length portrait of the prince at
Windsor Castle.
2. In 1639 Thomas-Francis returned to
Savoy to engage in a civil war to regain
territories that had been assumed in his
absence by Victor Amadeus' widow,
Christina, and her son, Charles
Emmanuel II. He eventually reconciled
with his sister-in-law and joined forces
with the French in 1642. Made a
lieutenant general by Louis XIII, he
fought against Spain. Mazarin favored
him and named him Grand-Master of
France after the fall of Prince Condé.
3. For an account of this tradition, see
Strong 1972.
4. Bellori 1672, 260. Bellori stated that
Van Dyck painted his portrait of *Charles I*
(National Gallery, London) "à cavallo ad
imitatione di Carlo Quinto espresso da
Titiano. ..."
5. Rubens continued this equestrian
portrait tradition with his magnificent
image of the Cardinal-Infante Ferdinand
made at the time of Ferdinand's
triumphal entry into Antwerp in March
1635 (Prado, Madrid). It is noteworthy
that Rubens placed Ferdinand in an
allegorical context, as he had with his
equestrian portrait of the duke of
Buckingham, whereas Van Dyck, in his
portrait of Prince Thomas-Francis of
Savoy, focused solely on the horse and
rider.
6. For the full document, which was first
published by Baudi di Vesme 1885, see
cat. 97. A replica of the Berlin painting is
at Windsor Castle (see n. 1).
7. Mauquoy-Hendrickx 1956, 225, cat. 63.

To the seventeenth-century mind no image more effectively conveyed the force of
leadership than the equestrian portrait. In this, one of Van Dyck's most spectacular
works, Prince Thomas-Francis of Savoy-Carignan, provisional governor of the Spanish
Netherlands, sits firmly astride his rearing white steed in gleaming armor, holding
aloft a baton symbolizing his role as commander. Around his neck hangs a medal
signifying his membership in the Order of the Annonciade.[1] The green drapery and
imposing architecture behind him set off his handsome figure, while the turbulent
sky in the distance both adds drama to the scene and suggests the turmoil that
confronted him during his command.

Thomas-Francis (1596–1656) came from the small principality of Savoy, which
because of its geographical location between France and Italy was constantly involved
in the broader political struggles between France and Spain. The strategic importance
of this principality can be measured in part by the alliances formed through marriage
of successive members of the House of Savoy. Thomas-Francis' father, Charles
Emmanuel I, duke of Savoy, was married to Catherine, daughter of King Philip II of
Spain and sister of Isabella Clara Eugenia, regent in the Spanish Netherlands.
Thomas-Francis' brother Victor Amadeus I, on the other hand, who succeeded
Charles Emmanuel as duke of Savoy in 1630, formed a French alliance with his
marriage to Christina, sister both to the French king Louis XIII and the English queen
Henrietta Maria.

The prince had been raised as a military leader by his father Charles Emmanuel I
during his struggles with Spain and France for control of Savoy and the adjacent
Montferrat during the 1620s. In 1626 his father had named him lieutenant general and
governor of Savoy, a position he continued to occupy after his older brother Victor
Amadeus succeeded his father as duke in 1630. Victor Amadeus was sympathetic to
French interests, despite Richelieu's obvious designs against the Piedmont and Savoy.
Thomas-Francis broke with his brother and allied himself with Spain. Because of his
military experience Philip IV named him commander of the Spanish forces in the
Netherlands to succeed Francisco de Moncada, marquis of Aytona, a position he held
from 1634–1639.[2]

By a quirk of fate Prince Thomas-Francis' responsibilities in Brussels quickly
became more than military. On 1 December 1633 his aunt, Isabella Clara Eugenia,
died. Philip IV named Thomas-Francis provisional governor until the arrival of the
new governor Cardinal-Infante Ferdinand, the king's younger brother. The reins of
government thus fell to the prince until Ferdinand's entry into Brussels in November
of 1634. During his short period of command, Thomas-Francis turned frequently to
the Abbé Scaglia [cat. 70], an old confidant of his father's, for advice and guidance.

Van Dyck's imposing painting belongs to a tradition of equestrian portraits that
reaches back to antiquity.[3] The most famous painted prototype, and one that Van

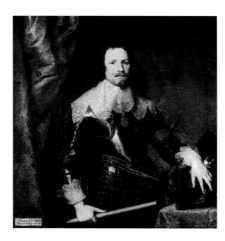

Fig. 1. Anthony van Dyck, *Prince
Thomas-Francis of Savoy-Carignan*,
1634, canvas, 112 x 103 (44¹/₈ x 40¹/₂).
Gemäldegalerie, Berlin

Dyck, according to Bellori, knew and emulated, was Titian's *Equestrian Portrait of Charles V* in the Prado.[4] Rubens as well had contributed substantially to the genre with, among others, his *Equestrian Portrait of the Duke of Lerma*, 1603, in the Prado, and his *Equestrian Portrait of the Duke of Buckingham*, c. 1625 (now destroyed; formerly collection of the earl of Jersey, Osterley Park).

Van Dyck's prowess as a painter of equestrian portraits, however, ranks second to none. From his Genoese equestrian portrait of *Giovanni Paolo Balbi* [see cat. 24, fig. 1] and *Marchese Anton Guilio Brignole-Sale* (Glück 1931, 200) to his imposing images of *Charles I on Horseback* (Glück 1931, 372, 381), he conveyed a sense of the grace and power of man and beast. Van Dyck's reputation in this genre must have preceded him to Brussels, for it is remarkable that when he arrived there in 1634 he was asked both by Prince Thomas-Francis and the commander of the Spanish forces whom he replaced, Marquis Francisco de Moncada (Glück 1931, 420), to paint them on horseback. For these portraits he chose two different poses, one frontal and one from the side, but the effect is equally regal. Both riders sit upon their steeds with an ease and assurance appropriate to their station.[5]

The date of Van Dyck's portrait of Prince Thomas-Francis can be fairly accurately established as the result of a receipt of payment he submitted on 3 January 1635. He received 500 "pattaconi" for this work and a half-length of the sitter, which is inscribed with the date 1634 [fig. 1].[6] For discussion of an oil sketch that may have served as a preliminary idea for this painting, see cat. 97.

Paulus Pontius engraved an image of the prince of Savoy from this equestrian portrait for the *Iconography*, in which he is identified as "GVBERNAT.GENERAL."[7]

<div align="right">A. K. W.</div>

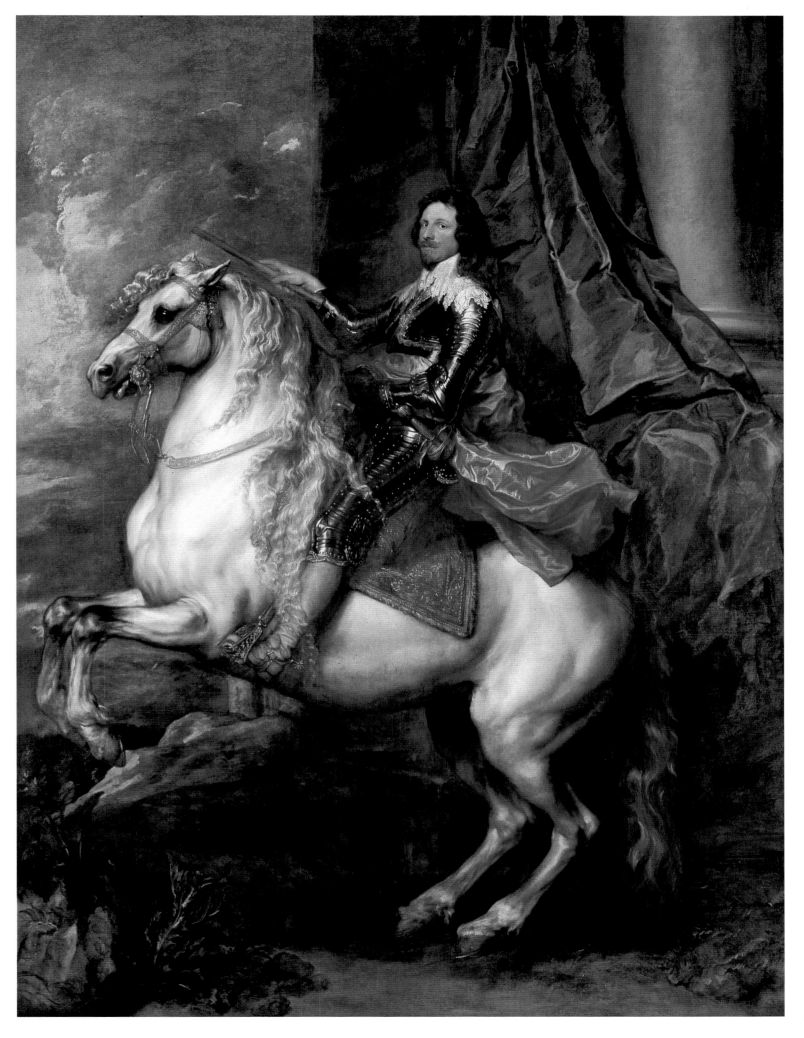

Princess Henrietta of Lorraine

1634
inscribed (lower left) *Henrietta/Lotharinga Princeps de Phalsburg, 1634* and (lower right) *Ant. Van Dyck Eques Fecit*
canvas, 213.4 x 127 (84 x 50)

The Iveagh Bequest, Kenwood (English Heritage)

PROVENANCE Brought from Brussels by Endymion Porter and given to Charles I, 1634–1635; Whitehall Palace, 1649; Commonwealth sale 27 October 1649; bought by Col. Webb; Cardinal Mazarin, Paris; bought by Philippe, duc d'Orléans, 1722; among Orléans pictures brought to England in 1792; bought by B. van der Gucht, probably 1793 (or 1796); his sale, Christie's, 11–12 March 1796, lot 70; earl of Carlisle by 1831; duke of Hamilton by 1842; Hamilton Palace sale, 17 June 1882, lot 18; bought by Davies; earl of Rosebery; Thomas Agnew & Sons, London; earl of Iveagh 1888

EXHIBITIONS London, Pall Mall, *Orléans Collection*, 1793, no. 52; London, Royal Academy, 1873, no. 132; London, Royal Academy, 1892, no. 130; London 1900, no. 59; London, Royal Academy, 1928, no. 192; Manchester City Art Gallery, *Exhibition of Old Masters Presented to the Nation by the Late Earl of Iveagh*, 1928, no. 10; Schaffhausen, Museum zu Allerheiligen, *Meisterwerke flämischer Malerei*, 1955, no. 28

LITERATURE *Description des Tableaux du Palais Royal, avec la Vie des Peintres à la Tête de leurs Ouvrages, Dédiée à Monseigneur Le Duc d'Orléans, Premier Prince du Sang* (Paris, 1727), 73; Vertue 1757, 88, no. 24; Smith 1829–1842, 3:94–95, no. 327 and 9:383–384, no. 54; Waagen 1854, 2:470, 500, and 3:298; Cust 1900, 91–92, 219, no. 59, 255, no. 49; Casimir Stryienski, *La Galerie du Régent Philippe, Duc d'Orléans* (Paris, 1913), 118, 190, no. 502; Glück 1931, 431, ill., 567; Kenwood 1953, 4, 8–9, no. 47, ill.; Antwerp 1960, 142 (under no. 107); London 1970, 11, ill.; Larsen 1988, no. 903, ill. 371

1. An excellent account of the events surrounding this period is found in Robert Parisot, *Histoire de Lorraine* (Paris, 1922) and *Biographie Universelle (Michaud) Ancienne et Moderne* (Paris, 1854–1865) 2:31, 357–359.
2. Richelieu, as part of his own ambitions, had hoped to persuade Gaston to marry his niece.
3. For a full account of this remarkable history see the "Mémoires de Gaston, Duc d'Orléans" published in M. Petitot, *Collection des Mémoires relatifs a l'Histoire de France* (Paris, 1824), 31:148–152.
4. Petitot 1824, 31:120–121. Although all sources identify Henrietta's husband as Prince Louis of Pfalzburg and Lixheim, the inscription beneath her portrait in Van Dyck's *Iconography* reads: HENRICA LOTHARINGIAE. PRINCIPISSA PHALSEBVRGAE, ET RIXHEIMAE. … See Mauquoy-

Henrietta of Lorraine, resplendent in a full-length black dress with white embroidered petticoat, elegant lace cuffs, and broad wired lace collar, stands before a stone structure draped with gold brocade. A young black attendant gazes up at her as he carries rose blossoms on a silver platter. Inscribed in the lower left on a simulated piece of paper is her name and title. It is an image that evokes wealth, nobility, and stability, yet the extraordinary circumstances under which Henrietta found herself at the time Van Dyck painted her portrait seem to belie all that the portrait tries to convey.

In the fall of 1634, Henrietta of Lorraine (1605–1660) was residing at the court in Brussels. Her full history is obscured in shadow, but it is intimately bound to the fortunes of the duchy of Lorraine and the plight of Gaston, duke of Orleans, younger brother of Louis XIII. With the flight of Maria de' Medici from France in 1631, the court of the Infanta Isabella in Brussels became a refuge for the queen mother and Gaston in their efforts to overthrow Cardinal Richelieu, whom Gaston accused of being an "usurpateur de l'Etat et de l'autorité royale."[1] Between 1631 and 1634 Gaston frequently resided in Brussels where he was given generous financial support by the Spanish government to support his ostentatious style of living and his military efforts against Richelieu and his brother the French king.

Of all of Gaston's treacheries against his brother none seems to have infuriated the king more than his secret marriage to Margaret of Lorraine, sister of Henrietta and of Charles IV, duke of Lorraine.[2] When in the fall of 1633 it was discovered that the marriage to Margaret, which had long been rumored but denied by all those concerned, had actually taken place, Louis XIII led his troops to Lorraine in a show of force against Charles IV.[3] Among the many conditions that the duke was forced to accept was that Margaret be turned over to the king. Margaret, however, dressed as a page in the service of another brother François, cardinal of Lorraine, escaped to Brussels to rejoin her husband. There she was warmly greeted by the duke of Orleans, Maria de' Medici, and the Infanta Isabella, who immediately increased the monthly stipend she granted to Gaston. In the beginning of September 1634 the king angrily denounced the marriage and had it declared "non valablement contracté" by the Parliament of Paris. At the same time he pronounced Margaret's brother and her sister Henrietta accomplices to this treason, banned them from the kingdom, and confiscated their property.

Henrietta had indeed been present in Nancy in 1631 when Gaston had first met and fallen in love with her younger sister. If, as seemed possible, Louis XIII remained childless, the match with Gaston, heir-apparent to the French throne, would have had important dynastic consequences for the house of Lorraine. Such an awareness seems also to explain Henrietta's willingness to receive kindly the attentions of Gaston's close friend and advisor, the seigneur de Puylaurens, although she was at that time married to Prince Louis of Pfalzburg and Lixheim.[4] The prince died shortly thereafter,[5] and Henrietta's hand seems then to have been pledged to Puylaurens.[6] In March 1634 Henrietta dramatically escaped from Nancy dressed as a man and fled to Brussels to join her sister. Once in Brussels she was instrumental in persuading Gaston to solemnize his covenant with his wife with an official church ceremony so that it could not be annulled by decree issued by either Richelieu or Louis XIII.

Henrietta's life at the court in Brussels was fraught with rancor. Having discovered that Puylaurens had turned to another woman, she bitterly sought to avenge herself.[7] She allied herself with the queen mother and her confidant in their increasing rivalry with Gaston and Puylaurens. In May 1634 Puylaurens narrowly escaped death through assassination, which may have been arranged partly at Henrietta's instigation. Finally in the fall of 1634, Puylaurens, tiring of exile and responding to enticements of wealth and power from Richelieu, managed to persuade Gaston to reconcile with his brother. On 8 October Gaston and Puylaurens, leaving Margaret behind and playing into Richelieu's hands, secretly fled Brussels and

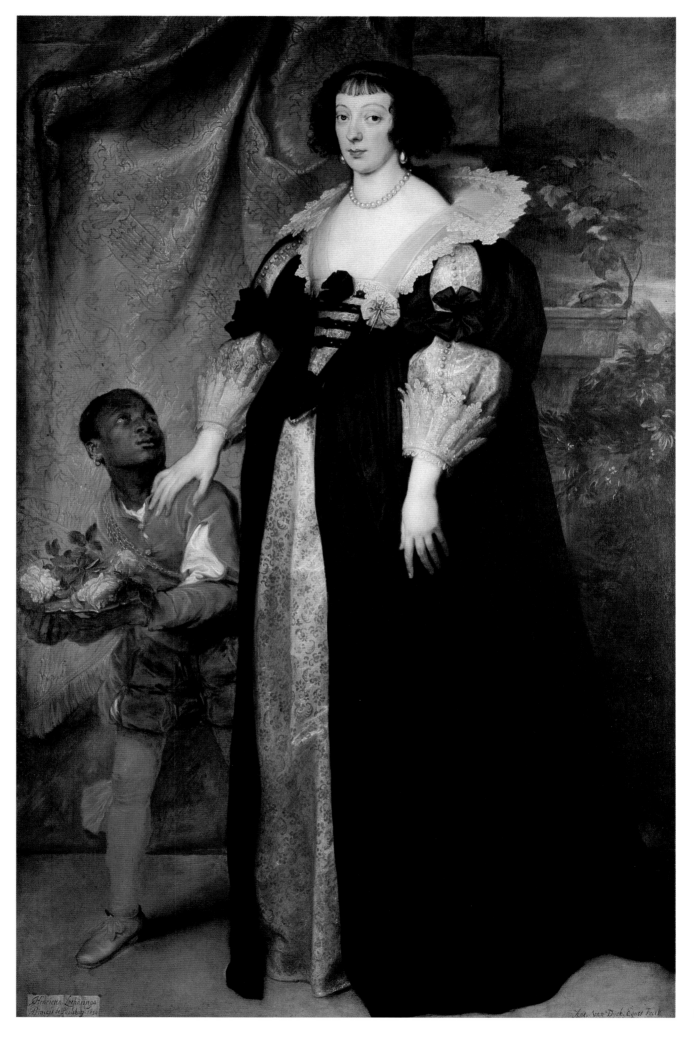

Hendrickx 1956, 283–284, cat. 124.
5. Petitot 1824, 31, 121: "Le prince de Phalsbourg trouva en ce voyage ce qu'il avoit témoigné tant désirer en partant, qui étoit la mort, étant trop généreux pour vouloir vivre davantage avec quelque sorte de déshonneur."
6. Julia Pardoe, *The Life of Marie de Medicis, Queen of France* (New York, 1890), 3:340.
7. Petitot 1824, 31:154–163.
8. Petitot 1824, 31:166–167. The memoirs also stress that Ferdinand's arrival meant that Gaston had to move from his spacious quarters in the court at Brussels.
9. Van Dyck's portrait of Margaret is in the Uffizi, Florence (Glück 1931, 430).
10. Henrietta remained in Flanders until 1643 when she participated in a rather scandalous marriage to Charles Guasco, the marquis de Sallerio. See M. le Comte d'Haussonville, *Histoire de la Réunion de la Lorraine à la France* (Paris, 1856), 246–248.
11. Vertue 1757, 88, no. 24. "Done by Sir Ant. Vandyke beyond seas. The picture of the Princess of Faulsburgh, sister to the Duke of Lorraine, with a blackmoor by her, at length, in a black gilded frame, brought from Brussels by Mr. Endymion Porter."

returned to France. Instrumental in their decision to leave was also the anticipated change in the political situation in Brussels. The new governor, Cardinal-Infante Ferdinand, and Henrietta's brother, the duke of Lorraine, who had fought valiantly alongside Ferdinand in the Battle of Nordlingen, were due to arrive in early November. Neither of them looked kindly upon Gaston or his advisor Puylaurens.[8]

Given the unfortunate political and personal circumstances in which Henrietta and Margaret of Lorraine found themselves in the fall of 1634, Van Dyck's commission to paint full-length portraits of the sisters seems quite extraordinary.[9] It is almost as though the portraits were conceived as defiant statement of the sitters' importance, both as individuals and as descendants of an old and distinguished family whose roots were intimately intertwined with European aristocracy.

In May 1635, with the advent of war between France and Spain, the political situation in Brussels deteriorated rapidly. French forces were so close to the city that Ferdinand began to evacuate precious furniture to the court in Antwerp. Maria de' Medici and Margaret moved there, and perhaps Henrietta as well.[10] They had to live in hiding because of the strong anti-French sentiments in Flanders. These circumstances may have persuaded Henrietta to sell her painting soon after it had been completed. In any event, when Endymion Porter returned to England after having been in Brussels in the winter of 1634–1635, he brought with him this portrait, which he presented to King Charles I and which subsequently hung prominently at Whitehall.[11] Porter's interest in the painting may have been the sitter's family connections to Charles I as well as its artistic quality. Mary Queen of Scots, the grandmother of Charles I, was the daughter of a princess from the house of Lorraine.

Although Henrietta's pose is derived from one Van Dyck frequently used [see, for example, his portrait of *Queen Henrietta Maria with Sir Jeffrey Hudson*, cat. 67], he nevertheless based his composition on a preparatory drawing [fig. 1]. The execution of this work is extremely fine, in particular the figure of the servant, where Van Dyck's brushwork is unusually free and spontaneous. The attitude of this figure as he looks up at his mistress also recalls a Van Dyck prototype, in particular the young boy in the portrait of a man and his son from the late 1620s in the Louvre [see cat. 50]. A copy of the Kenwood painting is in the Kunsthistorisches Museum, Vienna, while another was recorded in the possession of Lady Mary Thompson in 1887.

A. K. W.

Fig. 1. Anthony van Dyck, *Henrietta of Lorraine*, 1634, chalk with white heightening, 57.3 x 30.2 (22 ¹/₂ x 11 ⁷/₈). National Gallery of Scotland, Edinburgh

73
Sir Endymion Porter and Van Dyck

c. 1635
canvas, 119 x 144 (46³/₈ x 56¹/₈)
Museo del Prado, Madrid

PROVENANCE Possibly the painting that Cosimo de' Medici bought in the sale of Diego Duarte in 1668; acquired from the collection of Isabella Farnese, by the Palace of San Ildefonso, La Granja; in royal inventory of the Granja in 1746, no. 38; in 1794 in the palace of Aranjuez; in 1814 in palace of Madrid

LITERATURE Smith 1829–1842, 3:211–212, no. 745; Hymans 1893, ill. opp. 334; Cust 1900, 133, 140, 285, no. 211 (as "Sir Anthony van Dyck and John Digby, First Earl of Bristol"); Schaeffer 1909, 361, ill. (as "Van Dyck and John Digby, Earl of Bristol"); Prado 1913, ill. opp. 298, 299, no. 1489; Alexander J. Finberg, "Two Anonymous Portraits by Cornelius Johnson," *Walpole Society* 6 (1918), 7–8, ill. opp. 8; Glück 1931, 440, ill., 568; Van Puyvelde 1946, 148; Prado 1949, no. 1489, ill.; Gervas Huxley, *Endymion Porter, the Life of a Courtier 1587-1649* (London, 1959), 186, opp. 188 ill.; Antwerp 1960, 134 (under no. 97); London 1970, 10, ill.; Prado 1975, 1:110, no. 1489, 2:77, ill. 1489; Brown 1982, 151–152, pl. 152; London 1982–1983, 32, ill. 33; Larsen 1988, no. 1020, ill. 1020; Prado 1989, 206–207, ill.

1. Huxley 1959 contains much excellent material about Porter, including numerous excerpts from his letters.
2. Huxley 1959, 52.
3. Huxley 1959, 180.
4. Huxley 1959, 158–159.
5. Hookham Carpenter 1844, 24–25.
6. British Library, Egerton MS 1636, fol. 102, as quoted by Millar in London 1982–1983, 112. "Twas wondred by some that knew him thatt having bene in Italy he would keepe a Mʳˢ of his in his howse Mʳⁱˢ Leman + suffer Porter to keep her company."
7. Illustrated in London 1982–1983, 106, fig. 49. The painting is in the collection of Mrs. Gervas Huxley.
8. Huxley 1959, 188–190.
9. London 1970, 11.

In what must surely be considered a friendship portrait, Van Dyck portrayed himself in the company of Endymion Porter (1587–1649), one of the most remarkable members of the court of Charles I. This exceptional painting, the only instance in which Van Dyck appears with another sitter, suggests both the strong bonds between the two men and their profound differences in station and personality.

Van Dyck and Porter undoubtedly chose an oval format as a compositional device to suggest their closeness, while the rock upon which they both rest a hand symbolically refers to the steadfastness of their friendship. Nonetheless, as their contrasting costumes and expressions attest, their bonds must have been other than those of shared social class and temperament. Endymion Porter stands frontally, dressed in a fashionable white jerkin with elaborate lace collar and cuffs. His open, sympathetic expression conveys the warmth and kindness that was so remarked upon by his contemporaries and evident in his letters to his wife.[1] Van Dyck's costume, on the other hand, is simple and restrained, perhaps in recognition that he should not dress beyond his station, particularly in the company of such a close confidant to Charles I. In the way that he has situated his profile against a dark background, however, one also wonders if he chose black to focus attention on his face. His worth, he seems to suggest, is defined not by his exquisite wardrobe, but by his artistic genius, as evident here in his refined features and alert expression.

The associations between Endymion Porter and Van Dyck that culminated in this portrait, which was probably painted about 1635, date back to Van Dyck's first visit to England in the winter of 1620–1621. At that time Porter was in the service of George Villiers, the marquess of Buckingham. He was extremely close to his master, and had even married Olivia Boteler [cat. 83], the daughter of Villiers' favorite sister, Elizabeth. An official responsibility in his position as Master of the Horse was to handle the accounts of the marquess, one of which was a payment at the end of 1620 to "Van Dyke the picture drawer," perhaps for the double portrait of the marquess of Buckingham and his wife [see cat. 17].[2]

After Van Dyck's departure from England in 1621, Endymion Porter entered Prince Charles' own service and became involved in one of the most extraordinary events in contemporary history, the secret mission of George Villiers and the prince of Wales to Madrid to bring back the Spanish infanta as the latter's wife. Porter, who had lived as a youth in Spain and understood the language and customs of the Spanish court, accompanied the two nobles as they traveled incognito through France and Spain. Although the mission eventually failed in its purpose (even though the prince and Porter did scale the walls of the infanta's garden in an effort to approach her), the artistic marvels to be seen in the court in Madrid and in the Escorial, particularly the paintings of Titian, had a lasting impact on the artistic taste of the English court.

When Charles assumed the throne in 1625 Endymion was appointed a Groom of the Bedchamber, which essentially meant that he was a personal assistant to the king. Among his many tasks in that position was to help the king acquire works of art. He was, for example, involved with the negotiations being undertaken by Daniel Nys and Nicholas Lanier [cat. 48] for the acquisition of the Mantuan collection in 1627 and 1628.[3] In August 1629 he left London with a party, including the Abbé Scaglia [cat. 70], on a diplomatic trip to Spain.[4] After stopping in The Hague and Brussels, he visited Van Dyck in Antwerp, presumably to commission *Rinaldo and Armida* for Charles I [cat. 54]. After the sale of *Rinaldo and Armida* Van Dyck wrote a warm letter (in Spanish!) to Endymion indicating his desire to be of future service.[5]

Endymion Porter, as close confidant to Charles I, was undoubtedly instrumental in arranging for Van Dyck's return to London in March of 1632. Only four months later, on 5 July 1632, Van Dyck was knighted and named Principal Painter in Ordinary to their Majesties. In London Van Dyck and Porter seem to have strengthened their friendship, if one is to judge from the comments written some years later in the

pocketbook of Richard Symonds concerning Van Dyck, his mistress Margaret Lemon, and Endymion Porter.[6]

Van Dyck painted two portraits of Endymion Porter. The first, executed about 1633, was an intimate family portrait of Porter with his wife Olivia and their three sons.[7] The double portrait with Van Dyck exhibited here, to judge from the ages of the two sitters, dates somewhat later. Huxley has suggested that it was painted in Flanders during the winter of 1634–1635 when Van Dyck and Porter were both in Brussels after the arrival of the new governor in the Spanish Netherlands, Cardinal-Infante Ferdinand.[8] Van Dyck, who had returned to Antwerp in March 1634, had been summoned to the court to portray the new ruler after he had assumed his responsibilities in November of that year. Endymion Porter had come to Brussels to offer his king's congratulations. Apparently he was also instructed to purchase paintings from both Rubens and Van Dyck, for he returned with two masterpieces for the king, Rubens' *Landscape with Saint George and the Dragon* (Royal Collection, London) and Van Dyck's *Henrietta of Lorraine* [cat. 72].[9]

Whether Van Dyck executed this gesture of friendship in Brussels or, as would seem more likely, after he returned to London in the spring of 1635, the double portrait was undoubtedly intended for Endymion Porter's collection. Unfortunately the contents of that collection are not known, since no inventory was taken before it was dispersed during the Commonwealth. The success of this composition was not lost upon Van Dyck. He adapted it for two other commissions from the end of the 1630s, a double portrait of *Mountjoy Blount, Earl of Newport, and George, Lord Goring* (Glück 1931, 435) and that of *Charles Louis and Rupert, Princes of the Palatine* (Louvre, Paris; Glück 1931, 441).

A. K. W.

1635
canvas, 151 x 154 (58⁷/₈ x 60)

Galleria Sabauda, Turin, inv. no. 264

PROVENANCE By the end of 1635 sent by
Henrietta Maria to her sister Christina,
duchess of Savoy, in exchange for a
painting of Christina's children; at the
time of the French occupation the
painting was transported to the Louvre,
Paris; returned to Turin in 1815

EXHIBITIONS Antwerp 1930, no. 98, ill.
54; Turin 1951, no. 74; Genoa 1955, no.
91, ill.; Turin 1989, no. 22, ill.

LITERATURE Smith 1829–1842, 3:53, no.
181 (describes painting in reverse);
Phillips 1887, 258–259; Phillips 1896, 41,
120, 126; Cust 1900, 110, ill., 118, 266, no.
41; Schaeffer 1909, 336, ill., 511; Glück
1931, 375, ill., 559–560; Van Puyvelde
1946, 66; Sabauda 1951, 60, pl.; Millar
1955, 314; Whinney and Millar 1957, 73;
Sabauda 1968, 212, no. 43, pl.; Sabauda
1969, xv, pl. 75; Brown 1982, 181–182, ills.
179–180; London 1982–1983, 60–61, cat.
18; Tardito Amerio 1982, 12, no. 7, 44, ill.,
45, ill.; Larsen 1988, no. 807, ill. 306

1. Cust 1900, 110.
2. Phillips 1896, 41.
3. See Millar in London 1982–1983, 60–61,
cat. 18 (the painting, however, was not
exhibited).
4. Charles was born on 29 May 1630;
Mary on 4 November 1631; and James on
14 October 1633.
5. For further information on the Savoy
family, see cat. 71.
6. Baudi di Vesme 1885, quoted in
Sabauda 1968, 212. The basic source for
these letters between Henrietta Maria
and her sister is H. Ferrero, Lettres de
Henriette-Marie de France a sa sœur
Christina Duchesse de Savoie (Turin, 1881),
40, 43.
7. Quoted in London 1982–1983, 60,
cat. 18.
8. Quoted in Sabauda 1968, 212.
9. C. Willett Cunnington and Phillis
Cunnington, Handbook of English Costume
in the Seventeenth Century (Boston, 1972),
195.
10. See Millar in London 1982–1983, 61,
cat. 18, n. 1. Millar also suggested that
the apple he holds is a symbol of fruitful-
ness. The quotation is taken from J. Max
Patrich, The Complete Poetry of Robert
Herrick (Garden City, 1963), 148.

Van Dyck's genius for capturing the innocence and gentleness of children is evident throughout this exhibition. For someone who married late in life and seems to have had little contact with children, he had a remarkable sensitivity to those postures and expressions that distinguish children from adults, even children who have been thrust into adult roles at an early age. Of all of Van Dyck's portraits of children, however, none has excited such universal admiration as this touching image of three children of Charles I and Henrietta Maria. Cust described it as "the most beautiful piece of child-portraiture in the world. The composition is simple, not very ingenious or quite satisfactory, but the pose of the children is so easy and unaffected, that there seems to be no need for further elaboration."[1] The "brilliancy of the colour and the delicacy of the silvery tone" have been equally admired,[2] as well as the subtle textures of the materials, particularly the lace, that enliven the entire design.[3]

Van Dyck had received the commission to paint this portrait by July 1635, shortly after his return from Flanders. The three children, Charles, prince of Wales, Mary, Princess Royal, and James, duke of York, were respectively five, three, and one year old.[4] The request for their portraits must have come from the queen, for she and her older sister, Christina, duchess of Savoy, had decided to send each other portraits of their children.[5] The painting from the duchess of Savoy seems to have come first: in an undated letter, but probably written in July, the queen wrote to her sister: "Je vous remersie des pourtraits que vous m'avés envoyé de vos enfants. Je suis amoureuse de ma nièpce, et pour votre petit fils, je ne l'oserois louer, car il resemble trop au mien. Je vous envoyeray leurs portraicts dans une semaine."[6] The portrait of the queen's children seems to have been delayed for a very good reason: her daughter would not stand still long enough ("ma fille n'a jamais voulu avoir la pasiance de les leser achever tel qu'il est je le vous envoye j'en feray faire une autre pour elle qui sera mieux").[7] Finally, in the fall, the painting was ready. The ambassador from Savoy, Benoit Cize, wrote to the duke of Savoy on 29 November that the queen had shown him the portraits that had been painted of the royal children. He added, however, that the queen had told him that: "le Roy estoit faché contre le peintre Vendec, pour ne leur avoir mis leur tablié, comme on accoustume aux petits enfans, et qu'elle enscriproit à Madame sa soeur, pour le leur faire mettre."[8]

The king's anger against Van Dyck for having posed his children in "tablié" (literally "aprons") such as those worn by "petits enfans" could only have been directed at the infant "coat" worn by the eldest child, Prince Charles. Charles, who stands with his hand resting on the head of a large red-brown spaniel, wears a lace cap and a pale scarlet frock decorated with silvery-gray lace and ribbons. This type of

Fig. 1. Anthony van Dyck, The Three Eldest Children of Charles I, 1635, canvas, 133.4 x 151.8 (52¹/₂ x 59³/₄). Copyright reserved to H. M. Queen Elizabeth II

dress, which is also worn by James, duke of York, the youngest child on the right, was appropriate for boys up to the age of seven, although most boys seem to have been breeched slightly earlier.9 Charles, who was born on 29 May 1630, was five and a half years old at the end of November, an age the king clearly felt was sufficiently advanced for him to wear pants. Van Dyck, who had begun the portrait in the early summer when Charles was presumably still wearing a dress, clearly had never been informed that he should revise his costume once the portrait had become delayed.

Whether the king's anger or the queen's wish for "une autre pour elle qui sera mieux" persuaded Van Dyck to paint a revised portrait is not known, but shortly after this portrait was dispatched to Turin the three children posed again for the artist. This time Van Dyck represented Prince Charles in the breeches that would have been appropriate for his age [fig. 1]. The painting was kept by the queen and hung at Somerset House.

In such an official portrait a certain decorum has to be maintained, hence the king's ire. In other respects, however, Van Dyck carefully included allusions to the rank of the three children. Prince Charles stands apart from his siblings with his hand resting on the head of a large dog in a manner not dissimilar from that of the emperor Charles V in Titian's great painting, then in the royal collection [see cat. 66, fig. 3]. His importance is further stressed by the elaborate red carpet on which he stands and the green curtain behind him. James, duke of York, was the second in line to the throne. To enhance his stature he stands, in a very steady manner for so young a child, on a small platform. Van Dyck gave him further distinction by situating him against a rosebush. Mary is positioned slightly behind her younger brother, turned, as is James, in the direction of Prince Charles. As Millar has suggested, the roses on the carpet may be allusions to Robert Herrick's poem in honor of the young duke of York in which he wrote:

May his pretty Duke-ship grow
Like t'a Rose of *Jericho*:
Sweeter far, then ever yet
Showrs or Sun-shines co'd beget
May the Graces, and the Howers
Strew his hopes, and Him with flowers.10

A. K. W.

Charles I in Three Positions

1635–1636
canvas, 84.5 x 99.7 (33 ¼ x 39 ¼)

H. M. Queen Elizabeth II

PROVENANCE Sent by the king soon after
17 March 1636 to Gian Lorenzo Bernini
in Rome to assist in the sculpting of a
marble bust; in the possession of
Bernini's sons in Rome; bought in 1802
or 1803 from the Palazzo Bernini by
James Irvine for William Buchanan and
Arthur Champernowne; sale, Christie's,
London, 12 May 1804, lot 9; bought by
Stewart; bought from Champernowne by
Walsh Porter, whose son wrote to the
Prince of Wales on 21 December 1809
that the picture had been sold to William
Wells of Redleaf after the death of his
father; bought by George IV in 1822 from
Wells for one thousand guineas

EXHIBITIONS London, British Institution,
1819, no. 116; London, British Institution,
1826, no. 113; London, British Institution,
1827, no. 178; Leeds 1868, no. 785;
London, Royal Academy, 1870, no. 66;
Antwerp 1899, no. 50; London 1946–1947,
no. 30 (text vol.), 86, ill. (pl. vol.);
London 1953–1954, no. 138; London 1968,
no. 11; London 1972–1973, no. 86, pl. 86;
London 1988–1989, no. 11, ill.

LITERATURE Bellori 1672, 260; Filippo
Baldinucci, *Vita del Cavaliere Gio. Lorenzo
Bernino* (Florence, 1682), 88–89; Smith
1829–1842, 3:61–62, no. 212 and 9:375,
no. 26; Waagen 1854, 2:428; Walpole
1876, 1:270–271; Phillips 1896, 40; Cust
1900, 106–107, 211, no. 50, 264, no. 19;
Schaeffer 1909, 345, ill., 512; Cust 1909,
337–341; "Diary of Nicholas Stone,
Junior," *Walpole Society* 7 (1918–1919),
170–171; Eric Maclagan, "Sculpture by
Bernini in England," *Burlington Magazine*
40 (1922), 61–63; Vertue 1930–1955, 18:27
and 24:36; Glück 1931, XLIV, 389, ill.,
561–562; Royal Collection 1937, 76–77, ill.,
27; Gordon Albion, *Charles I and the Court
of Rome, a Study in 17th Century Diplomacy*
(London, 1935), 399, frontis.; Waterhouse
1953, 49, 38, ill.; Rudolf Wittkower, *Gian
Lorenzo Bernini, the Sculptor of the Roman*

With utmost care and sympathy Van Dyck crafted this poignant image of the king as a model for a bust-length sculpture to be carved by Gian Lorenzo Bernini in Rome. The fortuitous circumstances that united in one project the greatest portrait painter and the greatest sculptor of the day were in part motivated by artistic concerns and in part by political and religious ones. The significance of Van Dyck's portrait, however, cannot be measured by the unique circumstances that led to this unusual commission, for no image has had a greater impact on historical perceptions of the king's character and hence on opinions about the nature of his personal rule than this painting.

Van Dyck ostensibly portrayed the king in three positions to provide the sculptor with a full range of images from which to carve his bust. In general format he clearly followed a prototype believed to be by Titian but in actuality by Lorenzo Lotto, *Portrait of a Man in Three Positions*, that was then in the collection of Charles I [fig. 1]. The variety of costumes that Van Dyck depicted, the different attitudes of the hands, and the dramatic sky in the background, however, were not requisites for the sculpture but rather compositional effects conceived in pictorial terms. Implicit in the subtle flesh tones of the face, shimmering colors of the king's doublets, and broad painterly treatment of the sky, moreover, was Van Dyck's challenge to Bernini to carve in stone an image as lifelike as the one he could create in paint. Bernini seems to have understood the nature of the challenge, for in a discourse held shortly thereafter he emphasized how much more effective a sculpture made from life was than one made from a painting. He also acknowledged the limitations of marble versus paint. "How can itt than possible be that a marble picture can resemble the nature when itt is all one coulour, where to the contrary a man has on coulour in his face, another in his haire, a third in his lipps, and his eyes yett different from all the rest? Tharefore sayd (the Cauelier Bernine) I conclude that itt is the inpossible thing in the world to make a picture in stone naturally to resemble any person."[1]

The scenario that brought the painter and sculptor together was one steeped in the subtle intrigues of international diplomacy. The specific question in this instance revolved around Catholicism and its reception in England. Henrietta Maria had only been allowed to marry Charles by special dispensation of the pope, who made it very clear that he expected her to do all she could to further the cause of the Catholic faith once she was in England. By her mother, Maria de' Medici, she was instructed to pray each day for her husband's conversion, that he might turn to the true religion.[2] To a large extent Henrietta Maria succeeded in her charge. Toleration of Catholics in the court, even of the Capuchin monks that attended her, encouraged the papacy to believe that further improvements of the situation of the Catholics in England, and even the wanted conversion of Charles I, might be possible.

Fig. 1. Lorenzo Lotto, *Portrait of a Man in Three Positions*, c. 1530–1535, canvas, 52 x 79 (20 ½ x 31 ⅛). Kunsthistorisches Museum, Vienna

Fig. 2. Thomas Adye (?) after Bernini, *Charles I*, 18th century, marble. Copyright reserved to H. M. Queen Elizabeth II

Baroque (London, 1955), 16–17, 200–201, no. 39; Whinney and Millar 1957, 73; Royal Collection 1963, no. 146, ill. 70; Royal Collection 1977, 156, pl. 34; Gaunt 1980, 101, ill.; Lightbown 1981, 439–477; Brigstocke 1982, 486; Brown 1982, 174, ill. 173, pl. 174, 176; Howarth 1985, 162, ill. 112, 163–164; Wiemers 1987–1988, 258, ill., 259; Larsen 1988, no. 797, ill. 310

1. The diary of Nicholas Stone, Junior, which describes this meeting with Bernini on 22 October 1638, is published in *The Walpole Society 1918–1919*, ed. A. J. Finberg (Oxford, 1919), 7:170–171. Bernini's comments can be best understood in the context of the philosophical debates about the relative worth of sculpture and painting that were so important in sixteenth- and seventeenth-century art theory. See J. White, "Paragone: Aspects of the Relationship between Sculpture and Painting," *Art, Science and History in the Renaissance*, ed. C. Singleton (Baltimore, 1967), 43–108; and Leatrice Mendelsohn, *Pargoni: Benedetto Varchi's "Due Lezzioni" and Cinquecento Art Theory* (Ann Arbor, 1982).
2. See Quentin Bone, *Henrietta Maria: Queen of the Cavaliers* (Urbana, 1972), 29, 36–37.
3. For the chronology of the commission, see Wittkower 1955, 200–201, cat. 39.
4. For a transcript of Barberini's letter to Henrietta Maria about the transport, see Maclagan 1922, 63.
5. Albion 1935, 399.
6. Filippo Baldinucci, *The Life of Bernini*, trans. Catherine Enggass (University Park, 1966), 23.
7. See Cust 1909, 340.
8. Strong 1972, 95–96.
9. *The Poetical Works of Sir John Denham*, ed. T. H. Banks, Jr. (New Haven, 1928), 70. Quoted in Strong 1972, 27.

In 1634 the papal envoy Gregorio Panzani arrived in London, and through meetings with Henrietta Maria quickly succeeded in speaking with the king as well. As part of its diplomatic venture the papal court had decided to appeal to the king's love of art by sending him costly paintings and sculptures. Perhaps the greatest gesture toward Charles, however, was the dispensation Pope Urban VIII gave to Bernini in June 1635 to allow him to sculpt the bust of this Protestant king.[3] Subsequently, on 17 March 1636, the king officially requested Bernini to execute the bust after a painting "which we shall send you without delay." The bust was executed the next summer and, following special instructions provided by Cardinal Barberini, papal vice-chancellor, it was shipped from Rome in April 1637.[4]

Bernini's sculpture was enthusiastically received by the king and queen, who insisted on opening the case the very night it arrived.[5] According to Bernini's biographer, Filippo Baldinucci, the king was so overjoyed with the sculpture that he "took from his finger a diamond valued at six thousand scudi and, handing it to the cavalier's envoy, said: 'Adorn that hand which made so fine a work.'"[6] While this account is probably apocryphal, Queen Henrietta Maria did indeed send a diamond to Bernini, and later requested a sculpted bust of herself as well [see cat. 82].

Bernini's bust of Charles I was destroyed in the fire of Whitehall Palace in 1698. An engraving and a marble copy, however, record its appearance, which differed in many respects from the models provided by Van Dyck [fig. 2]. The most profound difference, as described by Cust, is that the "*volto funesto* of the painting has been changed by the sculptor to a more lively and genial expression."[7]

The *volto funesto* Cust ascribed to Van Dyck's image follows a long established tradition of reading into the king's expression a melancholic foreboding of his tragic death. Yet, as Strong has emphasized, such interpretations of the king's appearance postdate his death. In 1635 when Van Dyck painted this image, the king was at the height of his power, ruling as an absolutist monarch by Divine Right. The melancholia evident in his countenance is not a foreboding of the future, but rather a reflection of his divine nature.[8] His gentle and pious character was extolled in his lifetime in poetry as well, as in John Denham's *Cooper's Hill*, where he is equated with Saint George, the patron of the Order of the Garter, whose medal he wears conspicuously in Van Dyck's painting:

In whose Heroic face I see the Saint
Better expressed than in the liveliest paint,
That fortitude which made him famous here,
That heavenly piety, which Saints him there,
Who when this Order he forsakes, may he
Companion of that sacred Order be. ...[9]

Ultimately there are unmistakable Christ-like associations in this image, and the allusions to the Trinity juxtaposed to a turbulent sky may not be totally fortuitous. Van Dyck, in any event, has provided in this wonderful painting a lasting image of the mystique of divinity that surrounded Charles during the halcyon years of his reign as Divine Right Monarch.

A. K. W.

Thomas Howard, 14th Earl of Arundel, with His Grandson Thomas

c. 1636
canvas 144.8 x 119.4 (57 x 47)

The Duke of Norfolk, Arundel Castle

PROVENANCE Mentioned in a letter of the countess of Arundel to the Lord Deputy on 5 September 1636; in Arundel inventory 1655

EXHIBITIONS London, Royal Academy, 1880, no. 57; London 1887, no. 8; London, National Gallery, 1897; Antwerp 1899, no. 41; London 1900, no. 58; Antwerp 1949, no. 57; London 1953–1954, no. 136; London 1968a, no. 45; London 1982–1983, 31, no. 21, ill.; Oxford 1985–1986, no. 6, pl.

LITERATURE Inventory for Norfolk House, St James's, in 1777; Smith 1829–1842, 3:183–184, no. 629; Waagen 1854, 3:31; Walpole 1876, 1:330; Cust 1900, 132, 134 (opp.), ill., 199, no. 8, 210, no. 41, 219, no. 58, 268, no. 3; Schaeffer 1909, 355, ill., 513; Mary F. S. Hervey, *The Life, Correspondence and Collections of Thomas Howard, Earl of Arundel* (Cambridge, 1921, reprint New York, 1969), ill. 18, 353–354, 478, no. 119; Glück 1931, 473, ill., 573; Vertue 1930–1955, 26:54; F. H. C. Weijtens, *De Arundel-Collectie, Commencement de la fin Amersfoort 1655* (Utrecht, 1971), 6, 8–9, 30, no. 8, 48 n. 181, ill. 5; Brown 1982, 208, ill. 215; John Martin Robinson, *The Dukes of Norfolk, a Quincentennial History* (Oxford and New York, 1982), 112–113, 114, ill.; Howarth 1985, 160, ill. 110, 161–164, 166; Wiemers 1987–1988, 261, 263, ill.; Larsen 1988, no. 763, ill. 414

1. Literature on the life of the earl of Arundel is vast. See, for example, Hervey 1921; Parry 1981; Robinson 1982; Howarth 1985; Oxford 1985–1986.
2. The life of Thomas Howard, 5th duke of Norfolk (1626/1627–1677), did not unfold as his grandfather would have wished. The family fortunes deteriorated badly by the end of 1630s. In 1642 at the outbreak of the Civil War, Arundel retired to the low countries. He eventually moved to Padua where he died in 1646. Thomas and his father, Arundel's second son, Henry Frederick Howard, were in Padua with him, but by that time Thomas had contracted a fever that damaged his brain. He was confined at Padua and lived there in seclusion as an "incurable maniac" for the rest of his life. Shortly after Charles II's restoration to the throne, however, Thomas Howard was restored as 5th duke of Norfolk, thus, to a certain extent, fulfilling the dynastic ambitions of the earl of Arundel.
3. Howarth 1985, 105. Arundel managed to move his father's remains from the Tower burial ground to the Fitzalan Chapel at Arundel Castle in 1625.
4. Vertue 1930–1955, 26:54.
5. As quoted in Oxford 1985–1986, 16.

Although primarily remembered as one of the great patrons and collectors of his day, Thomas Howard, 14th earl of Arundel, was a powerful figure in the Stuart court, particularly after 1621 when he was created Earl Marshal by James I, an honor traditionally vested in his family. He was intensely proud of this role, which placed him at the head of the nobility, at the center of a vast network of patronage, and in close contact with scholars.[1]

In this powerful double portrait, painted about 1636, Van Dyck has conveyed the haughty strength of Arundel's character even as he tenderly rests his hand on the shoulder of his eight-year-old grandson Thomas. Arundel's armor, the Order of the Garter that hangs around his neck, and the conspicuously held Earl Marshal's baton clearly indicate that the intent was to convey far more than intimacy. Young Thomas looks upward toward the baton in clear recognition that he in turn will bear the responsibilities of this position of honor. The blank paper he holds in his right hand presumably indicates his willingness to learn under the guidance and instruction of the earl who has taken him so clearly under his protection.[2]

The dynastic implications of this painting are consistent with Arundel's preoccupation with restoring the prestige of his family to its rightful place at the head of British aristocracy, a position of prominence severely tested during the reign of Queen Elizabeth. Thomas Howard's grandfather, the 4th duke of Norfolk, had been executed in 1572 by order of Elizabeth, and his father, Philip, earl of Arundel, a staunch Catholic who was imprisoned on an unsubstantiated charge of treason, died in the Tower in 1595.[3] These disgraces destroyed much of the wealth and influence of the Howard family, but served to strengthen Arundel's resolve.

Arundel's endeavors to reestablish the importance of his family existed in the cultural as well as political spheres, for an important part of his family heritage was its history of collecting and patronage that extended over much of the sixteenth century. By nature aloof and not inclined to become involved in court intrigues despite the importance of his position as Earl Marshal, Arundel was, nonetheless, a passionate collector and a champion of humanistic learning. In 1612 he visited the Netherlands, where he first came into contact with Peter Paul Rubens before traveling on to Italy with Inigo Jones. There he studied ancient ruins, Renaissance architecture, and experienced firsthand the marvels of Venice. He was intensely proud of the collections of sculpture and paintings he formed with his wife Alatheia Talbot, and displayed portions of them in the backgrounds of the pendant portraits that Daniel Mytens painted of the pair about 1618 [figs. 1, 2]. His collections of drawings, manuscripts, and rare books were equally famous in his day.

This marvelous double portrait by Van Dyck in many respects encapsulates these various components of Arundel's broad interests. Arundel keenly felt the importance of portraiture as a vehicle for historical continuity. He took great pride in the Holbein portraits of his ancestors that he had inherited, and continued to collect paintings and drawings by this artist. One of his proudest possessions was a striking portrait of his great-great-grandfather, Thomas Howard, 3d duke of Norfolk, by Holbein, in which the duke of Norfolk also holds in his right hand the Earl Marshal's baton (Royal Collection, London). It is not beyond the realm of possibility that Arundel conceived this double portrait as a sequel to this image of his illustrious forebear. Arundel's own inclination, however, also drew him to Venetian art, and Van Dyck's successful assimilation of Titian's style made him a perfect choice for this statement of dynastic concerns. Van Dyck's achievement was particularly admired for its Venetian qualities by Vertue, who described this painting as a "most excellent Masterly piece by Vandyke wherein he has imitated the stile of Titian in his colouring."[4]

Equally important to painting in Arundel's mind, however, was sculpture, and it is fascinating to learn that Arundel sent this work, or a copy thereof, to his agent in

6. Howarth 1985, 162–163, assumes that the sculptor was Dieussart. Susan Barnes suggested to me the possibility that he might have been Du Quesnoy.

Rome, William Petty, as a model for a relief sculpture. In November 1636 Arundel wrote to Petty that he was sending "a Picture of my owne and my little Tom bye me; & desire it may be done at Florence in Marble Basso relievo, to trye a yonge Sculptor there whoe is sayide to be Valente Huomo, Francesco hath his name I could wish Cavaliere Bernino, or Fra [ncesco Fi] amengo, might doe another of the [sam]e."[5]

The sculptor Francesco referred to in Arundel's letter cannot be firmly identified. He could have been François du Quesnoy (1597–1643), who was known as Il Fiammingo, or François Dieussart (1622–1661), who had already completed some works for Arundel and who would later come to work at Arundel House.[6] The sculpture based on this work, if ever executed, has disappeared. It is not known how Arundel came upon the idea to use this work as a model for a relief sculpture, although the inspiration may have come from Van Dyck's triple portrait of Charles I that was to be used as a model for a bust by Bernini [see cat. 75].

Arundel's admiration of Van Dyck extended back at least to 1620. Although little is known of Van Dyck's stay in England in 1620–1621 beyond his portrait of *The Earl of Arundel* (J. Paul Getty Museum, Malibu), his *Continence of Scipio* [see cat. 22, fig. 2], which Arundel presented to the marquess of Buckingham, and his double portrait of *Sir George Villiers and Lady Katherine Manners as Adonis and Venus* [cat. 17], it seems clear that Arundel's support was crucial for Van Dyck's associations with the court of King James I. Arundel was also the one who granted a pass for Van Dyck that allowed him leave to travel, presumably so that he would be able to visit Italy and view there the marvels so admired by the earl himself. Once in Italy he had the opportunity to accompany the countess of Arundel from Venice to Padua and Mantua, not only to view with her the splendors of those artistic centers, but also to meet collectors and patrons, contacts that would prove important to him throughout the rest of his career.

The first evidence of Van Dyck's renewed contacts with Arundel seems to date only from the period after his visit to Flanders in 1634–1635. This painting was almost certainly executed between Van Dyck's return to London in the spring of 1635 and Arundel's embassy to Vienna in April 1636. During this same period he painted a portrait of Arundel's second son and father of young Thomas, Henry Frederick Howard, Lord Maltravers (collection of the duke of Norfolk). Van Dyck also received two later important commissions from Arundel. The first, the so-called *Madagascar Portrait*, 1639, depicts Arundel and his wife pointing to the island of Madagascar on a large globe, in commemoration of a scheme for the colonization of that island that he was at that time backing (collection of the duke of Norfolk). More directly related to the double portrait in concept is an image of the family dynasty, never completed, but presumably recorded in a small oil painting by Philip Fuytiers that is also still in the collection at Arundel Castle.

A. K. W.

Fig. 1. Daniel Mytens, *Thomas Howard, 14th Earl of Arundel and Surrey*, c. 1618, canvas, 214.6 x 133.4 (84 1/2 x 52 1/2). National Portrait Gallery, London, on loan to Arundel Castle, Sussex

Fig. 2. Daniel Mytens, *The Countess of Arundel*, c. 1618, canvas, 214.6 x 133.3 (84 1/2 x 52 1/2). National Portrait Gallery, London, on loan to Arundel Castle, Sussex

Charles I in Armor

c. 1636
canvas, 102.5 x 81 (40¼ x 32¾)

Private collection, England

1. Cust 1900, 98.
2. See, for example, the list of paintings presented to the king for payment at the end of 1638 in the "Memoire pour sa Magtie le Roy," reproduced in Hookham Carpenter 1844, 67–68.
3. Royal Collection 1963, 95, cat. 145.
4. Glück 1931, 559, no. 370, where the Longford Castle version is cited as the model for De Jode's engraving.

Van Dyck, as court artist to Charles I, had an unusually close relationship to the king and queen, one that seemed to intensify after Van Dyck's return from Flanders in the spring of 1635. To facilitate the visits of Charles I and Henrietta Maria to Van Dyck's lodgings at Blackfriars as they traveled along the Thames in their royal barge, they had a special landing dock and stairs built with funds from the royal treasury.[1] While they clearly admired the artist's work, most of the portraits Van Dyck made of the king and queen during the latter half of the 1630s were not for the royal collection but were commissioned to be given away to relatives, friends, and loyal supporters. This extremely fine half-length portrait in armor, which was only recently discovered, is probably one such painting. Although it is not known to whom the king presented this image, documents record similar portraits given as gifts during this period of the king's reign.[2]

This portrait, painted shortly after *Charles I in Three Positions* [cat. 75], depicts the king as an armored knight standing beside his crown and holding his commander's baton before him. A gold medallion with the image of Saint George and the Dragon hangs from the gold chain around his neck, symbolic of his role as Garter Sovereign. Charles wore this medallion, the so-called Lesser George, constantly, for in this Christian knight he found the ideals of chivalry that were so fundamental to his concept of kingship. These ideals are further suggested by the gentle yet dignified expression on his face, an expression that differs from that seen in *Charles I in Three Positions*. By widening the eyes and extending the mouth Van Dyck has subtly transformed the king's countenance to one that exudes the strength and compassion appropriate to a commander in whom trust is to be placed.

This image, known previously in a studio version that was once at Longford Castle (Glück 1931, 370), exhibits all of the mastery of Van Dyck's touch, from the softness of the flesh to the reflective sheen of the armor. Whether Van Dyck painted this portrait from life, however, is not known. The position of the head is similar to that seen in a number of other portraits of the king, in particular a full-length in the royal collection signed and dated 1636 [see Millar, fig. 9].[3] One of these, or a separate study now lost, may have been the source of the pose. In any event, this painting seems to have been the source for Pieter de Jode the Younger's engraving of Charles I.[4]

A. K. W.

Lady Mary Villiers with Lord Arran

c. 1636
canvas, 211.7 x 133.5 (83 3/8 x 52 9/16)

North Carolina Museum of Art, Raleigh,
Gift of Mrs. Theodore Webb, 52.17.1

PROVENANCE Dukes of Hamilton,
Hamilton Palace, Scotland, until 1881;
Christie's, London, 17 June 1882, lot 31;
E. B. Denison (?); Baron Alfred de
Rothschild (d. 1918), Halston; Lionel
Nathan de Rothschild (d. 1942), Exbury
House; David M. Koetser, New York

EXHIBITIONS North Carolina Museum of
Art, Carolina Charter Tercentenary
Exhibition, 1963, no. 73, ill.; Baltimore
Museum of Art, From El Greco to Pollock:
Early and Late Works by European and
American Artists, 1968, 22–23, ill.; London
1972–1973, no. 98, ill.; The Montreal
Museum of Fine Arts, Largillierre and the
Eighteenth-Century Portrait, cat. by Myra
Nan Rosenfeld, 1981, no. 11, ill.

LITERATURE Bellori 1672, 262; Waagen
1854, 3:297; Smith 1829–1842, 9:390–391,
no. 79; Walpole 1876, 1:330; Cust 1900,
117, 278, no. 128; North Carolina
Museum of Art 1956, 62, no. 112, ill. 112;
North Carolina Museum of Art 1966, no.
14, ill.; London 1982–1983, 28, ill. 32, 29;
North Carolina Museum of Art 1983, 138,
ill., 139; Larsen 1988, no. 972, ill. 340

1. Bellori 1672, 262.
2. Royal Collection 1963, 102, cat. 159.
3. Royal Collection 1963, 100, cat. 153.
4. After Stuart died in 1655 she remarried
once again, this time to Colonel Thomas
Howard.
5. Klara Garas, "Die Entstehung der
Galerie des Erzherzogs Leopold
Wilhelm," Jarhrbuch der Kunsthistorischen
Sammlungen in Wien (1967), 63:69, no.
289. "One peice of my Lady Duches of
Lenox at length with a cupid by her of Sr
Anthony Vandyke." Garas dates the
inventory (no. 15) 1638.

Bellori, in his Le Vite de Pittori of 1672, provided a particularly revealing commentary about this unusual double portrait. Van Dyck, he wrote, "made the portrait of the Duchess of Richmond, daughter of the Duke of Buckingham, and this portrait, because of its unique beauty put in doubt as to whether credit should be accorded to art or to nature. He portrayed her in the manner of Venus. Her portrait is accompanied by that of her son [sic], The Duke of Hamilton, completely nude, [posed as] cupid armed with his bow and his arrows."[1] Although Bellori's admiring words followed literary conventions that brought praise to sitter and artist alike, his choice to use them here does suggest that this double portrait was particularly well received by Van Dyck's contemporaries.

Sir Kenelm Digby, who provided Bellori with information about Van Dyck's English paintings, had a strong predilection for allegorical portraits [see cat. 64], a number of which Bellori described. Most of those portraits historiés are now lost, with the result that this portrait seems more unusual within Van Dyck's œuvre than it should be. It does appear, however, that Van Dyck used this genre primarily for English sitters, a fact that conveys much about aspects of taste in the English court. The underlying theme of Van Dyck's portraits historiés, from his early double portrait of Sir George Villiers and Lady Katherine Manners as Adonis and Venus of c. 1620 [cat. 17] to this work painted about 1636, paralleled court ideals of love and beauty [see also cat. 54]. Here the young Cupid holds aloft a large arrow as he looks upward at Lady Mary Villiers (1622–1685), perhaps as indication that his arrow has found its target.

The target was Sir Charles Herbert, whom she married on 2 January 1635. Cupid had aimed well, for her handsome spouse was the third son and heir of Philip, 4th earl of Pembroke, chamberlain to Charles I and one of the most enlightened patrons of the arts in his day. After their marriage Pembroke commissioned an enormous group portrait, with dynastic implications similar to those in the double portrait of the earl of Arundel and his grandson [see cat. 76]. In this work [see Brown, fig. 1], which still hangs at Wilton House, Pembroke proudly gestures toward his daughter-in-law, who stands in a place of honor in the middle of the composition, as though he is presenting her as the newest member of the family.

This double portrait must have been painted shortly after the large family portrait. Mary Villiers was only thirteen at the time of her marriage, and despite her stately pose and elegant wardrobe, an age of fourteen seems appropriate for her fair features. The subject, moreover, would have been decidedly inappropriate after 1636, for in that year her young husband, age sixteen, died of smallpox in Florence, where he had gone to join the army of the grand duke of Tuscany. Although she wed James Stuart,

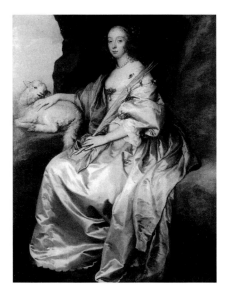

Fig. 1. Anthony van Dyck, Lady Mary
Villiers, 1637, canvas, 186.7 x 137.2
(73 1/2 x 54). Copyright reserved to
H. M. Queen Elizabeth II

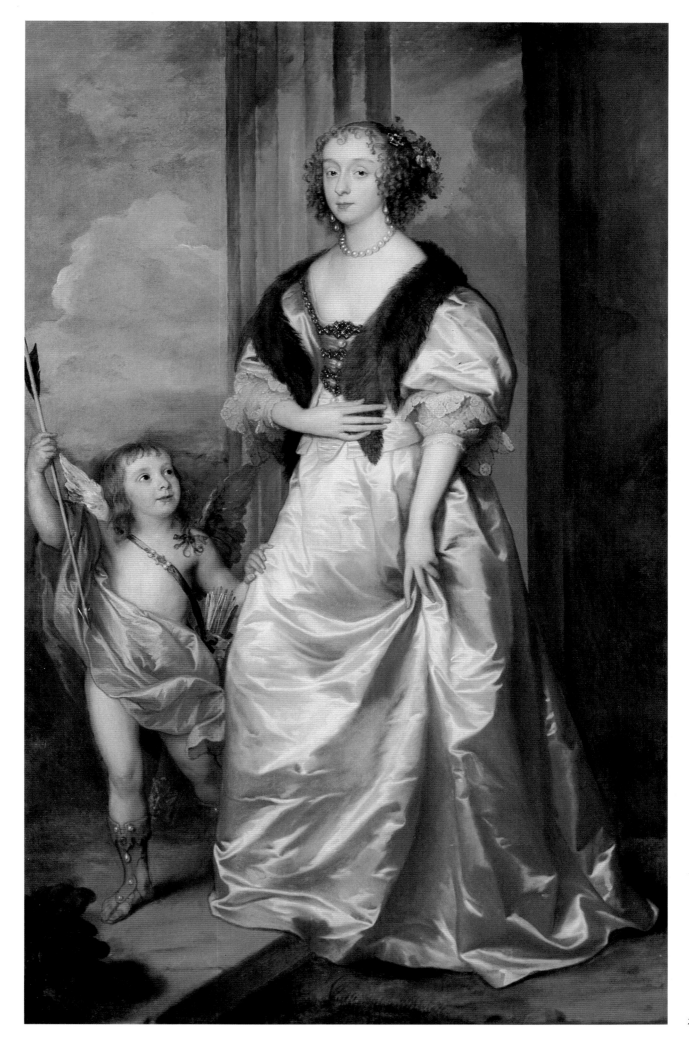

the duke of Lennox [cat. 66] on 3 August 1637, one can hardly imagine that she would commission a painting with such an amorous theme for that occasion. Far more appropriate was another *portrait historié* of Mary Villiers that Van Dyck painted for Charles I in which she was represented as Saint Agnes, the patroness of those about to be married [fig.1].[2] In this latter portrait, moreover, she appears to be distinctly more mature.

Mary Villiers was the only daughter of the duke of Buckingham and was a great favorite of the royal family. She and her two brothers, George and Francis, were raised in the royal nursery after the assassination of their father and provided with the same tutors and governors as were the children of the king and queen.[3] Her first marriage was celebrated in the Royal Closet at Whitehall, and when she was married to James Stuart she was actually given away by the king.[4] She appears rather frequently in Van Dyck's portraits, including the 1632 family portrait with her widowed mother and two brothers (Glück 1931, 402), and in a full-length portrait accompanied by Mrs. Gibson, a dwarf who was a painter and a page at the court, from the end of the 1630s (Glück 1931, 477).

The little Cupid who tries to draw her attention to the arrow he holds in his hand is Charles Hamilton, Lord Arran (d. 1640). His mother Lady Mary Feilding, the duchess of Hamilton (1613–1638), was the daughter of Susan Villiers, the sister of the duke of Buckingham; Lord Arran and Mary Villiers thus were first cousins. Lord Arran's father, the marquess of Hamilton [cat. 87], a close confidant to Charles I, was also an important patron and collector of paintings. Hamilton may have commissioned this painting since it appears in an early inventory of his collection.[5]

Tensions often exist between the allegorical and portrait aspects of a *portrait historié*, even for an artist as adept in both genres as was Van Dyck. This painting is no exception. Other than dressing Lord Arran as Cupid, Van Dyck has done little else to convey the allegorical nature of the image. Although Bellori, through the eyes of Digby, saw Mary Villiers as Venus, nothing about her pose or elegant white satin robe suggests such an association. Indeed, he has basically adapted a portrait type of a woman and child known from other examples [see cat. 37] without seriously reconsidering its demands. Despite a certain artificiality in concept, however, the execution is masterful. Indeed the painting is one of Van Dyck's most sensitive female portraits from the later years of his career.

<div align="right">A. K. W.</div>

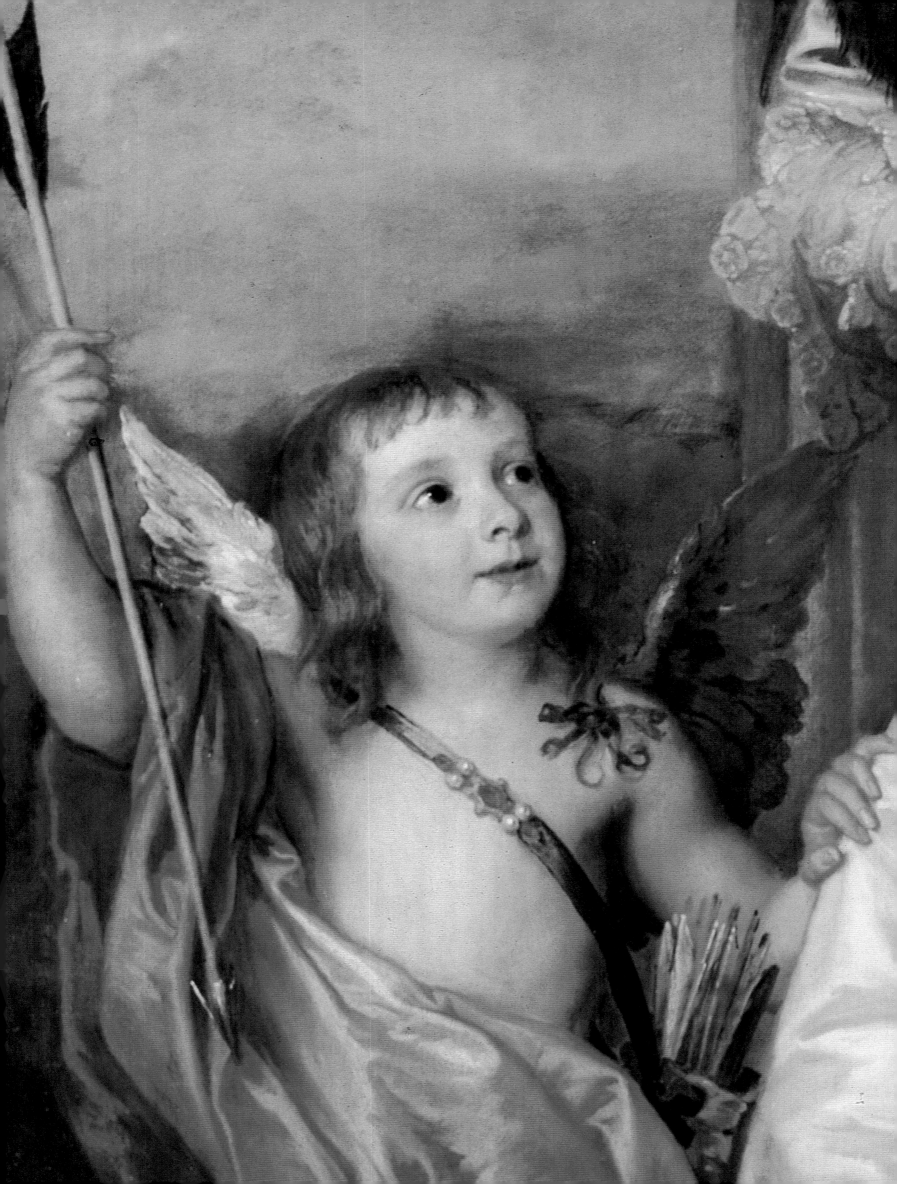

c. 1636
canvas, 114 x 207 (44 1/2 x 80 3/4)

Koninklijk Museum voor Schone
Kunsten, Antwerp

PROVENANCE Commissioned in 1634 or
early 1635 by Cesare Alessandro Scaglia,
Abbé of Stafforda and Mandanici, for the
Chapel of Our Lady of the Seven
Sorrows at the Franciscan church of the
Recolets, Antwerp; taken by the French
in 1794, and returned in 1815

EXHIBITIONS Antwerp 1899, no. 25;
Antwerp 1949, no. 7, ill. 4; Genoa 1955,
no. 83, ill.; Tokyo 1987, no. 83, pl.

LITERATURE Smith 1829–1842, 3:3, no. 4;
Cust 1900, 93–94, 95, ill., 209, no. 25, 248,
no. 33; Schaeffer 1909, 124, ill., 500;
Glück 1931, XLII, 367, ill., 558; Hooge-
werff 1949, 157–162, ill. 3; Koninklijk
Museum 1959, no. 36, pl.; Koninklijk
Museum 1970, 71, no. 404; Princeton
1979, 172, ill. 49; Brown 1982, 159–161,
ill. 161; Martin 1983, 42, 43, ill. 14; Larsen
1988, no. 1041, ill. 375

1. This later date was first suggested by
Hoogewerff 1949, 160.
2. *The Canons and Decrees of the Council of
Trent,* trans. T. A. Buckley, 1851, session
XIII, ch. IV, as quoted in Glen 1977, 92.
3. Martin 1983, 43.
4. Van Dyck may well have adapted this
pose from one often associated with the
grieving Mary Magdalene, as for example
in Mantegna's engraving of the *Entomb-
ment of Christ* or in Hans Baldung Grien's
woodcut of the *Lamentation.*
5. Antwerp 1949, 15, cat. 7.

Fig. 1. Anthony van Dyck, *The
Lamentation,* 1634, panel, 108.7 x 149.3
(42 3/4 x 58 3/4). Alte Pinakothek, Munich

Fig. 2. Anthony van Dyck, *Figure Study,*
c. 1636–1637, chalk with white
heightening on blue paper, 27.6 x 39.3
(10 7/8 x 15 1/2). The Pierpont Morgan
Library, New York

In this, Van Dyck's last surviving great religious painting, he captured the full pathos of the Virgin's intense grief. Unlike others of his lamentation scenes [fig. 1], she does not mediate between Christ's dead body and God above with prayerful, beseeching eyes: rather her expression and spread arms reflect the full agony and helplessness she feels at the loss of her only son. The tragedy of death here weighs heavily, not only through the Virgin's expression and the stark body of Christ, but also because of the constricted space of the horizontal composition.

This painting was placed over an altar that Abbé Cesare Alessandro Scaglia [see cat. 70] had erected in the church of the Recolets in Antwerp. Van Dyck must have received the commission when he was in Flanders in the winter of 1634–1635, but, as the altar was not consecrated until 1637, he probably executed the painting only after he had returned to London.[1] Stylistic considerations also support a later date. The stark, angular character of this *Lamentation* is strikingly different from the more sensual image of the theme Van Dyck painted in 1634 [see cat. 98].

Although Van Dyck's emphasis on the Virgin's grief was consistent with the altarpiece's destination in a chapel honoring the Seven Sorrows of the Virgin, he also conceived his image to accord with one of the most basic tenets of Counter-Reformation thought, the doctrine of transsubstantiation. Christ, although partially wrapped in a shroud with his head lying on Mary's knee, is displayed frontally so that his body and blood are brought forward to be presented to the viewer. Beneath his shroud is a flat gray rock, symbolic of the altar. The doctrine, as formulated at the Council of Trent, decreed "that, by the consecration of the bread and of the wine, a conversion takes place of the whole substance of the bread into the substance of the body of Christ our Lord, and of the whole substance of the wine into the substance of his blood."[2] The painting would thus have given added poignance to the rite of the Eucharist performed on the altar just below it.

Van Dyck achieved the remarkable force of Christ's corpse after making a careful chalk study from a model [fig. 2], where he actually tried out three different positions for Christ's left arm. He may have conceived the idea of having Saint John hold this arm from Annibale Carracci's etching of the *Pietà* (the *Christ of Caprarola*), where the same motif occurs.[3] The dramatic pose of the grieving Virgin, however, seems to have no direct precedent.[4]

The painting has unfortunately suffered a certain amount of damage and has lost some of its dramatic impact from extensive overpainting in the sky and the angel in the clouds at the upper right. It may also have been cropped at both top and bottom, to judge from the dimensions evident in the engraving after the painting by Schelte à Bolswert.[5]

A. K. W.

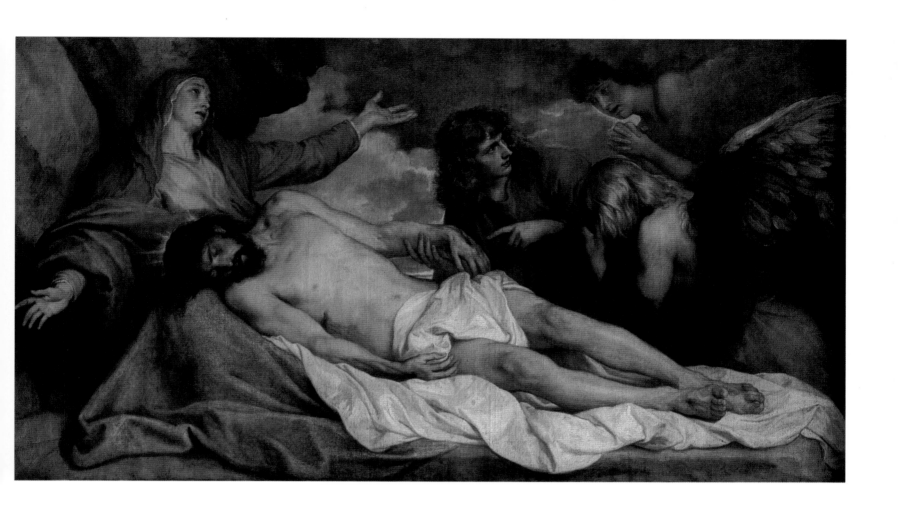

80
Sir Thomas Chaloner

c. 1637
canvas, 104 x 81.5 (23½ x 18¾)

The State Hermitage Museum, Leningrad

PROVENANCE In the collection of Sir Robert Walpole (1676–1745), 1st earl of Orford, Houghton Hall, Norfolk; inherited by his grandson George (1730–1791), 3d earl of Orford; acquired by Catherine II, empress of Russia, in 1779 with the Walpole Collection

LITERATURE Houghton Hall 1752, 46–47; Smith 1829–1842, 3:189, no. 648 and 9:394, no. 93; Hermitage 1870, 75, no. 620; Walpole 1876, 1:321–322; Cust 1900, 131, 272, no. 51; Rooses 1904, 115; Schaeffer 1909, 392, ill., 515; Hermitage 1923, ill. (no page nos.); Glück 1931, 445, ill., 569; Van Puyvelde 1946, 148; Hermitage 1958, 241, no. 222; Hermitage 1963, 126, no. 22, ills. 47–48; Larsen 1988, no. 784, ill.

1. Houbraken 1753, 1:187.
2. Houghton Hall 1752, 46.
3. Anthony A. Wood, *Athenæ Oxonienses* (London, 1817), 3:531–533, provides the basic biographical information on the sitter. Wood ascribes Chaloner's anti-royal convictions to anger about the loss of his father's alum mines in Yorkshire, which were claimed as royal mines early in the reign of Charles I.
4. Wood 1817, 3:532.

This noble portrait, one of the thirty-two Van Dycks that belonged to Robert Walpole at Houghton Hall,[1] was described in the 1752 catalogue of that important collection as: "Sir *Thomas Chaloner*, an admirable Portrait, three Quarters, by *Vandyke*. Sir *Thomas* was Governor to *Henry* Prince of *Wales* ... and in 1610 appointed his Lord Chamberlain. ... He died in 1615, and was buried at *Chiswick*."[2] This identification, however, which was also repeated in the 1778 mezzotint after the portrait by Richard Earlom, is clearly wrong. Had Van Dyck been asked to paint an ancestor portrait, he would not have dressed the subject so conspicuously in fashion characteristic of the mid-1630s.

If there was any basis to the identification of the portrait, and one needs to give the benefit of doubt to a painting stemming from such a distinguished provenance, then the sitter would have to have been the third son of Sir Thomas Chaloner, his namesake who was born in 1595 and died in 1661. The younger of the two Thomas Chaloners would have been in his early forties in 1637, the probable date of the painting to judge from Van Dyck's technique and the sitter's costume and hairstyle (see Glück 1931, 438, 439). This age does seem appropriate to the sitter. Just how Thomas Chaloner would have come to be portrayed by Van Dyck is a mystery, since he seems to have led a rather uneventful life on a family estate near Gisburgh in Yorkshire until after Van Dyck's death.[3] Only in 1643 did he enter the political arena when, elected a burgess for a corporation in Yorkshire, he served in the Long Parliament. At that time he spoke out strongly against the king and Archbishop Laud [see cat. 81, fig. 1]. He was among the king's judges who condemned Charles I to death. He continued to serve in Parliament, attempted some writing, but his career was a checkered one at best. He was reputed to have "loved to enjoy the comfortable importances of his life, without any regard of laying up for a wet day, which at his last he wanted."[4] Finally in 1660, just prior to the restitution of Charles II, Thomas Chaloner emigrated to Middelburgh in Zeeland where he lived in exile "in a fearful condition" before dying the following year.

Whether or not this portrait represents Thomas Chaloner, it is a masterful example of Van Dyck's genius for capturing at once man's dignity and frailty. This effect he achieved both through his sensitive rendering of the face, particularly in the modeling around the eyes, but also in the innovative pose, where the sitter forcefully gestures in one direction and gazes in another. Van Dyck exploited this device throughout his career [see cat. 30] but never to better effect. Here it interjects a dynamism to his portrayal that captures in a far different way than Frans Hals a sense of the moment. With Hals implied movement centers on the physical activities of the sitter; with Van Dyck it is a means to explore his psychological character. It is as though Van Dyck has captured an image of the sitter before he was prepared to put on his public facade. For an artist who was so often called upon to do just that, this portrait stands as one of those remarkable testaments to his sensitivity as an interpreter of the human psyche, and makes one regret that he was not free to exploit this remarkable aspect of his creative talent in more of his works.

A. K. W.

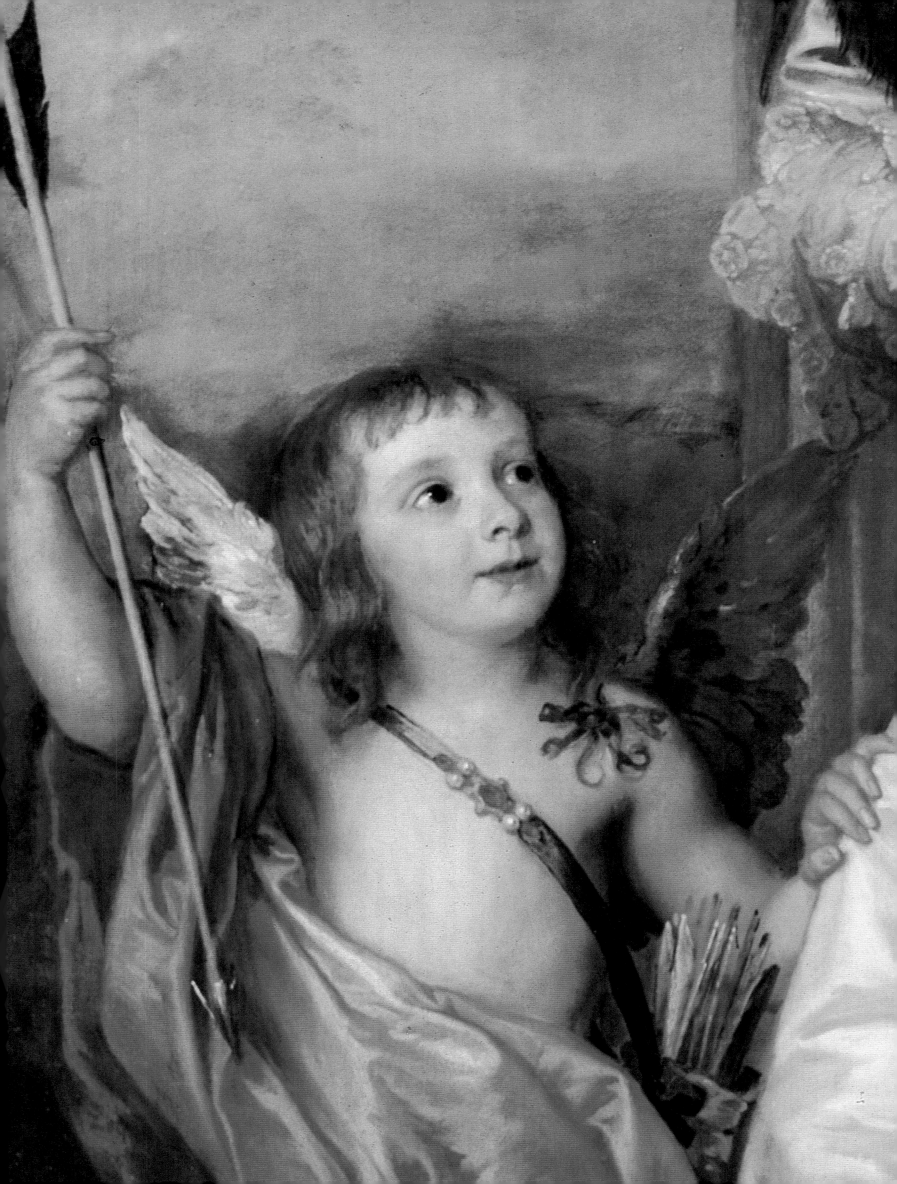

c. 1636
canvas, 114 x 207 (44 1/2 x 80 3/4)

Koninklijk Museum voor Schone
Kunsten, Antwerp

PROVENANCE Commissioned in 1634 or
early 1635 by Cesare Alessandro Scaglia,
Abbé of Stafforda and Mandanici, for the
Chapel of Our Lady of the Seven
Sorrows at the Franciscan church of the
Recolets, Antwerp; taken by the French
in 1794, and returned in 1815

EXHIBITIONS Antwerp 1899, no. 25;
Antwerp 1949, no. 7, ill. 4; Genoa 1955,
no. 83, ill.; Tokyo 1987, no. 83, pl.

LITERATURE Smith 1829–1842, 3:3, no. 4;
Cust 1900, 93–94, 95, ill., 209, no. 25, 248,
no. 33; Schaeffer 1909, 124, ill., 500;
Glück 1931, XLII, 367, ill., 558; Hooge-
werff 1949, 157–162, ill. 3; Koninklijk
Museum 1959, no. 36, pl.; Koninklijk
Museum 1970, 71, no. 404; Princeton
1979, 172, ill. 49; Brown 1982, 159–161,
ill. 161; Martin 1983, 42, 43, ill. 14; Larsen
1988, no. 1041, ill. 375

1. This later date was first suggested by
Hoogewerff 1949, 160.
2. *The Canons and Decrees of the Council of
Trent*, trans. T. A. Buckley, 1851, session
XIII, ch. IV, as quoted in Glen 1977, 92.
3. Martin 1983, 43.
4. Van Dyck may well have adapted this
pose from one often associated with the
grieving Mary Magdalene, as for example
in Mantegna's engraving of the *Entomb-
ment of Christ* or in Hans Baldung Grien's
woodcut of the *Lamentation*.
5. Antwerp 1949, 15, cat. 7.

Fig. 1. Anthony van Dyck, *The
Lamentation*, 1634, panel, 108.7 x 149.3
(42 3/4 x 58 3/4). Alte Pinakothek, Munich

Fig. 2. Anthony van Dyck, *Figure Study*,
c. 1636–1637, chalk with white
heightening on blue paper, 27.6 x 39.3
(10 7/8 x 15 1/2). The Pierpont Morgan
Library, New York

In this, Van Dyck's last surviving great religious painting, he captured the full pathos of the Virgin's intense grief. Unlike others of his lamentation scenes [fig. 1], she does not mediate between Christ's dead body and God above with prayerful, beseeching eyes: rather her expression and spread arms reflect the full agony and helplessness she feels at the loss of her only son. The tragedy of death here weighs heavily, not only through the Virgin's expression and the stark body of Christ, but also because of the constricted space of the horizontal composition.

This painting was placed over an altar that Abbé Cesare Alessandro Scaglia [see cat. 70] had erected in the church of the Recolets in Antwerp. Van Dyck must have received the commission when he was in Flanders in the winter of 1634–1635, but, as the altar was not consecrated until 1637, he probably executed the painting only after he had returned to London.[1] Stylistic considerations also support a later date. The stark, angular character of this *Lamentation* is strikingly different from the more sensual image of the theme Van Dyck painted in 1634 [see cat. 98].

Although Van Dyck's emphasis on the Virgin's grief was consistent with the altarpiece's destination in a chapel honoring the Seven Sorrows of the Virgin, he also conceived his image to accord with one of the most basic tenets of Counter-Reformation thought, the doctrine of transsubstantiation. Christ, although partially wrapped in a shroud with his head lying on Mary's knee, is displayed frontally so that his body and blood are brought forward to be presented to the viewer. Beneath his shroud is a flat gray rock, symbolic of the altar. The doctrine, as formulated at the Council of Trent, decreed "that, by the consecration of the bread and of the wine, a conversion takes place of the whole substance of the bread into the substance of the body of Christ our Lord, and of the whole substance of the wine into the substance of his blood."[2] The painting would thus have given added poignance to the rite of the Eucharist performed on the altar just below it.

Van Dyck achieved the remarkable force of Christ's corpse after making a careful chalk study from a model [fig. 2], where he actually tried out three different positions for Christ's left arm. He may have conceived the idea of having Saint John hold this arm from Annibale Carracci's etching of the *Pietà* (the *Christ of Caprarola*), where the same motif occurs.[3] The dramatic pose of the grieving Virgin, however, seems to have no direct precedent.[4]

The painting has unfortunately suffered a certain amount of damage and has lost some of its dramatic impact from extensive overpainting in the sky and the angel in the clouds at the upper right. It may also have been cropped at both top and bottom, to judge from the dimensions evident in the engraving after the painting by Schelte à Bolswert.[5]

A. K. W.

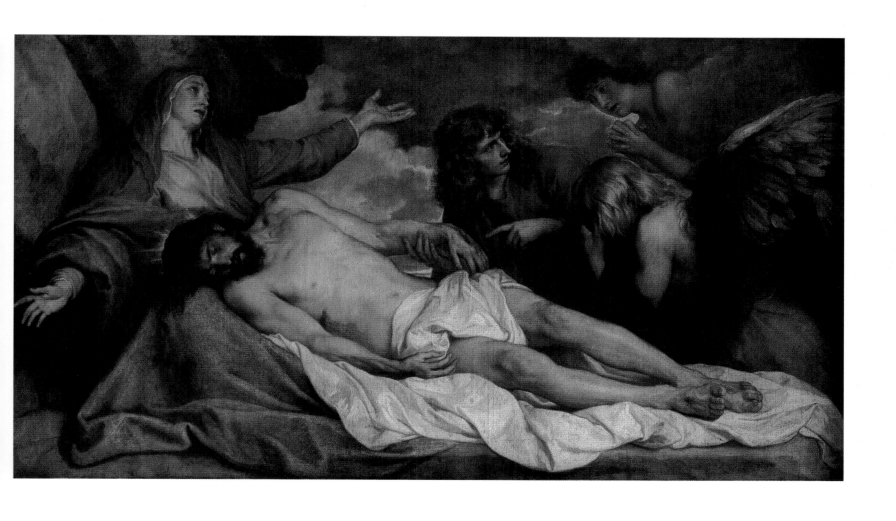

80
Sir Thomas Chaloner

c. 1637
canvas, 104 x 81.5 (23½ x 18¾)

The State Hermitage Museum, Leningrad

PROVENANCE In the collection of Sir
Robert Walpole (1676–1745), 1st earl of
Orford, Houghton Hall, Norfolk;
inherited by his grandson George
(1730–1791), 3d earl of Orford; acquired
by Catherine II, empress of Russia, in
1779 with the Walpole Collection

LITERATURE Houghton Hall 1752, 46–47;
Smith 1829–1842, 3:189, no. 648 and
9:394, no. 93; Hermitage 1870, 75, no.
620; Walpole 1876, 1:321–322; Cust 1900,
131, 272, no. 51; Rooses 1904, 115;
Schaeffer 1909, 392, ill., 515; Hermitage
1923, ill. (no page nos.); Glück 1931, 445,
ill., 569; Van Puyvelde 1946, 148;
Hermitage 1958, 241, no. 222; Hermitage
1963, 126, no. 22, ills. 47–48; Larsen 1988,
no. 784, ill.

1. Houbraken 1753, 1:187.
2. Houghton Hall 1752, 46.
3. Anthony A. Wood, *Athenæ Oxonienses*
(London, 1817), 3:531–533, provides the
basic biographical information on the
sitter. Wood ascribes Chaloner's
anti-royal convictions to anger about the
loss of his father's alum mines in
Yorkshire, which were claimed as royal
mines early in the reign of Charles I.
4. Wood 1817, 3:532.

This noble portrait, one of the thirty-two Van Dycks that belonged to Robert Walpole at Houghton Hall,[1] was described in the 1752 catalogue of that important collection as: "Sir *Thomas Chaloner*, an admirable Portrait, three Quarters, by *Vandyke*. Sir *Thomas* was Governor to *Henry* Prince of *Wales* ... and in 1610 appointed his Lord Chamberlain. ... He died in 1615, and was buried at *Chiswick*."[2] This identification, however, which was also repeated in the 1778 mezzotint after the portrait by Richard Earlom, is clearly wrong. Had Van Dyck been asked to paint an ancestor portrait, he would not have dressed the subject so conspicuously in fashion characteristic of the mid-1630s.

If there was any basis to the identification of the portrait, and one needs to give the benefit of doubt to a painting stemming from such a distinguished provenance, then the sitter would have to have been the third son of Sir Thomas Chaloner, his namesake who was born in 1595 and died in 1661. The younger of the two Thomas Chaloners would have been in his early forties in 1637, the probable date of the painting to judge from Van Dyck's technique and the sitter's costume and hairstyle (see Glück 1931, 438, 439). This age does seem appropriate to the sitter. Just how Thomas Chaloner would have come to be portrayed by Van Dyck is a mystery, since he seems to have led a rather uneventful life on a family estate near Gisburgh in Yorkshire until after Van Dyck's death.[3] Only in 1643 did he enter the political arena when, elected a burgess for a corporation in Yorkshire, he served in the Long Parliament. At that time he spoke out strongly against the king and Archbishop Laud [see cat. 81, fig. 1]. He was among the king's judges who condemned Charles I to death. He continued to serve in Parliament, attempted some writing, but his career was a checkered one at best. He was reputed to have "loved to enjoy the comfortable importances of his life, without any regard of laying up for a wet day, which at his last he wanted."[4] Finally in 1660, just prior to the restitution of Charles II, Thomas Chaloner emigrated to Middelburgh in Zeeland where he lived in exile "in a fearful condition" before dying the following year.

Whether or not this portrait represents Thomas Chaloner, it is a masterful example of Van Dyck's genius for capturing at once man's dignity and frailty. This effect he achieved both through his sensitive rendering of the face, particularly in the modeling around the eyes, but also in the innovative pose, where the sitter forcefully gestures in one direction and gazes in another. Van Dyck exploited this device throughout his career [see cat. 30] but never to better effect. Here it interjects a dynamism to his portrayal that captures in a far different way than Frans Hals a sense of the moment. With Hals implied movement centers on the physical activities of the sitter; with Van Dyck it is a means to explore his psychological character. It is as though Van Dyck has captured an image of the sitter before he was prepared to put on his public facade. For an artist who was so often called upon to do just that, this portrait stands as one of those remarkable testaments to his sensitivity as an interpreter of the human psyche, and makes one regret that he was not free to exploit this remarkable aspect of his creative talent in more of his works.

A. K. W.

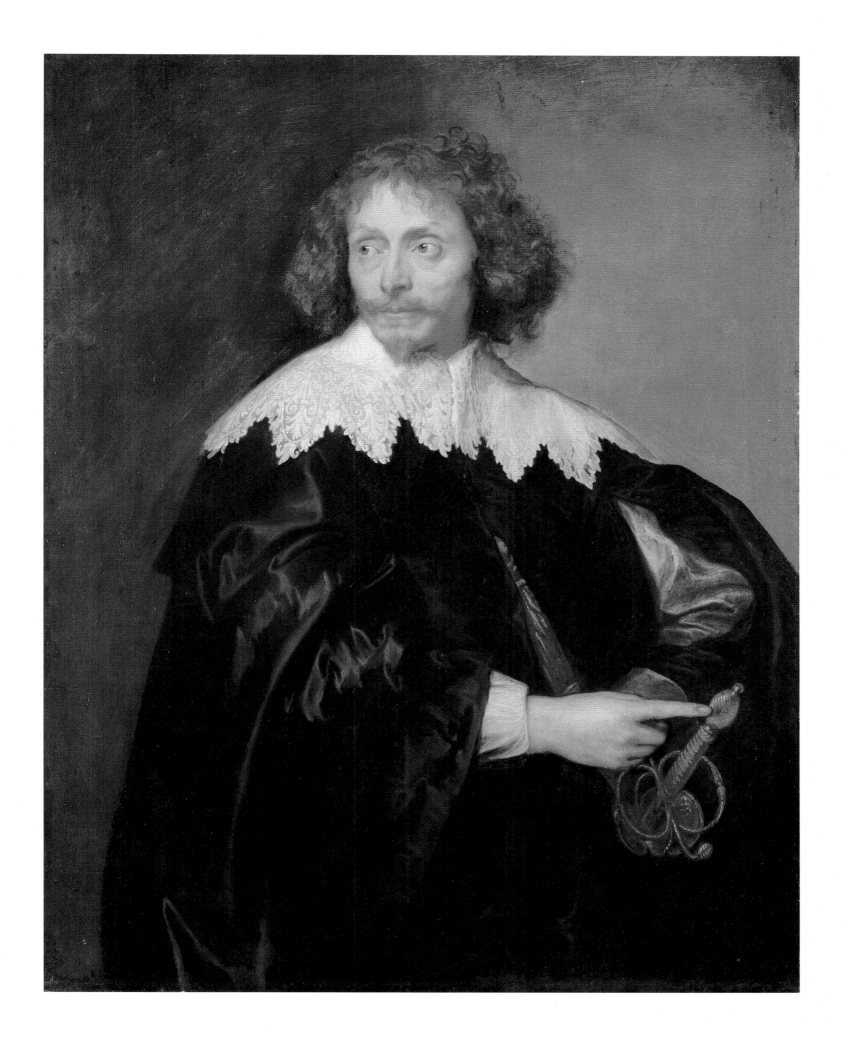

c. 1637
canvas, 97.8 x 80 (38 1/2 x 31 1/2)

The Viscount Cowdray

PROVENANCE François Langlois; marquis de Maisons (d. 1677); marquise de Ruffec; M. Dutrévoux; M. de Lautrec; chevalier de la Ferrière; prince de Conti; acquired by the duke de Praslin at the sale of the prince's collection in 1777 for 8,000 francs; bought by M. Paillet at the duke's death in 1793; Choiseul-Praslin collection, from which it was sold in 1808 for 6,003 francs; John Hoppner; bought by John Smith for 112 guineas at the sale of the Hoppner collection (9–10 March 1828, lot 111); Miss Tait; by 1887 owned by William Garnett, Quernmore Park, 1919; bought from Agnew by the 2d Viscount Cowdray in 1919

EXHIBITIONS London 1887, no. 40; London 1900, no. 122; London 1938, 25, no. 85, ill.; London 1953–1954, no. 158; Genoa 1955, no. 29, ill. 29; Manchester, City of Manchester Art Gallery, 1957, no. 76; London 1968a, no. 52, ill. 52; London 1982-1983, 50, no. 10, pl. 2

LITERATURE Smith 1829–1842, 3:89, no. 305; M. Faucheux, "François Langlois, dit de Chartres," Revue Universelle des Arts 6 (1857), 314–330; Cook 1900, 336; Cust 1900, 51–52, ill. opp. 52, 56, 201, no. 40, 222, no. 122, 242, no. 92; Schaeffer 1909, 216, ill., 504; London 1927, 211 (under no. 601); Glück 1931, 160, ill., 537–538 (as "a Bag-piper"); Ellis Waterhouse, "Seventeenth-Century Art in Europe at Burlington House—The Paintings," Burlington Magazine 72 (January 1938), 13, pl. 2; Antwerp 1960, 99 (under no. 63); Vey 1962, 240; Brussels 1965, 301 (under no. 320); London 1972, 41–43 (under no. 31); Gaunt 1980, 96, 97, ill.; Brown 1982, 111–112, ill. 104; Larsen 1988, no. 538, ill. 119

1. Cust 1900, 242, Glück 1931, 538, and

Langlois, dressed in a vivid red jacket and broad-brimmed hat, looks out with a disarming smile as he plays on a musette tucked under his arm. The informal quality of this striking portrait is one of the few instances where Van Dyck was commissioned to paint a male portrait engaged in a momentary activity. The unusual character of this image makes it difficult to determine where it belongs within Van Dyck's œuvre, and estimates have ranged from 1622–1627, Van Dyck's Italian period, to 1641, the last year of his life.[1] As will be argued here, however, it seems most probable that Van Dyck painted this work about 1637, when Langlois briefly visited London from his home in Paris.

Langlois, although an expert musician and adept at playing a number of instruments, was by profession an engraver, publisher, and art dealer. Born in Chartres in 1589, he is best known by his nickname "Ciartes" taken from his place of birth. During the early 1620s he lived in Florence, Rome, and apparently also briefly in Spain. In Italy he may have met Nicholas Lanier [cat. 48], a musician and one of the agents acquiring works of art for the earl of Arundel and the prince of Wales, for he, himself, soon took on that role as well. In 1625 he traveled to London where he brought paintings for both the new king and the duke of Buckingham. His activities in the next years are not documented although he may have been in Italy in 1630–1633.[2] By 1634 he had settled in Paris as a dealer of books and prints. His shop, "Aux Colonnes d'Hercule," was extremely successful and he worked closely with a number of artists including Stefano della Bella, Claude Vignon, and Jacques Stella. Langlois' wife Madeleine de Colmont, whom he married in 1636, inherited his business after his death. She in turn married Pierre II Mariette, whose firm grew to international fame under the guidance of his grandson Pierre-Jean Mariette (1694–1774).

Despite his work as an art dealer, Langlois seems to have been eminently proud of his prowess as a musician. In Claude Vignon's portrait of Langlois he is depicted with a similar type of bagpipe called a *sourdeline*. The print made after the painting is inscribed "Il ny a orgue ni autre instrument que la sourdeline ne surpasse estant touchee de celuici."[3]

The musette seen in Van Dyck's painting was a small bagpipe that was particularly popular in French aristocratic circles and was used for performances in which participants dressed in pastoral costumes. Langlois is posed in Van Dyck's portrait as a *savoyard*, an itinerant shepherd and musician. His mode of dress thus reflects the widespread fascination with Arcadian existence found in English, French, and Dutch courts of the second quarter of the seventeenth century.

Fig. 1. Anthony van Dyck, *William Laud, Archbishop of Canterbury*, c. 1635–1637, canvas, 121.6 x 97.1 (47 7/8 x 38 1/4). Fitzwilliam Museum, Cambridge, C. H. Shannon Bequest, 1937

Fig. 2. Anthony van Dyck, *François Langlois as Savoyard*, c. 1637, charcoal heightened with white chalk, 39.3 x 28.3 (15 1/2 x 11 1/8). Institut Néerlandais, Coll. F. Lugt, Paris

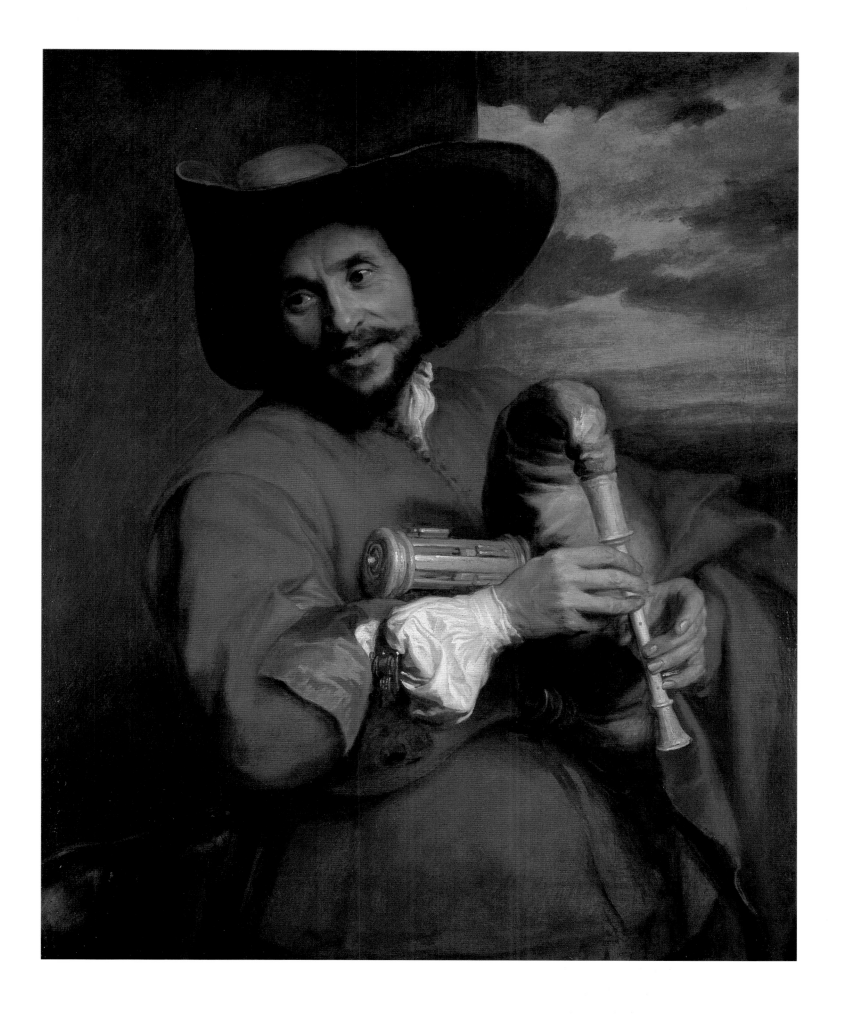

Antwerp 1960, 100, all placed the painting in the Italian period. Brown 1982, 111–112, dated it 1630; Millar in London 1982–1983, 50 cat. 10 dated it 1632–1634 as did d'Hulst and Van Hasselt in London 1972, 43, cat. 31. Vey 1962, 240, dated it 1641, as did Burchard as is evident from a handwritten notation in the archives of the Rubenianum in Antwerp.

2. An excellent biographical account appears in London 1972, 41–43, cat. 31.

3. Faucheux 1857, 316. Faucheux indicates that this information comes from Mariette.

4. The letter from Lanier to Langlois is published in Ph. de Chennevières and A. de Montaiglon, eds., *Abecedario de P. J. Mariette* (Paris, 1851–1860), 6:329–330. From the letter it is also clear that Langlois was in contact with Endymion Porter.

5. Bellori 1672, 262. Langlois was also in London in November 1641, at which time he may have acted as an agent in the sale of Titian's so-called *Ariosto* to Van Dyck shortly before the artist's death on 9 December 1641. See Harold E. Wethey, *The Paintings of Titian* (London, 1969–1975), 2:103, cat. 40.

The fully modeled features of Langlois' face and hands are consistent with Van Dyck's manner of portraiture in the years 1635–1637. During this period he painted a number of works that demonstrate a new boldness of touch, including the portrait of *William Laud, Archbishop of Canterbury* [fig. 1], that are quite comparable in handling. In these years he also favored a half-length format in which the background was divided between a flat wall and a view out to a landscape. One other detail that helps place this work around 1637 is the head of the dog in the lower left, which is virtually identical to the one that appears in Van Dyck's portrait of c. 1637 of *James Stuart, 4th Duke of Lennox and 1st Duke of Richmond* in the Iveagh Bequest, Kenwood [see cat. 66, fig. 4].

One wonders if Nicholas Lanier may have introduced Langlois to Van Dyck. Langlois' visit to London in September 1637 is documented through a letter written by Lanier to Langlois, so the two were definitely in contact.[4] Lanier would have known of Van Dyck's abilities in depicting sitters in allegorical dress, for he had been painted by Van Dyck posed as David playing the harp before Saul.[5]

Van Dyck executed a marvelous black and white chalk preliminary drawing for this painting in which, however, the sitter is not smiling [fig. 2]. In the drawing his face looks distinctly older and more melancholic, and the brim of his hat is splayed out rather than turned up on one side as in the painting.

A. K. W.

Queen Henrietta Maria

1637
canvas, 64.1 x 48.3 (25 1/4 x 19)

Memphis Brooks Museum of Art,
Memphis Park Commission Purchase,
inv. no. 43.30

PROVENANCE Probably presented to
William Feilding, 1st earl of Denbigh in
1637 or 1638; duke of Hamilton
Collection by the 1640s; by inheritance
until the Hamilton sale Christie's,
London, 17 June 1882; J. E. Reiss,
England; Reiss sale, 6 February 1914, lot
114; Thomas Agnew & Sons, London,
1914; Mrs. Bevan, London, 1927; Kings
Galleries, London, 1927; Warner S.
McCalle, Saint Louis, Missouri, 1943

EXHIBITION London 1982–1983, no. 54, ill.

LITERATURE Glück 1931, 387, ill., 561;
*Sixty Paintings Brooks Memorial Art Gallery
1916–1966* (Memphis, 1966), 62, 63, ill.;
*Painting and Sculpture Collection Memphis
Brooks Museum of Art* (Memphis, 1984),
57, pl. on cover; Larsen 1988, no. 875,
ill. 315

1. London 1982–1983, 94, cat. 53.
2. Filippo Baldinucci, *The Life of Bernini*,
trans. Catherine Enggass (University
Park, 1966), 23. Royal Collection 1963, 97,
cat. 148, noted, however, that the
manuscript in the Royal Library indicates
that the paintings would be brought to
Bernini by George Con, the papal agent
to the queen in London: "tiree sur le
portraiets que vous fournir [a le] sieur
Conneo."
3. These paintings are in the royal
collection. See Royal Collection 1963, 97,
98; cats. 148, 149. See also London
1982–1983, 94–95, cats. 53, 54.
4. Hookham Carpenter 1844, 67. The
value of each of these had been reduced
from £20 to £15.
5. Hookham Carpenter 1844, 67. The
value of this painting had been reduced
from £30 to £15.
6. Klara Garas, "Die Entstehung der
Galerie des Erzherzogs Leopold

The enthusiasm generated by Bernini's sculpted bust of Charles I when it arrived in London in April 1637 [see cat. 75] prompted Henrietta Maria to request one of herself as well. As with the sculpture of the king, hers was to have been created on the basis of images painted by Van Dyck that would be supplied to Bernini. This extremely handsome profile portrait was clearly conceived in relation to this enterprise.

As early as August 1637 the queen's wishes for a portrait bust had been conveyed to the papal court by George Con, the papal agent to the queen. Con then alerted Cardinal Barberini in November of that year that Henrietta Maria had been portrayed in three positions as was required by the sculptor. This seemingly straightforward commission, however, which must have been as desirable to the Vatican for political reasons as to the queen for aesthetic ones, was apparently beset by difficulties that have never been adequately explained. Something must have happened to the painting the queen sat for in 1637, for in June 1638 Con spoke to the king to ask if the queen could have an undisturbed week to have a single portrait made for the great Italian sculptor. This was agreed upon while the queen was at Greenwich and the king at the hunt. Van Dyck, however, was not available at that time, and only in August 1638 were the "portraits" for Bernini actually seen by the papal agent.[1] Nevertheless, not until 26 June 1639 did the queen actually send the following letter to Bernini: "The esteem that the King, my Lord, and I have for the statue that you made of him is accompanied by the satisfaction that we have in it as a work that merits the approbation of all who look upon it and compels me now to tell you that in order to make my satisfaction complete I would like a similar one of myself made by your hand from portraits that will be given you by Signor Lomes. ..."[2]

The portraits referred to in this letter have always been identified with three images of the queen executed by Van Dyck: a frontal view and a profile facing left in the royal collection [figs. 1, 2] and this profile of the queen facing right.[3] It seems unlikely, however, that the queen, who did not designate in her letter how many paintings she was sending, intended to provide Bernini with all three of these paintings. Bernini would hardly have needed two profile views of the queen to create his sculpture. Moreover, despite the basic similarity between the Memphis painting and the two works in the royal collection, certain stylistic differences exist that suggest that this work was executed at a different moment. The expression of the queen in the Memphis painting is less severe than that in the paintings in the royal collection, and the planes in the folds of the drapery are more crisply defined.

Documentary and technical evidence seems to confirm that the Memphis painting was not conceived at the same time as the works in the royal collection and that it was not among those works the queen referred to in her letter of June 1639. Van Dyck's "Memoire" (a list of paintings ordered by the king for which the artist was

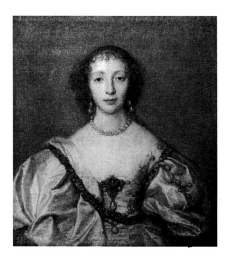

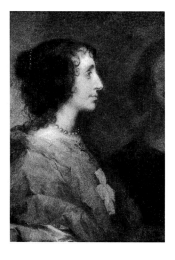

Fig. 1. Anthony van Dyck, *Henrietta Maria*, c. 1639, canvas, 78.7 x 65.7 (31 x 25 7/8). Copyright reserved to H. M. Queen Elizabeth II

Fig. 2. Anthony van Dyck, *Henrietta Maria*, c. 1639, canvas, 71.8 x 56.5 (28 1/4 x 22 1/4). Copyright reserved to H. M. Queen Elizabeth II

Fig. 3. Cat. 82, infrared photograph, detail

Wilhelm," *Jahrbuch der Kunsthistorischen Sammlungen in Wien* 63 (1967), 69. This painting is number 287 in inventory 15, which Garas says dates from 1638, although most other authors suggest a date in the 1640s. Lending support to this suggested provenance is the fact that Van Dyck's portrait of Lord Denbigh (National Gallery, London) is listed as number 291 in the same inventory.

7. London 1982–1983, 94, cat. 53.

8. One possibility is that the Christ-like associations of this three-in-one image were considered inappropriate for an image of the queen [see cat. 75].

9. A copy of this portrait of Henrietta Maria in the National Maritime Museum, Greenwich, indicates that the Memphis painting was reduced on all sides at a later date.

10. Baldinucci 1966, 24.

11. "Diary of Nicholas Stone, Junior," *Walpole Society* 7 (1918–1919), 171. Millar referred to this discourse in Royal Collection 1963, 97, cat. 148.

12. Quentin Bone, *Henrietta Maria: Queen of the Cavaliers* (Urbana, 1972), 109.

13. See Hookham Carpenter 1844, 66–68.

14. London 1972–1973, 126, cat. 238. Sir Oliver Millar kindly informed me about the existence of this sculpture.

owed payment at the end of 1638) mentioned only two paintings he had made of the queen for Bernini.[4] The third painting, the one here exhibited, may well be the piece described in the "Memoire" as "La Reyne envoye à mons. Fielding."[5] William Feilding, 1st earl of Denbigh, was the father-in-law of the marquess of Hamilton, and it was probably through him that Hamilton acquired the painting by the end of the 1630s. In one early Hamilton inventory it appears as "One peice of the queene to the waste syde faced of Sr Anthonye Vandyke."[6] Thus the Memphis version would already have been separated from those now in the royal collection before the queen finally wrote to Bernini in June 1639 to inform him that she was about to send the paintings to be used as a model for the bust.

Technical examination of the Memphis painting reinforces the hypothesis that this work was executed at a different time than the two works in the royal collection. An infra-red photograph reveals (more clearly than can be discerned with the naked eye) that this painting once belonged to a larger composition [fig. 3]. Before her was once her unfinished frontal image, which has now been cut in the middle of the figure. Van Dyck's original concept for this work probably resembled closely *Charles I in Three Positions*. This fragment, thus, must have been the work referred to by Con in November 1637 when he informed Cardinal Barberini that the queen had allowed herself to be painted in the three positions required by Bernini.[7] For some reason the idea of an image of the queen in three positions must have displeased the king or queen even before the execution of the painting was fully realized.[8] It was then cut down and given to the Lord Denbigh as a simple profile view of the queen.[9] This hypothesis would explain why the queen needed to sit once again for Van Dyck in the summer of 1638 and why Van Dyck listed only two paintings for Bernini in his "Memoire" presented to the king later that year.

Despite the positive tone of the queen's letter to Bernini, the portraits were never sent. No one knows why. Baldinucci attributed the failure to send the works to the "turbulence that broke out a little later" in England.[10] Millar believes that Bernini may have had no interest in sculpting another bust from a painting. The sculptor had explicitly told Nicholas Stone in October 1638 that since executing the bust of the king he had refused another request from the pope to "doe another picture in marble after a painting for some other prince. I told the Pope (says he) that if thaire were best picture done by the hand of Raphyell yett he would nott undertake to doe itt, for (sayes he) I told his Hollinesse that itt was impossible that a picture in marble could haue the resemblance of a liuing man."[11]

Another reason may well be that the drain on the royal treasury occasioned by the efforts to quell the Scottish insurrection had been too great to allow for this particular commission. During the summer of 1639 the queen was actively engaged in trying to raise money to support the king's expedition against the Scots by appealing to English Catholics to make a contribution in consideration of the clemency they had enjoyed under his rule.[12] Evidence of the financial strains is found in the cancellation in 1639 of Van Dyck's grand tapestry scheme for Whitehall depicting *Charles I and the Knights of the Garter in Procession* [see cat. 102], as well as the reduced sums given to Van Dyck for a number of paintings submitted for payment in his "Memoire" from the fall of 1638.[13]

Even if the commission with Bernini was ultimately unsuccessful, Henrietta Maria did succeed in finding a sculptor to execute her bust from the models provided by Van Dyck. The commission went to François Dieussart (1622–1661), a Flemish sculptor active in England. Her bust, dated 1640, is in the royal collection of Rosenborg Castle, Copenhagen.[14]

A. K. W.

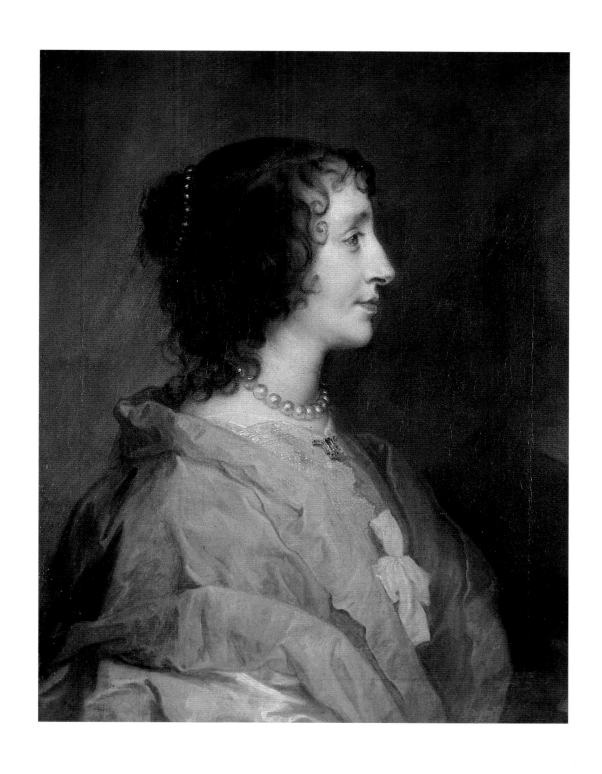

c. 1637
canvas, 135.9 x 106.7 (53 1/2 x 42)

The Duke of Northumberland

PROVENANCE Earl of Northumberland, seen by Symonds at Northumberland House on 27 December 1652; in Northumberland inventory 1671; by descent to present duke

EXHIBITIONS London 1968a, no. 58 (as "Portrait of a Woman"); London 1982–1983, no. 36, ill.

LITERATURE Cust 1900, 120; Larsen 1988, no. 951, ill. 951

1. There is much truth to Sanderson's quaint phrase (quoted by Walpole 1876, 1:327, n. 4): "Vandyck was the first painter who e'er put ladies' dress into a careless romance."
2. Much biographical information is contained in *Dictionary of National Biography* (London, 1896), 46:172–175; and Gervas Huxley, *Endymion Porter: The Life of a Courtier* (London, 1959).
3. London 1982–1983, 78, cat. 36.
4. Huxley 1959 quoted excerpts from a large number of letters from Endymion to Olivia, who referred to her as Olive.
5. As quoted in Huxley 1959, 139. The title of the poem is "An Ecologue or Pastorall between Endymion Porter and Lycidas Herrick."
6. *Dictionary of National Biography* 1896, 46:174.
7. Collection of Mrs. Gervas Huxley. Illustrated in London 1982–1983, 106, fig. 49.

To judge from Van Dyck's portraits, the men and women who populated the English court were not only blessed with grace and elegance, but they were also unburdened from the cares that so afflict the rest of mankind. Whether dressed in formal attire or, as in this portrait, flowing robes that billow provocatively in the gentle breezes of a summer day, his sitters convey the ideals of civility and refinement appropriate for this "blest isle."

Distinguishing myth from reality with Van Dyck's sitters is not easy, for invariably the image the artist created has played a crucial role in our appreciation of the subject's character. Historical documents are plentiful from this period, and although they often augment or modify the impression gained from one of his portraits, rarely do they act at variance to it. In this instance, however, they do. Nothing known of the life of Olivia Porter prepares us for this exotic image of a woman striding though a landscape, seemingly freed from all the constraints that English society could place upon her.[1]

Olivia was the fourth daughter of Sir John Boteler and his wife Elizabeth Villiers, who was the half-sister and favorite of George, the duke of Buckingham.[2] She met and married Endymion Porter [cat. 73] in 1619 when she was employed in Buckingham's service. An extensive correspondence has survived between her and her husband that not only demonstrates her strong, independent streak, but also their loving relationship despite the many periods apart occasioned by his obligations to Charles I. For most of their married life they lived comfortably, whether in London at their house in the Strand, or at Woodhall or Aston, country manor houses that belonged to them through their families. Only later in their lives during the Civil War did their financial situation deteriorate, and as with many royalists, these years involved periods of absence from the country as they sought exile with Queen Henrietta Maria in Paris as well as in Brussels. After Endymion's death in 1649 their large collection of paintings was dispersed, unfortunately without ever being catalogued; therefore its precise contents are not known. It may have been at this time that this striking portrait was acquired by the duke of Northumberland, in whose family's collection it has remained ever since.[3]

To judge from the remarkably fluid character of this portrait, one would never suspect that Olivia Porter gave birth to twelve children between 1620 and 1638, five of whom died in infancy. Information that can be gleaned about her life from correspondence and other sources makes it clear that she not only undertook responsibilities for running the household, but also helped oversee a number of Endymion's business ventures.[4]

If little in her own life suggests that she was able to enjoy the delights of an Arcadian existence, the appeal of the countryside was clear in her decision to live so much of her life away from London. Indeed, in this she differed from her husband Endymion, who was explicitly chided by the poet Robert Herrick for having left the joys of the pastoral existence for court life.

Thou leav'st our Hills, our Dales, our Bowers
Our fine fleeced sheep:
(Unkind to us) to spend Thine Hours
Where Shepherds should not keep.[5]

While this Arcadian painting of Olivia Porter may reflect her delight in a pastoral existence, it was not necessarily conceived in opposition to court life. As evident in Van Dyck's portrait of Philip Lord Wharton [cat. 63], the Arcadian ideal was an integral part of the court, fostered by the Christian Neoplatonism of its queen. Olivia Porter was, in fact, close to Henrietta Maria, and, in 1637, became particularly notorious as one of the first of the court ladies to convert to Catholicism.

The instrument of her conversion was the Reverend George Con, a Scotsman and

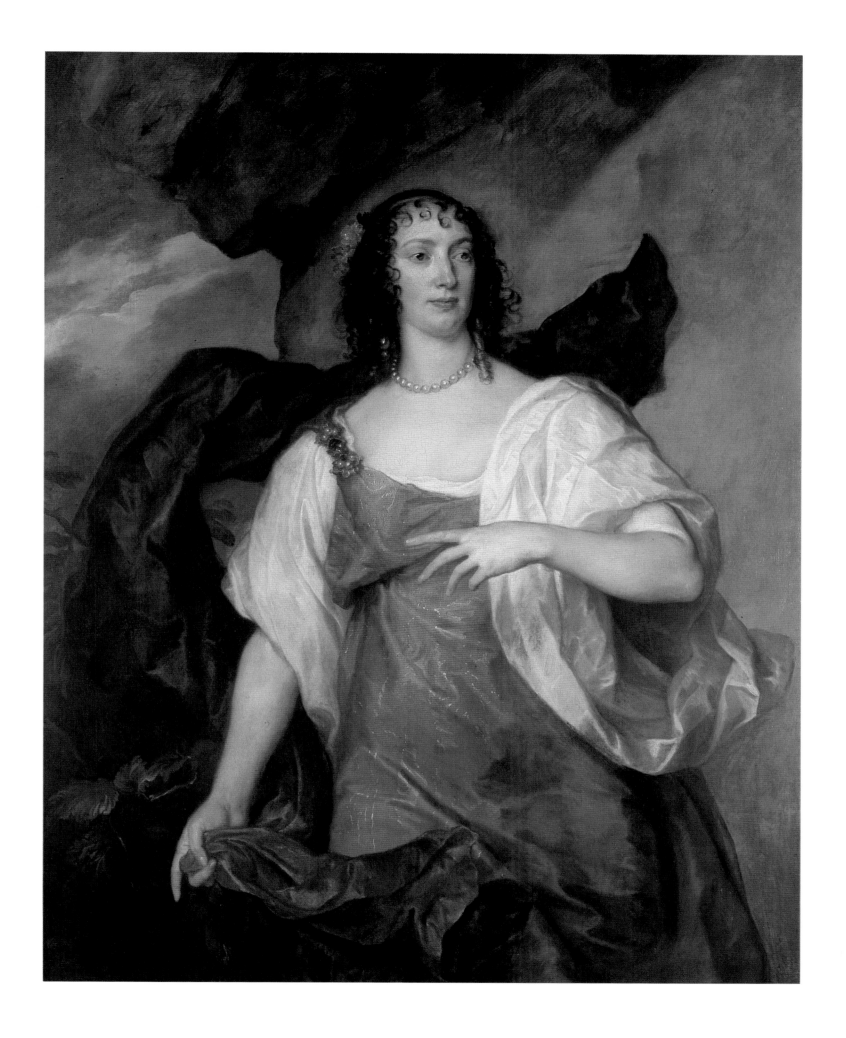

papal legate to Henrietta's court. Olivia as a new convert sought others and quickly became the "soul of the proselytising movement" in court circles.[6] Her successes caused widespread outrage among Protestants, some of which was, in later years, directed against Endymion himself.

Whether or not the unusual character of this image is in some way connected to her religious convictions is not known. Stylistically, however, the broad handling of forms, the fluid brushwork, and the bold, expansive character of the image relate to those works Van Dyck created around 1637. This date would accord well with the differences in age apparent between this work and her image in the family portrait Van Dyck painted about 1633.[7] Her pose may well reflect an Italian prototype, perhaps from Endymion and Olivia Porter's own collection; more certain is that this type of image had a tremendous impact in English portrait traditions, from Peter Lely to Thomas Gainsborough and Sir Joshua Reynolds.

A. K. W.

84
Thomas Killigrew and William, Lord Crofts

1638
signed *A. van, Dyck, 1638.*
canvas, 132.7 x 143.5 (52 1/4 x 56 1/2)

H. M. Queen Elizabeth II

PROVENANCE Brought from Spain by Sir
Daniel Arthur, a Jacobite exile; presumably among the pictures seen on
3 February 1729 by the earl of Egmont in
the house of George Bagnall, who had
married Sir Daniel's widow and who sold
the picture to Frederick, prince of Wales,
in 1748; Leicester House

EXHIBITIONS London, British Institution,
1820, no. 91; London, British Institution,
1834, no. 2; London, National Portrait
Exhibition, 1866, no. 754; London, Royal
Collection, 1871, no. 169; London 1887,
no. 109; Antwerp 1899, no. 61; London
1900, no. 65; London 1946–1947, no. 36
(text vol.), 88, ill. (pl. vol.); London
1953–1954, no. 164; London 1968a, no.
14; London 1988–1989, no. 9, ill., pl. 4

LITERATURE Smith 1829–1842, 3:62, no.
214 and 9:378, no. 36; Waagen 1854,
2:427, no. 4; Walpole 1876, 1:326–327;
Cust 1900, 134, 138 (opp.), ill., 204, no.
109, 212, no. 61, 220, no. 65, 276, no. 107;
Schaeffer 1909, 350, ill., 513; Vertue
1930–1955, 18:11 and 25:125; Glück 1931,
451, ill., 570; Royal Collection 1937, 91,
ill. 35; Waterhouse 1953, 50; Whinney
and Millar 1957, 72–73; Royal Collection
1963, no. 156; Millar 1963, 409; London
1968, 52 (under no. 53); Royal Collection
1977, 100, 103, ill. 114; Gaunt 1980, 96, 97,
ill.; Brown 1982, 212, 213, pl. 222; Larsen
1988, no. 891, ill. 406

1. The identification of this figure as
Lord Crofts, thoughtfully proposed by Sir
Oliver Millar, is the most convincing
suggestion yet advanced. See Royal
Collection 1963, 101, cat. 156.
2. Killigrew was arrested in 1642 for
taking up arms for the king. For
information on his life and work, see
Dictionary of National Biography 1892,
31:111–115.
3. Walpole 1876, 1:326–327.
4. Royal Collection 1963, 101, cat. 156.
Another suggestion proffered by Lionel
Cust (Cust 1900, 134–135) is that the
companion was William Murray, Groom
of the Bedchamber, who later became
earl of Dysart.
5. Francis Quarles, *Sighes At the
Contemporary Deaths of Those Incomparable
Sisters, the Countesse of Cleaveland and
Mistrisse Cicily Killegrve* (London, 1640).
6. Millar in Royal Collection 1963, 101,
cat. 156, associated these drawings with
funerary sculpture. He wrote that "the
larger of the two may be intended for his
deceased wife, the child clasped at her
side for her infant son Henry who had
been born on 9 April 1637, and the other
statue for Cecilia's sister Anne, countess
of Cleveland, who died on 16 January
1638."
7. For a comparable image in Rembrandt's œuvre see his painting of *Anslo*

In this, one of his most powerfully evocative double portraits, Van Dyck suggested the grief and mourning that come from death and the bonds of friendship that give strength and fortitude in times of loss. Thomas Killigrew (1612–1683) was only twenty-six years old when his wife Cecilia Crofts died on 1 January 1638, probably of the plague that ravaged London. Within a month Cecilia's sister Anne, countess of Cleveland, had died as well. With his wife's wedding ring bound to his wrist on a black band, and her small gold and silver cross inscribed with her intertwined initials attached to his sleeve, he broods in a melancholic pose while his companion attempts to bring him solace. Although the identification of his companion is not securely established, he is almost certainly the brother of the two sisters, William, Lord Crofts (c. 1611–1677).[1] At a time when early death all too often tore away loved ones and artists and poets were called upon to devise eulogies in paint, stone, and verse, no other memorial conveyed the sense of loss as poignantly as this.

Thomas Killigrew was closely connected to the court of Charles I. Page of Honour to the king, he remained a staunch royalist throughout his life.[2] He was also an active poet and playwright. His first literary endeavors took place in France in 1635. Shortly thereafter his bawdy comedy *Parson's Wedding* was performed in London, a play that helped establish his reputation as a wit. He was associated in particular with the poet Thomas Carew. Carew, who was also a friend of the Crofts family, wrote a poem in commemoration of the marriage of Killigrew and Cecilia Crofts on 29 June 1636. This and other literary connections with Carew led to a traditional identification of Killigrew's companion as this poet,[3] but, as Millar has pointed out, Carew, who was born in 1594/1595, was much older than Killigrew's companion.[4] Another contemporary, Francis Quarles, wrote a eulogy on the deaths of Cecilia and Anne that is much closer in character to the mood of Van Dyck's painting than Carew's verse. Quarles lamented their death, but then in stanza seventeen wrote: "Attend, you gentle eares A while, and wee will end Our sighes, and wipe away your teares." He, the poet, thus offers consolation through his words, and through the realization that "These Saints [have entered] that Celestiall Quire, where griefes do not explore, where joyes doe not expire."[5]

In much the same way as did the poet, Van Dyck introduced in this painting a figure who brings consolation to another through his words as well as through his presence. Here, as Killigrew sits languidly reflecting on the deaths of his wife and her sister as is indicated by drawings that appear to represent funerary sculpture on the paper he holds,[6] his companion earnestly speaks to him as he gestures toward a blank sheet of paper in his hand. Van Dyck has provided us with no text to follow, so insistent is he that the mood he created in the disposition of the figures and color harmonies is sufficient to convey Lord Crofts' message. Important also is the broken column in the background, which is emblematic of fortitude and strength as well as suggestive of the transience of earthly life.

The complex psychological interactions in this painting grow out of Van Dyck's portraits during the 1630s, first evident in his portrait of Henry Percy [cat. 65], where he developed his particular fascination in portraying the melancholic state of mind. This composition, in which someone attempts to soothe the anguish of melancholia through the spoken word, is, nevertheless, different, and suggests Van Dyck's awareness of literary conventions in which words serve as balm for the soul.[7] In translating this idiom into pictorial terms Van Dyck managed to convey through gesture and expression not only the different moods of the sitters, but also the impact of the one on the other.[8]

Van Dyck painted another portrait of Killigrew in 1638, a half-length in which he rests his hand on the head of a dog (collection of the earl of Bradford). In the same year Van Dyck painted his sister, Anne Killigrew, Mrs. Kirke, in a full-length portrait (Huntington Library).

<div align="right">A. K. W. 313</div>

and His Wife (Gemäldegalerie, Berlin-Dahlem). Joost van den Vondel's poem about Rembrandt's image of Anslo (published in 1644) challenges the artist in the following way: "O, Rembrandt, paint Cornelius' voice./The visible is the least important part of him: The invisible one only learns through the ears. He who wants to see Anslo, must hear him." (Seymour Slive, *Rembrandt and His Critics 1630–1730* [The Hague, 1953], 73).

8. This literary mode in Van Dyck's portraits from the late 1630s is also evident in a slightly different vein in his portraits of the poet Sir John Suckling (Frick Collection, New York) and Lord George Stuart, seigneur d'Aubigny [see cat. 63, fig. 1], where Latin texts are inscribed on rocks in the landscapes.

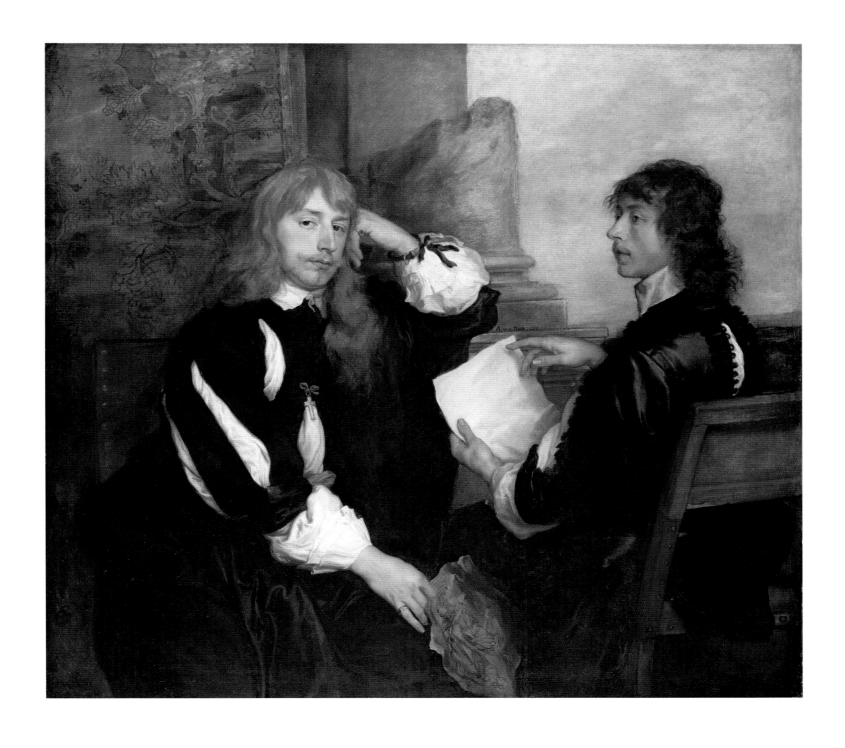

1639–1640
canvas, 199.4 x 191.8 (78 1/2 x 75 1/2),
additions at the top, between 9.5 and
10.8 (3 3/4 and 4 1/4), and bottom,
c. 5.7 (2 1/4)

H. M. Queen Elizabeth II

PROVENANCE Presumably painted for
Charles I; mentioned by Van der Doort,
in draft of the king's catalogue, as being
in the king's Long Gallery at Whitehall;
valued at £110 by the Trustees for sale
among the pictures from Wimbledon
House and sold to Robert Houghton on 8
October 1651; in the possession of Peter
Lely, at the Restoration declared by him
to the House of Lords Committee and
delivered to Thomas Chiffinch on 3
August 1661; thereafter at Whitehall,
Kensington, Hampton Court, and
Windsor

EXHIBITIONS Manchester 1857, no. 599;
London 1946–1947, no. 293; London
1953–1954, no. 282; Manchester, City of
Manchester Art Gallery, 1957, no. 136,
ill.; London 1968a, no. 15, ills. 8–9;
London 1972–1973, no. 109, ill.; London
1982–1983, 22, no. 58, ill. 58

LITERATURE A Catalogue of the Collection
of Pictures Belonging to King James the
Second (London, 1758), 14, no. 159; Smith
1829–1842, 3:74, no. 246; Waagen 1854,
2:360; Phillips 1896, 121; Cust 1900,
112–113, 251, no. 87; Schaeffer 1909, 126,
ill., 500; Royal Collection 1929, no.
663, ill. 663; Glück 1931, XLI, 362, ill., 558;
Oppé 1941, 186–191, ill. 1; Whinney and
Millar 1957, 74, ill. 23b; Damm 1966, no.
19, ill. 5; Royal Collection 1963, no. 166,
ill. 88; Larsen 1975b, 91, ill. 9; Royal
Collection 1977, 50, pl. 8; Gaunt 1980,
106, 107, ill.; Brown 1982, 186–188, pl.
187; Keyes 1983, 197; Larsen 1988, no.
1043, ill. 446, pl. 30; Master Drawings from
the National Gallery of Canada [exh. cat.
National Gallery of Art] (Washington,
1988–1989), 127, 129, ill. 3 (under no. 39)

1. The story of Cupid and Psyche is told
by Apuleius, a Latin writer of the second
century A.D. It is retold by Edith
Hamilton, Mythology (Boston, 1942),
121–134, from which this account is
taken. Psyche was punished because of
her curiosity. Although she had been
warned not to look upon the face of her
husband who came to her only at night,
she disobeyed his commands and looked
upon him with the light of a lamp. She
discovered that he was Cupid, but in the
process woke him. To try to win back the
god of love she went to Venus, his
mother. Venus, who was jealous of
Psyche because of her great beauty, gave
her a number of difficult tasks to
perform, one of which was to go to the
underworld with a box to bring back
some beauty from Proserpine.
2. Oppé 1941, 189. Oppé observed how
similar Van Dyck's representation is to
the actual description by Apuleius: "nihil
aliud quam dormiens cadaver."

Van Dyck has depicted in this sensual idyll the moment that Cupid rushes to
Psyche's side after finding her asleep in a landscape. Psyche had fallen into the "dull
lethargy" of sleep as punishment for opening the box Venus had given her to take to
the underworld to procure from Proserpine some of her beauty.[1] Psyche, succumbing
to her curiosity, wanted to see what beauty charm Proserpine had placed within it.
Although the box appeared to be empty, she was immediately overtaken by sleep and
lay there "precisely like a sleeping corpse."[2] With his feet barely touching the ground
as he approaches her, Cupid gazes down upon the beauty of her recumbent body
and reaches out to wipe the sleep from her eyes. As the story unfolds, he pricks her
with one of his arrows to wake her and then flies to Olympus to plead with Jupiter
that he should be allowed to marry this beautiful mortal. Jupiter agreed, and after
their marriage Psyche was given ambrosia to drink, which rendered her immortal.

Remarkably, this poetic image is the only mythological painting to survive from
Van Dyck's years as court artist for Charles I and Henrietta Maria.[3] In an environ-
ment as imbued in the Neoplatonic ideals of love and beauty as was that court, it is
surprising that Van Dyck was called upon so seldom to paint allegories similar to
those underlying the masques. His genius for translating into paint a poesie whose
subject was the fusion of sensual desire and idealized love was well known to the
king and queen through his magnificent Rinaldo and Armida, which had been in the
royal collection since 1629 [cat. 54]. In part this dearth of allegorical paintings is a
result of the enormous demands put on Van Dyck to execute portraits, but it is also
the result of the vagaries of time. Bellori listed four history paintings that Van Dyck
made for the king and queen during his years in England: The Dance of the Muses with
Apollo on Parnassus; Apollo Flaying Marsyas; the Bacchanals; and a Venus and Adonis with
Dancing Cupids.[4] Tragically all of these are lost. If one painting could stand for a whole
genre lost, however, it is Cupid and Psyche.

The specific intent for this painting is not known. It may be related to Henrietta
Maria's wish to decorate the "Cabinet" in the Queen's House at Greenwich, which
had only recently been constructed by Inigo Jones, with a cycle of paintings from the
story of Cupid and Psyche. Surprisingly, no evidence exists that Van Dyck was to be
one of the artists participating in this large decorative scheme, which was given to
Jacob Jordaens in the fall of 1639.[5] Whether or not executed for this project, the
painting was certainly intended for the king, as Van der Doort included it in his
catalogue of the king's collection.[6] As the entry for this painting was inserted into the
draft of the catalogue with a notation that the painting was unframed, Millar has
speculated that the work must have been executed very late in Van Dyck's career,
around 1639–1640.[7] The extremely thin execution of the landscape elements in both
the foreground and background further suggests that the painting was never
completely finished. The late date proposed for this painting would preclude it from
being identical to the item listed in Van Dyck's "Memoire" to the king from the
winter of 1638, where he requested payment for "Une piece pour la Maison a
Green Witz."[8]

The story of Cupid and Psyche had resonances in the Neoplatonic mythology of
the English court that found expression in poetry as well as painting. Cupid and
Psyche, for example, was the subject of an epic poem written in 1637 in honor of
Charles Louis, the son of Elizabeth of Bohemia, after his arrival in England to seek aid
in his efforts to reclaim the Palatinate. The author, Shakerley Marmion, emphasized in
the preface that his poem concealed an account of the Platonic progress of the soul.[9]
Psyche, who was mortal and was so beautiful that even Venus was jealous of her,
embodied earthly beauty. Cupid, on the other hand, embodied desire and divine love.
Their union represented the ideal of love as defined by Plato in The Symposium: "Love
is Desire aroused by Beauty;" and, in the Neoplatonic atmosphere of the English
court, would have symbolized the soul's ascent to divine fulfillment.[10]

Van Dyck's depiction of the story of Psyche and Cupid, for all of its sensual

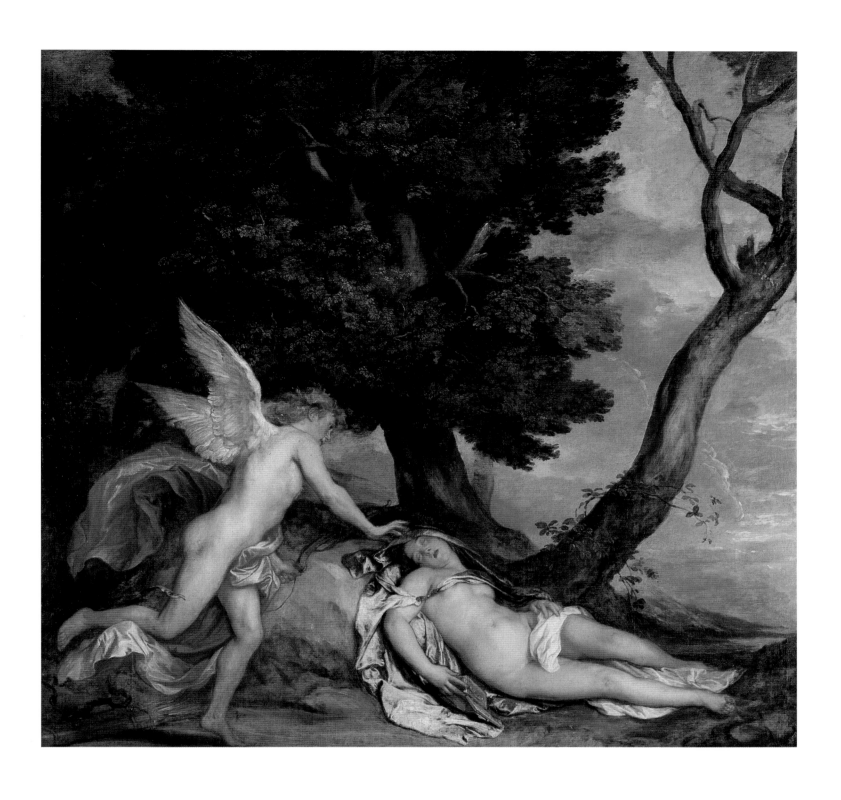

3. One other mythological painting that was probably not painted for Charles and Henrietta Maria from the end of Van Dyck's life is known, the *Andromeda* in the Los Angeles County Museum of Art. Van Dyck based this painting on Titian's *Perseus and Andromeda*, which he owned (Wallace Collection, London).

4. Bellori 1672, 263. The last painting is described as "vn altro ballo di Amori che ginocano, mentre Venere dome con Adone."

5. Although this commission, which was negotiated by the Abbé Scaglia, was first given to Jordaens, Balthazar Gerbier persuaded the king to enlist Rubens for the project as well, arguing that Rubens' figures and landscapes were more refined than those of Jordaens. Jordaens, after Rubens' death, took over the whole commission once again, but only after having been told to make "the faces of the women as beautiful as may be, the figures gracious and svelte." For a discussion of this commission, see D. Schlugheit, "L'Abbé de Scaglia, Jordaens et 'L'Histoire de Psyché' de Greenwich-House," *Revue Belge d'Archéologie et d'Histoire de l'Art* 7 (1939), 139–166; Christopher White, *Peter Paul Rubens: Man & Artist* (New Haven, 1987), 282–283.

6. Millar 1960a, 43, "bing onlij als it opan a straning fram. ..." The painting was located in the king's Long Gallery at Whitehall.

7. Royal Collection 1963, 104 cat. 166.

8. Hookham Carpenter 1844, 68.

9. Parry 1981, 197.

10. Parry 1981, 196. See also n. 1.

11. Oppé 1941, 189, noted these relationships and their suggestions of rebirth after death.

qualities, was clearly conceived with this philosophical concept in mind. Psyche lies, as described by Apuleius, "precisely like a sleeping corpse." Her earthly beauty, which seems heightened by the seductive way in which her drapes fall across her body, is weighted to the ground. Only with the spark of divine love will her soul be lifted to another realm. Van Dyck reinforced this concept with the juxtaposition of the dead and live trees that tower over the lifeless form of Psyche and the animated figure of Cupid.[11]

One other fascinating aspect of this painting is that it demonstrates Van Dyck's prowess as a landscape painter. While the free brushwork evident in the land, trees, and sky has its roots in Titian's *poesies*, the rhythms of the trees reflect an interest in landscape that is found in Van Dyck's wonderful watercolor drawings of the English landscape from the late 1630s.

A. K. W.

Thomas Wentworth, 1st Earl of Strafford, with Sir Philip Mainwaring

1640
canvas, 123.2 x 139.7 (48½ x 55)

Lent by permission of the Trustees of the Rt. Hon. Olive, Countess Fitzwilliam's Settlement and the Lady Juliet de Chair

PROVENANCE Earl Fitzwilliam, Wentworth Woodhouse

EXHIBITIONS London, British Institution, 1815, no. 140; London 1900, no. 82; London 1982–1983, no. 57, pl. 11

LITERATURE Smith 1829–1842, 3:170–171, no. 589 and 9:389, no. 74; Blenheim 1861, under no. 38; Walpole 1876, 1:327; Cust 1900, 130, (opp.), ill., 220, no. 82; Schaeffer 1909, 400, ill., 516, 284, no. 201; Glück 1931, 483, ill., 574; Michael Jaffé, "The Picture of the Secretary of Titian," *Burlington Magazine* 107 (March 1966), 114, 118, 120, 127, ill. 19; Brown 1982, 207, 208, ill. 212; Wiemers 1987–1988, 261, 262, ill.; Larsen 1988, no. 1005, ill. 396

1. Thomas Wentworth, born in 1593, was the son of Sir William Wentworth of Wentworth-Woodhouse and his wife Anne. Educated at Cambridge, he began his political career as a member of Parliament in 1614. Although he believed in a strong government, he disapproved of Buckingham's eagerness for war with Spain, and spoke out against European entanglements during the mid-1620s. He quickly became a leader in the House of Commons, particularly in the discussions about the Petition of Right in 1628. Shortly after Buckingham's death he was created viscount and then appointed by the king Lord President of the North. In 1633 he became Lord Deputy of Ireland and served effectively in that position until the king called him to London in 1639 to assist him in the Scottish crisis. He was a strong advocate for the crown's centralized authority. His own administrative skills matched those of Archbishop Laud, with whom he was in agreement. For an excellent account of his life and personality, see C. V. Wedgwood, *Thomas Wentworth: First Earl of Strafford 1593-1641: A Reevaluation* (New York, 1962).
2. Mainwaring was knighted in Dublin in 1634 at the time he assumed his responsibilities as secretary of state. Wedgwood 1962, 280, suggested that Mainwaring was elected M.P. for Morpeth in 1640 through the influence of the earl of Northumberland. After the death of the earl of Strafford he was little involved in politics, although shortly before his death he was elected M.P. for Newton, Lancashire.
3. For discussions of these paintings and the copies see London 1982–1983, 56, cat. 15; and 67–68, cat. 23. See also Wedgwood 1962, 212–213, for a discussion about his close relationship with Lady Carlisle, sister of the earl of

Thomas Wentworth (1593–1641) sits with the forceful stare of a man whose powerful personality and steadfast convictions raised him by the end of the 1630s to a position of importance second only to that of the king. Unlike the courtiers so often portrayed by Van Dyck, Wentworth did not assume his influence through family connections or gracious demeanor, but rather through his effectiveness as an administrator and as defender of the king's prerogatives. His assurance of his own capabilities is evident in his alert countenance and upright posture as he sits with one hand grasping the arm of his chair. The weight of the responsibilities he has assumed is clear as well from the black parliamentary robes he wears, the unfolded document he holds in his left hand, and the attentive gaze of his associate Sir Philip Mainwaring, who sits poised to record the earl of Strafford's pronouncement.

Van Dyck's remarkable portrait was painted in 1640, the year of Strafford's greatest personal triumph as well as the disgrace that led to his tragic death on 12 May 1641, when, condemned as a traitor by Parliament, he was beheaded before the jubilant crowd that had thronged London to witness the execution.[1] In September of 1639, at the behest of King Charles I, Wentworth had come to London from Dublin, where he had served effectively as Lord Deputy of Ireland since 1633. The king, faced with the revolt in Scotland that threatened his realm and a recalcitrant gentry who refused to pay levies imposed to raise funds for the army, had called Wentworth because of his forceful leadership and unswerving loyalty, which was premised on his conviction that the realm could only survive under the leadership of a strong king. Wentworth's influence quickly grew. In January 1640 he was raised to the rank of Lord Lieutenant of Ireland and named earl of Strafford. Shortly thereafter he persuaded the king to reconvene Parliament, which had not met since Charles had dissolved it in 1629. Under his guidance, he felt, Parliament would agree to back the king in subduing Scotland and provide the funds necessary to undertake a successful military campaign. He was wrong. Parliament balked and was quickly dismissed. Strafford, suffering from severe illness, was forced to his bed. Nevertheless, when the situation worsened in the north, he agreed to replace the earl of Northumberland as general of the English army after the latter fell ill. He left London at the end of August. The military campaign was a failure, in part because of the inefficiency of Hamilton [see cat. 87] and others. Strafford was held responsible for the disaster and for the king's unpopular policies. In November he returned to London where he was forced to confront the Parliament that eventually condemned him to death.

Van Dyck's painting was probably painted in the spring of 1640, before the sequence of disappointments that marked the end of Strafford's political power. It may have coincided with the opening of Parliament in April, which saw him reunited with Sir Philip Mainwaring (1589–1661), his faithful secretary of state in Ireland since

Fig. 1. Titian, *A Senator and His Secretary*, 1536–1538, canvas, 104 x 114.3 (41 x 45). By kind permission of the Duke of Northumberland

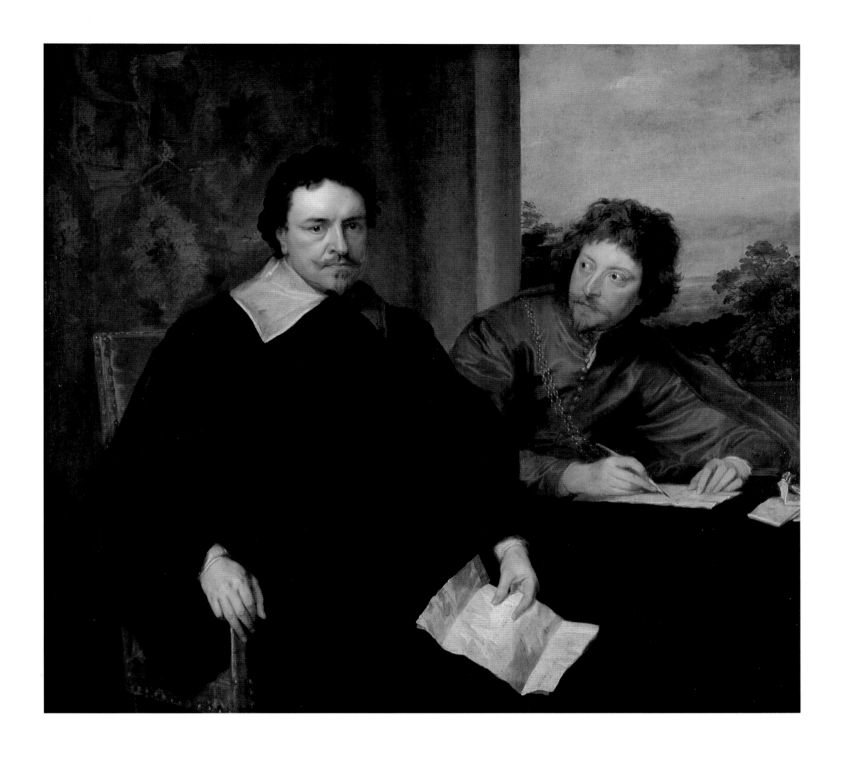

Northumberland and confidant to Queen Henrietta Maria.

4. For an exhaustive examination of this painting's history, the influence it had on Van Dyck, and an identification of Titian's subjects as Georges d'Armagnac, bishop of Rodez, with Guillaume Philandrier, see Michael Jaffé, "The Picture of the Secretary of Titian," *Burlington Magazine* 108 (1966), 114–125.

5. For the continued influence of this composition in British painting, see Jaffé 1966.

6. Walpole 1876, 1:327. Millar in London 1982–1983, 97, suggested that Van Dyck based his portrait of Wentworth on a portrait of the earl of Strafford in armor in the collection of the duke of Grafton. See also Millar's essay in this publication.

1634, whom he had arranged to have elected for Morpeth.[2] In any event, Van Dyck depicted Strafford together with one of his oldest and most trusted allies, one who could be counted on to support his and the king's policies in the House of Commons.

Strafford does not seem to have been someone with a particular interest in the arts, except, perhaps, in so far as portraits served his political aspirations. He first sat for Van Dyck in 1636, after he had returned from Ireland for various business enterprises in the summer and fall of that year. He was at that time extremely well received by the king and members of the court. Van Dyck's portraits depict him as a military commander dressed in armor. In one portrait he rests his hand on the head of a large Irish wolfhound in a pose derived from Titian's portrait of Charles V with a hound, then in the collection of Charles I [see cat. 66, fig. 3]. He commissioned copies of this and his other portraits by Van Dyck, all of which were patterned after Titian prototypes, to be distributed to those in his favor.[3] When Van Dyck painted this double portrait he turned to another Titian painting that Strafford clearly knew and admired, the great double portrait in the collection of the earl of Northumberland [fig. 1], which was at that time termed "a Senator and His Secretary."[4] The aura of power and dignity implicit in Titian's work must have seemed a fitting model for Strafford's own sense of his historic mission in the spring of 1640.[5]

The forcefulness of this portrait is perhaps nowhere better expressed than by Vertue who wrote of it: "I can forgive [Van Dyck] any insipid portraits of perhaps insipid people, when he showed himself capable of conceiving and transmitting the idea of the greatest man of the age."[6]

A. K. W.

c. 1640
canvas, 218.4 x 129.5 (86 x 51)

Collections of the Prince of Liechtenstein,
Vaduz Castle

PROVENANCE In the inventory of the
Hamilton archives before 1649 (as "One
peice of my lords at length in armor of
Sr.Anthony:Vandyke"); by descent;
duke of Hamilton, Hamilton Palace

EXHIBITIONS London, Royal Academy,
1873, no. 127; London 1887, no. 113;
London 1953–1954, no. 133; London
1982–1983, 31, no. 60, ill.

LITERATURE Smith 1829–1842, 3:168, no.
583; Cust 1900, 204, no. 12, 275, no. 90;
Glück 1931, 463, ill., 572; Larsen 1988, no.
856, ill. 391

1. Gilbert Burnet, *The Memoirs of the Lives
and Actions of James and William, Dukes of
Hamilton and Castle-Herald* (Oxford, 1852),
3. Biographical information in this entry
is largely taken from this source.
2. The political problems in Scotland
were complex and probably could not
have been solved by even a more
effective mediator than Hamilton. The
crises had roots in the Scots' fear that the
king's policies were threatening their
property (Act of Revocation, 1626), and
religion (Code of Canons, 1636; and the
subsequent introduction of a new prayer
book in 1637). For a particularly critical
account of his character and his effec-
tiveness as a spokesman for Charles I's
interests, see *Dictionary of National
Biography* 24 (1890), 180. For an excellent
discussion of this period, see Pauline
Gregg, *King Charles I* (London, 1981),
285–296.
3. Burnet 1852, 5.
4. As quoted from Clarenden's life of Sir
Thomas Coventry by David Nichol
Smith, *Characters from the Histories and
Memoirs of the Seventeenth Century*
(Oxford, 1918), 18.
5. Royal Collection 1977, 35, 36, 49.
6. For a discussion of Hamilton's
collection and publication of various
inventories of his paintings, see Klara
Garas, "Die Entstehung der Galerie des
Erzherzogs Leopold Wilhelm," *Jahrbuch
der Kunsthistorischen Sammlungen in Wien*,
63 (1967), 39–80. Hamilton's collection
was subsequently acquired by Archduke
Leopold Wilhelm shortly after Hamilton's
death in 1649.
7. An old copy of the painting in the
Scottish National Portrait Gallery was
inscribed and dated 1640 by a later hand
(*Scottish National Portrait Gallery Concise
Catalogue* [Edinburgh, 1977], 61, no. 777).
Interestingly, it was Hamilton, with the
king at York, who sent permission on 13
September for Van Dyck's departure to
Arundel, who had acted as Van Dyck's
intermediary (Cust 1900, 143).

James Hamilton (1606–1649), 3d marquess and 1st duke of Hamilton, did not have a
successful military career. Although, as is clear from Van Dyck's full-length portrait,
he wished to be known to posterity as a forceful and resolute leader, nothing could
have been further from the case. History records how in the late 1630s, when Charles
desperately needed strong and reliable commanders to counter the revolt in Scotland,
his cause was doomed not only by his own vacillations and inconsistencies, but also
by those of Hamilton and others of his most loyal supporters. Hamilton's lack of
fortitude was not missed by Van Dyck; for despite the sitter's bravura pose and
sheening armor, he looks out at the viewer with the gentle features of one more at
home with political intrigues than the vigorous demands of the battlefield.

The faith Charles placed in Hamilton was founded on a childhood friendship that
stemmed from family connections and a shared Scottish heritage. Hamilton's marriage
to Mary Feilding in 1620, moreover, had brought him into close contact with the duke
of Buckingham, since Mary was the daughter of Buckingham's favorite sister Susan
Villiers [see also cat. 78]. Hamilton bore the sword at the king's coronation in 1625.
After Buckingham's assassination in 1628 he was summoned from Scotland by the
king to fill Buckingham's position as Master of the Horse.[1] He was named Gentleman
of the Bedchamber at the same time (and served with Endymion Porter in that
position, see cat. 73) as well as a member of the Privy Council. In 1630 the king
conferred upon him the Order of the Garter, the medal of which hangs around his
neck in this portrait.

Hamilton seems to have been on especially close terms with the king's sister
Elizabeth, queen of Bohemia, and, at her behest, agreed to assist the king of Sweden,
Gustavus Adolphus, in his military campaign in Germany in hope that victory there
would help reinstate the king and queen of Bohemia in the Palatinate. The enterprise,
however, failed miserably and Hamilton returned to England in 1632. After the king's
coronation in Scotland in 1633, Hamilton retired from public affairs until 1638 when
he was called by Charles to assist him in quelling the uprisings in Scotland.[2]

Charles turned to the marquess of Hamilton for these delicate negotiations
because of his Scottish roots, but also because of his close personal attachments to his
kinsman. Hamilton's biographer wrote: "The king used him with so much tender
kindness, that his carriage to him spoke more of his affection of a friend than of the
power of a master; he called always him James, both when he spoke to him and of
him, as an expression of familiarity with him; and it was presently observed by all,
that none had more of the King's heart than he possessed."[3] Clarenden gave a
comparable assessment: Hamilton, he wrote, "had the greatest power over the
affections of the Kinge, of any man of that tyme."[4]

The two shared many interests, primary among them a love for art. Hamilton was
an active collector, but he also bought works for Charles. He and the king even
exchanged paintings.[5] His own collection was one of the finest in England,
particularly after 1639 when he acquired through the intermediary of his
father-in-law, Lord Feilding, important Venetian paintings from the collection of
Bartolomeo della Nave in Venice.[6]

Van Dyck probably painted this portrait in 1640, prior to his departure to Flanders
in the early fall.[7] As Millar has noted, the painting exhibits characteristics of Van
Dyck's very late English style: the tonality is rather cool, particularly in the flesh
tones, and the figure is not integrated completely into the schematically rendered
landscape backdrop.[8] The finest part of the painting is the head, which is delicately
rendered with softly blended brushstrokes. The halo effect around the head suggests
that Van Dyck painted this area first and from life, and completed the rest later.

Hamilton was one of Charles' principal advisors during the Civil War and
continued to be actively involved in Scottish issues. In 1643 the king named him a

8. London 1982–1983, 100. Millar noted that Van Dyck had previously used this backdrop for his portrait of Lady Clanbrassil (Frick Collection, New York).

duke in reward for his service. Finally, in 1648, Hamilton convinced the Scottish Parliament to allow the Scottish army to intervene in the English Civil War on the side of the royalists. He headed the army but was decisively beaten by Cromwell at the Battle of Preston. He surrendered to the Parliamentarians on 25 August 1648 and was executed on 9 March 1649, shortly after the death of the king.

A. K. W.

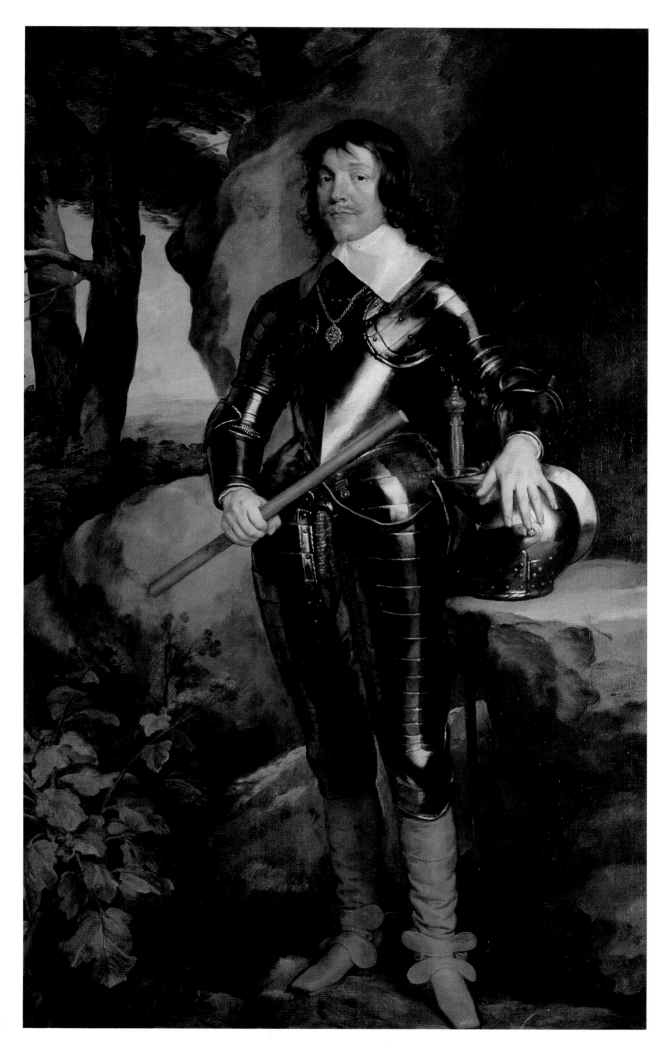

Photographed during
conservation treatment

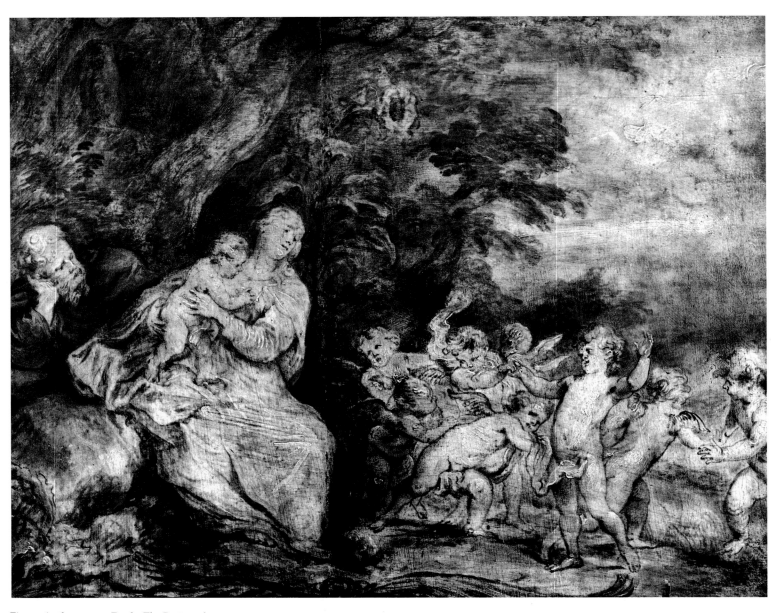

Fig. 1. Anthony van Dyck, *The Rest on the
Flight into Egypt*, panel, 32 x 40
(12 1/2 x 15 5/8). Suermondt Museum,
Aachen

Van Dyck's Oil Sketches

JULIUS S. HELD

The making of oil sketches prior to executing paintings on a larger scale played a less important role in Van Dyck's œuvre than it did in Rubens'. Engaged as he was in a large output of religious, mythological, and historical compositions, Rubens found small oil sketches on wood panels useful for a variety of reasons. They gave his patrons an idea what the finished work might look like. Sketches, or the slightly larger *modelli*, were useful as models in the studio, guiding his assistants in the various stages of the work. He used oil sketches also to clarify for himself how best to render a given action, and it is fascinating to follow the creative process by observing its transformations, either through a second or occasionally even a third sketch, or with the help of changes of plan visible as pentimenti in the panels themselves.[1]

As this exhibition demonstrates, multifigured narratives, so prevalent in Rubens' work, are not heavily represented in Van Dyck's. And while they are fairly numerous from his first Antwerp period, when he worked close to and in competition with Rubens, and reappear again in sizable numbers during his second Antwerp period, Van Dyck's energies were directed toward portraiture while he was in Italy, and even more so during his years as painter of the English royal house and the British court society. Portrait commissions rarely required more preparation than what a drawing in pen or chalk could provide, and Van Dyck apparently preferred the medium of drawing to develop his narrative compositions also. Many of his early projects for religious subjects intended for Antwerp churches were studied by him in ever-new variations. For each of his paintings of *The Betrayal of Christ* [see cats. 13, 14] and *The Bearing of the Cross*[2] we still have seven compositional sketches in pen and ink and in some cases wash, and for *Moses and the Brazen Serpent* [cat. 15][3] we have eight. The young Van Dyck evidently felt more secure with a flexible medium, such as drawing on paper, than with painting in oil on a wooden panel. These drawings reveal the impatience of a gifted young man: the lines drawn with the quill indicate the haste in which they were jotted down. In addition to the compositional sketches, Van Dyck made—also following Rubens' model—studies of single figures, using black chalk for this kind of work. Yet he occasionally turned to oil even in his early years. This is impressively demonstrated by the relatively large canvas of a horseman from Christ Church [cat. 88]. Done when Van Dyck was hardly more than sixteen or seventeen years old, the boldness in his use of the brush is astonishing. It is matched, however, by the study of a young woman, perhaps a study for a Magdalene [cat. 89], which is not only technically a work of vibrant intensity, but also indicative of Van Dyck's early developed gift for sensitive psychological characterization. With its "companion piece" in Vienna[4] it represents the large group of "study-heads" done by Van Dyck early in his career. They culminate in the series of Apostles [see cats. 19, 20] characterized by a range of physiognomic shape and expression for which there is no parallel even in Rubens' work.

The only compositional sketch dating from Van Dyck's pre-Italian years represented here is the small but lively interpretation of *The Expulsion of Adam and Eve* [cat. 90], painted on paper; the fact that Van Dyck also made studies in pen and ink for this composition suggests that he had a commission, or hoped to get one, for this subject; but no such painting is known.

While narrative subjects lagged far behind portraits during Van Dyck's years spent in Italy, a period in which his gift for portraiture reached levels of artistic accomplishment he never surpassed, he did paint a number of subjects that he must have prepared with preliminary studies; yet no oil sketches have been found and we know only one drawing for his most important work, *The Madonna of the Rosary* in Palermo [see cat. 46, fig. 4].[5] Van Dyck could have sketched the superb series of Genoese portraits directly on the large canvases after he had made drawings of the models' faces. The portrait sketch of Lucas van Uffel [cat. 92] does not necessarily tell us that Van Dyck made such small versions on panel for the portraits of his Italian patrons.

As Glück already suggested, the artist may have been thinking of the project that is now known as Van Dyck's *Iconography* when he painted the portrait of the Flemish merchant and collector.

The exact date of Van Dyck's return from Italy is not known, but he was again settled in Antwerp by March 1628. Rubens was away from Antwerp from September 1628 until early in March 1630 except for a very few days in 1629, a total of eighteen months; it can hardly be doubted that commissions that might have gone to Rubens were now given to Van Dyck, whose successes abroad had given him a prestige equal to that of his mentor. As he had been in Italy, the younger artist was much in demand as a painter of portraits. Yet he evidently was also approached to paint religious subjects, chiefly altarpieces, and most of his oil sketches for such canvases appear to have been done in the period when Rubens was elsewhere. Since Rubens had established the practice of providing oil sketches for major projects almost routinely, the patrons' expectations may have played a role in Van Dyck's making such sketches in larger numbers at that time.

It is unfortunate that this phase of his development as a painter of oil sketches could not be represented here as fully as it deserves. Since all the major sketches are painted on panel, many institutions are understandably reluctant to let them travel where they encounter atmospheric conditions different from their own. A number of outstanding examples thus are missing here. To mention but a few: *The Adoration of the Shepherds* in the Staatliche Museen (Gemäldegalerie) Berlin-Dahlem;[6] *The Crucifixion* in the Musées Royaux des Beaux-Arts de Belgique in Brussels;[7] two sketches, a *Raising of the Cross*[8] and a *Martyrdom of Saint George*,[9] in the Musée Bonnat in Bayonne; another *Martyrdom of Saint George* at Christ Church in Oxford;[10] the little-known and always misinterpreted sketch of *The Rest on the Flight into Egypt* (with dancing angels) in the Suermondt Museum at Aachen [fig. 1];[11] and two particularly important if somewhat later sketches, both in the Ecole des Beaux-Arts in Paris: one is the only surviving compositional record of Van Dyck's large painting of the Brussels *Magistrates*, destroyed in the bombardment of 1695;[12] the other a sketch for *Amaryllis and Mirtillo* ("The Kissing Game") known from three large versions [see cat. 60].[13]

Fortunately two superior examples of such sketches have been lent to this exhibition: *Saint Augustine in Ecstasy* [cat. 93], done soon after the artist's return from Italy, and *The Assumption of the Virgin* [cat. 96], probably one of Van Dyck's last works painted before he moved to London in 1632. In exemplary fashion these sketches permit us to specify the relationship of Van Dyck's oil sketches to those of his great model, Rubens. By the time Van Dyck painted these more or less monochromatic sketches, Rubens had developed a manner rich in coloristic suggestiveness and characterized by a broad application of the brush. Nothing could differ more from those sketches of Rubens (as for instance those done for *The Assumption of the Virgin*)[14] than those done by Van Dyck. With their stress on thin, long, drawn-out lines and pointed dark and light accents, they reveal, perhaps even more clearly than his larger paintings, Van Dyck's concern with delicate nuances of expression and nearly weight-less human forms. Moreover, technically they seem to be taking off from some sketches Rubens had painted precisely when Van Dyck was most under his spell, such as the sketch for the so-called *Coup de Lance* in the National Gallery, London,[15] a sketch which characteristically had for a long time been attributed to Van Dyck.

Several of these Van Dyck sketches of religious compositions have been repeated in fairly faithful copies that were attributed to the master himself until the true original was identified. Some of them may in fact have been painted by the same hand: the copy of the *Saint Augustine in Ecstasy* in the Ashmolean Museum at Oxford[16] is characterized by the same coarsening of the shapes and of the light and dark patterns as the sketch of *The Martyrdom of Saint George* in the Detroit Institute of Arts,[17] and there are still other sketches that may be by that hand.

A special and admittedly controversial category is represented by paintings done as models for engravings. Two such models have been included in the exhibition, to provide a forum for discussion about their attribution. In his seminal study on Van

Dyck's oil sketches, Horst Vey rejected all such models as copies prepared by the engravers themselves. He identified as such not only the two paintings here exhibited, but also the *Rinaldo and Armida* in Brussels[18] and the London sketch of the same subject,[19] *The Rest on the Flight into Egypt* in Aachen [see n. 11 and fig. 1], and *The Crucifixion with Saint Francis*, Princes Gate Collection, Courtauld Institute of Art.[20] In view of their high artistic quality and their stylistic correspondence one may well raise again the question whether Van Dyck might have painted these models for engraving himself. Engravers were highly skilled specialists who surely had some training in draftsmanship. Yet works like the *Saint Augustine in Ecstasy* [cat. 94] or *The Lamentation* [cat. 98] have been executed with a mastery only a fully trained painter would seem to have been capable of. All the details, from human faces and hands to the intricacies of drapery, have been done with such exquisite sensitivity that, had they been the work of the engraver, he would have been hailed as a painter as outstanding as he was a maker of prints. One should perhaps keep also in mind that Van Dyck, like Rubens before him, had a vested interest in the quality of the prints, and that he knew that a better product would result if he himself furnished the engraver with the model to work from. Moreover, the prints based on both examples exhibited here were published with dedications, the second one, indeed, to a person of discriminating taste, surely another reason for Van Dyck to prepare the printmaking with special care.

According to Bellori,[21] Van Dyck, when he was still working close to Rubens, made drawings of Rubens' compositions to be engraved by Vorsterman; not even the making of preliminary drawings was entrusted to the engraver himself. Now faced with the prospect of having some of his own works engraved, Van Dyck may have decided to do for his own works what he years before had done for several of Rubens' compositions, albeit in oil colors rather than in pen and ink. (Early in the 1620s Rubens had begun to prepare compositions to be engraved with the help of monochrome sketches in oil.)[22] Van Dyck surely was aware of that technique, one he could not possibly consider unworthy of his talent or too time-consuming. It remains to be seen whether in the framework of a comprehensive Van Dyck exhibition the two small models for engraving will be able to hold their own as another part of the artist's autograph activity.

NOTES

1. The first author to attempt a survey of Van Dyck's sketches in oil was Horst Vey (1965), and his study has remained the basis for all subsequent investigations despite some questionable judgments that Vey himself has disavowed.
2. Glück 1931, 11.
3. Glück 1931, 73.
4. Glück 1931, 72 (right).
5. Vey 1956, ill., now Liberna Stichting, Hilversum, the Netherlands.
6. Glück 1931, 250 (below).
7. Glück 1931, 246.
8. Glück 1931, 248.
9. Glück 1931, 153 (right).
10. Glück 1931, 252 (left).
11. Never seriously discussed, this Aachen sketch (32 x 40 cm, 12 1/2 x 15 5/8 in.), which is unfortunately disfigured by heavy yellow varnish, has frequently been passed off as the model for a print by Schelte à Bolswert (Glück 1931, 547, under s.260–261; Antwerp 1949, under no. 16; Van Gelder 1959, 75; Larsen 1988, 2:290). Bolswert's engraving is based on a composition often referred to as The

Holy Family with Dancing Angels. One version of it is in the Palazzo Pitti in Florence (Larsen 1958, no. 728), easily recognized by the group of three angels in the sky, and it is this composition that is reproduced in Bolswert's print. The other, and I believe more authentic version, is in the Hermitage, Leningrad (Glück 1931, 261), and instead of the angels features two flying partridges in the sky. The Aachen sketch is more closely connected with the Leningrad version, as was stated in a modest note in the Aachen catalogue (Städtisches Suermondt Museum, *Gemä-Kataloge* [Aachen, 1932], no. 129). The partridges are missing, but according to the catalogue some traces of the birds can be seen. (They looked to me like pentimenti.) The sketch agrees with the Leningrad canvas in other respects, especially the pose of Joseph, which is very different in the Pitti canvas and in Bolswert's print. Thus it is clear that the Aachen sketch cannot be linked with the engraving by Bolswert; more important still is the fact

that it has not at all the appearance of a model made for an engraver. It is unquestionably a sketch for the Leningrad canvas, exhibiting all the freedom and lightness of touch we know from Van Dyck's other sketches made in preparation of larger paintings, and if properly treated and cleaned would take its rightful place among the genuine compositional sketches of the master.
12. Vey 1956, 198, ill.
13. Vey 1956, 181, ill.
14. Julius S. Held, *The Oil Sketches of Peter Paul Rubens* (Princeton, 1980), nos. 377, 378, 379 pl. 368, 369, 370.
15. Held 1980, no. 352, pl. 347.
16. Vey 1956, 176, ill.
17. Glück 1931, 252.
18. Glück 1931, 548 (under s.265).
19. Gregory Martin 1970, 37–41.
20. Flemish Paintings & Drawings at 56 Princes Gate, London sw7, iv (Addenda) (London, 1969), 24 ill.
21. Bellori 1672.
22. Held 1980, no. 294, pl. 291.

88
Armed Soldier on Horseback

c. 1615–1616
canvas, 91 x 55 (35 1/2 x 20 1/2)

The Governing Body, Christ Church, Oxford

PROVENANCE General John Guise, bequest 1765

EXHIBITIONS London and Manchester, *Art Treasures of the United Kingdom*, 1857, no. 585; Antwerp 1960, no. 123; Liverpool, Walker Art Gallery, 1964, no. 17

LITERATURE *English Connoisseur* 2 (1766), 66 ("A finished sketch of King Charles The First's white horse"); Christ Church, *"A" Catalogue* (1776), 3; Christ Church, *Catalogue* (1833), no. 160; Guiffrey 1882, no. 970; Cust 1900, 233 (under no. 11 [?]); Tancred Borenius, *Pictures by the Old Masters … in the Library of Christ Church* (Oxford, 1916), no. 323, ill.; G. Glück, "Van Dyck's Anfänge: der heilige Sebastian im Louvre zu Paris," *Zeitschrift für bildende Kunst* 59 (1925–1926), 261; Glück 1931, 4–5; Vey 1956, 168–169 ill.; J. Byam Shaw, *Paintings by Old Masters at Christ Church* (Oxford, 1967), no. 246; Larsen 1980, 1:153, 462, and 2:130, no. 316; Ottawa 1980a, 55; Martin 1981, 399, no. 3

1. See A. E. Popham, *The Drawings of Leonardo da Vinci* (London, 1946), nos. 63b and 65.

As Glück was the first to recognize in 1931, this remarkable study can be connected with one of Van Dyck's earliest religious paintings, *The Martyrdom of Saint Sebastian* in the Louvre [see cat. 3, fig. 1]. Although the horse's head is overlapped by the right margin of the painting and the lower part of its body hidden behind an elderly man busy tying up the saint, the characteristic shape of its head and its turn to the left leave no doubt that the sketch was used for this part of the picture. The head of the soldier, while similar in pose, has been placed higher up; he calmly observes the action in the center.

In contrast to other authors, Vey twice expressed the opinion (1956 and 1960) that the Oxford sketch was done as an independent study and was only used when the artist found its inclusion in the larger painting to be helpful in telling the story. The sketch itself, however, makes this theory hardly acceptable. Not only would it be difficult to explain why both rider and horse turn their heads toward the left where obviously something attracts their attention, but also the only fully developed sections of the sketch, the heads of man and horse, appear here precisely as they were eventually shown in the large canvas. All else below is very lightly laid out, some parts done only in a few dark touches of the brush: the horse's left hind leg has been sketched so lightly as to be almost invisible. In fact, the horse's legs have been done rather carelessly and are anatomically flawed.

Hans Möhle, as reported by Vey in the 1960 exhibition catalogue, pointed out that Van Dyck's horseman contains an unmistakable echo of two Leonardo drawings.[1] While it is unlikely that Van Dyck knew any of these drawings (in which an advancing horse turns its head in the same way as Van Dyck's, while its rider, very much like Van Dyck's soldier, leans to the left), it is perfectly possible that he was acquainted with a pattern that ultimately can be traced back to Leonardo's studies of horses and riders. Rubens, however, does not seem to have been the intermediary, at least not in the sense Vey suggested when he cited Rubens' Lerma portrait of 1603 and his lost portrait of Archduke Albert as Van Dyck's "inspiration."

Van Dyck used the head of the soldier wearing the same helmet for another soldier appearing at the extreme left of the Paris canvas, though seen in reverse.

A copy of the painting on canvas, 85 x 54 cm (33 1/8 x 21 in.), formerly in the collection of Sir Evelyn De la Rue, Bt., was sold at Sotheby's, 26 October 1988, lot 51, ill.

Ever since the discovery through X-ray examination of the Edinburgh *Saint Sebastian* [see cat. 22] of a compositional arrangement analogous to the painting in the Louvre, the Christ Church sketch must be linked to that now-hidden picture. In fact, it raises the question hitherto not addressed in specific terms of which of the two versions, the one in Paris or the hidden one in Edinburgh, had been painted first. As far as I can tell, it is generally taken for granted that the smaller Paris picture came first. While it is true (as Martin 1981 stressed) that the young Van Dyck painted several compositions more than once, the hidden composition in Edinburgh is the only case where he obliterated what he had painted a number of years before. An artist who puts a painting aside, to use the canvas again at a later date and for another picture, normally does so if he is dissatisfied with what he had done. And since Van Dyck indeed painted the same composition in another (Paris) version, common sense, in the absence of any documentary evidence, would suggest that the "hidden" version was the first and, in view of its size, a rather ambitious work, which he put aside to do the composition over on a smaller scale. However that may be, the Christ Church sketch belongs to the phase when the artist worked out the details of the action.

J. S. H.

89
Young Woman Resting Her Head on Her Hand

c. 1616–1618
oil on paper, laid down on panel,
48.5 x 37.8 (19¼ x 14¾)

Private collection, New York

PROVENANCE Sir Francis Cook, Doughty
House, Richmond (acquired 1869);
thence by descent; sale Christie's,
2 December 1983, 121, by order of the
Trustees of the Cook Collection

LITERATURE Schaeffer 1909, 22; Bode
1909, 37; J. O. Kronig, *A Catalogue of the
Paintings at Doughty House ...* (London,
1914), 2: no. 248; Glück 1931, 72 left;
Van den Wijngaert 1943, 30; Larsen 1988,
2:98, no. 227 ill.

1. By O. van Veen, Rubens, Jordaens.
2. E. Mâle, *L'Art religieux après le Concile
de Trente* (Paris, 1932), 69.
3. Glück 1931, 67.
4. Denucé 1932, 356.

This study, painted in the forceful style of Van Dyck's earliest period and characterized by heavy impasto involving much lead white, is remarkable for the emotional intensity of the woman's expression. She looks up as if contemplating a painful subject, unmindful of her open gown and unkempt hair. It is very likely that Van Dyck tried to render the Penitent Magdalene, as several authors have assumed; but we do not know whether it was painted as a study for a larger painting, as a very similar study in Vienna [fig. 1] was surely done [see cat. 95], or was intended for another purpose. In technique and compositional arrangement it is so close to Van Dyck's early series of Apostles that one might consider the possibility that it, too, was part of a serial project, possibly of Christ with the Sinners; but while this subject is one frequently encountered in the seventeenth century, it has been always, as far as I know, treated in the framework of a single composition.[1]

Along with the Repentant Saint Peter, the Penitent Magdalene was for the doctrines of the Counter-Reformation the strongest affirmation of the sacrament of penance, whose value the Protestant reformers had denied. The solitary beauty, giving herself totally to her sorrow and remorse, became, as Mâle said, "l'image la plus pathétique de la pénitence qu'il fût possible d'imaginer."[2]

There is a certain irony in the fact that, while this moving image of spiritual suffering seems not to have been used by Van Dyck in any context related to its message, he did introduce it into a completely different and almost diametrically opposed subject, the *Drunken Silenus* [cat. 12].[3] In that painting a grizzled Silenus, bent over from the effect of age and intoxication, is accompanied by four young revelers. A subtle erotic interplay links two young men with a young woman who holds one of Silenus' arms while seductively looking over his shoulder at the two youths. It is astonishing to see how few changes in her face have transformed the Penitent Magdalene into a smiling temptress. It would be more fitting if we could claim that, just as in the Magdalene's life, the painted image of wantonness preceded and was transmuted, by the artist's decision rather than moral force, into an image of mortified purity. Alas, the Dresden Silenus was surely painted later, and it was the repentant sinner who reemerged in it as a voluptuous sex kitten.

Among the four sketches by Van Dyck itemized in the inventory of Jan-Baptista Anthoine (1691), no. 52, is listed thus: "Een geschetste Magdalena Tronie geplact opt pinneel van van Dyck. ... f. 60" (A sketched head of the Magdalene, laid down on Van Dyck's panel ... fl. 60).[4] This may have been the present picture.

J. S. H.

Fig. 1. Anthony van Dyck, *Study of a Woman's Head*, oil on paper mounted on wood, 49 x 43 (19¼ x 16⅞). Gemäldegalerie der Akademie der bildenden Künste, Vienna

c. 1620
oil on paper, laid down, 19.1 x 17.2
(7 1/2 x 6 3/4)

National Gallery of Canada, Ottawa

PROVENANCE Jonathan Richardson, Sr.
(1665-1745); Thomas Hudson (1701-1779);
Sir Joshua Reynolds (1723-1792); J. B. S.
Morritt, Rokeby Park, Yorkshire, and his
descendants; private collection, London;
acquired 1975

EXHIBITIONS London, Baskett and Day,
1973, no. 7; Princeton 1979, no. 23;
Vancouver, Master Drawings from the
National Gallery of Canada, Vancouver Art
Gallery, 1988–1989, 39

LITERATURE C. van Hasselt, Dessins
Flamands et Hollandais du Dix-Septième
Siècle [exh. cat.] (Paris, 1974), 35, under
no. 22; Benedict Nicolson, "Current and
Forthcoming Exhibitions," Burlington
Magazine 116 (1974), 53; Princeton 1979,
96; Ottawa 1980, 112–114; Larsen 1988,
1:477 ill., 2:466, no. A169 (as Dutch, late
seventeenth century); Anne-Marie
Logan, "Jan Boeckhorst als tekenaar,"
Jan Boeckhorst, 1604–1668, medewerker van
Rubens [exh. cat. Rubenshuis, Antwerp]
(Freren, 1990), 126 ill. 85 (attributed to
Jan Boeckhorst)

1. Holbein's Images of Death, though to a
large extent finished by 1526, appeared
first in Lyons in 1538 (Les simulacres et
historiées faces de la mort) with forty-one
woodcuts. Later editions, gradually
increased to fifty-eight images, were
published in 1545 and 1562. Stimmer's
woodcut was part of his Neue Künstliche
Figuren Biblischer Historien, published in
Basel in 1576. It is reproduced in Jaffé
1966a, 1: pl. CXLIII.
2. Julius S. Held, The Oil Sketches of Peter
Paul Rubens (Princeton, 1980), no. 6, pl. 7.
3. Jaffé 1966a, 1:65, 67–68; 2: 52v and
54v.
4. I. Q. van Regteren-Altena, Peter Paul
Rubens, tekeningen naar Hans Holbeins
Dodendans (Amsterdam, 1977).
5. Vey 1962, no. 1. Vey declared the
sketches on the back to be by another
hand, a view I rejected in my review of
Vey's book in 1964.
6. Vey 1962, nos. 44, 46. To the seven
drawings for the Brazen Serpent pub-
lished by Vey an eighth (of outstand-
ing quality) has since been added, now
owned by E. V. Thaw, New York.
7. In a codicil to his will (20 April 1668)
Boeckhorst bequeathed his painting of
Adam and Eve to a glass painter, Jacques
Horremans; in Horremans' inventory
(6–7 May 1678) that painting was
described more specifically as "het
Verdryven van Adam en Eva wt Aerts
paradys" (the expulsion of Adam and
Eve from the Earthly Paradise). See
Denucé 1932, 271. Helmut Lahrkamp,
"Johann Bockhorst, 1604–1668," Westfalen
60 (1982), 3–199 (following M.-L. Hairs)
identified a painting now at the
Staatsgalerie in Stuttgart as that work of

Uncommon as a self-sufficient subject, the *Expulsion of Adam and Eve from Paradise* was treated by several artists of the Italian Renaissance as part of major decorative cycles. In each case the mortified couple moves away from the angel who either pushes them out, as in Della Quercia's relief at the main portal of San Petronio in Bologna, or, with one hand on Adam's shoulder, walks threateningly behind them, as in Raphael's Loggie. Raphael's treatment of the subject owes much to Masaccio's at the Brancacci Chapel in the Carmine church in Florence, where the angel, however, flies overhead, as he does again in Michelangelo's Sistine Ceiling. In all of them the action is from left to right; and although one can assume that the artists conceived the first parents as walking side by side, they all chose a spatial arrangement suggesting that here, too, Eve precedes Adam, as she had done at the Fall.

With the stress clearly on the sense of shame and remorse of the first parents, the physical action in all the Italian examples proceeds at a leisurely pace: Adam and Eve simply walk away from the paradise they have lost. It is different when we come to the woodcuts of Holbein and Stimmer, they, too, forming part of larger cycles.[1] Both of these artists show Adam and Eve running as fast as they can from the threat of the angel flying above them. And while Stimmer still followed the traditional arrange-ment of Eve preceding Adam, in Holbein's woodcut it is Adam who rushes ahead, seemingly unaware that he is taking the path of Death, a gleeful skeleton playing a *vielle*. When Rubens sketched the Expulsion for the ceiling of the Antwerp Jesuit church, he dramatized the event still further by showing Death grabbing both Adam and Eve, though neither seems to be aware of their fate.[2] With Rubens as well as with Holbein and Stimmer the action unrolls, as always before, from left to right. Although it may have been painted about the time Rubens designed the ceiling decoration for the Jesuit church, a decoration Van Dyck was helping to execute, the Ottawa sketch is not connected in any way with Rubens' design (which actually was never painted full scale), and not only because it has none of the audacious foreshortening Rubens applied to all the ceiling sketches for that church.

In fact, of all the possible models for Van Dyck's interpretation of *The Expulsion of Adam and Eve*, Holbein's diminutive woodcut may well have been the most important [fig. 1]. The speed at which both figures are running from the angel's threatening sword, with Adam in the lead, and the striking parallelism of Adam's and Eve's bodies (even to the extent of one of Adam's legs crossing one of Eve's at the same angle) should make it clear that the artist knew and remembered Holbein's woodcut. His acquaintance with the entire set of the *Images of Death* has been established since Jaffé published the so-called Antwerp sketchbook, where no fewer than ten of Van

Fig. 1. Hans Holbein the Younger, *The Dance of Death: Adam and Eve Driven out of Paradise*, 1526, woodcut, 6.6 x 4.9 (2 9/16 x 1 7/8). The Art Institute of Chicago, The Stickney Collection, 1936.20

Boeckhorst (no. 1 of his catalogue), an attribution which in 1985 I declared "possible" but not completely convincing. See Denucé 1932, 271. See also J. S. Held, "Nachträge zum Werk des Johann Bockhorst (alias Jan Boeckhorst)," *Westfalen* 63 (1985), 14–37.

Dyck's drawings are based on Holbein's models.[3] Nor should one forget that at an early age Rubens himself had copied the entire series of Holbein's *Images of Death*; his copy of *The Expulsion of Adam and Eve* is unfortunately missing from the album (as are a few others) in which these early proofs of his precocity were assembled in the eighteenth century.[4]

So little is known about Van Dyck's practice of making sketches in oil early in his life that the attribution to him of the sketch in Ottawa would indeed be hazardous if it could not be supported by a drawing in Antwerp about which there can not be the slightest doubt.[5] On its verso Van Dyck several times sketched Adam's frantic effort to escape the angel's menace, and two or three times outlined Eve's parallel motion. He sketched the entire composition on the recto of the sheet in the tempestuous and unmistakable manner of his early drawings. Of the many possible analogies, one of the most compelling is with the eight drawings for the painting of *The Brazen Serpent* in Madrid [cat. 15], where we encounter the boldly swinging curves of the serpent in the Antwerp drawing again in the sheets where he sketched the serpent coiled around the pole erected by Moses.[6] Vey had considered the drawing one of Van Dyck's earliest, but a date around or after 1620 seems to be more likely.

What may have prompted the master to make studies for a painting of *The Expulsion of Adam and Eve from Paradise* we do not know. No painting of that subject by Van Dyck is known. In fact the only artist active in Antwerp on record to have painted an Expulsion as an independent piece (rather than as part of a cycle) is Jan Boeckhorst (1604–1668).[7] While the Ottawa sketch stands out as unique in Van Dyck's œuvre, it is in no way connected with Boeckhorst's (?) canvas in Stuttgart.

<div align="right">J. S. H.</div>

91
Saint Sebastian Bound for Martyrdom

c. 1620–1621
canvas, mounted on panel, 38.1 x 26.6
(15 x 10 1/2)

Anonymous lender

PROVENANCE by 1815, the earl of
Warwick

EXHIBITIONS London, Royal Academy,
1878, 290; London 1887, 136; London,
Agnew's (King's Lynn Festival Fund),
1963, 9; London 1968a, 14

LITERATURE W. Field, *A Historical and
Descriptive Account of the Town of Warwick*
(London [?], 1815); Ottawa 1980a, 54,
under no. 14; Larsen 1988, 1:164, ill.,
2:103–104, no. 241

1. Glück 1931, 5.
2. Thompson 1961, 318–320.
3. Glück 1931, 66.
4. Glück 1931, 134; Princeton 1979,
no. 30.

Within the space of seven or eight years Van Dyck painted three different versions of *Saint Sebastian Bound for Martyrdom*. All scholars seem to agree about their sequence. First came the canvas now in the Louvre,[1] where the saint looks out of the picture with an expression that is more sullen than resigned. The oil sketch with an armed soldier on horseback [see cat. 88] was made in connection with that painting. If my theory is correct Van Dyck had first painted another version of that composition but for unknown reasons put it aside, presumably before it was finished. As we know from X-ray photographs,[2] this version can still be discerned beneath the second formulation of the theme, now in Edinburgh [see cat. 22]. Van Dyck repeated the subject on another canvas of almost equal size now in Munich.[3] The sketch exhibited here appears to be the *modello* for the "hidden" composition, preceding both the Edinburgh and Munich versions. It differs sufficiently from both not to be taken as a copy. In the finished versions the right hand of the saint seems to be touched by the hand of the evil-looking bearded soldier whose head, too, is inclined more sideways than in the sketch. The old man tying the saint's legs has a more compact shape in the sketch, and the clump of trees above Sebastian are differently shaped and less detailed.

If the picture here subjected for the first time to critical examination proves indeed to be the *modello* for the Edinburgh painting, it assumes considerable significance, representing, as it does, the earliest compositional sketch still preserved by the master.

Critics generally acclaim this composition as the most satisfying interpretation of the theme. A few years later Van Dyck painted a third arrangement of this subject equally known from two versions (Alte Pinakothek, Munich, and Chrysler Museum, Norfolk).[4] It is the most melodramatic interpretation, yet the saint seems strangely unaffected by all the agitation around him. In fact, there is something curiously ingratiating in his expression, reminiscent—even physiognomically—of Van Dyck's contemporary self-portraits.

A copy of the three principal figures at the left, with the saint looking up at a small angel in the sky offering a palm branch (canvas, 66 x 54 cm), was at the Trafalgar Galleries, London, in 1976.

J. S. H.

Cat. 91 Photographed during conservation treatment

c. 1622–1625
panel, 19.5 x 16.6 (7⁵/₈ x 6¹/₂)

Private collection, London

PROVENANCE R. Kann, Paris; Dr. G. F.
Reber, Lugano; E. D. Reber, Munich,
1925; J. Sperling, Munich, 1930; H. Abels,
Cologne, 1931; F. Drey sale, Berlin
(Graupe), 17–18 June 1936 (no. 12); Mrs.
J. Patten sale, Sotheby's, 4 April 1962,
no. 35

EXHIBITIONS Fermoy Art Gallery,
*Exhibition of Pictures by Sir Anthony van
Dyck*, London, Agnew's (King's Lynn
Festival Fund), 1963, no. 16; London
1968a, no. 34

LITERATURE Glück 1931, 533 (under no.
126); Jaffé 1967, 155–162; Held 1982, 30;
Liedtke in Metropolitan Museum 1984,
59; Larsen 1988, 2: no. 419, ill.

1. Mauquoy-Hendrickx 1956, 46–47. See
also Paris 1981, introduction by Dieuwke
Hoop Scheffer.
2. See Spicer 1985–1986, 537–544.
3. See Vergara 1983, 283–286.
4. British Museum 1923, 2:62, under
no. 35.
5. Arpad Weixlgärtner, "Van Dyck in der
Kupferstich-Sammlung von Göteborgs
Konstmuseum," *Göteborgs Konstmuseum
Arstryck* (1955–1956), 45–93, was inclined
to accept Van Dyck's authorship for the
grisaille panels in principle, without
knowing the collection at Boughton
House in the original.

A native of the Netherlands, Lucas van Uffel (or Uffelen) was a wealthy merchant
and collector of art who was living in Venice when Van Dyck traveled in Italy. His
father, like many of his co-religionists, had left the southern Netherlands and had
settled in Amsterdam. Lucas, conducting business on an international scale, finally
made Venice his headquarters in 1616. About twenty years later he moved back to
Amsterdam, where his vast collection was sold after his death at an auction in 1639 at
which Rembrandt was present.

While it is by no means certain that the present sketch is indeed a portrait of
Lucas van Uffel, there is no doubt that it represents the same man as a canvas in the
Herzog Anton Ulrich-Museum of Braunschweig [cat. 31] and another in the
Metropolitan Museum of Art, New York [see cat. 31, fig. 1]. The identification of the
sitter of the Metropolitan Museum canvas (and by implication the one in Braun-
schweig) rests on two eighteenth-century pieces of evidence. On the back of an
impression of a mezzotint reproduction of the painting by Wallerant Vaillant
(Rijksprentenkabinet, Amsterdam) is a handwritten note: "De Heer van Uffel." A
letter about the painting, addressed to the then (1738) owner of the picture, Wilhelm
VIII, landgrave of Hesse-Kassel, likewise refers to it as "le Van Uffelen de Van Dijk."
Vaillant himself (1623–1677) had not recorded the name of the model. In fact another
impression of Vaillant's print is inscribed "Mr. de Nys Amatoor." Daniel de Nys, like
Van Uffel, was a Flemish merchant, established in Venice, and he, too, was a patron
of the arts. What might disqualify De Nys as a model is his age; born in 1572, he
would have been fifty at the very earliest date Van Dyck could have painted him
(1622), and still older if the portrait was painted at a later date. Unfortunately, the
date of birth of Van Uffel is not known.

The portrait sketch here exhibited raises one of the most difficult and still
unsolved problems of connoisseurship in the study of Van Dyck's works, the degree
of the artist's participation in the collection of prints known as Van Dyck's
Iconography. This collection of engraved portraits is a curiously mixed group of people
among whom artists (painters, sculptors, and printmakers themselves) as well as
collectors are by far the most numerous. The idea of such a publication was almost
certainly Van Dyck's own. In fact, he made a number of portrait etchings himself;
fifteen have been accepted by specialists as his work. By the time he died, the first
editor of the series, Martin van den Enden, had published eighty of these prints (not
counting Van Dyck's etchings). Of these, fifty-two were of artists and collectors, the
rest of princes, generals, statesmen, and scholars.[1] The majority of these engravings
were contributed by the foremost graphic artists of the time: Vorsterman, De Jode,
Schelte à Bolswert, and Pontius. The next editor, Gillis Hendricx, enlarged the
number to a hundred, but in subsequent years and under still other editors the
Iconography turned into an open-ended business enterprise with ever new portraits
added, some of them derived from Van Dyck paintings, others copied from models
by other artists.

While it has been clear to all students of the problem that allowance must be made
for exceptions, the procedure in the production of the *Iconography* can be summed up
like this: Van Dyck began making drawings in a variety of media, most frequently
chalk but also in pen and ink and washes, and in most cases from life. For people
who were unavailable or dead, such as Erasmus of Rotterdam, he had to rely on
whatever portraits were at hand. Vey lists forty such drawings, and some others have
been added since.[2] The models are caught in lively poses, sometimes turning
sideways as if in conversation with an unseen partner, sometimes holding an object
in their hands as they turn to the beholder; Vergara has shown that some of these
poses echo patterns established before and that Van Dyck's aim was to provide the
artists with a certain social distinction by making direct references to their
professional activities rare and quite marginal.[3] There are no women in the group of
artists, though noble ladies appear in other sections. The engravings agree—though

generally, as one would expect, in reverse—with the drawings except that they complete what in the drawings is often only outlined or occasionally even missing, such as details of costume, background, and even of hands. It is precisely these details that were provided by small grisaille panels, and I believe we must accept the fact that the engravers mostly worked from such panels, done in oil and not much different in size from the engravings based on them. I fully agree with Hind when he said "In general the oil grisaille panels appear to have supplied the engraver with Van Dyck's completed idea."[4] As Hind knew well, the largest group of such small panels, about forty, is owned by the duke of Buccleuch at Boughton House. Ten others are in Munich, and many more, some of them only copies, are scattered in various European museums. Even those at Boughton House differ considerably in quality. The question of whether any of them were painted by Van Dyck himself, and if so which, has never found a unanimous answer.[5]

In this connection the portrait of Lucas van Uffel assumes a certain importance. No matter whether it was made as a study for the Braunschweig canvas or, more likely, was painted afterward, it has been done with so much freedom and judicious economy that its attribution to Van Dyck should be beyond question. Thus we ought to consider whether Van Dyck at this early date had intended to include Van Uffel in the *Iconography*, even though in the end no engraving was made of the sketch and it does not figure in any of the editions of the great undertaking. As I see it, the significance of the Van Uffel panel lies in the standard of quality it offers, and against which all the other pretenders to a Van Dyck attribution will have to be measured. It is up to future research to make such judgments; at present I can only say that the best of the grisailles, particularly those at Boughton House, are not unworthy of the master himself.

J. S. H.

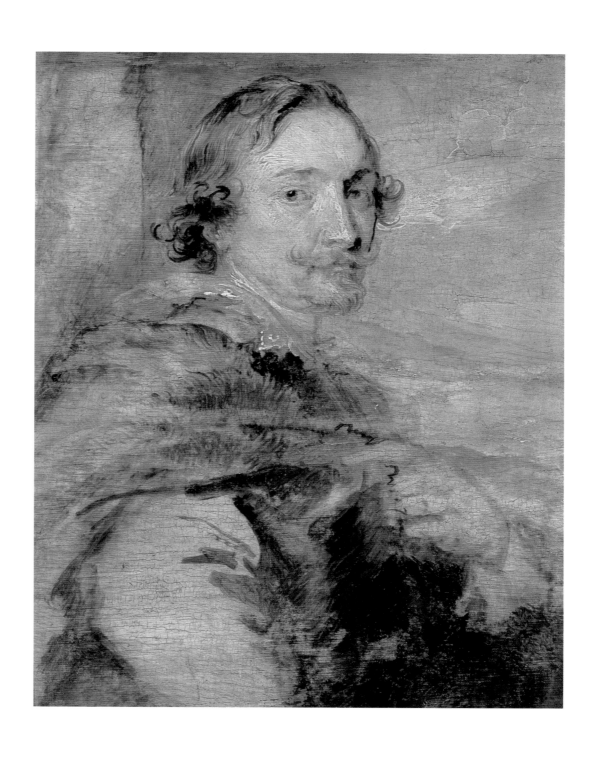

c. 1628
panel, 44.5 x 28 (17 1/2 x 11 1/4)
Private collection, The Hague

PROVENANCE Possibly identical with a sketch listed in the inventory of Alexander Voet, Antwerp, 18 February 1689: "Een schetse van Sint Augustinus, wit en swert, van van Dyck" (Denucé 1932, 311); Frederick Mont, New York

EXHIBITION Princeton 1979, 37, ill., 141

LITERATURE Brown 1982, 116; Larsen 1988, 1:242, 470 ("pale and faded," "at best a first attempt later discarded"), 2:258, no. 661 ill.

1. According to Rooses (1900, 41), this figure is rather Saint Nicholas of Tolentino, an Augustinian friar who was also venerated in the same church. I agree with those scholars who find the identification of that figure with the donor more persuasive.
2. Princeton 1979, 139.
3. Princeton 1979, 136.
4. Antwerp 1960, 157.
5. Antwerp 1960, cat. 124 ill.

Saint Augustine, dressed in an alb and pluvial, stands in the lower center of the composition; he leans backward and spreads his arms in a pose that indicates his complete openness to his spiritual experience. His eyes are directed to the figure of Christ seated above on clouds, surrounded by nine or ten small angels carrying a variety of objects. The saint is accompanied and supported by two large angels, one of whom looks at him admiringly while the other calls the attention of an elderly man kneeling at the right, and by implication of the beholder, to the heavenly vision. He most likely is Marinus Jansenius, the member of the Augustinian order who paid for the painting made from this sketch.[1] To the left kneels an elderly woman who seems to partake in the vision granted to the saint; she can reasonably be identified with Saint Monica, Saint Augustine's mother. The compositional arrangement in two zones, one in heaven, the other on earth, is quite conventional, commonly found, for instance, in renderings of the Assumption of the Virgin. Connections have also been pointed out with iconographic patterns of the story of Saint Francis, especially his stigmatization, where frequently the saint is accompanied and consoled by two angels.[2]

This is the original sketch for one of Van Dyck's major altarpieces, the left side-altar of the church of Saint Augustine in Antwerp [cat. 46]. The large canvas is well documented thanks to Ignatius Coenen, an eighteenth-century prior of the order of Saint Augustine, who on 15 May 1764 copied from the journal of records of the order an entry to the year 1628: "Hoc anno procurata est pictura admodum elegans Sti Augustini in extasi contemplantis divina attributa a Domino Van Dyck dipicta constitit 600 florenis" (In this year an extremely fine painting of Saint Augustine in ecstasy, contemplating divine attributes, was acquired; painted by Van Dyck, it cost 600 guilders). The copy of this entry is now part of the large collection of similar documents assembled by Frans Mols in fourteen volumes of notes, preserved in the Bibliothèque Royale in Brussels. In the same year, 1628, the members of the order acquired two more paintings for their church: for the side altar at the right, *The Martyrdom of Saint Apollonia* by Jordaens [cat. 46, fig. 2], and for the high altar, Rubens' *Madonna and Child Adored by Saints* [cat. 46, fig. 1], among them again both Augustine and Apollonia. For his still-larger painting Rubens received 3,000 guilders. It is not known what Jordaens was paid. As has been pointed out, "the paintings by Van Dyck and Jordaens might be said to illustrate two modes of gaining entrance to the court of saints, that is, through monastic devotion and martyrdom respectively."[3]

It has been suggested that the action here depicted is related to a specific episode in Saint Augustine's life, the so-called Vision at Ostia (*Confessions*, book 9, ch. 10). The only argument that might support this theory is the presence of the elderly woman at the left, who may be Saint Monica, since she is definitely referred to in the legend beneath the engraving by Pieter de Jode the Younger [cat. 46, fig. 5]. A few days before Monica's death she and her son had talked about the delights of eternal life as they were looking from a window across a garden of the house, when suddenly and simultaneously their souls transcended the concrete world and for a short time experienced almost proleptically the state of eternal bliss. Yet it is obvious, and has been well formulated by Pater E. Hendrikx of Nijmegen,[4] that while the Vision at Ostia may have served as a point of reference, Van Dyck's composition is certainly not an illustration of this or any other incident of the saint's life. Rather, with the trinitarian emphasis more clearly worked out in the large altarpiece, it is a summary of Augustinian piety and contemplation; nor is there any biographical significance in the attributes held by the angels. They are symbols current in the religious imagery of the seventeenth century.

In the process of transferring the design of the sketch to the large format Van Dyck made several important changes, intended primarily to give greater prominence to the saint himself. By reducing the interval between the lower and the upper sections of the composition, he gave to the former, being larger anyhow, a

compositional dominance it had not had before; and by various devices, as for instance the more grandly spreading pluvial, he gave a weightier appearance to the saint. Most noticeable is the change made with the figure of Saint Monica. Whereas in the sketch she is seen sideways and rendered as if experiencing a transport comparable to that of her son, in the final version her participation in the spiritual exaltation is considerably lessened, even though she is now seen more frontally. Greatly reduced in scale, she is placed further back in space, and with her piously folded hands before her breast forms a quiet echo of her son's trance rather than sharing it. The large angel between Augustine and his mother has been given a different role: instead of supporting the saint with both hands he now rests his right hand on Augustine's shoulder, and where he formerly seemed to be watching Augustine with youthful delight, he now looks at him with awe and great seriousness of expression. The artist shifted some of the gamboling putti from one side to the other, but essentially remained faithful to his variation of a thoroughly Rubensian motif often referred to as *Engelswolke* (cloud of angels), found similarly in Rubens' earlier versions of *The Assumption of the Virgin* (Buckingham Palace, London, Vienna, Brussels, and a drawing in the Albertina).

Until the relatively recent appearance of the present sketch, many scholars had accepted as Van Dyck's original a sketch at the Ashmolean Museum, Oxford (panel, 43 x 28 cm, 16 3/4 x 11 in.). As such it was exhibited and discussed in great detail in the 1960 exhibition at the Rubenshuis in Antwerp and the Boymans-van Beuningen Museum in Rotterdam.[5] Apparently aware of the weaknesses of that work, the authors of the catalogue claimed that many of the white highlights, especially in the upper half, are due to later repainting. Actually, the Oxford sketch reveals the same clearly inferior hand throughout. Yet since that sketch is in a better state of preservation than the original here exhibited, it permits a clearer reading of certain sections, and hence is of some documentary value.

<div align="right">J. S. H.</div>

94
Saint Augustine in Ecstasy

c. 1630
panel, 49.8 x 30.5 (19 5/8 x 12)

Yale University Art Gallery, New Haven,
Gift of Hannah D. and Louis M.
Rabinowitz, inv. no. 1959.15.26

PROVENANCE Paul Methuen, Esq.,
London, catalogue 1760, no. 39, catalogue
1805, no. 105; Sir Th. Baring, sale 1848,
vi/3, no. 86; earl of Northbrook, London;
Christian Holmes, New York; L. M.
Rabinowitz, New York

EXHIBITIONS London 1887, no. 156;
Antwerp 1899, no. 27; London 1900,
no. 159

LITERATURE Smith 1829–1842, 3: no. 5;
Hookham Carpenter 1844, 17, 196;
Waagen 1854, 2:182; Guiffrey 1882, 250;
W. H. James Weale, *A Descriptive Catalogue
of the … Pictures Belonging to the Earl of
Northbrook. The Dutch, Flemish, and French
Schools* (London, 1889), 88; Cust 1900,
2:249; Rooses 1900, 42; Schaeffer 1909,
88, 449; Glück 1931, 541 under no. 237
("Eigenhändige Grisaillenachbildung,
wohl für den Kupferstich"); Van den
Wijngaert 1943, 85 (model for the
engraving); L. Venturi, *The Rabinowitz
Collection* (New York, 1945), ill. 77; Vey
1956, 204, n. 19 ("Grisailleskizze nach
dem Gemälde, [für den Stich de
Jodes?]"); Antwerp 1960, 157–158 (by P.
de Jode d. J., made after the painting for
his engraving); Princeton 1979, 140
("modello for the engraving by Pieter de
Jode"); Larsen 1988, 1:242 ill., 2: cat. 660

1. See Antwerp 1960, 157: "De grisaille
die P. de Jode d. J. naar het schilderij …
gemaakt heeft. …" The picture was
indeed exhibited as P. de Jode's work
until recently.
2. Saint Augustine himself informs us (in
Contra Faustum Manichaeum 18, 23) that it
was the Manichaeans who depicted the
Trinity in the form of such a triangle.
3. J. B. Knipping, *De Iconographie van de
Contra-Reformatie in de Nederlanden*
(Hilversum, 1939–1940), 1:22v. Van
Dyck's use of the symbol is also
mentioned by J. J. M. Timmers, *Symboliek
en Iconographie der Christelijke Kunst*
(Roermond and Maaseik, 1947), 49 n. 32.

Except for a short period in recent times,[1] this painting has always been considered the work of Van Dyck himself. Since it was done without doubt to serve as the model for the engraving by Pieter de Jode the Younger (1606–after 1674), some scholars understandably have suggested that De Jode also had painted this model for his print [see cat. 46, fig. 5]. Yet as I said before, we have no evidence for assuming that professionally trained engravers had also undergone the equivalent of a painter's training to be able, as for instance in this case, to produce a work of the highest technical competence, not to mention its outstanding aesthetic quality.

What is still worth considering is whether this *modello* had preceded the execution of the large canvas with which it corresponds in virtually every detail, or was copied from it. One argument for its precedence might be the fact that the saint is dressed in a light gown (the alb) as in the sketch [cat. 93] instead of the solid black gown he wears in the Antwerp altarpiece. Yet it is questionable whether such color differentiations can indeed be applied to monochrome sketches; nor is it likely that such a detailed model had any valid function in the preparation of the large canvas itself. That Pieter de Jode, the engraver, was very young in 1628 can not be adduced in deciding this question: not only is there no reason why the *modello* must have been contemporary with the painting, but even if it was, we know how early, especially in engravers' families, the sons of engravers often had mastered their craft. The younger De Jode in fact was accepted as master in the artists' guild precisely in 1628–1629.

Reflecting the changes Van Dyck made when he transferred the design into the large format, the Yale panel and De Jode's print based on it allow us not only to examine these changes, but also to read some details more precisely than is possible in the sketch from The Hague [cat. 93]. In order to stress both the ecclesiastical dignity of Saint Augustine and his contribution to theological literature, the artist added a bishop's miter, crozier, and three books, one of them open, in the left foreground (the open one most likely the *Confessions*, the other two perhaps *On the Trinity* and *The City of God*]. The trinitarian concern of the saint is strongly indicated at the top of the composition where next to the seated Christ (extending his arms to show the wounds in his hands) and the dove of the Holy Ghost there floats an equilateral triangle inscribed with the hebrew word *Jehovah*.[2] The same triangle is repeated, and held up by one of the three putti below Christ at the left, but here it is inscribed with an "I" (for Iesus), and Christ's glance seems to be directed toward this object. The next putto raises a flaming sword (divine justice) while the third supports a radiating head, probably the sun (divine truth). At the left, the first putto holds a scepter crowned with an eye (God's wisdom),[3] the next a laurel branch (victory), the one above him a circle formed by a serpent biting its tail (eternity), his neighbor a large hoop clearly identified as the zodiac (symbolizing the heavens in general), and the last one pouring several objects from an urn (a lily signifying purity, a bridle for temperance, and another form difficult to read). One putto, lying on his back directly beneath Christ, has no attribute, his entire function apparently being a constant contemplation of the divinity enthroned above him.

J. S. H.

Cat. 94

346

95
Head of a Young Woman

c. 1630
inscribed at the upper left corner, 27, on
the lower right, 89, next to a seal of the
Liechtenstein arms.¹ The Antwerp
brandmark and a customs number *ML
No. 30* were seen on the back before a
modern cradle was applied
oil on paper, mounted on wood,
56.5 x 41.6 (22¹/₄ x 16³/₈)

Lent by The Metropolitan Museum of
Art, New York, Gift of Mrs. Ralph J.
Hines, 1957

PROVENANCE The princes of Liechten-
stein, Castle Felsberg, inventory 1780,
no. 1584; Schloss Vaduz (1944–1951);
Van Diemen–Lilienfeld Galleries, 1957;
Mrs. Ralph J. Hines (Mary Elizabeth
Borden), New York

LITERATURE Princeton 1979, 54 ill.;
Liedtke in Metropolitan Museum 1984,
77–79, pl. 32; Liedtke 1984–1985, 16–18,
ill. in color

1. The seal is in the form used in 1733,
according to Gustav Wilhelm as quoted
by Liedtke (Metropolitan Museum 1984,
79).
2. See Princeton 1979, 54–56, no. 8.
3. See Princeton 1979, 56, fig. 12.
4. Glück 1931, 41 (left).

There are several studies of the heads of young women that are solidly anchored in Van Dyck's œuvre [see cat. 89]. Walter Liedtke, the only author who has devoted serious study to the present sketch, linked it with the others despite the fact that he could not establish its use in any of the paintings he felt to be of its chronological period 1618–1620, a date proposed also by M. Roland and M. Jaffé (both verbally, according to Liedtke). The attribution was also supported by O. Millar.

I find it surprising that little attention has been paid to the remarkable technical difference between this head and two others—the one in this exhibition and the very similar one in Vienna [see cat. 89, fig. 1]. Connected as they are with such early paintings as the *Drunken Silenus* [cat. 12] and *Moses and the Brazen Serpent* [cat. 15], they are painted in the same rough manner, with a "loaded brush," and with stress on an intensely emotional expression, carried beyond the face into wildly curving masses of hair. The Metropolitan sketch, by contrast, is painted more thinly and more smoothly, and the gently flowing hair harmonizes well with the calm expression and delicate features. In fact there are several paintings, all from the second Antwerp period, that contain similar heads, and there is one, the *Mystic Marriage of Saint Catherine* [cat. 55], that is so close that I feel justified in calling the New York picture a study—if not actually made for it, at least used in its painting.

The back of the paper on which this sketch is painted appears to be filled with writing; the language, insofar as words have been made out, is Italian, but no modern technical device has succeeded in reading the text, which seems to deal with financial accounts. If this sketch is dated in the second Antwerp period, Van Dyck could very well have made it on paper he had with him; he also might have written the notes himself in the language he had spoken for five years (Millar thought they were in Van Dyck's handwriting).

The Metropolitan Museum study has been linked with a picture of the *Magdalene Repentant* (collection Mr. and Mrs. Bernard C. Solomon, Los Angeles).² With one hand holding a strand of her flowing hair, the saint looks down in a characteristic contemplative attitude at a skull in the other hand, which signifies the vanity of earthly pleasures. The Los Angeles composition was engraved, with the addition of some iconographically fitting still-life elements, and reduced to an oval shape, by Arnold de Jode (c. 1638–c. 1667).³ Although, due to a less than perfect state of preservation, the picture of the *Magdalene Repentant* differs from the more robust sketches in New York and Vienna, it surely belongs to that earlier group of works, the nearest analogy being some of the Apostles of the famous and much-discussed early series, for instance the *Saint John* (Budapest).⁴ Stylistically I find the *Magdalene Repentant* rather different from the *Head of a Young Woman*, but it shares with the latter the fact that it is painted on paper covered on the back with writing. That text too, unfortunately, has not been deciphered yet.

J. S. H.

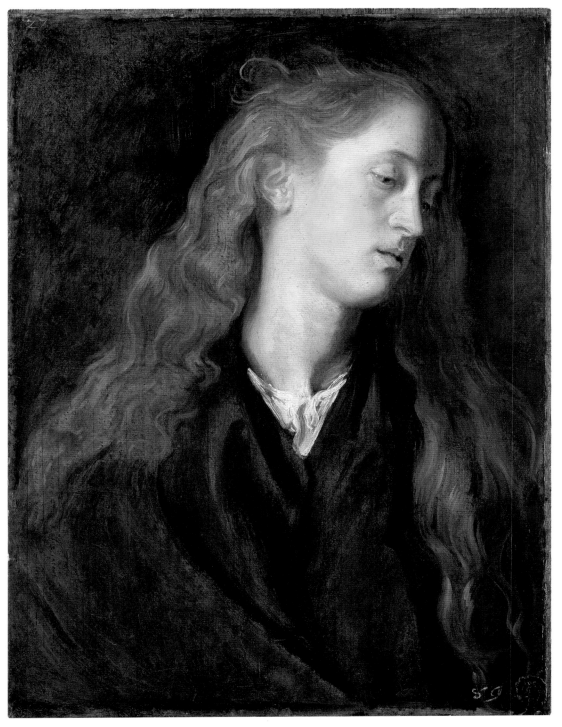

Cat. 95

96
The Assumption of the Virgin

c. 1630–1632
panel, 59.5 x 42 (23 1/4 x 16 3/8), without
lateral additions of 2.5 cm each; the
panel is made up of two boards, joined
vertically left of center; some restorations
have been made along that join

Gemäldegalerie der Akademie der
bildenden Künste, Vienna, inv. no. 643

PROVENANCE Collection Lamberg,
donated 1822; Lamberg inventory II,
no. 643 (as by Rubens)

EXHIBITIONS Antwerp 1960, no. 127;
Princeton 1979, no. 49

LITERATURE Heinrich Schwemminger,
*Verzeichnis der Gemäldesammlung der k. k.
Akademie der bildenden Künste in Wien*, 435,
no. 486 (manner of P. P. Rubens);
Theodor von Frimmel, *Geschichte der
Wiener Gemäldesammlungen* 4 (Leipzig and
Berlin, 1901); Cust 1900, 249, no. 52;
Eigenberger 1924, 37–39 (as by Van
Dyck); Robert Eigenberger, *Die
Gemäldegalerie der Akademie der bildenden
Künste in Wien* (Vienna and Leipzig,
1927), 117–118; Glück 1931, 253 (left) and
546; Vey 1956, 189–194; O. Kurz, "Van
Dyck and Reni," *Miscellanea D. Roggen*
(Antwerp, 1957), 179–182; Antwerp 1960,
160–161; Vey 1962 (under no. 70);
Margarethe Poch-Kalous, *Katalog der
Gemälde-Galerie, Akademie der bildenden
Künste in Wien* (1972), 99, no. 171;
Helmut Lahrkamp, "Der 'Lange Jan,'
Leben und Werk des Barockmalers
Johann Bockhorst," *Westfalen* 60 (1982),
44–45, ill.

1. David Freedberg, *The Life of Christ after
the Passion, Corpus Rubenianum Ludwig
Burchard* (Oxford, 1984), 7:138–195.
2. Otto Kurz, "Van Dyck and Reni,"
Miscellanea Prof. Dr. D. Roggen (Antwerp,
1957), 179–182.

More than in any other narrative sketch, Van Dyck used various colors here to achieve a striking pictorial variety. The Virgin's gown is a resplendent white, the angels are outlined in strokes of vermilion. Gray, ocher, dull reds, touches of pink, and lemon-colored highlights are used for the apostles below; the basic outlines of the figures are drawn in gray, with a fine brush. In the delicacy of the brushwork this is a particularly notable piece among the artist's oil sketches.

The general layout of the action follows the pattern that had become almost inescapable since Titian's *Assunta* (Frari Church, Venice). The upper half of the field is occupied by the Virgin, surrounded by angels, while below the apostles are assembled, reacting in different ways to the miracle they are permitted to witness. One feature of Titian's painting, however, failed to enter the iconographic mainstream: the figure of God the Father at the apex of the composition, welcoming the Virgin. Yet the turned-up head of the Virgin and her extended or prayerfully crossed arms imply his presence. Instead another detail Titian had not shown became virtually obligatory: the sarcophagus from which Mary had just risen. Moreover, while with Titian the attention of all the disciples is riveted on the soaring figure above, by the seventeenth century it is divided; some of them indeed follow the Virgin with their eyes and raise their hands in greeting or farewell, while others look into the sarcophagus, which is miraculously filled with fragrant flowers. By the time Van Dyck occupied himself with this theme, Rubens had painted the majority of his many renderings of the Virgin's *Assumption*.[1] The nearest to Van Dyck's Vienna sketch is Rubens' *Assumption* in the Antwerp cathedral [fig. 1], or even more the sketch for that picture, now at the Mauritshuis in The Hague. Like Rubens, Van Dyck included large angels, one offering a wreath, in the glory surrounding Mary, and he also included an apostle raising both arms to hail her, carried away with joy. Yet surprisingly he omitted one feature that Rubens had unfailingly used: a group of women, generally three, who hold the shroud Mary had left behind and admire the flowers that had miraculously appeared in it. It is this absence of the holy women that lends support to Kurz' argument that a major source of inspiration for Van Dyck's *Assumption* may have been Guido Reni's *Assumption* in Sant' Ambrogio in Genoa [fig. 2].[2] Reni too has only men assembled around the sarcophagus, and the pose of humble devotion on the part of Saint Peter kneeling at the right, while not identical with Reni's Peter, is close in sentiment and in compositional function. Nor should it be forgotten that Van Dyck had ample occasion to study Reni's work during

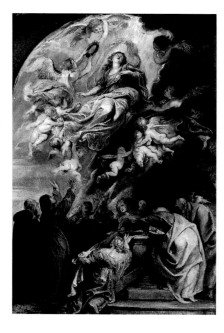

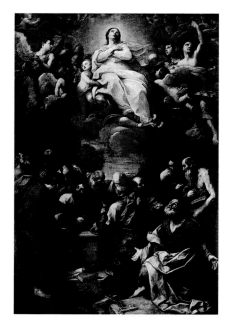

Fig. 1. Peter Paul Rubens, *The Assumption
of the Virgin*, c. 1620–1625, panel, 90 x 61
(35 3/8 x 24). Mauritshuis, The Hague

Fig. 2. Guido Reni, *The Assumption*,
c. 1614, canvas, 442 x 287 (174 x 113).
Chiesa di Sant' Ambrogio, Genoa

3. London, Bridgewater Gallery, 1855, no. 65.

4. *Engravings of the Marquis of Stafford Collection of Pictures* (London, 1818), 3: no. 16. The picture was sold at Christie's 18 October 1946. The not very faithful steel engraving is reproduced in Lahrkamp 1982, 44.

5. Denucé 1932, 147.

his lengthy stays in that Ligurian city. Yet next to the "softly curved and flowing parallel folds" that accompany the expressive gestures of the disciples in Van Dyck's sketch, Reni's draperies look indeed, as Kurz said, "angular and almost heavy."

No painting by Van Dyck is known for which this sketch could have been the model; yet I consider it most unlikely that Van Dyck might ever, as has been suggested, have made such elaborate sketches as mere exercises. At best he may have prepared such designs as a kind of "pump-priming," to persuade a likely patron to order a major altarpiece; and there are still other scenarios that might explain the reasons for his making such projects.

Glück mentioned two other versions. One was in the Bridgewater Gallery in London,[3] the other in the collection of Dr. Otto Lanz, Amsterdam. The former was engraved in steel as a work of Jan Boeckhorst by C. Warren.[4] The other (panel, 62.5 x 39.4 cm) was sold at Christie's, London, 21 July 1972, lot 117, "The Property of an American Collector." It is definitely inferior in quality to the Vienna panel, but has a fairly distinctive curvature at the top, indicating that the plan called for a semi-circular upper end of the design. One of these sketches may be identical with the copy mentioned in the inventory of the estate of Victor Wolfoet, 24–26 October 1652: "Een Hemelvaert van Onse Lieve Vrouwe, na van Dyck, op panneel, in lyste" (An Assumption of Our Lady, after van Dyck, on panel, framed).[5]

J. S. H.

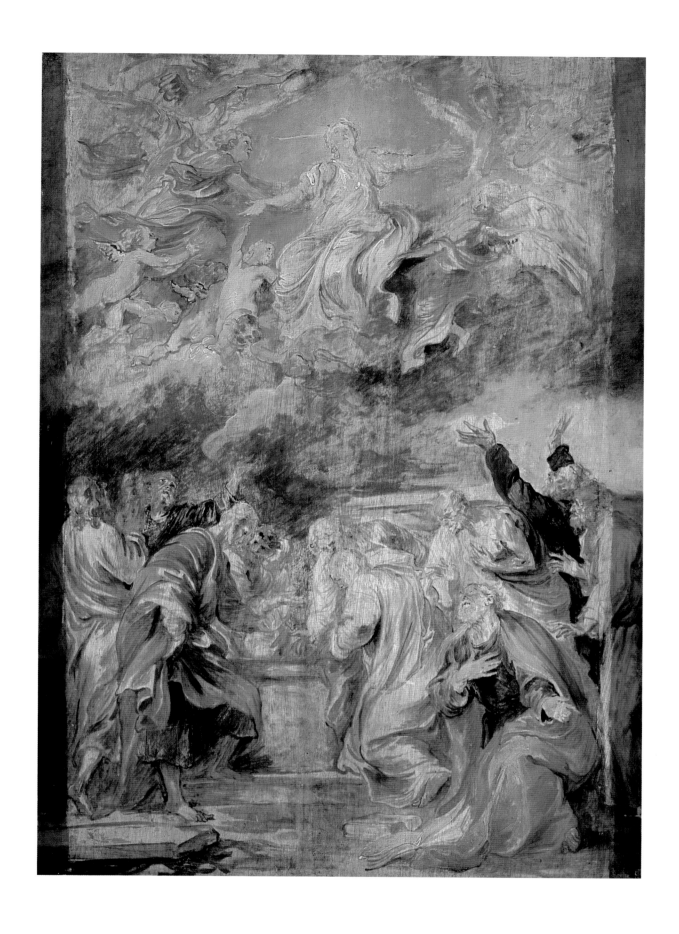

c. 1634
panel, 31.7 x 22.9 (12 1/2 x 9)

The Earl of Pembroke

PROVENANCE Bought by Philip, 4th earl, or Thomas, 8th earl (?) of Pembroke

LITERATURE Jonathan Richardson Jr., *Aedes Pembrochianae: or a Critical Account of the Statues, Bustos, Relievos, Paintings, Medals, and Other Antiquities and Curiosities at Wilton House ... By Mr. Richardson* (London, 1774); Smith 1829–1842, 3:196, no. 697; Waagen 1854, 3:154; Glück 1931, 380, 560; Vey 1956, 201 ill., 207, n. 47; Sidney, 16th earl of Pembroke, *A Catalogue of the Paintings & Drawings in the Collection at Wilton House, Salisbury, Wiltshire* (London and New York, 1968), 66, no. 171, pl. 60; Princeton 1979, 43–45

1. Glück 1931, 560 pl. 381 (note).
2. Glück 1931, 421.
3. Glück 1931, 422; Mauquoy-Hendrickx 1956, 163.
4. Velázquez's equestrian portraits conform to these types, too.
5. Glück 1931, 381.
6. London 1982–1983, 21, and Strong 1972, 78, still more emphatically spoke of the picture's "bucolic" and "pastoral" setting.

Astride a majestic horse seen sideways as it vigorously moves toward the right, the youthful bare-headed rider seems to fix the beholder with his glance. Dressed in half-armor across which falls a soft lace collar and in high riding boots, he rests the baton in his right hand on his trousered thigh. He is followed by a groom, only partially seen, who appears to carry his lord's helmet; other followers are indicated by two standards filling the upper left corner and a barely distinguishable arm holding one of them. Flying before him one genius (Glory?) holds a chaplet above the rider's head, while another (Victory?) is apparently meant to offer a palm branch, though that branch seems to float freely in air.

Although it is obvious that the sketch must have been connected with an important project, no corresponding painting has been found. This clearly has been the cause of the persisting uncertainty as to who is the soldier so honored by a major equestrian portrait. Not surprisingly the name of King Charles I himself has occasionally been mentioned, and a painting described in the 1683 inventory of the holdings at Wilton House as "1 of old King Charles on horseback," valued, rather highly at £80, might indeed have referred to Van Dyck's sketch. Glück considered seriously that the sketch may have been made for a never-executed representative portrait of Charles I, despite the fact of which he was aware that the horseman in the sketch has no physiognomic similarity with the king.[1] Glück did reject a tradition handed down at Wilton and still repeated in the catalogue of the collection (1968) according to which the model was the duc d'Epernon (1592–1661). Unfortunately that author mixed up the first duc d'Epernon, created by Henri III and indeed a faithful supporter of Maria de' Medici, with his son, whose dates alone would fit a relatively youthful portrayal done in the 1630s. In fact, the earl's date for the picture (c. 1621) is clearly untenable, as is his statement that Van Dyck assisted Rubens with the decoration of the Luxembourg Palace (the d'Epernon theory had been repeated by Waagen and Smith, but had been doubted by Vey). It was Gregory Martin who introduced a new candidate, Thomas-Francis, prince of Savoy-Carignan (1596–1656). Van Dyck had an opportunity to meet this prince when he spent about fifteen months on the Continent, most of that time in Brussels (March 1634 to June 1635). Van Dyck in fact made two portraits of the prince, which are still preserved and are datable with rare precision. The Biblioteca Civica in Turin still has the following autograph receipt by Van Dyck: "Io sotto scritto dico d'auer riceuuto la somma de sinque cento Pattaconi per mano del sig.re Bianco Tresoriere del sig.re Principe Tomaso, et essi per duoi ritratti fatti di mia mano. L'uno a cauallo et l'altro di meza postura et in segno di verita ho questo scritto et affermato di propria mano in Brusselles questi 3 di Januario Anº 1635. —Ant.º van Dyck."[2] The portrait of the prince "a cavallo," after some circuitous migrations, is now the pride of the Galleria Sabauda in Turin [see cat. 71]. Yet linking the Wilton sketch to that large canvas, while tempting, also causes difficulties. The only clear similarity is the striking turn of the rider's head to look intensely, from the corner of his eyes, at the beholder. The composition of the Turin canvas differs radically from the Wilton sketch. The least important difference is the reversal of the movement, as we now see horse and rider from the left rather than their right side, so that another solution for the hand holding the baton had to be found. Instead of depicting the white charger in a vigorous forward trot, the Turin painting shows it in the basically stationary pose known as *Levade*, there executed to a perfection worthy of the Vienna Hofreitschule. Moreover, there are no flags, no equerry carrying a helmet, no allegorical genii glorifying the rider's fame or prowess. If the Wilton sketch is pervaded by a sense of military action and movement, the Turin portrait of Thomas-Francis of Savoy-Carignan assumes the character of an icon of power and majesty. Admittedly, that does not necessarily mean that the two works cannot be linked; but if the Wilton sketch will be accepted

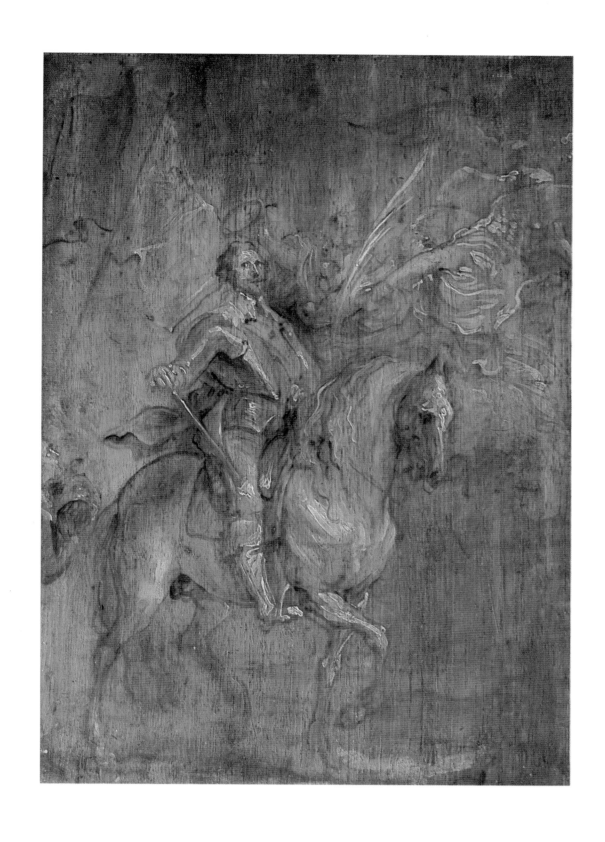

as Van Dyck's *prima idea* for the commission, some powerful influences must have been at work forcing him to abandon that plan, perhaps the wishes of the prince himself.

As mentioned before, Van Dyck made a second portrait "di meza postura" of the prince of Savoy-Carignan; it is now in Berlin and known also from an engraving Paul Pontius made of it for the *Iconography*.[3] While the prince's physiognomy in these portraits is not compellingly similar to that of the Wilton horseman, it shares with it the relative youthfulness (the prince was just short of forty when Van Dyck painted him) and some other features as well; enough, at any rate, that not even the difference in the length of hair would preclude the identification. Thus Gregory Martin's suggestion remains certainly the most likely solution. It is particularly welcome since it provides for the Wilton House sketch an unusually precise date, the terminus post quem being Van Dyck's arrival in Brussels in the summer of 1634 and the terminus ante quem his acknowledgment of having been paid in January 1635. As a sketch, it must belong to the beginning of that time frame.

Had the large version of the painting sketched in the Wilton House panel been executed as planned by Van Dyck, it would have made a highly original contribution to the history of equestrian portraiture. It is the dynamic quality of the horse's movement that gives to the work its distinction, since nothing of the sort had been applied to the theme before. Rubens had introduced three different patterns: a foreshortened view, with the horse coming toward the beholder (first found in his portrait of count Lerma, and later with Maria de' Medici at Ponts-de-Cé); a view from the side with the horse rising on his hind legs in a variation of the *Levade* (applied in his portrait of the duke of Buckingham, formerly at Osterley Park; its sketch at the Kimbell Art Museum at Fort Worth; and the lost portrait of Philip IV); or the horse walking calmly, seen in strict side view (the portrait of Philip II in Munich).[4]

It is not the diagonal movement in space that gives to the sketch its personal note, but the coiled energy embodied in the horse's gait. Having had to settle for one of the conventional patterns in his painting in Turin, Van Dyck salvaged some elements of the sketch when he painted, fairly late in his career, the portrait of *Charles I on Horseback* in the National Gallery, London.[5] But the impression of strong forward motion is gone. While an equerry still follows, holding a helmet, the driving power Van Dyck had projected in the Wilton House sketch has been mitigated by its "twilit sylvan setting."[6]

J. S. H.

98
The Lamentation

c. 1634
paper, mounted on wood, 33 × 45
(13 × 17½)

Bayerische Staatsgemäldesammlungen,
Munich, inv. no. 67

LITERATURE H. Hymans, *Lucas
Vorsterman, Catalogue raisonné de son œuvre*
(Brussels, 1893), 42; Glück 1931, 558,
under s.365; Vey 1956, 205, n. 32; Larsen
1988, 1:348, fig. 378a; 2:408, no. 1040

1. Hymans, *Vorsterman*, 1893, no. 35.
2. The other two paintings for Scaglia are
the full-length portrait in the collection of
the Viscount Camrose [cat. 70] and the
oval of the *Abbé in Adoration of the Virgin*
in the London National Gallery [see
Brown fig. 7].
3. See Hymans, *Vorsterman*, 1893, 42.
4. Millar 1969, 414–417, and London
1982–1983, 40, no. 1.
5. See Max Rooses and Charles Ruelens,
*Correspondance de Rubens et documents
épistolaires concernant sa vie et ses œuvres*
(Antwerp, 1887–1909), 2 (1898).

The composition of this Lamentation follows faithfully the arrangement of the larger canvas of the subject, also in the Alte Pinakothek in Munich [see cat. 79, fig. 1]. It was painted to serve as the model for the engraving by Lucas Vorsterman, which depicts the scene in reverse.[1] Although passed over, except for Larsen, as an engraver's copy (Vey: "Stecherkopie") by most scholars, this grisaille, like the similar one of Saint Augustine in New Haven [cat. 94], raises the question to what extent Van Dyck painted such models himself. For this problem see the closing remarks of my introductory text.

The large canvas is one of three paintings Van Dyck painted in 1634 for Abbé Cesare Alessandro Scaglia, a diplomat in the service of the dukes of Savoy.[2] There is good reason to assume that Vorsterman's engraving and of course the Munich grisaille on which it is based were done soon after the painting. Not only was it, after years of indifferent production, engraved by Vorsterman with his former supreme craftsmanship,[3] but also Van Dyck dedicated the print to an old patron of his, George Gage. In fact, if Oliver Millar's thesis is correct,[4] the portrait of a "connoisseur" or "art merchant" by Van Dyck in the National Gallery in London portrays this Anglican cleric who had figured prominently in Rubens' negotiations with Sir Dudley Carleton[5] and apparently remained a member of that ubiquitous circle of political agents and art connoisseurs of which Scaglia himself was such a prominent member. Since Gage died in 1638, there is not much leeway for dating the print, with the probability pointing to an early date, soon after the completion of the larger work. Given the quality of the print, and the importance assigned to it through Van Dyck's dedication to George Gage, the attribution of the Munich model to the artist himself, suggested by its style and overall quality, gains in likelihood on purely historical grounds. It evidently was never questioned by Hymans when he wrote: "Vorsterman, guidé cette fois par van Dyck, lequel, pour l'usage exprès de son graveur, *fit une grisaille de son tableau*, mit un soin extrême à faire revivre l'impression de ce superbe original."

J. S. H.

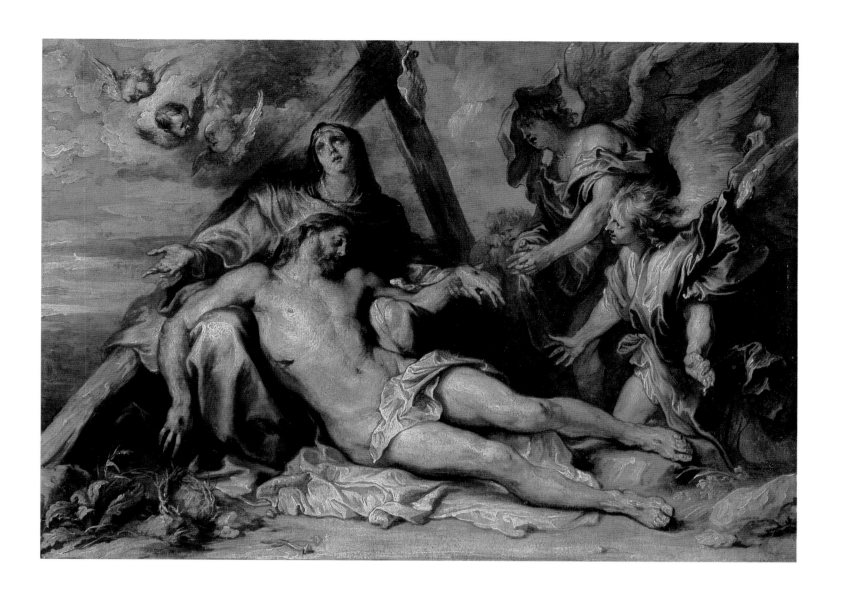

c. 1634–1635
panel, 26.5 x 40.5 (10 1/2 x 16)

Museum Boymans-van Beuningen, Rotterdam, on permanent loan from the State of the Netherlands, Office for National Art Property, since 1948, NK.2665

PROVENANCE F.-X. de Burtin, Brussels (as Rubens); J. P. Heseltine, London; sale, Amsterdam (A. Mak) 1–2 December 1925, no. 21; Fritz Hess, Berlin-Dahlem, sale Lucerne (Th. Fischer) 1 September 1931 (no. 11, as Rubens, ill. in reverse); F. Koenigs, Haarlem, on loan to the Museum Boymans, Rotterdam, 1935–1940; recovered from Germany after 1945 by the Dutch government

EXHIBITIONS London 1900, no. 235; Amsterdam, J. Goudstikker, 1933, no. 36 (as Rubens, with a note saying that most scholars give it to Van Dyck); Rotterdam, Museum Boymans, *Verzameling F. Koenigs Schilderijen*, 1935–1940, no. 10 (as Van Dyck); The Hague, Mauritshuis, *Herwonnen Kunstbezit*, 1946, no. 64 (as Van Dyck); d'Hulst and Vey in Antwerp 1960, no. 129; Recklinghausen, Städtische Kunsthalle, *Torso, das Unvollendete als künstlerische Form*, 1964, no. 271, ill.

LITERATURE Burtin 1808, 483; M. Rooses, *Rubens, Sa vie et son œuvre* (Antwerp, 1890), 4:348–349 (as Rubens); Cust 1900, 227, no. 235; R. Oldenbourg, *P. P. Rubens, Des Meisters Gemälde* (Stuttgart-Berlin, 1921), 469, n. to 357; *Gids Schilderkunst en Beeldhouwkunst* [exh. cat. Museum Boymans] (Rotterdam, 1951), no. 129a; Vey 1956, 197 ill.; *Catalogus schilderijen tot 1800* [exh. cat. Museum Boymans-van Beuningen] (Rotterdam, 1962), 47; A. Balis, *Rubens, Hunting Scenes, Corpus Rubenianum Ludwig Burchard* 18 (no. 2):216–217 (London, 1986); Larsen 1988, 1:477 (neither Rubens nor Van Dyck), 2:513–514, no. A310; Hella Robels, *Frans Snyders Stilleben- und Tiermaler* (1989), 478 (under no. 271)

1. When Rudolf Oldenbourg died in 1921, Ludwig Burchard took over the final editing of the new edition of the Klassiker der Kunst volume on Rubens. He himself later regretted having added the reference about the sketch here exhibited in a note to the Berlin canvas *Diana at the Stag-Hunt*, p. 357 (a picture destroyed in World War II). Yet until 1933 when it was exhibited, the sketch was accepted on Burchard's authority as by Rubens. On seeing it again at the Amsterdam exhibition, Burchard himself withdrew that attribution in favor of the one to Van Dyck.
2. *Mauritshuis Illustrated General Catalogue* (The Hague, 1977), no. 259, ill.
3. Denucé 1932, 170.

The composition is dominated by a long right-left diagonal, formed by the slender stag turning its head back toward its pursuers and the sleek white hound giving chase. Little is seen of a second hound. Both nymphs carry bows in their left hands, and the second looks as if she had shot an arrow though that missile is not seen. Both nymphs are dressed in light, fluttering garments. Some brambles and a stump fill the foreground while a few trees, only lightly indicated, accentuate the rear. The body of a dog lies crumpled below the stag.

Although the sketch was sold as a work of Rubens when offered with the collection of Fritz Hess in 1931,[1] the correct attribution, already expressed by Cust, was reestablished after 1935; it has never been questioned since, even though Vey found the sketch somewhat enigmatic (*rätselhaft*), presumably because no painting based on it has been found. Vey also thought that Van Dyck was responsible only for the two figures, while the landscape and the animals might have been done by an animal specialist. Such a collaboration, quite often found in larger paintings, is rather unlikely in a work of such small dimensions. Burchard, seconded by Balis, suggested the *animalier* Paul de Vos as a possible collaborator in any large painting based on this sketch, since the same stag reappears in a painting by De Vos in the Mauritshuis, The Hague.[2]

D'Hulst and Vey (in Antwerp 1960) called attention to the fact that, in the inventory of Jeremias Wildens (1653), the son of the landscapist Jan Wildens, there was a sketch of a hunt by Van Dyck ("Een jacht van van Dyck geschetst, op panneel, no. 689").[3] Even if this entry refers to another sketch, it is welcome as a confirmation of the existence of such a sketch in Van Dyck's œuvre.

The date of the exhibited sketch remains problematical. It can be accepted as certain that it was done while Van Dyck was on the Continent, after his return from Italy late in 1627. D'Hulst and Vey placed it in the so-called second Antwerp period, 1628–1632. Yet Van Dyck spent the entire year 1634 (and possibly some weeks before and after) in the Netherlands, most of it in Brussels. A date to this, the "third Antwerp-Brussels period" (d'Hulst and Vey), seems to be preferable, since the sketch has connections with Rubens' sketches of hunts that cannot be dated much earlier than that; some of Rubens' sketches, especially those done for King Philip IV of Spain, belong to the late 1630s and could never have been known to Van Dyck.

J. S. H.

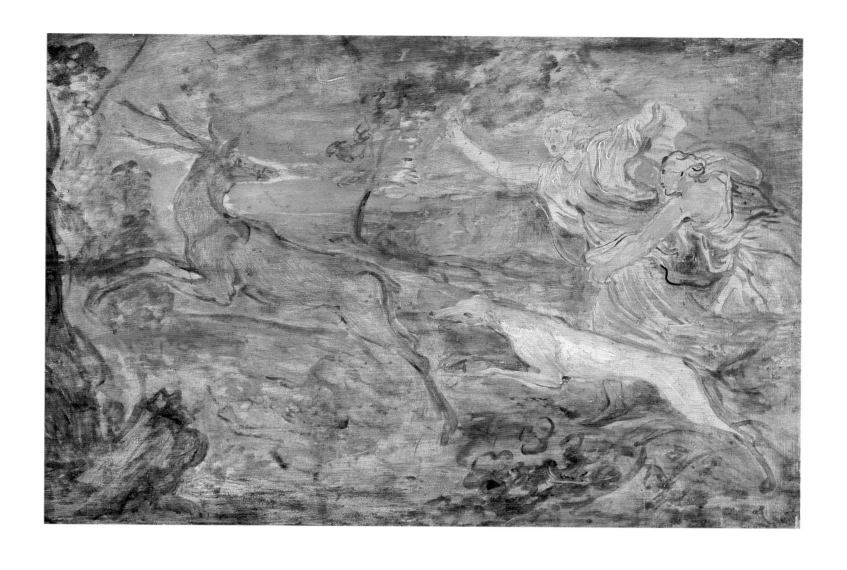

1636
panel, diameter 15.2 (6⅛)

Private collection

PROVENANCE Van Rotterdam sale,
Ghent, 1835, VII/6, no. 155(?); Schamp
d'Aveschoot sale, Ghent, 1840, IX/14, no.
244(?); Binoit de l'Epine, Valenciennes;
Estate of Elizabeth Lindsay Corbett sale
Christie's New York, July 1989, no. 123
(with commentary based on a manuscript
by Julius S. Held)

LITERATURE Max Rooses, Rubens, Sa vie
et son œuvre (Antwerp, 1890), 4:242, no.
1035 (on the basis of the sales catalogues
of 1835 and 1840)

1. Vey 1962, no. 168
2. Mauquoy-Hendrickx 1956, no. 115.
3. Glück 1931, 531, under 100.
4. Vey 1962, no. 193.
5. Frans Baudouin, Nicolaas Rockox,
Vriendt ende patroon van Peter Paul Rubens
(Antwerp, 1977), 41.
6. The date "1639" on Pontius' print,
though erased in state eight, may
indicate the year the engraving was
done. Such delays were not uncommon.

Small in size but rich in artistic and historical associations, this portrait represents Nicholas Rockox (1560–1640), nine times burgomaster of Antwerp, but also an antiquarian with a special interest in numismatics and a patron of the arts, with contacts with both Rubens and Van Dyck. He descended from an old patrician family and in 1589 had married Adriana Perez, the daughter of a wealthy banker whose family of "Marranos" (Jews converted to Christianity) had come from Spain in the early sixteenth century. The marriage remained childless, and Adriana died in 1619. In 1603, when he first served as burgomaster, Rockox bought two houses in the center of town and made them into a single grand dwelling. For the "great hall" of this house Rubens painted in 1609–1610 the *Samson and Delilah* acquired in 1982 by the National Gallery in London. Rockox commissioned Rubens also to paint a large *Adoration of the Magi* for the Antwerp town hall (now in the Prado, Madrid), the triptych of *The Descent from the Cross* (Antwerp cathedral), and another smaller triptych for his and his wife's tomb (now in the Koninklijk Museum voor Schone Kunsten, Antwerp). His portrait appears on the wings of both triptychs but Rubens never seems to have painted a separate portrait of his patron and friend. That was done by Van Dyck (1621, now in the Hermitage, Leningrad) before he left for Italy. At a later date, presumably between 1627 and 1632, Van Dyck made a portrait drawing of Rockox (Windsor Castle),[1] most likely to include it in his *Iconography*. In that drawing Rockox is shown half-length, turned to the left, his left hand resting on a lightly sketched sculpted head of a woman, presumably an ancient marble. For reasons unknown, this portrayal was not engraved as sketched in the Windsor drawing. Yet in 1639 Paul Pontius (1603–1658) engraved a bust portrait of Rockox turning to the right, enclosed in an oval frame on which a laudatory text is inscribed. That oval in turn is placed in an architectural setting shaped like an epitaph and crested by a cartouche with Rockox's coat of arms between two burning oil lamps. A poem of six lines composed by Gaspar Gevartius (1593–1666), a friend of both Rockox and Rubens, is inscribed on a socle below.

According to Mauquoy-Hendrickx the date "1639" was added to the print in the fifth state and Rubens' name as its author in the sixth, both to be erased in the eighth when "Ant. van Dyck pinxit" was added.[2]

Rubens' authorship for the design of this print was accepted by Rooses and by Glück,[3] while Vey[4] thought of Pontius himself as the author. A grisaille that Vey had postulated actually does exist (panel, 25 x 19.5 cm [9¾ x 7⅝ in.], Musée des Beaux-Arts, Strasbourg). As early as 1977 Frans Baudouin had come out strongly for Van Dyck's authorship of the portrait used in Pontius' engraving. He declared the legend provided in the eighth state of the print as the only acceptable one.[5] His well-reasoned argument, supported by the confrontation of the Windsor drawing and Pontius' print, receives additional confirmation from the emergence of the present painting. It quite evidently is based on the drawing in Windsor but stylistically is also characteristic of Van Dyck. Its virtually immaculate preservation, confirmed by X-ray and infrared photography, reveals a craftsmanship worthy of the only Flemish painter who in such works could rival Rubens.

Van Dyck could not have made the painting from life, for in 1636 he was settled in London.[6] Yet when he took up residence in London, he surely had taken with him at a minimum the contents of his studio, including his own drawings. Thus, when he decided to prepare a model of Rockox's likeness for the engraver, he had his own earlier drawing (Windsor), which may account for the somewhat younger appearance of Rockox, who in 1636 was seventy-six years old. The painter of the Strasbourg grisaille, perhaps Pontius, surely worked from the present sketch. He alone, however, was probably responsible for the design of the architectural framework, which is rather conventional and poorly linked to the portrait.

J. S. H.

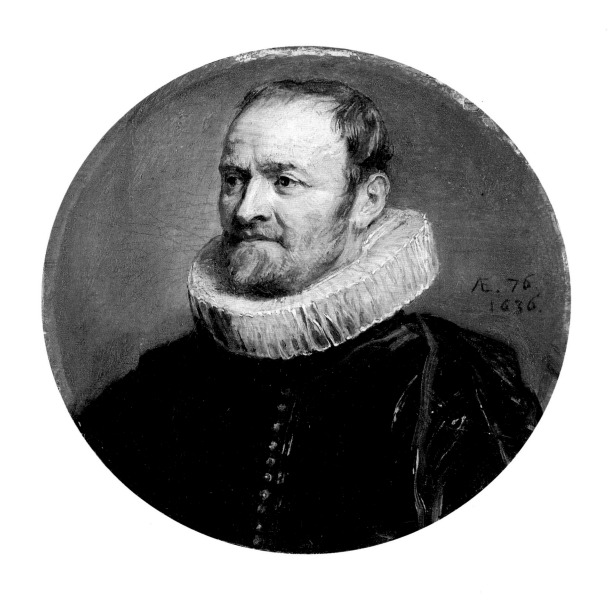

101
Princess Elizabeth and Princess Anne

1637
inscribed by a later hand, *The Prin-
cess/Elizabeth* (at left); *Henry Duke/of
Glocester* (at right)
canvas, 30 x 42 (11³/₄ x 16³/₈)

British Rail Pension Fund

PROVENANCE Lord Chesham

EXHIBITIONS London, Royal Academy,
winter 1879, no. 131; London, Agnew's,
Haig Fund Appeal, 1922, no. 2; London
1953–1954, no. 317; London, Agnew's,
European Pictures from an English . . .
(Hampshire), 1957, no. 13; London 1968a,
no. 49; London, Agnew's, 1984; London
1972–1973, no. 106

LITERATURE Glück 1931, 384; Royal
Collection 1963, 1:99; London 1982–1983,
no. 27; Larsen 1988, 1:308 ill., 2: no. 810

1. London 1982–1983, 72.

Despite the beautiful early calligraphy of the inscriptions, the identification of the
younger of the two children as Henry, duke of Gloucester (1639–1660), is mistaken. It
actually represents Princess Anne, who died so young "that her existence may have
been forgotten and the baby would have been identified therefore with the next royal
child."[1] In his "Memoire" of pictures he had painted for the king, Van Dyck called
the youngest child "Pʳ Anna," and he, if anyone, should have known. (It is also more
likely that little Princess Elizabeth would be shown caring for a baby girl rather than
an infant boy.)

Still, the sketch of the two children, and the large painting for which the sketch
has been used [fig. 1], demonstrate strikingly the freedom with which the artist
manipulated the appearance and the actions of small children, and especially of royal
children. Since Princess Anne was born 17 March 1637 and the painting was done in
that same year, the sketch was made most likely in May or June, when Anne was two
or three months old. Elizabeth, who was born 28 December 1635, was then at the
most a year and a half, still a very small child herself. Yet in the painting she
protectingly holds and supports her younger sister, making Elizabeth appear at least
twice her age.

Both children wear white skull-caps; a chain of pearls tied with a brown ribbon
circles Princess Elizabeth's neck and we see the top of a white shift she is wearing. In
the painting she is more formally dressed and her cap has a decorative pattern. Some
of her smoothly painted hair emerges from under the cap and partly covers her
forehead. Both heads appear in the same position, and in much the same relationship
to each other, as in the finished canvas. The plan for the organization of the charming
little group must evidently have been made by the artist before he sketched the two
heads. In view of their smooth finality, it is perfectly possible that they were painted
from drawings, with only intermittent reference to the life models. The masterly
economy and sure touch of the sketch place it at the end of whatever preparatory
work Van Dyck had done. I do not exclude the possibility that Van Dyck painted the
heads of the two princesses less as a study for the large painting than as a personal
offering to the queen.

J. S. H.

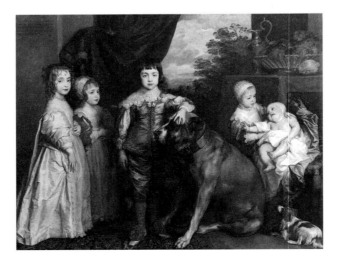

Fig. 1. Anthony van Dyck, *The Five Eldest
Children of Charles I*, 1637, canvas,
133.4 x 151.8 (52¹/₂ x 59³/₄). Copyright
reserved to H. M. Queen Elizabeth II

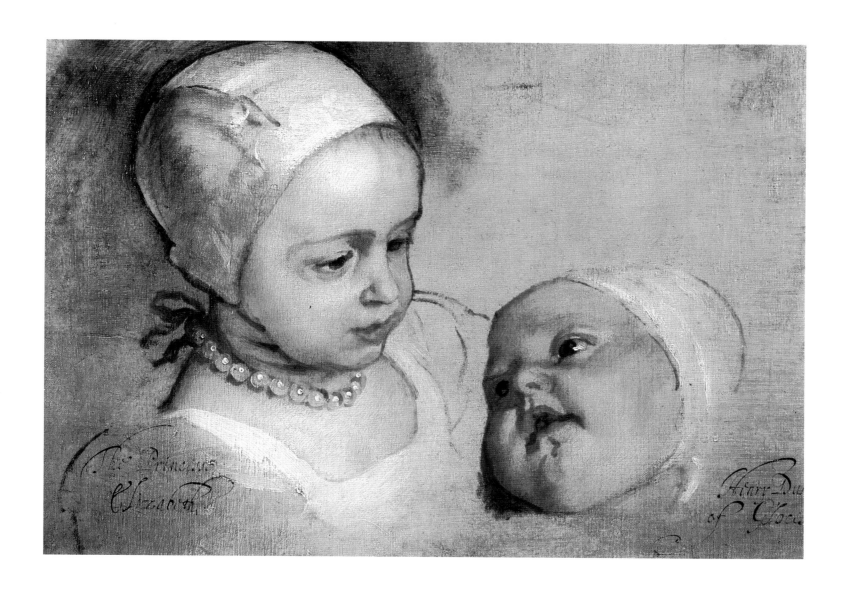

c. 1638–1639
panel composed of two pieces of wood, of slightly uneven length (68 cm at left, 63.8 at right, 29.2 x 131.8 [11 x 50¹/₂])

The Duke of Rutland

PROVENANCE Collection of Charles I; sold 16 July 1650 "a Skitts on 2 boards in black and white in oyle Cullors a long narrow peece w^ch was made for a moddell for a bigger peece where yo^r Ma^ty and the Lords of the Garters, goeing Precessioning upon S^t Georgs day"; sold for £5 to Wagstaffe; Sir Peter Lely, sale 1682, bought by Austin; Robert Henley, 2d earl of Northington, sale 1787, acquired by Sir Joshua Reynolds for the duke of Rutland; hence by descent

EXHIBITIONS London 1900, no. 232; London, Guildhall, 1906, no. 117; London 1953–1954, no. 551; Nottingham University Art Gallery, 1960, no. 23; Antwerp 1960, no. 134; London, Agnew's (King's Lynn Festival Fund), 1963, no. 26; London 1968a, no. 60; London 1972, no. 85

LITERATURE Bellori 1672, 318; Smith 1829–1842, 3: no. 457; Hookham Carpenter 1844, 68; Guiffrey 1882, 212–213; Cust 1900, 229, 241; Schaeffer 1909, xxxiv; F. W. Hilles (ed.), *Letters of Sir Joshua Reynolds* (London, 1929), 175, 176; Van den Wijngaert 1943, 165, 201; Millar 1954, 36–42; Vey 1956, 201, 217; Whinney and Millar 1957, 71–72; Per Palme, *Triumph of Peace* (London, 1957), 201–204, 282–284; Royal Collection 1963, 1:19; Edward Croft-Murray, *Decorative Painting in England*, 2 vols. (London,

The procession, moving from left to right on a shallow stage, is made up of more than fifty distinguishable figures. Where the train enters a large portal at the right, the artist tried to give the impression of a large crowd from which no individual participant emerges. It is only when he comes to the knights of the Order of the Garter, marching in groups of two, and occupying, as they should, the largest part of the sketch, that we see individual attitudes, gestures, and in some cases even physiognomies; they move freely and gracefully, their full robes trailing behind them. In accordance with a minutely prescribed tradition, they are followed by the officers of the order: the Register, the Garter King of Arms, and the Usher of the Black Rod.[1] Then come the prelate and the chancellor, and immediately before the king, the sword. Charles, carrying scepter and orb and, alone of all the figures, wearing a hat (at a rakish angle), walks beneath a canopy held by four gentlemen of the Privy Chamber. Two youths hold his train. He is followed by "persons of quality" and, separated by a column, by men carrying arms. Close to the king, a man seen from the back and holding a fierce dog(?) emerges from a lower level; in the list appended to Richard Cooper's print of the sketch he is identified as "Jeffery Hudson, the King's Dwarf."[2] On either side the composition is flanked by parts of stately but not clearly identifiable buildings; at the left we see a portico and behind it an open door from which still more figures are emerging. The soldiers, however, are coming from the outside. Between these buildings, and serving as a backdrop for the most prominent members of the procession, stretches a richly articulated wall in which wide bays with semicircular openings alternate with narrow ones that contain niches occupied by sculptures of royal figures. The wall is crowned by a balustrade from which a huge drapery, about the width of three bays, is suspended. For about half the width of the wall the artist indicated a second story, with space for additional figures, no doubt the queen and the ladies of the court watching from above. Processions like these were held annually to celebrate the Feast of Saint George, the patron saint of the Order of the Garter, on 23 April. Although originally staged at Windsor Castle, by the early seventeenth century the procession and the services connected with it were located at Whitehall.[3] It seems that the cortège formed twice: before entering the

1962–1970), 1:35; Oliver Millar, *Sir Peter Lely* [exh. cat. National Portrait Gallery] (London, 1978–1979), nos. 86–116; Millar in London 1982–1983, 86–87; Brown 1982, 190; J. Douglas Stewart, review of Millar in London 1982–1983, *Revue d'Art Canadienne/Canadian Art Review (RACAR)* 11, 1–2 (1984), 159–161; Larsen 1988, 1:318, 479, 2:315–316

1. For this and the following references to ceremonies of the Order of the Garter, see Elias Ashmole, *The Institution, Laws and Ceremonies of the Most Noble Order of the Garter* (London, 1672). I am also indebted to Palme 1957.
2. Jeffrey Hudson (1619–1682) was the favorite of Queen Henrietta Maria; his small but well-proportioned figure is seen next to the queen in her full-length portrait in the National Gallery of Art in Washington [cat. 67]. For his portrait by Daniel Mytens, showing him standing in front of a landscape with tall trees, see E. Tietze-Conrat, *Dwarfs and Jesters in Art* (London, 1957), 76 ill.
3. Palme stated (124) that during the early part of the seventeenth century "Whitehall ... was the favoured setting for the festival." Yet according to Strong (1972, 59–63), Charles I, deeply attached to the order, removed its festival from Whitehall to Windsor (Millar in London 1982–1983, 87).
4. See A. M. Hind, *Engraving in England in the Sixteenth & Seventeenth Centuries* (London, 1952), 1:104–121.
5. D. Rosand and M. Murraro, *Titian and the Venetian Woodcut* [exh. cat. National Gallery of Art] (Washington, 1976–1977), no. 89.

chapel for the morning service, and then a second time for the "perambulation of the circuits," finishing with entering the chapel a second time. After Inigo Jones' Banqueting House had been built (1622), the final act of the feast of Saint George, the grand dinner, was held in the big hall of that structure, the ceiling of which, by the time Van Dyck planned the Procession of the Knights of the Garter, had been adorned by nine large canvases by Rubens.

It was, in fact, the great hall of the Banqueting House that Van Dyck's Procession was planned for. As Bellori tells us, the project, supported by Sir Kenelm Digby, was to consist of four large tapestries which, besides the *Processione de' Cavalieri ne' loro habiti*, were to depict the Election of the King, the Institution of the Order of the Garter by Edward III, and the civil and military ceremonials as part of the royal functions. They were to hang below the narrow balcony of the hall and take the place that had before been used to display the famous Raphael tapestries of the *Acts of the Apostles*, replacing them by works "in doppio numero, e di grandezza maggiori." Not only do the dimensions of the planned tapestry correspond to the length and height (measured to the entablature) of the "gran salone" of the Banqueting House, but the planning of a balcony with female spectators, and the organization of the wall space below in terms of attached columns, consciously allude to the interior it was eventually to adorn. Nothing came of this ambitious plan; there was no money for it.

Most scholars have pointed to Marcus Gheeraerts the Elder's multiple etching of the procession of the *Knights of the Garter* of 1576 as the only pictorial precedent possibly available to Van Dyck;[4] yet though there is a thematic connection there is no formal one, since the procession in Gheeraerts' prints is broken up into separate pairs of marchers, all individually framed. Nor is there a need to point to Veronese (for instance his London painting of the *Family of Darius before Alexander*) for the essential horizontality of the setting, since a much closer prototype, as J. Douglas Stewart observed, is the *Procession of the Doge of Venice* published c. 1555–1560 in a woodcut printed from eight blocks; a later copy of these prints mentions Mattio Pagan as the publisher.[5] Nor should we forget that there are also Flemish paintings of long processions strung out horizontally, as for instance the *Procession of Religious Orders in Brussels* by Denis van Alsloot (Prado, Madrid, nos. 1348, 1616).

Yet it is in comparison to the stiff monotony of all such earlier processionals that the graceful fluency of Van Dyck's project and the variety of individual poses throughout the length of the sketch can be fully appreciated. Walking side by side, two knights are rendered as if conversing with each other; a knight may turn around

to talk to the marcher behind him or bow to the ladies above. Others seem to address the audience, as if conscious of their performing on a stage, not the least the king himself who looks straight out at the beholder. This "copious interplay ... of elegant gestures and complex movements" (Millar) succeeds in giving to the procedure a spatial freedom and implied depth that effectively hides the shallowness of the actual setting.

It is possible that the project was intended to commemorate the procession of the Knights of the Garter of 1638, which preceded the installation of the prince of Wales, though this is not confirmed by any document.

From Van Dyck's polite generality of physiognomic shapes and expressions it is impossible to recognize any individual members of the order, as Richard Cooper tried to do when he identified the knights walking directly in front of the sword of state as Walter Curle, bishop of Winchester, as prelate, and Sir Thomas Rowe as chancellor. The same is true for his identification of Philip Herbert, (4th) earl of Pembroke, and Thomas Howard, earl of Arundel, all of whom were likely to have occupied the parts assigned to them by Cooper but whose individual faces would hardly be recognizable without that prior knowledge.

<div align="right">J. S. H.</div>

Adhémar 1957
ADHÉMAR, Jean. "Marie Mauquoy—'L'Iconographie d'Antoine van Dyck'." *Gazette des Beaux-Arts*, 6th series, 49 (May), 345.

Adriani 1940
ADRIANI, Gert. *Anton Van Dyck: Italienisches Skizzenbuch*. Vienna.

Ainsworth 1982
AINSWORTH, Maryan Wynn, John BREALEY, Egbert HAVERKAMP-BEGEMANN, and Pieter MEYERS. "Paintings by Van Dyck, Vermeer, and Rembrandt Reconsidered Through Autoradiography." *Art and Autoradiography: Insights into the Genesis of Paintings by Rembrandt, Van Dyck and Vermeer*. New York.

Alizeri 1846-1847
ALIZERI, Federigo. *Guida Artistica per la Città di Genova*. 2 vols. Genoa.

Allegri 1981
ALLEGRI TASSONI, G. "La Madonna con il bambino dormente di A. van Dyck gia nella collezione Baldrighi." *Aurea Parma* 65/1 (1981), 51–55.

"Another Portrait of Queen Henrietta Maria." *Connoisseur* 91 (February 1933), 135.

Baes 1878
BAES, Edgar. "Le séjour de Rubens et de Van Dyck en Italie." *Mémoires couronnés et autres mémoires* 28.

Baldass 1957
BALDASS, Ludwig. "Some Notes on the Development of Van Dyck's Portrait Style." *Gazette des Beaux-Arts*, 6th series, 50 (November), 251–270.

Ballard 1941
BALLARD, L. E. "My Lady Killigrew by Sir Anthony Van Dyck." *Los Angeles Museum Quarterly* 1 (April), 6–9.

Bang 1927
BANG, A. C. "An Unpublished Van Dyck Portrait." *Burlington Magazine* 51 (September), 114–120.

Barnard 1938
BARNARD, O. H. "Van Dyck's Portrait of Jan de Wael." *Print Collector's Quarterly* 25 (April), 156–165.

Barnes 1986
BARNES, Susan J. "Van Dyck in Italy." Ph.D. diss. New York University, 2 vols.

Baudi di Vesme 1885
BAUDI DI VESME, Alessandro di. *Van Dyck. Peintre de Portraits des Princes de Savoie*. Turin.

Baudouin 1949
BAUDOUIN, F. S. E. "The Van Dyck Exhibition in Antwerp." *Burlington Magazine* 91 (December), 353–354.

Bellori 1672
BELLORI, Pietro. *Le vite de pittori, scultori et architetti moderni*. Genoa. Repr. Rome, 1931.

Bellori 1976
BELLORI, Giovanni Pietro. *Le vite de pittori, scultori et architetti moderni* (1672). Ed. E. Borea. Turin, 1976.

Benesch 1938
BENESCH, Otto. "Zur Frage der frühen Zeichnungen Van Dycks." *Die Graphischen Künste* 3:19–31.

Benesch 1946
BENESCH, Otto. "Van Dyck's Drawings of Children." *Gazette des Beaux-Arts*, 6th series, 30:153–164.

Benesch 1959
BENESCH, Otto. "Zum zeichnerischen Oeuvre des jungen Van Dyck." *Festschrift Karl M. Swoboda*. Vienna, 35–37.

Bertolotti 1887
BERTOLOTTI, N. A. *P. P. Rubens, Corneille de Wael, Jean Roos, Antoine van Dyck. Lettres et renseignements inédits*. Antwerp.

Blanc 1857
BLANC, Charles. *Le Trésor de la Curiosité tiré des Catalogues de Vente*. 2 vols. Paris.

Blomme 1898-1901
BLOMME, A. "Deux Tableaux de Van Dyck." *Bulletin de l'Académie Royale d'Archéologie de Belgique*, 5ème série des Annales, 1:425–426.

Boccardo 1987
BOCCARDO, Piero. "Per la Storia della Quadreria di Palazzo Spinola, Palazzo Spinola a Pellecceria, due Musei un una Dimora Storica." *Quaderni della Galleria Nazionale di Palazzo Spinola* 10:62–86.

Boccardo and Magnani 1987
BOCCARDO, Piero, and Laura MAGNANI. "La Committenza [of the Balbi Family]." *Il Palazzo dell' Università di Genova. Il Collegio dei Gesuiti nella strada dei Balbi*. Savona, 47–88.

Bode 1889
BODE, Wilhelm von. "Anton van Dyck [in der Liechtenstein Galerie]." *Die Graphischen Künste* 12:39–52.

Bode 1906
BODE, Wilhelm von. "Anton van Dyck als Mitarbeiter des Peter Paul Rubens." *Rembrandt und seine Zeitgenossen*. Leipzig, 255–282.

Bode 1909
BODE, Wilhelm von. *Great Masters of Dutch and Flemish Painting*. London.

Bode 1914
BODE, Wilhelm von. "Ein neuaufgefundenes Bildnis von Rubens' erster Gattin Isabella Brant." *Jahrbuch der Königlich Preussischen Kunstsammlungen*, 4:221–223.

Borenius 1928
BORENIUS, Tancred. "A Newly Discovered Altarpiece by Van Dyck: Martyrium des hl. Sebastian." *Pantheon* 2 (August), 386–388.

Borenius 1938
BORENIUS, Tancred. "Ein neuer Van Dyck für die National Gallery, London: die heilige Jungfrau mit dem Kinde." *Pantheon* 21, suppl. 15 (April), 122.

Borenius 1941
BORENIUS, Tancred. "Addenda to the Work of Van Dyck." *Burlington Magazine* 79 (December), 198–203.

Bouchot 1901
BOUCHOT, Henri. "La Femme Anglaise et Ses Peintres II: Van Dyck." *Revue de l'Art Ancien et Moderne* 10 (October), 225–240.

Van den Branden 1883
BRANDEN, Franz Joseph van den. *Geschiedenis der Antwerpsche Schilderschool*. Antwerp.

Brigstocke 1982
BRIGSTOCKE, Hugh. *William Buchanan and the 19th Century Art Trade: 100 Letters to His Agents in London and Italy*. New Haven.

Britton 1801
BRITTON, John. *The Beauties of Wiltshire, Displayed in Statistical, Historical, and Descriptive Sketches: Interspersed with Anecdotes of the Arts*. 2 vols. London.

Brown 1974
BROWN, Christopher. "Anthony van Dyck, The Abbé Scaglia Adoring the Virgin and Child." *Painting in Focus* 2, National Gallery, London.

Brown 1979
BROWN, Christopher. "Van Dyck at Princeton." *Apollo* 110 (August), 145.

Brown 1982
BROWN, Christopher. *Van Dyck*. Oxford.

Brown 1983
BROWN, Christopher. "Van Dyck's Collection: a Document Rediscovered." *Revue d'Art Canadienne / Canadian Art Review (RACAR)* 10:69–72.

Brown 1984
BROWN, Christopher. "Allegory and Symbol in the Work of Anthony van Dyck." *Wort und Bild in der niederländischen Kunst und Literatur des 16. u. 17. Jahrhunderts*. Ed. Herman Vekeman and Justus Müller Hofstede. Erftstadt, 123–135.

Brown 1987
BROWN, Christopher. "Van Dyck and Titian." *Bacchanals by Titian and Rubens*. Ed. Görel Cavalli-Björkman. Stockholm, 153–164.

Burchard 1929
BURCHARD, Ludwig. "Genuesischen Frauenbildnisse von Rubens." *Jahrbuch der Preussischen Kunstsammlungen* 50:319–349.

Burchard 1933
BURCHARD, Ludwig. "Anton van Dycks Bildnis des Kardinals Domenico Rivarola (1924). Reprinted in Glück 1933, 412–413.

Burchard 1938
BURCHARD, Ludwig. "'Christ Blessing the Children' by Anthony Van Dyck." *Burlington Magazine* 72 (January), 25–30.

Burchard 1938a
BURCHARD, Ludwig. "View of Rye by Anthonie Van Dyck." *Old Master Drawings* 12 (March), 47–48.

Burchard 1958
BURCHARD, Ludwig. "The De Witte Couple by Van Dyck." *Burlington Magazine* 100 (September), 319.

Burtin 1808
BURTIN, F. -X. de. *Traité Théorique et Pratique des Connaissances qui sont Nécessaires à Tout Amateur de Tableaux*. Brussels.

Buschmann 1916
BUSCHMANN, P. "Rubens en Van Dyck in het Ashmolean Museum te Oxford." *Onze Kunst* 29 (January–June), 1–24, 41–51.

Cammell 1937
CAMMELL, C. R. "Misnamed Portrait Group at the National Gallery: on the Canvas Lord John and Lord Bernard Stuart, Sons of the Duke of Lenox, on the Frame George and Francis Villiers." *Connoisseur* 99 (April), 202–205.

Chéron 1875
CHÉRON, Paul. "Les Eaux-fortes de Van Dyck et de Paul Potter." *Gazette des Beaux-Arts*, 2d series, 12 (September), 262–267.

Churchill 1909
CHURCHILL, Sidney J. A. "Sir Anthony Van Dyck's Visit to Sicily about 1624." *Burlington Magazine* 14 (January), 239–240.

Clarijs 1947
CLARIJS, Petra. *Anton van Dyck* (Palet Serie). Amsterdam.

Clayton 1960
CLAYTON, Thomas. "An historical study of the portraits of Sir John Suckling." *Journal of the Warburg and Courtauld Institutes* 13:105–126.

Cohen 1928
COHEN, Walter. "Studie St. Sebastian von Van Dyck." *Pantheon* 2 (November), 565.

Colasanti 1903
COLASANTI, A. "The Recently-Restored Pictures at the Brignole-Sale Gallery in Genoa." *Connoisseur* 6:27–30.

Collins Baker 1921
COLLINS BAKER, C. H. "The Chronology of English Van Dycks." *Burlington Magazine* 39 (December), 267–273.

"Complete Collection of Van Dyck's Etchings." *Chicago Art Institute Bulletin* 23 (May 1929), 56–57.

"The Complete Etched Portrait Work of Anthony Van Dyck from the Collections of Sir Peter Lely and Prosper Henry Lankrink." *Print-Collectors Bulletin* 3 (1934), 1–45.

Cook 1900
COOK, Herbert. "Correspondance d'Angleterre: L'Exposition van Dyck à Londres." *Gazette des Beaux-Arts*, 3d series, 23 (April), 334–341.

Corbet 1946
CORBET, A. "Antoon van Dyck en de Fransche portretschilders in de XVIIᵉ and XVIIIᵉ eeuwen." *Revue Belge d'Archéologie et d'Histoire de l'Art* 16:132–148.

"The Crowning of Christ with Thorns." *Connoisseur* 129 (June 1952), 111.

Cust 1900
CUST, Lionel F. S. A. *Anthony van Dyck: An Historical Study of His Life and Works*. London.

Cust 1902
CUST, Lionel. *A Description of the Sketch-book by Sir Anthony Van Dyck used by him in Italy, 1621–1627*. London.

Cust 1905
CUST, Lionel. *Anthony van Dyck*. London.

Cust 1907
CUST, Lionel. "The New Van Dyck in the National Gallery." *Burlington Magazine* 6 (August), 325–326.

Cust 1908
CUST, Lionel. "Notes on Pictures in the Royal Collections II." *Burlington Magazine* 12 (January–February), 235–237, 282–289.

Cust 1909
CUST, Lionel. "Notes on Pictures in the Royal Collections 13—The Triple Portrait of Charles I by Van Dyck, and the Bust by Bernini." *Burlington Magazine* 14 (March), 337–341.

Cust 1910a
CUST, Lionel. "Exhibition in New York of Portraits by Van Dyck." *Burlington Magazine* 16 (February), 302.

Cust 1910b
CUST, Lionel. "Notes on Pictures in the Royal Collections 16—The Equestrian Portraits of Charles I by Van Dyck 1." *Burlington Magazine* 17 (June), 159–160.

Cust 1911a
CUST, Lionel. "Notes on Pictures in the Royal Collections 20—The Equestrian Portraits of Charles I by Van Dyck 2." *Burlington Magazine* 18 (January), 202–209.

Cust 1911b
CUST, Lionel. *Van Dyck, a Further Study*. London and New York.

Damm 1966
DAMM, Margaret Minn. *Van Dyck's Mythological Paintings*. Ph.D. diss. University of Michigan.

Delâcre 1931
DELÂCRE, Maurice. "Sur un Dessin de l'Entourage de Van Dyck: Miracle de l'Ane par St.-Antoine de Padoue." *Gand Artistique* 10 (January), 7–12.

Delâcre 1932
DELÂCRE, Maurice. *Recherches sur le rôle du dessin dans l'iconographie de Van Dyck*. Brussels.

Delâcre 1934
DELÂCRE, Maurice. *Le Dessin dans l'Oeuvre de Van Dyck*. Brussels.

Delen 1930
DELEN, Andrien Jean Joseph. "Carrying of the Cross." *Old Master Drawings* 5 (December), 58–59.

Delen 1931
DELEN, Andrien Jean Joseph. "Un dessin inconnu d'Antoine van Dyck représentant le Portement de la Croix." *Revue Belge d'Archéologie et d'Histoire de l'Art* 1 (July), 193–199.

Denucé 1931
DENUCE, Jan. *Art-Export in the 17th Century in Antwerp*. The Hague.

Denucé 1932
DENUCE, Jan. *The Antwerp Art-Galleries, Inventories of the Art-Collections in Antwerp in the 16th and 17th Centuries*. The Hague.

Denucé 1949
DENUCE, Jan. *Na Peter Pauwel Rubens: Documenten uit den kunsthandel te Antwerpen in de XVIIᵉ eeuw van Matthijs Musson*. Antwerp/The Hague.

Descamps 1753–1754
DESCAMPS, J. B. *La Vie des Peintres Flamands, Allemands et Hollandais*. 3 vols. Paris.

Description 1773
[BRUSCO, G.] *Description des Beautés de Gênes et de ses environs*. Genoa.

"The Detroit Van Dyck Exhibition." *Cicerone* 21 (June 1929), 327–328.

"Deux tableaux de Van Dyck." *Académie Royale d'Archéolgie de Belgique* 1 (1898–1901), 421–439.

Díaz Padrón 1972
DIAZ PADRON, Matías. "Dos Nuevas Pinturas de Rubens y Van Dyck identificadas en España: 'San Pedro' y una Segunda Réplica a la 'Adultera'." *Archivo Español de Arte* 45 (October), 335–345.

Díaz Padrón 1974
DIAZ PADRON, Matías. "Una Piedad de Van Dyck atribuida a Rubens en el Museo del Prado." *Archivo Español de Arte* 47 (April–June), 149–156.

Díaz Padrón 1976
DIAZ PADRON, Matías. "La Exposición de Maestros Flamencos del Siglo XVII del Museo del Prado y Colecciones Españolas en el Museo Real de Bruselas." *Goya* 133 (July–August), 15–28.

Dobroklonsky 1931
DOBROKLONSKY, M. "Van Dycks Zeichnungen in der Eremitage." *Zeitschrift für bildende Kunst* 64 (March), 237–243.

Drossaers and Lunsingh Scheurleer 1974–1976
DROSSAERS, S. W. A., and Th. H. LUNSINGH SCHEURLEER. *Inventarissen van de Inboedels in de Verblijven van de Oranjes en daarmede gelijk te stellen stukken 1567–1795*. 3 vols. The Hague.

Dumont-Wilden 1910
DUMONT-WILDEN, L. "Exposition de l'Art belge au XVIIᵉ siècle à Bruxelles." *Les Arts* 106 (October), 2–27.

Durand 1900
DURAND, Jean. "L'Exposition Van Dyck à Londres." *Revue de l'Art Ancien et Moderne* 7 (March), 207–216.

"An Early Sketch by Van Dyck, Samson and Delilah." *Chicago Art Institute Bulletin* 18 (March 1924), 35–37.

Eigenberger 1924
EIGENBERGER, Robert. "Ergänzungen: zum Lebenswerke des Rubens und Van Dyck in der akademischen Gemäldegalerie in Wien." *Belvedere* 5:1–39.

Eisler 1975
EISLER, Colin. "Veronese, Flanders and France. A New Page from Van Dyck's Italian Sketchbooks." *Etudes d'art français offertes à Charles Sterling*. Paris, 207–212.

Félibien 1666–1688
FÉLIBIEN, André. *Entretiens sur les Vies et sur les Ouvrages des Plus Excellens Peintres Anciens et Modernes*. 3 vols. Trevoux.

Fell 1938
FELL, H. G. "Van Dyck for the National Gallery: The Abbé Scaglia Adoring the Virgin and Child." *Connoisseur* 101 (February), 99.

Fierens Gevaert 1903
FIERENS GEVAERT, Hippolyte. *Van Dyck, Les Grands Artistes*. Paris.

Fierens Gevaert 1910
FIERENS GEVAERT, Hippolyte. *Trésors de l'Art belge du XVIIᵉ siècle, Mémorial de l'Exposition d'Art Ancien à Bruxelles en 1910*. Paris.

Filipczak 1987
FILIPCZAK, Zirka Zaremba. *Picturing Art in Antwerp 1550–1700*. Princeton.

Filipczak 1989
FILIPCZAK, Zirka Zaremba. "Van Dyck's 'Life of St. Rosalie'." *Burlington Magazine* 131 (October), 693–698.

Fischel 1933
FISCHEL, O. "Sheet of Sketches by Anthony van Dyck." *Old Master Drawings* 8 (September), 20–23.

Francis 1955
FRANCIS, Henry S. "A Genoese Portrait by Van Dyck, Lady with Her Child." *Bulletin of the Cleveland Museum of Art* 42 (June), 115–117. Also in *Art Quarterly* 18:212.

Friedländer 1900
FRIEDLÄNDER, Max. "Die v. Dyck-Ausstellung in London, 31. Winter-Exhibition der Academy." *Repertorium für Kunstwissenschaft* 23:168–171. Repr. Berlin, 1968.

Fromentin 1876
FROMENTIN, Eugène. *Les Maîtres d'Autrefois*. Paris.

Frote-Langlois 1983
FROTE-LANGLOIS, Marianne. "Iconographie de François Langlois dit Ciartres." *Gazette des Beaux-Arts*, 6th series, 102 (October), 119–120.

Fry 1927
FRY, Roger. "Flemish Art at Burlington House." *Burlington Magazine* 50 (February–March), 58–73, 132–153.

Galesloot 1868
GALESLOOT, L. "Un Procès pour une Vente de Tableaux attribués à Antoine van Dyck 1660–1662." *Annales de l'Académie Royale d'Archéologie de Belgique* 24:561–606.

Garas 1955
GARAS, Klara. "Ein unbekanntes Porträt der Familie Rubens auf einem Gemälde van Dycks." *Acta Historiae Artium Academiae Scientiarum Hungaricae* 2:189–200.

Gaunt 1980
GAUNT, William. *Court Painting in England from Tudor to Victorian Times.* London.

Van Gelder 1939
GELDER, J. G. van. "Anthonie Van Dyck, Study of an Italian Nobleman Standing." *Old Master Drawings* 14 (June), 11–13.

Van Gelder 1959
GELDER, J. G. van. "Anthonie Van Dyck in Holland in de Zeventiende Eeuw." *Bulletin Musées Royaux des Beaux-Arts de Belgique* 1–2 (March–June), 43–86.

Van Gelder 1978
GELDER, J. G. van. "Pastor Fido-voorstellingen in de Nederlandse kunst van de zeventiende eeuw." *Oud Holland* 92:227–263.

Gillet 1913
GILLET, Louis. "Le Musée Jacquemart-André: Les Ecoles du Nord et l'Ecole espagnole." *Revue de l'Art Ancien et Moderne* 34 (December), 439–452.

Glen 1977
GLEN, Thomas L. *Rubens and the Counter Reformation: Studies in His Religious Paintings between 1609 and 1620.* New York.

Glen 1983
GLEN, Thomas L. "Observations on van Dyck as a Religious Artist." *Revue d'Art Canadienne / Canadian Art Review (RACAR)* 10:45–52.

Glück 1929
GLÜCK, Gustav. "Ein unveröffentlichtes Altargemälde Van Dycks." *Pantheon* 3 (March), 125–127, suppl. 23–24.

Glück 1930
GLÜCK, Gustav. "Van Dycks Jupiter und Antiope." *Pantheon* 3 (May), 201–202, suppl. 38.

Glück 1931
GLÜCK, Gustav. *Van Dyck, des Meisters Gemälde.* New York. 2d rev. ed. *Klassiker der Kunst* 13.

Glück 1933
GLÜCK, Gustav. *Rubens, Van Dyck und ihr Kreis.* Vienna.

Glück 1934
GLÜCK, Gustav. "Self-Portraits by Van Dyck and Jordaens." *Burlington Magazine* 65 (November), 194–201.

Glück 1936
GLÜCK, Gustav. "Some Portraits of Musicians by Van Dyck." *Burlington Magazine* 69 (October), 147–153.

Glück 1937
GLÜCK, Gustav. "Van Dyck's Equestrian Portraits of Charles I." *Burlington Magazine* 70 (May), 211–217.

Glück 1939a
GLÜCK, Gustav. "Notes on Van Dyck's Stay in Italy." *Burlington Magazine* 74 (May), 206–209.

Glück 1939b
GLÜCK, Gustav. "Van Dyck's Burnt Painting of the Brussels City-Council." *Old Master Drawings* 14 (June), 1–4.

Glück 1941
GLÜCK, Gustav. "Reflections on Van Dyck's Early Death." *Burlington Magazine* 79 (December), 193–199.

Glück 1942
GLÜCK, Gustav. "A 'Sacrifice of Abraham' by Van Dyck." *Burlington Magazine* 80 (January), 16–18.

Glück 1943
GLÜCK, Gustav. "Van Dyck Painter of Children." *Gazette des Beaux-Arts,* 6th series, 24 (July), 11–18.

Van Gool 1750
GOOL, Jan van. *De nieuwe schouburg der Nederlantsche kunstschilders en schilderessen. …* The Hague. Repr. Soest, 1971.

Göpel 1940
GÖPEL, Erhard. *Ein Bildnisauftrag für Van Dyck; Antonis van Dyck, Philippe le Roy und die Kupferstecher.* Veröffentlichungen zur Kunstgeschichte 5. Frankfurt.

Gordon 1983
GORDON, Pamela. "The Duke of Buckingham and Van Dyck's 'Continence of Scipio'." *Revue d'Art Canadienne / Canadian Art Review (RACAR)* 10:53–55.

Van de Graaf 1958
GRAAF, J. A. van de. *Het De Mayerne Manuscript als bron voor de Schildertechniek van de Barok.* Ph.D. diss. Utrecht.

Grancsay 1950
GRANCSAY, S. V. "Museum Armor and a Van Dyck Portrait from Vienna." *Metropolitan Museum of Art Bulletin* 8 (May), 270–273.

Graphischen Künste 1889
"Antoon Van Dyck." *Die Graphischen Künste* 12:39–52

Graves 1914
GRAVES, Algernon. *A Century of Loan Exhibitions 1813–1912.* 5 vols. London.

Guarienti 1753
GUARIENTI, Pietro. *Abecedario Pittorico del M. R. P. Pellegrino Antonio Orlandi Bolognese.* Venice.

Guiffrey 1882
GUIFFREY, Jules. *Antoine van Dyck: sa vie et son œuvre.* Paris.

Haberditzl 1914
HABERDITZL, Franz Martin. "Anton van Dyck." Ed. Ulrich Thieme and Felix Becker. *Allgemeines Lexikon der bildenden Künstler* 10. Leipzig.

Hardman 1976
HARDMAN, Sammy J. *Sir Anthony Van Dyck's Portraits of Lady Mary Villiers, Duchess of Richmond and Lennox.* Atlanta.

Harris 1973
HARRIS, John. "The Link between a Roman Second-Century Sculptor, Van Dyck, Inigo Jones and Queen Henrietta Maria." *Burlington Magazine* 115 (August), 526–530.

Heil 1929
HEIL, Walter. "Die Van Dyck Ausstellung in Detroit." With English trans. "The Van Dyck Exhibition in Detroit." *Pantheon* 4 (July), 300–305, suppl. 54–56.

Heil 1930
HEIL, Walter. "Sketches by Rubens and Van Dyck; Portrait Sketch of Lucas van Uffel and Martyrdom of St. George." *Detroit Institute of Arts Bulletin* 11 (March), 78–81.

Held 1951
HELD, Julius S. "Sketches by Lucas Francoys the Younger, Some Reattributions." *Art Quarterly* 14:45–55.

Held 1957
HELD, Julius S. "Artis Pictoriae Amator: An Antwerp Art Patron and His Collection." *Gazette des Beaux-Arts,* 6th series, 50:53–84. Republished in *Rubens and His Circle: Studies by Julius S. Held.* Ed. Anne W. Lowenthal, David Rosand, and John Walsh, Jr. (Princeton, 1982), 35–64.

Held 1958
HELD, Julius S. "'Le Roi à la Ciasse'." *Art Bulletin* 40 (June), 139–149. Repr. in *Rubens and His Circle: Studies by Julius Held.* Ed. Anne W. Lowenthal, David Rosand, John Walsh, Jr. (Princeton, 1982), 65–79.

Held 1960
HELD, Julius S. "Iconographie d'Antoine van Dyck: Catalogue Raisonné, by M. Mauquoy-Hendrickx." *Art Bulletin* 42 (March), 73–74.

Held 1964
HELD, Julius S. "Die Zeichnungen Anton van Dycks, by H. Vey." *Art Bulletin* 46 (December), 565–568.

Held 1969
HELD, Julius S. "Rubens and Vorsterman." *Art Quarterly* 32 (Summer), 125–127.

Held 1972
HELD, Julius S. "Van Dyck." *Encyclopaedia Britannica* 22:882–884, Chicago.

Held 1982
HELD, Julius S. "Rubens and Titian." *Titian: His World and His Legacy.* Ed. David Rosand. New York, 283–339.

Hevesy 1936
HEVESY, André de. "Rembrandt and Nicholas Lanier." *Burlington Magazine* 69 (October), 153–154.

Hind 1915
HIND, A. M. "Van Dyck: His Original Etchings and His Iconography." *Print Collector's Quarterly* 5 (April), 2–37, 220–252.

Hind 1927
HIND, A. M. "Van Dyck and English Landscape." *Burlington Magazine* 51 (December), 292–297.

Hoet 1752
HOET, Gerard. *Catalogus of Naamlyst van Schilderyen.* 3 vols. The Hague. Repr. Soest, 1976.

Hoffman 1947
HOFFMAN, Daphne M. "A Postscript: Head of a Little Girl Wearing a Cap by Van Dyck." *Gazette des Beaux-Arts,* 6th series, 32:125–126.

Hofstede de Groot 1916
HOFSTEDE DE GROOT, C. H. "Het portret van Stevens door A. van Dijck in het Mauritshuis." *Oud Holland* 34:68.

Holmes 1908
HOLMES, C. J. "Rembrandt and Van Dyck in the Widener and Frick Collections." *Burlington Magazine* 13 (September), 306–316.

Honour 1955
HONOUR, H. "Van Dyck at Genoa." *Connoisseur* 136 (November), 102–105.

Hoogewerff 1935
HOOGEWERFF, G. J. "Vijf nog Onbekende Werken van Antonie van Dyck." *Revue Belge d'Archéologie et d'Histoire de l'Art* 5 (July), 245–249.

Hoogewerff 1949
HOOGEWERFF, G. J. "Een 'Nood Gods' door Van Dijck Geschilderd." *Miscellanea Leo van Puyvelde.* Brussels, 157–162.

Hookham Carpenter 1844
HOOKHAM CARPENTER, William. *Pictorial Notices: Consisting of a Memoir of Sir Anthony Van Dyck, with a Descriptive Catalogue of the Etchings Executed by Him: and a Variety of Interesting Particulars Relating to Other Artists Patronized by Charles I.* London.

Houbraken 1753
HOUBRAKEN, Arnold. *De Groote Schouburgh der Nederlandtsche Konstschilders en Schilderessen.* 3 vols. The Hague. Repr. Amsterdam, 1976.

Howarth 1985
HOWARTH, David. *Lord Arundel and His Circle.* New Haven and London.

Howarth 1990
HOWARTH, David. "The Arrival of Van Dyck in England." *Burlington Magazine* 132 (October).

Hymans 1887
HYMANS, Henri. "Les Dernières Années de Van Dyck." *Gazette des Beaux-Arts.* 2d series, 36:432–440.

Hymans 1893
HYMANS, Henri. "Le Musée du Prado: Les Ecoles du Nord (Suite)." *Gazette des Beaux-Arts,* 3d series, 10:333–340.

Hymans 1894
HYMANS, Henri. "Le Musée du Prado: Les Ecoles du Nord, Rubens et le XVIIe siècle." *Gazette des Beaux-Arts,* 3d series, 11:73–92, 185–197.

Hymans 1899
HYMANS, Henri. "Quelques notes sur Antoine van Dyck." *Bulletin de l'Académie Royale d'Archéologie de Belgique,* 5th series, 7:400–420.

Hymans 1899a
HYMANS, Henri. "Antoine van Dyck et l'exposition de ses œuvres à Anvers à l'occasion du troisième centenaire de sa naissance." *Gazette des Beaux-Arts,* 3d series, 22:226–240, 320–332.

Hymans 1899b
HYMANS, Henri. "Ausstellungen und Versteigerungen: Anvers Exposition Van Dyck." *Repertorium für Kunstwissenschaft* 22:418–422. Repr. Berlin, 1968.

Hymans 1905
HYMANS, Henri. "Note sur le séjour de Van Dyck en Italie." *Bulletin de l'Académie Royale d'Archéologie de Belgique,* 119–122.

Hymans 1910
HYMANS, Henri. "L'Exposition de l'Art Belge au XVIIe siècle." *Gazette des Beaux-Arts,* 4th series, 4:166–169, 320–332, 326–344.

Hymans 1911
HYMANS, Henri. "Note sur le tableau de la Confrérie de N.D. du Rosaire de Van Dyck à l'église Saint Dominique à Palermo." *Annales de l'Académie Royale d'Archéologie de Belgique,* 293–297.

Imbourg 1949
IMBOURG, Pierre. *Van Dyck.* Munich.

Jaffé 1959
JAFFÉ, Michael. "The Second Sketch Book by Van Dyck." *Burlington Magazine* 101 (September), 316–319.

Jaffé 1965
JAFFÉ, Michael. "Van Dyck Portraits in the De Young Museum and Elsewhere." *Art Quarterly* 28:41–55.

Jaffé 1966a
JAFFÉ, Michael. *Van Dyck's Antwerp Sketchbook.* 2 vols. London.

Jaffé 1966b
JAFFÉ, Michael. "A Landscape by Rubens, and Another by Van Dyck." *Burlington Magazine* 108 (August), 410–416.

Jaffé 1967
JAFFÉ, Michael. "Van Dyck's Sketches for His Portraits of Duquesnoy and of Van Uffel." *Bulletin des Musées Royaux des Beaux-Arts de Belgique* 16:155–162.

Jaffé 1969a
JAFFÉ, Michael. "Van Dyck's Antwerp Sketchbook." *Master Drawings* 7 (Spring), 46–47.

Jaffé 1969b
JAFFÉ, Michael. "Some Recent Acquisitions of Seventeenth-Century Flemish Painting." *Report and Studies in the History of Art* 3:26–28, Washington.

Jaffé 1972
JAFFÉ, Michael. "The Flemish and Dutch Schools." *Apollo* 96 (December), 504–513.

Jaffé 1979
JAFFÉ, Michael. "A Vanitas by Van Dyck." *Apollo* 109 (January), 38–41.

Jaffé 1982
JAFFÉ, Michael. "Van Dyck Studies I: The Portrait of Archbishop Laud." *Burlington Magazine* 124 (October), 600–607.

Jaffé 1984
JAFFÉ, Michael. "Van Dyck Studies II: 'La Belle & Vertueuse Huguenotte'." *Burlington Magazine* 126 (October), 603–609.

Johns 1988
JOHNS, Christopher M. S. "Politics, Nationalism and Friendship in Van Dyck's 'Le Roi à la Ciasse'." *Zeitschrift für Kunstgeschichte* 51:243–261.

De Jongh 1975–1976
JONGH, E. de. "Pearls of Virtue, Pearls of Vice." *Simiolus* 8:69–97.

"Juicios del Cardinal-Infante Sobre Gaspar Crayer y Sobre Van Dyck." *Archivo Español de Arte* 64 (July 1944), 279–281.

Junius 1972
JUNIUS, Franciscus. *The Painting of the Ancients.* London, 1638. Repr. Farnborough, 1972.

Kelch 1975
KELCH, Jan. "Flemish Masters of the Baroque." *Apollo* 102 (December), 452–461.

Kelly 1935
KELLY, F. M. "Un Van Dyck du Cabinet de Gaignières en Amérique." *Gazette des Beaux-Arts,* 6th series, 13:59–61.

Kettering 1983
KETTERING, Alison McNeil. *The Dutch Arcadia, Pastoral Art and Its Audience in the Golden Age.* Montclair.

Keyes 1983
KEYES, George S. "Paintings of the Northern Schools." *Apollo* 117 (March), 194–200.

Ter Kuile 1969
TER KUILE, O. "Daniel Mijtens 'His Majesties Picture-Drawer'." *Nederlands Kunsthistorisch Jaarboek* 20:1–23.

Laban 1901
LABAN, Ferdinand. "Van Dycks Bildnisse eines genuesischen Senators und seiner Frau." *Jahrbuch der Königlich Preussischen Kunstsammlungen* 22:200–206.

Lafenestre 1914
LAFENESTRE, Georges. "La Peinture au Musée Jacquemart-André 2, Les Peintres Modernes du XVIIe au XIXe siècle, Ecoles Etrangères." *Gazette des Beaux-Arts,* 4th series, 11:32–50.

Lambotte 1921
LAMBOTTE, Paul. "An Unknown Painting by Van Dyck: 'Venus and Cupid'." *Apollo* 9 (June), 346–347. Repr. 1976.

Lambotte 1935
LAMBOTTE, Paul. "The Cordes Portraits at Brussels." *Apollo* 21 (April), 231–232.

"Landscape Drawing Attributed to Van Dyck: Country Road Flanked by Trees, with Two Ladies Seated in the Foreground." *British Museum Quarterly* 7 (December 1932), 63–65.

Larsen 1967
LARSEN, Erik. "Some New Van Dyck Materials and Problems." *Raggi* 7, no. 1, 1–14.

Larsen 1972
LARSEN, Erik. "Van Dyck's English Period and Cavalier Poetry." *Art Journal* 31 (Spring), 252–260.

Larsen 1975a
La Vie, les ouvrages et les élèves de Van Dyck. Manuscrit inédit des Archives du Louvre. Par un auteur anonyme. Ed. Erik Larsen. Brussels.

Larsen 1975b
LARSEN, Erik. "Le nu féminin couché dans l'œuvre d'Antoine van Dyck." *Konsthistorisk Tidskrift* 44:85–95.

Larsen 1979
LARSEN, Erik. "New Suggestions Concerning George Jamesone." *Gazette des Beaux-Arts,* 6th period, 9:9–18.

Larsen 1980
LARSEN, Erik. *L'Opera Completa di Van Dyck.* 2 vols. Milan.

Larsen 1980a
LARSEN, Erik. *Anton van Dyck II, die grossen Meister der Malerei.* Frankfurt.

Larsen 1985
LARSEN, Erik. *Seventeenth-Century Flemish Painting.* Freren.

Larsen 1988
LARSEN, Erik. *The Paintings of Anthony van Dyck.* 2 vols. Freren.

Lavallée 1917
LAVALLEE, P. "La Collection de Dessins de l'Ecole des Beaux-Arts." *Gazette des Beaux-Arts,* 4th series, 13:265–283, 417–432.

Lavalleye 1944
LAVALLEYE, J. "Frank van den Wijngaert, 'Antoon van Dyck'." *Revue Belge d'Archéologie et d'Histoire de l'Art* 14:174–175.

Lee 1963
LEE, Rensselaer W. "Van Dyck, Tasso, and the Antique." *Studies in Western Art, Acts of the Twentieth International Congress of the History of Art—Latin American Art, and the Baroque Period in Europe* 3:12–26, Princeton.

"Les Enfants de Charles I par Van Dyck." *Gazette des Beaux-Arts,* 2d series, 9 (1874), 231–233.

Leveson Gower 1910
LEVESON GOWER, Arthur. "The (so-called) Sheffield Portrait by van Dijck in the Royal Picture Gallery at the Mauritshuis in The Hague." *Oud Holland* 28:73–76.

Levey 1971
LEVEY, Michael. *Painting at Court.* London.

Levey 1983
LEVEY, Michael. "London 'Van Dyck in England' at the National Portrait Gallery." *Burlington Magazine* 125 (February), 106–110.

Liedtke 1984–1985
LIEDTKE, Walter A. "Anthony van Dyck." *Metropolitan Museum of Art Bulletin* 42 (Winter).

Lightbown 1969
LIGHTBOWN, R. W. "Van Dyck and the Purchase of Paintings for the English Court." *Burlington Magazine* 111 (July), 418–421.

Lightbown 1981
LIGHTBOWN, R. W. "Bernini's Busts of English Patrons." *Art, the Ape of Nature: Essays in Honor of H. W. Janson.* New York, 439.

Lohse Belkin 1987
LOHSE BELKIN, Kristin. "Titian, Rubens and Van Dyck: A New Look at Old Evidence." *Bacchanals by Titian and Rubens.* Ed. Görel Cavalli-Björkman. Stockholm, 143–152.

London 1824
An Account of All the Pictures Exhibited in the Rooms of the British Institution from 1813–1824 Belonging to the Nobility of England. London.

Luna 1986
LUNA, J. J. "Rubens y van Dyck en la corte de Carlos I de Inglaterra." *Historia* 16, 122:109–120.

Maison 1942
MAISON, K. E. "An Unpublished Genoese Portrait by Van Dyck." *Burlington Magazine* 80 (January), 18–19.

De Man 1979
MAN, R. de. "Kannunik Roger Braye (1550–1632), schenker van de 'Kruisoprichting' door Antoon van Dyck." *Handelingen van de Kon. Geschied- en Oudheidkundige Kring te Kortrijk* 46:39–94.

De Man 1980a
MAN, R. de. "Documenten over het Mecenaat van R. Braye (ca. 1550–1632) te Kortrijk en de Schilderijen van G. de Crayer en A. van Dyck." *Jaarboek van het Koninklijk Museum voor Schone Kunsten,* 233–259.

De Man 1980b
MAN, R. de. "Het Schilderij 'De Kruisoprichting' door Antoon van Dyck in Onze-Lieve-Vrouw te Kortrijk." *Handelingen van de Kon. Geschied- en Oudheidkundige Kring te Kortrijk* 47:53–154.

Mannings 1984
MANNINGS, David. "Reynolds, Hogarth and Van Dyck." *Burlington Magazine* 126 (November), 689–690.

Mantz 1874
MANTZ, Paul. "Galerie de M. Suermondt I-III." *Gazette des Beaux-Arts,* 2d series, 9:371–386, 437–453, 525–535.

Mantz 1881
MANTZ, Paul. "'Antoine van Dyck' by Jules Guiffrey." *Gazette des Beaux-Arts,* 2d series, 24 (December), 504–518.

Martin 1973
MARTIN, Gregory. "'The Age of Charles I' at the Tate." *Burlington Magazine* 115 (January), 56–59.

Martin 1975
MARTIN, Gregory. "The Abbot Scaglia." *Burlington Magazine* 117 (January), 52.

Martin 1977
MARTIN, John Rupert. "Van Dyck as History Painter: 'The Mocking of Christ'." *Proceedings of the American Philosophical Society, Philadelphia* 121, no. 3, 227–234.

Martin 1981
MARTIN, John Rupert. "Van Dyck's Early Paintings of St. Sebastian." *Art, the Ape of Nature, Studies in Honor of H. W. Janson.* New York, 393–400.

Martin 1983
MARTIN, John Rupert. "The Young Van Dyck and Rubens." *Revue d'Art Canadienne / Canadian Art Review (RACAR)* 10:37–43.

"Master and Pupil: Portrait of Rubens and Van Dyck by Van Dyck." *Connoisseur* 101 (February 1938), 82.

Mathews and Van Schaack 1968
MATHEWS, Shirley, and Eric VAN SCHAACK. "The Music in Van Dyck's 'Rinaldo and Armida'." *The Baltimore Museum of Art Annual III: Studies in Honor of Gertrude Rosenthal.* Part 1. Baltimore, 8–15, 75–76.

Mattison 1934
MATTISON, Bror Albert. "Anthonis van Dyck's Tavelsamling." *Tidskrift för Konstvetenschap* 18:48–64.

Mauquoy-Hendrickx 1956
MAUQUOY-HENDRICKX, Marie. *L'Iconographie d'Antoine Van Dyck: Catalogue Raisonné.* 2 vols. Brussels.

Mayer 1923
MAYER, August Liebmann. *Anthonis van Dyck.* Munich.

McNairn 1980a
MCNAIRN, Alan. "Dessins de Jeunesse de Van Dyck." *L'Oeil,* no. 300–301 (July–August), 22–27.

McNairn 1980b
MCNAIRN, Alan. "Ottawa: The Young Van Dyck." *Art Magazine* 12 (September–October), 27–30.

Meli 1878
MELI, G. "Documento relativo a un quadro dell'altar maggiore dell'Oratorio della Compagnia del Rosario di S. Domenico." *Archivio storico siciliano* 3:208–211.

Menotti 1897
MENOTTI, Mario. "Van Dyck a Genova." *Archivio Storico dell'Arte,* 2d series, 3:208–308, 360–397, 432–470.

Menotti 1899
MENOTTI, Mario. "Ritratto di Antonio van Dyck." *L'Arte* 2:254.

Menotti 1899a
MENOTTI, Mario. "L'Esposizione di Opere de Van Dick ad Anversa in Occasione del III Centenario della Nascita del Maestro." *L'Arte* 2:611–622.

Michiels 1882
MICHIELS, Alfred. *Van Dyck et ses Elèves.* Paris.

Millar 1951
MILLAR, Oliver. "Van Dyck's Continence of Scipio at Christ Church." *Burlington Magazine* 93 (April), 125–127.

Millar 1954
MILLAR, Oliver. "Charles I, Honthorst, and Van Dyck." *Burlington Magazine* 96 (February), 36–42.

Millar 1955
MILLAR, Oliver. "Van Dyck at Genoa." *Burlington Magazine* 97 (October), 312–315.

Millar 1958
MILLAR, Oliver. "Van Dyck and Sir Thomas Hanmer." *Burlington Magazine* 100 (July), 249.

Millar 1960a
MILLAR, Oliver (ed.). "Abraham van der Doort's Catalogue of the Collections of Charles I." *Walpole Society* 37:1–243.

Millar 1960b
MILLAR, Oliver. "L'Iconographie d'Antoine van Dyck: Catalogue Raisonné, by Marie Mauquoy-Hendrickx." *Burlington Magazine* 102 (June), 267–268.

Millar 1962
MILLAR, Oliver. "Some Painters and Charles I." *Burlington Magazine* 104 (August), 324–330.

Millar 1963
MILLAR, Oliver. "Van Dyck and Thomas Killigrew." *Burlington Magazine* 105 (September), 409.

Millar 1965
MILLAR, Oliver. "Three Little-Known Seventeenth-Century Paintings." *Apollo* 81 (January), suppl. 1–4.

Millar 1965a
MILLAR, Oliver. "The Early Portraits of the Russells." *Apollo* 82 (December), 468–469.

Millar 1967
MILLAR, Oliver. "A Van Dyck Sketchbook." *Apollo* 86 (July), 73.

Millar 1968
MILLAR, Oliver. "Van Dyck in London." *Burlington Magazine* 110 (June), 306–311.

Millar 1968a
MILLAR, Oliver. "Van Dyck at Agnews." *Burlington Magazine* 110 (December), 711–712.

Millar 1969
MILLAR, Oliver. "Notes on Three Pictures by Van Dyck." *Burlington Magazine* 111 (July), 414–418.

Millar 1972
MILLAR, Oliver (ed.). "The Inventories and Valuations of the King's Goods 1649–51." *Walpole Society* 43.

Millar 1983
MILLAR, Oliver. "Review of C. Brown, Van Dyck (1982)." *Times Literary Supplement* 25 (March), 308.

Moffitt 1983
MOFFITT, John F. "'Le Roi à la Ciasse'?: Kings, Christian Knights and Van Dyck's Singular 'Dismounted Equestrian-Portrait' of Charles I." *Artibus et Historiae* 7:79–99.

Monballieu 1973
MONBALLIEU, A. "Cesare Alessandro Scaglia en de 'Bewening van Christus' door A. van Dyck." *Jaarboek van het Koninklijk Museum voor Schone Kunsten, Antwerpen,* 263–264.

Monod 1910
MONOD, François. "L'Exposition Nationale de Maîtres Anciens à Londres." *Gazette des Beaux-Arts,* 4th series, 3:43–65, 242–261.

Montaiglon 1884
 MONTAIGLON, Anatole de. "Van Dyck en France." *Archives de l'Art français,* 5–7.
Montebello 1963
 MONTEBELLO, G. P. de. "Van Dyck, Painter of the Counter Reformation." *Metropolitan Museum of Art Bulletin* 22 (December), 133–142.
Mortley 1937
 MORTLEY, Clare Stuart. "Anthonie van Dyck." *Old Master Drawings* 12 (September), 25–28.
Moussalli 1948
 MOUSSALLI, U. "Van Dyck et Mytens, Portraitistes de Charles I^er." *Arts* (January), 1.
Müller Hofstede 1973
 MÜLLER HOFSTEDE, Justus. "New Drawings by Van Dyck." *Master Drawings* 11 (Summer), 154–159.
Müller Hofstede 1987–1988
 MÜLLER HOFSTEDE, Justus. "Neue Beiträge zum Oeuvre Anton van Dycks." *Wallraf-Richartz-Jahrbuch* 48–49:123–186.
Müller-Rostock 1922
 MÜLLER-ROSTOCK, Jenny. "Ein Verzeichnis von Bildern aus dem Besitze des Van Dyck." *Zeitschrift für bildende Kunst* 33:22–24.
Nevill Jackson 1902
 NEVILL JACKSON, F. "Lace of the Van Dyck Period." *Connoisseur* 2 (January–April), 106–115.
"A New Study of a Van Dyck Family Group now in the Detroit Institute of Arts." *Connoisseur* 134 (September 1954), 71.
Niemeijer 1981
 NIEMEIJER, J. W. "De Kunstverzameling van John Hope (1737–1784)." *Nederlands Kunsthistorisch Jaarboek* 32:127–230.
Nordenfalk 1938
 NORDENFALK, Carl. "Ein wiedergefundenes Gemälde des Van Dyck." *Jahrbuch der Preussischen Kunstsammlungen* 59:36–48.
Oppé 1931
 OPPE, A. P. "Studies: Recto, for the Picture of the Brazen Serpent in the Prado; Verso, for a Picture of the Mystic Marriage of St. Catherine, and Tracing from the Recto." *Old Master Drawings* 5 (March), 70–73.
Oppé 1941
 OPPE, Paul. "Sir Anthony Van Dyck in England." *Burlington Magazine* 79 (December), 186–191.
Ostrowski 1981
 OSTROWSKI, J. K. *Van Dyck et la Peinture génoise du XVII^e siècle.* Cracow.
"Paintings by Van Dyck at the Exposition de l'Art Belge au XVII^e Siècle à Bruxelles." *Les Arts* 9 (October 1910), 15–25.
Parry 1981
 PARRY, Graham. *The Golden Age Restor'd: The Culture of the Stuart Court, 1603–42.* Manchester.
Passavant 1836
 PASSAVANT, M. *Tour of a German Artist in England, with Notices of Private Galleries, and Remarks on the State of Art.* 2 vols. London.
Peacock 1985
 PEACOCK, J. "The 'Wizard Earl' Portrayed by Hilliard and Van Dyck." *Art History* 8, no. 2 (June), 139–157.
Pearson 1931
 PEARSON, E. T. "Engraved Portraits after Van Dyck." *Pennsylvania Museum Bulletin* 27 (December), 47–49.
Peat 1945
 PEAT, W. D. "Portrait of a Genoese Nobleman." *John Herron Institute Bulletin Indianapolis* 32 (April), 3.
Pedretti 1976
 PEDRETTI, Carlo. "A Newly Discovered Bozetto by Sir Anthony Van Dyck." *Burlington Magazine* 118 (October), 38–40.
Petersen 1976
 PETERSEN, J. H. "Some Notes on Van Dyck's Etching of Paul de Vos." *Revue Belge d'Archéologie et d'Histoire de l'Art* 45:27–31.
Petersen 1978
 PETERSEN, J. H. "Notes on Van Dyck's Two Subject Etchings." *Revue Belge d'Archéologie et d'Histoire de l'Art* 47:107–110.
Pettorelli 1914
 PETTORELLI, Arturo L. "Un' Opera Ignota di Antonio van Dyck." *Rassegna d'Arte* 1:212–216.
Phillips 1887
 PHILLIPS, Claude. "Correspondance d'Angleterre, Expositions rétrospectives de la Royal Academy et de Grosvenor Gallery." *Gazette des Beaux-Arts,* 2d series, 35:257–266.
Phillips 1892
 PHILLIPS, Claude. "Correspondance d'Angleterre, Exposition d'hiver de la Royal Academy." *Gazette des Beaux-Arts,* 3d series, 7:157–164.
Phillips 1893
 PHILLIPS, Claude. "Exposition de Maîtres Anciens à la Royal Academy." *Gazette des Beaux-Arts,* 3d series, 9:223–237.
Phillips 1896
 PHILLIPS, Claude. *The Picture Gallery of Charles I.* London.

Pigler 1956
 PIGLER, A. *Barockthemen: eine Auswahl von Verzeichnissen zur Ikonographie des 17. und 18. Jahrhunderts.* 2 vols. Budapest.
De Piles 1708
 PILES, R. de. *Cours de Peinture par Principes.* Paris.
De Piles 1715
 PILES, R. de. *Abrégé de la vie des peintres.* Paris.
De Piles 1744
 PILES, R. de. *The Art of Painting.* Trans. and ed. B. Buckeridge. London.
De Poorter 1969
 POORTER, Nora de. "Antoon van Dyck. Portret van Frans du Quesnoy (?)." *Openbaar Kunstbezit in Vlaanderen* 7:17a–17b.
Popham 1935
 POPHAM, A. E. "Drawings by Rubens and Van Dyck from the National Gallery." *British Museum Quarterly* 10 (August), 10–18.
Popham 1938
 POPHAM, A. E. "Drawing by Anthony van Dyck: Study for a Portrait of Albert de Ligne, Comte de Barbançon et d'Aremberg." *British Museum Quarterly,* 12 (April), 49–50.
"Portrait of Margarethe de Vos, by Anthony Van Dyck." *Boston Museum Bulletin* 29 (June 1931), 35–36.
"Portrait of Queen Henrietta Maria, Wife of Charles I of England." *Art Quarterly* 3 (1940), 112.
Van de Put 1912
 PUT, Albert van de. "'The Prince of Oneglia' by Van Dyck." *Burlington Magazine* 21:311–314.
Van de Put 1914
 PUT, Albert van de. "Van Dyck's 'Prince of Oneglia'." *Burlington Magazine* 25:59.
Van de Put 1941
 PUT, Albert van de. "Van Dyck's 'St. Martin' at Windsor and at Saventhem, L. van Puyvelde." (reply). *Burlington Magazine* 78 (January), 32.
Van Puyvelde 1933
 PUYVELDE, Leo van. "Les Débuts de Van Dyck." *Revue Belge d'Archéologie et d'Histoire de l'Art* 3 (April), 193–213.
Van Puyvelde 1940
 PUYVELDE, Leo van. "Van Dyck's 'St. Martin' at Windsor and at Saventhem." *Burlington Magazine* 77 (August), 36–42.
Van Puyvelde 1940a
 PUYVELDE, Leo van. "Van Dyck's Portrait of Isabella Brant." *Art in America* 28 (January), 2–11.
Van Puyvelde 1941
 PUYVELDE, Leo van. "The Young Van Dyck." *Burlington Magazine* 79 (December), 177–185.
Van Puyvelde 1942
 PUYVELDE, Leo van. "The Flemish Drawings in the Royal Collection at Windsor Castle." *Burlington Magazine* 80 (April), 92–98.
Van Puyvelde 1942a
 PUYVELDE, Leo van. "A Sketch in Oils by the Young Van Dyck, 'Christ on the Cross'." *Burlington Magazine* 80 (January), 18–21.
Van Puyvelde 1942b
 PUYVELDE, Leo van. "Van Dyck Replicas and a Virgin and Child at Baltimore." *Walters Art Gallery Journal* 5:114–118.
Van Puyvelde 1943
 PUYVELDE, Leo van. "Van Dyck and the Amsterdam Double Portrait." *Burlington Magazine* 83 (August), 204–206.
Van Puyvelde 1944
 PUYVELDE, Leo van. "Van Dyck and Bernini?" *Connoisseur* 114 (September), 3–8.
Van Puyvelde 1946
 PUYVELDE, Leo van. "Van Dyck's Style during his English Period." *Phoebus* 1:60–67, 145–150.
Van Puyvelde 1949a
 PUYVELDE, Leo van. "L'Atelier et les collaborateurs de Rubens." Part 1. *Gazette des Beaux-Arts,* 6th series, 35:115–128.
Van Puyvelde 1949b
 PUYVELDE, Leo van. "L'Atelier et les collaborateurs de Rubens." Part 2. *Gazette des Beaux-Arts,* 6th series, 36:221–260.
Van Puyvelde 1950
 PUYVELDE, Leo van. *Van Dyck.* Brussels.
Van Puyvelde 1955
 PUYVELDE, Leo van. "Van Dyck à Genova." *Emporium* 122:99–116.
Van Puyvelde 1958
 PUYVELDE, Leo van. "L'Esquisse-modèle du Saint Martin de van Dyck." *Zeitschrift für Kunstgeschichte* 21:183–186.
Van Puyvelde 1961
 PUYVELDE, Leo van. "Projets de Rubens et de Van Dyck pour les tapissiers." *Gazette des Beaux-Arts,* 6th series, 57:143–154.
Quandt 1959
 QUANDT, Russell J. "Restoring Van Dyck's Masterwork 'Rinaldo and Armida'." *Baltimore Museum of Art News,* 4–8.

Quednau 1980
 QUEDNAU, Rolf. "Zu einem Porträt von Jan Lievens." *Zeitschrift für Kunstgeschichte* 43:97–104.
Ratti 1766
 RATTI, C. G. *Instruzione di quanto può vedersi di più bello in Genova in pittura, scultura et architettura.* Genoa.
Ratti 1780
 RATTI, Carlo Giuseppe. *Instruzione di Quanto puo' Vedersi di piu' Bello in Genova in Pittura, Scultura, ed Architettura ecc.* Genoa.
Raupp 1984
 RAUPP, Hans-Joachim. *Untersuchungen zu Künstlerbildnis und Künstlerdarstellung in den Niederlanden im 17. Jahrhundert.* Hildesheim.
Réau 1912
 RÉAU, Louis. "La Galerie des Tableaux de l'Ermitage et la Collection Semenov." *Gazette des Beaux-Arts,* 4th series, 8 (November–December), 379–396, 471–488.
"Recherches sur le rôle du dessin dans l'iconographie de Van Dyck, by M. Delâcre." *Burlington Magazine* 62 (April 1933), 199.
Reder 1941
 REDER, Jacob. *The Portraits of the Brignole-Sale Family in the Palazzo Rosso in Genoa by Sir Anthony van Dyck.* New York.
Redig de Campos 1936
 REDIG DE CAMPOS, D. "Intorno a Due Quadri d'Altare del Van Dyck per il Gesù di Roma Ritrovati in Vaticano." *Bollettino d'Arte* 30 (October), 150–165.
Reeve 1989
 REEVE, L. J. *Charles I and the Road to Personal Rule.* Cambridge.
Ribeiro 1977
 RIBEIRO, Aileen. "Some Evidence of the Influence of the Dress of the Seventeenth Century on Costume in Eighteenth-Century Female Portraiture." *Burlington Magazine* 119 (December), 834–840.
Ribeiro 1978
 RIBEIRO, Aileen. "Van Dyck's Double Portrait in the National Gallery." *Burlington Magazine* 120:167.
Richardson 1953
 RICHARDSON, E. P. "Family Group by Van Dyck at Detroit Institute of Arts." *Art Quarterly* 16:228–234.
Richmond 1932
 RICHMOND, E. J. "Drawing by Van Dyck, Preliminary Study for the Figure of Malchus in the Betrayal of Christ in the Prado." *Bulletin of the Rhode Island School of Design* 20 (January), 14–15.
Ricketts 1905
 RICKETTS, Charles. "The portrait of Isabella Brant in the Hermitage." *Burlington Magazine* 7 (April), 83–84.
"Rinaldo and Armida from the Epstein Collection." *Baltimore Museum News* 8 (March 1946), 3–7.
Roberts 1907
 ROBERTS, W. "The Cattaneo Van Dycks." *Connoisseur* 18 (May–July), 41–47, 174.
Röder-Vles 1937
 RÖDER-VLES, D. "Een teekening van Anthonie van Dyck naar een klassiek relief." *Bulletin van de Vereeniging ter Bevordering der Kennis van de Antieke Beschaving* 12:8–13.
Rogers 1978
 ROGERS, Malcolm. "The Meaning of Van Dyck's Portrait of Sir John Suckling." *Burlington Magazine* 120 (November), 741–745.
Rogers 1982
 ROGERS, Malcolm. "Two Portraits by Van Dyck Identified." *Burlington Magazine* 124 (April), 235–236.
Rogers 1985
 ROGERS, Malcolm. "A Van Dyck Discovery: Charles II when Prince of Wales." *Apollo* 121 (January), 20–21.
Roland 1982
 ROLAND, Margaret. "Alan McNairn, The Young van Dyck." *Art Bulletin* 64 (March), 669–672.
Roland 1983
 ROLAND, Margaret. "Some Thoughts on van Dyck's Apostle Series." *Revue d'Art Canadienne / Canadian Art Review (RACAR)* 10:23–36.
Roland 1984
 ROLAND, Margaret. "Van Dyck's Early Workshop, the 'Apostle' Series, and the 'Drunken Silenus'." *Art Bulletin* 66 (June), 211–223.
Rooses 1900
 ROOSES, Max. *Fifty Masterpieces of Anthony van Dyck in Photogravure Selected from the Pictures Exhibited at Antwerp in 1899.* Trans. Fanny Knowles. London.
Rooses 1901
 ROOSES, Max. "Le Portrait de Nicolas Rockox par Van Dyck." *Bulletin de la Classe des Lettres et des Sciences Morales et Politiques et de la Classe des Beaux-Arts* 4:425–433.
Rooses 1904
 ROOSES, Max. "Die vlämischen Meister in der Ermitage." *Zeitschrift für bildende Kunst* 15:114–117.

Rooses 1905
 ROOSES, Max. "The Portrait of Isabella Brant in the Hermitage." *Burlington Magazine* 6 (March), 496–497.
Rooses 1906
 ROOSES, Max. "Van Dyck en Italië." *Bulletin de l'Academie Royale de Belgique* 2:137–145.
Rooses 1907
 ROOSES, Max. "Les années d'étude et de voyage de Van Dyck." *Art Flamand et Hollandais* 8 (July–October), 1–19, 101–110.
Rooses 1911
 ROOSES, Max. "De Vlaamsche Kunst in de XVII^e eeuw tentoongesteld in het Jubelpaleis te Brussel in 1910." *Onze Kunst* 19 (January–February), 1–12, 41–49.
Rosenbaum 1928a
 ROSENBAUM, Heinrich. *Der junge Van Dyck (1615–21),* Ph.D. diss. Ludwig-Maximilians University, Munich.
Rosenbaum 1928b
 ROSENBAUM, Heinrich. "Über früh-Porträts von Van Dyck." *Der Cicerone* 20 (May–June), 325–332, 361–365.
Rosenthal 1946
 ROSENTHAL, Gertrude. "The Van Dyck in the Epstein Collection." *Baltimore Museum of Art News* (March), 3–7.
Roskill 1987
 ROSKILL, Mark. "Van Dyck at the English Court: The Relations of Portraiture and Allegory." *Critical Inquiry* 14:173–199.
Rowlands 1970
 ROWLANDS, J. "Sketch for a Family Group by Van Dyck." *Master Drawings* 8 (Summer), 162–166.
"Rubens' and Van Dyck's Bacchanals after Titian." *Burlington Magazine* 93 (January 1951), 25.
Russell 1926
 RUSSELL, A. G. G. "Anthony van Dyck (1599–1641), Study (in reverse) for the picture of the Brazen Serpent in the Prado." *Old Master Drawings* 1 (June), 8.
Salinas 1890
 SALINAS, Antonio. "Antonio Van Dyck e il suo quadro per la Compagnia del Rosario in S. Domenico di Palermo." *L'Arte* 2:499–500.
Sandrart 1925
 SANDRART, J. von. *Teutsche Academie der Bau-, Bild- und Mahlerei-Künste von 1675.* Ed. A. R. Peltzer. Munich.
Schaeffer 1909
 SCHAEFFER, Emil. *Van Dyck: des Meisters Gemälde.* Stuttgart and Leipzig. *Klassiker der Kunst* 13.
Schaeffer 1926
 SCHAEFFER, Emil. "A Little Known Early Work, Pietà." *Der Kunstwanderer* 8 (January), 192.
Schinzel 1980
 SCHINZEL, H. *Raumprobleme des Ganzfigurenporträts in England von 1600 bis 1640.* Frankfurt.
"Le séjour de Van Dyck en Italie by M. Vaes," *Repertorium für Kunstwissenschaft* 50 (1929), 163–164.
Sharpe 1989
 SHARPE, K. *Politics and Ideas in Early Stuart England.* London, 1989.
Sidney 1981
 SIDNEY, Tessa. "Van Dyck's Portrait of Albert de Ligne, Prince of Arenberg and Barbançon." *City of York Art Gallery Preview* 33:3–11.
Singleton 1929
 SINGLETON, Esther. *Old World Masters in New World Collections.* New York.
"Sir Anthony Van Dyck (1599–1641)." *Burlington Magazine* 79 (December 1941), 172–174.
Sitwell 1941
 SITWELL, Sacheverell. "Van Dyck: an Appreciation." *Burlington Magazine* 79 (December), 174–177.
Smith 1974
 SMITH, Alistair. "Van Dyck's Equestrian Portrait of Charles I." *Burlington Magazine* 116 (September), 539.
Smith 1977
 SMITH, Alistair. "A Van Dyck Double Portrait in the National Gallery." *Burlington Magazine* 119 (December), 859.
Smith 1982
 SMITH, David R. *Masks of Wedlock: Seventeenth-Century Dutch Marriage Portraiture.* Ann Arbor, Michigan.
Smith 1829–1842
 SMITH, John. *A Catalogue Raisonné of the Works of the Most Eminent Dutch, Flemish, and French Painters.* 9 vols. London.
Soprani 1674
 SOPRANI, Raffaelle. *Le vite de' pittori, scultori, ed architetti Genovesi e de' Forastieri che in Genova operarano.* Genoa.
Special Issue Devoted to Van Dyck and Rubens. *Burlington Magazine* 111 (July 1969), 413–443.
Speth-Holterhoff 1957
 SPETH-HOLTERHOFF, S. *Les peintres flamands de cabinets d'amateurs au XVII^e siècle.* Brussels.

Spicer 1985–1986
 SPICER, Joaneath. "Unrecognized Studies for Van Dyck's 'Iconography' in the Hermitage." *Master Drawings* 23–24 (Winter), 537–543.
Stechow 1960
 STECHOW, Wolfgang. "Anthony Van Dyck's 'Betrayal of Christ'."*Minneapolis Institute of Arts Bulletin* 49 (January–June), 4–17.
Sterling 1939
 STERLING, Charles. "Van Dyck's Paintings of St. Rosalie." *Burlington Magazine* 74 (February), 52–63.
Stewart 1979
 STEWART, J. Douglas. "Van Dyck as a Religious Artist: Art Museum Princeton University." *Burlington Magazine* 121 (July), 427–428.
Stewart 1981
 STEWART, J. Douglas. "Ottawa: The Young van Dyck at the National Gallery of Canada." *Burlington Magazine* 123 (February), 120–125.
Stewart 1983
 STEWART, J. Douglas. "'Hidden Persuaders': Religious Symbolism in Van Dyck's Portraiture; With a Note on Dürer's 'Knight, Death and the Devil'." *Revue d'Art Canadienne / Canadian Art Review (RACAR)* 10:57–68.
Stewart 1986
 STEWART, J. Douglas. "'Van Dyck' by Christopher Brown." *Revue d'Art Canadienne / Canadian Art Review (RACAR)* 13:138–141.
Van der Stighelen 1987
 STIGHELEN, Katelijne van der. "The Provenance and Impact of Anthony van Dyck's Portraits of Frans Snijders and Margaretha de Vos in the Frick Collection." *Mercury* 5:37–48.
Stokes 1904
 STOKES, Hugh. *Sir Anthony van Dyck.* London.
Stopes 1913
 STOPES, Charlotte C. "Gleaning from the Records of the Reign of Charles I." *Burlington Magazine* 22 (February), 276–282.
Strong 1972
 STRONG, Roy C. *Van Dyck: Charles I on Horseback.* New York.
Strong 1973
 STRONG, Roy. *Splendour at Court.* London.
Stuart-Wortley 1934
 STUART-WORTLEY, C. E. "Van Dyck Drawing of Anne, Countess of Northumberland." *Burlington Magazine* 65 (December), 284–285.
Stuart-Wortley 1936
 STUART-WORTLEY, C. "Hollar-van Dyck Lady Identified: Portrait Called Katharina Howard and Here Identified as Elizabeth, Lady Herbert of Ragland." *Print Collector's Quarterly* 23 (January), 18–24.
Stuart-Wortley 1937
 STUART-WORTLEY, C. "Portrait of a Man, Edinburgh, National Gallery of Scotland." *Old Master Drawings* 12 (September), 26–28.
Sutton 1981
 SUTTON, Denys. "Early Patrons and Collectors." *Apollo* 114 (November), 282–297.
Swarzenski 1924
 SWARZENSKI, Georg. "Van Dyck's Portrait of the Earl of Arundel." *Bachstitz Gallery Bulletin* 5–6 (January), 10–14.
Szwykowski 1859
 SZWYKOWSKI, Ignatz von. *Anton van Dyck's Bildnisse bekannter Personen.* Leipzig.
Tally 1981
 TALLY, Kirby Mansfield. *Portrait Painting in England: Studies in the Technical Literature before 1700.* London.
Tardito Amerio 1982
 TARDITO AMERIO, Rosalba. *Galleria Sabauda. 150° anniversario (1832–1982): alcuni interventi di restauro.* Turin.
Teodosiu 1965
 TEODOSIU, A. "Une étude d'Antoine van Dyck dans la collection du Musée d'Art de la République Populaire Roumaine." *Revue Belge d'Archéologie et d'Histoire de l'Art* 34:201–209.
Thijssen 1987
 THIJSSEN, L. G. A. "Diversi Ritratti dal Naturale a Cavallo: een ruiterportret uit het Atelier van Rubens geïdentificeerd als Ambrogio Spinola." *Oud Holland* 101:50–64.
Thompson 1961
 THOMPSON, Colin. "X-Rays of a Van Dyck 'St. Sebastian'." *Burlington Magazine* 103 (July), 318–320.
Thompson 1975
 THOMPSON, Colin. *Van Dyck: Variations on the Theme of St. Sebastian.* Edinburgh.
Thoré 1865
 THORE, Théophile Etienne Joseph. *Trésors d'Art en Angleterre.* 3d ed. Paris.
Tiethoff-Spliethoff 1978
 TIETHOFF-SPLIETHOFF, M. E. "De Portretten van Stadhouder Frederik Hendrik." *Jaarboek van het Centraal Bureau voor Genealogie* 32:106–107.
Tietze-Conrat 1932
 TIETZE-CONRAT, Erica. "Van Dyck's 'Samson and Delilah'." *Burlington Magazine* 61 (December), 246–247.

Tietze-Conrat 1950
 TIETZE-CONRAT, Erica. "Das 'Skizzenbuch' des Van Dyck als Quelle für die Tizianforschung." *Critica d'arte* 8 (March), 425–442.
Tolnay 1941
 TOLNAY, Charles de. "Flemish Paintings in the National Gallery of Art." *Magazine of Art* 34 (April), 191–199.
Toynbee 1943a
 TOYNBEE, Margaret R. "Some Early Portraits of Princess Mary, Daughter of Charles I." *Burlington Magazine* 82 (April), 100–103.
Toynbee 1943b
 TOYNBEE, Margaret R. "Van Dyck and the Amsterdam Double Portrait, L. van Puyvelde, Reply with Rejoinder." *Burlington Magazine* 83 (October), 257–258.
Toynbee 1948–1949
 TOYNBEE, Margaret R. "Discussion—Van Dyck Portraits in the Corcoran Gallery of Art, Comments on L. van Puyvelde's Article, with His Reply." *Phoebus* 2:48, 144.
Trapier 1957
 TRAPIER, Elizabeth du Gué. "The School of Madrid and Van Dyck." *Burlington Magazine* 99 (August), 265–273.
Urbach 1983
 URBACH, Susan. "Preliminary Remarks on the Sources of the Apostle Series of Rubens and van Dyck." *Revue d'Art Canadienne / Canadian Art Review (RACAR)* 10:5–22.
Vaes 1924
 VAES, Maurice. "Le séjour de Van Dyck en Italie (Mi-Novembre 1621–Automne 1627)." *Bulletin de l'Institut Historique Belge de Rome* 4:163–234.
Vaes 1925
 VAES, Maurice. "Corneille de Wael." *Bulletin de l'Institut Historique Belge de Rome* 5:137–247.
Vaes 1927
 VAES, Maurice. "L'auteur de la Biographie d'Antoine van Dyck de la Bibliothèque du Musée du Louvre: Dumont, amateur d'art à Amsterdam." *Bulletin de l'Institut Historique Belge de Rome* 7:139–141.
Vaes 1941
 VAES, Maurice. "Il Soggiorno di Antonio van Dyck alla Corte di Torino, 4 dicembre–febbraio 1623." *Bollettino Storico-Bibliografico Subalpino* 43:227–239.
Valentiner 1910
 VALENTINER, Wilhelm R. "Frühwerke des Anton van Dyck in Amerika." *Zeitschrift für bildende Kunst* 21:225–231.
Valentiner 1913
 VALENTINER, W. R. "Rubens and Van Dyck in Mr. P. A. B. Widener's Collection." *Art in America* 1 (July), 158–170.
Valentiner 1914
 VALENTINER, W. R. *The Art of the Low Countries: Studies.* Garden City, New York.
Valentiner 1914a
 VALENTINER, W. R. *Gemälde Van Dycks in Amerika.* Berlin.
Valentiner 1929
 VALENTINER, W. R. "Die Van Dyck Ausstellung in Detroit." *Zeitschrift für bildende Kunst* 63 (August), 105–111.
Valentiner 1949
 VALENTINER, W. R. "Van Dyck's Portrait of Mary Villiers, Duchess of Richmond and Lennox, with Mrs. Gibson, Her Dwarf." *Los Angeles Museum of Art Bulletin* 3:12–15.
Valentiner 1950a
 VALENTINER, W. R. "Rinaldo and Armida by Van Dyck." *Los Angeles Museum Quarterly* 8, no. 1, 8–10.
Valentiner 1950b
 VALENTINER, W. R. "Van Dyck's Character." *Art Quarterly* 13:86–105.
Valentiner 1950c
 VALENTINER, W. R. "Van Dyck's Rinaldo and Armida, Inspired by Tasso's Jerusalem Delivered: Earliest Version of the Painting Acquired by the Los Angeles Museum." *Art News* 49 (March), 34–37.
Vandalle 1933
 VANDALLE, M. "Les cent portraits par Antoine van Dyck." *Revue Belge d'Archéologie et d'Histoire de L'Art* 3 (October), 289–316.
Vergara 1983
 VERGARA, Lisa. "Steenwijk, De Momper and Snellinx: Three Painters' Portraits by Van Dyck." *Essays in Northern Art Presented to Egbert Haverkamp-Begemann on His Sixtieth Birthday.* Doornspijk, 283–286.
Vertue 1757
 VERTUE, George, Ed. Abraham van der Doort, *A Catalogue and Description of King Charles the First's Capital Collection.* London.
Vertue 1930–1955
 VERTUE, George. "Notebooks." *Walpole Society* 18 (1930), 20 (1932), 22 (1934), 24 (1936), 26 (1938), 29 (1947), 30 (1955).
Vey 1956
 VEY, Horst. "Anton van Dycks Ölskizzen." *Bulletin des Musées Royaux des Beaux-Arts* 5:167–208.

Vey 1957
VEY, Horst. "Einige unveröffentlichte Zeichnungen Van Dycks." *Bulletin des Musées Royaux des Beaux-Arts* 6:175–210.

Vey 1958
VEY, Horst. *Van Dyck-Studien*. Cologne.

Vey 1959
VEY, Horst. "De Apostel Judas Thaddeus door Van Dyck." *Bulletin Museum Boymans-van Beuningen* 10:86–96.

Vey 1960
VEY, Horst. "Anton van Dijck—über Maltechnik." *Bulletin des Musées Royaux des Beaux-Arts* 96:193–201.

Vey 1961
VEY, Horst. "Die Kunstsammlung Pastor Theodoor van Dycks." *Bulletin des Musées Royaux des Beaux-Arts* 10:19–28.

Vey 1962
VEY, Horst. *Die Zeichnungen Anton van Dycks*. 2 vols. Brussels.

Vey 1967
VEY, Horst. "Die Bildnisse Everhard Jabachs." *Wallraf-Richartz-Jahrbuch* 29:157–187.

Vickers 1978
VICKERS, Michael. "Rupert of the Rhine: a New Portrait by Dieussart and Bernini's 'Charles I'." *Apollo* 107 (March), 161–169.

Volk 1980
VOLK, Mary Crawford. "New Light on a Seventeenth-Century Collector: The Marquis of Leganés." *Art Bulletin* 62 (June), 256–268.

Voss 1963
Voss, Hermann. "Eine unbekannte Vorstudie Van Dycks zu dem Münchner Sebastiansmartyrium." *Kunstchronik* 16:294–297.

Waagen 1838
WAAGEN, G. F. *Works of Art and Artists in England*. London.

Waagen 1854
WAAGEN, G. F. *Treasures of Art in Great Britain: Being an Account of Paintings, Drawings, Sculptures, Illuminated MSS., &c. &c.* 3 vols. London.

Waagen 1857
WAAGEN, G. F. *Galleries and Cabinets of Art in Great Britain: Being an Account of more than Forty Collections of Paintings, Drawings, Sculptures, MSS., &c. &c.* (Forming a supplemental volume to the Treasures of Art in Great Britain, three volumes). London.

Waagen 1866
WAAGEN, G. F. *Die vornehmsten Kunstdenkmaler in Wien*. 2 vols. Vienna.

Walpole 1876
WALPOLE, Horace. *Anecdotes of Painting in England; with Some Account of the Principal Artists*. 3 vols. London.

Walton 1910
WALTON, William. "Exhibition in New York of Portraits by Van Dyck." *Burlington Magazine* 16 (February), 296–302.

Walton and Cust 1909–1910
WALTON, W., and L. CUST. "Exhibition in New York of Portraits by Van Dyck." *Burlington Magazine* 16:296–302.

Wark 1956
WARK, R. R. "A Note on Van Dyck's Self-Portrait with a Sunflower." *Burlington Magazine* 98 (February), 52–54.

Waterhouse 1945
WATERHOUSE, Ellis. "Van Dyck and the Amsterdam Double Portrait." *Burlington Magazine* 86 (February), 50–51.

Waterhouse 1953
WATERHOUSE, Ellis. *Paintings in Britain 1530–1790*. Baltimore.

Waterhouse 1978
WATERHOUSE, Ellis. *Anthony van Dyck, Suffer Little Children to Come unto Me / Antoine van Dyck, Laissez les enfants venir à Moi*. Masterpieces in the National Gallery of Canada, no. 11. Ottawa.

Watson 1950
WATSON, F. J. B. "Van Dyck's Portrait of a Young Italian Nobleman in the Wallace Collection." *Burlington Magazine* 92 (June), 174–177.

Webb 1950
WEBB, M. I. "Sculpture by Rysbrack at Stourhead." *Burlington Magazine* 92 (November), 307–315.

Weyerman 1729
WEYERMAN, Jacob Campo. *De Levens-beschrijvingen der Nederlandsche Konstschilders en Konstschilderessen*. 4 vols. The Hague.

Whinney and Millar 1957
WHINNEY, Margaret, and Oliver MILLAR. *English Art 1625–1714*. Oxford.

White 1960
WHITE, Christopher. "Van Dyck Drawings and Sketches." *Burlington Magazine* 102 (December), 510–516.

White 1969
WHITE, Christopher. "Van Dyck's Antwerp Sketchbook, by Michael Jaffé." *Burlington Magazine* 111 (July), 459.

White 1986
WHITE, Christopher. "The Portrait of Mountjoy Blount, First Earl of Newport, by Sir Anthony van Dyck." *In Honor of Paul Mellon: Collector and Benefactor*. Ed. John Wilmerding. Washington, 382–387.

Wiemers 1987–1988
WIEMERS, Michael. "Die Seele im Bildnis: Anmerkungen zu einem englischen Porträtgedicht des 17. Jahrhunderts." *Wallraf-Richartz-Jahrbuch* 48–49:249–268.

Van den Wijngaert 1943
WIJNGAERT, Frank van den. *Antoon van Dyck*. Antwerp.

Wishnevsky 1967
WISHNEVSKY, Rose. "Studien zum 'Portrait Historié' in den Niederlanden." Ph.D. diss. Ludwig-Maximilians-Universität, Munich.

Wittler 1928
WITTLER, Lelia. "The Cattaneo-Lomellini Van Dycks." *International Studio* (August), 35–41.

Woodward 1960
WOODWARD, John. "Van Dyck at Nottingham." *Burlington Magazine* 102 (July), 339–340.

Wortley 1931
WORTLEY, Clare Stuart. "Van Dyck and the Wentworths." *Burlington Magazine* 59 (September), 102–107.

Wyzewa 1910
WYZEWA, T. de. "L'Exposition de l'Art Flamand du XVIIe siècle au Palais du Cinquantenaire." *Revue de l'Art Ancien et Moderne* 28 (September–October), 177–194, 301–316.

EXHIBITION CATALOGUES

Amsterdam 1947
Kunstschatten uit Wenen, Meesterwerken uit Oostenrijk. Rijksmuseum.

Amsterdam 1948
Meesterwerken uit de Oude Pinacotheek te München. Rijksmuseum.

Antwerp 1899
Exposition Van Dyck à l'occasion du 300e anniversaire de la naissance du maître / Van Dijck Tentoonstelling ter Gelegenheid der 300e Verjaring der Geboorte van den Meester. Koninklijk Museum voor Schone Kunsten.

Antwerp 1930
Trésors de l'Art Flamand du Moyen Age au XVIIIe siècle: Mémorial de l'Exposition d'Art Flamand Ancien à Anvers 1930. 2 vols. Antwerp and Paris, 1932.

Antwerp 1949
Van Dyck Tentoonstelling. Koninklijk Museum voor Schone Kunsten.

Antwerp 1960
D'HULST, Roger-A., and Horst VEY. *Antoon van Dyck, Tekeningen en Olieverfschetsen*. Antwerp, Rubenshuis, and Rotterdam, Museum Boymans-van Beuningen.

Antwerp 1983
Antoon van Dyck op de Meir. Kolveniershof.

Brussels 1910
Trésor de l'Art Belge au XVIIe Siècle, Mémorial de l'Exposition d'Art Ancien à Bruxelles en 1910. 2 vols. Brussels and Paris, 1912–1913.

Brussels 1947
Les Relations Artistiques Austro-Belges Illustrées par les Chefs-d'Oeuvres des Musées de Vienne. Palais des Beaux-Arts.

Brussels 1965
Le Siècle de Rubens. Musées Royaux des Beaux-Arts de Belgique.

Chicago 1954
Masterpieces of Religious Art. The Art Institute of Chicago.

Cologne 1968
Weltkunst aus Privatbesitz. Kunsthalle.

Detroit 1921
Fifty Paintings by Anthony van Dyck. The Detroit Institute of Arts.

Detroit 1929
Eighth Loan Exhibition of Old Masters, Paintings by Anthony van Dyck. The Detroit Institute of Arts.

Eastbourne 1984
Drawings and Etchings by Anthony Van Dyck 1599–1641: An Exhibition of the Artist's Original Portrait Drawings and Their Related Engravings from the Devonshire Collection, Chatsworth. Towner Art Gallery.

Elewijt 1962
Rubens Diplomate. Château Rubens.

Genoa 1955
100 Opere di Van Dyck. Palazzo dell'Academia.

Liverpool 1959
The Heywood-Lonsdale Loan. Walker Art Gallery.

London 1835
A Catalogue of One Hundred Original Drawings by Ant. Vandyke, and by Rembrandt van Rijn, coll. by Thomas Lawrence. Lawrence Gallery.

London 1887
Exhibition of the Works of Sir Anthony van Dyck. Grosvenor Gallery.

London 1900
Exhibition of Works by Van Dyck. Royal Academy of Arts.

London 1927
Catalogue of the Loan Exhibition of Flemish & Belgian Art, a Memorial Volume. Ed. Martin Conway. Royal Academy of Arts.

London 1938
17th Century Art in Europe, an Illustrated Souvenir of the Exhibition of 17th Century Art in Europe at the Royal Academy of Arts.
London 1946–1947
Catalogue of the Exhibition of the King's Pictures (text vol.); *The King's Pictures, an Illustrated Souvenir of the Exhibition at the Royal Academy of Arts* (pl. vol.).
London 1949
Masterpieces from the Alte Pinakothek at Munich. National Gallery.
London 1953–1954
Flemish Art 1300–1700. Royal Academy of Arts.
London 1955
Artists in 17th Century Rome. Wildenstein.
London 1968
Van Dyck, Wenceslaus Hollar & the Miniature-Painters at the Court of the Early Stuarts. The Queen's Gallery, Buckingham Palace.
London 1968a
Sir Anthony van Dyck, a Loan Exhibition of Pictures and Sketches Principally from Private Collections in Aid of the National Trust Neptune Appeal and the King's Lynn Festival Fund. Thomas Agnew and Sons, Ltd.
London 1970
Endymion Porter and William Dobson. Cat. by William Vaughan. The Tate Gallery.
London 1972
Flemish Drawings of the Seventeenth Century from the Collection of Frits Lugt. Institut Néerlandais, Paris. London, Victoria and Albert Museum, 1972; Paris, Institut Néerlandais, 1972; Bern, Kunstmuseum, 1972; Brussels, Royal Library of Belgium, 1972.
London 1972–1973
The Age of Charles I, Painting in England 1620–1649. Cat. by Oliver Millar. The Tate Gallery.
London 1982–1983
Van Dyck in England. Cat. by Oliver Millar. National Portrait Gallery.
London 1988–1989
Treasures from the Royal Collection. Cat. by Oliver Millar. The Queen's Gallery, Buckingham Palace.
Lucerne 1948
Meisterwerke aus den Sammlungen des Fürsten von Liechtenstein. Kunstmuseum.
Manchester 1857
European Old Masters. City of Manchester Art Gallery.
Minneapolis 1972
The J. Paul Getty Collection. The Minneapolis Institute of Arts.
Moscow 1972
Portret v evropeiskoi zhivopisi xv-nachala xx veka (The Portrait in European Painting from the 15th to the Early 20th Century).
New York 1909
Exhibition of Portraits by Van Dyck from the Collections of Mr. P. A. B. Widener and Mr. H. C. Frick. M. Knoedler & Co.
New York 1985–1986
Liechtenstein: The Princely Collections. The Metropolitan Museum of Art.
New York 1988a
Dutch and Flemish Paintings from the Hermitage. The Metropolitan Museum of Art; The Art Insitute of Chicago.
New York 1988b
Dutch and Flemish Paintings from New York Private Collections. Cat. by Ann Jensen Adams and Egbert Haverkamp-Begemann. National Academy of Design.
Ottawa 1980a
The Young Van Dyck / Le jeune Van Dyck. Cat. by Alan McNairn. National Gallery of Canada.
Ottawa 1980b
Van Dyck's Iconography / L'Iconographie de Van Dyck. Cat. by Alan McNairn. National Gallery of Canada.
Oxford 1985–1986
Patronage and Collecting in the Seventeenth Century: Thomas Howard Earl of Arundel. Cat. by David Howarth. The Ashmolean Museum.
Paris 1936
Rubens et son Temps. Cat. by René Huyghe. Musée de l'Orangerie.
Paris 1977–1978
Le Siècle de Rubens dans les collections publiques françaises. Grand Palais.
Paris 1981
Antoon van Dyck et son Iconographie. Institut Néerlandais.
Princeton 1979
Van Dyck as a Religious Artist. Cat. by John Rupert Martin and Gail Feigenbaum. Princeton University, The Art Museum.
Rotterdam 1985
Masterpieces from the Hermitage, Leningrad. Museum Boymans-van Beuningen.
Sarasota 1984–1985
Baroque Portraiture in Italy: Works from North American Collections. Cat. by John T. Spike. Sarasota, The John and Mable Ringling Museum of Art, and Hartford, Wadsworth Atheneum.

Tokyo 1987
Space in European Art. The National Museum of Western Art.
Turin 1951
La Moda in Cinque Secoli di Pittura. Palazzo Madama.
Turin 1989
Diana Trionfatrice: Arte di Corte nel Piemonte del Seicento. Cat. by Michela di Macco and Giovanni Romano. Pasco del Valentino.
Vaduz 1967
Flämische Malerei im 17. Jahrhundert: Ausstellung aus den Sammlungen seiner Durchlaucht des Fürsten von Liechtenstein. Cat. by G. Wilhelm. Vaduz, 1968.
Vaduz 1974
Peter Paul Rubens: aus den Sammlungen des Fürsten von Liechtenstein. Cat. by G. Wilhelm.
Vienna 1977
Peter Paul Rubens (1577–1640). Kunsthistorisches Museum.
Vienna 1981
Gemälde aus der Eremitage und dem Puschkin-Museum. Kunsthistorisches Museum.
Washington 1975–1976
Master Paintings from the Hermitage and the State Russian Museum, Leningrad. National Gallery of Art.
Washington 1978–1979
The Splendor of Dresden: Five Centuries of Art Collecting. Washington, National Gallery of Art; The Metropolitan Museum of Art, New York; The Fine Arts Museums of San Francisco, California Palace of The Legion of Honor.
Washington 1985–1986
The Treasure Houses of Britain, Five Hundred Years of Private Patronage and Art Collecting. National Gallery of Art.
Washington 1985–1986a
Collection for a King: Old Master Paintings from the Dulwich Picture Gallery. Washington, National Gallery of Art; Los Angeles County Museum of Art.

COLLECTION CATALOGUES

Alte Pinakothek 1974
BACCHESCHI, Edi. *The Alte Pinakothek of Munich and the Castle of Schleissheim and Their Paintings.* Edinburgh.
Alte Pinakothek 1986
Alte Pinakothek Munich. Bayerische Staatsgemäldesammlungen, Munich.
Arundel Club 1916
The Arundel Club, for the Publication of Reproductions of Works of Art in Private Collections and Elsewhere. London.
Baltimore Museum of Art 1939
The Jacob Epstein Collection in the Baltimore Museum of Art, Baltimore.
Blenheim 1861
SCHARF, George. *Catalogue Raisonné; or a List of the Pictures in Blenheim Palace; with Occasional Remarks and Illustrative Notes.* 2 vols. London.
Brera 1950
Catalogue de la Pinacotèque de Brera à Milan.
Brera 1977
Pinacoteca di Brera. Milan.
British Museum 1923
HIND, A. M. *Catalogue of Drawings by Dutch and Flemish Artists Preserved in the Department of Prints and Drawings in the British Museum.* London.
Cleveland Museum 1958
MILLIKEN, William M. *The Cleveland Museum of Art.* New York.
Cleveland Museum 1978
Handbook of the Cleveland Museum of Art. Cleveland.
Cleveland Museum 1982
European Paintings of the 16th, 17th, and 18th Centuries (part 3). Cleveland.
Corsham Court 1806
BRITTON, John. *An Historical Account of Corsham House, in Wiltshire; the Seat of Paul Cobb Methuen, Esq. with a Catalogue of His Celebrated Collection of Pictures.* London.
Corsham Court 1974
COOMBS, David. "The Methuen Collection, Corsham Court, Wiltshire." *Connoisseur* 187 (November), 154–169.
Crozat 1755
Catalogue des Tableaux du Cabinet de M. Crozat, Baron de Thiers, Paris. Repr. Geneva, 1972.
Crozat 1968
STUFFMANN, Margaret. "Les tableaux de la collection de Pierre Crozat; Historique et destinée d'un ensemble célèbre, établis en partant d'un inventaire après décès inédit (1740)." *Gazette des Beaux-Arts,* 6th series, 72 (July–September), 94–143.
Dulwich 1980
MURRAY, Peter. *Dulwich Picture Gallery, a Catalogue.* London, and Totowa, New Jersey.

Gemäldegalerie Berlin 1971
KLESSMANN, R. *The Berlin Gallery*. London.

Gemäldegalerie Berlin 1978
PARSHALL, Linda B., trans. *Catalogue of Paintings 13th–18th Century*. Berlin-Dahlem.

Gemäldegalerie Berlin 1986
Gemäldegalerie Berlin, Gesamtverzeichnis der Gemälde.

Gemäldegalerie Dresden 1765
Catalogue des Tableaux de la Galerie Electorale à Dresde.

Gemäldegalerie Dresden 1876
HÜBNER, Julius. *Catalogue of the Royal Picture Gallery in Dresden.*

Gemäldegalerie Dresden 1905
WOERMANN, Karl. *Katalog der Königlichen Gemäldegalerie zu Dresden.* 6th enl. ed.

Gemäldegalerie Dresden 1987
Staatliche Kunstsammlungen Dresden, Gemäldegalerie alte Meister Dresden, Kataloge der ausgestellten Werke.

Getty 1972
FREDERICKSEN, Burton B. *Catalogue of the Paintings in the J. Paul Getty Museum.* Malibu, California.

Hermitage 1774
Catalogue des Tableaux qui se trouvent dans les Galeries et dans les Cabinets du Palais Impérial de Saint Pétersbourg.

Hermitage 1864
WAAGEN, G. F. *Die Gemäldesammlung in der kaiserlichen Ermitage zu St. Petersburg.* Munich.

Hermitage 1870
Ermitage impérial, Catalogue de la Galerie des Tableaux, Les Ecoles germaniques. Saint Petersburg.

Hermitage 1923
WEINER, P. P. von. *Meisterwerke der Gemäldesammlung in der Eremitage zu Petrograd.* Munich.

Hermitage 1955
DOBROKLONSKY, M. V. *Gosudarstvennyi Ermitazh, Risunki Flamandskoi Shkoly.* Moscow.

Hermitage 1958
BAZIN, Germain. *Musée de l'Ermitage; Les Grands Maîtres de la Peinture.* Paris.

Hermitage 1963
VARSHAVSKAYA, M. *Van Dyck Paintings in the Hermitage,* Leningrad.

Hermitage 1964
The Hermitage, Dutch and Flemish Masters. Leningrad.

Herzog Anton Ulrich-Museum 1976
Verzeichnis der Gemälde vor 1800. Braunschweig.

Herzog Anton Ulrich-Museum 1978
KLESSMANN, Rüdiger. *Herzog Anton Ulrich-Museum Braunschweig.* Munich.

Houghton Hall 1752
WALPOLE, Horace. *Aedes Walpolianae: or, a Description of the Collection of Pictures at Houghton-Hall in Norfolk, The Seat of the Right Honourable Sir Robert Walpole, Earl of Oxford.* London.

Imstenraedt 1971
LEY, Henry. "The Imstenraedt Collection." *Apollo* 94 (July), 50–59.

Kaiser-Friedrich-Museum 1921
Beschreibendes Verzeichnis der Gemälde in Kaiser-Friedrich-Museum, Berlin.

Kenwood 1953
The Iveagh Bequest Kenwood, Catalogue of Paintings. London.

Koninklijk Museum 1959
Koninklijk Museum voor Schone Kunsten te Antwerpen: Oude Meesters. Brussels.

Koninklijk Museum 1970
Musée Royal des Beaux-Arts, Anvers. Catalogue Descriptif: Maîtres Anciens, n.p.

Koninklijke Musea 1984
Koninklijke Musea voor Schone Kunsten van België, Inventariscatalogus van de oude schilderkunst. Brussels.

Kress 1977
EISLER, Colin. *Paintings from the Samuel Kress Collection: European Schools Excluding Italian.* Oxford.

Kunsthistorisches Museum 1767
WENCESLAO, Giuseppe. *Descrizzione completa di tutto ciò che ritrovasi nella galleria di pittura e scultura.* Vienna.

Kunsthistorisches Museum 1783
MECHEL, Christian von. *Verzeichniss der Gemälde der kaiserlich königlichen Bilder Galerie in Wien.* Vienna.

Kunsthistorisches Museum 1896
Führer durch die Gemälde-Galerie. Alte Meister. 3 vols. Vienna.

Kunsthistorisches Museum 1963
Katalog der Gemäldegalerie, Wien, Kunsthistorisches Museum.

Kunsthistorisches Museum 1987
BALIS, Arnout, and others. *Flandria Extra Muros: De Vlaamse Schilderkunst in het Kunsthistorisches Museum te Wenen.* Antwerp.

Liechtenstein 1767
FANTI, V. *Descrizzione completa di tutto ciò che ritrovasi nella galleria di pittura e scultura di Sua Altezza Giuseppe Wenceslao del S.R.I. Principe Regnante della casa di Lichtenstein.* Vienna.

Liechtenstein 1780
DALLINGER, J. *Description des tableaux et des pièces de sculpture que renferme la galerie de son Altesse François Joseph Chef et Prince Regnant de la Maison de Liechtenstein.* Vienna.

Liechtenstein 1896
BODE, Wilhelm von. *Die Fürstlich Liechtenstein'sche Galerie in Wien.*

Liechtenstein 1927
KRONFELD, A. *Führer durch die fürstlich liechtensteinsche Gemäldegalerie in Wien.* Vienna.

Liechtenstein 1943
STROHMER, Erich V. *Die Gemäldegalerie des Fürsten von Liechtenstein in Wien.* Vienna.

Liechtenstein 1980
BAUMSTARK, Reinhold. *Masterpieces from the Collection of the Princes of Liechtenstein.* Trans. by R. Wolf. New York.

Louvre 1793
Catalogue des objets contenus dans la Galerie du Muséum Français. Paris.

Louvre 1799
Notice des tableaux des écoles française et flamande, exposés dans la Grande Galerie du Musée Central des Arts. Paris.

Louvre 1852
VILLOT, Frédéric. *Notice des tableaux exposés dans les galeries du Musée national du Louvre.* 2d part, Ecoles Allemande, Flamande et Hollandaise. Paris.

Louvre 1922
DEMONTS, Louis. *Catalogue des Peintures Exposées dans les Galeries; Ecoles Flamande, Hollandaise, Aliemande et Anglaise.* 3 vols. Paris.

Louvre 1979
BREJON DE LAVERGNEE, Arnauld, Jacques FOUCART, and Nicole REYNAUD. *Catalogue Sommaire illustré des peintures du Musée du Louvre. I Ecoles flamande et hollandaise.* Paris.

Louvre 1987
GOWING, Lawrence. *Paintings in the Louvre.* New York.

Mauritshuis 1985
HOETINK, H. R. (ed.). *The Royal Picture Gallery Mauritshuis.* Amsterdam, The Hague, and New York.

Mauritshuis 1987
BROOS, Ben. *Meesterwerken in het Mauritshuis.* The Hague.

Metropolitan Museum 1931
BURROUGHS, Bryson. *The Metropolitan Museum of Art, Catalogue of Paintings.* New York. 9th ed.

Metropolitan Museum 1980
BAETJER, Katherine. *European Paintings in the Metropolitan Museum of Art by Artists Born in or before 1865, a Summary Catalogue.* 3 vols. New York.

Metropolitan Museum 1984
LIEDTKE, Walter A. *Flemish Paintings in the Metropolitan Museum of Art.* 2 vols. New York.

Minneapolis Institute 1970
Catalogue of European Paintings in the Minneapolis Institute of Arts.

Minneapolis Institute 1988
LAWALL LIPSCHULTZ, Sandra. *Selected Works, the Minneapolis Institute of Arts.*

Musée Jacquemart-André 1948
Catalogue Itinéraire. Paris.

National Gallery Canada 1987
LASKIN, Myron, Jr., and Michael PANTAZZI (eds.). *Catalogue of the National Gallery of Canada, European and American Painting, Sculpture, and Decorative Arts.* 2 vols. Ottawa.

National Gallery London 1970
MARTIN, Gregory. *The Flemish Schools, circa 1600–circa 1900.*

National Gallery London 1987
BROWN, Christopher. *The National Gallery Schools of Painting, Flemish Painting.*

National Gallery Scotland 1957
New National Gallery of Scotland, Catalogue of Paintings and Sculpture. Edinburgh.

National Gallery Washington 1975
European Paintings: An Illustrated Summary Catalogue.

National Gallery Washington 1976
WALKER, John. *National Gallery of Art, Washington.* New York.

National Gallery Washington 1985
European Paintings: An Illustrated Catalogue. Washington.

North Carolina Museum of Art 1956
VALENTINER, W. R. *Catalogue of Paintings Including Three Sets of Tapestries.* Raleigh.

North Carolina Museum of Art 1966
STANFORD, Charles W., Jr. *Masterpieces in the North Carolina Museum of Art.* Raleigh.

North Carolina Museum of Art 1983
 BOWRON, Edgar Peters (ed.). *The North Carolina Museum of Art, Introduction to the Collections.* Raleigh.
Palazzo Bianco Genoa 1970
 Catalogo provvisorio della Galleria di Palazzo Bianco, Genoa.
Petworth 1920
 COLLINS BAKER, C. H. *Catalogue of the Petworth Collection of Pictures in the Possession of Lord Leconfield.* London.
Petworth 1954
 Petworth House Sussex. London.
Petworth 1989
 GORE, St. John. "Old Masters at Petworth." *The Fashioning and Functioning of the British Country House.* Vol. 25. Studies in the History of Art, Washington, 121–131.
Pinacoteca Capitolina 1890
 VENTURI, A. *The Capitol Picture-Gallery, Rome.*
Pinacoteca Capitolina 1960
 PIETRANGELI, Carlo. *Musei Capitolini, Rome.*
Pinacoteca Capitolina 1978
 BRUNO, Raffaele. *Roma Pinacoteca Capitolina.* Bologna.
Pinacoteca Capitolina 1984
 LA ROCCA, Eugenio. *Capitoline Museums, Rome.* Milan.
Pinacoteca Vicenza 1934
 ARSLAN, Wart. *La Pinacoteca di Vicenza.* Rome.
Pinacoteca Vicenza 1962
 BARBIERI, Franco. *Il Museo Civico di Vicenza, Dipinti e Sculture dal XVI al XVIII Secolo.* 2 vols. Venice.
Prado 1913
 MADRAZO, Don Pedro de. *Catalogue des Tableaux du Musée du Prado.* Madrid.
Prado 1949
 SANCHEZ CANTON, F. J. *The Prado Museum Pictures, Statues, Drawings and Jewels.* Madrid.

Prado 1975
 DIAZ PADRON, Matías. *Escuela flamenca, siglo XVII, Museo del Prado.* 2 vols. Madrid.
Prado 1989
 BALIS, Arnout, and others. *Flandria Extra Muros, De Vlaamse Schilderkunst in het Prado.* Antwerp.
Royal Collection 1841
 [SEGUIER, W.] *Catalogue of Her Majesty's Pictures in Buckingham Palace.*
Royal Collection 1929
 COLLINS BAKER, C. H. *Catalogue of the Pictures at Hampton Court.* Glasgow.
Royal Collection 1937
 COLLINS BAKER, C. H. *Catalogue of the Principal Pictures in the Royal Collection at Windsor Castle.* London.
Royal Collection 1963
 MILLAR, Oliver. *The Tudor, Stuart and Early Georgian Pictures in the Collection of Her Majesty the Queen.* 2 vols. London.
Royal Collection 1977
 MILLAR, Oliver. *The Queen's Pictures.* London.
Sabauda 1951
 Ventiquattro Capolavori della Galleria Sabauda di Torino. Galleria Sabauda.
Sabauda 1968
 BERNARDI, Marziano. *La Galleria Sabauda di Torino.* Turin.
Sabauda 1969
 MAZZINI, Franco. *Turin: The Sabauda Gallery.*
Widener 1913
 VALENTINER, W. R., and C. HOFSTEDE DE GROOT. *Pictures in the Collection of P. A. B. Widener at Lynnewood Hall, Elkins Park, Pennsylvania.* Philadelphia.

List of Works Exhibited

Index

Photo Credits

Photos are to be credited to owners of works of art except as indicated below.

Brown fig. 3 Edward Reeves, Lewes, fig. 7 Alinari, Florence, fig. 9 Kunstverlag Wolfrum, Vienna; Filipczak figs. 3, 4 Anderson, Rome; Stewart fig. 1 A.C.L., Brussels. Cat. 6, fig. 1, and cat. 52, fig. 1, Walter Wachter Atelier; cat. 11, fig. 1, and cat. 76, fig. 2, Courtauld Institute, London; cat. 24, fig. 1, Foto Amoretti-Parma; cat. 34, fig. 3, and cat. 71, fig. 1, Jörg P. Anders Photoatelier; cat. 42, fig. 1, Beedle & Cooper, Northampton, England; cat. 43, fig. 2, Rick Gardner, Houston; cat. 46, fig. 5, B. Huysmans; cat. 58, fig. 1, Frequin Photos, Voorburg; cat. 60, fig. 1, Bildarchiv Foto Marburg; cat. 61, fig. 2, Ralph Kleinhempel; cat. 66, fig. 1, Pfauder; cat. 67, fig. 1, and cat. 78, fig. 1, Photo Studios Ltd., London; cat. 96, fig. 2, Alinari